U0136677

Shung Ye Museum of Formosan Aborigines Monograph 3

THE FORMOSAN ENCOUNTER

Volume II: 1636-1645

THE FORMOSAN ENCOUNTER

Notes on Formosa's Aboriginal Society:
A Selection of Documents from
Dutch Archival Sources

Volume II: 1636-1645

Edited by
Leonard Blussé & Natalie Everts

Published by
Shung Ye Museum of Formosan Aborigines
Taipei 2000

This publication has been sponsored by
Shung Ye Museum of Formosan Aborigines

Cover illustration: 'Landtag auf der Insul Formosa'. Drawing by C. Schmalkalden. From: *Die wundersamen Reisen des Casper Schmalkalden nach West- und Ostindiën 1642-1652/[Casper Schmalkalden]*. Nach einer bisher unveröffentlichten Handschrift bearbeitet und herausgegeben von Wolfgang Joost. Leipzig 1983.

ISBN 957-99767-7-5

Distributor:
SMC PUBLISHING INC.
14, Alley 14, Lane 283, Roosevelt Rd. Sec.3
Taipei 106, Taiwan, ROC
Tel. (886-2) 2362-0190 Fax (886-2) 2362-3834

CONTENTS

PREFACE

In the first volume of *The Formosan Encounter*, which appeared in 1997, the editors strove to make available 17th century archival data about Formosan aboriginal society to an international readership which does not feel comfortable reading Dutch. As a result we also added to the selected texts, various excerpts taken from the *Dagregisters van het kasteel Zeelandia, Taiwan* (The Diaries of Zeelandia Castle, Taiwan), which we have also been editing over the past years. Shortly after *The Formosan Encounter* appeared, Professor Chiang Shu-sheng accepted, at the invitation of the Tainan municipal government, the challenging task of making a complete Chinese translation of the four volumes of the Zeelandia Diaries (1629-1662). Prof. Chiang's excellent translation of Volume I of these diaries has recently been published, with the others to follow in the years to come. Because the editors want to avoid any future overlapping of the texts, they have decided to refer in the present volume, whenever it is possible, to the four main source publications on the Dutch period in Taiwan which are also available in Chinese, Japanese or English. First of all the *Dagregisters van het kasteel Zeelandia*, the *Dagregisters van het kasteel Batavia* (of which the entries on Taiwan and Japan have been annotated and translated into Japanese by Murakami Naojiro and Nakamura Takashi), the *Generale Missiven* (the annual letters written by the Governor General, of which the entries on Taiwan have been annotated and translated into Chinese by Cheng Shaogang in his Leiden thesis of 1995), and finally Reverend William Campbell's *Formosa under the Dutch*, which really consists of straight translations of a 19th century Dutch source publication by J. Grothe on the Dutch mission on Formosa, as well as a part of *'t Verwaerloosde Formosa* (The Neglected Formosa) by Formosa's last VOC governor, Frederik Coyett, and the chapter on Formosa in Francois Valentijn's *Oud en Nieuw Oost-Indien*. Consequently we have selected the source material for this volume solely from unpublished letters and reports in the VOC archives at The Hague.

The selection of source material for publication is an arduous job because the same events are often described in many different letters and reports. Our choice of the sources is based on such considerations as first-

hand knowledge and experience of the author, but we also quote from letters and instructions from higher echelon officials, such as the Governor of Formosa and the Governor-General in Batavia, because of the great impact of their writings on the actual execution and application of Dutch power in Formosa. When necessary, we have added (in cursive writing) excerpts from important published and unpublished material in order to fill in the lacunae in the historical narrative.

In the process of translating the often rather tortuous Dutch sentences written by Company servants some 350 years ago we were privileged to receive a lot of assistance from friends and colleagues. Wouter Milde helped us out with some translation work to meet the deadline. Anne Simpson critically ploughed through the entire English translation and fashioned it into a form of English, which, hopefully, is easier to understand than the original 17th century Dutch version. Without the patient guidance of Cynthia Viallé we would never have succeeded in preparing a copy ready version of this book. We are grateful to Peter Kang for allowing us to use a map of Hualien and surroundings. We hope to include more of his maps of the southern and western plains of the island in our next volume. A detailed map of the northern aboriginal villages can be found in Ang Kaim's monograph about a VOC map of the greater Taipei area, *Ku ti-t'u k'ao-shih*. For the explanation of the exact locations of the Formosan villages mentioned in this volume we refer to the list of historic place names in Vol. II of the *Dagregisters van het kasteel Zeelandia*.

We should also like to thank Eric Yu and the staff of the Shung Ye Museum of Formosan Aborigines for their generous support of this project, but most of all for their patience with the snail's pace of the production process, the inevitable outcome of busy academic commitments elsewhere. Thanks also to the staff of the NIAS institute at Wassenaar for offering hospitality and excellent facilities so that this book could be completed under near perfect conditions.

NIAS, Wassenaar, 3 October 2000

Leonard Blussé & Natalie Everts

INTRODUCTION

Pacification, Exploration and Expansion

In 1636 the Dutch administration of Formosa which had so far been limited to the direct vicinity of Zeelandia Castle, situated on a spit of land at the entrance of the bay of Tayouan (today's Tainan city and surroundings), entered into a second phase: the large-scale expansion of territorial rule over the south, the east and the north of the island. Shortly after he had subjugated the rebellious village of Mattouw, in January 1636 Governor Putmans reported with relief that the limits of Dutch authority had been expanded to about one and a half day's walk to the north, the east and the south of Zeelandia Castle. Little could he have foreseen the enormous territorial expansion in the years that followed.

Indeed by 1645 all of the island's plains and lower mountain regions were pacified to the extent that internecine strife between the various tribal settlements had been contained – it even became possible to travel overland from Zeelandia to the two northern settlements Tamsuy and Quelang (today's Tansui and Chilung) and Pimaba (nowadays Taitung) in the east. The texts selected in this volume are all in one way or another connected to this expansive movement, which started as a veritable rush forward but finally lost momentum due to lack of resources, sufficient manpower and natural causes such as the outbreaks of epidemics, fulfilling the adage that it is easier to conquer a country than to rule it.

By the middle of the 1630s the Dutch administration at Zeelandia Castle had at long last succeeded in achieving stable trade relations between this entrepot and the Chinese seaboard. Now that the triangular trade between China's coastal province of Fukien, the Dutch settlement on Tayouan and the port of Nagasaki in Japan was picking up, a new interest arose at Zeelandia Castle in the possible tapping of Formosa's local resources. Deerskin and dried venison, which were bartered by the hunters of Formosa's western plains for Chinese and Dutch commodities, were much in demand in both Japan and China. Consequently it was decided to set up a trading network throughout the western plains of Formosa and to hand out hunting licences to Chinese hunters so that the Dutch trading

settlement might be amply provided with these profitable export commodities. But in order to create the necessary stable conditions in the countryside, the recent murders of Company employees by hostile Formosan tribes had to be avenged to regain some respect from the local population.

It was now up to the authorities to decide how to settle accounts with the two Formosan village communities where in the preceding years large scale murders of Dutch personnel had been perpetrated. At the island of Lamey or Gouden Leeuwseiland – today's Hsiao Liu-Ch'iu – shipwrecked Dutch crews had been wilfully massacred by the local population, while in 1629 the villagers of Mattouw had killed more than sixty drunken Dutch soldiers after having entertained them to what turned out to be their last meal. For further details of this grisly event we refer to the entries in Volume I of *The Formosan Encounter* and Volume I of the *Dagregisters van het kasteel Zeelandia, Taiwan*.

Chronologically speaking the detailed description of the island of Lamey by Commander Claas Bruyn, who was sent in 1633 on a reconnaissance mission to the island, should perhaps have been placed in Volume I. Yet we chose to insert it into the present volume as the opening piece because it is so closely connected with the operations against the population of that island that followed throughout the late thirties and early forties. Bruyn's mission was a failure as a military operation. When his force accompanied by allied warriors from Sincan, reached the shore, the islanders disappeared without leaving a trace in the island's many grottos and as a result not a single enemy was caught on this first trip. In 1635 additional troops were sent by the High Government of the Indies in Batavia to assist in the punitive expeditions against Lamey and Mattouw. While the well-prepared campaign against Mattouw turned out to be a walkover ending in the destruction of the village, and was soon followed up by a peace treaty, the expedition against Lamey became a veritable nightmare. Some three hundred islanders suffocated in the grottos where they had sought refuge, several hundred were caught and deported, and a large number fled into the hills where they could not be ferreted out until many years later. After the Lamey massacre a long drawn out correspondence was carried on between the authorities in Taiwan backed by the local clerics, who felt that the remaining inhabitants on the island should be left alone, while the High Government in Batavia ordered the complete deportation of the inhabitants from the island instead.

Throughout this volume the reader runs across almost continual references to the pacification of the tribes through punitive expeditions, elaborate peace treaty rituals in which the handing over of potted bamboos symbolizes the transfer of power, the organisation of annual *landdagen*, jamborees where representatives from the villages clothed in velvet gowns would meet with the governor and swear allegiance, the occasional resettlements of entire villages, or the grouping of many small ones into one large conglomeration in order to make them easier to control and to provide them with schoolmasters, and so on. A massive effort was undertaken not only to convert the Formosans to Christianity – see Campbell's *Formosa under the Dutch* on this issue – but also to train them to read and write because according to the tenets of the protestant faith every responsible Christian adult should be able to read the bible. The tithes in kind, which the Company introduced, were primarily meant to sustain this quite impressive administrative endeavour. Governor Caron reported to Governor General Van Diemen in Batavia, that at the annual *landdag* of 1644 interpreters were explaining in six different languages to a (probably dumbfounded) audience of Formosan warriors, such profound issues as to how they should discern between the duties of the Dutch clerics and the political administrators stationed in their villages and who they should contact for what issue. There can be no doubt about it: matters were being pushed too far.

The Company may have been promoting the good works of the Lord, but at the same time the worship of Mammon was not forgotten either. The 1635-45 period can also be styled as the decade of exploration. Rumours about gold deposits on the eastern side of the island drove the Dutch to design elaborate schemes, which can all be found in this publication, to reach the sites on the other side of the island. It was not until 1645 that this gold fever abated somewhat when it was finally understood that the gold originating from that area actually consisted of gold particles collected in small quantities from mountain torrents.

As already stated in Volume I, the reader should keep in mind that all data published here in English translation are drawn from reports by Company officials whose primary task it was to keep their superiors – the Governor-General in Batavia and the Directors of the Company in the Netherlands – posted on the native affairs in Taiwan. We are dealing here with colonisers

who were often at loss as to how to face an unnerving number of challenges posed by the unruly local tribes not to speak of Taiwan's physical environment with its earth tremors, typhoons, locust plagues, and recurring epidemics. As such these data represent the viewpoint of early-modern European colonisers with their own particular value system and self-righteous vocabulary and often rather ponderous style. Yet the close reader will see that there was by no means a *communis opinio* among the Dutch as to how to turn the strife ridden Formosan countryside into a relatively peaceful environment. Once leaders such as Governor Putmans and his successor Van der Burch, as well as the Reverend Junius realized that severe punishment did not function as a deterrent but on the contrary resulted in mass killings, they found themselves at loggerheads with the Governor General Van Diemen in Batavia who ordered full scale deportation of refractory tribes. For all their shortcomings these men on the spot tried to carry through various administrative reforms and well meant innovations, but many of these operations came to naught simply because the set targets turned out to be too ambitious. It took some time before the rather small group of Dutch clerics, schoolmasters and administrators understood that Formosan tribal society could not be simply reorganized, reformed or modernized on a whim.

Occasional remarks about the repercussions of the introduction of new marriage regulations, the prohibition of infanticide, the building of graveyards, or complaints that tributary charges were not being paid in a specific season because of certain sowing and harvest taboos, or just an offhand remark that the males of Pimaba refused to carry loads from the beach to the Company's local godown, but left this arduous task to their women, give us a glimpse of the traditional manners and customs which traditional Formosan native society continued to honor and preserve. We even meet with recognizable individuals such as the adventurous regent Redout and his brother-in-law regent Toea in Pimaba, the proud ruler of Lonckjouw in the south, and the redoubtable Quataong or Tackamacha ruler of 18 villages in the northwestern plain who secretly traded with Chinese 'pirates'. Antagonism between the plains aborigines and those from the mountain area was a common phenomenon as becomes clear from the reports about raids by montagnards amongst the plains aborigines but also from the fact that the people of the Cavalan plains in the east referred to their brethren in the mountains as 'monkey heads'.

While reading and browsing through the selected data in this volume, the reader should always keep in mind what kind of data they are and what the intention of the author of the original report or letter must have been. At the highest level there is the correspondence between the Governor and Council of Formosa and the Governor-General and Council in Batavia, the so-called High Government of the Indies. Without exception the letters of the Governor-General are full of reproaches about the high costs of the Formosan administration, and in particular the high costs of the protestant mission, which was Company sponsored. Of particular interest are, on the other hand, the letters selected from the correspondence between Governor Hans Putmans and Robertus Junius, the energetic clergyman in Sincan. Both question the rationale of the Dutch punishment of native culprits, which is often so brutal in its execution, that it escapes the understanding of those involved. Junius even proposed to escort the deported Lamey people back to their homesteads on the island if they were allowed to return to their former existence. In the instructions, which Putmans left to his successor Van de Burch, he also cautioned against too rash an introduction of Dutch laws and customs. These might be 'too heavy a fare for the weak stomachs of the Formosans' he warned. How right he was! Throughout the text we run across references to punitive campaigns which destroyed more than they corrected, and the introduction of a tax system which not only turned out to be too heavy on the fragile local economies but also was grossly unfair because it over-taxed the weak and under-taxed the rich villages.

Once peace was concluded in 1637 with the ruler of Lonkjouw (today's Heng-ch'un) in the south, plans could be made to open the overland path to the eastern side of the island. The instruction given by Governor Jan van der Burch to Lieutenant Johan Jurriaensz. spells out in detail the strategy he should follow. Jurriaensz. was to inquire very diplomatically whether the ruler would not be willing to live in peace with his neighbours in Pimaba at the eastern side of the island, so that the road to the Cavalangh mountains in the northeast, where the gold sites were said to be situated, could be opened up.

Already in January 1638, Pimaba (today's Taitung) was reached. Here Junior Merchant Maerten Wesselingh was stationed to learn the local languages and gather information about the gold sites. During the three years that Wesselingh remained on and off in Pimaba, he sought without success to gain access to the gold sites in the north. Yet his indefatigable

search resulted in the collection of a lot of information about the surrounding people, which still is exceedingly useful for the historian of the eastern tribes. In 1641 Wesselingh met with an untimely end when he was murdered with his companions by villagers from the vicinity of Pimaba. Not until one year later, after the Spanish castle of *La Sanctissima Trinidad* at Quelang on the northern tip of the island had been conquered, was at long the Castillian Domingo Aguilar found, a man with local knowledge who was willing to guide the Dutch from the north to the dreamed of gold sites. It was of course a bitter disappointment when it was discovered that their were no gold veins in the mountains but that all the gold was collected from deposits washed down by mountain streams.

The main issues in the years that followed were basically the stabilisation of the local government, the imposition of taxes in all territory under control, the division of authority between the clerics and the political administrators and finally, in 1645, the incorporation of the only territory which had not yet been subjugated in the northwest, the land of the Quataongh situated in between Tamsuy and Betgilem (today's Changhua region). How difficult a task lay ahead becomes amply clear from the many reports about 'refractory' native headman and 'sly' Chinese traders who were infiltrating the native settlements and inciting the inhabitants against Dutch rule. That at least is the tenor of the reports of the beleaguered merchants of Zeelandia Castle who quite suddenly discovered that after a decade of leaps forward they were willy-nilly ruling the largest territorial colony of the Dutch East India Company.

ILLUSTRATIONS

Note or memorandum of the names of the villages and surrounding fields made on behalf of the States General and on the orders of Governor Jan van der Burch, by Junior Merchant Maerten Wesselingh, Pimaba, 10 February 1638-20 August 1639.

Manuscript of Nr. 86: VOC 1131, fol. 841-844. ARA.

Rinadoumoan
tolldrikan
Bornoes
sabotto
sayman
terrowatil
curolpta
tockwry
massisy
caradalau
pottry
dadiliy
Labodan
tesurre Redan
collalouw
parriwan
sagedri
tabewohan
trapissau
tocobocobul

Carocwaod
Bibis
barikil
tadaugis
sapprat

Dit sijn dorpen int loog ge-
vooret gelegen waer van
men int de sommige 2½ da-
gen vijlde gemen op
placte en sied int
de sommige 1 a 1½ dagh nae
dat per weder sies vertoon
dese tegen over haen dorp
voorlaren d'inhabitan
in alle quartieren dat sunde
den anderen 1000 weerbar
mannen int loopdrid comde

Dit zijn vijf dorpen ge-
vooret genoord den pinamba
onder zee aen gelegen
maer zijn doorde van pinam
ba vooet op roek vant logde
gemassacooet dat vooorsaeet
de pinambaes in cool tot
op een wonuich nade andere
danam Angdele es wer weder
abt 18 mijlen wooetb om
de noort van pinamba
vt roylte comde

4.

Cavadonio
cobiongan
dirckidurck
toltukbos
tallassyn
bonnuweit
poutscenocy
borroborras
tarratway
sappide .

Dit zijn 10 dorpen soo voor aen
niet ge... aldus werck zijde
van ... gelegen zijn waer
onder ... 3 drie louc
jouwer, toe andere ... zijn in
d.º drie lousjouckes doorden
niet moor als 200 woorbaren
mannen doch d'andere soude
... d'... leger... ...
... ... van de
ge... voort zonder de
dorpen niet minder als 5000
man uijt te voeren .

Doloswack
Racky
bangsoor
cattangl
toutesatsa
tarradey
daivadas
matsar
Lupor
perromooy
talanger

Dit zijn dorpen die drie louc
jouwer toe ende waer van de
sommige voor aen niet ge...
... ... opde vlacte gelegde
zijn doch zijn onder des dorpen
drie die niet meer voor handen waen
... ... van longen ...
dorpen die uijt geto... zijn
... waren talanger perromooy
Carradey de voor... ... doorden
... voor handen mogen niet
de andere om trent 800 woor
baren mannen uijt brengen

Sinano
dattraya
dalan
illebetau
Rabats
daracop

Dit zijn de voornaemste dorpen ...
dorpen soo de compaä noordwest
nae dat van alle quartieren soo daer
ontrent leggen voor laden wort soo soude
daer ontallijcke menichte van menschen
in woude dat oock geloof... ... waer
de zinnen daer... met alde om leggende
dorpen soo tractueren niet en zijn
dat een voor hands van laden winnen
en men ge... oock dickwils
waer door ontrent de werden quam
schoonen gesien die

Dit voorn plaende door de comm...
gecol uijtgedaegde 1650 ...
Jnaunden

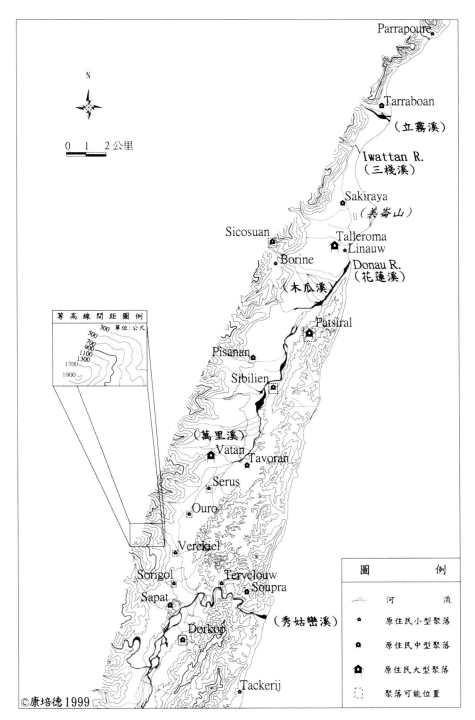

Map of the Hualien area on the east coast of Taiwan

From: Peter Kang, *Chih-min chieh-chu yü ti-kuo pien-chui: Hualien ti-chü yüan-chu-min shih-chi chih shih-chiu shih-chi-ti li-shih pien-ch'ien* (Colonial contact and imperial frontier: historical change among the Hua-lien aborigines from the Seventeenth- to the Nineteenth century) Taipei 1999.

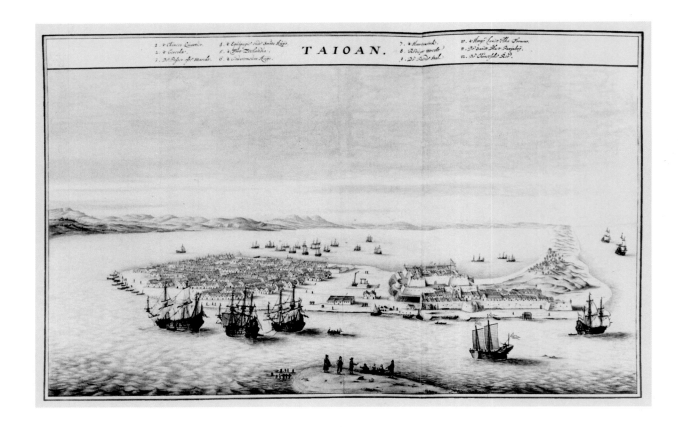

View of 'Taiouan' peninsula with the town and Zeelandia Castle (1644)

Atlas van der Hem Collection, Österreichische Nationalbibliothek, Vienna

Map of the sown rice fields of Saccam

The map was drawn by Senior Merchant Simon Jacobsz Domkens who, on 3 September 1644, was commissioned with Senior Merchant Cornelis Caesar to collect the rent from the Chinese tenants in Saccam and to lease out the fields again to the highest bidding Chinese. See: VOC 1148, fol. 169, *DRZ*, II, p. 315.
Map collection, Algemeen Rijksarchief Den Haag, inv. nr. 4 VEL 1126.

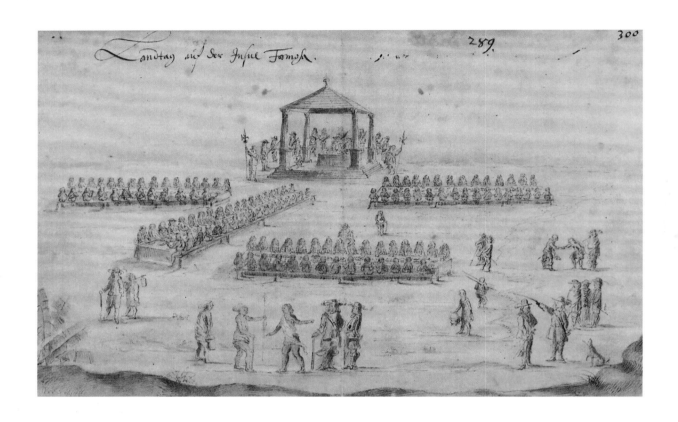

Landtag auf der Insul Formosa

From: *Die Wundersame Reisen des Caspar Schmalkalden nach West- und Ostindien 1642-1652*, edited by W. Joost, (Leipzig 1983).

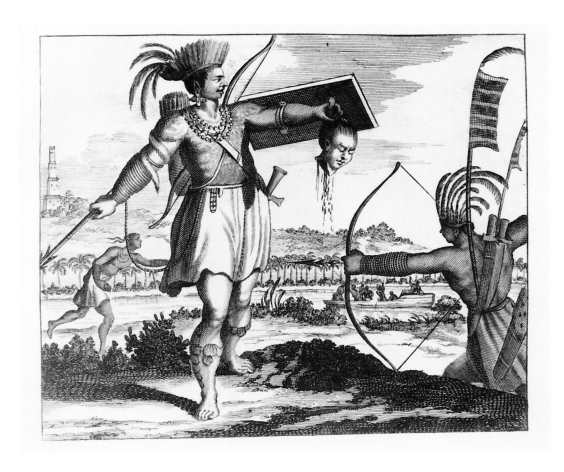

Formosan warriors

From O. Dapper, *Gedenkwaardig bedrijf der Nederlandsche Oost-Indische Maetschappye op de Kuste en in het keizerrijk van Taising of Sina*, Amsterdam 1670, p. 22.

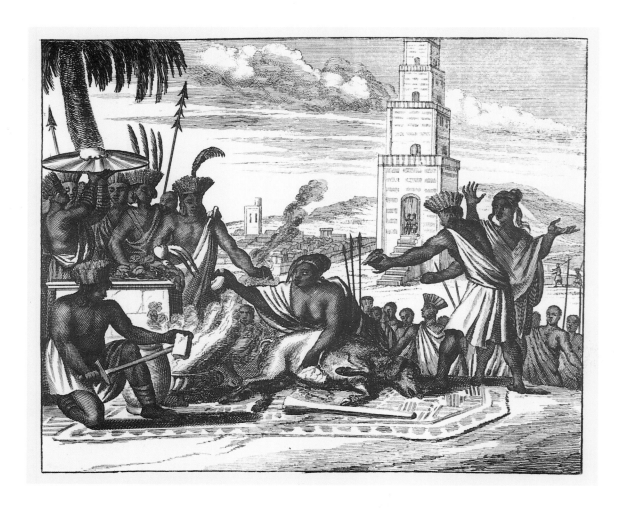

Consecration of a house by a priestess

From O. Dapper, *Gedenkwaardig bedrijf der Nederlandsche Oost-Indische Maetschappye op de Kuste en in het keizerrijk van Taising of Sina*, Amsterdam 1670, p. 26.

LIST OF DOCUMENTS

All documents are stored at the Algemeen Rijksarchief (General State Archives) in The Hague, the Netherlands, with the exception of the *Discourse*.

The major part of the documents at the Algemeen Rijksarchief belong to the Archives of the Verenigde Oost-Indische Compagnie (VOC). The remaining documents are to be found in the Teding van Berkhout Collection.

After the number and heading of each entry the following information is given:

• Location reference of the original:

VOC Archives of the Dutch East India Company and the inventory number as listed in *The Archives of the Dutch East India Company (1602-1795)*. The page numbers (abbreviated *fol.*) are those of the original manuscripts.

TEDING Teding van Berkhout Collection and the inventory number as listed in the inventory of the collection.

• References to previously published excerpts. These appear in abbreviated form. Full citations are given in the bibliography.

DRZ *Dagregisters van het kasteel Zeelandia, Taiwan 1629-1662*

FORMOSA *De VOC en Formosa 1624-1662, een vergeten geschiedenis*

FORMOSA UNDER THE DUTCH
 Formosa under the Dutch, described from contemporary records

DRB *Daghregisters gehouden in 't Casteel Batavia*

1. Short Description of the site and situation of the Golden Lion Island by Commander Claes Bruyn, [November] 1633.
VOC 5051.

2. General Missive, 4 January 1636.
VOC 1116, fol. 17. Extract.
FORMOSA, pp. 148-149.

3. Missive Governor Hans Putmans to Governor-General Hendrick Brouwer.
Tayouan, 18 January 1636.
VOC 1120, fol. 219-224. Extract.
DRZ, I, p. 235; DRB 1636, pp. 18-23.

4. Agreement between Governor Hans Putmans and the Zeelandia Council on behalf of the VOC on the one side, and the headmen of Mattouw on behalf of the community on the other side.
Tayouan, 18 December 1635.
Collectie Aanwinsten 119 (1866 A XII), fol. 349-351 (February 1636).
DRB 1636, pp. 19-22.

5. Missive Governor Hans Putmans to Governor-General Hendrick Brouwer.
Tayouan, 21 February 1636.
VOC 1120, fol. 232-237. Extract.
See also FORMOSA UNDER THE DUTCH, p. 112; ZENDING, III, pp. 77-78; DRZ, I, p. 235.

6. Missive Governor Hans Putmans to Reverend Robertus Junius.
Tayouan, 19 January 1636.
TEDING 14, fol. 7.

7. Missive Reverend Robertus Junius to Governor Hans Putmans.
Sincan, 20 January 1636.
TEDING 15, fol. 16.

17. Memorandum of Reverend Robertus Junius about the advisability of sending some Formosan youths to Holland to be educated as schoolteachers or ministers and continue the propagation of the Gospel on Formosa [undated 1635/1636].
Collectie Aanwinsten 306 (1885 A IX).
FORMOSA UNDER THE DUTCH, pp. 144-147; ZENDING, III, pp. 127-131.

18. Dagregister Zeelandia, 14 March-4 October 1636.
VOC 1120, fol. 403-455.
DRZ, I, pp. 237-275.
See also FORMOSA UNDER THE DUTCH, pp. 112-115; ZENDING, III, pp. 79-85.

19. Missive Governor Hans Putmans to Governor-General Hendrick Brouwer.
Tayouan, 23 March 1636.
DRB 1636, pp. 75-77; DRZ, I, p. 236.

20. Missive Reverend Robertus Junius to Governor Hans Putmans.
Sincan, 23 March 1636.
TEDING 15, fol. 19.

21. Missive Governor Hans Putmans to Reverend Robertus Junius.
Tayouan, 23 March 1636.
TEDING 14, fol. 12.

22. Missive Governor Hans Putmans to Reverend Robertus Junius.
Tayouan, 25 March 1636.
TEDING 14, fol. 11.

23. Missive Reverend Robertus Junius to Governor Hans Putmans.
Sincan, 30 March 1636.
TEDING 15, fol. 20.

32. Missive Governor Hans Putmans to Reverend Georgius Candidius.
Tayouan, 15 May 1636.
TEDING 14, fol. 15.

33. Missive Reverend Robertus Junius to Governor Hans Putmans.
Sincan, 15 May 1636.
TEDING 15, fol. 25.

34. Missive Reverend Robertus Junius to Governor Hans Putmans.
Sincan, 23 May 1636.
TEDING 15, fol. 26.

35. Missive Governor Hans Putmans to Reverend Robertus Junius.
Tayouan, 24 May 1636.
TEDING 14, fol. 14-15.

36. Extracts taken from the Zeelandia Castle Resolution-books, concerning
the resolutions on the island of Lamey, taken in the Formosa Council.
VOC 1170, fol. 581-583. Extract 2 June 1636.

37. Dagregister Zeelandia, extracts concerning Lamey.
VOC 1170, fol. 610-611. Extracts 2, 4 June 1636.
DRZ, I, pp. 255-256.

38. Missive Reverend Robertus Junius to Governor Hans Putmans.
Sincan, 13 June 1636.
TEDING 15, fol. 31.

39. Instruction from Governor Hans Putmans to Sergeant Cornelis van
Daelen on how to act as provisional commander of the armed forces
remaining on Golden Lion Island.
Tayouan, 10 June 1636.
VOC 1170, fol. 630-631.

40. Extracts taken from the Zeelandia Castle Resolution-books, concerning
the resolutions on the island of Lamey, taken in the Formosa Council.
VOC 1170, fol. 583-584. Extract 14 June 1636.

41. Missive Reverend Robertus Junius to Governor Hans Putmans.
Sincan, 29 June 1636.
TEDING 15, fol. 27-28.

42. Dagregister Zeelandia, extracts concerning Lamey.
VOC 1170, fol. 614-615. Extracts 12 July, 15, 17 September 1636. Also in:
VOC 1120, fol. 430-431, 435, 450-452.
DRZ, I, pp. 261, 272-273.

43. Missive Reverend Robertus Junius to Governor Hans Putmans.
Sincan, 3 July 1636.
TEDING 15, fol. 28-30.

44. Missive Reverend Robertus Junius to Governor Hans Putmans.
Sincan, 7 July 1636.
TEDING 15, fol. 30.

45. Missive Reverend Robertus Junius to Governor Hans Putmans.
Sincan, 15 August 1636.
TEDING 15, fol. 31-33.

46. Missive Reverend Robertus Junius to the Directors of the Amsterdam
Chamber.
Sincan, 5 September 1636.
VOC 1121, fol. 1308-1356.
FORMOSA UNDER THE DUTCH, pp. 116-144; ZENDING, III, pp. 85-131.

47. Missive Reverend Robertus Junius to Governor Hans Putmans.
Sincan, 8 September 1636.
TEDING 15, fol. 34.

48. Missive Reverend Robertus Junius to Governor Hans Putmans.
Sincan, 16 September 1636.
TEDING 15, fol. 35.

49. Missive Governor Hans Putmans to Reverend Robertus Junius.
Tayouan, 17 September 1636.

TEDING 14, fol. 18.

50. Extracts taken from the Zeelandia Castle Resolution-books, concerning the resolutions on the island Lamey, taken in the Formosa Council.
VOC 1170, fol. 585-586. Extract 17 September 1636.

51. Extracts taken from the Zeelandia Castle Resolution-books, concerning the resolutions on the island of Lamey, taken in the Formosa Council.
VOC 1170, fol. 588-589. Extract 2 October 1636.

52. Missive Governor Hans Putmans to Reverend Robertus Junius.
Tayouan, 3 October 1636.
TEDING 14, fol. 18-19.

53. Missive Governor Johan van der Burch to Governor-General Anthonio van Diemen.
Tayouan, 5 October 1636.
VOC 1120, fol. 288-323. Extract fol. 310-314.
See also FORMOSA UNDER THE DUTCH, pp. 147-148; ZENDING, III, pp. 132-134.

54. Original Missive Governor Hans Putmans to Governor-General Anthonio van Diemen.
Tayouan, 7 October 1636.
VOC 1120, fol. 252-282. Extract fol. 258-262.
See also FORMOSA UNDER THE DUTCH, pp. 148-149; ZENDING, III, pp. 135-136.

55. Memorandum on the way the people of Lamey are to be allocated over the ships of this fleet.
Tayouan, [...] October 1636.
VOC 1123, fol. 724.

56. Missive Reverend Robertus Junius to Governor Hans Putmans.
Sincan, 18 October 1636.
TEDING 15, fol. 35.

57. Missive Reverend Robertus Junius to Governor Hans Putmans.
Sincan, 22 October 1636.
TEDING 15, fol. 36.

58. Missive Reverends Robertus Junius and Assuerus Hogesteijn to the Batavia Church Council.
Sincan, 27 October 1636.
VOC 1121, fol. 1337-1339.
FORMOSA UNDER THE DUTCH, pp. 149-151.

59. Memorandum or advice by ex-Governor Hans Putmans for his successor, Governor Johan van der Burch, on the day of his departure to Batavia.
Tayouan, 10 November 1636.
VOC 1120, fol. 19-34. Extracts.
See also FORMOSA UNDER THE DUTCH, pp. 152-153; ZENDING, III, pp. 144-146.

60. Missive Governor Jan van der Burch to Governor-General Anthonio van Diemen.
Tayouan, 14 November 1636.
VOC 1120, fol. 334-364. Extracts.
See also FORMOSA UNDER THE DUTCH, pp. 151-152; ZENDING, III, pp. 141-143.

61. Resolution taken by Governor Johan van der Burch and the Formosa Council.
Tayouan, 25 November 1636.
VOC 1123, fol. 788.

62. Dagregister Zeelandia, 1 November 1636-17 October 1637.
VOC 1123, fol. 835-912. Summary.
DRZ, I, pp. 289-295.
See also FORMOSA UNDER THE DUTCH, pp. 154-157; ZENDING, III, pp. 147-152.

63. General Missive, 28 December 1636.

VOC 1119, fol. 158, 164, 243. Extracts.
FORMOSA, pp. 156-157, 160-161, 167.

64. Resolution taken by Governor Johan van der Burch and the Formosa Council.
Tayouan, 31 January 1637.
VOC 1123, fol. 796.

65. Instruction from Governor Jan van der Burch to Lieutenant Johan Jurriaensz on his departure as an emissary to Lamey, Lonckjouw and Taccareyang.
Tayouan, 3 February 1637.
VOC 1170, fol. 631-635.

66. Dagregister Zeelandia, 17, 18 February 1637.
VOC 1123, fol. 835-912. Summary.
DRZ, I, pp. 307-308.

67. Dagregister Zeelandia. Extracts concerning Lamey.
VOC 1170, fol. 617. Extract 17 February 1637. Also in: VOC 1123, fol. 859.
DRZ, I, p. 307.

68. Dagregister Zeelandia, 27 February, 13 March 1637.
VOC 1123, fol. 835-912. Summary.
DRZ, I, pp. 311, 318-319

69. Resolutions taken by Governor Johan van der Burch and the Formosa Council.
Tayouan, 15, 22 April 1637.
VOC 1123, fol. 807-811.

70. Dagregister Zeelandia. 10 May 1637.
VOC 1123, fol. 878. Extract.
DRZ, I, p. 333.

71. Missive Governor-General Anthonio van Diemen and Council to Governor Johan van der Burch.
Batavia, 23 May 1637.
VOC 859, fol. 636-400. Summary.

72. Missive Governor-General Anthonio van Diemen and Council to Governor Johan van der Burch.
Batavia, 28 July 1637.
VOC 859, fol. 515-538. Summary.

73. Extracts taken from the Zeelandia Castle Resolution-books, concerning the resolutions on the island of Lamey, taken in the Formosa Council.
VOC 1170, fol. 590-591. Resolution 2 June 1637.

74. Dagregister Zeelandia. 13 June 1637.
VOC 1123, fol. 883. Summary.
DRZ, I, p. 339.

75. Extracts taken from the Zeelandia Castle Resolution-books, concerning the resolutions on the island of Lamey, taken in the Formosa Council.
VOC 1170, fol. 591-592. Resolution 13 July 1637.

76. Resolution taken by Governor Johan van der Burch and the Formosa Council.
Tayouan, 12 August 1637.
VOC 1123, fol. 823-824.

77. Original missive Governor Jan van der Burch to Governor-General Anthonio van Diemen.
Tayouan, 17 October 1637.
VOC 1123, fol. 744-781. Extract.
See also FORMOSA UNDER THE DUTCH, pp. 158-160; ZENDING, III, pp. 155-159.

78. Dagregister Zeelandia, 18 October 1637-14 December 1638.
VOC 1128, fol. 427-510.
DRZ, I, pp. 373-449.

See also FORMOSA UNDER THE DUTCH, pp. 160-165; ZENDING, III, pp. 159-168.

79. Dagregister kept by Governor Jan van der Burch on the expedition with an army of 300 soldiers and about 1400 inhabitants to the great village of Vavorolangh situated to the north.
Vavorolangh etc., 25 October-1 November 1637.
VOC 1128, fol. 429-434. Summary.
DRZ, I, pp. 375-378.

80. Missive Governor Jan van der Burch to Governor-General Anthonio van Diemen.
Tayouan, 14 November 1637.
VOC 1123, fol. 935-938.

81. Resolution.
Tayouan, 23 November 1637.
VOC 1128, fol. 514.

82. Dagregister kept on the voyage to Pangsoya and the Golden Lion Island to punish the inhabitants who had offered resistance to the General Company. Pangsoya etc. 26 November 1637-1 December 1637.
Extracts from the Dagregister Zeelandia, concerning Lamey.
VOC 1170, fol. 617-620. Extracts 26, 27 November 1637.
See also VOC 1128, fol. 441-446.
DRZ, I, pp. 385-389.

83. Original missive Governor Jan van der Burch to Governor-General Anthonio van Diemen
Tayouan, 12 December 1637.
VOC 1123, fol. 913-921.
FORMOSA UNDER THE DUTCH, p. 165.

84. Resolution.
Tayouan, 19 January 1638.
VOC 1128, fol. 521.

85. Extract from the Dagregister of Johan Jurriaensz. van Linga, Captain of the Zeelandia garrison on his voyage to Pimaba, 22 January-12 February 1638.
VOC 1128, fol. 556-568.

86. Note or memorandum of the names of the villages and surrounding fields made on behalf of the States General and on the orders of Governor Jan van der Burch, by Junior Merchant Maerten Wesselingh.
Pimaba, 10 February 1638-20 August 1639.
VOC 1131, fol. 841-844.

87. Report by Merchant Cornelis Fedder to Governor Jan van der Burch on his inspection of the results of the missionary work in the villages of Soulang, Mattouw, Sincan, Bacaluan and Tavocan.
Tayouan, 8 February 1638.
VOC 1128, fol. 459-461.
DRZ, I, pp. 402-405; FORMOSA UNDER THE DUTCH: pp. 160-163; ZENDING, III, pp. 160-168.

88. Dagregister Zeelandia, 7 May 1638.
VOC 1128, fol. 473. Summary.
DRZ, I, pp. 417-418.

89. Resolution.
Tayouan, 7 September 1638.
VOC 1128, fol. 544-545

90. Extracts taken from the Zeelandia Castle Resolution-books, concerning the resolutions on the island of Lamey, taken in the Formosa Council.
VOC 1170, fol. 592-593. Extract 7 September 1638.

91. Extracts from the Dagregister Zeelandia, concerning Lamey.
VOC 1170, fol. 621. Extract 30 September 1638. Also in: VOC 1128, fol. 493.
Published in: DRZ, I, p. 436.

92. Resolution.

Tayouan, 4 October 1638.
VOC 1128, fol. 455-456. Summary.

93. Resolution.
Tayouan, 18 October 1638.
VOC 1128, fol. 547-548.

94. Original missive Governor Jan van der Burch to the Amsterdam Chamber.
Tayouan, 18 November 1638.
VOC 1128, fol. 361-377. Extract fol. 373-375.

95. Resolution.
Tayouan, 25 October 1638.
VOC 1128, fol. 550-551.
See also Collectie Sweers 1. East India letters, extracts and acts, 1620 to 1674 (1640), fol. 191-194.

96. Dagregister kept by Governor Jan van der Burch during his expedition to Vavorolangh with an armed force of 210 soldiers to punish its inhabitants.
Vavorolangh, 27 November-4 December 1638.
VOC 1128, fol. 501-509.
DRZ, I, pp. 442-448.

97. Missive Governor Jan van der Burch to Governor-General Anthonio van Diemen.
Tayouan, 4 December 1638.
VOC 1128, fol. 402-417. Extracts.

98. Missive Governor Jan van der Burch to Governor-General Anthonio van Diemen.
Tayouan, 9 January 1639.
VOC 1130, fol. 1323-1343. Extract.

99. Original missive Governor Jan van der Burch to Governor-General Anthonio van Diemen.

Tayouan, 12 March 1639.
VOC 1130, fol. 1405-1417. Extract.

100. Extract Dagregister Zeelandia, 18 March-4 November 1639.
VOC 1131, fol. 664-739.
DRZ, I, pp. 452-484. Summary.

101. Extract Dagregister Zeelandia, 27 March 1639-24 January 1640.
Collectie Sweers 7, fol. 25-51.
See also DRZ, I, pp. 485-505; FORMOSA UNDER THE DUTCH, pp. 176-179;
ZENDING, III, pp. 189-193.

102. Journal or dagregister by Junior Merchant Maerten Wesselingh on the
expedition to the east coast of Formosa, via the central mountain range, 11-
21 May 1639.
VOC 1131, fol. 835-840.

103. Short Memorandum and instruction by Governor Jan van der Burch for
Sergeant Jan Barentsz, departing with the junk of Samsiack to Lamey.
Tayouan, 15 May 1639.
VOC 1131, fol. 621-623; VOC 1170, fol. 636-637. Extract.

104. Extracts taken from the Zeelandia Castle Resolution-books, concerning
the resolutions on the island of Lamey, taken in the Formosa Council from
2 June 1636 to 27 February 1645.
VOC 1170, fol. 581-600. Extracts 16 and 23 May 1639.

105. Dagregister Zeelandia, 14, 22 June 1639
VOC 1131, fol. 664-739. Summary.
DRZ, I, pp. 466-467.

106. Account of the proceeds derived from hunting and the expenses of
Reverend Robertus Junius in the Tayouan accountbooks.
[Tayouan], 30 September 1639.
VOC 1131, fol. 649-658.
FORMOSA UNDER THE DUTCH, pp. 167-173; ZENDING, III, pp. 173-188.

107. Orders and instructions from Governor Jan van der Burch for Junior Merchant Maerten Wesselingh and Sergeant Jurriaen Smith during their stay in Pimaba and on the way to Kinadauan and Boenoch.
Tayouan, 30 September 1639.
VOC 1131, fol. 845-848.

108. Original missive Governor Jan van der Burch to Governor-General Anthonio van Diemen.
Tayouan, 4 November 1639.
VOC 1131, fol. 424-547.
See also FORMOSA UNDER THE DUTCH, pp. 179-182; ZENDING, III, pp. 194-200.

109. Extract from the report of Commissioner Nicolaas Couckebacker on his mission to Tonking and his visit to Formosa.
On board the *Rijp*, 8 December 1639.
VOC 1131, fol. 222-315.
See also FORMOSA UNDER THE DUTCH, pp. 182-183; ZENDING, III, pp. 200-203.

110. Dagregister Zeelandia, 16 December 1639.
Collectie Sweers 7, fol. 42. Summary.
DRZ, I, pp. 488-489.

111. Missive Governor Joan van der Burch to Governor-General Anthonio van Diemen.
Tayouan, 28 January 1640.
VOC 1133, fol. 177-198. Extract.

112. Missive President Paulus Traudenius to Governor-General Anthonio van Diemen.
Tayouan, 20 March 1640.
VOC 1133, fol. 147-162. Extract.
FORMOSA UNDER THE DUTCH, p. 184; ZENDING, III, pp. 204-205; DRZ, I p. 495.

113. Missive Governor-General Anthonio van Diemen to President Paulus Traudenius.
Batavia, 13 June 1640.
VOC 1134, fol. 329-372. Extracts.

114. Extracts from the Dagregister Zeelandia, concerning Lamey.
VOC 1170, fol. 622. Extract 8 August 1640.

115. Extracts from the Dagregister Zeelandia, concerning Lamey.
VOC 1170, fol. 622. Extract 30 August 1640.

116. Extracts taken from the Zeelandia Castle Resolution-books, concerning the resolutions on the island of Lamey.
VOC 1170, fol. 596. Extract 9 October 1640.

117. Extracts from the Dagregister Zeelandia, concerning Lamey.
VOC 1170, fol. 622-623. Extract 23 October 1640.

118. Missive Reverend Robertus Junius to Governor-General Anthonio van Diemen.
Tayouan, 23 October 1640.
VOC 1134, fol. 112-115.
FORMOSA UNDER THE DUTCH, pp. 184-188; ZENDING, III, pp. 206-213.

119. Original Missive Governor Paulus Traudenius and the Formosa Council to the Amsterdam Chamber.
Tayouan, 5 November 1640.
VOC 1136, fol. 961-962.
DRB 1640-1641, 6 December 1640, pp. 113-116.

120. Extracts taken from the Zeelandia Castle Resolution-books, concerning the resolutions on the island of Lamey. 30 November and 20 December 1640.
VOC 1170, fol. 596-597. Extracts.

121. Extracts from the Dagregister Zeelandia, concerning Lamey. 27 December 1640.

VOC 1170, fol. 623. Extract.

122. Original missive Governor Paulus Traudenius and the Formosa Council to Governor-General Anthonio van Diemen.
Tayouan, 10 January 1641.
VOC 1134, fol. 103-111. Extract.
See also DRB 1640-1641, pp. 175-176.

123. Missive Governor Paulus Traudenius to Governor-General Anthonio van Diemen.
Tayouan, 22 January 1641.
See also DRB 1640-1641, pp. 248-249; DRZ, II, p. 4.

124. Extracts from the Dagregister Zeelandia, concerning Lamey.
VOC 1170, fol. 624. Extracts 1, 10 and 23 February 1641

125. Missive Governor Paulus Traudenius to Governor-General Anthonio van Diemen.
Tayouan, 17 March 1641.
DRB 1640-1641, pp. 264-268; DRZ, II, pp. 4-6.

126. Extract from the dagregister Tayouan, about the first 'Land Day' held on Formosa.
Tayouan, 11 April 1641.
VOC 1170, fol. 638-639. Summary.
DRZ, II, pp. 1-3.

127. Missive Governor-General Anthonio van Diemen to Governor Paulus Traudenius.
Batavia, 26 June 1641.
VOC 865, fol. 196-221. Summary.

128. Missive Reverend Robertus Junius to Governor-General Anthonio van Diemen.
Tayouan, 21 October 1641.
VOC 1140, fol. 210-213. Extracts.

VOC 1140, fol. 286-288.

137. Missive Secretary Christiaen Smalbach to Governor Paulus Traudenius.
Pimaba, 26 April 1642.
VOC 1140, fol. 289-291.

138. Missive Governor-General Anthonio van Diemen to Vice-Governor
Paulus Traudenius.
Batavia, 28 June 1642.
VOC 866, fol. 332-351. Summary.

139. Instruction from Governor Paulus Traudenius to the Captains Hendrick
Harroussé, Johan van Linga, Commander Pieter Baeck and the other
officers of the ships *Wijdenes*, *Zantvoort*, *Waterhont*, *Kievit*, *Waeckende
Boey*, the junks *Goede Hoop*, *Goede Fortuyn* and the pilot boat on the
expedition to Quelang.
Tayouan, 17 August 1642.
VOC 1140, fol. 309-312. Extract.

140. Missive of the Quelang Council to Governor Paulus Traudenius.
Quelang, 28 August 1642.
VOC 1140, fol. 292-294. Extract.

141. Missive Captain Hendrick Harroussé to Governor Paulus Traudenius.
Quelang, 4 September 1642.
VOC 1140, fol. 313. Extract.
See also FORMOSA UNDER THE DUTCH, p. 189; ZENDING, III, p. 215.

142. Missive Captian Hendrick Harroussé to Governor Paulus Traudenius.
Quelang, 6 September 1642.
VOC 1140, fol. 314-315. Extract.

143. Resolutions taken by Field-Commander Johannes Lamotius c.s.
Quelang, 14 September-7 October 1642.
VOC 1140, fol. 301-302. Resolution 14 September 1642.

151. Instruction from Field-Commander Johannes Lamotius to Lieutenant Thomas Pedel, commander of Tamsuy and his Council.
Tamsuy, 10 October 1642.
VOC 1146, fol. 679-680.
DRZ, II, pp. 45-47.

152. Missive Major Hendrick Harroussé to Field-Commander Johannes Lamotius.
Quelang, 19 October 1642.
VOC 1140, fol. 320-321. Extract.

153. Missive Field-Commander Johannes Lamotius c.s. to Governor Paulus Traudenius.
Tamsuy, 26 October 1642.
VOC 1140, fol. 316-319. Extracts.

154. Interrogation of a certain Castilian named Domingo Aguilar, on the order of Governor Paulus Traudenius and carried out by representatives of the Formosa Council, in the conquered fortress Quelang concerning the location of the gold deposits on Formosa.
Quelang, undated [October 1642].
VOC 1140, fol. 445-447.

155. Original missive Governor Paulus Traudenius to the Amsterdam Chamber.
Tayouan, 3 November 1642.
VOC 1140, fol. 448-454.
FORMOSA UNDER THE DUTCH, pp. 191-192; ZENDING, III, pp. 220-222.

156. Articles and conditions presented by Field-Commander Johannes Lamotius and the Quelang Council to the inhabitants of Formosa who have accepted these rules and are willing to be united under Company protection.
Quelang, undated [10 November 1642].
VOC 1146, fol. 713.

157. Extract of the missive from Field-Commander Johannes Lamotius to Governor Paulus Traudenius, dealing with the punishment of rebels.

VOC 1170, fol. 598. Resolution 30 January 1643.

166. Extracts from the Dagregister Zeelandia, concerning Lamey.
VOC 1170, fol. 625-626. Extracts 11, 16 February 1643.

167. Instruction from Governor Paulus Traudenius to President Maximiliaen Lemaire.
Tayouan, 25 February 1643.
VOC 1146, fol. 793-797. Extract.
See also FORMOSA UNDER THE DUTCH, pp. 190-191; ZENDING, III, pp. 218-220.

168. Dagregister Zeelandia 25 February-15 November 1643.
VOC 1145, fol. 266-424. Summary.
DRZ, II, pp. 49-210.

169. General Missive, Batavia, 7 March 1643.
VOC 1141, fol. 384-389.
See also FORMOSA, p. 210; DRZ, II, pp. 16-17.

170. Resolutions taken by President Maximiliaen Lemaire and the Formosa Council in Tayouan, 1 March-9 October 1643.
VOC 1145, fol. 425-468. Resolution, 21 March 1643.
See also for 16 April, 11 September, and 25 September FORMOSA UNDER THE DUTCH, pp. 191-192; ZENDING, III, pp. 220-222.

171. Verbal or Narrative of the most important events compiled from successive pieces of advice of the factory Tayouan 22 March 1643-20 March 1644, Batavia [April] 1644.
DRB 1643-1644, pp. 144-148.

172. Dagregister Zeelandia 25 February-15 November 1643.
VOC 1145, fol. 284. Summary of March 1643.
DRZ, II, pp. 67, 68.

173. Missive President Maximiliaen Lemaire to Ordinand Andreas Merquinius.

Tayouan, 31 March 1643.
VOC 1146, fol. 548.

174. Dagregister Zeelandia 25 February-15 November 1643.
VOC 1145, fol. 284. Summary.
DRZ, II, p. 75.

175. Missive Sergeant Christiaen Smalbach to President Maximiliaen
Lemaire.
Tawaly, 19 April 1643.
VOC 1146, fol. 517-518.

176. Dagregister kept by Sergeant Christiaen Smalbach.
Pimaba, 22 March-19 April 1643.
VOC 1145, fol. 294-300. Summary.
DRZ, II, pp. 78-84.

177. Missive Governor-General Anthonio van Diemen to President
Maximiliaen Lemaire.
Batavia, 23 April 1643.
VOC 867, 220-233. Summary.

178. Resolution taken by President Maximiliaen Lemaire and the Formosa
Council.
Tayouan, 27 April 1643.
VOC 1145, fol. 441-442.

179. Missive President Maximiliaen Lemaire to Sergeant Christiaen
Smalbach.
Tayouan, 28 April 1643.
VOC 1146, fol. 514-515.

180. Extract from the Dagregister kept by Provisional Captain Pieter Boon
on the exploration expedition to the goldmines.
Quelang etc., 28 April-11 May 1643.
VOC 1145, fol. 353-358. Summary.
DRZ, II, pp. 137-142.

188. Resolution taken by President Maximiliaen Lemaire and the Formosa Council.
Tayouan, 21 May 1643.
VOC 1145, fol. 447.

189. Missive Captain Hendrick Harroussé to President Maximiliaen Lemaire.
Quelang, 23 May 1643.
VOC 1146, fol. 489-491. Extract.

190. Missive Lieutenant Thomas Pedel to President Maximiliaen Lemaire.
Tamsuy, 28 May 1643.
VOC 1146, fol. 503-506. Extract.

191. Missive President Maximiliaen Lemaire to Captain Hendrick Harroussé.
Tayouan, 6 June 1643.
VOC 1146, fol. 481. Extract.

192. Missive President Maximiliaen Lemaire to Captain Hendrick Harroussé.
Tayouan, 10 June 1643.
VOC 1146, fol. 482-483. Extract.

193. Missive Captain Hendrick Harroussé to President Maximiliaen Lemaire.
Quelang, 11 June 1643.
VOC 1146, fol. 496-497. Extract.

194. Missive Sergeant Christiaen Smalbach to President Maximiliaen Lemaire.
Pimaba, 13 June 1643.
VOC 1146, fol. 522-525. Extracts.

195. Missive Anthonio van Diemen to President Maximiliaen Lemaire.
Batavia, 23 June 1643.
VOC 867, fol. 454-473. Extract.

196. Missive Captain Hendrick Harroussé to President Maximiliaen Lemaire.
Quelang, 25 June 1643.
VOC 1146, fol. 497-499. Extract.

197. Missive Captain Hendrick Harroussé to President Maximiliaen Lemaire.
Quelang, 7 July 1643.
VOC 1146, fol. 500. Extract.

198. Missive Captain Hendrick Harroussé to President Maximiliaen Lemaire.
Quelang, 10 July 1643.
VOC 1146, fol. 501. Extract.

199. Missive Captain Hendrick Harroussé to President Maximiliaen Lemaire.
Quelang, 22 July 1643.
VOC 1146, fol. 501-502. Extract.

200. Resolution taken by President Maximiliaen Lemaire and the Formosa Council.
Tayouan, 29 July 1643.
VOC 1145, fol. 455.

201. Instruction from President Maximiliaen Lemaire to the corporal of the cadets Cornelis van der Linden in Pimaba.
Tayouan, 30 July 1643.
VOC 1146, fol. 566-568. Extracts.

202. Missive President Maximiliaen Lemaire to ordinand Andreas Merquinius.
Tayouan, 2 August 1643.
VOC 1146, fol. 549-550. Extract.

209. Original missive President Maximiliaen Lemaire to Governor-General Anthonio van Diemen.
Tayouan, 12 October 1643.
VOC 1145, fol. 213-262. Extracts.
See also FORMOSA UNDER THE DUTCH, pp. 196-197; ZENDING, III, pp. 231-233.

210. Missive Reverend Robertus Junius to President Maximiliaen Lemaire.
In Pangsoya in the house of schoolteacher P. Barentsz., 21 October 1643.
VOC 1146, fol. 603-605.

211. Missive President Maximiliaen Lemaire to Anthonio van Diemen.
Tayouan, 19 November 1643.
VOC 1145, fol. 193-202. Extracts.

212. Missive President Maximiliaen Lemaire to Governor-General Anthonio van Diemen.
Tayouan, 9 December 1643.
VOC 1145, fol. 203-210. Extract.
See also FORMOSA UNDER THE DUTCH, p. 197; ZENDING, IV, p. 1.

213. Dagregister Zeelandia 12 July 1643-20 March 1644. Summary of January 1644.
ARA, *Survey of microfilms of archival data kept in foreign archives* 486, Collectie Gijssels. (The manuscript is kept in the Landes bibliothek Karlruhe, Germany.)
DRZ, II, pp. 211-236.

214. Extract missive President Maximiliaen Lemaire to Governor-General Anthonio van Diemen.
Tayouan, 15 January 1644.
DRB 1643-1644, pp. 28-29.

239. Memorandum of the headmen of the villages situated in the Bight and in the province of Cavalangh who appeared before the Honourable Field-Commander Pieter Boon and have submitted themselves voluntarily to the Company.
[Tamsuy, 25 September 1644].
VOC 1147, fol. 465.

240. Missive Governor François Caron to Governor-General Anthonio van Diemen.
Tayouan, 25 October 1644.
VOC 1148, fol. 256-280. Extracts.
See also FORMOSA UNDER THE DUTCH, pp. 203-205.

241. List or memorandum of the annual expenses the General Company has to defray for the church works on Formosa and what receipts can be expected from the inhabitants every year.
Tayouan, [undated 1644].
VOC 1148, fol. 428.

242. Resolution, Tayouan, 31 October 1644.
VOC 1148, fol. 246-248.

243. Dagregister of Governor François Caron on his voyage from Batavia to Tayouan, with the ships *Vrede*, *Swarten Beer*, the galliot *Hasewint* and the pilot boat.
Tayouan, 25 July-15 November 1644.
VOC 1148, fol. 140-211. Extract.
DRZ, II, pp. 301-357.

244. Resolution, Tayouan, 5 November 1644.
VOC 1148, fol. 252.

245. Resolution, Tayouan, 14 November 1644.
VOC 1148, fol. 253-254.

246. Missive Governor François Caron to Governor-General Anthonio van Diemen.
Tayouan, 17 November 1644.
VOC 1149, fol. 691-695. Extract.
See also DRB 1644-1645, pp. 149-155; DRZ, II, p. 358.

247. Formosa Narrative compiled by Senior Merchant Johan Verpoorten from the reports sent from Tayouan between 2 December 1644 and 1 December 1645.
Batavia, [1 December 1645]. VOC 1158, fol. 1-51.
See also FORMOSA UNDER THE DUTCH, pp. 205-208; ZENDING, IV, pp. 17-21; DRB 1644-1645, pp. 123-176.

248. Order and instruction from Governor François Caron for Reverend Simon van Breen, departing to Vavorolang and the neighbouring villages to act as administrator in local political affairs during the absence of the Company representative in that district.
Tayouan, 7 December 1644.
VOC 1149, fol. 672-673.

249. Instruction from Governor François Caron for Merchant Antony Boey, departing as political administrator to the Southern villages.
Tayouan, 13 December 1644.
VOC 1149, fol. 674-677.

250. Original missive Governor François Caron to Governor-General Anthonio van Diemen.
Tayouan, 27 December 1644.
VOC 1149, fol. 635-643. Extract.
See also FORMOSA UNDER THE DUTCH, p. 205; DRB 1644-1645, pp. 155-160; DRZ, II, pp. 358-359.

251. Instruction from Governor François Caron to Sergeant Michiel Jansz., on his journey to Pimaba.
Tayouan, 3 January 1645.
VOC 1155, fol. 616-618. Extract.

252. Missive Governor François Caron to Governor-General Anthonio van Diemen.
Tayouan, 7 January 1645.
DRB 1644-1645, p. 160; DRZ, II, p. 359.

253. Extracts from the Dagregister Zeelandia, concerning Lamey.
VOC 1170, fol. 626-627. Extracts 10, 14 January, 12 February 1645

254. Instruction from Governor François Caron to the Senior Merchants Cornelis Caesar and Hendrick Steen, and Captain Pieter Boon on the expedition to Tamsuy and Dorenap in the north.
Tayouan, 20 January 1645.
VOC 1155, fol. 619-623. Extracts.

255. Missive Governor François Caron to Governor-General Anthonio van Diemen.
Tayouan, 15 February 1645.
VOC 1155, fol. 585-597.
See also FORMOSA UNDER THE DUTCH, pp. 208-209; DRB 1644-1645, pp. 164-169; DRZ, II, pp. 359-360.

256. Extracts taken from the Zeelandia Castle Resolution-books, concerning the resolutions on the island of Lamey, taken in the Formosa Council.
VOC 1170, fol. 599-600. Extracts 14 and 27 February 1645.

257. Dagregister Zeelandia 15 March-18 November 1645.
VOC 1158, fol. 655-765. Summary of March 1645.
DRZ, II, pp. 361-464.

258. Resolutions Tayouan, 20 March-16 November 1645.
VOC 1149, fol. 870-903. Resolution 20 March 1645.
See also FORMOSA UNDER THE DUTCH, pp. 209-210; ZENDING, IV, pp. 23-24.

259. Instructions from Governor François Caron for Senior Merchant Philip Schillemans on his journey to Soetenau and the south to consolidate the peace with the allied villages and to summon the inhabitants of the newly pacified neighbouring villages to appear at the next assembly.
Tayouan, 21 March 1645.
VOC 1149, fol. 748-749. Extract.

260. Resolution Tayouan, 21 March 1645.
VOC 1149, fol. 871-872.

261. Dagregister Zeelandia. April 1645.
VOC 1158, fol. 663-670. Summary.
DRZ, II, pp. 368-377.

262. Resolution, Tayouan 11 April 1645.
VOC 1149, fol. 874.

263. Instruction from Governor François Caron for Captain Pieter Boon, departing to Pimaba and the island of Bottol.
Tayouan, 18 April 1645.
VOC 1149, fol. 746-747. Extracts.

264. Missive Junior Merchant Jan van Keijssel to Governor François Caron.
Tamsuy, 26 April 1645.
VOC 1149, fol. 764-766. Extract.

265. Dagregister Zeelandia. April-May 1645.
VOC 1158, fol. 682-683. Summary.
DRZ, II, pp. 386-387.

266. Missive Governor François Caron to Junior Merchant Jan van Keijssel.
Tayouan, 20 May 1645.
VOC 1149, fol. 791-793. Extract.

267. Dagregister Zeelandia. 1 June 1645.
VOC 1158, fol. 689. Summary.
DRZ, II, pp. 393-394.

268. Resolution, Tayouan, 5 June 1645.
VOC 1149, fol. 879.

269. Missive Governor-General Cornelis van der Lijn to Governor François Caron.
Batavia, 19 June 1645.
VOC 869, fol. 273-288. Summary.

270. Resolution, Tayouan, 20 June 1645.
VOC 1149, fol. 880. Extract.

271. Missive Junior Merchant Jan van Keijssel to Governor François Caron.
Tamsuy, 28 June 1645.
VOC 1149, fol. 773-776. Extract.

272. Instruction from Governor François Caron for Sergeant Abraham van Aertsen to reside in Pimaba.
Tayouan, 5 July 1645.
VOC 1149, fol. 744-745.

273. Resolution, Tayouan, 15 July 1645.
VOC 1149, fol. 883-884. Extract.

274. Missive Junior Merchant Jan van Keijssel to Governor François Caron.
Tamsuy, 17 July 1645.
VOC 1149, fol. 779. Extract.

275. Resolution, Tayouan, 28 July 1645.
VOC 1149, fol. 886. Extract.

276. Missive from Governor-General Cornelis van der Lijn to Governor François Caron.
Batavia, 31 July 1645.

VOC 869, fol. 416-421. Summary.

277. Dagregister Zeelandia. August 1645.
VOC 1158, fol. 713, 720. Summary.
DRZ, II, pp. 416, 422.

278. Missive Governor François Caron to Junior Merchant Jan van Keijssel.
Tayouan, 19 August 1645.
VOC 1149, fol. 794-799. Extracts.

279. Instruction from Governor François Caron to Senior Merchant Hendrick Steen, on his way to the Company settlements in Tamsuy to assist Junior Merchant Jacob Nolpe in organising the Northern Land Day.
Tayouan, 1 September 1645.
VOC 1149, fol. 738-741. Extract.

280. Missive Governor François Caron to Senior Merchant Hendrick Steen.
Tayouan, 10 September 1645.
VOC 1149, fol. 800. Extract.

281. Missive Merchant Jacob Nolpe to Governor François Caron.
Tamsuy, 16 October 1645.
VOC 1149, fol. 786.

282. Missive Governor François Caron to President Cornelis van der Lijn and the Batavia Council.
Tayouan, 25 October 1645.
VOC 1149, fol. 817-866. Extracts.
See also FORMOSA UNDER THE DUTCH, pp. 210-213.

283. Resolution, Tayouan, 10 November 1645.
VOC 1149, fol. 899. Extract.

284. Instruction from François Caron for Senior Merchants Cornelis Caesar, Nicasius de Hooghe and Lieutenant Hans Pietersen Tschiffellij on the expedition to the eastern part of Formosa.
Tayouan, 27 November 1645.

VOC 1160, fol. 598-608. Extracts.

285. General Missive, Batavia, 31 December 1645.
VOC 1154, fol. 68-85.
FORMOSA pp. 237-239.

286. Missive Governor François Caron to President Cornelis van der Lijn
and the Batavia Council.
Tayouan, 31 January 1646.
VOC 1160, fol. 147-170. Extracts.

DOCUMENTS

Prologue

(Commander Claes Bruyn on 12 November 1633 set sail from Tayouan with the yachts Rijswijck *and* Wieringen, *together with four junks for the punitive expedition to Lamey with two companies of soldiers and about sixty sailors, reinforced with about 250 native Formosan warriors, from Sincan as well as from other villages. All of these were very eager to fight the islanders because they considered themselves to be mortal enemies of the people of Lamey.)*[1]

1. Short Description of the site and situation of the Golden Lion Island by Commander Claes Bruyn, [November] 1633. VOC 5051.

Het Goude Leeuws eylant bij de inwoonders van Formosa Lamey genaempt, is geleegen op de hoochte van 22 graden, 21 minuten benoorden de Linea Equinoctiael Z.O.N.N.W. van de zuythouck van Formosa, omtrent vier mijlen van de houck van Tancoya, Z.Z.O., N.W.W. omtrent drie mijlen. Is niet hooch noch laech maer middelmatich lant drie à vier mijlen in de circonferentie meest rond doch in 't noort-oost ende Z.W. weynich lanckwerppich; heeft grote meenichte van clappesbomen hier en daer oock eenige bosschagie en de creupelruichten, doch meest aen Z.Z.O. en N.O. zijde; heeft rontomme geen gront als op een half canonschoot van de wal op 28 à 30 vaem santgront met crael vermengt. Naerdercomende is vuyl ende clippachtich, heeft aen de N.W. zijde drij cleyne santbayckens aen de Z.W. zijde een ditto (daermen mits verscheyden ontwijffelijck teeckens vermeynt 't jacht *Beverwijck* gebleven ende aengecomen is) ende aan de Z.O. zijde witte strant van puer cral, met een schoone valeye vol clapper ende andere boomen, het strant met een creupelbosch dicht beseth sijnde ende dit was de plaetse daer het volck landen, welck creupelbosch, dat omtrent een musquet breet is, deur sijnde compt men in de voorseyde valije vol met clapperboomen so playsant beseth dat te verwonderen is. De gront onder deselve is hier en daer met

pattatessen als andere dingen besayt ende soo suyver dat een lust om sien
is. Dese valije deur sijnde, compt men tegen 't hooge geberchte dat een
rugge omtrent midden op 't eylant is, loopende van N.O. tot in 't Z.W.
langs het eylant meest in 't midden, latende aen beyde zijde seer schoone
ende lustige valije ende beemden. Dit geberchte is in 't opgaan vol dicht
en groot creupelbosch gelijck oock alle andere die vonden hier en daer in
de valeijen, maer boven op wonderlijk schoon ende lustich, veel meede
met pattatessen besayt ende met clappernooten ende palmiten beseth.
Het dorp ofte negrie dat d'onse verbrandden, hadden sij op hoochste van
dit geberchte aen de Z.W. zijde op de maniere van alle Indische natiën,
doch op veelen deelen niet soo goet als die van Sinkan ende andere dorpen
maer veel cleynder, staende d'selve in twee rije en laten een grooten ende
breeden straet als een marct in 't midden ofte tusschen beyden. Achter het
dorp naer 't westen, omtrent een groote steenworp, is op het hoochst van
't selve geberchte in een verwonderens- ende besienswaerdige spiloncque,
daer men seyt sij haer bij overval van vianden (gelijck gelooflijck is) altijt
in begeven ende vluchten met al 't geene dat meede crijgen connen. De
speloncke is, segh ick, een wonderlijcke clove in dien hooghe berch die
meest steenachtich is, lopende in de lengte metten selven berch omtrent
een halff mijl eyndende in de valye aen de selve sijde, daer een bequamen
uytganck (gelijck noch op twee à drie andere plaetsen) heeft; den inganck
van 't geberchte is bij ende achter 't dorp, gelijck als met eenen trap van
langsamer hant ende gemackelijcke affgangh. Boven is de cloove heel
naeuw dat men op eenige plaetsen daerover springen soude ende met
dichte bosschagie overwassen qualijck can gesien werden ende is niet
sonder perijckel bij onvoorsichtheyt ofte doncker van dach in te loopen,
maer onder ongelijck wijder, gaande de canten onder uyt ende so diep dat
men op veel plaetsen geen gront sien can. Ja, men gelooft dat beneeden
noch heele hoolen en gaten onder 't geberchte zijn, daer terloops niet uyt
te crijgen sijn, ende dese plaetsen is haren toevlucht als zij van hare
vianden overvallen werden. Sulcx dat degene die het selve eylant soude
willen depopuleeren, moste subitelijck ende onversiens comen ende dan de
toegangen besetten, als wanneer in corten tijt de inwoonders door
hongersnoot buyten twijffel hun selffs in handen souden comen overgeven.
De inwoonders, soo veel men verstaen can, is naar 't seggen van de
Soulanghers affcomstich en soude bij onweer der custvlooten bambousen
met vrouw ende kinderen daerop gedreven zijn; tot confirmatie van haer
voorgevende dat eenige van hare woorden verstaen; doch anders sijn tale
van die van Formosa heel verschijden, maer in manieren, gestaltenisse van
lichaam, couleur ende godtsdientsen d'selve meest gelijck: heel barbaris

ende wreet alles doodende; ende was van andere natiën alsoo geen vrunden als die van 't eylant becoomen connen ende met de hooffden ofte backeneelen (dat voor haar grootste schat houden) seer proncken, haere dapperheyt ende manheyt met d'selve te kennen geven volgens de maniere van de Formosanen; hebben geen gooden ofte godtsdienst als die haer selven practiseren; hare vruchten zijn clappesnooten in groote menichte, palemijt, pattates ende millie (daer oock gelijck die van Formosa massycauw off dranck van maeken en wonderlijck droncken in drincken connen), sonder rijs, alhoewel het lant ende valeyen daertoe bequaem ende vruchtbaar genouch toe schijnen; andere vruchten hebben geen vernomen, noch verstaen daer te wesen.

Gevogelte isser gants weynich, oock geen hoenderen, weynich duyven ende cleyn gevogelte als musschen. Als ons volck daer aen lant was, wiert er in 't dorp een gebraden vogel gevonden, soo groot ende grooter als een gans, dat wij oordeelden een cropvogel te sijn, die apparent in water ofte morassen becomen hadden. Wilt ofte viervoetich gedierte isser geen als menichte van tamme varckens ende huyskatten die den drie à vier in de huysen gesien sijn, anders weet men van geene te spreken. Sij generen haer oock met vissen op bamboese vlotjens ofte catte merauwen, voor schuytgewijs een weynich oploopende tegen 't rollen van de zee, zonder dat practiseeren eenich vaertuych te maecken niettegenstaande daer wel gelegentheyt ende hout toe hebben; sijn oock seer wantrouw, ende laten niemant toe op het eylant te comen handelen noch wandelen met niemant als met Chineesen, die om eenige cleynicheeden, groote menichte ende veel duysende clappesnooten jaerlijcx (in de maenden januarij en februarij als wanneer de Chinesen op de hardervangst ofte teelt op de custe van Formosa comen) geruylt ende dat noch (soo men de Chinesen gelooven mach) sonder gesien te werden, want de Chinesen daer comende leggen haer goet op 't strant en gaen wech, daer de eylanders dan soo veel clappusnooten tegen ofte bijleggen als daervoor geven willen; soo 't dan de Chinesen aanstaet neemen de nooten ende d'ander 't goet, soo niet neempt elck 't sijne.

Dese luyden, alsoo niemant betrouwen, hebben geen vrunden maar al de weerelt, als vooren geseyt is, tot viant, insonderheyt die van Formosa dat hare doot vianden sijn, daervan oock dickwils bij nacht ende onversiens met cleyn vaartuych, gelijck haer maniere is, besprongen, niet het geheel eylant maar eenich huys dat steelswijs ende als dieven soetelijck, sonder dat het iemant gewaer wert, soucken open te breken; al doot slaande wat vinden tot kinderen die eerst gebooren sijn, toeneemende de hooffden, armen en voeten met haar. Maer in 't opbreecken die van 't huys 't selve

gewaer werden ende gerucht maecken, vlieden de bespringers datelijk in
haer vaertuych ende vertrecken sonder eenige resistentie.

Men presumeert dese eylanders mede de vervloucte maniere van kinder
dooden, als d'inwoonders van Formosa te hebben, vermits niet meer en
populeeren ofte vermeerderen. Want soo veel hebben connen vermercken
ende van anderen verstaen, isser weynich volck (naer den langen tijt, die
buyten alle menschen gedencken is) die daar op geweest sijn, dat 't selve
eer doet gelooven.

Water isser op 't gebergte niet, maer moeten d'inwoonders 't selve uyt de
valeyen halen ende boven brengen; hebben groote, uyt boomen
uytgehoolde backen daer 't selve in bewaren.

Dit gemelte eylant, is soo lustich ende vermaeckelijck dat het niemant
soude willen gelooven die het niet gesien heeft, ja veel confirmeeren dat
geen lant in Indiën, ja Poelewij, datwegen sijn playsantie grootelijck
berucht ende vermaert is, bij dit niet is te vergelijcken; meenen oock soo
't selve behoorlijck gecultiveert wert, alsoo d'aerde goet ende vet is,
allerhande vruchten van de werelt, insonderheyt d'Indische, souden geteelt
connen werden.

The Golden Lion Island, named Lamey by the Formosans, is situated on
the latitude of 22°, 21 minutes N of the equinoctial line, S E, N N W of
the southern tip of Formosa, at about four miles off the point of Tancoya,
S S E, N W W about three miles. The island is neither high nor low but
of an average height for a normal landmass, three or four miles in
circumference and has, apart from the slightly elongated northeastern and
southwestern tips, a round shape. A large quantity of coconut trees grow
on the island and so does some coppice and thicket here and there, mostly
at the southsoutheastern and northeastern side; it has no mooring grounds
as far as half a canonshot from the shore, at 28 or 30 fathom, which
consist of sand mixed with coral. Closer to the shore it is rocky and full
of cliffs. Three small sandy bays are situated on the northwestern side,
and another one (where several signs indicate that this is undoubtedly the
spot where *Beverwijck* ran aground and was wrecked) on the southwestern
shore.[2] On the southeastern side is the white coral beach, where our men
landed. Inland it is densely covered with thicket for about the length of a
musketshot. Once having crossed this small barrier one reaches an
amazingly beautiful valley, nicely covered with an abundance of coconut-
and other trees. It is a treat for the eye to see how here and there the soil
is seeded with sweet potatoes as well as other crops. Having passed

through that valley one reaches the ridge of the high mountains, that stretches all the way along the centre of the island from the northeast towards the southwest. Everywhere the slopes are wooded with thicket but we found the valleys beautiful and attractive, seeded with sweet potatoes and planted with coconut trees and palmettes.

The native village, which our men set afire, was constructed like those of all Indian nations and positioned on the southwestern side at the top of the mountains although it was in no way as well built as Sincan or other Formosan villages. The houses were set up in two rows leaving a large, wide street rather like a market in the middle. Behind the village, at about a stones throw away in a westward direction and on the top of the mountains is situated a curious cavern in which, it is said, they quite undisturbedly seek refuge with as many of their belongings as they can carry along when enemies raid them. The cave, I say, is a curious gorge in the high mountain. The inside is stony and runs the length of that mountain for about half a mile and issues on the same side in the valley where there is (apart from two or three other exits) a good way out. The entrance to the cave in the mountains is situated right behind the village and is easy to reach, rather like descending a gentle staircase. On top the gorge is so narrow that at places one can jump from one edge to the other. Because it is densely overgrown with brushwood the gorge can hardly be seen and one may run the risk of, either due to carelessness or darkness, tumbling down into the depths. Lower down, the gorge is much wider and so deep that at many places one cannot see the bottom. It is believed that down below there are more subterranean caves where the islanders cannot be caught and which serve them as hiding places. Consequently those who would like to depopulate this island should land unexpectedly and immediately occupy the entrance ways to ensure starvation will force the inhabitants into surrendering themselves.

As far as we understand, the inhabitants are said to originate from Soulang. Once upon a time in a storm some men together with women and children had drifted to the island in a fleet of coastal bamboo rafts. The fact that, in spite of the great diversity in Formosan languages, the Soulang people said they were able to understand some Soulangian words would serve as confirmation of that presumption. In their manners, stature, skin colour and religion they are quite similar to those of Soulang. The Lameyans are very cruel and barbaric, killing every soul

[who happens to set foot on their island] consequently they can not count upon the friendship of other Formosan nations, only of those from their own island. According to their customs they show off heads and skulls which they consider their greatest treasures, thus displaying their bravery and manliness. The people of Lamey do not celebrate their gods or worship differently from elsewhere. Their fruits of the land are coconuts, available in large quantities, palm kernels, sweet potatoes and millet (from which they, just like the Formosans, brew *massycauw*, a liquor with which they can drink themselves stone-drunk). Although the fields and valleys seem to be fertile enough, no rice is cultivated, nor are any other fruits or crops grown on the island. Birds are quite rare and only some pigeons and small birds like sparrows live on the island: they have no poultry. However when our men were on the island an enormous roasted bird was discovered in the village, much larger than a goose. Presumably it was a pelican they had caught in the sea or in the marshes. There is no game nor are there any four-footed animals on the island except a quantity of domesticated pigs and some cats, that have been seen only in three or four houses. The people make a living from fishing for which they employ little bamboo rafts *catte merauwen* or catamarans constructed with a sloping prow to withstand the rolling waves but, although they are provided with enough wood or other materials, they do not built any other kind of vessel.

They are extremely distrustful and they allow nobody to set foot on the island, neither to barter nor to walk, apart from some Chinese who once a year (during the months of January and February when they set out to the Formosa coast for the mullet fisheries) pay a visit to the island to barter trinkets for many thousands of coconuts. According to the Chinese (if we can believe what they tell us) the trade takes place without the participants actually seeing each other. The Chinese put their goods on the beach and leave right away and when they return after a while to the place were they left their goods they find an amount of coconuts the islanders consider to be fit for the goods. If the Chinese agree they take away the coconuts while the islanders take the goods. If they do not agree both parties take back what is theirs.

Because these people do not trust anybody and have no friends they consider the whole world as their enemy, especially those from Formosa who are their arch-enemies. Indeed these Formosans sometimes come to

the island unexpectedly in the night, as is their habit, in a small vessel, to raid not the whole island but just to burgle an isolated house like thieves, without being seen, beating to death every soul they come across - even the infants - taking the heads, arms, feet and hair. As soon as some of the inhabitants of the house raise the alarm the intruders run back to their vessels without offering any resistance and leave immediately.

Presumably these islanders also practise the dreadful custom of infanticide, just like the inhabitants of Formosa, because the population of Lamey does not increase. As far as we have learned from others, Lamey was sparsely populated, considering they have been living there from time immemorial. Indeed it is more than likely that [infanticide] is followed.

Because there is no water available in the mountains where the village is situated, the inhabitants have to fetch it from the valleys and carry it all the way to the top. The water is kept in large troughs, made from hollowed out tree trunks. This island is such a delightful and enjoyable place that somebody who has not been there himself would hardly believe it possible. However, many people do confirm that no country in the Indies can be compared with this island, not even Poulo Ai which is famous and reknowned for its natural beauty. We are of the opinion that the soil is rich and fertile and that if the lands were properly cultivated all kinds of crops (including those of the Indies) could grow there.

1636

2. General Missive, 4 January 1636.
VOC 1116, fol. 17. Extract.
FORMOSA, pp. 148-149.

3. Missive Governor Hans Putmans to Governor-General Hendrick Brouwer.
Tayouan, 18 January 1636.
VOC 1120, fol. 219-224. Extract.
DRZ, I, p. 235; DRB 1636, pp. 18-23.

fol. 220: Corts naer 't vertreck van *Venloo* op 16en november is de tocht op Mattau de 23en dito des morgens voor dage met ontrent 500 blancke coppen, verdeylt in zeven compagnieën, bij der handt genomen ende de victorie desselven daechs met sonnenonderganck, Gode zij lof, (met verlies van 26 van d'hare zoo mans, vrouwen als kinderen die de Sinckanders, zeer op hun verbittert sijnde, al doot sloegen zonder dat eene van d'onse gequetst is geworden) over deese brutale heydens becomen, die gantsch geene ofte zeer weynich wederstandt deeden, maer zoodra ons vernamen hun op de vlucht begaven, verlatende meest alles wat hadden uitgezondert eenige cleederen, daermede zij verliepen. Haere plaetsen rontom haere huysen, die zeer groot ende met veele pinangh- ende clappusboomen beseth zijn, waeren overal met menichte van padijhuyskens ende verckenscooten, die meest vol waeren, fray in ordre geboudt, dat wij (uitgezondert het geboomte dat niet door den brandt verslonden wierd) des anderen daechs tot straffe ende revengie van de leelijcke moort aen d'onse over 6½ jaer begaen, alt'samen door 't vuer lieten verteeren.
Op 28en ditto verscheenen hier voor den raet, naerdat hun vrijgeleyde was toegesecht, nevens eenige Sinckanders ende Soulanghers met domine Junius twee van de overste ofte outste van Mattau, die zeer demoedich hare voordesen begaene faulte bekennende, ernstelijck uit last ende vanwegen het gantsche dorp om vreede versochten, presenterende wat wij begeerden te mandeeren. Zij wilden 't gaerne alles naercomen (fol. 221) ende haer, gelijck de Sinckanders, onder ons submitteren, waerop hun verscheijden geraemde artijcquelen door domine Junij in haere tale wierden voorgestelt, omme d'selve haere gemeynte in't generael voor te stellen. Dat zij aennamen te volbrengen, niet twijffelende off se zouden alt'samen daertoe verstaen ende in corten met goet bescheyt weder terugge

keeren, gelijck sulcx oock op den 3en december passado gebeurde, als wanneer in meerder getal met verscheyden pinangh- ende jonge clappusboomkens met aerde in tresellen, ofte aerde wijde commen geplandt (waermede zij haer landt ende vruchten van dien aen den Hoogmogende Heren Staten Generael opdroegen) weder voor den raet verscheenen, belovende uit den naem van haere gantsche gemeynte deese nevensgaende ende aen hun voorgestelde poincten in allen deelen naer te comen ende onderhouden, tot welcken fijne eenen dach om 't accort in presentie van d'ingesetenen van d'andere omliggende dorpen te proclameeren) wiert gestelt, sulcx dat het selve op den 19en december effect gesorteert ende zoo hier in Mattau als Sinckan geaffigeert is.

Van gelijcke is op 22 passado den tocht op Taccareyang waervan voordeesen hebben mentie gemaeckt met ontrent 500 van d'onse ende 400 à 500 zoo Sinckanders als andere inwoonders van de omleggende dorpen bij der hant genomen ende naer lange marcheerens op den 25en, met vercrijginge van negen hooffden van de hare ende apparent vele gequetsten, mitsgaders ruïne van haer gantschen dorp, zoo aen boomen als huysen die overal vol padij lagen ende verbrandt zijn, seer wel ende gelukkich (zonder datter ymant van d'onse, als alleene drij die in de beenen een weynich van voeth-angels zijn gequetst geworden, is gebleven) uitgevallen. Ende arriveerden op 28en dito met veel buyts onder d'inwoonders weder aen 't fort Zeelandia, waervoor dien Almogenden Godt ende Gever alles goets in alle Eeuwigheyt moet gelooft ende gedanckt zijn, die hetselven wil laeten gedijen tot Zijns Naems eere, bekeeringe deesen heydenen ende des Compagnies nutticheyt ende welvaert.

In dit dorp Taccareyangh vonden verscheyden cledinge ende een loop van een Hollants roer, zijnde naer alle apparentie een seecker merckteecken dat d'onse bij deese inwoonders van dit dorp zijn vermoort. Sulcx dat het blijct den Alvoorsienden Godt onsen leytsman in deesen is geweest ende ter rechter plaetse daer de wrake behoorde te geschieden, heeft gebracht, zijnde noch drie à vier cleynder dorpen daer ontrent ende dichterbij gelegen, d'welcke wij (ter oorsaecke ons volck seer moede gemarcheert waeren, het broot ons begon te mancqueeren, den grooten wech die gecomen waeren weder moesten keeren, te meer d'inwoonders van Sinckan daer zeer om riepen), resolveerden in esse te laten, oock met sulcken insicht om preuve te nemen ende sien off men haer met Sinckan con vereenighen ende alsoo mede onder onse subjectie brenghen.

Dit dorp Taccareyangh ontrent 12 à 13 mijlen Z.O. van Tayouan gelegen is, naer 't seggen der Chineesen ende Sinckanders, het grootste van

(fol. 222) haere nabuyren, zeer vermaert, stropende ende rovende alles dat daerontrent compt te stranden, zonder imandt die becomen in 't leven te laten. Weshalven onder deese inwoonders overal seer ontsien ende gevreest zijn geweest. Sulcx dat onsen naem ontsach ende authoriteyt onder deese brutale heydenen ende omliggende dorpen (ziende wat wij connen te wege brengen) daer zeer sal door vergroot ende gestijft werden. Echter was het dorp van Mattau veel grooter ende schoonder van huysen als Taccareyangh, maer ditto dichter met huysen betimmert, seer rijck van vellen ende verckens, waerin haeren meesten rijckdom bestaedt […].

fol. 220: Shortly after the departure of the *Venloo* on 16 November 1635, the expedition against Mattouw was undertaken. Approximately 500 white men, divided into seven companies had left Tayouan early in the morning of the 23rd of that month. At sunset on the same day, thank the Lord, victory was achieved over these insolent pagans and none of our men was hurt, though from their side they lost 26 men, women and children (all of them beaten to death by the Sincandians who were very incensed at them). The people of Mattouw offered very little or no opposition, but fled as soon as they saw us, leaving behind almost everything they owned apart from a few clothes they were wearing. The yards around their houses, being very large and planted with many pinang- and coconut trees, contained a multitude of neatly arranged rice-barns and pigsties everywhere, filled with supplies. We had everything burnt down by the next day (except those trees that did not catch fire) as a means of punishment and revenge for the vile murder committed on our people 6½ years before.

Once safe-conduct had been granted to them, two of the headmen or elders of Mattouw appeared over here before the Council (together with several inhabitants of Sincan and Soulang and the Reverend Junius) on the 28th. Very humbly they confessed to the crimes they had committed in the past and requested for peace on behalf of the entire village, offering anything we liked to order them. They were eager to comply with everything (fol. 221) and were ready to submit themselves to us just as the Sincandians had done. At this point Reverend Junius proposed several premeditated terms to them in their own language, so that they could present these to their community. They gladly assented to do so, trusting that they (their people) would all agree with those terms and that they would return with the affirmative message very soon, which indeed

occurred on 3 December, when the headmen reappeared before the Council. This time they came with more people, carrying with them several pinang and young coconut trees planted in wide earthen pots (by means of which they dedicated their land and its fruits to the High and Mighty Gentlemen of the States General) promising on behalf of their entire community to comply with the accompanying points presented to them and carry them out completely.[3] For this purpose a certain day was chosen (to proclaim the agreement in the presence of the inhabitants as well as those of the other surrounding villages), so that it was carried out and made public on 19 December in Mattouw as well as in Sincan.

Likewise the expedition against Taccareyang, which we mentioned before, was undertaken with approximately 500 of our men together with 400 to 500 Sincandians, as well as other inhabitants of the surrounding villages, on the 25th after a long march had been brought to a good and fortunate end (without losing any of our men, but for three soldiers who were slightly wounded in the legs by foot-traps). The expedition succeeded in capturing nine heads of the enemy and many of them were injured as well. The entire village was ruined and all trees and houses, completely filled with paddy everywhere, were burnt to the ground. On the 28th of December we returned to the fortress Zeelandia accompanied by allied natives who were carrying an enormous amount of loot with them, for which the Lord Almighty and the Giver of all good things who will make prosper in His Name the conversion of these pagans and the welfare and interest of the Company, must be praised and thanked.

In this village of Taccareyang we found several items of clothing and the barrel of a Dutch musket, which would seem to be a certain sign that our men were killed by the inhabitants of this village. So that it is clear that God Almighty acted as our guide in this case and led us to the right place where revenge should be taken. There are three or four other smaller villages situated in the neighbourhood, which we decided to leave undisturbed (for the reason that our people were very tired from the march, and that we were almost running out of bread, and had to return along the same long road on which we had come especially because the Sincandians beseeched us to do so). Therefore we decided to leave them in peace, also with the idea in mind to try and find out whether they could be united with Sincan and be subjected to us in that way.

This village of Taccareyangh, situated at approximately twelve to thirteen miles southeast of Tayouan, is, according to the Chinese and the Sincandians, the largest of all the neighbouring villages, (fol. 222) reknowned for poaching and pillaging everything that happens to be stranded, and saving nobody's life, for which reason they are seriously feared and held in awe by all their neighbours. Thus our name, power and authority among these impudent pagans and surrounding villages will be magnified and strengthened now they have seen what we are able to accomplish. The village of Mattouw was, however much larger and its houses were far more neatly built than those in Taccareyangh, but that village was more densely built, and very richly provided with deerskins and pigs, which represents most of their resources. [...].

4. Agreement between Governor Hans Putmans and the Zeelandia Council on behalf of the VOC on the one side, and the headmen of Mattouw on behalf of the community on the other side.
Tayouan, 18 December 1635.
Collectie Aanwinsten 119 (1866 A XII), fol. 349-351 (February 1636).
DRB 1636, pp. 19-22.[4]

fol. 349: Eerstelijck beloven wij Tavoris, Tunchuij, Tulologh ende Tidaros uit den naem ende van wegen de gantsche gemeente van ons dorp Mattouw dat wij alle de hooffden ende andere gebeenten van de gemassacreerde Nederlanders die wij volgens onse costuyme te pronck plachten te dragen ende noch bij ons mochten berusten door het gantsche dorp onder een yder sullen doen opsamelen ende wederom met d'eerste gelegentheyt in Sincan aen d°. Junio leveren, mitsgaders alle de musquetten ende voorder geweer als cleedinge, soo ende sulcx als 't selve onder ons soude mogen bevonden werden.

Ten anderen soo geven wij met dese overgeleverde clappus- ende pinanghboomkens in d'aerde geplant te verstaen, dat wij transporteeren ende opdragen volcomentlijck ende in allen delen aende Ho. Mo. heeren Staten Generaal vande Vereenichde Nederlantsche provintiën alsulcke pretentiën ende eygendommen als wij wegen onse voorouders ende het besith dat wij jegenwoordich in 't dorp Mattouw ende ten platte landen daer omtrent gelegen sijn hebbende, soo verre onse jurisdictie van 't oosten tot aen 't geberchte, ten westen tot aen de zee ende het noorden ende suyden soo verde als ons commandement is streckende, soude mogen

geërft ofte dus lange in eygendom door 't besidt volgens aller volckeren recht verkreegen hebben.

Ten derden dat wij om geender hande oorsaecken naer desen meer eenige wapens tegen de Hollantse natie haere bontgenooten ofte geallieerde vrunden bij der hant sullen neemen maer ter contrarie boven gemelte Ho. Mo. heeren Staten Generael erkennen, respecteeren, gehoorsamen ende houden voor onse beschermheeren, onder wien ons gaerne ende gewillich submitteeren, tot welcken eynde (ende omdat alles met des te beter ordre soude mogen toegaen) belooven wij mede te gehoorsamen ende naer te comen allen 't geene ons de vier opperhooffden (die d'heer gouverneur sal gelieven daertoe uyt een dubbelt getal van onse outste te committeeren ende stellen) in billickheyt gelasten, commandeeren ende beveelen. Item dat geduerichlijck een prinse-vlaggetien op eene van onse vier principale kercken drie maenden om drie maenden sullen laeten wayen, alwaer oock soo daer iets remerquabels voorvalt, sulcx dat onse outsten ofte opperhoofden van 't dorp mosten tesamen comen, de vergaderinge sullen houden.

Ten vierden dat soo wanneer d'heer gouverneur met eenige andre dorpen ofte inwoonders deses lants comt in oorlooge te vervallen, ons altijt willich ende bereyt sullen laeten vinden om die nevens de Nederlandse natie te beoorlogen ende vermeesteren, waertegen weder de Nederlantse natie (mits dat d'oorloge in redenen bestaet ende deselve wel kennisse van d'heer gouverneur wert beslooten bij der hant te nemen) sal gehouden wesen ons naer vermogen in aller billicheyt te assisteeren ende helpen, voor soo veel des Compagnies constitutie wil toelaten.

fol. 350: Ten vijffden dat wij alle Chineesen die in Wankan ofte elders kalck branden als die het plattelant omme haere negotie in hertevellen excerceeren nootwendich moeten gebruycken, vrijelijck sonder eenige verhindering ofte overlast hun aen te doen overal sullen laten passeeren ende repasseeren, daer ende ter plaetsen daer het hun belieft, sonder nochtans eenige Chineese roovers, verloopene Nederlanders, ofte hunne slaven op te houden, ofte huysvestinge te verleenen, maer ter contrarie datelijck naer gedane requesitie deselve sullen weder geven ofte selffs aen 't casteel brengen.

Ten sesten dat soo wanneer ons een prinsen stock bij den deurwaerder, 't sij aen imant particulier ofte wel een meerder getal vertoont wert, datelijck in Sincan oftte aen het casteel (om eenige saecken te verantwoorden oftewel andersints gebruyckt te werden) te compareeren, 't selve datelijck sullen naercomen ende obedieeren.

Ten sevensten ende jongsten dat wij tot erkentenisse van onse misdaet in 't massacreeren vande Nederlanders begaen, op denselven dach dat sulcx geschiet is, alle jaeren een grooten sooch ende beer aen 't fort bij den gouverneur sullen brengen, waervoor sijne Ed. tot onderhoudinge van vrientschap ons weder sal vereeren met vier princevlaggetiens ofte vaendeltiens. [...].

fol. 349: Firstly, we Tavoris, Tunchuij, Tulologh and Tidaros promise in name and on behalf of the entire community of the village of Mattouw that all the heads and other bones of the massacred Dutchmen that we, according to our customs, use to show off and which still are deposited with us, will be assembled by everyone throughout the entire village in order to return them at the first opportunity to Reverend Junius, as well as all muskets or other weapons, and clothes which may be found in our midst.

Secondly by handing over sprigs of palm and pinang trees planted in earth we make known that we completely and in every part transport and submit to the High and Mighty Gentlemen of the States General of the United Dutch Provinces all pretensions or possessions that we own on behalf of our ancestors and the possessions we own today in the village of Mattouw and on its surroundings or may have inherited or have acquired as a possesion according to the law of all nations, as far as our jurisdiction reaches from the east until the mountains, from the west to the sea, and as far as our command reaches to the north and south.

Thirdly that after this we will never take up arms again against the Dutch nation, her allies or allied friends but on the contrary we shall acknowledge, respect and obey the above mentioned High and Mighty Gentlemen of the States General, and regard them as our patrons to whom we submit ourselves gladly and willingly, for which purpose and in order to make everything happen in good order, we also promise to obey and to fulfil everything, the four headmen (who will be chosen and delegated by the lord Governor out of a double number of our elders) will fairly order or command us to do. Also that the colours of the Prince of Orange will be flown on top of one of the four principal churches every three months, which will also be the place where, if something unusual happens, the elders or headmen will assemble.

Fourth, if the lord Governor should wage war on some other villages or inhabitants of this land we shall always be ready to take up arms against

the enemy and fight side by side with the Dutch nation, just as the Dutch shall be obliged to assist and help us (subject to the governor's approval of the reasons for starting that war), according to their ability as much as will be allowed by the Company's constitution.

fol. 350: Fifth, all Chinese, who are engaged in Wancan or elsewhere in lime burning or all those who need to pass through the lowlands in order to excercise their trade in deerskins will be given free passage in both directions without causing them any inconvenience or obstruction. However if any Chinese pirates, Dutch deserters or runaway slaves should stay or hide themselves in our neighbourhood we shall not accommodate them but on the contrary we shall immediately, upon request, return them or deliver them to the castle ourselves.

Sixth, if the guard shows us a staff with the coat of arms of the Prince of Orange, either to somebody in particular or to a number of people, we shall directly comply with this and appear (in order to account for certain matters or for whatever other service) in Sincan or at the castle gate.

Seventh, in recognition of the crime we committed by massacring the Dutch, we shall each year, on the day the crime was committed, deliver a large sow and a boar at the fortress to be offered to the governor in exchange for which His Honour will bestow on us four Prince's flags or small banners.

5. Missive Governor Hans Putmans to Governor-General Hendrick Brouwer.
Tayouan, 21 February 1636.
VOC 1120, fol. 232-237. Extract.
See also FORMOSA UNDER THE DUTCH, p. 112; ZENDING, III, pp. 77-78; DRZ, I, p. 235.

(On 8 January, on the same day the crime was committed seven years earlier, an expedition to Soulang was undertaken to get hold of seven inhabitants of that village who actually had taken part in the massacre of the Company soldiers in the Mattouw River in 1629 and were also guilty of beating to death a 'visitor to the sick' who had been stationed in Soulang to learn the language. Some of the people of Soulang, not being guilty of murder, begged that their houses might not be burnt down. They surrendered and promised to accept all the conditions the VOC had

*imposed on Mattouw. The next day (10 January) the troops returned to
Sincan with the seven murderers from Soulang, who were executed
immediately upon arrival in Sincan on the square in front of the church
'as an example to these cruel pagans'. On 31 January peace with Soulang
was finally concluded. Meanwhile, on 12 January, a visit was paid to
Tevorang, a village in the mountains which was on friendly terms with the
VOC. The elders were willing to renounce their idols and serve God
instead.)*

fol. 234: [...] Nadat wij ontrent twee uyren binnen voorz. dorp gerust ende
wel vruntlijck onthaelt waren, trocken den selven wech die gecomen
waren, wederom terugge ende arriveerden den 13^{en} dito namiddach weder
in Sincan. De principale van 't dorp met ontrent honderd man sterck, die
23 à 24 potten van haer besten dranck ons nadrougen ende geleyden tot
ontrent twee uyren gaens buyten haer dorp, daer zij haer affscheyt
naemen, ernstlijck versouckende met haer in vrede te willen continueren,
oock de behulpsaeme hant te bieden tegens haer vianden wat vorder in 't
gebercht wonen; 't welck hun wiert toegesecht na gelegentheyt te
presteren.

Het geberchte dat passeerden, was overal met goede en groene cruyden en
gras beset en daer de houcqen off canten door de snelle affloopende
revieren weggestroomt waren, was 't meest cley- en santachtig, met groot
en cleene keyen en singel vermengt. In eenige valeyen tegens 't hangen
van 't geberchte vonden cleene slag van vreemde eyckelboomkens ende
ontrent eenige beecxkens bamboezen, doch het groote geberchte te
landewaert van Tevoran gelegen, verthoonde hem rijcker van groote
boomen te wesen. De gemelte groote revieren was de eene naest de
zeecant gelegen zandich, met weynig modder vermengt, en de lantlijxte
met geheel groote ende cleene keyen met sant ende modder.

Naer gedaene insinuatie aen d'inwoondren van Taccareangh ende daer
ontrent gelegene dorpen, om wat redenen wij dito Taccareang gantsch
vernielt ende geraseert, mitsgaders d'omleggende ditos volgens onse
loffelijcke costuymen ende christelijcke medoogentheyt noch vreedelijck
(fol. 235) (op hoope datt van hare barbarische magneren van moorderijen
soude disisteren ende opdracht haerder landen aen den Hoog Mogende
Heren Staten Generael te doen, sonder deselve aen te tasten, gelijck wel
hadde connen geschieden) in haere volle possessie hadden laten sitten,
verschijnen op 4^{en} couranti seven principaele hooffden van de dorpen
Taccareang, Tamsuy, Tapoliang ende Zoatalau, raporterende dat onse aen
haere gedaene aenbiedinge van vreede, met het senden eeniger Sincanders

ende twee Hollanders, hun seer lieff en aengenaem was geweest ende dienvolgende van hare gemeenten van voorz. vier principael dorpen waren gecommitteert om van vreede te handelen. Tot een erkentenis van dat voordesen qualijck gedaen hadden, brachten 17 levendige varckens, die in danck gelieffden te accepteren.

Waerop hun door de tolcken lieten aendienen, dat haere comsten ende rapporten ons wel gevielen, doch dat hun alvoren, eer wij in vrede quaemen te treeden, eerst de articulen ende conditiën van vrede zouden laeten voorlesen, om deselve haere gemeente voor te dragen. Ende lieten hun d'articulen, weynich van de Mattause en Soelangers verschillende, duydelijck en promptelijck vertolcqen, dewelcke zij belooffden haere gemeente aen te cundigen, niet twijffelende of zij en souden alles consenteren ende gaerne nacomen. Sulcx, dat wij niet en twijffelen off den vrede sal volcomentlijck sijnen voortganc nemen, dat voor onse als de Chinese natie, mitsgaders de Sincanders, en bij stranden eeniger schepen off joncquen, alsmede het frequenteren van de hertejacht, zeer vorderlijck soude wesen want van alle het vaertuyg dat voordesen daer ontrent quam te stranden, wierde niet alleen de goedren gerooft, maer ooc het volcq van dootgesmeten. 't Welck wij verhoopen met desen vrede nu niet meer sal geschieden, dat Godt geve.

Met desen vrede van de Taccareanders ende Timsuiers zoude onse limiten van ontrent drie mijlen, die wij om de zuyt van Tayouan alleenelijck vrijelijck in 't jagen plachten te mogen gebruycken, tot ontrent de 14 à 15 mijlen uitgebreyt ende vergroot sijn. Ende zoo die van Favorolang, een dorp ontrent zes à zeven mijlen benoorden Wanckan gelegen, het mede recht meenen (gelijc voorgeven) ende alreede daerom verzocht hebben, soo souden onse palen mede ongeveer soo verde om de noort, ende ontrent anderhalven dach reysens in 't geberchte oostwaerts uitgebreyt werden, 't welck niet alleen tot grooten dienst ende nutticheyt van de Generaele Compagnie inde negotie van hertevellen, maer ooc tot sonderling gerieff van de Chinesen ende inwoonders sal comen te strecken [...].

fol. 234: [...] After having rested for about two hours in that village and having been welcomed very well in a friendly manner, we returned along the same route and arrived in Sincan in the afternoon of 13 January. Upon leaving the village, the headmen of Tevorang had escorted us for about two hours with about a hundred men who carried 23 or 24 pots of their best liquor. On parting they requested us very seriously that the peace should be continued and if we could assist them in the wars against

their enemies who dwell a little further away in the mountains. We promised to do so if the situation would permit us to.

The mountains which we passed were grown over with fine, green herbs and grass. Wherever edges were eroded by swift streams of water running down the slopes, they consisted of clay or sand mingled with small or large rocks and shingle. In some valleys against the mountain slopes we found an odd type of small oak tree and near small streams we found bamboos. The high mountains situated in the hinterland of Tevorang held an abundance of large trees. Among the large rivers, the one situated near the sea shore was sandy and muddy. The water of the other river, on the inland side, contained large and small rocks with sand and mud.

Seven principal headmen of the villages Taccareyang, Tamsuy[5], Tapouliang and Swatalauw appeared on 4 February. We had informed the inhabitants of Taccareyang and the surrounding villages for what reasons we had destroyed and ruined Taccareyang completely, while we had left the surrounding villages without doing any harm to them, as we could have easily done, in concurrence with our praiseworthy customs and christian charity (fol. 235) thus hoping they would abandon their barbarous ways of murder and would dedicate their land to the High and Mighty Gentlemen of the States General. They reported that the peace proposal, awarded to them by a few Sincandians and two Dutch envoys, was pleasant and agreeable to them, whereupon they had been commissioned by the communities of these four important villages to negotiate for peace. As a sign of their confession of all wrongs committed in the past, they offered 17 living pigs, which they asked us to accept with their gratitude.

Thereupon we ordered the interpreters to let them know that we were pleased by their visit and their message, but that before peace could be concluded we would have the articles and conditions of peace read aloud to them, so that first they could present these to their own communities. Then we had the articles (which were hardly different from the ones presented to Mattouw and Soulang), translated clearly and accurately to them at once, and they promised to announce them to their communities, confident that they would consent to it all and comply with it. So that we do not doubt that complete peace will be achieved. This would be favourable to our nation, as well as to the Chinese and the Sincandians because no longer should anyone fear that, in case of the running aground

of any ships or junks over there or during deer hunting, any goods will be stolen or people murdered as used to happen in the past. We sincerely hope that this peace will guarantee that things like that will never happen again, so giveth God.

Thanks to the peace concluded with the people of Taccareyang and Tamsuy the limits of about three miles to the south of Tayouan, where we already were allowed to hunt freely in the past, will be extended and enlarged to approximately fourteen to fifteen miles. The people of Vavorolangh, a village situated about six or seven miles north of Wancan, have already appealed for peace and if they really do mean what they purport, our boundary posts could also be projected at the same distance to the north and as far as one and a half day's journey towards the east. This will not only be very advantageous to the trade in deerskins of the General Company, but will also provide the Chinese and the inhabitants with much comfort. [...].

6. Missive Governor Hans Putmans to Reverend Robertus Junius. Tayouan, 19 January 1636. TEDING 14, fol. 7.

Op gisteren morgen gewert ons UE. missive van den 17e courantij waeruit met verwonderinge verstaen den matroos noch niet te voorschijn is gecomen, en [dat] den selven bij de Chineesen, die bambousen ontrent Soelang cappen, geweest is sonder te specificeeren den dach wanneer gemelte matroos bij de Chineesen zoude zijn geweest.

Dat Jaques eenig gelt met de mutse van de matroos zoude genomen hebben can wel wesen, waerdoor den selven vermoort ende bij de Chineesen geweest te zijn strijt wat tegen den anderen; alsoo gemt. Jaques, zulx van meeninge geweest zijnde na alle apparentie ter eerster instantie, eer van hem scheyde, zoude geëffectueert hebben, als wanneer den matroos oock niet bij de Chineesen zoude connen geweest zijn. Weshalven om seeckere informatie te becomen één à twee Chineesen, daer bij den matroos zoude geweest zijn, noodig in Zincan zullen dienen te verschijnen om naer den dach te verneemen en ontrent wat tijt de matroos bij hun is geweest, mitsgaders alsoo aen de waerheyt te geraecken. Onderentusschen can't niet schaden Jaques en den andren Tavacander met behendicheyt in verseeckeringe bij UE. werden genomen.

Den winthont sal mede, gelijck UE. schrijven gedaen hebt, in aller manieren dienen vande Soulangers gevordert, van gelijcken de hoofden van d'onse; het eene bij UE. becomen cont daer laeten begraven.

Op het brengen der goederen van de schuldige Zoulangers in Sincan als het verbranden haerders huysen, behouft men, als 't maer schijns genoug heeft, onses oordeels niet al te vast te staen, maer wel op het bannissement van haere perzoonen; ten aensien de huysen gemeenlijck hun veele toecomen ende de goedren van de schuldige seer qualijck bij de oudste in Soelang door haer cleene authoriteyt zullen connen becomen werden. Doch alles dient soo veel mogelijck in allerhaest gevordert, met aensegging, ingevalle niet binnen weynig daegen 't selve effectueeren, wij met onse macht andermael sullen genootsaeckt sijn daer te verschijnen, als wanneer oock alleene eenige weynige die hun billickheyt wel verthoont hebben sullen verschoonen.

Soo den matroos bij hun is omgebracht, sal den moordenaer oock dienen aen ons gelevert te werden gelijck UE. sijn adviserende. Dienen mede met den eersten te antwoorden off bereyt sijn, gelijck die van Mattau, opdracht van hun lant aen de Hoog Moogende Heeren Staten te doen ende deselve voor haere beschermheeren aen te nemen.

Morgen ofte overmorgen sal seeckeren Chinees genaemt Souco bij UE. verschijnen om een licentie brieffken tot het vangen der herten in cuylen. UE. can denselven op zijn versoucq mede gelijck aen andre één verleenen om ontrent Soulang zijn neeringe te doen, ten welcqe fyne wij UE. op morgen off overmorgen eenige derselver brieffkens zullen toesenden. Den prijs cont accomodeeren naerdat voor desen gegeeven hebben. Na wij uyt de Chineesen verstaen soude om goede pertij hertevellen te becomen gantsch noodich zijn, sulx dat het getal gelijck in vorige jaeren bij de inwoonders geschiet is wel mach geconsenteert werden.

Yesterday morning we got your missive of the 17th of this month[6] from which we learn with amazement that the [Dutch] sailorman still has not shown up and that he has paid a visit to the Chinese, who are chopping bamboo near Soulang. But you have not given any specification on which day he would have met those Chinese.

That Jacques[7] would have taken some money and the cap of the sailor could well be the reason why this sailor was murdered, yet the fact that the sailor has visited the Chinese seems to be a bit contradictory, because if Jacques would have had the idea of killing the sailor, apparently he would have done that on the first occasion before they had parted, so that

the sailor could not have met the Chinese. In order to gain trustworthy information it is necessary that one or two of the Chinese, with whom the sailor could have met, will appear in Sincan to tell us on what day and what time the sailor had supposedly visited them, so that we may get nearer to the truth of this incident. In the meantime it could not do much harm if Jacques, together with the other man from Tavacan, is taken into custody.

The greyhound, as Your Honour has written, should be requisitioned from the Soulangians in every conceivable way, just like the heads of our men [whom they have killed]. The one head that Your Honour has already got, can be buried yonder.

In our opinion Your Honour should not make too much fuss about the handing in of the goods of the guilty Soulangians to you in Sincan or about setting fire to their houses, but what does matter is these persons' banishment from the village. According to their customs the houses generally do belong to many of them. For that reason it will be very difficult for the elders of Soulang, who hardly effectuate any authority, to obtain the goods of the guilty ones. Yet everything has to be carried out as soon as possible by telling them that if they will not comply with our demand within a few days, we again will have to appear with our force in which case we also will only show mercy to those few who have shown themselves forthcoming.

If the mariner has been killed by them, then they are obliged, as you have advised us, to actually turn in the murderer to us. They will also, on the first possible occasion, have to reply to us if the Soulangians are willing, just like the inhabitants of Mattouw have done, to surrender and dedicate their land to the High and Mighty Gentlemen of the States General and to accept them to become their patrons.

Tomorrow or the day after tomorrow a certain Chinese, named Souco, will appear before Your Honour to request a license to catch deer by means of pitfalls. At the same time Your Honour can grant him and others, upon his request, also a note which will serve as a permit to run a small business in or around Soulang, as to that purpose we will tomorrow or the day after tomorrow send Your Honour some of these permits. You can fix the price at the same level as has been given before. As we understand from the Chinese, if we want to be sure of getting a good

quantity of deerskins, it will be absolutely necessary to allow them the same amount that was permitted to the inhabitants in former years.

7. Missive Reverend Robertus Junius to Governor Hans Putmans. Sincan, 20 January 1636. TEDING 15, fol. 16.

> Twee dingen hebbe ick gistren de Soulangers van mij gaende gerecommandeert. Het eene was datse neffens de Bacluanders souden soucken naer den matroos die verlooren is, het andre datt dan alle bij malcandren verzamelt zijnde soude bitcharen off niet gesint sijn, dewijle trachten in vreede met ons te treeden, haer dorp ende hare velden aen onse natie over te geven, ons voor beschermheeren te erkennen ende aen te neemen (buyten deese pays sluytende de gene die voor desen ons volcq gemassacreert hebben, die den schiltwacht gequest ende de honden gewondett hebben). Beyde sijn se naergecomen. Hebben den matroos niet connen vinden, noch can van niemant vernemen waer gebleeven is. Soo den moordenaer te voorschijn comt, Soulang heeft daer niet tegen dat hij gevatt ende weder gedoodett worde, dat t'sijnder tijt geschieden can, den persoon ons notoir ende kennelijck geworden zijnde.
>
> Zoo veel belangt het overgeven van haer dorp en lant aen onse natie, staen sij mede toe bereyt sijnde haere aerde ende haere vruchten ons op te dragen ende alles te doen datt Mattau gedaen heeft soo wanneer sulcx van ons geëyscht sal worden. Sulcx verstaende, hebbe vruntschap met haer gesprooken ende haer aengeseyt dat voor haer bij zijn Ed. intercederen. Zoude zijn Ed. gelieve dan ons te laten weten wanneer deze opdracht geschieden zal (mijns oordeels is 't hoe eerder hoe beter) ende waer, off hier in Sincan ende off datelijck outsten sullen maecken, off wachten tot de generale vergadering aller dorpen; daer op met de eersten bescheyt verwachten sal. Soo veel de schuldige belangt, sullen t'zijner tijt noch gecregen worden; soo veel de gene aengaett, die de honden gesmeten ende de schiltwagt gequest hebben, soude men straffe connen affvorderen na haere wijse ende dan mede in den vreede besluyten, alleenlijck uitlaetende de dootslagers [...].

Yesterday, I recommended two things to the Soulangians who departed from here: firstly that they, like the people from Bacaluan, should search for the lost mariner, and secondly that they should assemble in order to deliberate whether they are willing, while they are negotiating peace with

us, to surrender their village and fields to us and to recognise and accept
us to become their patrons (however those who have earlier massacred
our men and those who have hurt the sentinel or wounded the hounds will
be excluded from this peace). They did observe both terms. Yet the
mariner has not been found, nor did anybody tell us of his whereabouts.
Soulang does not oppose that the murderer should be taken captive and
executed (as a reprisal) which may happen once we have found who that
person is.

Concerning the surrender of their village and land to our nation they are
also ready to do so by dedicating their land and fruits to us and
complying with everything that Mattouw has done before, in case we
demand them to do so. When we heard this, we made friends with them
and told them that we would intercede on their behalf with Your Honour.
Your Honour should let us know at your earliest convenience when the
transfer of sovereignty can happen and on which location, either here in
Sincan and whether we can immediately appoint the elders, or whether it
would be better to wait until the General Assembly of all villages; we
await your answer at the earliest opportunity. As to the guilty ones, in
due course we will seize them; yet, concerning those who have flung the
hounds and wounded the sentinel they could be punished according to
their own customs and afterwards they can be included in the peace
treaty; only the murderers will have to be excluded.

8. Missive Governor Hans Putmans to Reverend Robertus Junius. Tayouan, 21 January 1636. TEDING 14, fol. 8.

UE. missive vanden 20en stanty is ons op heden als wanneer uwen vorigen
gedateert 17de hadden beantwoort, een weynig daerna wel geworden,
waeromme dese tot antwoortt, voor soo veel daer inne niet en is
gementioneert, sal dienen.

Dat die van Soulang haer, soo wel als die van Mattauw gedaen hebben,
bereyt thoonen om haer lant aen de Hoog Moogende Heeren Staeten te
transporteeren ende volcomen opdracht aff te doen, hebben in onsen
vorigen geschreven. UE. gerecommandeert haer scherpelijck te
onderrichten tot welcken eynde zulcx geschiett. UE. dient haer dan
vooreerst (alsoo persoonlijck naer Wanckan van meeninge sijn te
vertrecken) ende 't op een dach of vier ofte vijf niet aencomt, aen te

dienen dat haer t'onser wedercomste daer jegens prepareeren, als wanneer mede de verkiesinge van d'outste in Soulang ende d'andere dorpen sal connen werden gedaen.

Aengaende de oorloge t'apayseeren tussen die van Tilosen ende Tivorang, connen UE. mede soo veel mogelijck tegens de generale vergaderinge handelen, gelijc oirbaerlicxt bevint te behooren, op dat daer naer in mach werden gedisponeert hoedaenig haer sullen hebben te reguleeren.

Today, we received your letter written on the 20th of this month, a little while after we had answered your last letter dated the 17th. This letter, as far as things have not yet been mentioned, will serve as an answer to your letter [of the 20th].

We wrote in our last letter that those from Soulang show themselves ready, in the same way as those of Mattouw have done, to hand over their land to the High and Mighty Gentlemen of the States General and to dedicate it completely. We recommend you to instruct them clearly to which purpose this is done. Because we intend to personally leave for Wancan and because it does not matter if four or five more days go by, Your Honour should first inform them to prepare themselves for our return, when the election and appointment of the elders in Soulang as well as the other villages can take place in our presence.

As regards the reconciliation of Tirosen and Tevorang and putting an end to their warfare, you may act towards the general meeting as you consider necessary, so that along these lines may be disposed how they will have to comport themselves.

9. Missive Governor Hans Putmans to Reverend Robertus Junius.
Tayouan, 21 January 1636.
TEDING 14, fol. 8-9.

UE. missive gedateert 19 stantij is ons op den 20[en] dito wel geworden. Op den teneur desselffs dient dit ondervolgende in antwoort: Dat UE. seggen Jacques bequamer van hier uit sijne velden als uyt Sincan door UE. sal connen geschieden, hadde connen becomen werden, wij weten tot op heden niet waer de velden van Jaques zijn en UE. heeft ons 't selve in sijne missive oock niet aengecundicht, weshalven sulcx bij ons oock niet in 't wercq gestelt can werden. Soo UE. ons de velden van Jaques, 't sij met een Sincander ofte imant die daer bekent is herwaerts te senden, haddet laeten aenwijsen, wij zouden gesien hebben of 't selve beter door UE. van

daer zal connen verricht ende oock de waerheyt van gemelte Jaques beter in Sincan als wel bij ons hier can ondervonden werden. (fol. 9)

Een bekent swartt te senden om den hont uit Soelang te haelen, wij weten niet datter imant aen Sackan onder de swarten is die bij de honden bekent sijn, weshalven Christoffel UE. met dese onse missive toesenden, om met Kockje ofte imant anders die met de wilden wat can spreecken, derwaerts te gaen om den hont te becomen, waerbij haer oocq onse goede meeninge sal blijcken, ende dienen UE. met een man à twee altemett derwaerts te senden sulcx te confirmeeren om haer alsoo te meer daer door aen te trecken ten waere dese persoonen groot prijckel souden loopen.

Watt aengaett UE. meene dat door cleene authoriteyt vande outste de quatdoenders uit Soulang geheelijck niet gebannen sullen connen werden, ofte sullen al in drie à vier dagen weder comen, ende dienvolgende soo men pays met haer wil maecken soo vast daerop niet dienen te staen. Wij antwoorden hierop dat 't selve haer evenwel serieuselijck dient voorgestelt ende dat men alleen met de goede (sonder de quaatdoenders daer in te trecqen) pays maeckt, opdat zijluyden in toecomende als gemelte quaatdoenders (gelijc UE. meynt) dat (als daer niet meer op dencken) zullen connen gecregen werden, bij ons aengetast wierden, haer niet en beroupen dat met haer mede pays gemaectt hebben. Doch op 't uitbannen zoo heel hert te staen dunctt ons mede ongeraeden, alleene dat, gelijck boven gesechtt, uit het contractt dat met de goede sullen aengaen om onse optie open te houden, geslooten werden.

Belangende de clappus- en pinangboomkens dat die zoo UE. meynen wel gewillig sullen leveren, gelijck die van Mattouw gedaen hebben, wij sijn van 't selver gevoelen. Maer dient haer alvoren de beduydinge desselfs wel scherpelijck uitgedruckt, op dat weten mogen wat onse meeninge daer mede is, ende zij niet en dencken dat het alleen met de boomkens aen ons te geven te doen is.

Den persoon die den man gequest heeft dient mede, neffens d'andre, gebannen en zijn huys in brant gesteecken, ofte wel in onse handen gelevert, de hondensmijters wat men daer mede doen sal en connen wij geen ordre opgeven, maer dienen UE. met voorsichtigheyt daer in te handelen sulcx als dunctt dat met haere humeuren en naer eysch van 't quaat te straffen best overeenkomt.

Wij approbeeren met UE. dat het beter is dat men de Chineesen met een hasegay in plaatse van met brieffkens te geven licentieert in cuylen herten te vangen, weshalven daerbij sulcx sullen laeten. De luyden oocq veel aff te nemen dunctt ons mede niet geraden also 't ons principael te doen is

om den handel van hertevellen te meer te vergrooten en in toecomen een
goede quantiteyt voor de Compagnie te mogen becomen.

Your Honour's missive dated the 19th of this month reached us on the 20th
to which the following serves as an answer: Your Honour communicates
to us that Jacques, could have been easier rounded up in his fields from
Tayouan, then you would be able to do from Sincan. Yet until now we do
not know where Jacques' fields are located and Your Honour also has not
mentioned it in your missive. Consequently we can not carry this out. If
Your Honour could have pointed out his fields, be it by a Sincandian or
someone else familiar with the situation over there, then we could have
concluded if the matter could be better solved by yourself from Sincan or
whether actually the truth about the mentioned Jacques could better be
investigated by us here at Tayouan. (fol. 9)

Regarding the sending of a trusted 'black' man in order to collect the
greyhound from Soulang, we do not know if someone could be found
among the blacks[8] in Saccam who is known to the dogs. Therefore we
send Christoffel[9] over to Your Honour with the missive in order to go
thither together with Kockje[10] or somebody else who is able to
communicate to some extent with the savages to get the hound, so that
these people can clearly see our good intentions. Your Honour should let
the two men be accompanied by two others just by means of confirmation
in order to draw them closer to us, unless you would consider that these
persons would run a great risk.

Regarding Your Honour's opinion that on account of the little authority of
the elders of Soulang it will be impossible to have the malefactors
expelled from that village, or if they should actually be sent off then they
surely would return to Soulang within three or four days as if nothing has
happened at all, and that you therefore think that if we wish to conclude
peace with them, we ought not insist too much on the banishment - Our
answer to this matter is that this should be seriously put forward to them:
that we only want to make peace with the good ones (without including
the wrongdoers). So that in the future when the mentioned malefactors
can be seized and punished by us (when they themselves have forgotten
about it), they can not appeal to the fact that the Company did conclude
peace with them. Nevertheless we do agree that it seems unwise to insist
too strongly on the banishment. Yet we should only be careful that by

concluding peace with the loyal ones we keep an option open [for the just punishment of the others].

Concerning the coconut and pinang trees that, as you think, they are willing to donate to us just as those of Mattouw have done, we share the same opinion. But you have to be sure that they will be informed strictly beforehand about the precise meaning so that they will be aware of our opinion about this and that they will not think it merely has to do with handing over the trees to us.

The person who has hurt the [Dutch]man also has to be banished or handed over to us, like the others, and his house has to be set afire as well. About what should be done with the men who have beaten and wounded the dogs we can not give you any orders but we do expect Your Honour will deal with them carefully in a way that you consider to be best in accordance with their behaviour and the seriousness of the crime.

We approve, just as Your Honour, of the fact that it will be better to license the Chinese to hunt deer with assegai then to allow them with licences to catch deer in pitfalls. We shall leave it as it is. To take away too much from the [native] people is, in our opinion, also not a wise thing to do, as our principal intention is to increase the trade in deerskins as a whole so that in the future we may get a large quantity for the Company.

10. Missive Reverend Robertus Junius to Governor Hans Putmans. Sincan, 24 January 1636.
TEDING 15, fol. 17.

[...] De luyden meest sijn noch vervaert en zoo blijven, sullen altijt met ons volcomen zijn geapaiseert, derhalve het daer voor houde dattet best waere de opdracht eersdaegs te laeten geschieden in Tayouan in vougen als met Mattauw, dan zouden haere goederen weder in 't dorp en haer gemoederen watt geruster gestelt worden. Soo veel die belangt die het woort voeren, sullen connen gecreëert werden in presentie van alle de dorpen, dat noch lichtelijck in 14 daegen niet sal konnen geschieden also Dorko, Tirosen, Takareij, Tevorang vreesen hier te comen om de pocken die hier regueeren, die nochtans noodig dienen te verschijnen. De articulen die sij approbeeren sullen, connen dan andermael gerepiteert werden.

De opdracht van Baculuan can wel uytgestelt worden tot den dach der vergadringe, dit dunckt ons soo om veel reden geraden, sullende hier op met den eersten bescheyt verwachten, ben mede bereyt, om dattet

ordentlijck toegae, selver met haer aff te comen - soo 't sijn Ed. soo verstaet.

De pocken houden noch niet op, 150 zijnder al gestorven, oock mede onse Arrisauw, het jonge manvolcq wert veel aengetast. Wat den hont belangt heeft Christoffel zijn Ed. twijffel verthoont, wert gesustineert dat doot is.

[...] The people remain apprehensive and they will continue to be so, in spite of remaining at peace with us. Therefore I think that it would be best if the ceremonial transfer of their territory to the States General in Tayouan should occur soon, just as it went with Mattouw. They can then bring their goods back into their village and their feelings can be calmed down a little. As for those who will speak on behalf of their communities, they can be selected and created as elders by us in the presence of all the delegates of the villages. However this can not take place within fourteen days because the inhabitants of Dorko, Tirosen, Takarey, Tevorang, who should most definitely appear, do not dare to come over to this place for fear of the smallpox that is still rampant over here. The articles they will have to approve of [before the peace can be concluded] can then be rehearsed once more.

For many reasons we deem it expedient to postpone the commission to Bacaluan until the day of the assembly of the villages; we do expect to get your comments on this matter as soon as possible. So as to arrange everything in good order, I am most willing to personally come over with some of the villagers to you, if Your Honour wants me to.

The smallpox continues to rage. About 150 people have already died, Arrisauw being among them. Many of the young men have perished. Christoffel has expressed his doubt about the [whereabouts of the] greyhound, it is supposed to be dead.

11. Missive Governor Hans Putmans to Reverend Robertus Junius. Tayouan, 7 February 1636.
TEDING 14, fol. 10.

UE. missive gedateert 6^{en} deser is ons op gisteravont welgeworden, dienen deze weynige regulen op den teneur desselfs in antwoorde.

[...] soo en connen UE. niet seker laeten weten wanneer onsen persoon tot de proclamatie van den generalen vreede in Sincan zullen connen transporteren, ten aensien over zeven à acht dagen naer alle apparentie in

't principaelste van 't affdepecheren onser scheepen sullen wesen ende 't
selve doch, terwijl d'heer mayoor hier noch is, niet sal connen geschieden,
sulcx dat daer niet veel aengelegen is off 't selve noch vijf à zes dagen
langer als UE. gepréschrijbeerden tijt aenloopt, te meer oock omdat die
van Terrokeij volgens UE. schrijven alsdan qualijck zouden connen
verschijnen en is apparent wat langer aenloopende dat dan neffens alle
andre gelijckelijck claer zijnde, sullen connen comen, dat oock onses
oordeels veel beter zal zijn. [...].

Your Honour's missive dated the 6th of this month[11] reached us safely
yesterday evening. These few lines serve as an answer to it.
[...] so we are not able to let Your Honour know exactly when we can
personally come to Sincan for the proclamation of the general peace, as in
all probability in the coming seven or eight days we will be occupied with
the principal affairs of making ready the dispatch of the ships to Batavia.
Furthermore while the major[12] is still present here at Tayouan, the
meeting in Sincan can not take place. Thus it does not really matter if that
has to be postponed for another five or six days after the date you have
suggested us, the more so because those of Terrokey, as you say, would
have trouble showing up [in time]. If we take a little more time, it is
probable that they can be ready like all the others and come over. This, as
far as I am concerned, is much better.

12. Missive Governor Hans Putmans to Robertus Junius.
Tayouan, 15 February 1636.
TEDING 14, fol. 10-11.

UE. missive gedateert 12[en] stantij is ons op den 13[en] dito wel geworden en
hebben den teneur desselffs wel verstaen sulcx, dat op gistren de zaecke
nopen die van Vovorolang in raede hebben voorgestelt, maer is om
verscheyde goede consideratiën geresolveert, ten insien geen sekerheyt en
hebben hoe de saecke gepasseert is, haerlieden te insinueeren dat binnen
tien dagen in Sincan sullen verschijnen om haere saecken te
verantwoorden, gelijck UE. bij de copie vande insinuatie hier neffens
gaende connen beoogen en dienen UE. de getranslateerde in 't Chinees bij
de gevouglijcxte middelen aen haer te laeten bestellen.
Den corporael van d'adelborsten Thomas Pedel, over Mattau en Wancan
alhier verscheenen, hebben goet gedacht (wederom op gelijcke wijse)
derwaerts te largeeren, also verstaen de Chineesen aldaer seer onwillich

tegens d'onse zijn en d'selve bijnaer (niet tegenstaende de presentatie van betalinge aen haer gedaen wert) geen huysvesting ofte eenig gerieff willen geven, weshalven UE. hem Joost off Kockjen (fol. 11) neffens noch drie à vier soldaten sullen bijvougen om andermael een preuve te nemen hoedanig vande Chineesen sullen bejegent werden, wij bevinden dat deselve met dese vernederinge aan de inwoonders haer seer groots en stout overal aenstellen; sulcx dat dese zaecke nootwendig sal dienen gematigt en voorgecomen te werden. Want derven zij dit aen d'onse doen wat souden sij in toecomen aende inwoonders niet derven bestaen? Weshalven, omme hier in tijdelijck te versien, UE. op 't naeuste eens sal dienen bij Lampsack off d'inwoonders te vernemen, wat hiervan zij, met waerschouwinge aen gemelte Chineesen dat zij de onse wel en vrundelijck bejegenen, en daer overnachtende huysvestinge verleenen [...].

We received Your Honour's missive, dated the 12th of this month,[13] on the 13th. Because I clearly understood its general tenor I presented the case of the people of Vavorolangh at the meeting of the Tayouan Council yesterday. The matter was resolved due to several good considerations, because we were not certain about what really had happened. As you will see from the copy enclosed we have announced they should show up in Sincan within ten days to account for their case. Could you please send them the translation in Chinese at your earliest convenience.

We have decided to send the corporal of the cadets, Thomas Pedel, who arrived here over Mattouw and Wancan, back by the same route, because we have understood that the Chinese over there are behaving themselves very badly towards our men and that although they have been promised payment in return, they have hardly shown themselves willing to provide lodging or any other service to travellers; therefore Your Honour has to assign Joost[14] or Kockjen to Pedel (fol. 11) besides three or four soldiers as to once more investigate how they are received by the Chinese. In view of this latest humiliation we do find that the Chinese show themselves very bold and audacious towards the inhabitants. Therefore this matter should necessarily be prevented and contained. Because what else might not come out of this? If they already dare to treat our people in such a way, then what could not happen to the inhabitants? In order to take care of this for the time being, Your Honour should hear Lampsack or the inhabitants very carefully about the truth of this, and at the same time, the Chinese will have to be warned that they must treat our men in

a friendly and considerate way and that they are obliged to provide lodgings for them [...].

13. Missive Reverend Robertus Junius to Governor Hans Putmans. Sincan, 16 February 1636.
TEDING 15, fol. 17.

> Gaet hier weder terugge de copie van 't examen der gevangenen Sincanders; hebbende op UE. begeeren de plaetsen vervult die openstonden en hier en daer wat weggenomen en oock toegedaen, vertrouwe het claerder nu sijn zal. Ick hebbe het metter haest moeten stellen om mijn memories wille, derhalven soo wat heenen aen malcandren hangt doch de waerheyt is claer en naeckt daer meest aen gelegen is, bereyt zijnde dat ten allen tijden te willen verclaaren al waer 't oock voor duysenden menschen.
>
> Dinsdach toecomende is den dach die gestelt is dat de dorpen zullen verschijnen. Soo se dan tijdelijck comen sal sijn E. waerschouwen laeten, meene evenwel dat zijn Ed. evenwel 's woensdachs morgens tijdelijck genoug comen zal.
>
> Dat den brieff belangt die na Vorovolangh moet gesonden werden is bestelt en oocq het gene de Chineesen toucheert in Mattauw daer van breeder met zijn E. sullen spreecken soo met lieff hiercomt [...].

Herewith we return to you a copy of the interrogation of the Sincandians taken captive; at Your Honour's request I have filled in the omitted answers and here and there taken some details out and added a few so I trust the contents are now clearer. Because of my [short] memory, I have written it in quite a hurry which is the reason why it is a bit uncorrelated, but the truth is clear and just as it is presented. I am willing to testify to my statement at all times even if it were before a thousand people.

Next Tuesday is the day fixed for the assembly of the villages. If the people from the villages show up on time I will send a message to Your Honour to warn you, yet I do feel that Your Honour will be well on time if you arrive on Wednesday morning.

Concerning the letter, that had to be delivered to Vavorolangh, it has now been sent; as for the Chinese in Mattouw we will discuss that matter exhaustively when Your Honour arrives here in person.

14. Missive Reverend Robertus Junius to Governor Hans Putmans.
Sincan, 18 February 1636.
TEDING 15, fol. 18.

[...] Gisterenavont keert Kockjen weder uit Mattau rapporteert dat vanden Chineesen wel onthaelt ende bejegent zijn [...].

Morgenavont verwachte ick die te verwachten staen. Ick verhoope zijn E. op de roode rocken der Sincanderen dencken sal ende overmorgenochtent, waere wel noodich (soo 't zijn E. soo verstaett), afgedaen can werden.

Wij zijn van meeninge door het Blindemansdorp onse reyse te nemen om alsoo de Sincanders daer wonen mede te waerschouwen binnen een sekere tijt weder in 't dorp te keeren omdat geen ignorantie voorwenden connen, oostelijck ende zuydelijck eenige huysen van ons gelegen is het al aengedient, vreese die swaerlijck zullen vercrijgen, off aen de eene off de andre wat extreems geattenteert sal moeten werden, gelijck gistren gebleecken heeft, dat een seker vrouwe die wij spraecken dat de oude huysjens zoude verlaeten, noch tegen onse wille een nieuw huysjen liet bouwen, ende dat noch op den sondach. Doch van dese zaecke breeder mondelijck, soo Godt wil, sullen spreecken.

[...] Yesterday evening Kockjen returned from Mattouw reporting that he had been welcomed and treated well by the Chinese [...].

Tommorrow evening I expect all of them [the representatives from the villages] to arrive. I do hope that Your Honour will not forget [to bring] the red coats for the Sincandians and that on the morning of the day after tomorrow everything (if Your Honour agrees) can be dealt with.

We plan to travel via the Blind man's village so as to warn the Sincandians living over there to return to their village within a certain time, so they can not pretend any ignorance. This has already been told to the people living in several houses situated to the east and to the south of us though we fear it will be difficult to get them back unless we can make use of some extremity to force them to. We already witnessed disobiedience yesterday when a certain woman, whom we had earlier asked to leave the little old houses, ordered, against our will, a new one be built even on a Sunday! About this matter we will speak to you, if God wishes so, in further detail directly.

15. Missive Reverend Robertus Junius to Governor Hans Putmans.
Sincan, 20 February 1636.
TEDING 15, fol. 18-19.

Als desen schreeff warender al verscheyde uit verscheyde dorpen aengecomen, te weten van: Pansoja, Tarokeij, Tirosen, Dorko, Tevorang, Magijram, Mattauw, Bacluan. Soulang was noch niet gecomen, gelijck mede niet van Takareijan, die alle uyren verwachtende ben. Haer is aengeseyt dat sonder twijffel op morgen avont sijn E. hier sijn sal met de rocken en appendentiën van dien, gelijck oock vertrouwe sijn E. verschijnen sal. Zoo de comste van zijn E. langer uitstelt sal haer beswaerlijck hier langer houden connen, hier alreede een groot getal bijeen versamelt.

Onder de soldaten die sijn E. in sijn suite medebrengen zal, zoude mijns oordeels ten respecte van dese vreemdelingen de pijkeniers met haer iseren gewaett seer gevouglijck connen gestelt werden, want bij haer vreemt clinctt dat de onse isere rocken hebben, diese dan selver connen beoogen.

't Waer mede vorderlijck dat de rocken, de rottangen en soo iet wat, morgen tijdelijck vooruit wiert gestiert dat siende dese verre gelege dorpen haer verlangen vermeerdren zoude gelijck zijn E. mede Cocjen vroug met een vendel conde (bescheyt brengen) ons toe laten comen, alsoo haer allen bekent is dat Cockjen (fol. 19) om zijn E. de aencomst deser luyden bekent te maecken gesonden hebben. [...] Die van Teywan zijn mede verscheenen, Soelang is hier dichte bij, resteert alleen Takareijan die t'avont verwachten.

While I was writing this letter several inhabitants of several different villages had already arrived from Pangsoya, Tarokey, Tirosen, Tevorang, Magijram, Mattouw, Bacaluan. Soulang had not yet arrived, like Taccareyang whom I have already been expecting for hours. I told everyone of them that without doubt Your Honour will arrive here tomorrow evening with the coats and accessories, and I sincerely trust that Your Honour indeed will do. If the arrival of Your Honour is postponed I do believe that I hardly can make them, who have already assembled here in great numbers, to stay any longer.

Among the soldiers who will accompany Your Honour in your retinue, it would be wise if some pikemen dressed in their coats of mail should come along to impress these inhabitants because it is quite incomprehensable to them that our men do wear iron coats. Thus they

will be able to see the spectacle for themselves. It would also be advisable to send ahead of time the coats, the canes and everything for tomorrow in order to increase[15] the longing of these far away villages. Also Your Honour could send Kockjen ahead early in the morning with a banner announcing the message of Your Honour's arrival, because they are all aware of the fact that Kockjen had been sent to Your Honour to inform you of the arrival of all these people. [...] Those of Teywan have also arrived, Soulang is too close by [these people can come when they like]. Only those of Taccareyang haven't shown up yet but they are expected to arrive in the evening

(In the next missive ex-Governor Hans Putmans, while sailing back to Batavia, informs his superiors of the developments which took place on Formosa when he was in command at Zeelandia Castle. He provides them a.o. with an outline of the expeditions that were undertaken in the first part of 1636 to pacify several villages and reports on the meeting of the villages in Sincan on 22 February.)

16. Missive former Governor Hans Putmans to the Directors of the Amsterdam Chamber.
On board the ship *Banda*, 2 August 1637.
VOC 1120, fol. 1-18. Extract January-November 1636.

fol. 9: [...] Den 13[en] ditto [January 1636] voorde middach quamen alle wel geluckich wederom in 't fort Zeelandia.

Dit alsoo door de sonderlinge bestieringe ende schickinge Godes zeer geluckich verricht zijnde wiert onse authoriteyt ende aensien onder dese blinde heydenen zoo seere verheven ende geëstimeert (als noyt diergelijcke maniere van oorlogen gesien hebbende) dat niet alleene die van Soulang, Backeluan ende Taccareyangh hunne landen aen den Nederlantse staet, gelijcq die van Mattauw gedaen hadden, quamen opdragen maer oock die van Pangsoia, Tapouliang ende veele daer ontrent gelegene dorpen van gelijcken sulcx presteerden.

Ende om dit wat meerder aensiens te geven ende alle dese dorpen die meest onder ende teegens den anderen geoorlocht hadden met eenen vasten bant van vreede aen de Generale Compagnie mitsgaders onder den anderen te verbinden, lieten alle de outsten van voorschreven ende meer andere daer ontrent gelegene dorpen tot 22 in 't getal op den 22[en] februario anno

1636 in Sinckan verscheynen daer den vrede met groot contentement en
vergenoegen tot extraordinaire verwonderinge van een ider (als sulcx noyt
meer bij haer gehoort ofte gesien zijnde) den vreede wiert getroffen ende
geproclameert. Hier sach men vianden waer tusschen bij haer gedencken,
Jae voorouders tijden, geen vreede maer continueel dootelijcke oorlooge
geweest was, malcanderen cussen, soenen en in 't vrundelijck onthaelen,
elck op zijne maniere (naer dat van ons met een gastmael wel onthaelt
waren) vreucht bedrijvende.

Doch alvooren naerdat den vrede geproclameert was ende de Compagnieën
onser soldaten noch met blancke wapenen in ordre stont, wierden over
ider dorp, naer dat groot ofte cleyn waren, de sommige één, andere twee
ende oock eenige drij vande alder principale van aensien tot hooffden ende
bevelhebbers, ider over zijne gemeynte genomineert ende alle nevens den
anderen bij ons in goede ordre gestelt; mitsgaders ider met eenen swarten
fluwelen rock ende rottangh, Item ider dorp met een princevlaggetjen (om
wat aensiens te hebben ende daer voor bij de hare erkent te werden)
vereert, van gelijcken om onder gem. banne zoo wanneer sich imant
rebelleerde (fol. 10) ofte eenige vianden den oorloge wilden aendoen in 't
velt te verschijnen, ofte bij 't blijven of 't stranden van eenige onser
scheepen ('t welcq Godt verhoede) met gemelde vaendel bij d'onse te
verschijnen en alsoo alle hulpe ende assistentie te bewijsen, doch
principael om hun bij d'onse bekent te maecken dat onse vrunden sijn,
ende alle daer uyt te resulterene onheylen voor te comen.

't Welck gedaen zijnde ider weder met vreucht naer zijn dorp ende wij
naer 't fort Zeelandia vertrocken. Niet alleene is deesen vreede tot op ons
vertreck van Tayouan, dat was den 15en november lestleden, bundich ende
zeer vreetsaem met goet contentement van een ider onderhouden ende
gecontinueert, maer zijn allencxkens zoo nu en dan (gelijck breder bij
seeckere missive van domine Robartus Junius aen U Ed. geadresseert
gelieven te beoogen) verscheyden andere dorpen, die sommige van selfs
sulcx versoeckende, ende eenige op onse aenschrijvinge daertoe
resolverende, mede onder gemelte verbandt van vrede gebracht, zoo dat
het getal van 22: tot op 57 dorpen verhoocht is, die de Generaele Comp.e
voor haere beschermsheeren alle hebben aengenomen ende erkent.
Waeronder wel de aensienlijcxste zijn 15 dorpen op 't zuyteynde van
Formosa gelegen, daervan d'inwoonders Lonckjouwers genaemt werden,
die aldaer het landt een goet gedeelte aen d'oost- ende oock westzijde
besitten ende oorloge voeren tegens seeckere natie genaempt de
Pimabaers, die naer het seggen van deese Lonckjouwers mede aende
oostzijde van 't geberchte een groot stuck weechs noordelijker van haer,

sijn geseten ende oorloge voeren tegens d'inwoonders die d'goutmijne besitten. Dese voorschreven Lonckjauwers zijn veel beter geciviliseert als d'inwoonders van eenige van de voorverhaelde dorpen. De vrouwen als mans alle gecleet gaende ende werden van één opperhooft (die sij seer ontzien) als van een soevereyn prince geregeert, die van alle dat er gesayt ofte gemaeyt mitsgaders met de jacht becomen wert, zijn gedeelte ofte partie geniet ende in plaetse van tol naer hem neempt. [...].

fol. 9: [...] On the 13th of January 1636 before noon we fortunately all arrived again at the fortress Zeelandia. [...]

After God's extraordinary rule everything was carried out in a very fortunate and successful way, our authority and esteem among these blind pagans has risen to such a high level (because they had never seen anything like our methods of warfare) that not only the people of Soulang, Bacaluan and Taccareyang have dedicated their lands to the state of the Dutch Republic, like Mattouw had already done, but even those of Pangsoya, Tapouliang and many other neighbouring villages did the same.

And so as to give it all a little more prestige in order to tie these villages, which all used to make war against each other, into a tight alliance of peace to the General Company as well as to each other, we invited all the headmen of the mentioned villages and also of some other places of the region [to congregate]. On 22 February A.D. 1636 a total number of 22 appeared in Sincan, this to the great satisfaction and to the absolute amazement of everyone (as something like that had never happened before on Formosa), and peace was concluded and proclaimed. Former enemies, among whom as far as they remembered - yes, as far back in their ancestors' times as they could recall - deadly feuds had gone on continuously, now embraced and kissed each other. After we had treated them to a banquet everybody was merry in his own way.

Before the actual peace was proclaimed and while the companies of our soldiers were still standing in line with sloped arms, one, two or or on some occasions three of the principal and most distinguished headmen and commanders from every village, according to its number of inhabitants, were successively nominated principals of their communities. All of them were ranked side by side and received a black velvet coat and a cane. Likewise a Prince's flag was donated to every village (so as to gain a little more standing and recognition among each other), so that under the afore mentioned agreement, in case one of them would start a rebellion or

(fol. 10) if some enemies wanted to start a war, they will bring their troops into the field; likewise if one of our ships (God forbid) should run aground on their coasts, they can appear to our people carrying that banner, so it will be clear that they want to give their help and assistance; the banner will principally be used to show that they are friends in order to prevent any calamity which could result from confusion.

After everything was accomplished everyone returned to his village in a merry mood and we left for Zeelandia. On 15 November [when I left Tayouan for Batavia] this peace not only seemed to be conclusive because it had been concluded to everybody's satisfaction in a very peaceful way, but little by little (as becomes obvious from a missive by Reverend Robertus Junius sent to Your Honour)[16] even several other villages requested peace for themselves. Some also decided to join the alliance after we had invited them to do so. This increased the total number of allied villages, which do recognize the General Company to be their patrons, from 22 to 57. Included are the 15 most principal villages situated on the southern tip of Formosa, which inhabitants are known as the people of Lonckjouw, who own a great deal of the land to the eastern - as well as to the western side. They are fighting a war against the people from a certain nation named Pimaba, who, according to the people from Lonckjouw, also dwell on the eastern side of the mountains yet a great deal further to the north, and who also are fighting against the inhabitants who own the goldmines. The mentioned people from Lonckjouw are far more civilised than the inhabitants of any of the other villages we have spoken about before. The women as well as the men all go round dressed. They are ruled by one chief (who is held in high esteem) who rules like a sovereign prince and who gets (instead of a toll) his share from everything which is sown, reaped or which is caught by hunting. [...].

17. Memorandum of Reverend Robertus Junius about the advisability of sending some Formosan youths to Holland to be educated as schoolteachers or ministers and continue the propagation of the Gospel on Formosa [undated 1635/1636].
Collectie Aanwinsten 306 (1885 A IX).
FORMOSA UNDER THE DUTCH, pp. 144-147; ZENDING, III, pp. 127-131.

18. Dagregister Zeelandia, 14 March-4 October 1636.
VOC 1120, fol. 403-455.
DRZ, I, pp. 237-275.
See also FORMOSA UNDER THE DUTCH, pp. 112-115; ZENDING, III, pp. 79-85.

19. Missive Governor Hans Putmans to Governor-General Hendrick Brouwer.
Tayouan, 23 March 1636.
DRB 1636, pp. 75-77; DRZ, I, p. 236.

(On 4 February seven headmen of the villages Tacareyan, Tamsuy, Tapouliang and Swatalauw appeared before the Council in Tayouan to request for peace. They brought 17 pigs along to offer as a sign of regret for all the wrongdoings they had committed in the past. The envoys were willing to accept the conditions for peace as phrased in the articles of the agreement settled with Mattouw and Soulang, but they had to communicate them first to their fellow-villagers. The ministers Candidius and Junius believed, now that the punitive expeditions had proven to be successful, that the results of the propagation of the Gospel among the Formosans could be quite favourable, if only enough teachers could be found to carry out the missionary work in the 22 newly pacified villages. The conspiracy against Candidius and Junius that was discovered in Sincan the preceding year, had resulted from the interdiction of a religious festival by those ministers. According to the customs of the people of Sincan 'Limgout' was celebrated in the ancestor's honour on a certain fixed day. The principal conspirators had been taken into custody. One of them was sent over to Tayouan while another had been killed when he tried to escape.)[17]

20. Missive Reverend Robertus Junius to Governor Hans Putmans.
Sincan, 23 March 1636.
TEDING 15, fol. 19.

[...] Jaques zit noch gevangen, can noch niet vernemen waer den matroos begraven is, hij hout daer voor dat begraven is maer secht dat hij 't niet gedaen heeft. Zijn E. gelieve ons te laten weten wat met den gevangen man sullen doen.

Wij hebben de Sincanders weder voorgestelt dat in 't dorp dienen te comen, eenige willen daertoe niet wel verstaen, mijns oordeels is 't hoognoodich dat ontrent het dorp de velden maecken, soo wisten sijn E. ons haest bijcomen, zoude noch de saecke uitstellen tot sijn E. comste en zoude dan eenige dingen mede connen reformeeren die noodich verbetert dienen.

Dicka verwachten wij dagelijx die al vijf à zes dagen geleden vertrocken is naer Dalivo ende vier dorpen noortlijck van Tarokeij leggende om pays met haer te maecken daer van wij goede tijdinge verbeyden, gelijck mede noch vijf dorpen verwachten, oostelijck van Tacareian leggende, die onsen pays verzoucken. De rocken ende stocken sijn mede noodig, ja, meer soo met de bovenstaende dorpen in vreede treeden.

Kockjen komt tegen de middach van Pangsoya weder hier, secht wel onthaelt te sijn, wat dat gepasseert is ende in wat dorpen geweest zijn, zullen verstaen als Gillis comt die onderweeg is ende sijn E. sullen over schrijven.

Kockjen secht mede van 13 varckens, honderd hertevellen en rijs die al langh geleden aen Chineesen ter hant gestelt is om aen sijn E. te behandigen, van dorpen oostelijck van Tacareyan leggende, die achtergehouden zijn. Den Chinees diese ontfangen heeft, is op Tayouan, wert genaemt Taturicq van d'inwoonders. Wat daer van is sal sijn E. apparent connen verstaen; nader bescheyt door Gillis daer van becomen hebbende sal het bekent maecken.

[…] Jacques is still in prison yet I have not been able to find out where the [Dutch] sailor has been buried. Jacques asserts that the man is buried but says he did not bury him. Your Honour should let us know what we should do with the captured man.

We again have proposed to the Sincandians that they should come into the village but some of them are not at all willing to comply. In my opinion it seems to be quite reasonable that the surrounding fields should be farmed. If I only knew that Your Honour would soon come over than I would postpone this matter until your arrival so that you and I could together reform a few things that really need to be improved.

We are daily expecting the return of Dicka[18] who left five or six days ago for Dalivo and four villages situated to the north of Tarokey to negotiate peace with them and from which we are expecting good reports; likewise we expect five villages located eastward from Tacareyan that

have requested us for peace. The coats and canes are very important, yes, even more so if we conclude peace with those villages mentioned above.

At noon Kockjen arrived here from Pangsoya and he says that he has been welcomed well. About what has happened and which villages he has visited we will hear more when Gillis arrives. Then we will write Your Honour about it.

Kockjen also tells us about 13 pigs, a hundred deerskins and rice that had been handed over long ago by the inhabitants of the villages eastward from Tacareyan to Chinese for delivery to Your Honour. However, the presents have been held back. The Chinese who had received it, known by the inhabitants as Taturicq, is at present in Tayouan. Your Honour may find out the truth about that matter; if we get more specific information from Gillis we will let you know.

21. Missive Governor Hans Putmans to Reverend Robertus Junius. Tayouan, 23 March 1636.
TEDING 14, fol. 12.

UE. missive gedateert 23 stantij is ons naermiddach wel geworden dienen dese weynige regulen op den teneur desselfs in antwoorde. [...]

Bij den raet is ons om verscheyde consideratiën goetgevonden dat wij ons met d'eerste gelegentheyt ende mooy weder in perzoon naer Wancan zullen transporteeren, soo haest daer weder vandaen comen sullen bij gelegentheyt ons eens naer Sincan transporteeren, doch sullen alvooren sulcx laeten weten. UE. connen ondertusschen de saecke zoo veel mogelijck daer naer prepareeren. De articulen, bij UE. voor desen aen ons voorgestelt, laet ons eens schriftelijck die pertinent toecomen opdat daer op wat mogen mediteeren en dan met fondament op alles ordre stellen, de rocken zullen UE. met d'eerste gelegentheyt (alzoo het tardement van 't selve naer 't root flueel geweest is) laeten toecomen ofte ten alderlangsten op onse compste medebrengen.

't Mishaegt ons dat Cockjen van Pangsoja wedercomende alhier is aengeweest ende ons niet eens aengesproocken, maer ter contrarie de saecke wel aen den luytenant, Sr. Van Sanen en andre (in plaets van ons volgens plicht aen te spreecken) verhaelt heeft, sonder eenige kennis naer behoren aen gem. persoonen te doen off den Chinees de varckens en de hertevellen vande inwoonders affgeëyscht is, oft wel uyt vrijen wille gesonden sijn, daer sij nochtans ter contrarie wel hadde behoren den Chinees eens bij ons te brengen om kennisse van saecken te crijgen. UE.

sullen hem daerover bestraffen, dat sulcx in toecomende niet meer en doet
ofte dat qualijck daer over vaeren sal; gelieft mede aen hem pertinent te
vernemen off den Chinees die de varckens ende hertevellen vande
voorschr. dorpen, oostelijck van Taccareijang gelegen, ontfangen heeft wel
kennen soude alsmede off de goederen door de Chineesen geëyscht,
affgevordert ofte wel uit eygen wille door de inwoonders aen hem
behandicht zijn; soo aen den Chinees kennis heeft sal noodich sijn gem.
Kockjen weder met den eersten hier verschijnt.
Wij hebben over de saecken van Jaques met den raet gedelibreert en is om
verscheyde insichten goetgevonden UE. aen te schrijven dat op
overmorgen ten alderlangsten met Jaques als mede twee Baculuanders die
den matroos gedragen hebben, mitsgaders de Chinees daer des andren
daegs bij was, item den Baculuander daer hem Jaques op beroupt soo 't
geene van de dragers is, en voorts met alle de gene die kennisse daervan
hebben eens sult herwaerts comen, jae condet morgen achtermiddach
geschieden te liever condet ons sijn, alsoo selver de saecke eens souden
ondersoucken ende ons vertrecq naer Wanckan daer naer sullen traineeren.

We got Your Honour's missive, dated the 23th of this month, today late in
the afternoon. These few lines will serve as an answer to it. [...]
During the Council meeting it was decided for several reasons that we
shall go again in person to Wancan on the first possible occasion, good
weather permitting. On our return from there we may well pass through
Sincan. We shall let you know beforehand. In the meantime Your Honour
will have the possibility to prepare everything in advance. Could you
write down the relevant information presented to us before, and have it
delivered to us so that we will be able to ponder it a little and then draw
our conclusions on a solid base. The coats (which were delayed because
they had to be made from red velvet) will be sent over to you on the
earliest occasion or in any case will be taken along by us on our journey
to Sincan.
It displeases us that Kockjen, on the way back from Pangsoya, came to
Tayouan but did not even come to see me. On the contrary he has
discussed the case with the lieutenant, Sr. Van Sanen and others (instead
of, in accordance with his duty, addressing himself directly to me)
without telling these persons, as he should have done, whether the
Chinese had demanded the pigs and deerskins from the inhabitants or
whether they had been sent on their own initiative and free will. In fact,
they could have sent this Chinese over to us in order to inform us. Your

Honour shall have to reprimand Kockjen about that, so that he will not do
this again in the future or else he will have to face the consequences.
Would you also ask him emphatically whether he could recognize the
Chinese man who received the pigs and deerskins of the mentioned
villages situated to the east of Taccareyang, and also ask him whether
these goods had been demanded by this Chinese or that they had been
handed over by the inhabitants voluntarily. If he knows that man, then the
above mentioned Kockjen must return to Tayouan as soon as possible.

In the Council we also have discussed Jacques' case. For several reasons
it was resolved to inform Your Honour that on the day after tomorrow at
the latest you will need to come down to us bringing with you Jacques,
the two men from Bacaluan who carried the sailor, the Chinese he had
visited on the day before his disappearance, as well as the man from
Bacaluan to whom Jacques refers - in case this man does not happen to be
one of the carriers, and all other people who are involved in this case.
Yea, if that can be accomplished tomorrow in the late afternoon it would
be better for us so that we shall be able to investigate this ourselves. The
moment of our departure to Wancan may be adjusted to this business.

22. Missive Governor Hans Putmans to Reverend Robertus Junius.
Tayouan, 25 March 1636.
TEDING 14, fol. 11.

[...] Belangende de zaecke van Jaques, dat UE. meene sulcx irritatie zoude
verwecken en de inwoonders en Chineesen niet wel zouden connen
hiergebracht werden sonder veel tijts te versuymen, wij approbeeren 't
selve met UE. en sullen zoo haest (meenende op morgen onze reyse aen te
vangen) van Wancan wedercomen, ons naer Sincan (dat wij achten
toecomende maendach zal zijn) transporteeren om alsdan de saeck te
behandelen. UE. connen alles daernaer soo veel mogelijck prepareeren en
voorz. Chineesen als inwoonders tegen gemt. tijt daer laten verschijnen.

Tapegij alias Gillis is gistren wel bij ons geweest maer heeft ons geene
omstandicheeden gerelateert. UE. connen voorz. inwoonders aldaer
ophouden tot onse comste, maer dat de clappus- als andre boomkens
souden werde geplant sonder alvoren de opdracht gedaen en de beduydinge
desselffs aen d'inwoonders wel en behoorlijck voorgestelt om haer (gelijck
andre gedaen is) onse meeninge (met presentie van onsen persoon) grondig
te doen verstaen.

Concerning Jacques' case, we do agree with your opinion that it only would cause a lot of irritation and that it would be well-nigh impossible to bring over the inhabitants and the Chinese to Tayouan without losing a lot of time. Therefore we shall, as soon as we have returned from Wancan (our intention is to leave tomorrow), go to Sincan (where we expect to be next Monday) in order to deal with this matter. Your Honour can prepare everything as much as possible and see to it that the mentioned Chinese and inhabitants will appear around that time.

Tapegij alias Gillis came to see us yesterday but did not give us any information. Your Honour can keep the above mentioned inhabitants over there until our arrival but the coconut- and other trees may be planted, although not until the inhabitants have had a proper explanation in my presence about the transfer and its meaning, so as to be sure that they (like others before them) will thoroughly understand our intentions.

23. Missive Reverend Robertus Junius to Governor Hans Putmans. Sincan, 30 March 1636.
TEDING 15, fol. 20.

Die van Dolatock verlanghen seer na huys, versochten gistren meermaels haer vertrecq dat haer niet dorste toestaen om alsoo met UE. ordre te contrarieeren, derhalven haer onthalen en vastlijck toeseggen dat sijn E. op morgen hier soude sijn soo hebben haer noch gehouden. Wij hoopen dan zijn E. ons op morgen bijcomen sal, opdat dese luyden des te eerder vertrecken mogen.

De rocken en de stocken verhoopen wij sijn Ed. mede brengen zal, gelijck mede niet schaden conde den princestocq die aen die van Dolatocq dan mochten verthoonen en sij het haere dorpen mochten aenseggen, voorts staen de saecken met al de dorpen redelijck daervan met sijn E. mondelijck hoope te spreecken.

Die van Tevorang die voor desen met geen kinderpocken plachten gequelt te werden hebben se jegenwoordig seer, verscheyde zijn al gestorven. Die van Tajouhan die se noch niet hebben en daervoor vreesen, quamen eenige dagen, 10 à 12 stercq zijnde, alhier om mij te roepen en onthalen voor haer sterven alsoo vreesen de pocken haer wech mochten nemen, doch mijn occupatiën, niettegenstaende zij ernstelijck aenhielden, wilden 't niet toelaeten; derhalven mede sont een Duytse met onsen Jan, die treffelijk onthaelt werden, om den andren wech te vinden ende te kennen; dede haar door 't geberchte gaen dat veel nader is maer moeyelijcker wegen. Met

drie glasen van hier gaende waeren se op den middach ginder. Segge dat over groote gebergte gingen soo dat zij segge het niet mogelijck was met paerden den wech te passeeren ende moeyelijck is voor voetvolcq; een questy onder haer geresen zijnde hebben doen mede ter neder geleyt en haer met malcanderen bevredigt, gelijck oock de Chineesen met haer die over haer claegden [...].

Those from Dolatock are very much longing for home and yesterday they requested us several times to allow them to depart. We did not dare to comply with this request as we would then be acting contrary to your orders. Therefore we entertained them and promised them that Your Honour would surely arrive here tomorrow which was the only way to detain them. We sincerely do hope that Your Honour will come tomorrow so that these people can depart, and the sooner the better.

We do hope that Your Honour will take along the coats and canes and it also would cause no harm to show the Prince's staff to those of Dolatock which afterwards they then may tell their villages. Furthermore the relations with all the villages seem to be fine as I hope to explain to you in person.

Those of Tevorang, who in the past were not afflicted by the smallpox at all, currently are suffering very much, several of them have already died. A few days ago some ten or twelve inhabitants of Tajouhan, who are not yet affected and who fear that disease, came to see me and tried to convince me to go along with them to be entertained in their village because they fear that the pox may well carry them off. Notwithstanding their insistence, my urgent occupations did not allow me to go, so I asked a Dutchman to join our Jan, who as a matter of fact were welcomed excellently. In order to explore and get to know the other route they took the road through the mountains, which is shorter but also much harder to pass. Leaving at the time of three bells in the morning they arrived already yonder at noon. On their return they told me that they had crossed high mountains and that it would be impossible to take that road on horseback and that it also was quite tough for footmen. They had even settled a dispute in that village and appeased the disputing parties with each other just as they had reconciled some Chinese, who had complained about some inhabitants, with the villagers.

24. Instruction from Governor Hans Putmans for Lieutenant Johan Jurriaensz. and other members of the Council, on how to behave during the punitive expedition to the Golden Lion Island and after the conquest.
Tayouan, 19 April 1636.
VOC 1170, fol. 628-629.

fol. 628: *(Men zeilde naar de Tamsuy rivier:)* [...] omme aldaer 10 à 12 Pangsoyers (die hun daer op 't strandt sullen verthoonen ende ten deele de spraecke van d'inwoonders van 't Goude Leeuws eyland conden verstaen) in te nemen ende door desen middel onse vijanden des te beter ende eerder in handen te bekomen. [...]

fol. 629: *(Na de landing op Lamey moesten de VOC-soldaten met behulp van hun inheemse bondgenoten proberen om:)* [...] de inwoonders door manquement van spijse ofte dranck eyndelingen door hongersnoodt mogen gedrongen werden hun in uwe handen over te geven; ondertusschen sult alle mogelijcke middelen aenwenden om haer, 't sij door de Pangsoyers uyt hare holen en speloncken, met toesegginge van haer leven te behouden, te crijgen, ofte - soo daer niet toe verstaen willen - met stanck van swavel en pick als andere benauden reuck daeruyt te drijven. Ende gemerckt het wel een geruymen tijt soude mogen aenloopen eer men dese menschen uyt haer hoolen souden connen gecrijgen ende hetselve nochtans ons principael disseyn en oogmerck is om daer toe te geraecken, soo werden U Eds. gelicentieert een gantsche maendt op gem. Goude Leeuws Eylandt (soo niet eer geschieden kan) met dese macht te verblijven [...].

Die na gedane furie, in d'welcke men seer qualijck imandt die onder dese inlandtse natie compt te geraecken kan verschoonen in onse handen comen te vervallen, principael vrouwen ofte kinderen, sult soo veel mogelijk sonder irritatie van onse swarten kan geschieden, het leven vergunnen ende al t'samen herwaerts aenbrengen. [...].

(The men should proceed southward in two junks together with the added sampans along the shore of the Formosa mainland to the Tamsuy River in order to:)
fol. 628: [...] fetch ten or twelve Pangsoyans from there (who will appear on the beach and who can partly understand the language spoken by the inhabitants of the Golden Lion Island) so that we will be able to catch our enemies faster and easier. [...]

(The next day at dawn they will cross over and anchor on the south-eastern side of the island. Afterwards the lieutenant, together with the Company-soldiers and as many inhabitants of Pangsoya as possible, will land with the sampans in order to attack the enemy. (fol. 629) They have to make sure that the islanders:) [...] lacking food and drink will be forced by starvation to surrender themselves. In the meantime you should apply all means to lure them out of their caves and caverns, either with the help of the Pangsoyans and with the promise that if they surrender their lives will be spared; if they are not willing not to do so, you should ferret them out [of their hiding places] with the stench of sulphur, tar and other sultry malodours. Because it may be quite some time before one can smoke these people out of their caves, and because it is our principal intention and aim to achieve this, therefore Your Honours are allowed (if it can not be accomplished earlier), to stay a whole month on the mentioned island together with your army. [...]

As for those Lameyans who, after the heat of the fight will without doubt fall into our hands - especially the women and children - we should try to save their lives and bring them altogether hither [to Zeelandia Castle], without causing serious irritation to our allied 'blacks' [the allies from Formosa].

25. Missive Robertus Junius to Governor Hans Putmans.
Sincan 19 April 1636.
TEDING 15, fol. 21.

Niet tegenstaende na UE. ordre den gistren van mij gesondenen Sincander belast hebbe van de dorpen Soelang, Mattauw ende Bacluan elcq maer tien off twaalf te roupen, soo is 't evenwel dat zij uit alle voorsz. dorpen in een groot getal verschijnen, zoo dat oordeel wel bij de 300 sullen uitmaken alle bij malcanderen zijnde, doch gelijck geseyt hebbe Sijn E. can der zoo veele wederom zenden als 't hem belieft want na hare maniere niet wel derven achterblijven als er ergens te vechten is, al wouden sij, om te ontgaen dat niet bespott werden voor verweerderen en geen chrijschluyden te zijn uitgeroepen werden, oversulcx wederkeeren haer niet seer mishaegen sal; Ja gelooven het veele aengenaem zijn sal die daerbij niet sullen verliesen maer winste doen, dat daerin bestaett dat nu meester zijnde van haer medegenomen massecau die dan oock sullen mogen uitdrincken. Mijns oordeels sal een groot getal schadelijck zijn also dit

volcq gaerne loopende, eenen siende loopen alle beginnen te loopen, meer als 60 à 70 off ten hoogsten honderd soude genough sijn. Om die te krijgen ware best de Soulangers werde aengeseyt zij 12 uit haer dorp selver wilden kiezen, zoo die van Mattauw, item Bacluan; onse Sincanders souden wat meerder van getal connen zijn om dat vorige getal uit te konnen maecken. Dit hebbe nodich geacht Sijn Ed. te verwittigen. Tarovang opperste van Soulang is den brenger deses.

Although according to your order I sent the Sincandian to the villages Soulang, Mattouw and Bacaluan to recruit from every village not more than ten or twelve people [for the expedition to the island Lamey], nonetheless great numbers of inhabitants have shown up here from all these villages. I am of the opinion that they now make up about 300 men altogether. However, as I said before, Your Honour can send as many of them back to their villages as he pleases. It is their custom never to stay away whenever fighting is in the offing, because they do not want to run the risk of being mocked at for being a coward or for not being a true warrior. In that respect they will not mind too much if they are sent back. Indeed, I believe that it will please many of them. They have nothing to lose but only to gain because they can now freely dispose of the *massecau* they brought along, which in fact they will be allowed to swallow up completely. I do think that too great a number of them could be harmful as these people do like to run and when they see one start running they all start to run. Some sixty or seventy people or a hundred at the most will be enough for this expedition. In order to get that number the best thing to do would be to announce to the Soulangians that they may select twelve people from their village. The same goes for Mattouw and Bacaluan. Our Sincandians may show up with a little more to complete the above mentioned number. I thought it necessary to inform his Honour about this. Tarovang, chief of Soulang, is delivering this message.

26. Missive Reverend Robertus Junius to Governor Hans Putmans. Sincan, 20 April 1636.
TEDING 15, fol. 22.

Gistren tegen den avont verscheenen noch hier een groot getal soo Mattauwers als Soulangers, alle om te vechten toegerust, die ons vraegden wanneer dat de onse vertrecken souden; die ten antwoort gaff, zonder

twijffel al vertrocken waeren, oversulcx wel weder mochten keeren. Gevraegt waerom niet na ons voorstellen maer tien hier lieten comen, seyde dat de eene voor de andere niet dorste blijven alsoo beschaemt waeren om alsoo voor te comen dat niet bespott wierden. Het was haer aengenaem dat van mij verstonden dat weder souden keeren alsoo het daer voor houden dat veele van haer dat niet eens gemeent hebben en daerom oock zoo laet quamen, hebbende voldaen, alleen maar verthoonende dat wilden gaen vechten. Crijgen voor sulck een middel veel drancq en toonende niet ongehoorsaem te sijn als wij haer laten roupen, maer gewillich en bereyt.

Tilag Soulanger heeft eenige dagen geleden in de dorpen noortelijck van Tarokeij gelegen geweest en brengt ons een pijle van Jarissang, zijnde het grootste dorp, versoucken een Hollander off twee met Tilach mochten comen, dat daer gesint zijn hier te comen en oock bij zijn Ed. op Tayouhan. Mijns oordeels is dit geraeden en proffijtellijck alsoo met eens hier te coomen haer herten zoo verre zullen winnen dat in toecomende van selver comen sullen. Tilag is bereyt, op morgen hier comende, daer na toe te gaen. Hij versoeckt Joost met hem mee te gaen noch een die daer toe mede wel bereyt is. Wij twijffelen niet off Sijn Ed. sal dit approberen, sal dito Joost dan mede connen in Tarockeij gaen, daer wij noch niet geweest sijn. Hier op soo Sijn Ed. ons noch heden conde antwoorden, soude Joost morgen ochtent de reyse met noch een stil persoon aennemen.

Van Tilag hoopen wij morgen zeeckre tidinge van den dootslager. Hij sustineert en meent dat een Soelanger gedaen heeft, genaemt Karingatt, 't is één van de vrunden van Sackau die in Sincan onthooft is, zijnde mede schuldich aen den vorigen moort; heeft mede noch geen straffe gegeven, naerder bescheyt sal mij nader doen schrijven.

Het brieffken dat met Tevorang gistren hadde mede gegeven, die met een troep Soulangers ontrent Sincan was en met Cornelis wederkeerden, gaet hierin gesloten. Lampsack dat mij verwondert is alsnog niet verscheenen. [...].

Yesterday evening a great number of people from Mattouw as well as Soulang appeared once more, all of them equipped for fighting, and asking when our men would depart for Lamey. We answered they should return home, because the expedition force had undoubtedly left. When we asked why they had not sent only ten warriors as we had requested them, they said that they felt embarrassed to stay behind out of fear of being ridiculed. It suited them well to hear from me that they should go back again. Many of them did not really mean to go, indeed that was the

reason they came here so late. They have complied with the request only by showing us that they would be willing to fight. In this way they receive a lot of liquor and show us they are willing and ready to fight instead of being disobedient when we call on them for their assistance.

A few days ago the Soulangian Tilach visited the villages situated to the north of Tarokey and brought us an arrow originating from Jarissang, the largest village in that area. They request the coming of one or two Dutchmen together with Tilach. They are willing to come over here as well as to Your Honour on Tayouan. In my opinion it would be most beneficial if first we could get them here in Sincan, so that we may win their hearts to such an extent that in the future they will come of their own free will. Tilach, who will come tomorrow, has agreed to pay them a visit once more. He asked whether Joost will accompany him on that journey as well as somebody else who is ready to do so. We do not doubt that Your Honour will approve of this, so that Joost can also go to Tarockeij, which we have not yet visited so far. If Your Honour can answer us today then Joost may depart tomorrow morning together with another peaceful person.

From Tilach we do hope to get a message about the murderer. He suggests and supposes that a Soulangian by the name of Karingatt has committed this crime. He is one of the friends of Sackau who was beheaded in Sincan. He is also guilty of that murder. He has not yet been meted out any punishment. Upon getting any further information I will write you to keep you informed.

The little note that I gave to Tevorang yesterday, who stayed together with a party of Soulangians in the neighbourhood of Sincan and who returned with Cornelis, is included in this letter. To my surprise Lampsack has still not arrived. [...]

27. Dagregister Zeelandia, Extracts concerning Lamey 18 April-29 May 1636.[19]
VOC 1170, fol. 601-609. Extracts.
DRZ, I, pp. 243-254.

fol. 601: Den 18en en 19en April zijn vast doende om alle preparade tot den tocht van 't Goude Leeuws Eylant te maken, 't welck op heden vaerdich en claer zijnde is het volck over de 100, soo soldaten als matroosen, van

d'onse nevens ontrent 70 à 80 inwoonders vande omliggende dorpen sterck zijnde, in drie jonckens en eenige champans geïmbarcqueert [...]

23, 24 ende 25^en dito. [...] Becomen een missive [...] van de luytenant [...] waer inne adviseert dat op [...] den 21^en deser met de gantsche macht aen 't Goude Leeuws eylandt waren geweest, alwaer op haere aencomste resconter van ontrent twintig derselver inwoonderen hadden gecregen die zeer furieus tegens onse wilden vechten, sulcx dat d'selve bijnaer aen 't lopen hadden gebracht, doch soo haest d'onse, met vier à vijf goede musquettiers daeronder, chargeerden hebben datelijck met verlies van drie van hare, behalve eenige gequetste, de vlucht genomen, sonder dat d'onse d'selve doenmaels meer te zien conden crijgen en sonder tegenstant in haer dorp trocken, (fol. 602) 't welck datelijck (behalven seecker plaetsken dat tot een rendevous behielden) in 't brant staecken, in meyninge om aldaer een wijle te verblijven, maer gemerckt geen water op 't eylandt en conden becomen zijn weder met de gantsche macht naar Tamsui vertrocken [...].

fol. 603: Primo Mey [...] des middaechs arriveert alhier een jonck van 't Goude Leeuws Eylandt in hebbende 42 gevangenen van desselfs inwoonderen daeronder acht mans persoonen de reste alt'samen vrouwen en kinderen. Uyt 't rapport van de mede gecomene Nederlanders met de jonck (hebbende door d'haesticheyt d'onse geen missive gesonden) verstaen dat op 26^en deses de gantsche macht uyt Tamsuy geassisteert met ontrent tachtig Pangsoyers en ontrent zoo veel Zinckanders weder naer 't Goude Leeuws Eylandt was vertrocken en dat d'onse sonder tegenstant met den gantsche ommeslach gelant en op een bequame plaetse (wel bepaggert) waeren geweest. Ondertusschen waren de Sinckanders ende Pangsoyers uyt geweest om d'inlanders van 't eylandt op te zoecken die een speloncke met een groot deel inwoonders hadden gevonden, weshalven d'onse datelijcq daer nae toegingen, dito plaetse met een pagger lieten omsetten en met veertig soldaten wel bewaren, haere alle middelen van spijs en dranck ontnemende mitsgaders met allerley bange roocken benauwende, sulcx dat eyndelijcq op 29^en passado haer in onse handen overgaven en bovengem. getal tot de speloncke die heel groot is en drie verscheyden uytgangen heeft (waer van de twee gestopt sijn) quamen cruypen, in dito cuylen vermeynden d'onse een goet getal menschen te sijn meest al t'samen vrouwen en kinderen. [...].

fol. 604: 3 May. Des morgens arriveert andermael een jonck en een missive van [...] Lamey [...] ophebbende 79 gevangenen [...] verders verstaen uit gemelde missive datter een jammerlijcke gekerm van vrouwen ende kinderen in dese speloncke is, en wert bij d'onse gesustineert een groot deel menschen daer in te zijn, goet quartier van 't leven te behouden is

haer tot verscheyden malen bij d'onse aengebooden geweest, doch hadden g'alligeert dat d'onse eerst twee à drie dagen van 't eylandt zoude vertrecken, anders vreesen dat hare misdaet aen de Nederlanders geperpetreert, datelijcq zouden gewroocken werden. Presenterende mede als dan gout ende silver aen d'onse te willen geven, dat wij achten aldaer weynich te zullen sijn en maer alleene bij haer gepractiseert werdt om d'onse van 't eylandt af te crijgen en haer als dan ondertusschen van alles te versien, tegens d'onse te vesten offte wel andersints te verbergen.

Bij d'onse sijn aldaer gevonden acht isere stucken en drie anckers van *Beverwijck* mitsgaders een Spaens ancker en eenige Hollandsche vilten met stroo hoeden, sulcx dat aldaer naer alle apparentie wel eenich Portugijs ofte wel eenich Castiliaens vaertuych aldaer mede gebleven moet zijn.

Des achtermiddachs compt weder een joncqe ende een missive, mitsgaders 79 gevangenen van Lamey, [...] verstaen mede dat de mannen die hun hier en daer op 't lant buyten de speloncken noch onthouden, zoo nu en dan op 't onversienste d'onse gaerne zouden bespringen, doch zoo haest eenige musquets daer op gelost werden, nemen datelijck de vlucht, sulcx dat oock altemets noch eenige hoofden werden gecregen.

4en dito. Arriveerden twee joncquen van 't Goude Leeuws Eylandt, ophebbende d'eerste 66 ende andere 35 gevangenen, (fol. 605) noch al meest vrouwen en kinderen, daeronder oock den oppersten van dito eylandt, nevens 11 andere mans persoonen. Uyt missive per dito joncque ontfangen verstaen, dat dese speloncke noch niet leedich is, ende niet seeckers connen weten hoe veel menschen daer noch in zijn. Geene diergelijcke speloncken - naer d'onse uyt de gevangenen verstaen - en zijnder geen meer op 't eylant, maer de geene die haer noch buyten verhouden, verbergen haer in opene clippen, daer 't lant rondom mede beseth is, mitsgaders in de creupelruychte. [...]

Wert ons mede per gem. missive aengeschreven dat den bovengem. oppersten naer 't gout en silver dat zij uyt de cuylen soo d'onse twee à drie dagen wilden vertrecken, beloofft hadden te geven, gevraecht is, doch seght geen te hebben, maer dat eenige jaeren geleden aldaer een schip gestrant is (waer van 't volck soude verdroncken zijn) ende welcks gelt in haere handen was vervallen, doch dat 't selve aen haer vrouwen en kinderen verdeelt hadden.

Nopende 't verongelucken van 't schip ende 't verdrencken van ons volck werden d'onse door andere gevangenens bericht, datter ontrent vijftig aen landt zijn gecomen en twee dagen tegen de wilden gevochten, sulcx dat haer ontrent veertig mannen affgeslaegen hadden, doch eyndelijck den tweeden dach met regenachtich weder vande wilden overvallen, ende

alt'samen doot geslaegen waren. De rechte seeckerheyt hiervan hoopen in toecoomende bij naerder examen te vernemen. [...]

7en dito. Naer middachs arriveert een jonck van Lamey met 29 gevangenen, noch als vooren meest vrouwen en kinderen, met een missive aen d'Ed. heer gouverneur Putmans gedateert 5en stantij, welckers teneur verstaen dit de leste die uyt dese voorverhaelde speloncke te becomen sijn. Weshalven d'onse, op 4en couranti geen gewach meer hoorende, daerin sijn geweest, en bevonden ontrent 200 à 300 dooden in dito speloncken (die vermits den grooten stancq niet tellen conden) behalven noch degeene die bij haer verbrandt zijn. Zulcx dat volgens 't schrijven van d'onse ontrent 540 zielen in dese speloncke zijn geweest, waervan 323 levendich alhier becomen hebben, daeronder (fol. 606) niet meer als 53 mannen, 125 vrouwen en de reste alt'samen kinderen. Het was een jammer geweest (naer dat uit gem. missive verstaen) om aen te zien d'ellende daerin dese menschen door haren hartneckigen aert (zonder aen de onse te willen overgeven) vervallen waeren. Het schijnt den Almogende tot een rechtvaerdige straffe over dese brutaele heydenen (voor haere misdaet in 't dootslaen van d'onse en veele andere geperpetreert, zijnde tegens den natuyre en redelijcke aert van 't menschelijcke geslachte aller menschen vijandt) dese saeke soodaenich heeft gelieven te dirigeeren.

Naer naerstich ondersoeck hebben d'onse (meenende een grooter schat te vinden) niet meer als 39½ croonen die zij hier en daer aen haere coraelen als andersints gehecht en onder de soldaeten gelaeten hadden, becoomen.

De resterende menschen op dit eylandt sijnde, werden vermoet haer in clippen als creupelruychte te verbergen, doch hebben d'onse daer van noch geen seeckerheyt maer verhopen d'selve mede erlangen, Godt de Voorste, in handen te becomen. Dat Godt geve, opdat alsoo dit eylandt (de saecke nu door Sijnen sonderlingen segen dus verre gebracht sijnde) van dese moordadigen hoop eens mach gesuyvert en bevrijt werden.

10en dito. Arriveert een joncq en een missive in dato 8en stantij gedateert van Lamey, medebrengende 21 stucx derselver inwoonderen die bij d'onse uyt seeckere nieuw gevonden speloncke ontrent een musquetschoot van de voorige gelegen becomen sijn, in dito speloncke waren ongeveer 38 à 40 zielen, doch zijn de resterende meest mans die hun in onse handen niet wilden geven, doorschooten als met graenaten ter neder gevelt. Het andere volck meest manspersoonen die haer noch op voorschr. eylandt onthouden blijven niet in speloncken maer meest op de hoochten tusschen de clippen in bosschagiën als andersints vluchtich en is het gants eylandt overal, jae selffs tot inde clippen, met clappus en piesangh beplant die haer tot haren noodtdrufft connen dienen, sonder dat d'onse sulcx konnen verhinderen,

oversulcx qualijck in onse handen sullen te becoomen zijn, als door lanckheyt van tijt.

11en dito. Arriveert andermael een jonckjen van Lamey met 31 gevangenen 't seedert 8en courantij bij d'onse met twee andere speloncken, die haer bij eenige gevangenen wierden (fol. 607) aengewesen, becoomen en verstaen uit de missive gedateert 10en deser dat ontrent veertig manspersoonen in 't opsoecken van voorsch. speloncken die haer aen de onse verthoonen, doch soo haest eenige musquets daerop gelost wierden, sijn met verlies van één hoofft datelijck weder verloopen; ende hebben d'onse doen, voorts soeckende, geen menschen dien dach meer vernomen, alleene vonden veele velthuyskens die tusschen de bosschagiën ende de zeestrant in stonden die de onse alt'samen (zijnde versien met boontjes, millie als andere eetbare waeren) in brandt staecken en weder naer 't quartier vertrocken.

16en dito. Arriveert een jonck van Lamey met 11 gevangenen die zoo nu en dan bij d'onse (met perthiën uytloopende) becoomen sijn. Uyt missive vande aldaer sijnde vrunden aen d'Ed. heer gouverneur geaddresseert, verstaen hoe dat de resterende inwoonders hun alt'samen in 't geberchte, de clippen, als bosschagie vluchtich houden, zonder meer in speloncken haer te verschuylen, uit oorsaecke naer d'onse sustineren hun bewust is dat wij eenige gevangenens hebben die hun de cuylen aenwijsen. Oversulcx hebben de vrunden aldaer op 12en courantij eenen anderen middelen bedacht ende haer door twee oude wijven die tot desen eynde bij d'onse behouden werden en een Pangsoyer (die daer toe bereyt was) laeten aencundigen dat medelijn met haer hadden, dienvolgende dat hun met den anderen zouden beraden en in handen van d'onse overgeven om alle vordere hostiliteyt (fol. 608) te preveniëren. Waerop tot antwoort dienden dat ons tegens den avondt op seeckere plaetse die daertoe nomineerden, bescheyt souden laten weten, gelijck ontrent sonnenonderganck in presentie vande daertoe gecommitteerdens geschieden, en quamen 10 à 12 mans persoonen die van verre toeriepen dat de Hollanders bedriechelijck met haer handelen en leuchenaars waren, overşulcx d'selve niet en vertrouden. Waerop zonder antwoorde te verwachten wederom gescheyden zijn, sonder dat d'onse haer 't sedert hebben vernoomen.

18en dito. Verstonden dat op gisteren en eergisteren twee joncken van 't eylandt Lamey met 42 gevangenen daeronder 11 manspersoonen waeren gearriveert die haer vrijwillich, op de gedane beloften van dat het leven sullen behouden, in onse handen hadden begeven, ende verhoopen d'onse dat de resterende zoo wannneer vernemen dat haer mede broeders bij den leeven blijven, in corten wel sullen volgen dat Godt geve.

Op dato arriveert andermael een jonck van Lamey met 32 vrijwillige van desselfs inwoonders alt'samen hebbende haer geweer, die gelijck als de voorverhaelde 11 op gisteren gecomen haer op onse gedane beloften van niet te sullen sterven offte eenich leet aengedaen werden haer selffs in onse handen hebben begeven [...].

25en dito. [...] Wert ons mede gerapporteert hoe dat op 22en courantij seeckere joncque met 42 vrijwilliche Lameyers van daer onder 't opsicht van een sergeant, vijf soldaten en den trompetter was affgevaerdicht die haer ontrent Tamsui tegens d'onse geopposeert hadden, meenende deselve overboort te (fol. 609) crijgen offte andersints te vermeesteren, doch d'onse haer cloeckmoedich tegenstaende, hebben gem. Lameyers meest alt'samen de vlucht in 't water genomen excepto, elff persoonen daervan ses bij d'onse doot geslagen en vijf inde joncque behouden, die door Sr. Hartsinck nevens 18 andere ditos hier gebracht sijn, de reste wert bij d'onse gepresumeert dat in Tamsui sullen te lande gecomen wesen [...]

28en dito. Arriveert een joncque van Lamey met vier gevangenens en verstaen uyt de missive van den luytenant aen d'Ed. heer gouverneur dat Pangsoyers twee hooffden van verloopene Lameyers hebben becoomen, mitsgaders dat d'onse twee nieuwe vlotjens aen 't eylandt hebben gevonden met al sijn toebehooren waeruit presumeerden datter eenige weder aldaer souden verscheenen zijn, weshalven d'onse daer nacht en dach wacht op houden op hoope dat d'selve door desen middel weder in handen zullen vervallen. [...]

29en dito. Arriveert een joncque van Lamey met twintig gevangenen zoo mannen, vrouwen als kinderen ende verstaen uyt de missive van den luytenant datter twee van de voordesen verloopene Lameyers weder in haere handen vervallen en onder dese twintig herwaerts gesonden werden. De Pangsoyers hebben mede drie hoofden daervan becoomen de reste zouden in 't geberchte gevlucht zijn, waerop die van Tamsui dagelijcks uytgaen [...].

fol. 601: The 18th and the 19th of April we are busy with all the preparations for the expedition to the Golden Lion Island. Today, everything being ready, the force with a strength of over a hundred men, soldiers as well as seamen, besides seventy or eighty inhabitants from the surrounding villages have embarked in three junks and some sampans. [...]

23, 24 and 25th ditto. [...] *(We received a message from the lieutenant that)* he, together with the whole force, on the 21st of this month had been to the Golden Lion Island. Upon their arrival they had an encounter with

about twenty warriors, who fought very fiercely against our allies, so that they almost forced them to run. Yet as soon as our men, including four or five able musketeers, charged, they fled immediately with a loss of three and some casualties. They were not seen anymore, so that our men without meeting any more resistance marched in to their village (fol. 602) which was instantly set on fire, except for one place which we kept as our rendezvous, as we meant to stay there for a while. However as we were not able to find any water our complete force left the island again for Tamsuy. [...]

fol. 603: May first, [...] in the afternoon a junk from the Golden Lion Island with 42 captives (eight men, and the remainder being all women and children), arrived over here. From the report delivered to us by the Dutchmen on board that junk (because they were in a hurry they had not managed to write us a missive) we came to know that they had left Tamsuy for the island on the 26th of this month, assisted by about eighty men from Pangsoya and nearly as many Sincandians. The complete force had landed without meeting any resistance and they had come across a strategic spot surrounded by a palissade. In the meantime the warriors of Sincan and Pangsoya went out to search for the inhabitants of the island and had found a cavern in which a large number of the inhabitants were hiding. At once our men went there and erected a stockade which completely surrounded the cavern and forty soldiers received orders to guard it, and cut off any supply of food and drinks. At the same time the inhabitants were distressed by all kinds of noxious fumes, so that on the 29th of last month they surrendered. The above number came crawling out of the cavern, which happens to be very large and has three different exits (two of which are sealed off). Our men assume that quite a number of people, mostly women and children, are hiding in those holes. [...]

fol. 604: 3 May. In the morning once more a junk arrives from Lamey with 79 captives on board. From the appended missive we learn that a pitiful crying can be heard from the women and children in the cavern. Our men believe that it contains quite a large number of people. Several times they have been offered a safe exit but they allege that we first should leave the island for two or three days, otherwise they fear that the crimes they have committed against the Dutch will immediately be avenged. They also promised to give us their gold and silver, which we deem to be of little value, it is only a trick to get rid of us. Such a ruse

would enable them to supply themselves with everything in the meantime, and to construct defences or to secure or hide themselves in some other way.

We did find eight metal guns and three anchors of *Beverwijck* as well as a Spanish anchor and some Dutch hats made of felt and straw, so that apparently also some Portuguese or Castilian ship must have ship wrecked over there.

In the late afternoon another junk calls at Tayouan from Lamey bringing another 79 captives along and a missive. We understand that on Lamey there are still some men to be found hiding in places outside the caverns and who every now and then would like to assault us by surprise. Yet as soon as any muskets are fired, they at once go on the run. Consequently we were able to to take a few more heads.

On the 4th ditto two junks arrived from the Golden Lion Island, of which the first one carried 66 and the other 35 captives, (fol. 605) mostly women and children, but also the highest chief of the mentioned island with eleven men. From the missive we received by that junk we learn that the cavern is not yet empty, and that it is not known with certainty how many people still remain in there. From the captives our men were told that no other similar caverns exist on the island, but that the people who are still hiding outside, are hiding themselves in the open cliffs, which surround the island, as well as in the brushwood.

By the same missive we were also informed that the mentioned chief had been asked about the gold and silver that the people in the caverns had promised us if we were willing to leave the island for two or three days. He said that they did not have any, but that several years ago a ship had ran aground (its crew had drowned) and that they had got its money, and that this had been divided among the women and children.

About the shipwreck and the drowning of our men, we were informed by other captives that about fifty persons had reached the shore and that these had fought the savages for two days in such a way that they had managed to beat off about forty men. Yet finally, on the second day they had been attacked again by the savages in rainy weather and had all been beaten to death. We do hope soon, by further interrogation, to find out the truth about this. [...]

May 7. In the afternoon a junk arrives from Lamey with 29 prisoners, as before mostly women and children, bringing a missive to the Honourable

Governor Putmans, dated the 5th of this month. From its contents we discover that the last remaining people have been captured from the mentioned cavern. Consequently on the 4th, when from below no sound was heard anymore, our men went down into the cave and discovered about 200 to 300 dead bodies - not including those who had been burnt by them. The exact number could not be counted because of the awful stench. So that according to this letter about 540 souls had been inside the cavern, from which we have brought 323 people alive over here, among whom (fol. 606) there were not more then 52 men and 125 women, the rest being altogether children. From the missive we understand that it has been a deplorable sight to witness the misery of these people, because owing to their stubborn character they had refused to surrender. It seems it has pleased the Almighty to conduct this affair in such a way as to let them be brought to justice for beating to death our people and others. The crimes they have committed run counter to the natural and reasonable character of the human race and have turned them into everybody's enemies. After a thorough search our men (who thought to find bigger treasure) discovered only 39½ coins which the Lameyans here and there had threaded on strings of beads or otherwise, and had given to our soldiers. The remaining people on the island, are supposed to be hiding on the cliffs and in the thickets, although we do not know this with certainty. We hope also to get hold of them, praise the Lord! God willing (after having succeeded thus by His blessing) this island may forever be freed and cleared of this murderous gang.

On the 10th ditto a junk arrives from Lamey carrying a missive dated the 8th of this month. It brings along another 21 inhabitants whom were captured by our men from a newly discovered cavern, situated at about the distance of a musket shot from the previous one. In that cavern were another 38 or 40 souls, however the remaining were men who, because they refused to submit themselves to us were shot or slain by grenades. The other folk, mostly men, remaining on the island are not in the caverns but have mostly fled to the heights between the cliffs and in the spinney or elsewhere. Since the whole island, even the cliffs, is covered by planted coconut and bananapalms, these provide the fugitives with food, while it is impossible for us to prevent them from sustaining themselves. It will be hard for us to seize them in the short term.

The 11th ditto another little junk arrives here from Lamey with 31 captives who have been seized since the 8th of this month out of two other caverns, that were indicated to our men by some of the prisoners (fol. 607). We learn from the missive of 10 May that, while the soldiers were searching for those caverns, about forty warriors had appeared. Yet as soon as some musket shots were fired at them, they ran off, leaving one dead man behind. That day our men did not succeed in finding anybody else, yet they discovered many little houses standing between the thicket and the beach in which there were supplies of beans, millet and other provisions. After our men had set fire to these, they returned to their quarters.

(On the 12th ditto, in the Formosa Council a resolution was taken to erect a wooden pallisade on Lamey for a garrison of thirty men under the command of a sergeant, with the aim of eventually getting hold of the remaining islanders and in order to offer protection to the Chinese tenants of Lamey.)

On the 16th a junk arrives with eleven captives whom our men had occasionally been able to catch while on patrol. From the missive of our friends over there we understand that the remaining inhabitants all are hiding in the mountains, on the cliffs as well as in the thickets. They do not seek refuge in the caverns anymore which, as our men presume, is due to the fact that they must be aware that some of the captives are pointing out these holes to us. Therefore our friends have devised a new trick, on the 12th. Using two old women, who were kept on Lamey for this purpose, together with a man from Pangsoya (who was willing to do so) we announced the survivors that we pitied them and asked them, in order to prevent further hostilities, to reconsider and to surrender themselves to us. (fol. 608) They answered that at sunset they would appear at a certain place and let our delegates know their decision. Indeed about ten to twelve men actually showed up, yet they shouted to us from a distance that the Dutch were liars and cheats so that they did not trust them. Thereupon, without waiting for an answer, they disappeared. Since then our people have not heard from them again.

On the 18th of May we understood that yesterday and the day before yesterday two junks arrived from the island of Lamey with 42 captives, among them eleven men whom, on our promises of sparing their lives, voluntarily had submitted themselves to us. We sincerely hope that the

others, God willing, will follow their example soon, when they hear that
their brothers have remained alive.

On the same day another junk arrives from Lamey with 32 inhabitants,
who have freely surrendered to us their weapons on the condition that we
would keep our promise to spare their lives and to refrain from doing any
harm to them.

On the 25th ditto was reported to us that on the 22 May a certain junk,
under command of a sergeant, together with five soldiers and the
trumpeter, sailed from Lamey with 42 islanders who had surrendered
voluntarily. Near Tamsuy the captives had attacked the crew with the
intention of throwing them overboard (fol. 609) or trying to overwhelm
them in some other way. Yet when our men valiantly held them off, all
the Lameyans together dived into the water except for eleven men, of
whom six were beaten to death and five could be kept in the junk. These
were brought by Sr. Hartsinck, together with 18 others to Tayouan. We
presume that the others will have reached the shore near Tamsuy. [...]

The 28th ditto a junk arrives from Lamey with four captives and we
understand from the lieutenant's missive to the Honourable Lord
Governor that the Pangsoyans did get hold of two heads of the runaway
Lameyans, also that two new little rafts with all the gear had been found
on the island so we presume that some more will reappear at that place.
Consequently our men keep watch over the beach day and night, hoping
that we will be able to seize them again. [...]

On 29th May a junk arrives from Lamey with twenty captives, men,
women as well as children and we learn from the lieutenant's missive that
his men got hold of two of the runaway Lameyans, who were among
these twenty sent over to us. The Pangsoyans also managed to get three
heads of them and it seems that the rest of these Lameyans, who are daily
pursued by the people of Tamsuy, fled into the mountains.

28. Missive Reverend Robertus Junius to Governor Hans Putmans.
Sincan, 22 April 1636.
TEDING 15, fol. 23-24.

Gistren tegen den avont verschijnt alhier Lampsack naer denwelcken met
verlangen hadden uitgesien, is op Tajouhan geweest heeft Ds. Candidius
aen sijn deur cloppende gesocht, niet vindende heeft hem tot ons gekeert.
Alsoo selver met Sijn E. niet spreecken can verhaelt veele dingen van die

van Loncjou, daer eenige dagen gecontinueert heeft. Van den oppersten wel onthaelt en bejegent sijnde, sonden vooruit bode, aen lant gesett zijnde, die hem aenseyden hare comst ende waerom. Dat verstaen hebbende heeft se datelijck bij hem ontboden. Sij hem opende waerom dat gecomen waren meteenen de schenckagie presenterende, daerop dat geantwoort hadde: 'soo de Hollanders met hem wilde vreede hebben, dat daer niet tegen hadde, doch soo niet dat het oocq soo goet was'. De Chineesen hielden aen en gaven hem te verstaen dat het noodich was, off dat nogh onse macht te vreesen hadde. Daer op antwoorde dat wij niet wel de berge soude connen opklimmen die seer hoog zijn en soo wij 't deden hem te machtig sijnde, het dan verloopen en noch op hooger bergen soude climmen. In somma het gincq soo verre dat meerder sinnelijckheyt in ons begost te krijgen door het raport dat Lampsack van ons dede. Soo dat tot antwoorde gaven eerst een Hollander wilden sien die zij, noch hare voorvaders, ooit gesien hadden en dat zij dan de schenckagie eerst zouden aennemen die met Lampsack terugge is gecomen, ende dan van haer volcq met ons wilden sturen ende alsoo een vast verbont maecken. Sijn broeder soo ick versta was seer graeg met Lampsack te comen doch den principalen hadde er tegen. De Chineesen om hem alle bedenckinge te laeten vallen versekerden haer persoonen en goederen soo lange daer, tot dat hij soude weder zijn gecomen, doch conden niet verwerven dat imant mede quam soodat een Hollander daer komende die 16 dorpen (want twee daervan hij selve verdreven heeft), tot ons geneycht sullen krijgen. Met welcke luyden niet alleen noodig maer oocq proffijtelijck wesen sal in vreede te treeden, niet alleen omdat door dat middel de zeestrant noch meer bevrijt crijgen, want daer ontrent dorpen heeft (daerom oock de Chineesen die aende oostzijde van 't geberchte handelen om des quaden waters wille genootsaeckt zijn den oppersten van Lonckjauw eerst schenckagie te brengen, opdat soo stranden versekert mogen zijn), maer oocq den wech nader maeckt naer het gout.

Dit volcq, zeyt Lampsack, is noch het civilste dat hij hier op 't eylant gesien heeft, maer hebben cleene en leelijcke huysen, gaen behoorlijck gecleett, de vrouwen dragen rocken tot haer enclauwen en bedecken oock haer borsten, sijn meer van een wit coleur als dese. Hij weet veel te seggen van den oppersten, wiens broeder hier comen sal; segt dat meer als hondert dagelijx van hem gevoet off die van zijn tafel eten etc. Dat hiervan resteert mondelijck. Over twee à drie dagen wort een Chinees op Tajowan verwacht, die aldaer het woort voert en heel prompt met die van Lonckjauw spreecken kan. Die gecomen zijnde sal met Lampsack ende Chinees afcomen ende wijtlopich met Sijn E. nopende Loncjau spreecken.

Datter gout is bij de vianden van Lonckjauw dat is seker, niet dat uit
d'aerde gegraven wordt, maer zantgout dat inde revieren gevonden wert.
[...] (fol. 24)
Gistren in den nacht is Joost met noch een Hollander mitsgaders Tilag na
Dalivo, Jarrissang, Valaula, Devoha ende Tossarang, vertrocken, dorpen
noortlijck noch leggende van Tarokey, die tegen sondach off maendach
met eenige inwoonders van de vorige dorpen weder verwachten zal.
Tilach ondersouck gedaen hebbende na den man die den matroos mochte
gedoot hebben begint weder te twijffelen, doch secht rechtuit dat het
Jaques niet is, neemt voor noch nader ende nauwer daerna te vernemen.
[...].

Yesterday evening Lampsack, to whose arrival we had been looking
forward, showed up in Sincan. He told us that he had gone to Tayouan
were he had knocked on Reverend Candidius' door. Yet when, after
searching, the latter could not be found, Lampsack had returned to us.
Because he himself could not speak directly with His Honour he related
many things to us about the people of Lonckjouw, where he had spent a
few days being treated and entertained very well by the headman. As soon
as Lampsack and his company had gone ashore, they had sent over a
messenger to inform the headman of their arrival and the reason for their
visit. The headman immediately sent for them. Upon presenting him with
a gift and explaining to him the purpose of their visit he had answered: 'If
the Dutch would like to conclude peace with him he would have nothing
against it, yet he did not mind either if they were not willing to do so.'
The Chinese persisted and made clear that he had better agree with
concluding peace or he might later fear for the weight of the Company's
power. He said that the Dutch would not be able to climb the high
mountains, and if we ever would manage to do so and became too
powerful, he could still run off and climb even higher mountains. On
account of what Lampsack reported to him about us the headman of
Lonckjouw and his people eventually became more and more interested in
getting to know us. They answered that they first wanted to meet a
Dutchman, because none of them nor any of their ancestors had ever seen
one. They also wanted Lampsack to take his gift back with him and [told]
that they would only accept it upon his return if a Dutchman would come
along as well. Also they came up with the idea of sending some people of
their nation first to conclude a lasting agreement. As I understand the

headman's brother wanted very much to come along with Lampsack, yet the principal headmen were against it. In order to remove these objections, the Chinese offered, while he was away, to stand surety for him in person or by forfeiting their belongings until his return. Anyhow the Chinese could not arrange for anyone to come along. Yet it seems likely that if a Dutchman appears in Lonckjouw he will well be able to unite those 16 villages in friendship, (because two of them had been driven away by the chief himself) within our range of power. It is not only necessary for the Company to conclude peace with the headman of Lonckjouw, but it will also be a great advantage: not least because we can thus render the beaches safer, as some of his settlements are located along the seashore. This is why the Chinese, who trade at the eastern side of the mountains, have to bring gifts to the chief of Lonckjouw, because of the tricky waters [on that side of the island]. Thus they may be saved [by the local people, instead of being beaten to death] in case of an accident. Another reason why a lasting peace is desirable is because this will open the road to the places where gold can be found.

Lampsack tells us that these people are the most civilized to be found on the whole of this island. Though they dwell in ugly little houses they go around well dressed. The women wear skirts down to their ankles and cover up their breasts. They seem to be more fair-skinned then those [from Sincan]. He has a lot to tell about the headman, whose brother is about to meet us; he is feeding or sharing his table with over a hundred people every day etc. What remains to be said will be told to you orally in about two or three days, when a Chinese can be expected to arrive at Tayouan. He is their spokesman and is capable of communicating very well with the people of Lonckjouw. Once he has arrived he will together with Lampsack and another Chinese tell you about Lonckjouw in extenso. It is sure that gold can be found in the area of Lonckjouw's enemies. Yet it is not the kind which can be dug from the earth, but gold dust which can be found in the streams. [...]

fol. 24: Yesterday at night Joost together with another Dutchman and Tilach left for Dalivo, Jarrissang, Valaula, Devoha, and Tossarang, villages situated to the north of Tarokey. They will be expected to return on Sunday or Monday together with some of the inhabitants of those villages.

Tilach, who investigated who might have killed the [Dutch] sailor, starts doubting again yet he assures us that Jacques did not commit that crime. He intends to continue his investigations further.

29. Missive Reverend Robertus Junius to Governor Hans Putmans. Sincan, 28 April 1636.
TEDING 15, fol. 24-25.

Het gepasseerde op Lamey heeft zijn Ed. schriftelijck beter als mij mondelijck van dese Sincandren connen verstaen, over de drie hier gebrachte hooffden hebben zij haere gewoonlijcke vreugde gepleegt; het comt wel en is vorderlijck datse alle drie van onse Sincandren gecregen sijn. De quetsure van Dicka en den andren is cleen, sal eer lange gecureert zijn. Het hindert haer niet te gaen en hare affaire te verrechten; in 't herwaert comen hebben sij gerescontreert Tamsuiers, die onsen Sincander redelijck verre hebben gedragen, alsoo met der daet betoonende dat te voren was gesecht. Soo ick versta, sijn der alweder een deel croonen gevonden, soo van die van Pangsoja als Sincan. Sincan gelooft dat den honger haer sal doen voor den dagh komen off immers gehoor geven. Ten waere dit quaet weder, souden al eenige weder haer ginswaerts getransporteert hebben, hetwelcke zij mij vragen niet heb connen afslaen te meer alsoo selver haer vaertuyg en cost versorgen zullen.

Mij is van een vrouwe voor waerheyt geseyt den verlooren matroos van eenen Tamosey alias Tapanga is gedoodet die ons volgden als uittrocken, zijnde vergramt dat het dack en de rijshuysken bij zijn huys schaloos gemaectt wierden, doen daer overnachten, zijnde een inwoonder van dat huys, zoo de vrouw secht is 't openbaer onder haer maer uit vreese derven sij 't niet aen ons openbaeren. Dit heeft Dicka, listigheyt gebruykende, dese vrouwe affgehaelt, soo dat wederom gevoele om Jaques niet lange te houden (die noodig dient sijn velt te prepareeren soo hij sayen sal) dat op hanttastinge vrijlijck mochte gelargeert werden. Dicka gelooft vastelijck dat Tamasoy bovengent., den man is. Hierover verwachten ordre van Sijn E. Jaques foute aen den matroos begaen heeft wel soolange detentie verdient gelijck hem dat dan sullen seggen en voor de Sinckanders uitdrucken.

De stucken Sinckan consernerende, die Zijn E. ons schriftelijck hadde medegegeven en insonderheyt (fol. 25) de leeraressen belangende, zijn haer voorgestelt; hebbe niet connen mercken off dochten haer redelijck. De leeraresse, tot acht toe, dede ick roupen, haer hetselve claerlijck voorstellende om alle, soo alle pretentiën van ignorantiën haer te benemen.

[Zij] beloofden het na te comen, dat wij verhoopen veel goeds doen sal. Na het resterende zullen wij uytsien op dat de schole ingestelt mach werden en het werk van Tavokan begonnen.

Vierhondert bambousen uit Sincan heeft Sijn Ed. eersdaechs te verwachten soo den regen cesseren wil, daervan elcq huys vier te laten cappen geconsenteert heeft, sijnde het gene sijn E. ons belast (segge) laetst recommandeerde. [...] Joost is noch niet verscheenen (het sal de Chineesen die op Tayouan na dese reyse wachten apparent lancq vallen) die icq geloove noch in de noortlijke dorpen is, en door het water verhindert wort te keeren. Soo neffens Christoffel noch twee gevonden conden werden, ware goet en dit langer uit te stellen onnodig, al is 't dat niet veel connen spreecken, watt schade alsoo niet veel beschouwe en dat gesproocken moet weerden op Tayouan één à twee van haer gecomen zijnde geschieden can. [...].

What has happenend on Lamey has been reported in writing to Your Honour much better than I have been able to understand from what I was told by the returned Sincandians themselves. They have celebrated their delight in the customary way about the three heads they seized from the enemy. It is quite lucky and advantageous that the three heads were all taken by our Sincandians. Dicka and the other only got hurt in a minor way and it won't be long before their wounds have healed. In any event, it does not hinder them too much to go out and about on their business. On their way home they had met with people from Tamsuy who had been kind enough to voluntarily carry our Sincandian over quite a distance, which shows what I have written you about their prestige. As I understand another quantity of the crowns [or coins] has been found on the island, by those of Pangsoya as well as of Sincan. The Sincan people believe that hunger will force the Lameyans to turn up or at least comply with our order to surrender. They would already have transported themselves again to Lamey if the weather had not been so bad, and I could not turn down their request, the more so because they themselves will provide the vessel and supplies.[20]

The truth about the lost mariner has been told to me by a woman. He was killed by a certain Tamosey alias Tapanga, who at that time had secretly followed our men when they left. He had been angry that the roof of his house and the small rice storage shed had been destroyed when the men had spent the night. Tamosey was the occupant of that house, the woman

tells us. It is publicly known to all of them, yet they dare not tell us. Dicka, by using some cunning, has managed to elicit the secret from this woman. Consequently I again feel that Jacques (who urgently has to prepare his fields before he is able to sow), should be released on slapping hands. Dicka does believe firmly that the above mentioned Tamosey is the man that has committed the crime. We await His Honour's orders about how we are supposed to act. Yet for Jacques' neglect of duty he did deserve some kind of punishment like the detention he got, this we will confirm to him as well as to the Sincandians.

We have presented to the villagers the documents about Sincan which Your Honour had given us, including the one dealing about (fol. 25) the priestesses. As far as I can see they considered them to be reasonable. I called in the priestesses, all eight of them, and explained it clearly to them, in order to do away with all pretended ignorance. They responded that they were willing to comply with our rules, which we hope will bring about a good result. The remaining business we shall try to accomplish as well so that the school may be instituted and that the work of conversion in Tavokan may get started.

His Honour can expect soon, if only the rains would stop, the delivery of four hundred bamboo canes from Sincan. Every house has agreed to cut down four, that being the number last recommended by His Honour. [...]

Joost has not yet appeared (which will not be welcomed by the Chinese at Tayouan who have been waiting a long time for the result of this journey) as I do believe he is still staying in the northern villages, because his return is hindered by floods. If besides Christoffel only two others can be found, it is better not to postpone any longer, even if we are unable to communicate well with the inhabitants. This indeed will not cause too much harm because what ought to be said can be discussed as soon as one or two of the inhabitants of those villages have arrived in Tayouan. [...]

30. Missive Governor Hans Putmans to Reverend Robertus Junius.
Tayouan, 29 April 1636.
TEDING 14, fol. 13.

UE. missive gedateert 28en deser is ons op heden voormiddach wel geworden, dient dit naervolgende in antwoorde: 't Behaegt ons met UE. mede wel dat de drie hooffden bij die van Sincan alleen becomen zijn. Zij hebben daeraan bethoont haer mannelijckheyt en dat meester willen zijn,

dat de quetsuren haer niet en hinderen is ons lieff. UE. mogen vrijlijck alle die met haer eygen champans en costen weder derwaerts willen vertrecken licentie daertoe verleenen, soo lange ons volcq (die wij aengeschreven hebben soo den regen continueert herwaerts te comen doch goet weder blijvende, bij alle mogelijcke middelen het eylant sien te vermeesteren en het volcq in haer gewelt te crijgen) niet weder en comen, alzoo zulx in 't minste geen hinder en can toebringen.

Dat UE. oordeelt men Jaques op hantastinge wel mochte largeren gemerckt UE. uit seeckere vrouwe verstaen heeft den manslacht van den matroos bij eenen Soulanger geperpetreert te zijn, wij connen sulcx vooralsnog niet approberen op 't seggen van een vrou die mogelijck bij Jaques daertoe wel mocht geëxamineert en gecocht wesen. Maer dienen UE. bij alle vrundelijcke en amiable ofte wel, soo 't noodich bij UE. geoordeelt wert, harde middelen, 't sij aende outsten en hooffden ofte imant perticulier van Soulang, te vernemen wat vande saecke zij en dat de waerheyt daervan openbaren, al soude UE. haer beloven (door dien de saecke soo lange geleden is) dat den persoon, niet tegenstaende den doot verdient heeft, niet sullen aen de lijve straffe, dat hem alleen maer aenwijsen, namelijck en soodaanige straffe doen geven als haer manieren medebrengen op dat alsoo met fondament in soodaanige dubieuse zaecken mogen disponeeren.

[...] Dat Joost noch niet verscheenen is en UE. meenen men Christoffel met noch één à twee andren na Lanckjauw neffen de Chineesen mocht senden, te meer Joost in Sincan oocq dienstich is, wij oordeelen datter tenminste imant behoorde te wesen die de tale can spreecken om bij voorval van saecken op 't één en 't ander doch spaersaem en matelijck te antwoorden; dan sullen UE. nader advijs hierop verwachten en, zoo Joost niet en comt, sullen Cockjen ordre geven dat uit Pangsoja met de Chineesen zich derwaert transporteert neffen twee andre van hier. [...].

This will serve as an answer to your missive dated the 28th of this month which reached us early in the afternoon: As is Your Honour, we are also very pleased that the three heads were seized only by men from Sincan. In such way they have shown their manliness and that they want to be distinguished as masters. That they do not bother about their wounds we do appreciate as well. Your Honour will be allowed to freely permit all of them who are willing to leave with their own *sampans* and on their own costs to go to the island, as long as they cause no trouble whatsoever to our men (whom we have ordered that, if the rains should continue they

have to come forward, yet when the weather stays fair they should, by all possible means, try to overpower the island and seize the inhabitants by force).

Your Honour judges that Jacques could be released on a hand-slapping basis because Your Honour learned from a certain woman that the killing of the sailor was committed by a Soulangian. However we can not accept this merely on the basis of the words of a woman who might possibly have been bribed and urged on by Jacques. You should by all friendly and amicable means, and if you consider that necessary, by harsh interrogation, try to find out from the elders, headmen or anyone particular in Soulang, the truth about that case so that the truth will become public. You may even promise them (as it happened such a long time ago) that the perpetrator, notwithstanding he deserves the death-penalty, will not be punished, but that they should only indicate the perpetrator and give him a just punishment according to own their customary law, so that dubious cases like this one can in future be dealt with in a fundamental way.

[In connection with your proposal] that Christoffel, together with one or two others, should be sent to Lonckjauw besides the Chinese, because Joost has not yet appeared, the more so because Joost is required in Sincan, we do feel that at least one person should go who speaks the language, who will be able, if necessary, to answer in a restrained and calculated manner. We will await your comment and, if Joost does not show up, we shall eventually order Cockjen to transport himself thither from Pangsoya together with the Chinese and two others from here. [...]

31. Missive Governor Hans Putmans to Reverend Robertus Junius. Tayouan, 1 May 1636. TEDING 14, fol. 14.

UE. missive van dato deser is ons op gisteren per Joost wel geworden. Belangende dat denselven inde vijf noortelijck gelegene dorpen niet naer merite en soo als gemeynt hadde onthaelt is, doet ons vreemt, doch 't can wel wesen dat het soodanig als UE. meynen toegegaen is ende alleene onder de inwoonders om haer particulier genut ofte andre consideratiën soodanig besteecken zij, daer van den tijt de leermeester sal sijn ende ons de waerheyt subministreeren.

Op gistren zijn alhier met een jonck van 't Goude Leeuws Eylandt aengebracht 44 zoo mans, vrouwen als kinderen en werdt bij d'onse niet getwijffelt ofte sullen deselve alt'samen binnen corten tijt in haere handen en gemelt becomen. D'Almogende zij gedanckt voor Zijne genade en gewenste succes, van dese zaecqe geen meerder perticulariteyten als dese. [...]

Met advijs vanden raett hebben Joost neffens den corporaal Christoffel en den soldaat die mede uit Sincan gecomen is, met twee jonckjens die bij ons na 't Goude Leeuws eylandt tot overvoer vande gevangenen op gistren gesonden sijn, na Tampsuy gelargeert om van daer met de Chineesen voorts na Lonckjau hare reyse te vervorderen.

Wat belangt UE. gesondene AB boucxkens (dat weder hier neffens gaet) en can bij ons niet wel verstaen werden. UE. seggen in sijne missive aldus: als een AB gestelt was dat dan seggen souden *nanang i:* en vocalen a: e: i: o: u: *nanangh i sesuma*; a: b: d etc. Wij connen wat de vocalen en a b aengaet alles wel begrijpen maer *nanangh* en *sesuma* can bij ons niet verstaen werden. Dienvolgende om onnoodig schrijven t'eviteeren gelieve UE. selffs aldaer een bouckjen in forma als het wesen moet te formeeren en alsdan sullen 't selve van Pitt pertinent laeten copiëren, te meer oock deselven alhier in seeckere boucken te schrijven noch eenige dagen noodich hebben, anders souden UE. den selven aldaer laten toecomen. [...].

Yesterday we got Your Honour's letter of that date by Joost. It seems a bit strange to us that he was not welcomed in the five villages situated to the north according to the customary standards, nor entertained as had been expected. However, it may well be, as Your Honour suggests, that these inhabitants are only after their private benefit or that it was contrived in that way for other considerations. Time will show us and will provide us with the truth.

A junk from Golden Lion Island brought 44 people of Lamey over to us, men as well as women and children and we do not doubt that all of the islanders will soon fall into our hands. The Lord Almighty be thanked for His mercy and the success we wished for. We can not provide you with any more particularities about this case for the time being [...]

Provided with the Council's advice Joost, as well as the corporal Christoffel and the soldier who also came over from Sincan, have been dispatched to Tamsuy on the two junks that we sent to the Golden Lion Island yesterday in order to carry the captives, so that they may from

there onwards continue their journey to Lonckjouw together with the Chinese.

Concerning the ABC-books you sent (returned to you together with this letter) we do not understand them very well. Like Your Honour is telling us in your missive AB stands for *nanang i*: and the vowels a: e: i: o: u *nanangh i sesuma*; a: b: d: etc. We do comprehend what you tell us about the vowels and AB but we do not get what you mean with *nanangh* and *sesuma*. Therefore, so as to avoid unnecessary writing, we request Your Honour to compile a little book in the proper form yourself, which we will have copied precisely by Pitt. We need him over here for a few days to carry out some writing in several books otherwise we would have sent him over to you.

32. Missive Governor Hans Putmans to Reverend Georgius Candidius. Tayouan, 15 May 1636.
TEDING 14, fol. 15.

Op huyden morgen verschijnt alhier van Lonckjouw den corporael Christoffel neffens den broeder van den oppersten en 14 van zijn dienaeren tot suyte, rapporterende dat Joost en den soldaet aldaer, tot zij de retour weder in haer dorp comen, in ostagie zijn verbleven en dat op haer eerste aencomen in Lonckjou wel onthaelt wierden; doch dat den oppersten noch al twijffelde off wij terecht meenden, tot twee à drie verscheyde reysen vrij wat beschonken zijnde d'onse een groote vreese aengejaegt heeft met haer de parring in de neck te leggen, allegueerende dat sij verspieders waeren, comende het landt besichtigen om dan in toecomende haer te beoorlogen. Maer den broeder vanden voorsz. grootvorst, altijt een goetgevoelen vande Nederlanders hebbende, schijnt dat dese saecke doorgedreven heeft om herwaerts te comen, voorgevende volgens hare heydense costuyme dat uit den droom als de vogelsang (die hij nu twee à drie dagen gehoort hadde ende goet was), zulcx wel wiste, over sulcx gelijck endelick sich herwaert heeft getransporteert. Wij hebben haer wel beleeft en vruntlijcq onthaelt dat haer welgevallen heeft. Verzochten aen ons om na Sincan te gaen en haer daer mede wat te vermaecken 't welcq haer toegestaen hebben. UE. gelieve haer lieden alt'samen wel te onthalen en tracteeren en als zij weder comen soo gelieve UE. neffen Lampsack om van alles noch breeder met haer te handelen en spreecken sich mede eens herwarts te transporteeren.

The brother of the ruler of Lonckjouw with a following of 14 of his servants arrives here this morning in addition to corporal Christoffel. He reports that Joost and the soldier will stay behind as hostages until their return to the village and that from their arrival in Lonckjouw onwards they were entertained well. However the ruler himself seemed to have doubts about our good intentions. Quite drunk on two or three occasions he terrified our men greatly by thrusting a machete against their necks, alleging that they actually were spies coming to inspect his territory with the intention of making war on them later. Yet the brother of the mentioned potentate showed nothing but friendly feelings towards the Dutch, and it seems that it was he who forced the matter of paying a visit, pretending that it was all right as he had, according to their pagan customs, heard in dreams the right birdsong (to which he had listened for at least a day of two or three). Thus he knew he was right so that at last he had gone thither.[21] We have welcomed them in a polite and friendly manner which pleased them very much. We complied with their request whether they could come over to Sincan to divert themselves a little. So we beg Your Honour to be so kind as to welcome them altogether and treat them well and upon their return you and Lampsack could perhaps accompany them on their return journey so as to be able to communicate a bit further with them.

33. Missive Reverend Robertus Junius to Governor Hans Putmans. Sincan, 15 May 1636. TEDING 15, fol. 25.

Het gepasseerde van heden heeft zijn E. van Sr. Paulo en Smit zonder twijffel verstaen. De name van die borge staen voor Jaques zijn: Takoug en Sangarau. Wij dancken sijn E. dat ons toestaett Pitt en Ariaen om de ABC boucxkens te schrijven die wij wel 100 stux sullen moeten hebben, dat zij niet sonder grooten tijt te verquisten sullen konnen doen en oock niet één handt soude wesen. Wij hebben een bequaam jongman in onse corteguaerde uitgevonden die een bequaam hant en snel van schrijven heeft, die ik oordeele ons hier meede sal kunne gerieven, daertoe oocq (soo gecontenteert wert) geneygt is, die op morgen daeraen sal setten, die se alleen alle sal connen uitschrijven, derhalven Pitt en Ariaen, die misschien in Tayouan noodig zijn, niet langer hebbe derven ophouden maer weder gestiertt. Desen schrijver is mij gistren bekent geworden,

daerom oocq hierneffens gaen. Maendach toecomende, soo Godt wil, sullen wij de school beginnen, sijnde voor eerst van meeninge als schoolmeester daer in te stelien Andreas Markinius, die wij daertoe cappabel vinden. Hij gaet hier neffens, soude gaerne met zijn E. spreecken nopende het ontfangen van contanten. Ick hebbe hem gesecht sijn E. 20 realen hadde toegestaen daer beneffens 6 voor de montkosten [...].

His Honour must undoubtedly have already learned from Sr. Paulo [Traudenius] and Smitt what has happened today. The names of those who stand bail for Jacques are: Takoug and Sangarau. We thank His Honour that he allows Pitt and Ariaen to write the ABC-books of which we need over a hundred copies, which they will not be able to carry out without spending a lot of time and then [the books] would also not be written by one hand. We did find an able young man in our garrison who disposes of a competent and swift hand of writing, and who, in my opinion, will fulfill our needs, and who will (if sufficiently remunerated) be willing to do this job. He will start tommorrow, and will be perfectly able to finish the writing single-handedly. Consequently Pitt and Ariaen who may be needed in Tayouan, and whom we did not dare to keep up here any longer, have been sent back. Because I found out about this writer only yesterday, they go together with this letter. Next Monday, if God wishes it, we will start the school. At the moment we think of appointing Andreas Markinius, whom we consider to be competent to act as schoolmaster. He is also going over because he would like to speak with Your Honour about the payment he will receive. I have told him that Your Honour had allowed 20 reals [a month], besides six for victuals. [...].

34. Missive Reverend Robertus Junius to Governor Hans Putmans. Sincan, 23 May 1636.
TEDING 15, fol. 26.

[...] Hier neffens gaen vier Lameyse vrouwen, twee die zijn E. geordineert heeft (daervan de joncxte met de hooge neuse bequaemst oordeele zoo zijn E. imant na 't eylant wil stieren, zijnde een vrouwe die veel te seggen heeft, de oude is meer gemiscontenteert laet niet te clagen), de ander twee op haer verzoucq, hebbende noch kindren op Tayouwan, die zij gaerne sou haelen, connen als er meer comen weder gezonden werden,

zoo 't zijn E. en den raet soo verstaet de Sincanders houden daeglicx aen,
om de andre, zij tracteren haer als haer eygen volcq.
Eenige dagen geleden hebben die van Vovorolang weder de pijpen gestelt:
de Chineesen vijf gequest, drie medegenomen, de andre goet ontnomen en
verjaegt. [...]
Hier heeft sijn E. oocq Gillis die neffens Jan zende, om oft'er wat te
vertolcken waer. Carel in Tavacan is seer met sieckte gequelt denwelcken
wij op zijn verzoucq van meeninge zijn heden te gaen besoucken.

Herewith four women from Lamey are sent to you, the two that His
Honour has ordered to come over (in my opinion the youngest of them,
the one with the high nose being a woman of influence, will be the most
able if His Honour wishes to send anyone to the island. The elderly
woman, who is continuously complaining, is quite discontented. The two
others go on their own request. Both of them have children on Tayouan
and they would very much like to fetch them. Whenever more people are
brought over from Lamey, these can always be sent back to Sincan. His
Honour and the Council should be aware that the Sincandians do treat the
Lameyans just as well as their own people and that they keep on asking
for the others to be brought over to their village as well.
A few days ago those of Vavorolangh again made a shameful exhibition:
five Chinese have been hurt, three have been kidnapped and the others,
after being robbed of their belongings, were chased away. [...]
Besides Jan, His Honour also will see that Gillis has been sent over, in
case any translation work needs to be done. Carel in Tavocan, who
requested that we pay a visit, is suffering much from illness.

35. Missive Governor Hans Putmans to Reverend Robertus Junius.
Tayouan, 24 May 1636.
TEDING 14, fol. 14-15.

Op gisteren gewert ons UE. missive van 11en couranti neffens het a: b
boucxken, waer van wij één hebben laten copiëren dat hier neffens gaet
om bij UE. beoogt en soo 't noodich is gecorrigeert te werden, vermits de
heylige daegen is 't selve niet eer voor op heden connen geschieden.
Aengesien die van Zoulang den dootslag met alleman loochenen soo blijft
dese zaecke noopende Jaques voor de raet noch twijffelachtigh om aff te
handelen, doch om deese man soo veel mogelijck voor schade te bevrijden
dunctt ons niet ongeraden dat UE. eens ondersoucken ofter eenige van

sijne vrunden off Zincanders (fol. 15) voor zijn comparatie willen borge
blijven, onder conditie ingevalle Jaques quame te verloopen zijluyden den
selven souden moeten weder in onse handen leveren, als wanneer wij niet
en twijfelen off den raet sal inclineeren om Jaques op gemelte borgtocht en
hanttastinge vrij te laeten. Dit dunctt ons den naesten middel te wesen om
voorz. Jaques, als gesecht is, voor schade te bevrijden.
Hierboven seggen een bouckjen hier neffens te gaen, gelijck oocq niet
beter en wisten doch naderhant verstaen dat het Pitt niet lesen can,
weshalven goetgedacht hebben UE. denselven, neffens Ariaen toe te
zenden om aldaer bij UE. gedaen te werden.

Yesterday we received Your Honour's missive dated the 11th of this
month,[22] and also the ABC-book, of which we ordered one copy to be
made, and which we hereby return to you as to be adjudged by you and if
necessary to be corrected. Because of the holy days we have not been able
to send it to you earlier.

As a result of the fact that the inhabitants of Soulang altogether do deny
the manslaughter, Jacques' case remains too doubtful for the Council to
conclude. Yet in order to safe guard this man as much as possible against
damage it does not seem unwise to us that Your Honour should try to find
out whether some of his friends or Sincandians (fol. 15) will be willing to
stand bail for him, on the condition that if Jacques should run off they
would be obliged to return him back into our hands. In that case we do
not doubt that the Council will be inclined to release Jacques on bail and
handslapping. This seems us to be the best way as to protect the
mentioned Jacques, as has been said above, against damage.

We told you above that we sent you the little ABC-book, indeed we were
sure that it actually had been done, yet afterwards we came to know that
Pitt had not been able to read it, so we deemed it better to send him
together with Ariaen over to you, so that the job can be carried out in
your presence.

36. Extracts taken from the Zeelandia Castle Resolution-books, concerning the resolutions on the island of Lamey, taken in the Formosa Council.
VOC 1170, fol. 581-583. Extract 2 June 1636.[23]

fol. 581: 2 Junij. Aengesien 't Goude Leeuws eylant ofte Lamey bij d'onse door de genade des Heeren g'incorporeert ende in ons gewelt gebracht is sulcx dat veele derselver inwoonderen, ontrent 't getal van 490 zielen (daer onder ongeveer 150 mans persoonen de reste alt'samen vrouwen en kinderen), alhier zijn hebbende. Ende om niet mis te tasten in wat voegen men met de selve soude handelen soo men nu ende dan tot verscheyde tijden bij d'Ed. heer Gouverneur met de vrunden daerover is gediscoureert om des te vruchtbaerder resolutie te mogen trecken; soo geeft zijne gemelte Ed. den raedt in serieuse bedenckinge (naer dat alvoorens de faulte bij die van Lamey tegens d'onse ende andere natiën geperpetreert en wederom de merckelijck groote ende rechtvaerdige straffe die haer door de schickinge ende rechtvaerdige handt Godes, ons als instrumenten daer toe gebruyckende, nu jongst met onse gedaene tocht in 't veroveren van 't eylandt is toegebracht, rijpelijk tegens malcanderen geballanceert waren) hoedanich men met dese luyden sal handelen: 't sij dat men deselve met de eerste commoditeyt alt'samen naer Batavia sal versenden om aldaer ter discretie van de Ed. heer Generael en raden van Indiën gebruyckt te werden, ofte wel op 't versoeck van de Sincanders, die om de vrouwen en kinderen onder haer te hebben gants inclineeren ende selfs verscheyden malen versocht hebben onder belofte van de selve te onderhouden ende als haer eygen natie op te voeden, jae, soo de Ed. heer Generael ende Raden van Indiën 't selve niet en approbeeren, altijt op onse requisitie sonder pretentie van eigendom d'selve weder in onsen handen sullen leveren. In Sincan verdeelen, 't is sulcx ende dient voor 't principaelste genoteert dat de vrouwen ende kinderen in Sinckan zijnde, in tijt ende wijlen noch tot het christen gelove soude connen gebracht werden. Oock soude dit een middel wesen om Sinckan te vergrooten daer wij altijt naer, om verscheyden goede insichten (fol. 582) ende 't selve des te meer aen ons te verbinden, getracht hebben. Daer ter contrarie deselve hier behoudende sulcx niet alleene excessieve moeyte om wel bewaert te werden maer oocq groote oncosten de Generale Compagnie, soo om deselve te voeden als te cleden sal toebrengen, ende in Sinckan sijnde soude de Compagnie daervan geheel ontlast [zijn]. [...] Alle 't welcke bij den presenten raedt wel rijpelijk overwogen mitsgaders de daeruyt te volgen voordeelen ende schaden tegens den anderen gebalanceert sijnde, vinden eyndelijck naer

lange discoursen ende overweginge van saecken met sijne Ed. geraden 't naervolgende:

Eerstelijck, dat men alle de vrouwen ende jonge meyskens mitsgaders de jongens die niet boven de 10 jaren oudt sijn (alsoo niet boven een maent) om dese zielen al t'saemen te spijsen van rijs geprovideert sijn, onder de Sinckanders sal verdeelen ende in vrijheyt stellen, met soodanigen conditie dat sijluyden deselve niet en sullen vermogen te veralieneren, vercoopen in andere dorpen versenden ofte andersints vervremden, maer ter contrarie verobligeert zijn, als haer eygen natie gemelte luyden te onderhouden ende bij haer te laten woonen. Mitsgaders soo d'Ed. heer Generael sulcx niet gelieft te approbeeren, maer voornoemde lieden alt'samen naer Batavia te versenden ordineert, voorschreven Sinckanders, dan gehouden sullen wesen deselve sonder eenich tegenseggen weder in onse handen te leveren.

Belangende de manspersoonen ende aencomende jongens, dat men die in Compagnies wercken sal gebruycken soolange tot dat de schepen naer Batavia comen te vertrecken om als dan naerder over te versenden der selver te resolveren. Mede verstaet den Raet dat men 60 van bovengemelte Lameyers naer Wanckan om aldaer tot alle noodige wercken in 't opmaecken der ronduyt gebruyckt te werden, nevens 20 soldaten om op deselve te passen sal zenden alsoo daer nodich om calck steen als aerde te dragen vereyscht werden.

Eyndelijcq wert mede goetgevonden op 't versoeck van eenige vande principaelste Compagnies dienaers als getrouden alhier dat men eenige meysgens ende knechtiens onder deselve sal (fol. 583) verdeelen, om bij haer op hun eygen costen opgevoet te werden onder soodanigen reserve dat deselve niet sullen mogen vercoopen ofte andersints vervreemden, noch oocq sonder licentie uyt Tayouan vertoeven maer gehouden blijven soo d'Ed. heer Generael als boven sulcx niet is approberende deselve weder te restitueren. [...].

fol. 581: 2 June. Since, by the mercy of the Lord, Golden Lion Island or Lamey has been incorporated and brought under our domination, many of the inhabitants, about 490 souls (among them about 150 men, the rest being women and children), are now residing over here. Yet, so as not to make too many errors in the way we ought to deal with these people, the Lord Governor together with his friends [the councellors] has several times discussed how to take the right resolution. For that matter His Honour had made suggestions to his Council about what decision had to be taken, having first related the crimes that were committed by the

Lamey people against our men as well as against other nations. He also indicated that the strikingly severe but righteous punishment administered by the recent expedition, which resulted in the conquest of the island by our men, who served as instruments to carry out the fair judgement the Lord compensated for their crimes. Should we either on the first occasion altogether send the people of Lamey over to Batavia where they will be dealt with as the Governor-General and the India Council decide, or should we accede to the request of the Sincandians who are very much inclined to allow the Lameyan women and children to come and live in their midst. They even asked us to do so on several occasions, affirming that they will provide for all their needs and will raise them like those belonging to their own nation. Yea, in case the Honourable Lord General and the Council of India should disapprove of that, the Sincandians were willing to deliver them if required to do so, without making any claims of ownership, back into our hands. Should they be divided among the Sincandians it should be noted that, first of all, those women and children from Lamey living in Sincan after some time can be converted to the Christian Faith. Moreover it could be a means to increase Sincan's population, something which we are always aiming at for several good reasons (fol. 582) and in order to strenghten our mutual alliance. If, on the contrary we keep them here at Tayouan, it will not only cause the Company serious trouble to accommodate them but it will also incur heavy expenditure for their maintenance. If they stay in Sincan the Company will be completely exempted from this. [...]

Finally, after the Council had balanced the pro's and cons against each other, it was finally decided after long discourses and deliberations with His Honour, as follows:

Firstly, that all the women and young girls as well as the boys below the age of ten (and not being one month older) as to be able to feed all of them and provide each soul with rice, will be set free and divided among the Sincandians provided that these are not allowed to alienate, to sell, or to send the women and children from Lamey to other villages or to estrange them in any other way, but on the contrary that they are obliged to maintain and accommodate them in the same manner as they would treat people of their own nation. It is understood that if the Honourable Lord Governor-General does not agree with it, and ordains that the mentioned people should be sent over to Batavia, that in that case the

Sincandians should, without any objections, obey this order and return the Lamey people into our hands. Concerning the men and the adolescent boys, they will be employed to serve in the Company's construction works until the next departure of ships for Batavia, when we will further resolve the question of whether they should also be dispatched to that place or not.

Also the Council has decided to send 60 of the mentioned Lameyans to Wancan, besides 20 soldiers to guard them, in order to be employed in the building of the redoubt as they are needed over there to carry earth, stones and mortar.

Finally the Council complied with the request of some of the most prominent Company servants and married couples here at Zeelandia to distribute some girls and little boys among them (fol. 583) with the purpose of raising them in their midst at their own expense on the condition that these children may never be sold nor alienated or taken elsewhere away from Tayouan without having a specific licence to do so. They [also] are bound to restitute the children in case the Honourable Governor-General as mentioned above does not approve of our arrangements. [...].

37. Dagregister Zeelandia, extracts concerning Lamey.
VOC 1170, fol. 610-611. Extracts 2, 4 June 1636.[24]
DRZ, I, pp. 255-256.

(On 2 June, because the amount of rice available is not sufficient to feed all these people [from Lamey] and in order to convert them to the Christian faith with less trouble and expenditure, the Honourable Governor and Council decided that all Lamey women and daughters, as well as the boys who are not older than ten years, will be lodged with the Sincandians.)[25]

> fol. 610: [...] Naerdat uit den lieutenant als andere vrunden vernemen, zouden naer alle apparentie ontrent 1000 menschen op dit eylandt geweest zijn, waervan over de 500 in onse handen vervallen zijn en herwaerts gesonden ende jegenwoordich noch 483 te weeten 134 mans persoonen, 192 kinderen en 157 vrouwen in 't leven zijn, de reste excepto die noch in 't leven zijn, zijn door den oorloge vermelt als door hartneckichheyt in de kuylen gestorven (fol. 611) welckers getal heel groot is ende bij d'onse niet seeckers can geweten werden.

Dit Gouden Leeuws eylandt is heel schoon beplant [...] en wert oversulcx bij d'onse gepresumeert dat dese luyden zoo noch lange op dit eylant waren gebleven sulcx soude toegenomen hebben, dat genootsaeckt souden geweest sijn, malcanderen te verdelgen ofte verjagen, also anders het eylandt haerlieden geen voetsel soude connen geven hebben. Zijluyden zijn oock, zoo d'onse tot verscheyde omstandicheden hebben bespeurt, alreede eenichsints twistich geweest doch niet soodaenich dat de wapenen gebruyckt hebben, maer alleen zoo 't schijnt om perticuliere oorsaecken, alsoo d'eene sich meende van Tamavallangcis geslacht te wesen dat zoo vele d'onse connen vernemen het oudste geslacht is, en d'ander weder een ander geslachte noemende. Watter van is en connen niet seeckers weten door dien geenige natie hier te lande hun prompt verstaen connen.

4en dito, vertrecken 288 zoo vrouwen als kinderen vande Lameyers nevens twee gecommitteerde tot den raedt met den secretaris en den predicant Junius naer Sinckan om de verdeelinge aldaer in debita forma te doen. [...].

fol. 610: [...] As we are informed by the lieutenant and other friends the island had apparently been inhabited by about 1000 people, of whom 500 had fallen into our hands and have been sent over to Tayouan. Today 483, that is, 134 men, 192 children and 157 women are still alive. Except for these, all others have died either in the war or because of their own obstinacy (fol. 611) in the caverns. This number is considerable, although we are unable to calculate the exact figure. This island is well cultivated [...] therefore our men presume that, if these people had continued to stay on the island, their number naturally would have been increased, to such an extent that eventually it would have been necessary for them to exterminate or chase away each other, otherwise the island could not have provided enough food for all of them. As our men have sensed on several occasions, they already had had some discord but not to the extent of raising up arms against each other. These quarrels originated from particular causes, as some of them claimed to belong to the *Tammavallangcis* lineage, which, as far as we know, is the oldest family, while others mentioned another lineage. We will never get to know the exact truth as none of the people from other nations here is able to understand the Lamey language very well. [...]

On 4 June, 288 Lameyans, women as well as children, besides two delegates from the Formosa Council, together with the secretary and the

Reverend Junius left for Sincan in order to carry out the distribution as agreed.

(In his missive of 2 June 1636[26] to Reverend Robertus Junius, Governor Hans Putmans had informed the reverend briefly about the contents of the resolution that had been taken that day in the general meeting of the Council about the seized Lameyans who had been deported to Tayouan.[27] Putmans asked Junius to send to Tayouan one or two Sincandians, who were able to communicate to some degree with the Lameyans, to act as interpreters. In a missive of 13 June Junius reveals something about the living conditions of the deported islanders in Sincan.)

38. Missive Reverend Robertus Junius to Governor Hans Putmans. Sincan, 13 June 1636. TEDING 15, fol. 31.[28]

> [...] Van de Lameyers comen dagelijx clachten, de sommige zijn luy, de sommige maecken haer ziecq als zij rijs zullen stampen en in 't velt gaen, de sommige loopen wech, sommige slaen de Sincanse vrouwen etc, soo datter geen dach passeert off Sincan klaegt over haer, wij antwoorden haer zoo wij best oordeelen, eenige zijn der al gestorven, eenige soo 't schijnt sullen eerlang sterven, sij roupen seer om haer mans ende om weder na haer eylant te mogen gaen, eenige vrouwen roupen om haer kinders etc. [...].

[...] We get daily complaints about the Lameyans, some of them are lazy, others pretend or make themselves ill when they should be threshing rice or working out in the fields. Some of them try to run away while others beat up Sincandian women and so on, so that altogether not one single day has passed by without complaints from Sincan, to which we try to respond in the best possible way. Some of them have already died, while others look as if they will die soon. They call for their husbands and beg to be allowed to return to their island, some women cry for their children and so on. [...].

39. Instruction from Governor Hans Putmans to Sergeant Cornelis van Daelen on how to act as provisional commander of the armed forces remaining on Golden Lion Island.
Tayouan, 10 June 1636.
VOC 1170, fol. 630-631.

fol. 630: [...] ende niemandt sonder U speciael verloff buyten den pagger om eeniger hande oorsaken te laten om water, brandhout ofte andere nootlijckheden te halen buyten moeten gaen, sal 't selve onder opsicht van een corporael ende ten minsten ses soldaten geschieden om alsoo alle disordre ende 't moescoppen ofte verspreyen van 't volcq ende andere daeruyt te volgende ongelucken soo veel mogelijck sij voor te comen.

Wij verhoopen de resterende Lameyers voor het vertrecq van onsen ommeslagh van daer bij Ued. omtrent den pagger sullen sijn verschenen ende Ued. deselve, volgens daer gelaten ordre, beleeffdelijck sult hebben bejegent, latende haer in vrijheyt sitten daer sij hun nederslaen, sonder nochtans eenich van U volcq daer in haer quartier te laten gaen om de daeruyt te volgene onheylen te verhoeden; doch om met deese luyden bekent en niet geheel van haer vervreempt te werden sal 't noodich wesen dat Ued. selffs, met noch eene vande sivielste soldaten ende somtijts den corporael ofte andere vande bequaamste personen hun soo nu en dan eens in 't vrundelijckste gaen besoecken sonder in eenigerhande manier haer iets te beschadigen ofte aff te nemen.

Doch ingevalle het gebeurde ende dese Lameyers die naer presumptie vanden luytenant weynich in getalle sijn, hun geheel vreemt ende vijandelijck tegens U vertoonden sonder haer ergens omtrent U neder te setten, soo sult gij met goede toeversicht 12 à 16 man teevens in één parthijen, doch dicht bij den anderen, dagelijcx laten uytgaen ende alles in U gewelt sien te becomen, dat crijgen cundt. [...]

Wij hebben alle inwoonders deses landts dat onse vrunden ende bondgenoten sijn laten aendienen dat naer desen niet meer op 't Goude Leeuws Eylandt sullen verschijnen, sonder dat alvooren bij ons met een brieffken daer tot licentie becomen hebben, als wanneer hare princevlaggen tot een teycken sullen medebrengen [...].

fol. 630: [...] and you should not allow any of your men for whatever reason to leave the stockade without your special permission. As to get water, firewood, or other necessities they are only allowed to go out under supervision of a corporal and six soldiers at the least in order to

avert all disorder, and prevent other accidents from happening, such as pillaging or the scattering of the men over the island.

We do hope that before the departure of our entire force from there the remaining Lameyans will have made their appearance before Your Honour near the palisade and that Your Honour, according to the orders that have been given to you, will treat them courteously. You should leave them in peace and let them settle down where they wish and forbid any of your men to go and visit their quarters in order to avert problems. Yet in order to get to know these people and to avoid alienation from them it will be necessary that Your Honour yourself, together with the most mannerly of your soldiers, or sometimes with the corporal or anyone else from the most competent of your men, will pay them a friendly visit without causing them any inconvenience by doing them any harm or taking anything from them. In case the remaining Lameyans, whose number, as presumed by the lieutenant, is limited, should, behave very strangely and antagonistically towards you, without settling themselves down somewhere near to you, then you should send 12 or 16 men, well prepared and in one closely formed party, out on a daily patrol, and try to get as many of them under your control as you can get. [...] We have announced to all our friends and allies among the inhabitants of this land, that after this they will not be allowed on the Golden Lion Island anymore, without a license from us, in which case they are obliged to carry their Prince's flag as a sign.

(In his missive to Reverend Robertus Junius of 16 June 1636,[29] Governor Hans Putmans mentions that at the meeting of June 14th the Council had decided[30] that a man from Lamey, the son of an old woman who had been very useful to the Company on Lamey on several occasions, besides 15 or 16 elderly men who are too old to be of any service to the Company or to pose any danger, would be released and sent over to Sincan where these old men will be taken care of by the Company. He asks the minister to find out whether the Sincandians will agree to this proposal and says that the Council thought they could not have too many objections, and that it would be very agreeable to these Lameyans especially to the ones whose children are living in Sincan.)

40. Extracts taken from the Zeelandia Castle Resolution-books, concerning the resolutions on the island of Lamey, taken in the Formosa Council.
VOC 1170, fol. 583-584. Extract 14 June 1636.

fol. 583: Den Raet op dato bij de Ed. heer Gouverneur Putmans vergaedert sijnde, heeft sijne Ed. naer lecture van seeckere missive, gedateert 13^{en} couranti, door den sergeant Van Daelen op 't eylant Lamey geschreven, in den selven geproponeert ende voorgestelt aengesien de resterende inwoonderen aldaer noch op 't eylant zijnde haer tegens d'onse vrundelijck verthonen zonder eenich hostiliteyt te gebruycken ende onse dagelijcx met parthijen in 't velt gaen, of men gemelte Van Daelen niet behoorde aen te schrijven dat daerinne continueert ende voorts alle bequame middelen aenwent om haer omtrent 't houte wambeys ofte eenige andere plaetse te doen nederslaen ofte wel dat men 't selve om eenige consideratiën sal naer laten ende sulcx op sijn beloop inwachten om daernaer door eenige andere middelen daerin te disponeeren. [...]

fol. 584: [...] alsoo seeckeren Lameyer, zijnde de soone van een oude vrouwe die d'onse op 't eylant in verscheyden saecken veel diensten gedaen heeft, door voorspraecke vanden luytenant ende andere uyt de kettingh is gelargeert, off men denselven ten respecte van bovengemelte niet, nevens 15 à 16 oude mannen die geen dienst conde doen naer Sinckan behoorde te largeren, ofte wel dat sulcx om andere motieven die den raet soude mogen moveren sal naergelaten worden.

Op alle 't welcke door den presenten raden wel rijpelijck geleth ende overdacht sijnde concluderen met sijne Ed. gesamentlijck 't naervolgende: Eerstelijck dat men den sargeant Van Daelen sal aenschrijven dat de Lameyers gelijck tot noch toe gedaen heeft wel bejegent maer dat denselve te waere om gewichtighe redenen (gelijck nu jongst twee vande selve gedaen heeft, in geen blocken sluyt noch oock binnen de pagger van 't houte wambays laet comen, doch dat haer onderentusschen annimeert ende de gemoederen soo veel mogelijck t'onswaerts soect te trecken om alsoo in tijt ende wijlen deselve mede van daer te crijgen. [...]

Ten [...] laetste dat men bovengemelte Lameyer, die sijn moeder in Sinckan heeft, nevens 15 à 16 oude dittos volgens bovengemelte voorstel derwaerts sal largeeren alsoo de Compagnie daerdoor geen sonderlinge schade can toecomen ende de oude mannen, doch geene dienst (alleen des Comp^s. cost genieten) connen doen.

fol. 583: While the Council was meeting on this date [14 June] on the orders of Governor Putmans, His Honour has posed the question, after having read a certain missive written on the 13th of this month by Sergeant Van Daelen on Lamey (who informs us that the inhabitants who are still remaining on the island do behave in a very friendly manner towards us without showing any hostility and that our men leave the corral daily with a small party of soldiers to go out into the fields), whether we should either write back to Van Daelen and ask him to see to it that the situation continues just like that, but that he also will by all means try - once the situation is right - to get hold of the last Lameyans in or near the wooden fence or any other place, or should he, considering the words of Van Daelen, wait a little longer and let things take their course and deal with these matters by other means.

fol. 584: As a certain man from Lamey, the son of an old woman who has served us so well on the island on several occasions, has been released out of his chains at the intercession of the lieutenant, [His Honour wonders] whether we should not let him go to Sincan, together with 15 or 16 old men who are not capable of doing any more service, or whether the Council, owing to other motives, should abstain from doing so.

After everything had been considered carefully by the present councillors and His Honour, the following was concluded: First Sergeant Van Daelen should be informed that he should continue to treat the Lameyans well and that he should only under exceptional circumstances put them in chains as he has recently done with two of them. Nor should he allow them to enter the compound. Yet that in the meantime he also should try to see if they can not be animated towards becoming a little more favourably inclined towards us, so that after a while they can be removed from their island. Finally it was decided that the man of Lamey, whose mother lives in Sincan, besides the 15 or 16 old men would, according to the proposition mentioned above, be sent over to that place, because it will not harm the Company, and moreover because the old men (who are cared for by the Company) are in any case not able to be of any more service.

41. Missive Reverend Robertus Junius to Governor Hans Putmans.
Sincan, 29 June 1636.
TEDING 15, fol. 27-28.

het subject van onse materie daervan met UE., laetst op Tayouhan zijnde, sprack was onder andre dat hier verstont en bevont veele haer te vergrijpen en schuldich te maken in 't begaen van hoererije, dat niet alleene geperpetreert wort onder de groote, maer oocq onder de cleene, de jonge, niet alleen van onse Sincanders maer oocq veel van de Chineesen met christen vrouwen, derhalven versocht van zijn E., ons ordre gelieffden te geven hoe in dese zaecke zoude procederen, op dat de quaetdoenders in dit stucq gestutt, verhindert en tegengegaen mogten werden; het welcke soo niet geschiet staet te verwachten dit quaet noch daeglijx meer ende meer groeyen ende toenemen zal, inzonderheyt zij weten dat ick 't weet en haer daer over niet geschiedene sullen beginnen te gelooven sulcx geoorloft te zijn, doch verhoope zijn E. in dese saecke wel verzien will. […].

The subject about which, among others, I recently talked with Your Honour, when I was in Tayouan, was that many of the inhabitants are guilty of whoring, which not only is perpetrated by the adults yet also by the young ones, not only by our Sincandians but also often by Chinese with christian women. Therefore I requested Your Honour whether you could give us orders as to how we are supposed to proceed in this matter, in order to prohibit these malefactors and stop them. If nothing happens it can be expected that this evil will increase day by day, especially since they know that I am aware of it. If nothing is done about it, they will simply begin to believe that it is permitted, so I do hope that His Honour will dispose of this matter accordingly. […]
(Junius continues this letter by complaining about the sinful, impious and incapable behaviour of the recently appointed schoolmaster Andries Markinius and he asks that this man be given a reprimand.)

42. Dagregister Zeelandia, extracts concerning Lamey.
VOC 1170, fol. 614-615. Extracts 12 July, 15, 17 September 1636.[31]
Also in: VOC 1120, fol. 430-431, 435, 450-452.
DRZ, I, pp. 261, 272-273.

fol. 614: 12en July. Naer middags arriveert een joncque van Lamey den lieutenant met de van hier vertrocken 30 soldaten, raporterende dat 30 hooffden hadden becomen, daeronder een levendige jongen, d'reste waren alt'samen door d'inwoonders (zijnde daeronder eenige mans, en voorts vrouwen en kinderen), doot en den cop affgeslaegen, d'oorsaecke van 't wederkeeren was dat de wilden tot het maken der paeden en langen continuatie aldaer niet wel conden resolveren, en als dan voor d'onse als bij lange verblijven op dito eylandt niet te verrichten was. [...]

fol. 615: 15 September. [...] Wijders wert mede geresolveert alle de Lameyers te weten mans personen met hare vrouwen naer Batavia zullen vervoert werden, zoo wel de geene die noch mochten comen als die alreede hier zijn.

Den 17en dito. Compt weder een jonckje van Lamey met 100 soo mans, vrouwen en kinderen.

(On 30 June Sergeant Cornelis van Dalen, a corporal and a cadet were beaten to death by some Lameyans, a soldier managed to escape this attack. On July 2, a resolution was taken by the Formosa Council to send 30 Company-soldiers together with a large number of inhabitants of Sincan, Soulang, Mattouw, Bacaluan and some warriors from the southern villages Pangsoya, Taccareyang and Dolatock to Lamey to go and try once and for all to transport the remaining people off the island. On the 5th of July, the force departed from Tayouan under the command of the lieutenant. Two days later they had landed on Lamey together with about 300 'savages' of the surrounding villages.)[32]

fol. 614: In the afternoon of 12 July a junk from Lamey arrives at Tayouan with the lieutenant and 30 soldiers. They report that they did get about 30 heads of Lameyans, some men but also some women and children, who, except for one young boy who is still alive, were all beaten to death and decapitated by the allies. The reason they came back so soon was that the allied 'savages' were not willing to stay on the island any longer to help us make passable paths or anything else. Consequently it was also of no use for us to stay any longer as we had nothing to do. [...]

fol. 615: 15 September. [...] Also it was resolved that the Lameyans, the men together with their wives, those already here as well as those still to come, will all be transported to Batavia.

On the 17th ditto, another small junk arrives from Lamey with 100 people: men as well as women and children.

(The lieutenant informs us that he had fetched about 90 men from Pangsoya to join him. After their arrival on Lamey they had caused so much fear to the remaining islanders that the mentioned 100 people had immediately surrendered. The lieutenant is of the opinion that there are not many people left to take away. So upon the arrival of the 100 Lameyans in Tayouan it was resolved to first disembark them. Afterwards these people, and the 18 others who arrived shortly before them and another 23 in Sincan, will be divided over the different ships that will take them to Batavia.)

43. Missive Reverend Robertus Junius to Governor Hans Putmans. Sincan, 3 July 1636.
TEDING 15, fol. 28-30.

Wij hebben UE. begeeren voltrocken, aengaende den tocht na het eylant Lamey. Ick twijffele niet off binnen weynig dagen (soo quaet weder het niet verhindert) een groot getal deeser inwoondren op het eylant haer sullen verthoonen. Heden, alle voor onse kerke vergadert zijnde, hebbe het haer voorgestelt en tot het henen gaen haer geanimeert, zoo dat niet twijffele aen Sincan. Na Soulang, Mattauw, Bacluan hebben wij boden gesonden, haer laetende aenseggen dat op morgen avont, zijnde vrijdach, hier mosten zijn alsoo de meeninge is dat se Saterdach 's morgens van hier zullen vertrecken, die champans hebben, die weynich zijn, sullen te water gaen, het grootste getal sal te lande gaen, sullende vergadren aen de reviere van Tampzuy daer vandaen zij lichtelijck met champans off met een jonck overgesett connen werden.

Ick heb de Sincanders moeten belooven dat aen zijn E. schrijven wilde dat toch van onse soldaten haer geen overlast mochte gedaen worden, daerover zij (voor desen geschiet te zijn) clagen. Insonderheyt zoo wat goet off oude rommel vinden, dat haer doch niet affgenomen mocht werden, gelijcq mede (fol. 29) geschiet is voor desen; en als zij het niet datelijck laeten volgen zoo trecken zij van leer, haer dreygen met den houwer te slaan, dat mijns oordeels niet veel goets can baaren. Wij verhoopen zijn E. sorge dragen zal dat dit voorgecomen worde.

Eersdachs verwachten wij mede ordre van zijn E. nopende de hoerenjagers die in haeren voortgancq dienen gestutt te werden off veel quaets hier veroorsaecken zal, alwaer't maer weynige cangans geven daer mede ken't eenigsints belett worden. [...]

Zo veel de hartenvangst belangt wij hebben alreede 198 realen ontfangen [...] daarvan alreede bij de 100 zijn geconfirmeert, soo aen arbeytsloon voor Chineesen [...], als aen andre. [...] Met het overige gelt moet Dicka maentlijcx betaelt (daervan goeden dienst trecken), daervan dienen de outste van verscheyde dorpen onthaelt te worden die nu en dan bij ons comen, ja oocq van meeninge zijnde haer alle (zoo niet vreesde voor den regen) hier eens te roupen en met malcandren te vervroylijcken, dat niet twijffele off haer seer aengenaem zoude sijn ende de liefde tussen ons en haer sal doen groeyen. Hadde dan liever de 14 realen van Sr. Smit betaelt wierden. Doch soo 't sijn E. anders verstaet, sijn E. gelieve het te laten weten, het sal geschieden na UE. begeeren. [...]

Wij bedancken zijn E. voor het toezenden van metselaers die weynich sement mede gebracht hebben. Verzoucken drie canassers toegemaecte sement die in 't packhuys al gemaeckt is soo zullen zij het platt connen pleysteren daer de pleystering aff is, zes canassers gesisten calcq is haer noodich daerse de kercq die de calck is afgevallen weder mede bestrijcken moeten. Dit is haren (fol. 30) eyssch, dit stucken met calck is insonderheyt buyten noodich voor den regen.

We have complied with Your Honour's wish about the expedition to the island Lamey. I do not doubt that within a few days (if they are not disturbed by bad weather) a great number of inhabitants will show up on the island. Today, while they had all gathered in front of our church, I proposed that they join the campaign and stimulated them to go, so that I do not doubt at all that the warriors of Sincan will join the party. We sent messengers over to Soulang, Mattauw, Bacaluang announcing to them that tommorow evening, on Friday, they should be here as we intend to depart from here on Saturday morning. The few who own sampans will go by water, yet the greatest part will go overland. The Tamsuy river will serve as their rendezvous, from where they can easily be ferried across by sampans or with a junk.

I had to promise the Sincandians that I should write to His Honour and beseech you that they will not be inconvenienced anymore by the Company-soldiers (as has happened before). The inhabitants especially complain (fol. 29) that in the past, whenever they found some old goods or

any junk, it was taken away from them and seized by the soldiers who even threatened to use their backswords [if they would not immediately hand these things over to them.] According to me this can not lead to anything good. Consequently we hope that His Honour will ensure that this can be prevented from now on.

One of these days we also expect Your Honour's order what to do about the whore-hoppers who badly need to be stopped or else we will face a great deal of trouble. If only they could be fined a few cangans that already could contribute a little in keeping them from doing this in the future.

(According to Junius the Company already had earned 198 reals from the levies on the hunting of deer by the Chinese, although a few Chinese, some of them living in Mattau and in Tirosen, had not paid their contribution yet. According to Lampsack they were very poor and had caught hardly any deer, consequently it was not expected that they would pay anything at all. From that sum the Company had already spent about a hundred reals on all kinds of matters and the payment, which was permitted by the governor, for the school of 14 reals a month:) From the remaining money Dicka has to be paid every month (he is very useful to the Company) and the headmen of several villages every now and then have to be entertained as well. Yet at the moment I do feel that (if they are not restrained by the rain) they should be invited again altogether so as to treat them to a merry banquet, something which they undoubtedly would appreciate very much and which, because it strenghtens the bonds of love between us, would at the same time be very benificial to the Company. We would prefer Mr. Smit to pay the 14 reals (for the school), but if you have different ideas, please let us know. [...]

We are greatful to His Honour for sending us the bricklayers who brought some cement along. However they do ask for another three baskets of cement, which has already been prepared in the warehouse, with which they can plaster the terrace roof where the stucco has come down, and another six baskets of slaked lime are also needed for plastering the walls of the church which have decayed. That is their request (fol 30) for now and this plastering is required especially to protect the outside walls against the rains. [...].

44. Missive Reverend Robertus Junius to Governor Hans Putmans.
Sincan, 7 July 1636.
TEDING 15, fol. 30.

[…] Wij verstaen hier veel Soulangers, Backluanders, veel uit de cleene dorpen alsmeede Sincanders na Lamey vertrocken zijn, ende onder allen desen niet eenen Mattauwer dat mij vreemt dunctt en noch te verstaen geeft voor ons vreesen, ja lichtelijck daar voor houden zoo met ons gaen de één of de ander noch mochte vande onse vastgehouden worden. Icq neme voor eersdaegs de outste van Mattauw te ontbieden en nopende dit subject met haer te spreecken, soo excusabel haer verclaren, mede twee à drie van onse natie met haer laten gaen opdat de vruntschap niet vermindre alsoo langen daer geen Hollanders geweest zijn, dat niet twijffele off sijn E. approbeeren sal.

(The bricklayers returned after finishing their work and schoolmaster Andries Markinius continued his work following his reprimand by Junius in the name of Governor Putmans:)
We understand a lot of warriors from Soulang, Bacaluang and from the small villages as well as from Sincan have left for Lamey, but not one single man from Mattouw was among them, which seems quite strange to me as it could only indicate that the men from Mattouw still fear us and believe that if they join us on an expedition we may easily detain one or the other. I intend before long to invite the headmen from Mattouw and discuss this subject with them. In case they demur their excuses two or three men of our nation should return with them to their village, as it has been a long time since any Dutchman has paid them a visit, so as to see to it that our mutual friendship will not diminish. I am certain that His Honour will agree with this.

45. Missive Reverend Robertus Junius to Governor Hans Putmans.
Sincan, 15 August 1636.
TEDING 15, fol. 31-33.

Eenigen tijt geleden hebben wij een sekere vrouwe Vacca genaemt met Tidirin, haren man, op haer verzouck inden houwelijcken staet inde volle vergadering bevesticht, onder welcke niet lang daerna een verschil is geresen resulterende vanden man, soo de vrouwe seyt, omdat haer weynig

goedren hadde gegeven. Dit verstaen hebbende, hebbe mij datelijck bij de verschillende gemoederen laeten vinden, daer doen zoo verre met haer handelde dat niet anders conde zien off die gemoederen waren vereenicht, doch dat het vier van oneenicheyt in haer harten noch verborgen gelegen heeft, immers dat de vrouwe (fol. 32) den man niet begeert heeft ons geleert de experiëntie, voor eenige dagen verstaende datse met een ander boeleerde, die mede een vrouwe heeft, Gavail genaemt. Dit heeft Vacca selver bekent, het seggende tegens eenen andren, dat se Tideris niet begeerde, datse Gavail lieff hadde, ende dat hij vrij zijn goet mochte weder thuys haelen, dat zij Vacca bij Gavail hielt ende bij hem geslapen hadde, zoo veel de Hollanders belangde, zij milde straffe geven daerom zij den vader bij ons sent om met ons te handelen vande straffe ofte cleeden die se geven zoude. Ick heb se gistren met haaren boeleerder gesocht, maer schuylen, can se tot noch toe niet crijgen, soude se anders in de boeyen laten setten hebben.

Dit vorige heeft ons geoccasioneert de saecke van Joost bij de hant te nemen. Verstont soo veel dat de waarheyt kon zien en uit haer eygen manieren en humeuren mij persuadeerde den malignant in de corps de guarde gebracht hebbende, datelijck het soude bekennen, gelijck (Godt betert) genoug gebleken is, hebbende voor mij en Dicka, bevelhebber van Sincan, geconfesseert vijf malen vleeselijck met Tagutel, Joosten vrouwe, geconferseert hadde: eens al staende buyten het huys, twee mael op Joosten kooy, twee mael op één van haar koojen, dit is al geschiet als Joost na Loncjauw was, daer hij eenigen tijt moste remoreeren. Hebbende dit verstaen van de man Pakoy genaemt, hebbe de vrouwe datelijck laeten roupen, die wij in ons huysken lieten brengen, haer vragende off zulcx als Packoy bekent hadde niet waer was, heeft eerst beginnen te loochenen, doch haer hebbende verscheyde circumstantiën aangewesen van haer overspel heeft zij, datselve dat Packoy bekent hadde, oocq bekent, sij seggende hij is de oorsaecke daer van, hij wederom op haer schuywende, soo dat dese saecke claer en openbaer is. Joost die hier nevens gaet verzoucqt van zijn overspelig wijff mach worden verlost, en ontbonden worden.

Hier hebben wij verscheyde paren van overspelige, wat nu dese geleert sal werden, en daerop zal het heele dorp zien zoo dese luyden niet anders overcomt als maer eenige dagen gevangen te houden, sullender weynich om geven, ja zouden gelooven haer eer sal stijven om zulcx weer te doen, soo dese niet merckelijck gestraft werden tot een exempel van andre, immers soo hart dat het haer smert, soo sullender eer lange meer gevonden werden, die sullen doen als de bovenstaende Vacca, geen sin

hebbende tot den man, sullen 't ons selver laeten aenseggen opdat se van den man mogen affcomen. Grooter is nog de foute van Joosten vrouwe, als oock van dien man die met haer geboeleert heeft, omdat dit affront aen één van onse natie gedaen heeft, aen haeren man die zooveel oncosten aen haer gedaen heeft, haer watse begeerde copende, van dewelcken zij niet anders als alles goets seggen can, die tegen Joost selver geseyt hadde: 'soo ick overspel begae, laet mij vrij dooden, want ick weet wel de Hollantse manieren'. Der Sincandren hier in is voor desen geweest, alsser overspel bedreven was, soo 't den getrouden man ter ooren quam, omdat de outsten hier geen recht in uitspraecken, soo was hij zijn eygen rechter, loerde op den gene die bij zijn vrouwe (fol. 33) geslapen hadde nam hem waer en hebbende gelegentheyt gevonden, 't was oocq hoe hij 't dede, off van voren off van achteren, hieu hem met een houwer of parring daer hij hem raecken conde, 't sij in 't hooft, inde beenen, ermen off op een ander plaetse ende soo was hij gecontenteert, ondertusschen van zijn overspelich wijff al sijn goet halende datter gebracht hadde en haer verlaetende.

Mijn gevoelen hiervan is, zoo Tagutel met Paccey aen één pael gebonden is ende gegeeselt wierden dat het seer profijttelijck zoude zijn ende veele van overspel bevrijden. Ick can sien uit hare manieren dit geschiedene geen quaet met hem sleepen sal, oock het dorp niet irriteeren, maer sullen seggen heel wel gedaen te sijn, zijnde noch minder straffe als off met een houwer in 't lijff gehactt wierden. Dit geeselen is bij haer niet als bij ons, zij is daerom bij dese natie soo eerlijck als te vooren, de slagen daer sal se op letten, den man is nog eene oocq van onse scholieren, heeft in 't dorp, noch de sijne, niet veel te seggen. Geen van beyde zijn Sincanders, hij is in 't dorp met sijn moeder gecomen die de Sincanders voor desen verdreeven hadden, gelijck nu deese Lameyers onder haer woonen, soo is hij oock hier coomen woonen, zij is een Tapatoroanse vrouwe die, vijf huysen stercq zijnde, hier woonen ende in geen achtinge zijn, ja al jaegden wij die vijf huysen wegh daer souden de Sincanders niet veel om geven, off 't ware dat saegen haer dorp hierdoor vermindert wierde, de andere twee can ick hier niet crijgen, al roup ick se al souck ick se, zij comen niet, wij vinden niet, van UE. verwachten wij ordre.

A little while ago at the general meeting we did confirm a certain woman named Vacca in the estate of holy matrimony with her husband Tidirin, yet soon afterwards a dispute arose between them. According to the woman the husband was to blame for causing the disagreement because he had given her too little goods. Having understood this I went to get information from both the parties but as far as I could see they were

living in harmony once again. However, we discovered that the fire of discord still simmered, hidden in their hearts. We found out, because the woman (fol. 32) did not feel any desire for her husband. A few days ago I found out that she had committed adultery with another man, named Gavail, who is also married. Vacca herself has confessed to this by saying to somebody else that she loved Gavail and that she no longer wanted Tideris, and that the latter could freely come to collect the goods he had given her and take them back to his home. She confirmed that she loved Gavail and that she had slept with him, and as far as the Dutch were concerned, that she did not fear them as they only meted out mild punishments to which purpose she sent her father to negotiate with us about the proper punishment and how many pieces of cloth she should be sentenced to give. Yesterday I tried to find her, together with her lover but, because they are in hiding, I have not been able to find them, otherwise I would have ordered them to be put in chains.

(The Formosan wife of Joost had also slept with another man, while her husband was away.) This has caused us to take a look at Joost's case. I found out enough to see the truth from their own manner and temper. This persuaded me to seize the malefactor and put him in chains, so that if he should immediately confess his sins, which indeed (God be praised) he did do. He confessed to me and Dicka, chief of Sincan, that he had had sexual intercourse five times with Tagutel, Joost's wife: one time standing outside the house: the second time twice on Joost's berth; and the next two times on one of her berths; all this had happened when Joost was gone off on his mission to Lonckjouw, where he had to stay over for a while. Having been informed about all this by the man, named Packoy, I immediately called in the woman, whom I ordered to be brought into my house, asking her right away if everything that was confessed by Packoy corresponded with the truth. First she started to deny it, however after I had confronted her with several circumstances of her adultery, she finally also confessed to what had been confessed by Packoy, saying that he had caused her to do so, while he on the other hand is reproaching her, so that this case can be considered open and clear. Joost, who will deliver this letter to you in Tayouan, requests to be released and divorced from his adulterous wife.

Over here in Sincan we do have several pairs of adulterers, yet the question is how to deal with them? If the entire village sees that these

persons are punished by only a few days of confinement the inhabitants will think lightly of this matter. Indeed, it will rather stimulate people into doing so again if these sinners are not punished in a harsh manner as a deterrent to others. Otherwise soon the more people will follow Vacca's example. Whenever their feelings for their husbands are gone and they get tired of them, they will just tell us, so that they can get rid of them. Even greater were the sins of Joost's wife, as well as the mistakes of the men who fornicated with her, because this affront was committed against one of our nation, a lawful husband who has spent so much money on her and bought her everything she asked for. She even once said to him: 'if I would be unfaithful, you may freely have me killed as I am aware of Dutch customs'. The Sincandian custom in the case of adulterers has always been (because the elders themselves can not mete out justice on this), that whenever a cuckold has found out about his spouse committing adultery he may act as his own judge. He used to watch the movements of the one who had slept with his wife (fol. 33) until he found the right occasion to take revenge. The act vengeance consisted of gashing the man with his chopper or machete by surprise either from the front or from behind wherever he could hit him on the head, on the legs or on other parts of the body. Having thus obtained satisfaction he would take all the goods he had given earlier to his adulterous wife and would leave her.

My feeling is that preferably Tagutel and Packoy[33] should be punished in public by tying them together to a pillory to be flogged. This will be the best method to discourage many people from fornication. From their customs I can see that if flogging should be carried out this would not lead to any trouble as it would not irritate them; on the contrary they would respond very positively. Although it seems to be quite a minor punishment compared with being hewn at with a machete, this flogging does have a different effect on their nation than it would have on us, they will be very attentative to the lashes, that is why the result is as just to them as would be the former penalty. The guilty man, Packoy, is also one of our pupils at school, and commands little respect in Sincan or in his own village. Neither of them is of Sincandian origin. He came to Sincan together with his mother from a settlement from which the inhabitants were driven away by the Sincandians [and afterwards they were adopted by their adversaries] so he came to live here just like the Lameyans have come to live among them. Tagutel is a woman from the Tapatoroan, who

are dwelling in Sincan with five houses and are not held in any esteem. Indeed, if we should drive these people away with their five houses, the Sincandians would not care at all apart from the fact that their village would become somewhat smaller. The other two, Vacca and Gavail, no matter where I search for them, I have still not been able to track them down. They have not shown up, so I will await Your Honour's orders on how to deal with them.

46. Missive Reverend Robertus Junius to the Directors of the Amsterdam Chamber.
Sincan, 5 September 1636.
VOC 1121, fol. 1308-1356.[34]
FORMOSA UNDER THE DUTCH, pp. 116-144; ZENDING, III, pp. 85-131.

47. Missive Reverend Robertus Junius to Governor Hans Putmans.
Sincan, 8 September 1636.
TEDING 15, fol. 34.

Hiernevens gaen de selvige perzoonen die geoordeelt hebben bequaemst om de resterende Lameyers, noch niet met ons vereenigt zijnde, te vereenigen, niet twijffelende off den Lameyer Vagiau, die hier mede gaet om dit te verechten zijn devoir doen sal, sijnde niet alleen aen ons gewent maer oocq nu en dan vruntschappe van ons genoten hebbende, hij en laet niet na gelijck ook andre, te spreecken dat daer naer weeder op haer lant mochten geset worden, veele van haer hier weynig te eten krijgende soo zij clagen. Wij hebben haer tot antwoort gegeven dat zulcx in onse macht niet staett dat het van UE. moet comen. Ick gevoele hiervan zoo 't zoo geviele dat niet twijffele off dese luyden zeer souden voor ons vreesen, ja doen alles wat wij begeeren, immers niet souden derven dencken te doen tegens het gene haer souden belasten en zoo zij seggen, willen haer hier verthoonen als UE. begeeren sal. Zouden evenwel den Lameyer Vigiau, soo zulcx geschiede, hier houden. Die seer toeneempt in de Sincanderse tale, die oock bij haer veel vermach, door dien ick geloove den vrede vast zoude connen gehouden werdende, eenige andre die men daartoe soude connen gebruycken. En soo men mochte vreesen dat sij de pijpen souden stellen dat is: den vreede breecken, dat ick niet can voorsien, niet liever zoude het dan deese inwoonders zijn, die nu qualijck ergens een plaats hebben daar se connen gaen vechten daermede sij datelijck soude connen vernedert werden, dat geschiede zoude, connen zonder eene Hollander

mede te laten gaen, zijnde nu haer de gelegentheyt der plaetse ende inwoondren bekent. Soo zijn E. hiertoe can verstaen, ick meene aen desen vreede onder haer te stellen, dervende bijcans verseeckeren dat dien vreede niet sullen breecken, maer alles doen wat wij begeeren. 't Is bedrouft te sien hoe dat dese luyden hier suckelen, haer gehuyl en geween een steenen hert bewegen zou. Tot noch toe is 't mij niet meugelijck geweest haere naemen op te schrijven alsoo over en weder loopen, geen seecker huys houdende, zij verhoopen altijt van een quaet huys een goet huys zullen treffen en crijgen dickwils slimmer, weynich meedoochentheyt wert bij veele Sincanders over dit volcq gevonden.

Zijn E. behoufte niet alle weder te stieren, cander vooreerst soo veel stieren als 't hem belieft en d'andre noch hier laeten. Daerna haer weldragentheyt gesien hebbende zoudender meer connen bijcomen. Zoo ick oyt yet wat hebbe connen voorsien zoo can ick nu voorsien dese zaecke wel uitvallen zoude, dat niet twijffelen off Gode behagen zal.

Zoo veel mij aengaet ben bereyt selver met haer te gaen en dese zaecke een beginsel te geven, siende dese zaecke betreft veele zielen, heeft mij vrijmoedich gemaeckt, verhoope van UE. niet qualijck geduyt zal werden dat mijn gevoele laet weten.

Zoo Godt wil sullen ons claer maecken tegens sondach aldaer dienst te doen, sal arbeyden de vergadering, soo veel mogelijck is, contentement te doen nae de geringe gave van den Almogenden ons onwaerdige verleent.

De zaecken van Sincan als de omleggende dorpen verthoonen haer naer wensch, Gode zij danck, eenige dagen geleden zijn ons hasegayen hier toegezonden van vijf dorpen oostelijck van Taccareijan gelegen, hebbende tevooren van drie al ontvangen, die mij bij provisie plaets gegeven hebben, haer aenseggende dan selver dienen te verschijnen, dat dan van meeninge ben deselve bij UE. te brengen en dat den vrede dan gemaeckt sal werden. Dese acht dorpen bij de andre gevougt daer mede vereenigt zijn, daer in Sincan mede gesloten is, brengen uit 57 dorpen, gelooft zij de Heere die dit zoo beschickt heeft!

Herewith those persons come over whom we believe to be the most competent to round up the remaining Lameyans. I am sure that the Lameyan Vagiau, who will join the expedition to carry this out, will act according to his duty. He is not only used to us but having been treated with friendship, and every now and then been granted a favour, he nevertheless, like many others of his nation, does not refrain from expressing his hope that they may be sent back to their island. Many of the Lameyans staying over in Sincan complain that they receive [too] little

food. We have responded that it is beyond our power to send them back, and that we have to await and obey Your Honour's orders. I have the feeling that if we comply [with their demands] because they continue to fear us very much, they will do anything that we desire them to do, in any case they surely would not dare to do anything contrary to that which we order them to do. Indeed, they even confirmed that they will comply with Your Honour's wishes whenever you should ask them to present themselves again. Whatever the case may be we would like to keep the Lameyan Vagiau over here with us. His knowledge of the Sincandian dialect has vastly improved and he is held in high esteem by the villagers. I think that peace could be maintained through him. Some other people could be used for the same purpose. Yet in case one fears for uprising - that is that they would revolt, which I believe very unlikely to happen - in that case the inhabitants of Sincan would love to fight them, as nowadays they hardly have the opportunity to demonstrate their courage in combat. As a result the Lameyans would immediately be humiliated and taught a lesson. All this could be taken care of without the company of one single Dutchman, because the local situation of the island and its inhabitants is now sufficiently known to the Sincandians. If His Honour would follow up on this, I mean to conclude peace with the people of Lamey, I almost dare to ascertain that this peace will never be broken, but that they will comply with everything we want them to do. It is very sad to see how these people are struggling over here, their crying and weeping would even move a heart of stone. I have not yet been able to register them and write down their names as they keep on moving around from one household to another. They never stay long in one place as they continually hope to be lucky enough to move from a bad house to a good home, yet most of the time they often end up in even worse situations, as the Sincandians on the average show very little compassion for these wretches.

It is not necessary that Your Honour should send all of the Lameyans back at one time, but he can send as many as he pleases and leave the others over here for the time being. Having born witness to their good behaviour you still could order more to come over. If ever I could anticipate anything, I now can foresee that this case will turn out very well, without doubt much to the pleasure of the Lord.

As far as I am concerned I am willing to join them in order to help them to make a start. Awareness that this case concerns so many people has made me rather candid. Nevertheless I do hope and feel that Your Honour will not interpret my frankness negatively.

God willing I shall prepare myself to be next Sunday of service in Tayouan and I will do everything in my power to please the congregation by using the limited talents bestowed on this unworthy one by the Almighty.

Thanks God matters at Sincan as well as the surrounding villages are living up to our expectations. A few days ago assagais were sent to us by five villages situated to the east of Taccareyang, after having received them already from three villages at an earlier date, whom we had provisionally accepted as allies, letting them know that the actual peace can only be concluded if they themselves will show up when I will introduce them to Your Honour. When these eight villages are included with the others that already have been united with the Company, including Sincan, we count up to 57 villages, praise be the Lord who made this happen!

48. Missive Reverend Robertus Junius to Governor Hans Putmans.
Sincan, 16 September 1636.
TEDING 15, fol. 35.

> Hiernevens gaen vier Lameyers, twee mannen en twee vrouwen die naer UE. begeren naer Lamey om de andre te roepen gesonden connen werden. De andre zijn onder de Sincanders. Elck heeft de zijne medegenomen die binnen drie à vier dagen zullen arbeyden met haere vrouwen ende vrunden aff te senden. Wij hebben dese vier soo veel onthaelt als oordeelen proffijtelijck, onder andren heeft elck een cleetjen gecreegen. Wij willen niet twijffelen off dese luyden op Taywan mede wel onthaelt sullen werden. Nevens haer gaet één van onse bevelhebbers uit Sincan, Tapegij genaemt, die wij tot compagnie van de Lameyers medesenden (den vorigen Sincander conde niet wel resolveren andermael derwaerts te gaen) den welcken onderwesen hebbende, op Lamey comende, spreecken sal.

Herewith go four Lameyans: two men and two women, who according to your wish can be sent to the island to call in those remaining there. The others are to be found among Sincandians, who have assigned them to

their households. We shall see to it that within three or four days they will all be sent over to you together with their women and kin. These four Lameyans have been entertained well as we consider that to be beneficial, among other presents each of them has received a piece of cloth. We do not doubt that at Tayouan these people will be treated accordingly. These Lameyans will be accompanied by Tapegij, one of the Sincan headmen (as the Sincandian who went there before could not arrange to go thither for another time), whom we have instructed to address the remaining islanders upon arrival.

49. Missive Governor Hans Putmans to Reverend Robertus Junius. Tayouan, 17 September 1636. TEDING 14, fol. 18.

De joncqe met de twee door UE. herwaerts gesondene Lameyers, te nacht weder derwaerts vertrocken zijnde, verschijnt op heden naerden middach andermael alhier een joncq met 99 zielen, daer onder 35 mans, de rest alt'samen vrou en kindren ende gemerckt wij niet en connen resolveeren dese menschen naer Sincan alt'samen te zenden zoo hebben met den raet goetgevonden UE. bij desen aen te schrijven dat ons de resterende Lameyers, vande 23 die UE. jonxt hebt mede genomen, op den ontfangst deses datelijck met UE. in compagnie, ofte zoohaest mogelijck is, gelieft herwaert te brengen opdat zijlieden, vernemende dese 99 Lameyers gecomen waeren, niet en pretendeeren en seggen dat nu niet wederom naer 't eylant en behoeven te gaen en dienvolgende daer willen blijven, weshalven UE. oock recommandeeren deese zaecke aldaer met UE. vertreck soo secreet te houden als doenlijck sij, opdat degene die met UE. sullen herwarts comen niet onwillich zijn om mede te gaen.

Wij hebben oock noodich met UE. te communiceeren hoedanig met dit volc zullen handelen alsoo onse en des raets meeninge is de manspersoonen alt'samen met haer vrouwen, zoo zij eenige in Sincan ofte hier mogten hebben, naer Battavia te largeeren ende weder de vrouwen en kindren die nu gecomen zijn ende geen mans hebben, in plaetse van de vrouwen die uit Sincan mochten gehaelt werden, terugge te zenden. Dienvolgens UE. recommandeeren, naer den ontfanck deses, met de gemt. Lameyers zoo haest herwaerts te comen als eenigsints doenlijck is, op dat hoe eer hoe liever een eynde van deese zaeck mogen become. UE. gelieve één van de bequamste Sincanders nevens gemt. Lameyers aff te brengen die best met haer spreecken en overeencomen can.

After the junk with the two Lameyans you sent, sailed again to Lamey at night, another junk appeared here today in the afternoon with 99 souls. Among them are 35 Lameyan males, the remainder are all women and children. Since the members of the Council could not resolve to send all these people to Sincan, it was agreed that we should write to Your Honour that on receiving this missive you immediately shall see to it that the remaining Lameyans, of the 23 you recently took along to Sincan, will be brought to Tayouan, either accompanied by you or be given an escort, as soon as possible, in order to prevent that, when they will become aware of the arrival of the 99 Lameyans mentioned, they will not again pretend ignorance, and say that they do not have to go to their island and that as a consequence they want to stay in Sincan. Because of this we do recommend Your Honour to keep this matter as secret as possible until your departure, so as to make sure that those who are supposed to come along with you to Tayouan, will not become unwilling to do so.

We also consider it necessary to deliberate with Your Honour how we should deal with these people as we and the Council are of the opinion that the men and women and, if their spouses are living in Sincan or here at Tayouan, should be transported to Batavia. The women and children who have arrived recently, who do not have any husbands, could then be sent to Sincan instead of those wives who will go along with their husbands to Batavia. Therefore we urge Your Honour upon receiving this letter to come over as quickly as possible with these Lameyans so that we will be able to conclude this case as quickly as possible. Your Honour is also requested to bring along one of the foremost Sincandians who will be most able to communicate with the mentioned Lameyans.

50. Extracts taken from the Zeelandia Castle Resolution-books, concerning the resolutions on the island Lamey, taken in the Formosa Council.
VOC 1170, fol. 585-586. Extract 17 September 1636.

fol. 585: Eensdeels door dreygementen ende anderdeels door schrick van weder beoorloght te werden, hun in sijne handen ende soo voorts herwaerts goetwillichlijck hadden getransporteert, ende dat verhoopt de resterende, die nog niet en can weeten hoeveele sij in getale zijn door desen middel mede sal connen becomen. [...]

[...] Waer op bij den Raet rijpelijck geleth sijnde, vinden met sijne Ed. eenstemmich geraeden dat men alle de op heden gecomen Lameyers alhier sal behouden ende vooreerst aen lant (fol. 586) nemen ende dat men de resterende 18, die noch van de voordesen gecomen 23 in Sinckan sijn, op stante pee nevens d°. Junij sal herwaerts ontbieden, om nevens dese mede op de schepen verdeelt te werden [...].

(On 17 September a resolution was taken with reference to the letter of Lieutenant Jan Jeurriaensz, written on Lamey a day before and received via the junk which carried 99 Lameyans. According to the letter, upon the arrival of ninety warriors from Pangsoya, those people:) (fol. 585) had surrendered themselves to the lieutenant, partly because of threats and partly out of fear that we would once more wage war against them; furthermore that they had willingly complied with their transport to Tayouan. [The lieutenant] hopes that the remaining islanders, whose exact number still is not known, can also be collected in this way. [...]
The Council paid serious attention to this case and entirely agreed with His Honour that all the Lameyans that arrived here today shall be kept here for the time being on land (fol. 586) and that the remaining 18, out of the 23 who arrived earlier and who still are dwelling in Sincan shall be ordered to come over immediately, accompanied by Rev. Junius, as to divide them all over the ships that will set sail to Batavia [...].

51. Extracts taken from the Zeelandia Castle Resolution-books, concerning the resolutions on the island of Lamey, taken in the Formosa Council.
VOC 1170, fol. 588-589. Extract 2 October 1636.

fol. 588: [...] den luytenant (fol. 589) met 40 à 50 soldaeten op morgen, ofte overmorgen Godes weder ende wint sulcx toelatende naer Wanckan sal largeren om volgens voorgestelde propositie inder beste voegen mogelijck alle de gelegentheyt vande revier en den wech van Vavorolang te ondersoecken. [...]
Ten anderen dat men 't Eylant Lamey voor een jaer ende soo grooten somma sal verpachten als immers becomen connen, aen sulcke Chinesen die 't selve soude mogen versoecken, [...] mits dat men tot haere bescherminge vooreerst negen soldaten onder 't opsicht van een goed officier sal laeten verblijven om de resterende inwoonders die daer noch op zoude mogen wesen met hulpe der Chineesen in onse handen te

becomen, ende hun voor overlast vande daer te verschijnen inwoonders deses eylants Formosa te bevrijden. [...].

(Because it was perceived that some inhabitants of Vavorolangh behaved in a hostile way towards the Chinese fishermen at Wancan, and because there were also rumours that they were planning to commit something against the redoubt at Wancan, the Council felt that the time had come to teach Vavorolangh a lesson.[35] Unfortunately, because of a lack of men, an expedition against these disobedient people had to be postponed until the ships from Japan had arrived at Tayouan. Until that time, it was decided:)

fol. 588: to send the lieutenant tomorrow or the day after (fol. 589) together with forty or fifty soldiers to Wancan and, if weather and wind permits, to have them explore the situation of the river and the road leading to Vavorolangh as best as they can. [...]

Likewise the resolution was taken to lease the island of Lamey out for a year for the highest possible sum to those Chinese who requested it, [...] on the condition that for the time being nine soldiers will be placed on Lamey for their protection under the command of a qualified officer, in order to collect, possibly with the help of the Chinese, the remaining inhabitants and also to free the Chinese from the inconvenience which could be caused by the appearance of other inhabitants of Formosa on the island.

52. Missive Governor Hans Putmans to Reverend Robertus Junius.
Tayouan, 3 October 1636.
TEDING 14, fol. 18-19.

Op gistren avont, een weynich voor den ontfanck van UE. missive, hadden met de raet geresolveert den luytenant met 40 à 50 soldaten naer Wancan te largeeren om van daer te water met champans een preuve te nemen vande wech en gelegentheyt te waeter naer Vovorolangh, om in toecomende bij gelegentheyt een tocht op deselve te doen. Bij aldien zijluyden nu de kinderpocken hadden soude heel wel voor ons comen en alsoo wij met UE. nopende dese saeck als oock hoe 't met onse omleggende Mattau, Soulang als andre staen off zij zouden willen medegaen, soo hebben goet gedacht UE. aenteschrijven dat met den eersten noch van daege herwaerts gelieft te comen, om dan oock met

eenen nopens 't ontslag vanden politicquen dienst in Sincan met UE. te communiceeren daer op ons dan verlaeten, zullen UE. spoedich verwachten. (fol. 19) Wij approbeeren dat die zaecke van Dorcko en die van Mattau soodanig bij UE. is affgehandelt. Daeruit is te bemercken dat ons ontsach aldaer noch plaets heeft en zij ons vreesen dat den Almogende geve hoe langer hoe meer mach toenemen en wassen.

Yesterday evening, soon after we had received Your Honour's missive it was decided in Council to send the lieutenant together with forty or fifty soldiers to Wancan. They are to sail from there in sampans in order to explore the route to Vavorolangh by water so that in future an expedition can be sent out to that place. Because those villagers are suffering at the moment from the smallpox this should be the right time. Therefore we thought we should write to Your Honour to come over to us today on the first possible occasion, as we need to communicate with Your Honour about this matter as well as about the present state of the affairs with the surrounding villages of Mattouw, Soulang as well as the others, and to find out whether they may be willing to come along with us on an expedition like that. We would also like to discuss with Your Honour the matter of your resignation from the political administration of Sincan. We entrust you to comply with our wish and will expect you to arrive here soon. (fol. 19) We approve of the way you have dealt with those matters of Dorko and Mattouw. From this we learn that the Company's authority is still be recognized over there and that they continue to fear us which, we hope, God willing, will increase even further.

53. Missive Governor Johan van der Burch to Governor-General Anthonio van Diemen.
Tayouan, 5 October 1636.
VOC 1120, fol. 288-323. Extract fol. 310-314.[36]
See also FORMOSA UNDER THE DUTCH, pp. 147-148; ZENDING, III, pp. 132-134.

fol. 310: [...] Op U Ed. voordesen gegevene ordre soo hadde onsen predecesseur voor mijn aencompste alhier het Goude Leeuws eylandt ofte Lameyers eylandt (fol. 311) genaempt, andermael doen besoecken ende van daer, door goede oorloghe becomen, ontrent de 500 coppen, waervan eenige vrouwen ende kinderen, in Saccam gevoert, de mannen in de

kettingh gecloncken ende bij provisie soo in Wanckan als hier om te
wercken verdeelt waeren. Die wel versorght ende in cost ende dranck
onderhouden sijn geworden, behalven die de felle doot door eene
uytterende sieckte wechgeruckt hadde.

Geduyrende den aentocht op 't gemelte eylandt soo hadden d'onse een
houten wambaysken (bevrijt met een pagger van zestig voeten in 't
viercandt) gemaeckt ende dertig soldaten daerop geleyt, die onderwijlen
vernemen zouden hoe haer de verblevene Lameyers wilden comporteren,
hoe sterck noch waeren ende van haer gelegentheyt soodanich informeren,
dat daerop bij den gouverneur Putmans alsulcke ordre mocht werden, als
sijn Ed. ende den raet naer de merite van haer misdaet, oock de humeur
van de natie ende constitutie van dese plaetse soude verstaen te behooren.
Ende onderwijlen soo heeft sijn Ed. met ons soo in als buyten rade
discoursen gevoert, hoe men met d'selve Lameyers wijders behoorde te
handelen, ende was domine Junius hierover van advijs, dat ten aensien van
den christelijcke aert behoorde men een gedeelte van de Lameyers op 't
eylandt onder ons gesach te laeten ende de reste in Sinckan te verdeelen,
alsoo vertroude, haer nu voorts aen obediënt souden aenstellen ende wij
aen haer doen soude nemen een wel gevallen, daertoe hij presenteerden
allen goeden iver te contribueren die in sijn vermogen was.

Daer jegens zijn Ed. ende wij ende den raet van opinie waeren den besten
middel behoorden te gebruycken omme dat volck van 't eylandt te lichten
ende egeene aldaer te laten, veel minder in Sincan onder de inhabitanten te
verdeelen. t'Avont of morgen door weder toeneminghe van haer natie niet
andermael d'onse soo jammerlijck quaeme om 't leven te brenghen als
voordesen aen die van den *Gouden Leeuw* ende *Beverwijcx* gebleecken is,
sijnde dit een volck die nimmer meer sullen naelaeten bij voorvallende
gelegentheyt haer te revengeren van dese actie. Oorsaecke al te
wraeckgierich van nature gevonden worden ende onder de Sinckanders te
verblijven al te grote verbitteringe onder dat geseggelijcken [volck] in
voorvallende gelegentheyt verwecken soude, waerdoor de tweede
dwaelinghe erger als d'eerste ontstaen conde. Want tracterende van haeren
ommeganck ende naturele conditie, soo heeft ons gebleecken, dat een ider
niet genouch van haer bloetgierich gemoet en weet te spreecken, waerdoor
alle dese omleggende dorpen, Sincan, Soulang, Mattouw, Pangsoya, met
haer in oorlooghe stadich geweest sijn. Want verscheyde natiën die door
ongeluck schipbreucke geleden ende op dat eylandt haer wilden salveren,
waeren alweder van de Lameyers elendich omgecomen, zoo dat een
ijgelijck riep de welverdiende straffe, welcke haer al langen tijt over 't
hooft gehangen hadde, als nu wel terechte over deselve Lameyers gecomen

zijn. Hadden haer in den eersten aentocht soo eyghen wraeckgierich getoont, dat se liever haerselven in de cuylen hebben willen versmoren laeten, als dat se haer in onse handen begeven soude hebben, niettegenstaende aen dito Lameijers verscheyde insinuatiën gedaen waren van niet een soo disperate resoluytie te willen bij der hant nemen, tot vercortinge van haer eygen leven, maer was tevergeefs.

Onderwijlen (fol. 312) onsen predecesseur sich van de Lameyers gelegentheyt geïnformeert hebbende, hadden met ons en de raet goet gevonden, dat op 10en september passato derrewaerts een troupe van tien soldaten onder 't commando van den luytenant Jan Jeuriaensen te committeeren, met sich mede nemende een Lameyer ende sijn vrouw, die van de Sincanders best waeren getracteert, nevens twee Sincanders die met den luytenant spreecken conden ende des gouverneurs ende raets intentie aen sijn mede Lameyers soude te kennen geven, met vertrouwen dat voor d'Hollanders niet te vreesen hadden. Sij souden soo getracteert worden, als aen de constitutie van hem, selfs Lameyer, conden sien, haer aenseggende, dat se naer een goet ende vrij landt souden gevoert werden, ende hadden desen zijn exercitie dagelijcx met harten vangen op Sincan genomen. Alle 't welcke door voorsz. Lameyer aengedient wesende, soo souden haer oock aenseggen dat alle de Lamayers die op 't gemelte eylandt waeren, haer vrijwillich in hande van onsen luytenant voorsz. begeven souden, ofte dat hij andertsints ordre hadde haer weder de oorloch aen te doen, alsoo wij gezint bleven geene Lameyers op 't eylandt te laeten.

Daerop gevolcht is, dat den luytenant twee dagen nae sijn vertreck ons 23 Lameyers met een joncken toegesonden heeft, die met soo een soete aenspraecke hadden becomen ende versocht aen de heer gouverneur ordre hoe met de resterende Lameyers die noch op 't eylandt waeren, handelen soude, waervan adviseerde datter een partij dagelijcx van in de pagger quamen om met d'onse te spreecken. Daerop onsen predecesseur den luytenant weder ordre gaf andermael dese preuve bij der handt te nemen, ende ginghen daernevens noch twee andere Lameyers van die nu jonghst gecomen ende wel getracteert, die oock hadden in Sinckan bij haer vrouwen ende volck geweest, ende haer souden weeten te seggen wie noch in 't leven waeren, die aldaer wel getracteert wierden, sulcx dat voorsz. twee Lameyers de verclaringhe van den eersten souden confirmeren, omme door soodanighen middel het volck sonder bloetstortinghe van lant te crijgen.

Maer ingevalle den luytenandt vermerckte desen middel geen effect conde sorteren, soo was hij geauthoriseert omme sich met sijn volck op het houte

wambas in goede ordre claer te houden, laetende soo veel Lameyers ongewapent (soo als gemeenelijck quame) binnen de pagger comen als geraden dochte, haer dan aenseggende of hun nu wilden vrijwillich in onse handen begeven, oft' onse wapenen proeven, wijders daertoe soodanighen middelen te gebruycken omme 't volck in onse handen te becomen als in een voorsichtich luytenandt vereyscht worde. Hierop was gemelten luytenandt met een jongxjen nae Pangsoya aen 't landt Fermosa overgesteecqen ende aldaer van onse subjecten negentig Pangsoyers becomen die voordesen oorloch tegens de Lameyers gevoert hadden, ende nu haer gantsch dienstich verthoonden sooals meermaels voordesen gedaen hadden, om d'onse tegens d'selve te assisteeren. Welcke Pangsoyers volgens de verclaringe van den luytenant haer soo gewillich in 't opsoecken ofte naejagen van de Lameyers gethoont hadden, dat denselven daervan niett genoch en wist te spreecken wegens het gesach ende goede ordre, die haer opperhooft onder deselve gestelt hadde ende het hooft werd er van sijn volck gerespecteert wiert omme des gegevene luytenants last te achtervolgen.

Onderwijlen de verdrevene Lameyers, vernemende de compste van de Pansoyers, die bevreest scheenen dat weder haer beurt worden zoude, begaven haer gewillich in (fol. 313) onse handen 112 Lameyers, daervan ons den luytenant op den 13en september met een joncxken toesont honderd stucx, bestaende in 35 mannen, 35 jongens ende dertig vrouwen. Welcke honderd stucx, nevens 23 stucx door domine Junio van Sincan gebracht (wesende t'samen 123 coppen) in de twee scheepen *Bommel* en *Texel* sijn verdeelt geworden, die U Ed. met deselve staen toe te comen. Wijders soo hadde sijn Ed. ende de raet in consideratie genomen den vrijwilligen dienst die de Pangsoyers aen de Generaele Compagnie in desen gepresteert hadden ende omme haer in toecomende tot gelijcken te animeren, de negentig Pangsoyers toesont een vereeringe van vier pangsijs, vier swarte fluweelen ende tien cangans, die bij den luytenant onder hunlieden nae rato souden werden verdeelt, daerover gemelte Pangsoyers den luytenant grote danckbaerheyt bethoonden, met presentatie van haeren dienst wanneer wij die maer begeerden.

Hierop compt den luytenant met een joncxken van 't eylandt Lameye den 23e september, medebrengende noch 23 Lameyers, rapporteerende datter gantsch geen meer op 't geseyde eylandt vernemen conden. Hadden daer noch 14 soldaten gelaeten omme tot ons nader ordre aldaer te verblijven, sulcx dat (Gode sij loff) dit volck van 't voorsz. eylandt met goede ordre affgecregen sijn. Dat alles wel geluckt is ende geen volck van ons gecost heeft, anders als een sergeant, corporael ende adelborst, die van hun

selven sonder geweer affgegaen ende door de Lameyers 't hooft afgecloncken sijn geworden. Daertegen onsen predecesseur een tocht liet doen, daer se dertig hoofden haelden, 't welck soodaenighe alteratie in de Lameyers veroorsaeckte dat 't sedert niet meer soodaenighe actiën bij der handt genomen, maer haer redelijckerwijse aengestelt hebben. Door welcke gedaene tocht des Compagnie's macht alhier over dese omliggende dorpen als Sincan, Soulang, Mattouw, Pangsoya ende andere, seer redoutabel is geworden ende haeren naem des te gesachelijcker onder dese inhabitanten in extime gebracht sij. Want voordesen ijder dorp tegens den anderen oorloch gevoert hebbende, sijn door ontsach van wapenen bevredicht geworden ende in soodanighe goede ordre gebracht, dat de Compagnie in voorvallende gelegentheyt haer welbetrouwen ende gebruycken moghen jegens invasie ofte overval van oorloghe. Oorsaecke d'één van d'ander suspeckt zijn ende dienvolgende niemant getrouwer als de Compagnie blijven zoude. Dat ons niet quaelijck comen sal wanneer genootsaeckt worden de obediënste te gebruycken omme de rebellighe in dwanck te houden, soo als hieronder een exempel voegen zal.

Wijders opdat de Compagnie soude genieten de vruchten van desen tocht op 't eylandt Lameye, soo blijft onsen predecesseur van meyninghe 't voorsz. eylandt aen de Chineesen te laeten verpachten, dat ick meyne vooreerst niet min als 250 à 300 realen in 't jaer renderen zal. 't Gevolgh wil ons wijders den tijt leeren.

Het dorp Vavorolangh, gelegen zes à zeven mijlen bijnoorden Wanckan, dat voordesen mede op de capitulatie van de dorpen Taccareyangh, Tamsui, Tapoeliangh, Sataliouw, Mattou ende Soelangh den vrede hadde gepresenteert, heeft sich 't sedert 't verleden jaer vrij wat vreempt tegen ons aengestelt, want den 22 junio lestleeden hebben een partije Vavorolanghers in Wanckan bij nacht onse Chineesen, sittende over d'andere zijde van de (fol. 314) revier om haer visch-neringe te plegen, comen overvallen ende naer haer dorp seven stucx dito medegevoert hebbende, haer niet alleen het haer des hoofts afgesneden, maer sijn oock dickwils gedreyght geworden haer het leven te benemen. Doch naerdat gemelte Vavorolangers de geseyde zeven Chineesen tot den laesten augusto hadden bewaert, hebben die doen rantsoeneren ende weder nae Wanckan gesonden.

Item liepen 't sedert de geruchten dat oock ontrent een troupe van 180 à 190 Vavorolangers haer bij nacht onthielden op het Calcken eylandt, alwaer vijf à zes nachten compareren souden omme het houte wambays, op Wancan gelegen, aen brandt te steecqen, dat d'onse te meer goede wacht doen houden ende op haer hoede wesen.

Naer men rucht, staen op 't voorsz. dorp ongeveer 344 huysen ende is met 1000 persoonen bewoont, houdende sich den cappiteyn van 't dorp, over de vijandelijcke attentaten jegens Wanckan voorgenomen bij de Vavorolangers, soodanich gemiscontenteert dat ingevalle wij geresolveert waren 't voorsz. dorp met macht aen te tasten, den voorsz. cappitein met 3 à 400 coppen sich stil wilde houden ende naer het bosch begeven souden, ende tot een teecken dat met ons niet in oorloghe, maer in vrede te leven genegen was, soo wilde dan een briefken, in Chineese taele geschreven, aen sijn deur placken, opdat wij daeraen hem souden kennen. Ende omme met ons ind't vriendelijck te spreecken, soo bleef genegen binnen weynich dagen af te comen.

Wij sullen niet naelaeten 't gepasseerde ende noch voorvallende vijandelijcke actiën nader met onsen predecesseur te overleggen, omme met des te beter fondament de saecke soodaenich te dirigeeren, dat met de gevoechelijckxte middel ende op 't seeckerste dit dorp soude worden aengetast, opdat de rechtveerdighe straffe gevoelen mogen ende onse lemiten ten zuyden ende noorden van Tayouan ende ten oosten 1½ dag reysens in 't geberchte vrij ende vranck tot allen tijden bevrijt ende paysijbel beseten mogen werden. [...].

fol. 310: **Before my arrival Your Honour had ordered my predecessor to pay another visit to the Golden Lion Island, or the island of Lamey as it is also named. By force of arms he got hold of about 500 islanders, some of the women and children were brought over to Saccam, while the men were put into chains and provisionally divided either to work here or in Wancan. They are [in good health] well taken care off, and supplied with food and drink except for those who have been carried off by a wasting disease.**

During the expedition on the said island, our men had constructed a little fortification (surrounded by a square bamboo fence of about sixty feet on each side) to serve as an encampment for thirty soldiers who were to assess the strength, behaviour and temper of the remaining people of Lamey. This information could serve Governor Putmans and the Council to consider their crimes as well as the merits of this case and make a right decision on what should be done with that nation. Meanwhile his Honour has discussed with us, both in and outside the council meetings, in what manner we should deal with these Lameyans. The Reverend Junius advised, that from the Christian point of view we should let some of the Lameyans stay on the island under our authority. The others could be

divided among the people of Sincan, because he trusted that they would behave themselves obediently from now on, and that he would see to it, as far as he could, that we would be satisfied with their behaviour.

However, we were opposed to this. In our own opinion, as well as that of his Honour and the Council, we agreed that we should evacuate the entire population of that island and should not leave any of them over there, nor leave anyone of them among the Sincandians, because this nation will never let an opportunity pass by when, after some time, their number has again increased, to revenge themselves. Once more they will murder our people just as they have done in the past when they killed the crews of the *Gouden Leeuw* and *Beverwijck*! If they should remain under supervision of the Sincandians the bitterness among the Lameyans, caused by their revengeful nature, could turn in turn give way to new deviations of a far more serious kind then those that have happened before. Because we have become aware that their natural condition and the way they treat others is attended with so much bloodlust that all inhabitants of the surrounding villages Sincan, Soulang, Mattouw, Pangsoya have always been on a war footing with them. In the past people who were unfortunate enough to be shipwrecked on Lamey and sought a safe haven on the island, have been massacred by the islanders, so that every one clamored for the well deserved punishment, which had hung above their heads and now at long last had hit them. During the first expedition of the Company-soldiers, our announcement that the Lameyans should not desperately take their own lives were to no avail; they demonstrated their vindictiveness by preferring to be suffocated in the caves, rather than surrender themselves to us. Meanwhile my predecessor having informed himself about their condition, agreed with us and the Council on 10 September last, to send a group of ten soldiers under the command of Lieutenant Jan Jeurriaensz over there. They were accompanied by a man, who was himself a native of Lamey, and his wife, who both had been treated well by the Sincandians, together with two men from Sincan who were able to communicate with the lieutenant. The man from Lamey had to indicate to his fellow Lameyans that the Governor and Council did not intend to do them any harm and that they did not have to fear the Dutch at all. They would be treated well as they could observe from his own physical condition. They would be taken to a free country, just as he had been free in Sincan to go and take his daily exercise in deerhunting. After the

mentioned Lameyan had made all this clear to his fellow islanders, he also had to tell them that everyone either had to surrender voluntarily or they would have to face the consequences because the lieutenant had got specific orders to again wage war on them if they would not give in, because we did not intend to let one single Lameyan remain on the island. Two days after his departure, the lieutenant managed to send a junk over with 23 Lameyans who had been persuaded with these gentle words. He also awaited orders from the governor about what should be done with the remaining people, a group of whom came everyday to the fence to speak with our men. My predecessor again gave orders to the lieutenant to try the same trick once more. To that purpose two other men from Lamey were accompanying him, who recently had come over themselves, and been well treated and had been to Sincan to visit their wives and people. These were supposed to inform them who were still living there and were being treated well. Thus they could confirm the positive words spoken by the man sent earlier, so that by these means finally these people from Lamey could be evacuated without any more bloodshed.

However, in case the lieutenant would feel that all this was to no avail, then he was authorised to get ready with his men, allow as many Lameyans as usual to enter the wooden fortification unarmed, upon which occasion he should force them to make a choice between surrender or getting acquaintained with our arms. Furthermore he was allowed to use all possible means, an experienced and prudent lieutenant could think of, for the purpose of getting hold of these [obstinate Lameyans]. Thereupon the lieutenant crossed over with a little junk from Lamey to Pangsoya on the Formosan mainland in order to fetch ninety allies from Pangsoya, who in the past had fought a war against Lamey, and who, just as they had done several times before, were most willing to assist us against their enemies. According to the lieutenant's statement, he could hardly find the right words to express the readiness these Pangsoyans had shown in tracing and hunting down the Lameyans. Their own chief, due to his authority and the good order that he kept among his men, was greatly respected by his subjects, had agreed to carry out the lieutenants assignment.

Meanwhile, when the ousted Lameyans got to know about the arrival of the Pangsoyans, they became very much afraid that they would once more get their share of violence, so 112 men voluntarily surrendered

themselves (fol. 313) to us. On 13 September the lieutenant sent one hundred people: 35 men, 35 boys and thirty women, over to us on board a small junk. To that number of a hundred the Reverend Junius added 23 more who came over from Sincan (bringing the total amount to 123 heads) who were divided over the two ships *Bommel* and *Texel* and will soon be sent over to your Honour. His Honour and the Council considering the voluntary service the ninety Pangsoyans had rendered this time to the General Company and in order to encourage them to behave just like that in the future, decided to favour them with four pansies, four pieces of black velvet and ten *cangans*. The lieutenant saw to it that these presents were distributed according to their merits, for which they expressed their sincere gratitude telling him that they would be at our service again whenever we needed them.

Hereupon the lieutenant came back from Lamey on 23 September bringing along another 23 Lameyans, reporting that no more could be found there anymore. Fourteen soldiers were left until further notice, so that (God be praised) these people are taken off their island in good order. Everything worked out well for the VOC with no loss of life except for a sergeant, a corporal and a cadet, who had left the fence without carrying arms and who were beheaded by Lameyans. To revenge this deed of violence our predecessor sent a punitive expedition which succeeded in getting thirty enemy heads, which caused such an alteration in their behaviour, as to put an end to all violent actions since. From that time on they have comported themselves quite reasonably. The success of this expedition greatly contributed to the Company's power. Her strength became very noteworthy and her name is now held in high esteem among all the inhabitants of our surrounding villages Sincan, Soulang, Mattouw, Pangsoya and others. Each village used to fight against the others, yet now they are pacified because of awe for the arms of the Company. Thus they have been brought into such a good order that the Company may count on their loyal assistance in case of an invasion or the outbreak of war. Because they still suspect each other they each yield pride of place to being as faithful to the Company as they can be. This surely will do us no harm and we will benefit from it. Whenever it is necessary to keep one rebellious village in check we will invite the most obedient of the others to assist us, just as we have already done as will be proven from the following example.

Furthermore, in order that the Company may enjoy the fruits of the expedition to Lamey as well as possible, our predecessor came up with the idea to lease out that island to the Chinese which, in my opinion, would yield a profit of no less than 250 or 300 reals a year. What the outcome is, only time will tell.

The village of Vavorolangh, situated six or seven miles to the north of Wancan, had already expressed a wish for peace, partly due to the fact that they had witnessed the capitulation of the villages Taccareyang, Tamsuy [in the south], Tapoeliang, Swatalauw, Mattouw and Soulang. However, since last year, they have been behaving rather strangely towards us, for on the night of 22 June last, a party of Vavorolanghians raided the Chinese in Wancan, who were fishing on the other side of the river. (fol. 314) Seven of these Chinese were kidnapped and taken to Vavorolangh where not only was their hair cut off but, what is more, they were threatened several times that their lives would be taken as well. Yet after the Vavorolanghians had kept these seven Chinese fishermen at ransom until the last day of August, they were released and sent back to Wancan with some provisions.

Also rumours circulated that a group of about 180 to 190 men from Vavorolang loitered near Calcken island at night, where they appeared five or six nights later to set fire to the little wooden redoubt situated on Wancan. This once more induced us to be alert and double the guards.

We are told that Vavorolangh consists of about 344 houses and has 1000 inhabitants. The captain or headman of Vavorolangh was so enraged about these alleged hostilities committed by some of his men against Wancan, that in case we did resolve to attack the village with force, he would go off with about 300 or 400 of his men, and stay quietly in the woods for a while. This would be a sign that he wanted to live in peace with us instead of making war, he would leave a note on his door, written in Chinese, so that we would understand him well. He intended to come over to Tayouan within a few days to speak with us in friendly terms.

We will not fail to discuss the past hostilities further, or indeed those that will occur in the future, with our predecessor in order to be better prepared to conduct the matter in such a way as to be able to use the best possible method to attack this village so that they may suffer their lawful punishment. Then within the Company's boundaries to the south and to the north of Tayouan, and way into the mountains as far as one and a half

day's journey to the east, people will be free to go where they want and everything will be in peaceful possession. [...].

54. Original Missive Governor Hans Putmans to Governor-General Anthonio van Diemen.
Tayouan, 7 October 1636.
VOC 1120, fol. 252-282. Extract fol. 258-262.
See also FORMOSA UNDER THE DUTCH, pp. 148-149; ZENDING, III, pp. 135-136.

fol. 258: [...] 't Zedert ons jonxste schrijven in dato 15 maert passado per de joncke *Quinam* wert bij den raet in dato 16en april lestleden goet gevonden met ontrent one hundred blancke coppen ende ontrent zeventig Sincanders, mitsgaders eenige Pangzoyers, 't Goude Leeuw's eylant, onder de inwoonders Lamey genaemt, te besoecken ende andermael een preuve te nemen oft'men 't selve van dese brutale barbaren niet alleen tot soulagement van onse, maer oock selffs de Chineesen ende alle andere natiën die de Chineese Zee moeten gebruycken, conde ontblooten ende onder onse jurisdictie ende gehoorsaemheyt brengen, met zoodanigen intentie dat d'onse, zoo dese wilde menschen hun weder (gelijck te voren gepleegt hadden) in de speloncken en hoolen sochten te verbergen, men d'selve (naerdat ons quartier eerst wel was verzorgt met eenen pagger off andersints) zouden omvangen ende alsoo sien te besluyten, mitsgaders door hongersnoot, brant, spookerij, off het inwerpen eeniger granaten daeruit te crijgen ende zoo lange daer te verblijven, totdat dit noodige werck door Godes genade volbracht was, ofte naer sich de zaecke verthoonde, naerder mochten resolveeren.

Met desen tocht, die ontrent de 40 dagen geduyrt heeft, zijn ons in verscheyde tijden zoo mans, vrouwen als kinderen, toegesonden 554 zielen, daervan onderwegen eenige gestorven, overboort gesprongen ende alsoo om 't leven gecomen zijn. Bovendien waeren naer gissing, zoo in de speloncke als in 't velt zeer hertneckig (hun niet willende in onse handen begeven) doot gebleven ontrent 300 ditos, maeckende t'samen een getal van 854 zielen, daervan dit eylant (met overgroot genougen van dese hier ontrent gelegene dorpen, onse bontgenoten, die continueerlijck met die van Lamey in oorloge zijn geweest) is ontbloot geworden.

Voor 't opbreecken van onse macht om weder herwaerts te keeren hadden aen lieutenant Johan Jeuriaensen (die wij 't opperste gesach over dese troupe nevens noch twee raetspersoonen hadden gegeven) geordineert een

pagger van clappusboomen (zijnde zestig voet in 't viercant met een houte wambays in 't midde van dito) tot verseeckeringe van d'onse interim te maecken ende met den raet bij naerder resolutie goet gevonden (ten oorsaecke men bemerckte hun noch groote partie deser inwoonderen (fol. 259) zoo hier en daer in 't bos en de clippen onthielden), dertig soldaten met eenen sargeant in gemelte werck bij provisie te laeten, ende ondertusschen sien te vernemen bij wat middel men de resterende menschen 't sij met gewelt ofte wel andersints in handen zoude connen becomen.

Eenige dagen naer dat den lieutenant met den gantschen ommeslag (laetende als voren gesecht dertig man daer verblijven) herwaerts vertrocken was, begonde deser wilde menschen zoo nu en dan ontrent den geseyden pagger ja oocq somtijts daer binnen te comen clappesen als andre aervruchten aen d'onse vereerende. Zulcx dat hun de middelen om tot ons desseyn ende goet voornemen te geraecken geheel schoon begont te verthoonen. Soo langen tot dat onsen daergelaeten opperhooft den sargeant (wel expres strijdende jegens zijne ordre) sich met een corporael ende twee adelborsten (die hem gesamentlijck naer sekere plaetse vrij wat verder van 't houte wambays, daer eenige swarten vermoede om een praetjen te maecken off te drincken zonder anders yets als hun sijtgeweer bij hun te hebben), transporteerden ende op 30en junij seer deerlijck (van dese barbaren, niet connende haer aengeboren wreetheyt naerlaeten), zijn vermoort ende 't hooft afgeslagen. Uitgesondert één van d'adelborsten die't ontliep ende d'onse 't gepasseerde quam bootschappen. 't Welcq ons den dach daer naer aen 't fort lieten weten, waerop datelijck om onse achtbaerheyt onder dese menichte van inwoonders te behouden ende onse corts vercregene authoriteyt ende victorie niet te stutten, met den raet goetgevonden onsen luytenant voorsz. met 25 zoldaten ende ontrent 270 inwoonders van verscheyde dorpen op 5 julio wederom derwarts te zenden omme dit leelijck fait wederom te revengieeren. Die in twee à drie daegen dat daer remoreerde dertig hooffden, daeronder eenige vande moordenaers, heeft becomen als wanneer geenige meer connende attrapperen (door dien hun in creupelruygte ende clippen onthielden), op 12en dito met dese victorie weder terugge keerden, met soodanigen ordre daerlaetende gelijck hem was aengezeyt dat d'onse weder alle soete middelen in 't werck zouden stellen om de resterende aen te locken ende wel te bejegenen, mitsgaders met meerder voorsichticheyt haere saecken te beleggen, alsoo wij geenigen andren middel conden voorsien ofte bemercken om dit eylant te suyveren.

Ondertusschen hadden sekeren Lameyer die d'onse nevens zijn moeder in eenige zaecken wat behulpelijck was geweest zijn vrijdom in Sincan vergunt. Die allenskens de Sinckanse taele wat begonde te leeren om in tijt ende wijlen eenige vruchten daervan te raepen.

Ende om dese zaecke voor ons vertreck tot een gewenst uiteynde te brengen, ons garnisoen daer vandaen te lichten ende het eylant aen eenige Chineesen te verhuyren, wiert bij den raet in dato 28 augusty passado goetgevonden desen bovengemt. Lameyer met drie Sinckanders, den luytenant ende tien soldaten wederom derwaerts te gebruycken ende voor de derde mael preuve te nemen ofte men met desen geseyden Lameyer (onder toesegginge van vrijheyt aen alle die gewillichlijck herwarts wilden retourneeren te vergunnen) de resterende noch op 't eylant hun onthoudende conde becomen, ende bij desen weg niet winnen ende voor 't jonxste met alle de inwoonders hun t'overvallen ende te laeten opzoucken. Waermede zoo veele is gevordert dat hun ter eerster aencomste aldaer 23 persoonen, alle cloucke mannen, vrijwillich in handen van d'onse begaeven. De reste, 't zij door wantrouwe ofte andersints, conden zulcx noch niet resolveren. Weshalven den luytenant voornt. met negentig inwoonders van Pangsoya hun weder den oorlooge aendede met becominge van vier hooffden, hun des andren daegs den vrede ende vrijdom weder laetende aenseggen ende vertrock voorz. luytenant (fol. 260) om dat des te onbeschreimder bij onse pagger zoude verschijnen wederom met de Pangsoyers naer Tampzuy, alvoren ordre aenden zarjeant laetende, dat zoo eenige binnen de pagger verscheenen men d'selve zoude vasthouden. Doch zulx niet willende lucken quam met ongeveer honderd Pangzoyers den 2en dach wederom op voorz. eylant alswanneer soodanigen schrick eyndelijck onder dese menschen is gevallen, dat soo veel men bemercken conde allen die op 't eylant waeren hun in onse handen ende alsoo herwaerts (zijnde te saemen met de vorige 23: 151 zielen) hebben getransporteert, echter werden zoo mans, vrouwen als kindren tot ontrent het getal van twintig wel bekende naer gissing noch gemist ende alsoo den luytenant op 23en passato met 21 vande bovenstaende 151 hier, Gode zij loff, wel geparesseert, hebbende den sarjant Teeck met 17 blancke coppen ende twee caffers om te sien off noch eenige menschen conde vernemen tot onse naerder ordre daer gelaeten, brengende de rest vande zoldaten wederom terugge.

Geduyrende dese tochten hebben hun die van Sincan, Soulang, Bacaluan, mitsgaders d'andre hier ontrent gelegene dorpen ende vlecken, maer voornamentlijck die van Pangzoya zeer gewillichlijck in alles laeten gebruycken dat men niet beter zoude connen off mogen wenschen ja als

onse eygene soldaten selffs, dat voorwaer in soo cleenen tijt dat noch meest met alle deese dorpen in oorlooge saeten, veel gewonnen is ende wij daeruit besluyten noch goede diensten uit dit volcq te trecken zal zijn. Onse maniere ende daente staet hun gans wel aen ende verzoucken dat wij hun d'selve door padres ende schoolmeesters gelijck in Sincan zouden laeten leeren, voorwaer een uitnemende gewenschte zaeck omme veele heydenen tot bekeeringe te brengen, ja wij gelooven qualijck plaetse in de werelt beter als dese omme de Heere veel zielen toe te brengen, zoude connen gevonden worden. Nergens anders aen schortende als goede ivrige ende stichtelijcke leeraers ende jonge quanten om tot schoolmeesters ende tolcken te gebruycken.

Met dese gevangene Lameyers is bij den raet goetgevonden alles tot UE. naerder approbatie, in volgende wijse te handelen: namentlijck alle de vrouwen ende kindren zijn onder de Sinckanders op hun ernstig verzoucq verdeylt om dit dorp in menichte van menschen te doen toenemen ende deselve alsoo tot het christen geloof te brengen, onder conditie dat zoo U Ed. zulcx niet en approbeerden, alsdan die in 't leven sijn wederom sullen moeten restitueeren ende d'selve niet zullen vermogen onder den andren ofte aen andre dorpen veralieneren ofte vervreemden, maer d'selve gehouden zullen zijn in voller vrijheyt als haer eyge natie te tracteeren. De gevangene mansperzoonen zijn twee aen twee aenden andren geslagen in ketens ende soo in Wancan in 't maecken vande ronduyt als hier in 's Compagnies wercken gebruyckt, doch meest al gestorven. De rest gaen hiernevens. Alle de knechtkens boven de acht à negen jaeren out, zijn buyten de ketting in 's Compagnies wercken hier en daer gebruyct.

De joncxste becomene die vrijdom toegesecht ende belooft is, zijn op de scheepen (als bij ingeleyde memorie te zien is), verdeelt ende gaen alt'samen costi. Onses oordeels zouden dese luyden bequaem in Banda ofte andersints gebruyckt connen werden.

fol. 261: Dewijle met de saecke van Lamey dus besich waeren hadden mede om tot kennisse te comen waer ontrent het gout hier op Formosa valt, inde maent april eerst door seeckeren Chinees in Sincan woonachtigh, Lampsack genaemt, laeten ondersoucken off men met den oversten van Lonckjouw niet een goede vrede ende bondich contractt tusschen ons ende gem. Loncjouwers, mitsgaders die van Pangzoya (onse bondgenoten) zoude connen te wege brengen. Bestaende voors. Lonckjouw in een getal van 16 dorpen aen 't zuyteynde van Formoza gelegen, grensende aende limiten ofte lantpalen van die van Pangzoya aen de westzijde van Formosa, ende aen de oostzijde aen seeckere dorpen Pimaba genaemt, welckers ingesetene gestadich oorlog voeren (naer de affirmatie van veele en

verscheyde Chineesen die lange daeromtrent woonachtig sijn geweest) tegens d'ingesetene daer het bekende gout aen d'oostzijde van Formosa zoude vallen. Welcken voorz. Chinees aldaer wel onthaelt ende hem veele door gemt. overste naer d'Hollanders gevraegt zijnde. Wilde het schenckatietjen hem toegesonden niet voor en aleer eenige van d'onse daer quamen, hun niet misdaen zoude werden. Welcken, volgende op de rapporten van voorz. Lamphacq, in May passado een tolck, een corporaal ende een soldaat derwaerts largeerden, die daer wel onthaelt wierden ende quamen den corporael op 15de met den broeder vanden oppersten ende 15 andre van Lonckjouw hier weder aen 't fort, hebbende d'andre twee in ostagie vande hier aengelangde Lonckjouwers bij den oversten gelaeten.

Desen voorz. oversten van Lonckjouw excuseerden hem om selffs in persoon herwaerts te comen also hunnen zaytijt voor de hant was, maer liet ons door zijnen broeder weten dat tegens 't aenstaende noordermouson, zoo wanneer wij hem een joncxken wilden toesenden, hier soude verschijnen om eene bondiger vreede te maecken.

t' Allen gelucke was ter dier tijt hiermede verscheenen den oppersten van Pangsoya die met die van Lonckjouw in gestadigen oorloge tot noch toe zijn geweest (weshalven om onse goede meeninge uit te drucken en aen hun te verthoonen) perthiën soetelijck tot den vreede aenmaenden waertoe oock scheenen t'inclineeren, zulcx dat aen wederzijden bij provisie stilstant van wapenen (tot naerder confirmatie) wiert belooft. 't Welcq oock tot noch toe is onderhouden ende zijn also gemt. Lonckjouwers met den oversten van Pangzoja gesamentlijck, naer wel onthaelt waeren met goet contentement ende genougen weder elcq naer zijn plaets vertrocken ende zijn hier door onse limiten van 't fort Zeelandia (Godt zij loff) tot aen het zuyteynde ende een goet gedeelte vande oost van Formoza uitgebreydet.

Wij en twijffelen niet zoo men dese zaecke wilde met ernst bij der hant nemen ofte men soude met diergelijcke macht gelijck hier 't voorleden jaer geweest is, versterckt zijnde met pertij Pangzoyers ende dese Lonckjouwers, zonder merckelijck tegenstant, niet alleene ter plaetsen daer 't gout valt maer oocq door 't gansche landt van Formosa daermen wilde wesen, marcheeren. Maer zulcx onderleggende zoude men onses oordeels inde maenden van maert, april ende mey met joncken tot ontrent de plaetsen daer 't gout valt vaeren ende aldaer landen moeten om ons volcq door al te veel marcherens niet machteloos te maecken. De zeeckerheyt dat daer ontrent aende oostzijde van Formoza gout valt is niet alleen dat dese inwoonders van Loncjouw maer oock selffs de Spanjarden ende hare slaven, mitsgaders de Chineesen 't selve gantsch voor de waerheyt confirmeren.

fol. 262: Die van Vovorolang, daer van in onse missive van dato 21 februari mentie gemaeckt is, dat onsen vreede mede versocht hadden, verthoonen hun nu dagelijx even moedich met de Chineesen inde revier van Wancan, die daer visschen en calcqbranden, somtijts t'haere te onthaelen. Selffs mede te nemen ende oock somwijlen eenige doot te slaen ende quetsen, niet tegenstaende eene van hunne oversten in Sincan onsen vreede als boven verhaelt versocht hadde.

Na ons de Chineesen rapporteeren zoude gemt. oversten (die bij dᵒ. Junij extraordinarij volgens haere wijse wel onthaelt was) noch tot den vreede ende ontrent 300 à 400 vande zijne inclineeren, ende jegens de Chineesen gesecht hebben dat soo wanneer de Hollanders in Vovorolang quamen hij zijne huysen met Chineese papiertjes zoude laeten beplacken ende sich in de ruychte begeven sonder tegens ons te vechten. Zij wilden zijnent halven doch versoucken dat als men de huysen quam te verbranden de zijne zoude laten staen. Hij zoude dan datelijck den vrede weten te maecken sulcx dat het schijnt wel eenigsints vreesen het hun d'een off d'ander tijt gelden zal ende oock wel eenige tot vreede inclineeren, maer den meesten hoop schijnt noch tot hunnen barbarischen manieren van moorden en rooven genegen te zijn.

Dit dient in alle manieren gestraft en voorgecomen maer ten aensien niet boven de honderd cloucke soldaten connen uitmaecken ende het noch dagelijx geregent heeft is sulcx (alzoo 't vrij een groot en machtig dorp is, ende wel met meerder macht dient bijder hant gevatt) naergelaten. Wij zijn van meeninge op haere comste in Wancan eens te laeten passen ende sien off men yets remercabels waerdig op hun soude connen attenteeren, om daer door haren hoogmoet wat te dempen ende sien off tot vreden te brengen zijn, anders zoude het hoognoodich wesen dat dit dorp vernedert wierde om alsoo allenskens naer Girem te comen, daer vandaen dit mouson groote partij hertevellen naer China ende zoo voorts naer Japan vervoert zijn.

In onse missive van dato 13ᵉⁿ maert passado maecken mede mentie dat de padres van Quelang al tot ontrent gecomen ende d'inhabitanten (zoo de Chineesen ons doenmael rapporteerden) onder den coninck van Spangies gehoorsaemheyt gebracht hadden. Doch corts daeraen vernaemen eerst uyt de Chineesen eenige loopende tidinge dat d'inwoonders van Tampzuye bij nacht het Spaens houten fort (daer zijnde) overrompelt ende ontrent de dertig Spanjarden dootgeslagen ende de reste door den donckeren nacht naer Quelang gevlucht waeren. 't Welcq den 21ᵉⁿ mey daeraen niet alleenlijck geconfirmeert maer oock voorde waerheyt vorders gerelateert wiert dat gemt. Castilianen in Quelang met de daer ontrent gesetene

inwoonders (ten oorsaecqe twee hoenders ende drie gantang rijs jaerlijcx van ider getrout persoon hadden gesocht te lichten ende alsoo eenen tol in te voeren) overal in oorloog waeren vervallen. Welcke tidinge alsnoch blijft continueeren, d'inwoonders daer ontrent ende in Tampzuy geseten souden meest naer 't geberchte vertrocken ende hun fortresse in Tampsuy weder op novo gebout ende beset zijn. Eerlangs hoope vaste ende sekerder tiding uit de joncqe van Aymoy tot twee in 't getal derwaerts genavigeert zijn, te vernemen.

fol. 258: [...] Since our last letter of 15 March, sent over with the junk *Quinam*, the Council agreed on 16 April to send to Golden Lion Island (named Lamey by the inhabitants), a party of a hundred white men, about seventy Sincandians and also some men from Pangsoya to make a second attempt to clear the island from these brute barbarians and bring it directly under our authority and jurisdiction, not only to relieve our people but also to the benefit of the Chinese and all nations that sail the China Sea. The intention on this occasion is that, if these wild people again (as they have done before) should try to hide themselves in the caves and caverns, our men (once they have put our camp in order with a fence or otherwise) should lay siege to them and decide according to the circumstances, how to get them out by starving them to death, by setting fire, by haunting them or by throwing grenades into the caves, and stay there just as long as necessary to bring, through God's mercy, this requisite job to an end.

As a result of this expedition, which took about forty days, 554 souls, men, women and children, were eventually deported and sent over, of whom several died underway by jumping overboard and drowning themselves. Also we guess about 300 people died on the fields or in the caves because they stubbornly refused to surrender themselves to us. Together this adds to a total number of 854 souls of which this island has now been cleared (much to the satisfaction of our allies the inhabitants of the neighbouring villages on Formosa who have been in a continuous state of war with Lamey).

Before breaking the camp and returning with his forces to Tayouan we had ordered the lieutenant Johan Jeurriaensz – to whom we had given the command (while two men were adjoined to act as councillors) to construct a square pallisade of coconut trees (about sixty feet on all sides with a wooden fortification in the middle) which could serve as a provisional

encampment to safeguard our men. Because it was noticed that a rather large party of Lameyans was still hanging around in the woods and near the cliffs, the Formosa Council decided to leave thirty soldiers together with a sergeant provisionally in that stronghold in order to find a way, either by the use of force or otherwise, to bring these remaining people under our command.

Some days after the lieutenant had returned with his whole complement (except for the thirty men staying behind as mentioned above) to Tayouan, these wild people started to come near the fence, yes they even sometimes entered the compound to offer coconuts or root vegetables to our men so that it looked as if we were going to reach our objectives until the commander, the sergeant and the remaining soldiers, (acting very much counter to his orders) on 30 June together with a corporal and two cadets left the stronghold, only carrying their side arms. Together they strolled to a place at quite a distance where they expected to meet some blacks to have a chat or a drink with them. They were promptly tragically murdered and beheaded by these barbarians who were not able to desist from their innate cruelty except for one of the cadets who managed to escape and brought the message back to the others. The next day fort Zeelandia was informed, and immediately the Formosan Council passed a resolution, in order to maintain the respect of this multitude of inhabitants towards us and in order not to forfeit our recent victory and authority, to send, on 5 July, the lieutenant again with 25 soldiers and about 270 men from several villages over to Lamey to avenge this vile offence. While our men were there, they captured thirty enemy heads, including some of the murderers themselves. On the 12th of July, when there were no others to capture (because they had fled and were hiding themselves in the thickets and on the cliffs), the soldiers returned victoriously to Tayouan. They again left some men behind with the same instructions as before, yet to act with even more caution and to treat the remaining Lameyans with kindness with the objective of getting hold of them, because we cannot think of any better method to clear this island.

In the meantime a certain man from Lamey who, together with his mother had assisted us in Sincan in several matters and to whom we had granted freedom, little by little succeeded in learning the Sincan language, which in time surely will be beneficial to us.

With the intention of concluding the case satisfactorily once and for all, before my departure and to remove the garrison from there and farm out the island to some Chinese, it was decided by the Council on 28 August to send the mentioned Lameyan with three Sincandians, the lieutenant and ten soldiers over for the third time, to see if they could try (by promising freedom to anybody who would voluntarily return with the soldiers to Tayouan) to remove the remaining islanders from Lamey. If, however, this did not work out, then we would attack them and ferret them out with a united force of all their enemies. This worked out quite well as upon arrival 23 persons, all stout men, voluntarily surrendered themselves in to our hands. However the remainder, be it from distrust or otherwise, could not resolve to do the same, so that the lieutenant after having again waged war on the Lameyans with ninety men from Pangsoya, captured four heads, and thereupon again proposed peace to them and told them once more that if they surrendered they would be given freedom. To ensure that they would not be to afraid to appear at the fence, the lieutenant with the Pangsoyans left the island again for Tamsuy, leaving orders behind for the sergeant that anyone who might show up and enter the enclosure, should be detained. Because of the failure of that plan, the lieutenant returned again to the island on the second day, accompanied by about one hundred Pangsoyans. This force caused so much fear among the remainder of the people of Lamey that it finally resulted, as far as we could observe, in their surrender. A total of 151 souls (including the 23 who had already surrendered earlier) were transported to Tayouan. However we must submit that some twenty people, men, women and children, are still missing. On 23rd of last month, God be praised, the lieutenant appeared here bringing 21 of the mentioned 151 people along, together with most of the men. Meanwhile Sergeant Teeck had received orders, until further instructions, to stay behind with 17 European soldiers and two 'blacks' to see if he could succeed in getting hold of some of the last of the Lameyans; the other soldiers have been brought back.

We have had support during these expeditions from Sincan, Soulang, Bacaluan and from other villages and hamlets situated in our neighbourhood, and especially from the inhabitants of Pangsoya, who have collaborated very willingly and in every respect have been so useful that we could not have wished it any better: they served us just as our own soldiers did. Indeed so much has been accomplished, in such a short

time with all these villages with which we were in a state of war, that we expect to derive a lot of assistance from these peoples in the future. Our ways and methods suit them so well that they have made a request for ministers and schoolteachers to teach them just as is being done in Sincan. This truly is an excellent opportunity to convert so many heathens so that we believe one hardly can find a better place in the world where so many souls can be brought in to the hands of the Lord. We are only lacking in good, eager and exemplary teachers and young chaps for employment as schoolteachers and interpreters.

The Council has resolved, upon Your Honour's further approval, to deal with the captives from Lamey as follows: namely to divide all women and children among the Sincandians (upon the request of Sincan) in order to increase the number of people of that village, and to convert them at the same time and bring them to the Christian faith. On condition that if Your Honour does not approve of this, the Sincandians will have to return all of them and in the meantime are not allowed to alienate or send them away to other villages, but have to maintain them in freedom and treat them just as they would treat their own people. Most of the captured men have already succumbed, having been put in chains in pairs, and set to work either at the construction works of the fortification in Wancan, or over here to serve in the Company-works. The others have been sent over to Batavia. All boys over eight or nine years old, have been made use of, without chains, here and there in the Company-works.

The ones we got most recently, and to whom we promised freedom have been divided over the ships, as can be seen from the inserted memorandum[37], and all will go together to Batavia. In our opinion these people could best be employed in Banda or elsewhere.

fol. 261: When we were occupied with the Lamey matter we also tried to increase our knowledge about the sites where gold can be found on Formosa. In the month of April we sent a Chinese named Lampzack, who is living in Sincan, to Lonckjouw to talk to the headmen there and investigate whether a just peace could be concluded in the form of a solid treaty between them, us and also our allies in Pangzoya. Lonckjouw consists of 16 villages situated near the southern tip of Formosa; its territory borders the limits or landpoles of Pangzoya to the west and to the east it is adjacent to certain villages named Pimaba, whose inhabitants (according to the affirmation of several Chinese who have lived over there

for quite some time), continuously wage war against the peoples of the eastern side of Formosa where gold is supposed to be found. The above mentioned Chinese was welcomed heartily in Lonckjouw and the headmen asked him many questions about the Dutch. They refused to accept the gift sent to them, before one of us has paid them a visit, promising that none would be harmed. Acting upon the Lampzack's report, last May an interpreter, a corporal and a soldier travelled to that place and received a friendly welcome. In return the brother of the chief of Lonckjouw together with a party of 15 others came here to pay a visit to Tayouan, while the other two Dutchmen remained in Lonckjouw as hostages of the headman, until the return of these envoys from Tayouan.

This ruler of Lonckjouw excused himself from personally visiting Tayouan, because the sowing season was just about to begin. However through his brother he let us know that in the next season of the northern monsoon, he would gladly come to Tayouan to negotiate a conclusive peace, if only we would be good enough to send a small junk over to fetch him.

To everyone's luck, the headmen of Pangzoya showed up as well about that time. They had so far been involved in a continual state of war with Lonckjouw. So as to show them our goodwill we urged both parties with sweet words to conclude peace, to which they seemed to be inclined, such that a mutual suspension of arms (to last until further confirmation) was promised. Something to which the parties have so far adhered to. Afterwards, having enjoyed a warm welcome at Zeelandia and feeling very content, the men from Lonckjouw together with the chiefs of Pangzoya left together for their villages. This greatly expanded the boundaries of Zeelandia Castle (God be praised) as far as to the southern tip and well into the eastern part of Formosa.

We do not doubt that if we would deal with this case seriously and should we be able to mobilize a force as we managed to do last year, reinforced with a party of warriors from Pangzoya and Lonckjouw, we could march with little resistance not only to the places where gold is supposed to be found but also through the entire land of Formosa wherever we would like to be. But if we seek to attain these objectives I believe we should sail on junks to the gold sites in the months of March, April and May, and land over there to prevent our men from becoming powerless from exhaustion from too long a march. The certainty that gold can be found

on the eastern side of Formosa is not only affirmed by the people of Lonckjouw but also by the Spanish, their slaves and by the Chinese who confirm it to be absolutely true.

fol. 262: Those from Vavorolangh, who have requested peace (as has been mentioned in our missive of 21 February)[38], show up every day with bravoura near the Wancan River where the Chinese occupy themselves with fishing and lime burning, sometimes stealing things from the Chinese and, on other occasions, in spite of the fact that one of their chiefs came to Sincan to request for peace, they even kidnap them, molest them or beat the Chinese to death.

According to the reports of the Chinese this headman of Vavorolangh, who had been welcomed extraordinarily well by the Rev. Junius, still was inclined to conclude peace together with about 300 or 400 of his men. He has told the Chinese that as soon as the Dutch appear at Vavorolangh he would glue little pieces of Chinese paper on the houses of his people and disappear with his men into the brushwood without picking a fight against us. In his name the Chinese requested us that if we should come over to burn down Vavorolangh would we be so kind as to leave his houses intact. He would then be able to conclude peace with us. In view of this it seems that some of them rather fear that we might retaliate for their crimes and consequently they are favourably inclined towards peace, however the greater number of them seems still to be more inclined to continue their barbarious habits of murdering and robbing.

This has to be prevented and punished by all means. But due to the fact that it still is raining every day and also because we will not be able to send more than hundred able soldiers we have refrained from doing so. It is rather a large and mighty village for which we need a somewhat bigger force. In the meantime we decided to keep an eye on their coming to Wancan, and we will see if anything remarkable can be undertaken against them which may dampen their arrogance and see to it whether they can not be brought to peace. Otherwise it will be really necessary to humiliate this obstinate village so that the route to Gielim will be safe, from where during this monsoon season a large quantity of deerskins have been transported to China and from there onwards to Japan.

In our missive of 13 March last[39] we mentioned also that the Spanish *padres* in Quelang had already come as far [Gielim] not only convert the inhabitants but (as the Chinese had reported to us then) also to place them

under the authority of the Spanish king. However shortly afterwards we got to know from the Chinese that they had heard that the inhabitants of Tamsuy had attacked the wooden fort at night and had beaten to death about thirty Spaniards while the remainder had managed to escape to Quelang under the cover of darkness. On 21 May this message was confirmed as being true, and it was said that the Castilians everywhere in Quelang were in a state of war with the local inhabitants because they had tried to levy taxes on the local people (by introducing a yearly tribute on every married person consisting of two fowls and three *gantang* of rice), which had caused disturbances everywhere. This situation continues and most of the people of Quelang and Tamsuy have sought refuge in the mountains, while the fortress of Tamsuy is said to have been rebuilt and occupied once more. Soon we hope to receive a more definitive message about the situation there from the crews of the two junks from Amoy who have sailed to the north.

55. Memorandum on the way the people of Lamey are to be allocated over the ships of this fleet.
Tayouan, [...] October 1636.
VOC 1123, fol. 724.

Memorie hoe ende op wat wijse de Lameyers op de scheepen onder deese vloote verdeelt zijn te weeten: 47 mannen, 38 vrouwen, 38 kinderen: zijnde 123 persoonen verdeelt op de scheepen *Bommel* ende *Texel* van de geene die jongst door den luytenant herwaerts sijn gesonden ende haer vrijwillich (onder belofte van vrijdom te genieten) in onse handen begeven hebben.

Zeven mannen, vier vrouwen, één meysken: op 't jacht *Hoochcaspel* mede van de geene die haer vrijwillich in onse handen begeven hebben onder bovengemelde conditiën; 38 jongens op 't jacht *Daman*, 18 manspersoonen op 't jacht *Cleen Bredamme*: deese zijn van de geene die voor desen met de wapenen zijn vercregen. Tesamen 191 persoonen zoo mans, vrouwen als kinderen, die per deese scheepen naar Batavia gaen.

Memorandum how and in what way the Lameyans are allocated over the ships of this fleet: 47 men, 38 women, 38 children: in all 123 persons were allocated over the ships *Bommel* and *Texel*. These are the ones who were recently sent over to Tayouan by the lieutenant, and who have

surrendered voluntarily on the promise that in return they would enjoy freedom.

Seven men, four women, one girl: on the yacht *Hoochcaspel*, belonging also to the group that surrendered itself under the mentioned conditions; 38 boys on the yacht *Daman*, 18 men on the yacht *Cleen Bredamme*: these are the persons who were taken by force. In all there are 191 persons, men, women as well as children, who will embark in these ships heading for Batavia.

56. Missive Reverend Robertus Junius to Governor Hans Putmans. Sincan, 18 October 1636.
TEDING 15, fol. 35.

Op onse aencomste alhier zijn verscheyde oocq alhier met hare clachten verscheenen, onder andren comt mede eenen Kava, die wij een wijle tijts geleden inden huwelijcken staet met eene, Valutoch genaemt, hebben bevesticht, ons verhalende hoe dat hij eenen Sampa, joncman, 's nachts bij zijn vrouw gevonden hadde. Hij verzouckende van zijn vrouw te scheyden en zijn goedren weder te hebbe, dat mij genootsaeckt heeft dese zaecqe te moeten ondersoucken. De vrouwe die met haren man quam gevraegt sijnde, heeft het geloochent ende niet tegenstaende gistren iterativelijck gevraegt ende ondervraegt zijnde, heeft niet tot confessie willen comen. Den boeleerder in de corps de guarde gebracht zijnde, die wij alle de omstandicheden verthoonden die vanden man verstaen hadde, heeft het niet veele bewimpelt maer volcomentlijck bekent dat doen den man hem vont, vleeselijck met haer hadde geconverseert, dat bekende niet alleen voor mij en Joost maer oocq voor twee van zijn bevelhebbers en om de vrou tot bekentenis te brengen hebben heden in presentie van twee outsten den overspeelder bij de overspeelige vrouw gebracht, in welckers presentie hij het weder beleden heeft, seggende tegen de vrouwe: 'waerom wilt ghij 't loogenen, ick hebbe het bekent'. De vrouwe dit gehoort hebbende heeft opgehouden met liegen en de waerheyt beleden, zoo dat dese zaecqe claer is.

Mijns oordeels behooren dese luyden niet alleen als de vorige maer harder gestraft om veel redenen. Ick hebbe gelooft dat het geeselen bij haer meer gegolden zou hebben, soo icq versta vragende daer niet veel naer. Ja, zij zouden gezegt hebben (zoo gesegt wort) die voor desen gegeeselt zijn: 'het doet wel seer eenen dach à 2 maer daer na is 't gedaen'. Met den outsten hier van discourerende, gevoelen met mij 't beter waere in stelle als in

are[40] wierden gestraft, dat is beter waere gegeeselt als haer goet van haer
gehaelt, alsoo arm zijn ende niet veel hebben.

Die van Tevorangh hebben ons vrundelijck verzocht door vijf perzoonen
daertoe uitgezonden dat op haer feest wilden verschijnen alsoo van
meenige waeren ons te onthaelen, dat om mijne occupatiën geëxcuseert
hebben, zullende morgen in mijn plaetse Joost met noch een Duytsman
largeeren alsoo gevoele dit onse gemoederen meer en meer vereenigen
ende de vruntschap vermeerderen zal, dat niet twijffelen UE. aengenaem
wil zijn.

Upon our arrival here several people came forward with complaints.
Among these was one named Kava who, some time ago, had been
confirmed in the state of matrimony with a woman named Valutoch. He
told us that one night he had discovered a young man, Sampa, with his
wife. Therefore he asked to be divorced from her and to have his goods
restored, which urged me to investigate this case. The woman, who
appeared before me together with her husband, denied her adultery upon
questioning. She continued to do so yesterday and, notwithstanding she
had been interrogated frequently, she was not willing to confess. When
we had brought the fornicator into the guardhouse, and confronted him
with all the circumstances as understood from the husband, he did not try
to hide anything, but confessed completely that when the husband found
him he had had sexual intercourse with his wife. He not only confessed it
to me and to Joost but he also told it to two of his headmen, and in order
to bring the woman to a confession we presently confronted the adulterer
with the adultress. He repeated his confession in her presence and said to
her: 'why do you want to deny it as I have already confessed it'. When
the woman heard this she stopped lying and acknowledged the truth, so
that this case has been settled.

It is my opinion that these people should not be brought to justice in the
same way as other adulterers on other occasions, for on this occasion
there are many reasons for imposing a more severe punishment on them.
I used to think that they considered flogging to be quite a penalty but
upon questioning them it turns out to be different. Yes, the culprits who
have received the lashing are supposed to have said (as I was told): 'it
hurts for a day or two, but afterwards it is done'. Having consulted the
elders about a just penalty, I believed that instead of flogging alone, we

should flog them and take away their belongings as well, as they are poor and do not possess much.

Those from Tevorangh have kindly requested us through five delegates whether we would be willing to appear at their party as they intended to entertain us in their village. On account of my engagements, I have excused myself, but I shall send Joost together with another Dutchman to Tevorangh as I am convinced that this will contribute to further unite us and it will increase our mutual friendship, which undoubtedly will be very agreeable to Your Honour.

57. Missive Reverend Robertus Junius to Governor Hans Putmans. Sincan, 22 October 1636.
TEDING 15, fol. 36.

Morgenavont, zijnde donderdach, is den gesetten dach op welcqe gevoele de outste van de noortlijcke ende oostlijcke van ons gelegene dorpen immers enige daervan verschijnen zullen, dewelcke, zoo zijn E. niet verschijnt, lichtelijck een dagh off twee connen opgehouden worden, alsoo eenige lange geleden hier niet sijn geweest en hier zijnde, vinden zullen daermede haer connen recreeren. [...]
Ick hadde gaerne gesien de zaecke vande twee gevangens die van vrijdach aff geseten hebben, hadden connen voor de comste van de outsten affgedaen worden, daerover twee mael aen zijn E. hebbe geschreven ende alsnoch geen antwoorde becomen, ick gevoele dese brieven UE. niet behandicht moeten zijn. [...]
Heden met twee outsten uitgevaren zijnde ontmoeten een Chinees, die inde reviere niet verre van Sincan viste, na sijn brieffken gevraegt liet mij en sien vanden inhout als hier nevens gaet, alleen een andren Chineesen naem zijnde. In 't wederkeeren met onse champan vonden een ander, daervan het briefken hier nevens gaet, die ick om de outste te contenteeren mede nam ende in de corps du guarde gesett hebbe. Hem vragende waerom niet ontrent Taywan viste, gelijck zijn brieffken inhielt, wist niet in te brengen. Zulcqe Chineesen werden hier veel gevonden tot groot miscontement der Sincandren die liever haer reviere vrij hadden opdat al te met selver daer mochten visschen. Wat met desen Chinees zullen doen, gelieve zijn E. ons te ordineeren. Mijns oordeels (zoo 't mochte wesen) waere het Sincan aengenaem zoo van dit visschen mochten bevrijt worden. Ondertusschen zoo 't UE. verstaet soo sal 't geschieden, waerop met den eersten als oock

wat de twee gevangene overspeelders geleert sal worden antwoort verwachten zal.

Tomorrow evening, Thursday, is the fixed day on which I believe some of the elders of the villages situated to the north and to the east of us will certainly visit Sincan. If Your Honour will not appear, I will easily be able to keep them here for another day or two because some of them have not been here for quite a long time and will be glad to be entertained. [...]

I had preferred to have the case of the two captives, who have been in prison since Friday, taken care of before the arrival of the elders. I have twice written about this to Your Honour but have received no reply, which gives me the feeling that perhaps the letters have not properly been delivered to Your Honour [...]

When we sailed out with two elders we encountered a Chinese, who was fishing in the river not far away from Sincan. Upon being asked for his permit, he showed me one with contents I am now sending you: his permit was in the name of another Chinese. When we returned with our sampan we met another Chinese – I send his permit herewith – whom I have arrested and have shut up in the guardhouse, in order to please the elders. When I asked why he was not fishing near Tayouan (as his permit allowed) he had no comment. Such Chinese are often found here to the dismay of the Sincandians, who prefer to have the river free for their own fishing. Your Honour should instruct us how to deal with this Chinese. If I may be allowed to express my judgement, Sincan would prefer to be protected from this [Chinese] fishing. In the meantime I shall act according to your wishes which I shall expect to hear together with your orders on how to punish the two adulterers.

58. Missive Reverends Robertus Junius and Assuerus Hogesteijn to the Batavia Church Council.
Sincan, 27 October 1636.
VOC 1121, fol. 1337-1339.
FORMOSA UNDER THE DUTCH, pp. 149-151.

59. Memorandum or advice by ex-Governor Hans Putmans for his successor, Governor Johan van der Burch, on the day of his departure to Batavia.
Tayouan, 10 November 1636.
VOC 1120, fol. 19-34. Extracts.
See also FORMOSA UNDER THE DUTCH, pp. 152-153; ZENDING, III, pp. 144-146.

fol. 25: [...] De inhabitanten van Formosa dient men geen lasten vooreerst op te leggen:

Comende dan ter voorsz. materie, zoo seggen wij, dat nu en (niettegenstaende d'inwoonders hier te lande groove, plompe, oock vuyle, leelijcke barbaren ende heydenen, nochtans van het natuerlijck (fol. 26) begrijp ende oordeel om het goede uit het quade te onderscheyden ende iets met haer verstandt te vatten en leeren niet vreempt zijn) met goeden toevoorsicht deze swacke teere magen vooreerst met sware spijse van onse veelvuldige Vaderlantsche costuymen ende loffelijcke wetten (alhoewel prijselijck zoo het sonder perijckel van argar daertoe te brengen waere) niet sal durve t'overladen, nochte oock eenige lasten (alsoo onvermogen zijn) van tollen, imposten, forts- als andere ordinarie diensten (gelijck in Amboyna geobserveert wert) opleggen, alsoo door de rebuste wildicheyt deser natie ende lossen bandt van alle geyle, vuyle vrijheyt die onder haer gemeen is, de rechte deucht van eerbaerheyt, rechtvaerdicheyt noch redelijckheyt niet alleene geen plaetse onder haer en heeft, maer oock bij hun voor geheel wreedt, hart ende onverdraechelijck wert gehouden. Dienvolgende deese luyden oock, met een sonderlinge lanckmoedicheyt nu en dan hunne domme faulten wat toegevende ende door de vingeren siende, meest met sachte, soete middelen ende somtijts (alsser authoriteyt vereyst wert) harde sporen, sullen dienen gegouverneert.

Hoe deselve dienen in vrede gecontinueert: Eenige quaetwillige met de staet van de Compagnie oftewel het eene dorp met het andere in questie vervallende, dient men de oorloge op 't alderleelijckste haer af te schilderen ende hun met alle billijcke redenen vooreerst, zoo 't mogelijck zij, terneder te setten ende bevreedigen, gelijck hetselve meest lichtelijck te doen ende tot noch toe gecontinueert is. Doch zoo partieën hun echter gegraveert ende aen het verbandt ofte den getroffen vreede niet en hielden, zoo behoort men onses oordeels de saecke echter (zoo wanneer het eene dorp tegens 't ander doende is, en de Compagnie daer niet veel aengelegen (mitsgaders geen behoorlijcke sufficiënte macht om hun daertoe te constringeeren bij de handt is) ongemerckt, gelijck off men sich daermede

niet verder wilde bemoeyen, te laeten passeeren totdat se den anderen door den oorloge verswackt mitsgaders gekrenckt hebben ende men beter macht ende gelegenheyt vercregen heeft om hier alsdan met authoriteyt daertoe te brengen. Houdende voor een vaste maxime dat het beter is somtijts wat van zijne gerechticheyt voor eenen cleynen tijt te desisteeren, als sich de ongestadige fortuyne ende swaere lasten vanden oorloge (om cleene ofte geringe saecken) lichtvaerdich te onderwerpen. Doch zoo wanneer dese plaetse van een redelijck guarnisoen versien is, sulcx dat den meest schuldichsten naer behooren met des Compagnie's als der bontgenoten macht sonder perijckel can gestraft ende gecorrigeert werden, zoo sal 't selve naer merite van de misdaet tot onderhoudinge van vreede ende ontsach oock dienen bij der hant genomen ende met behoorlijcke respeckt uitgevoert. [...].

fol. 28: Den oversten van Lonckjauw met een joncxken te laten halen: Om meer en beter kennisse te crijgen van de gestalte deses eylants ende waerontrent het gout, dat zoowel bij de Spangjaerden als Chineesen ende inwoonders geconfirmeert wert aen d'oostzijde in 't geberchte is vallende, dient, hoe eer hoe beter, beseyndinge met een cleen joncxken ende twee à drie Hollanders mitsgaders eenige daerontrent bekende Chineesen naer Lonckjauw (dat bestaet in 16 dorpen) gedaen, omme het oppperhooft aldaer, tot confirmatie van onsen begonnen vreede (gelijck alreets voordesen belooft heeft selve te verschijnen), herwaerts te bringen ende wijders van zijne vijanden de Pimabaers (die aen de inwoonders daer 't goudt is vallende, (fol. 29) naer 't seggen der Chineesen, zoude grensen) in 't breeder spreecken.

Wij en twijffelen niet, ofte men sal door eenige Chineesen die 't geheele landt doorswerven, den vreede tussen die van Pimaba ende de Lonckjauwers in 't soete aenradinge oock connen treffen ende zoo voorts naer de goudtmhijne geraecken, ofte ten minsten seecker bescheyt vandaer becomen, hetwelcke te ondersoecken U Ed. per instructie oock op het serieuste wert gerecommandeert.

't Zoude onses oordeels oock niet ongeraeden zijn, dat men desen oversten van Lonckjauw voorstelde off zijn landt, gelijck alle andere dorpen meest gedaen hebben, aen de Hoog Mogende Heren Staten Generael wilde opdragen; doch zoo men vermerckt iets daertegens heeft, dient men 't selve te laten varen ende tot naerder gelegentheyt uit te stellen.

Belangende die van Taccareyang, Dolatock, Tapouliangh ende veel meer andere dorpen om de zuyt gelegen, gelijck U Ed. bekent is, houden haer stil ende thoonen haer gants vreet- ende gehoorsaem, mitsgaders gewillich.

Alleene die van Vavorollangh verthoonen haer noch viantlijck: Alleene die van Vavorolang om de noort gelegen, hebben, naerdat onsen vreede 't voorleden mouson versocht hadden, hun 't sedert tot verscheyde reysen in Wanckan onder de Chineesen vrij wat vreempt aengesteld sulcx dat wel nodich waeren zijluyden daerover naer merite wierde gecastijt. Maer alsoo den wech te water ons onbekent ende volgens de rapporten vanden luytenant (die jongst om de gelegentheyt te ondersoecken gecommitteert heeft geweest) gants onbequaem ende ditto plaetse vrij verder van hier gelegen is, zal 't selve over Mattauw te lande seer beswaerlijck met zoo weynich volck als men present can maecken connen geschieden, zoo om den staet van de Generaele Compagnie alhier in dit quartier niet te periculiteren, als de loffelijcke authoriteyt en de vercregene victorie (met een de minste nederlaege) niet wederom te verminderen ende te krencken.

Ten waere de vijff te verwachtene scheepen *Noortwijck*, *Oudewater*, *Swaen*, *Schagen* ende *Huysduynen* hier gelijck uit Japan voor den 15en november aenstaende quaemen te arriveren ende alsdan twee compagniën soldaten (mits de matroosen in 't fort treckende) conden uitgemaeckt (fol. 30) werden, als wanneer wij oock niet en twijffelen ofte alles (Godt de Voorste) zoude tot wijder uitbreydinghe onser lemyten als vergrootinge in den handel van de hartevellen connen voltrocken ende bij der handt genomen werden.

De vrede met hun te besluyten, soo sulcx versoecken: Wij presumeeren ende verhoopen oock, naer dat dese Vavorollangers uit de Chineesen verstaen sullen hebben, dat inspectie van haer wegen door d'onse zij genomen, wel lichtelijck door vreese (als zijnde een seer opgeblasen doch vreesachtige natie) den vreede weder sullen versoecken, dat in dese conjuncture om ons respect te behouden (nu geen sonderlinge macht van wel geoeffende soldaten bij der handt hebben), gants wel ende nuttelijck voor de Generale Compagnie zouden comen, mits den vreede op billijcke conditiën hun toestaen [...].

fol. 25: [...] [In the margin] For the time being taxes should not be levied on the inhabitants of Formosa: Coming to this subject we would like to mention that (notwithstanding that the people of this land are rude, blunt, filthy as well as ugly barbarians and pagans, yet they have a natural (fol. 26) understanding and conception of how to discriminate between right and wrong and to comprehend something with their minds, and they are willing to learn something) any judgement we make should not administer these weak stomachs with an overdose of the victuals of our multiple national customs and praiseworthy laws (although it surely would be

laudable if we could do so without running the risk of irritating them), nor should we impose any levies on them such as tolls or impositions (because they are impecunious), or force them to do service on the [construction works in the] forts or similar public duties (as it is done in Amboyna). Because as a result of the robust wildness of this nation and the loose ties of all the lascivious shameless freedom which is the general rule among them, the right morals of virtue, justice or reasonableness do not exist among them; what is more, any such punishment would be considered unacceptably cruel and unbearable. Consequently these people should be governed with extraordinary lenience, forgiving them and making many allowances for stupid errors, yet whenever authority is demanded spurs are certainly required.

[In the margin] How peace with them should be continued: Whenever trouble arises, either between ill-willed people and the Company, or one village and another, war should be depicted in the most repugnant manner and, if possible, we should try to pacify them with reasonable motives and negotiate peace with them which has been practised so far and is not so hard to do. But if a conflict between parties has deteriorated, if they do not adhere to the peace agreement (in case one village raises up arms against the other and it doesn't have direct consequences to the Company), then we believe we should let things take their natural course (because we have insufficient power to force them to stop fighting) and pretend we do not care, until the two parties fighting have exhausted each other in the war, and we have found a better opportunity to discipline them. I adhere to the maxim that sometimes it is better to play down the enforcement of justice for a while than to submit oneself rashly to the uncertain fortunes and heavy burdens of war. Yet, as soon as this place has a considerable garrison, then the guilty ones may receive their proper punishment at the hands of the Company and its allies without any problem. Then according to the committed crime punishment will be meted out with decent respect in order to maintain peace and authority. [...].

fol. 28: [...] [in the margin] To send for the chief of Lonckjouw by junk:
In order to get a better knowledge of the situation of this island and the locations where gold can be found, as has been confirmed by the Spaniards as well as by the Chinese and the local inhabitants as being on the eastern side of the mountains, we should send forthwith a small party

consisting of two or three Dutchmen (together with some Chinese familiar with the local affairs) on a small junk to Lonckjouw (which consists of 16 villages) to pick up the chief (who has already promised to come over to Tayouan himself) so as to show him our good intentions and to confirm the peace agreement. Over here he will also be able to inform us about his enemies from Pimaba (its territory, according to the Chinese, is situated next to that of the inhabitants on whose land the goldfields are supposed to be found).

fol. 29: We do not doubt that we can, with the help of some Chinese, who travel the whole countryside, manage to cajole the people from Pimaba and Lonckjouw to start peace talks, so that we will be able to approach the goldmines or at least get a little more information about the sites, as is also seriously recommended to Your Honour in the instruction [you have received from the Governor-General].

We believe also, that it would not be inexpedient to propose the headman of Lonckjouw to dedicate his land, just as all the other villages have already done, to the High Mighty Gentlemen of the States General. If however it should become clear that he is not inclined to do so, then one should postpone this until later when a better opportunity presents itself.

As Your Honour knows Taccarreyang, Dolatock, Tapouliang and a lot of other villages situated in the south keep themselves quiet and behave peacefully, obediently and willingly.

[In the margin]: Only those of Vavorolangh still behave in a hostile manner: Only those of Vavorolangh (situated in the north), after they requested us for peace last monsoon, have on different occasions acted quite strangely against the Chinese in Wancan, so that they deserve to be chastised accordingly. But because the water route is unknown to us and the overland route, as advised by the lieutenant (who was recently sent over there in order to explore the situation), was totally impassable, and because that place is situated at rather a great distance from here, it will be difficult to reach by way of Mattouw, with the few men who are presently available for such an expedition; that is if we do not want to risk and harm the position of the General Company and all the laudable authority and victory already obtained without suffering one single defeat. If, however, the five ships *Noortwijck*, *Oudewater*, *Swaen*, *Schagen* and *Huysduynen* arrive here from Japan before 15 November next, then two companies of soldiers (provided that the sailors will move into the

fortress) can be put together. (fol. 30) If that is the case, we do not doubt that everything (God the first) can be accomplished to extend our boundaries as well as to take up and expand the trade in deerskins.

[In the margin] To conclude peace with them if they request it: We also hope and presume, that as soon as we will send an expedition army to their village (as the Vavorolangians have understood from the Chinese that we intend to do), they will out of fear request for peace once more. Given the circumstances (because we are presently not able to form a considerable force owing to a lack of soldiers at our disposal) it will be very good and beneficial to the General Company to conclude peace with them on fair conditions.

60. Missive Governor Jan van der Burch to Governor-General Anthonio van Diemen.
Tayouan, 14 November 1636.
VOC 1120, fol. 334-364. Extracts.
See also FORMOSA UNDER THE DUTCH, pp. 151-152; ZENDING, III, pp. 141-143.

fol. 341: Het dorp Vavorolang, daervan in mijne generale missive mentie maeckte van dat sich tegens onse staet opposeerde, is de saecke dienaengaende bij onsen voorsaet in naerder consideratie genomen ende bij den raet goet gevonden den luytenant met vijftig soldaten te committeren, omme haer gelegentheyt af te sien, dat bequamelijck (soo eenige meenden) met twee Sincanders, die kennisse van den wegh hadden, te water zoude connen geschieden, omme naer bevindinge van saecken daerop te resolveren in wat voegen men deselve met hulpe van onse subjecten zoude aentasten ende onder onse gehoorsaemheyt brengen. Sijnde dit Vavorolang (fol. 342) een dorp daer niet alleenelijck veel hartevellen vallen, maer de daerontrent gelegene dorpen oock veel sijn gevende. Die daerdoor passeren moeten, ende in oorloge blijvende soude den toevoer in 't voorsz. dorp connen gestut werden, dat met de beste middel moet voorgecomen werden.

Hierop comt den luytenant voorsz. den 13en october passato van 't gemelte dorp weder terugge, rapporterende dat geen rechte toeganck van de gelegentheyt des wechs te water hadde connen vinden. Hadden bijnoorden Wanckan een soute riviere gerescontreert, alwaer soo weynich water bevont, dat met de champantgens niet anders als met 't hoogste water passeren conden ende sulcx noch soo traegh, dat drie à vier dagen hadde

doorgebracht ende noyt sooveel gevordert, dat de reduyt in Wanckan uyt het gesicht hadden connen raken. Wanneer dan noch de wegh in zee uytquam, daer de stortinge sich soodanig verthoonde, dat resolveerde liever terugge te varen, als door deselve barning net soo een voorsiende perijckel te passeren. Waerbij ons genoegsaem bleeck, met de tocht te water voor ons niet te doen waere ende consequentelijck te lande soude moeten geschieden. […].

fol. 347: Soo heeft sich verthoont den luytenant Jan Jeuriaensz. die hem wel geerne zeven à acht jaeren in de dienst van de generaele Compagnie noch wil verbinden […]. Sijn met denselven soo verde in gespreck gecomen, dat hem […] eerstdaegs na Sincang transporteren zal, bij domine Junio, om de spraecke te leeren, onder den naem van dat derwaerts gaet leggen om de visite der dorpen te doen, dat onderwijlen van hem oock geschieden sal. […].

fol. 341: The case of the village of Vavorolangh, about which in my general missive I have mentioned that it opposed itself against our presence, has been looked into by my predecessor; it was resolved by the Council to order the lieutenant together with fifty soldiers to investigate their state of defence and the local situation, something which, according to some, could be accomplished best over sea with the assistance of two Sincandians who are well acquainted with the area. On basis of the findings it can then be decided how, with the help of our subjects, they may be attacked and be brought under our control [in the future].

Not only Vavorolangh (fol. 342) but also the neighbouring villages deliver many deerskins. In case of war this village could stop the transit of deerskins, which we must prevent by every means available.

On 13 October the lieutenant returned from the mentioned village. He reported to us that he had not been able to find the right course to reach the entrance of the village by water. He had found a salt water river to the north of Wancan, but it contained so little water that even with the small sampans they could only pass it at high tide, which took them so long that after three or four days the redoubt of Wancan was still in sight. When they at last reached the mouth of this river they saw a very dangerous surf. They resolved that it would be better to return, instead of exposing themselves to such breakers. From this it became clear that it would not be possible for us to use the water route; consequently we had to focus on the land route. […][41]

fol. 347: Lieutenant Jan Jeurriaensz had himself indicated that he would like to be employed for another seven or eight years in the service of the general Company. We agreed to send him soon to Sincan to learn with Reverend Junius the local language under the pretext that he is stationed there in order to visit the villages, which in the meantime he will also carry out.

61. Resolution taken by Governor Johan van der Burch and the Formosa Council.
Tayouan, 25 November 1636.
VOC 1123, fol. 788.

fol. 788: [...] Door domine Junio, predicant in Sincan, vandaer op gistren alhier gecomen seeckere aengedient wesende, hoe dat die van Lonckiauw om de suyt met ons in een onverbreeckelijcke altijt duyrende vreede te comen ten hoogsten inclinerende waren, daer toe den geenen die voorsz. plaets als opperhooft regerende is presenteert sich in persoon herwaerts te transporteren omme daervan behoorlijck ende op 't bondigste te tracteren mits dat men op sijn versouck een joncqen senden zoude waermede gevoeggelijck overcomen mochte. Ende dewijle dese occasie niet dienden voorbij te gaen om alle naeburige dorpen hoe langer hoe meer t'onswaerts ende tot vrede te trecken ende des Compagnies limiten op Ilha Formosa te vergrootten, opdat eyndelijck de consequente voordeelen daervan trecken mogen, wort eenpariglijck goetgevonden dat men een joncqen met Chineesen gemant naer Lonckjouw ten fijne als vooren metten eersten weeder en wint toelatende depescheren sal [...].

fol. 788: [...] Yesterday Reverend Junius, minister in Sincan, arrived here and told us that he had been assured that the people from Lonckjouw in the south are very much inclined to conclude an indissoluble, everlasting peace with us. The ruler of that place declares himself to be ready to come over to Tayouan in person to negotiate the conclusive treaty, provided that we send him a small junk (when he requires it) in which he can suitably make the journey. Because we ought not let slip this occasion to strengthen the alliance with all the neighbouring villages and thus extend the Company's boundaries on Formosa, it was decided by unanimous vote, in order to reap the consequent profits of peace, to send

a junk with a Chinese crew over to Loncjouw for the mentioned purpose, as soon as weather and wind allows us to do so.

62. Dagregister Zeelandia, 1 November 1636-17 October 1637.
VOC 1123, fol. 835-912. Summary.
DRZ, I, pp. 289-295.
See also FORMOSA UNDER THE DUTCH, **pp. 154-157;** ZENDING, **III, pp. 147-152.**

(Corporal Sprosman, who was stationed in Pangsoya, arrived in Zeelandia on 27 November accompanied by four headmen: Tacomey of Pangsoya and Nalialiach, Tamarowey of Sengwen, a village near Pangsoya, Ticcarovang of Jamick and Tivorongol of Tararahey. They came to pay their respects to the governor. On 14 December, the ruler of Lonckjouw, accompanied by his brother, his brother-in-law, one of his councillors and a retinue of thirty people, came to request peace. On 20 December, the headmen of seven villages situated in the Dae mountains: Taraquang, Honavahey, Hovongoron Goroy, Dedakiang, Hosakasakey, Houagejagejang and Hopourourey, situated to the east of Taccareyang, appeared at the castle to subject themselves officially to the VOC.)[42]

63. General Missive, 28 December 1636.
VOC 1119, fol. 158, 164, 243. Extracts.
FORMOSA, **pp. 156-157, 160-161, 167.**

1637

64. Resolution taken by Governor Johan van der Burch and the Formosa Council.
Tayouan, 31 January 1637.
VOC 1123, fol. 796.

fol. 796: Alsoo nu onlangs tot een absoluyten vrede gecomen sijn met het vorstendom Loncqiauw, bestaende in een getal van 17 wel gepeupleerde dorpen grensende aen 't landt Pibamba waermede in oorlooge sijn, sulx oock doen die van Pibamba met Cavolan, off de plaetse daer ontrent men successivelijck verneemt de verhoopte goutmineralen sijn gelegen, ende omme daervan eenmael met fondament geïnformeert te mogen worden, is goetgevonden één uyt deser vergaderinge na Loncqiauw te committeeren die sich op alles wel inquirerende de Loncqiauwers met alle discretie dienaengaende hooren ende wijders is 't doenlijck die van Pibamba onsen vrede oock aanbieden [...] omme soo eyndelijc voorsz. goutminerale, door een bequame deur te connen aentreffen, wort daertoe geëligeert ende genomineert den lieutenant Jan Jeuriaensz d'welcke hem sonder uytstel van tijt, weder en wint sulx toelatende, met 's Comp. joncqen [...] na Loncqiauw transporteren zal; mits hem alvorens tot assistentie den tolcq Cambing, Chinees, en vijf à zes soldaten tot sijne suitte, om wat meerder aansiens te maecken toevougende; dat oock gemelten luytenant in Taccareiang ende de andere naest geleegenen dorpen sich vervouge d'opperhoofden derselver plaetse uyt de naem van den gouverneur neffens een geringe te doene schenckagie op 't vrundelijckst begroeten, ende hun gesamentlijck, vorders tot continuatie van gehoorsaemheyt aenmanen sal. [...].

fol. 796: Because we recently concluded a definite peace with the principality of Lonckjouw, consisting of 17 quite densely populated villages, adjacent to Pimaba, and because Lonckjouw is at war with Pimaba just as Pimaba wages war on Cavelangh (the place where the supposed gold-mines are situated) therefore it was decided to commit one person out of this general meeting to Lonckjouw in order to gain sufficient information and inquire amongst the Lonckjouw people with due discretion whether we could possibly propose peace to the people of Pimaba as well, with the ultimate purpose of opening the door to the

mentioned gold-mines. Lieutenant Jan Jeurriaensz was appointed to travel without delay to Lonckjouw on the Company junk. In order to add some prestige to his assignment he will be accompanied by a squad of five or six soldiers and the Chinese Cambing will serve as his interpreter. The mentioned lieutenant is also ordered to visit Taccareyang and some of the other neighbouring villages with the commission to pay his respects in the name of the governor to the headmen, and to extend his greetings to them with some small gifts and to urge them all to continue their obedience to the Company. [...].

65. Instruction from Governor Jan van der Burch to Lieutenant Johan Jurriaensz on his departure as an emissary to Lamey, Lonckjouw and Taccareyang.
Tayouan, 3 February 1637.
VOC 1170, fol. 631-635.

fol. 631: Alsoo met de persoonele verschijninge van den vorst van Loncquiauw ende heer van 16 à 17 dorpen, den voordesen versochte vrede tusschen de Generale Vereenigde Oostindische Compagnie ende sijn landt den 14en december passado genoegsaem is bevesticht geworden, doordien t'sijnen aenweesen alhier aenden Nederlandtsen staet hun altoos beloofden als goede getrouwe onderdanen ende bondgenoten te dragen, ende onder onse gehoorsaemheyt te submitteren, soo meenden wij een deure geopent en wechbereyt te hebben omme metter tijt kennisse te bekomen waer het goudt valt [...].

fol. 632: De sekerheyt van 't goudt daer omtrent sijnde (Cavolangh om d'oost van Quelangh), wert oock bij de Loncqiauwers sterck geaffirmeert ende men bericht ons dat dese plaets aen d'oostsijde van Formosa voor schepen noch voor joncken geen anckergrondt maer een seer barre ende clipachtige custe is, ende dienvolgende te water aen te doen seer periculeus, dat wijders gemelte goudt niet uyt 't gebergte maer uyt sekere revier gehaeldt wert, sulcx gemelte Loncqiauwers een seeckeren tijt geleden van dese hare vijanden een dorp vermeestert ende eenich goudt doenmaels oocq bequamen, souden gesien hebben.

De principaele insichten van onsen voorsaet, den heere Hans Putmans, en den raet deser plaetse om met een vorst van Loncqiauw in vrede te leven, sijn geweest ten eynde allenxkens tot klaerder kennisse van dese saecke souden geraecken ende oock onsen naem soo langs soo meer onder dese brutale natie uyt te breyden en kontbaer te maecken, mitsgaders dese arme

menschen naerder sielen mettertijt tot beter civiliteyt ende soo 't Godt Almachtich gelieffde te segenen, eyndelinge tot het christengelooff te brengen. Sulcx dat de saecke door domino Junio soo verde gebracht sij dat op onser aencomste in goede terme van vrede stonden, sijnde de vorst sijn broeder, voor desen alhier geweest en weder met contentement vertrocken omme onse goede genegentheyt tot den vrede sijn broeder aen te condigen, ende alsoo den wech tot goede vereeninge te prepareren.

Onderwijlen naerder kennisse waer het goudt valt becomen hebbende, sijn wij bericht dat dese plaetse omtrent drie à vier dagen reysens van Loncqiauw om de noort gelegen leyt ende voeren dese Loncqiauwers oorloge tegens die van Pibamba de welcke in vijantschap sijn tegens die natie in wiens landt dit goudt valt; ende soude den vorst van Loncqiauw geerne sien dat wij den vrede, die van Pibamba souden aenbieden omme, ingevalle deselve weygerde t'accepteren, wij redenen mochten hebben haer den oorloge aen te doen; ende blijft dien roup continueren dat den wech om Pibamba te water aen te doen te periculeus sij, maer te lande wel gelegen. Wij sijn oock bericht dat die van Pibamba mede verscheyden stucken goudts van haer vijandt daer 't goudt valt verovert hebben ende eenige van ons sijn hier die hetselve gesien hebben [...]

fol. 633: [...] dat den vorst selffs in persoon met sijn suitte hier geweest sijnde den versochten vrede met ons beslooten ende met goet genoegen onthaelt, à contento weder vertrocken ende op ons versocht heeft tot meerder confirmatie desselfs vreede, wij wilden per eerste gelegentheyt Ued. in persoon derwaerts senden, ten eynde van sijner sijde U soodanich tractement van onsentwegen mochte aendoen, als verclaerden hem in sijn regard gedaen hadden.

Sulcx dat wij om voorige consideratie met onsen rade goetgevonden hebben Ued. persoon als commissaris uyt onsen rade derwaerts te committeren [...]. Ende ten eynde in voorvallende gelegentheyt niet sout verlegen vallen soo hebben wij Ued. toegevoecht onsen tolcq Cambingh, die de Lameytse spraecke wel kunnende Ued. behulpich wesen kan, sulcx wij te meer aen hem dese saecke hebben willen vertrouwen, omdat hij een gegageert tolcq van de Comp. wesende, dit ons dessein te secreter soude blijven ende soo weynich ruchtbaer werden als doenelijck. Met lieff in Loncqiauw gecomen wesende sult den vorst ende heer desselfs plaetse hartelijck groeten ende hem van onsentwegen veel goets toewensen. Die Ued. tot een teken van ons goede genegentheyt t'hemwaerts dit nevensgaende goude ringsken behandigen sult, omme ons daer mede te gedencken, seggende dat Ued. gesonden wort op sijn versoeck ende onse gedane toesegginge, tot meerder confirmatie van onse aengegane vrede op

den 14^{en} december passato met onser beyder handtgevingen becrachticht. Soo bij gelegentheyt met denselven in discourse comende, cont soetelijck en met discretie vernemen, wat vijanden om de noordt van hem gelegen is hebbende, ende off men deselve niet soude connen bevredigen, ondertusschen wel lettende wat mijnen dese aengaende is maeckende. Ingevalle Ued. dan vermerckte daer tegens hadde, dient hetselve niet verder aen te roeren maer allegre sijnde de saecke vorders poucheren, goede acht nemende op d'antwoorde Ued. is gevende, ende daer naer in discours formeren. Wij sijn van gevoelen dat om de broeder te sonderen wel het geraetsaemste soude wesen, daer Ued. geduyrende sijn aenweesen alhier groote vrijmoedicheyt tegens gebruyct hebt ende denselven sich wat blijgeestiger als den vorst selffs van natuyre is thoonende, doch willen wij Ued. hieraen niet precijs binden, maer sijt voorsichtich U discoursen wel gebruyckende.

Spreeckende dan van die van Pimaba, dat wel souden willen op U nemen die met hem te bevredigen, doch geensints dient Ued. onsen naem te gebruycken maer dat van op uwe seyt, als 't maer den vorst behaecht wij daeraen een welgevallen nemen sullen, dan voorts gaende tot die plaetse daer 't (fol. 634) goudt valt hoe sterck van volcq daer sijn, wat wech om tot den selven te comen moet genomen werden, hoe ver van Pimaba gelegen, wat geweer dat hebben, om wat redenen tegens Pimaba oorlogh voeren, ende off men die niet soude konnen bevredigen, off andersints den oorloch aenseggen [...]. Presenteerende U persoon omme met die van Pimaba te spreecken, Ja tracht te wercken, dat versoecken twee à drie gecommitteerde van Pimaba, nevens U, tot ons te brengen omme de vrede tusschen die van Pimaba als Loncqiauw in onse presentie te becrachtigen ende voorts gedurichlijck in lieffde, vrede en eenicheyt met den anderen te leven [...].

Ende sult Ued. dan meteen en passant na Tacareyangh, Dolatocq, (fol. 635) Tapoeliangh als andere om de zuyt gelegene dorpen [gaan]. Vereysen tot dien eynde Tacquamey, opperste van Pangsoya met den corporaal Warnaer Sprosman mede nemende, om Ued. den wech aentewijsen ende dat de visite behoorelijck in de beste forma soude geschieden. [...].

fol. 631: Following the personal appearance at Zeelandia Castle of the ruler of Lonckjouw and lord of 16 or 17 other villages on the 14th of December, the requested peace between the General United East India Company and his country has been effectively concluded; this came about because, while he was present over here, he promised that his people will always behave as loyal subjects and allies to the Dutch State and submit

themselves with obedience, we believe that the door has been opened and the way has been cleared to find out presently where the gold sites may be. [...]

fol. 632: That gold can certainly be found about Cavelangh, to the east of Quelang, is also strongly confirmed by the people from Lonckjouw. They also inform us that the eastern shore of Formosa has no suitable place for ships or junks to anchor, and that it is a very rough and rocky coast and therefore very difficult to reach by sea. The Lonckjouw people had seen that the gold was not found in the mountains but was reclaimed from a certain river, when some time ago they conquered their enemies in a certain village, they got hold of some gold.

The principal aims of our predecessor, Mr. Hans Putmans, and the Council of this place, were to live in peace with the ruler of Lonckjouw, and eventually gain a better knowledge of this issue as well as to spread our reputation and make it widely known among this brutish nation, and thus see whether the souls of these poor people can in due time be rendered more civil and if the Almighty Lord will give them His blessings, and whether they can finally be converted to the Christian Faith. Upon our arrival in Tayouan we realised that the Reverend Junius had already achieved a situation in which we could live on friendly terms in peace. The ruler's brother had already visited Tayouan and had left again contentedly to proclaim to his brother our positive inclination towards peace and to prepare the road towards unity.

Meanwhile we gained better knowledge about the site where gold could be mined. It was reported to us that this place is situated three or four days away to the north of Lonckjouw, and that these villages wage war on those from Pimaba who are in turn hostile towards the inhabitants of the nation where the gold can be found. The ruler of Lonckjouw would be pleased to see that in case our peace offer to the inhabitants of Pimaba is rebuffed, we may feel justified to start a war against them. Also it is confirmed that it is too difficult to reach Pimaba by the sea route, but that travelling overland is no problem. We had another message that those of Pimaba captured several nuggets of gold from the enemy of the gold region and that a few of us here have seen them. [...]

fol. 633: [...] now that the ruler has come to Tayouan in person with his followers and has concluded peace with us, and has departed contentedly after being entertained to his satisfaction, he requested us to send an

emissary, as the further confirmation of this peace. We now intend to send, on the first possible occasion, Your Honour in person, so that he may offer you (as our representative) as warm a welcome in return as he himself says he met with while being here. From these considerations we have agreed to send Your Honour as a delegate from our Council.

(On the way to Lonckjouw Jurriaensz will also have to pay a visit to Lamey) and to save you from possible embarrassment we have ordered the interpreter Cambingh, who is fluent in the language of Lamey, to assist you. We have entrusted him this assignment, because he is enlisted as interpreter on the Company's payroll, therefore we can be sure that our plan may be kept secret and receive as little publicity as possible. As soon as Your Honour has arrived in Lonckjouw, you will offer the ruler and lord of that place our sincere regards and give him our best wishes. At the same time you will present the enclosed small gold ring to him as a memento. You may tell him that you have been sent on his request and on our pledges to further confirm the peace we concluded on the 14th of December last, which was ratified by both our signatures. If you should have the opportunity to enter into discourse with him, you should, with kind words and discretion, try to find out more about his enemies in the north and whether we cannot make peace with them. In the meantime you should pay attention to his expression in reaction. If Your Honour should notice that the ruler should be opposed against [this peace-making], then you should not mention the issue anymore but cheerfully change the subject and with zest continue with other matters. You should pay attention to his answers and direct your response to his words. We do feel that it would be best if you could manage to sound out his brother privately, as Your Honour acted very frankly towards him during his stay over here, and because his nature seems to be more cheerful than that of his brother. Though we do not want to tie you too precisely to these instructions, we want you to be careful while you speak. As far as the people of Pimaba are concerned, you should tell him that you yourself would be willing to mediate in bringing peace between Pimaba and Lonckjouw. However you should never mention our name but intimate that you are acting on your own discretion and that whatever pleases the ruler best, will be favoured by the Company. Then you should continue the conversation by asking information about the area where the gold is mined, (fol. 634) how many people are living there, what road should be

taken to reach that destination and how far away it is from Pimaba, what weapons the inhabitants use and why they are at war with Pimaba, and whether peace cannot be reached, or whether we should instead declare war on them. [...] You could then volunteer to open negotiations with Pimaba. Yes, try to reach a situation where they will request you to arrange for two or three delegates from Pimaba to go along with you to Tayouan so that an agreement between Pimaba and Lonckjouw can be concluded in our presence so that from then on they will continuously live in love, peace and harmony with each other. [...]

(Afterwards he should return with the small junk via Lamey and Pangsoya back to Tayouan. Nevertheless he himself should go ashore in Pangsoya and continue his journey overland) and then Your Honour should immediately travel on and, on the way, visit Taccareyang, Dolatock, (fol. 635) Tapouliang and the other villages situated in the south. It will be necessary to take along with you Tacquamey, chief of Pangsoya, and corporal Warnaer Sprosman, to act as your guide so that the visitation will take place properly in the best possible way. [...]

66. Dagregister Zeelandia, 17, 18 February 1637.
VOC 1123, fol. 835-912. Summary.
DRZ, I, pp. 307-308.

(When Lieutenant Johan Jurriaensz arrived on 5 February in Lonckjouw, he was welcomed by the ruler of Lonckjouw, his brother and a party of fifty persons, and was taken to Dolaswack, one of the ruler's villages, where he was lodged in the ruler's house. As confirmation of the treaty, concluded the preceding year with the governor on behalf of the Company, the ruler was offered a gold ring and some presents for his wife, his daughter and his brother. On his inquiries about the gold deposits, Jurriaensz was told by the people of Lonckjouw that the mineral could be mined eastward of Pimaba. He was also informed that if he desired to reach those places it was necessary first to take up arms against the two arch-enemies of Lonckjouw: Tawalij, a village situated at about twenty miles to the north, that could only bring a hundred warriors into the field, and Pimaba, located another six or seven miles to the north, which could recruit about 1000 men. In order to carry out a successful expedition against those villages the ruler of Lonckjouw offered

the lieutenant that he would send a force of 960 men along together with a guide. He also was willing to provide the whole army with sufficient provisions. On 18 February Jurriaensz returned to Tayouan accompanied by five of the principal inhabitants of Taccareyang and Dolatock, as well as one headman of Tolasoy, a village of about 400 houses, situated to the east of Taccareyang and known to be former enemies. Upon the joint request of these envoys peace was concluded with the Company.)

67. Dagregister Zeelandia. Extracts concerning Lamey.
VOC 1170, fol. 617. Extract 17 February 1637.[43] Also in: VOC 1123, fol. 859.
DRZ, I, p. 307.

> fol. 617: Met 't jonckjen Loncjauw dat 't Lameyers eylandt en passant hadde aengedaen, becoomen mede schrijvens van Jan Barentsz sergiandt over ons guarnisoen aldaer, daeruyt verstaen [...] dat noch verscheyde inwoonderen haer op voorschr. eylandt onthouden in speloncken ende elders. [...].

fol. 617: With the small junk Lonckjauw, that *en passant* had called at Lamey, we received also a letter from Sergeant Jan Barentsz, commander over the Company's garrison quartered over there. He informs us that several inhabitants are still living on the mentioned island, in caverns and elsewhere. [...]

68. Dagregister Zeelandia, 27 February, 13 March 1637.
VOC 1123, fol. 835-912. Summary.
DRZ, I, pp. 311, 318-319

(On 27 February Lieutenant Jurriaensz returned, having been requested to escort the headman of Tolasoy (named Tamasadoy) back to his village. He reported that he had managed to travel another three miles eastward into the mountains to a certain village named Talacobos in the local language. The population of Talacobos, (the chief was called Tartar), consisted of about 2000 people, both men, women and children, all sturdily built. The women were of quite a fair complexion, in fact they were more fair-skinned then those of Tolasoy and with more refined manners. The houses were built of stones hewn out of the cliffs. Some green ginger was

cultivated in the neighbourhood and the lieutenant had seriously urged the villagers to extend the planting. On 13 March a message reached Tayouan that a group of twenty armed Mattouw warriors had returned from a victorious raid to Vavorolangh. They had obtained three enemy heads.)

69. Resolutions taken by Governor Johan van der Burch and the Formosa Council.
Tayouan, 15, 22 April 1637.
VOC 1123, fol. 807-811.

fol. 807: [...] [15 April] de reyse door Loncqiauw, sijnde de naeste ende bequamste wegh na Pibamba, dat te lande geschieden moet, seer beswaerlijck can aengewent ende volvoert worden, alsoo Pibamba ongeveer de dertig mijlen noordelijcq van Loncqiauw aende oversijde van 't gebergte leyt, dat men desen tocht oock niet anders dan met een aensienelijcke macht van volck soude connen aenveerden, omme soodanige dorpen als met de Loncqiauwers ende andere onse bondgenoten noch in oorloge sijn tot vrede ende gehoorsaemheyt te brengen, waertoe als nu vermits de overheyt van onse presente guarnisoen niet contribueren connen niettegenstaende de Loncqiouwers tot het aengeven der wapenen seer sijn aenradende, derhalven gelet [...] (fol. 808) men veel gevoegelijcker te water als te lande vermits de grootte distance des wegs, Pibamba can aenlangen. [...] Hiertoe [is] uyt onse vergaderinge genomineert den oppercoopman Cornelis van Sanen die hem met het jonxken dat daertoe al [...] aengeleyt is ten eersten [...] derwaerts transporteren sal mits voorsz. joncjen te mannen met 12 Nederlanderen ende 15 Chinesen, item voor den tijt van twee maenden te provideren, van ammonitie van oorloge ende andere nootlicheden behoorlijck te versien, mitgaders daer beneffens voorsz. Van Sanen eenige dienstige cleyne schenckagiën voor de grootten van Pibamba mede te geven. [...].

fol. 810: [22 April] Alsoo, Gode sij loff, die het werck vande bekeeringe der heydenen door domine Junio als een goet instrument soodanigh segent dat die van Mattauw, Soulang ende Baccluang, al eenigen tijt geleden hebben beginnen te solliciteren haer doch van schoolmeesters soodanigh wilden versien [op] dat sij luyden hare kinderen inde leere Jesu Christo mochten werden geleert; also voortaen genegen waren Godt alleen te dienen waertoe al seeckeren tijd geleden hare afgoden hadden verworpen.

Dat wijders gemelten do. Junio ons voorgedragen heeft hoe noodigh 't principaelste dorp Pangsoya, omde zuyt gelegen, insgelijx de

omherleggende dorpen, Dolatocq, Verovorangh in de reviere Tamsuy, mede mochten yder van een schoolmeester versien werden, aengesien ons door den corporael Warnaer Sprosman die aldaer 1½ jaer omde spraeck te leeren gelegen heeft verseeckert worden aldaer vrij wat goets in 't werck vande bekeering der heydenen te verrichten sij, ende dat gemelten do. Junio versouct persoonelijck na Pangsoya mochte verreysen omme dit werck een goet begin te geven.

fol. 807: [...] [15 April] The travel route through Lonckjouw is the quickest and most convenient way to reach Pimaba. Yet because Pimaba is located about thirty miles to the north of Lonckjouw on the opposite side of the mountains it is very difficult to make that journey overland. This journey can only be carried out with a considerable force necessary to pacify and subdue those villages which are at war with Lonckjouw or our other allies. Nevertheless, although Lonckjouw is very willing to render military assistance, since our garrison at present does not dispose of enough men (fol. 808), it would be more sensible to travel to Pimaba by sea, considering the long distance [of the route overland]. To that purpose the Council has appointed senior merchant Cornelis van Sanen to sail, on the first possible occasion, to Pimaba in the small junk that is ready to leave port. He will be given provisions for two months, as well as ammunition and other necessities and will be accompanied by a crew of twelve Dutchmen and fifteen Chinese. Van Sanen also will take along some gifts for the Pimaba headmen. [...].

fol. 810: [22 April] Praise the Lord, who has blessed the conversion of the heathens by using Reverend Junius as a capable instrument, so that the inhabitants of Mattouw, Soulang and Bacaluan, have been applying for schoolteachers for some time so that their children may be taught the Christ's teachings. They confirmed that from now on they are willing to serve only God, and that they therefore have already renounced their idols.

Junius proposed to the Council that we should send out schoolteachers to the important village of Pangsoya, as well as to the neighbouring villages Dolatock, Verovorongh, all located in the southern region of the River Tamsuy, given the fact that corporal Warnaer Sprosman, who has been stationed there for 1½ years to learn the language, has confirmed that quite a positive result is to be expected from the propagation of the

Gospel in that area. Reverend Junius has asked for permission to travel to Pangsoya in person to make a good start with this work.

(The Council unanimously resolved to dispatch Junius to the south to shoulder this sacred duty. Schoolteacher Jan Pietersz, van Amersfoort, who was known to be rather experienced in the Sincan language and of pious behaviour, was stationed in the largest village Mattouw, the more so because the village elders themselves had requested very seriously that he should come and teach them. To make this possible they were willing to build him a house as well as a school at their own expense. Likewise catechist Andries Markinius, of Emmerich, was ordered to continue his work in Bacaluan where he taught 82 pupils in the Sincan language. Here the villagers had already built a school and a house at their own expense. Catechist and schoolteacher Hans Oloff, of Dantzig, was sent to Soulang. The people also promised to built a house and school that could compare with the buildings in Mattouw and Bacaluan. Catechist Jan Michielsz was to be sent to Pangsoya where he would be assisted by corporal and schoolteacher Warnaer Sprosman, who was already somewhat experienced in the language of Pangsoya. Soldier Marcus Thomasz, of Bergen op Soom was appointed in Dolatock as a provisional schoolteacher. Likewise soldier Cornelis Huybertsz Trebellij, of Gorcum was to be used as provisional schoolteacher in Verovorongh in the Pangsoya area.)

70. Dagregister Zeelandia. 10 May 1637.
VOC 1123, fol. 878. Extract.
DRZ, I, p. 333.

(On 10 May Governor Johan van der Burch received a letter written by the Rev. Junius, in which he stated that the two Dutchmen, who had travelled to Tevorang upon the request of the inhabitants on the 7th of that month, had safely returned to Sincan. They had been welcomed extraordinarily well, and the inhabitants of Tevorang had proved to be very inclined to continue and confirm the concluded peace with the state of the United Dutch Provinces. A few days earlier, about forty men from Mattouw and Bacaluan had managed to hunt twenty heads among their enemies of Vavorolangh.)

71. Missive Governor-General Anthonio van Diemen and Council to Governor Johan van der Burch.
Batavia, 23 May 1637.
VOC 859, fol. 636-400. Summary.

(The Governor-General and Council were very pleased to receive positive messages about the Formosan inhabitants. They were particularly pleased to hear that the island of Lamey had been purged of the cruel murderers (some of whom were killed while the others were deported from their island) and that it had now been leased out to some Chinese. Most of the Lameyans who had been transported to Batavia had already died. They seemed not to be able to suffer the climate. The loyal behaviour of settlements like Sincan, Soulang, Bacaluan, Saccam was considered to be a very important asset to the Company. The High Government had also learned with satisfaction that the principal headman or ruler of Lonckjouw, a village that consisted of 16 settlements, had come to the castle to conclude peace with the Company. This also accounted for the fact that the headmen of seven more villages: 'Taraquang, Hounavahij, Horongorongorij, Dedadikeangh, Hosakasakey, Hovageyageyangh and Hopouwoch' had subjected themselves to the Dutch administration. Although the Formosans still seemed to be rather unreliable, the Company had to make the most of the situation and reduce them to submission as best as possible. Mutual discord often forced them to raise up arms against each other. Therefore, each time a village showed agressive behaviour against one of the others, the Company had to enter the conflict in order to rebuke the aggressor with force. This was thought to be necessary to maintain the general peace, to establish Company authority and to carry on with the pacification of the inhabitants. Viewed from that perspective, Senior Merchant Paulus Traudenius was ordered to send a considerable punitive expedition to the· disobedient inhabitants of Vavorolangh, for which he could count upon the necessary means sent to him from the High Government. It would be preferable if the Company government on Formosa could bring about peace between Lonckjouw and Pimaba, as it would open the route to the gold sites.)

72. Missive Governor-General Anthonio van Diemen and Council to Governor Johan van der Burch.
Batavia, 28 July 1637.
VOC 859, fol. 515-538. Summary.

(The High Government desired an expedition to be undertaken from Lonckjouw along the east coast to Pimaba, in the northern direction. Subsequently, the Company soldiers, having concluded an alliance with the inhabitants of Pimaba, should request some warriors to guide them to those villages that they knew to be producers of gold. The men had to see to it that those settlements would be subjected to the Company, either in a friendly way or by force.)

73. Extracts taken from the Zeelandia Castle Resolution-books, concerning the resolutions on the island of Lamey, taken in the Formosa Council.
VOC 1170, fol. 590-591. Resolution 2 June 1637.

fol. 590: [...] daerbij den selven is aenschrijvende dat 't resteerende volck op voorsz. eylandt bestaende nae ondervindinge in ongeveer 21 mans ende acht vrouwen, item zeven kinderkens 't zedert 2 may passado, hun vrijwillich ontrent ons houte wambeys in twee troupen d'eene onder en d'ander op 't geberchte te neder geslagen ende verscheyde huysgens tot haer grieff gemaect hebben. Oock dagelijcks eenige aen ende inde pagger van voorsch. houte wambeys met d'onse mondeling gespreecq ende discoursen comen, onder anderen gantsch rustich versoeckende dat alle vorige geresen onlusten mogen geassopieert, de wapenen afgeleyt ende van vrede gehandelt worden, hun presenterende de goede gehoorsaemheyt te willen submitteren in teycken van dien diversche fruyten ende andersins d'onse toebrengende. [...]

fol. 591: [...] eenparich goetgevonden ende gearresteert de saecke met voorschr. eylant ende resterende volcq in state te houden, oversulcx haerluyden ter plaetse daer hun hebben nedergeslagen te dulden, mits den sergeant Jan Barentsen bij schrijvens expresselijck te gelasten tot dat men hem anders ordonneeren, sal voorsz. volcq wel met vrundelijcqe ende minnelijcke bejegeninge doorgaen te frequenteren maer geen derselver binnen de pagger van 't houte wambeys te gedoogen, onder wat pretext toch soude mogen wesen, omme der trouweloose heydenen van yets

vijandelijcks te connen attenteren geen voordeel in te ruymen ofte open
deur te geven.

*(On 2 June 1637 a resolution was passed on acount of the letter adressed
to Governor Jan van der Burgh written by Sergeant Jan Barentsen on 27
May 1637 'on the scarcely populated island Lamey' about his experiences.
The sergeant had written:)*

fol. 590: that he estimates that there are about 21 men, eight women and
seven small children remaining on the island. Since May second they have
voluntarily divided in two groups and settled near the pallisade: one group
has erected dwellings at the foot of the hills and the other group has done
the same on the brow of the hills. Every day some of them also appear
near and inside the fence of the mentioned wooden pallisade to converse
with us. Among other things they very quietly request that all the quarrels
that had formerly occurred may now be settled, so that the arms can be
laid down and negotiations for peace can be started. As a proof of their
good intentions to submit themselves in obedience to us, they brought
various fruits over to us. [...]

fol. 591: [...] It was unanimously agreed and resolved to keep things on the
island in the present state and to tolerate the remaining inhabitants in the
places where they have settled, yet it was written to Sergeant Jan
Barentsen explicitly that until he receives further orders he may continue
to visit these people and treat them in a friendly and amiable manner, but
he should not permit any one of them to enter the fence of the wooden
pallisade for whatever reason, so as not to provide these perfidious
heathens an opportunity or an open door to commit a hostile act.

74. Dagregister Zeelandia. 13 June 1637.
VOC 1123, fol. 883. Summary.
DRZ, I, p. 339.

*(On June the 13th assistant Johannes van den Eynden reported that the
villagers of Vavorolangh, even though they were inclined to conclude
peace with the Company, had attacked some Chinese, who were living in
that area as fishermen, hunters and lime burners. All of these were in the
possession of Company licences. In addition these warriors had even
attacked a Company sampan. Sergeant Jan Barentsz reported from Lamey*

*that he still counted 47 Lameyans, men, women and children on the
island.)*

75. Extracts taken from the Zeelandia Castle Resolution-books, concerning the resolutions on the island of Lamey, taken in the Formosa Council.
VOC 1170, fol. 591-592. Resolution 13 July 1637.

fol. 591: Te deser vergaderinge mede geresumeert hebbende de confessie van Tagutel, wettige getroude huysvrouwe van Tahanang, woonachtigh tot Sinckan g'apprendeert inde redoute aldaer, gedaen op de intergatorie jegens de selve geproduceert. Waerbij blijckt voorsz. gevangene genoechsaem met louter opsedt den 9[en] deses seecker jongsken ofte Lameys (fol. 592) kint dat bij haer inwoonde, in 't water des reviers Sinckan gestooten, off met een arm daer bij 't selve genomen hadde gemickt heeft, sulcx dat voorsz. kindt in haer aensien ende bijweesen is comen te verdrincken, sonder dat sij 't selve heeft onderleyt weder te salveeren maer alsoo versmooren laeten, weshalven men de gevangene nae rechts behooren weder straffe soude connen toecomen. Doch geleth op 't instantelijck voorspreecken der outste ende principaelste Sinckanders tot genade aen domine Junio gedaen, mitsgaders 't advijs van gemelte Junio desen aengaende schriftelijck gegeven, de straffe des doots voor die teere natie wat te hart comen, ende daeruyt een groote verbitteringe off oock wel een scheur in 't goede werck der bekeringe resulteeren conde omdat voorsz. kint, Lameys sijnde, een ingebooren Sinckander daerom sterven soude moeten, oversulcx de straffe nuttiger ende de gevangenen alleen met strengelijck geeselen te belasten. Om welcke redenen de saecke ingesien ende verstaen wort de straffe in dier voegen naer de pronunciatie van sententie in forma publijcquelijck inden dorpe Sincan ten gewoonlijcken rechtsplaetse te laeten voortgaen mits de inwoonderen wel stricktelijck aen te kundigen haer voor sulcke en diergelijcke enorme handdadigheeden meer te plegen wel te wachten off dat men deselve, sonder conniventie ofte genade, na rechten: dat is de doot, als moorders procedeeren sal [...].

fol. 591: In this meeting a summary was given of the confession made by Tagutel, lawful wedded wife of Tahanang[44], living in Sincan and imprisoned in the fortification there, after she had been interrogated. From Tagutel's answers it became clear that on the 9th of this month, she had intentionally pushed, or taken by the arm and flung, a certain little

boy or child from Lamey (fol. 592) who lived with her, into the water of the Sincan River. Consequently that child drowned while she was standing by and looking without even trying to rescue the child, but merely letting it perish. Therefore the detainee should be punished according to the law. Yet thanks to the instant mediation of the elders and principals of Sincan who begged Reverend Junius for mercy, as well as Junius' written advice concerning this case, in which he argued that the death penalty would be too harsh a judgement for this easily offended nation, he believed it was better to deal out a more acceptable sentence and severely mete out lashes to the imprisoned woman. If a native of Sincan should have to die because of what happened to a child born on Lamey, this could easily result in great bitterness or even in the interruption of the conversion work. For this reason, on further careful consideration of the matter, we decided to carry out the punishment, after the pronunciation of the verdict in public at the ordinary site of the court in the village of Sincan, and furthermore to make it strictly clear to the inhabitants that they should in future beware of committing such hideous deeds, because they will be dealt with without connivence or mercy as murderers who deserve their legitimate verdict: that is the death sentence. […].

76. Resolution taken by Governor Johan van der Burch and the Formosa Council.
Tayouan, 12 August 1637.
VOC 1123, fol. 823-824.

Op heden ten huyse van den gouverneur verschenen zes persoonen van een plaetse Heyankan genaemt, om de noordt van Formosa, omtrent ½ mijlken van Vavorolang gelegen, welcke alhier op eergisteren per Chinese joncq aengecomen wesende, verclaren specialijck van 't voorsz. dorp geauthoriseert te comen omme aen den gouverneur den vrede te versoucken. Te meer seggen haer daertoe verstout te hebben, ten respecte noyt met de Vavorolangers tegens onsen staet haer hebben willen vermengen, maer althoos sich neutrael gehouden, op hoope dat den langen gewenschten vrede tusschen ons ende haer eens mochte getroffen worden ende diergelijcke.
Ende alhoewel den gouverneur ende Raedt van gevoelen blijven het soo pluys met het geseyde dorp niet en is als gemelte persoonen wel voorgeven dat noyt jegens onse bontgenoten sich souden hebben vergrepen

maer alle begane erreuren als insonderheyt noch de jongste gecommitteerde faulte, seer aerdigh op de Vavorolangers weten te schuven, wanneer verhaelden de jonge manschappen van dat dorp, ongeveer acht dagen geleden in de Mattauwsche velden haer vijandelijck hadden gethoont, niet onweerdige onse gegevene passen te violeren, daertoe veertig persoonen Chineesen 't haer afgesneden, ende soo seyden voor ijder een cangan te geven, weder gerantsoeneert hadden als andere hostille actie meer, ten desen dienende verhalende. Soo is echter om verscheyde goede consideratiën goetgevonden de geseyde persoonen in antwoort te dienen, dat wij den aengepresenteerden vreede voor den tijt van zes weecken aennemen mits dat wij ondertusschen wel exactelijck naer haer doen sulle vernemen hoe haer tegens onsen staet comen te comporteren, omme na expiratie van gemelten tijt den aengepresenteerden vrede wijders te confirmeren, off wel den oorlogh met de wapenen te doen gevoelen. Dat alsoo danckelijck geaccepteert hebben, waerop de twee voornaemste gecommitteerden ijder met drie cangangs ende drie catty toebacq, item de vier andere wilden, ijder met een cangang ende een catty toebacq, mitsgaders den Chinesen tolcq met twee realen van achten in spetie (fol. 824) hun vereert geworden, waermede hun afscheyt vanden gouverneur becomen hebben […].

Today, six delegates showed up at the governor's residence, who arrived here in a Chinese junk the day before yesterday, from a place named Heyankan, situated to the north of Tayouan about half a mile from Vavorolangh. They explained that they were specially commissioned by their village to request the governor for peace. They wanted us to know that they had been bold enough to come all the way to inform us that they had never intended to plot with Vavorolangh against our establishment but that, on the contrary, they had always remained impartial, and that they hope that the long desired peace may be materialized between them and us, and so on.

Both Governor and Council sense that the story of this village is a bit fishy as they (the people of Heyankan) are pretending never to have have molested our allies, and are very good at shifting all committed sins on the account of the people of Vavorolangh. Likewise they said that about eight days ago, in the fields around Mattouw, young lads of that village had been hostile and had violated the passes handed out by us and had cut off the hair of forty Chinese. They said that they had ransomed each of these [Chinese] for the price of a piece of cloth. Still, for several good

reasons, it has been decided by the Council to reply to the delegates [of Heyankan] that we are willing to accept the peace proposed to us for a period of six weeks and, in the meantime, we shall investigate exactly how they comport themselves towards us, so that depending on the outcome, after the time period has expired, Governor and Council will either confirm the proposed peace or will wage war against Heyankan. The delegates accepted the resolution with gratitude and before they said farewell to the governor the two most eminent of them were each presented with three *cangans*, three catties of tobacco, while the four other savages were given one *cangan* and one catty of tobacco each. The Chinese interpreter (fol. 824) was offered two reals of eight, in cash. [...].

77. Original missive Governor Jan van der Burch to Governor-General Anthonio van Diemen.
Tayouan, 17 October 1637.
VOC 1123, fol. 744-781. Extract.
See also FORMOSA UNDER THE DUTCH, pp. 158-160; ZENDING, III, pp. 155-159.

> fol. 764: [...] Hierop waeren den 12en Augustij t'onsen huyse verscheenen zes persoonen van een plaetse Heyankan. [...] Dese lieden confirmeerden de viantlijcke actie van de Vovorolangers tegens d'onse op 4 Augustij voorz. gepleegt ende bleeven van opinie dat de bejaerde persoonen wel tot vreede genegen waeren maer dat het altoos door de jonge manschappen was belet geworden, sulcx om dit woeldrige volckjen tot ons devoir te brengen, blijven wij voornemens in december aenstaende met een macht van 300 coppen Nederlanders persoonlijck derwaerts te transporteeren, ende 't selve dorp Vovorolang door onse waepens tot gehoorsaemheyt te reduceeren [...].

fol. 764: [...] Then on 12 August there appeared at our house six people from a place called Heyankan. [...] These men confirmed the mentioned hostilities perpetrated by the Vavorolangians against our subjects on 4 August; they believed that the adults were inclined towards peace but that this was continuously prevented by the young men. Consequently in order to subject these unruly people we intend in December to personally lead a force of about 300 Dutchmen there to bring Vavorolangh to its knees by force of arms. [...].

78. Dagregister Zeelandia, 18 October 1637-14 December 1638.
VOC 1128, fol. 427-510.
DRZ, I, pp. 373-449.[45]
See also FORMOSA UNDER THE DUTCH, **pp. 160-165;** ZENDING, III,
pp. 159-168.

*(On 24 October in the Council a resolution had been adopted to
undertake a punitive expedition against the rebellious village of
Vavorolangh as a warning to all other inhabitants of Formosa.)*[46]

**79. Dagregister kept by Governor Jan van der Burch on the
expedition with an army of 300 soldiers and about 1400 inhabitants to
the great village of Vavorolangh situated to the north.**
Vavorolangh etc., 25 October-1 November 1637.
VOC 1128, fol. 429-434. Summary.
DRZ, I, pp. 375-378.

*(On the 29ᵗʰ of October, the expedition overland to Vavorolangh was
undertaken, after the allied warriors of Sincan, Bacaluan, Soulang,
Mattouw and Tirosen had joined the Company soldiers. The allies,
commanded by Reverend Junius on horseback, marched in front as
guides, and were followed by the advance guard of Company soldiers
under the command of captain Jan Jurriaensz. The main force drawn up
in battle formation was led by provisional lieutenant Thomas Pedel.*
*The next day, 30 October, the army advanced to Vavorolangh. At first
800 men appeared on a field before the village who, when the Company
forces came near, withdrew into their village except for twelve
Vavorolangh braves who took a stand while shooting with arrows. A man
from Mattouw got wounded, but afterwards one of the heads of the enemy
was captured by an ally from Mattouw. Without meeting with much
resistance the allies, together with one company of Dutch soldiers,
thereupon marched into the village. When breaking through the bamboo
pallisade, which was about thirty feet wide, eight more enemy heads were
captured. From the windward side, the village, which had four broad
streets, was set afire. About 2200 houses, filled with padi and millet, were
burned to the ground. Vavorolangh had been a large affluent village, of
about 3500 inhabitants, as large as Mattouw. The 800 warriors, who had*

clashed with the Company soldiers in the first phase of the battle, would all have been killed by musket bullets if they had continued their resistance, but because they had quickly fled they had not suffered too many casulties. The Vavorolangians were all of rather a tall stature. In general they seemed to be one head taller than the other Formosans, who feared them for being the most aggressive warriors on the island. If Dutch troops had not been present during the fight the allies surely would have been beaten by the Vavorolangians even if they had been outnumbered. That night in camp, when the balance of the fight was drawn, it became clear that three Dutchmen were wounded, three allied Formosans were killed and two were wounded. The enemy had lost at least 22 men.

At about eleven in the evening a Sincandian entered the camp. He explained that he, on the journey home just outside Vavorolangh, had to stay behind because he had been hurt by an arrow. He had succeeded in drawing the arrow out of his body just at the moment when the Vavorolangians, who had taken refuge, returned into their village. In order to ensure remaining unrecognized as an enemy, he had thrown away his shield and assagay (as the Vavorolangians are used to fighting only with bow and arrows) and succeeded in putting on a Vavorolangian robe he had captured earlier as booty. Thus he had managed to escape. Meanwhile he had heard men, women and children crying over their great losses of houses and supplies. After his wounds were treated the Sincandian was taken over to his peoples' quarters in the camp.

On the morning of 1 November the allies from Mattouw, Soulang, Tirosen, and Bacaluang left, and Governor Jan van der Burch embarked with his men in sampans to return to Tayouan. With the assistance of 1400 Formosan warriors 300 Company soldiers had carried the day over Vavorolangh. About 800 warriors fought bravely to defend their large village. The Formosan allies had managed to capture 22 enemy heads, yet three warriors of Mattouw were killed and several were wounded. In all about 4000 houses and rice-barns were destroyed and the nursery of pinang and coconut trees was burnt down. In a letter to Governor-General Anthonio van Diemen, Governor Johan van der Burch gave the following account of this victorious expedition:)

80. Missive Governor Jan van der Burch to Governor-General Anthonio van Diemen.
Tayouan, 14 November 1637.
VOC 1123, fol. 935-938.

[...] hoe den 30en October op Vrijdach de Vavorolanders hun in 't velt 800 sterck hebben verthoont ende voor haer dorp in de ruygte met pijlen schietende vonden leggen, omme ons het incomen van haer dorp te beletten, dan met chargeren van musquetten die doordrongen, is de wech gebaent geworden dat ordentelijck met de vier compagniën daerinne gemarcheert, ende door den hulpende handt des Alderhoogsten, meester van haer dorp geworden sijn. Wij hebben meest alle hare vruchtboomen doen omcappen, den padij ende geerst welcke juyst alle van 't velt becomen hadden met meest haer huysen in asschen geset. Hebbende onse inhabitanten 22 hooffden Vavorolangers becomen, ende na men rucht sijnder wel eens soo veel gequetst geworden, sulx dat de Vavorolanders grootte schade geleden hebben, ende twijffele niet off dese hoogmoedige natie sal door de geledene straffe wel tot redelijckheyt ende onder onse gehoorsaemheyt te brengen sijn. Daertegens is van onser sijde den provisionelen luytenant Thomas Pedel met een pijl in sijn buyck gequetst, ende drie onser inhabitanten gebleven. Dit Vavorolangh is voorwaer geen cleen dorp geweest maer mach wel den naem van een groot voeren, also gisse Batavia met den gantschen ommeslach (fol. 936) daer wel in leggen can ende wort op 3500 sielen gehouden dat te voeden gehadt heeft.

Bij onsen ervarenste crijgsluyden wort getuyght dat dese Vavorolanders inden tocht haer soodanich hebben gecomporteert, sulx mede vanden Eerweerde predicant Junio gaffirmeert wordt, als nog oyt die van Mattauw, Soulangh, Baccluang ende d'andere dorpen om de zuyd gedaen hebben. Dattet een wrevelmoedige, halsterrige ende oock wraeckgierige natie is, hebben ondervonden in 't becomen van een jongen Soulanger, die se in de furie de beenen vanden anderen ructen, ende beetten in 't been omme haer bloetdorstich hart te wreecken. Doch heeft sulcx den voorvechter niet naer vertelt, alsoo op staende voet, met een cougel gevelt, ende van sijn eygen volck wechgesleept wierde. Souden andertsins d'onse 't hooft becomen hebben. Echter moet haer dit gevoelen van onse wapenen hart drucken blijckende aen de verclaringe van den gequetsten Sincander hier van gedaen, waervan sijn avontuyr bij ons dachregister staet, dat Ued. als een noterensweerdige saecke gelieft naer te lesen. Naerdat netto zeven etmalen op desen tocht geweest ende weder gekeert waren, soo hebben wij

tot een besluyt van dese onse actie den 2^{en} November een Biddach laten houden, ende den Alderhoogsten Crijgshelt gedanct voor de Victorie.

[...] On Friday, the 30th of October the Vavorolangians appeared in the field before their village with an army of 800 men strong. We found them in the brushwood shooting at us with arrows, in order to prevent us from entering the village. However, with God's help, after making a charge with our muskets we succeeded in fighting our way through. Next we marched with the four companies of soldiers into the village and took possession of it. Subsequently we had most of their fruit trees chopped down and most of their houses, as well as the harvest of paddy and millet, which had just been brought in, were burnt to the ground. Our Formosan comrades captured 22 heads of their Vavorolangian enemies and it was rumoured that twice as many got wounded. Thus Vavorolangh was considerably damaged and we do not doubt that because of the punishment they suffered these conceited people will be subjected to the Company and brought to their senses. On the other hand the provisional lieutenant Thomas Pedel was hurt in his belly by an arrow and three of our allied inhabitants got killed. Indeed, Vavorolangh, was not a small village, and deserved to be called a large one, because even the city of Batavia together with all its surroundings could fit completely into its territory. It could feed a population estimated at 3500 souls.

Our most experienced soldiers testified - and so did the Reverend Junius - that in the turmoil of the battle the Vavorolangians had fought valiantly enough to overshadow the Mattouw, Soulang, Bacaluan or any of the other villages situated south of Tayouan. How spiteful and obstinate a nation it is we witnessed when they overpowered a young man from Soulang, whose limbs they tore apart and bit in his legs to seek revenge their bloodthirsty hearts. But the perpetrator who took a lead in this didn't live to tell the tale, because forthwith he was hit by a bullet. If he had not been dragged away by his own people, surely our allies would have seized his head. The heavy defeat they suffered at our arms undoubtedly becomes clear from the testimony of the wounded Sincandian, whose adventure is noted down in the journal, which is worth taking notice of.[47] Upon our return to Tayouan, after we had been out on this victorious expedition for seven days, it was decided to celebrate with a day of prayer on November second: the Almighty Warrior be praised for this victory.

(On 15 December five headmen delegated by the inhabitants of Vavorolangh as well as the small villages Heyankan and Vassican, being part of greater Vavorolangh, came to Tayouan to transfer their lands to the States General on the same conditions as the earlier pacified villages had done. According to their customs they offered the governor five little trees planted in pots and two pigs as a means of confirmation of the contract. In return the Company offered them protection.)

81. Resolution.
Tayouan, 23 November 1637.
VOC 1128, fol. 514.

(On 23 November a resolution was taken at Zeelandia Castle to send a punitive expedition out to Pangsoya to arrest the murderers of Tacomey, former chief of that village. In October, directly after the murder, corporal Warnaer Sprosman, stationed in Pangsoya as schoolteacher, had fled to Tayouan for safety reasons.)[48]

82. Dagregister kept on the voyage to Pangsoya and the Golden Lion Island to punish the inhabitants who had offered resistance to the General Company. Pangsoya etc. 26 November 1637-1 December 1637.
Extracts from the Dagregister Zeelandia, concerning Lamey.
VOC 1170, fol. 617-620. Extracts 26, 27 November 1637.
See also VOC 1128, fol. 441-446.
DRZ, I, pp. 385-389.[49]

fol. 617: Primo december retourneert [...] van Pangsoya om de zuydt den heer gouverneur Van der Burch, met de geheele troupe soldaten, bestaende in 140 koppen, daermede den 26en van de voorleden maendt November geaccompagneert derwaerts is vertrocken geweest. Hebben op sijn arrivement aldaer de gecomploicteerde perpetreurs aende moort van Taccamey, haeren opperhoofd, voor desen wegen de Generale Comp. ter voors. plaetse met advijs der inhabitanten van dien gecoren, in apprehentie becomen ende drie derselver (naer dat haer beschuldinge tot 't voorschr. feyt publijckelijck bij forma van sententien was vercondicht) ter executie stellende tot een exempel van andere quaetwilligen doen decapiteeren ten overstaen ende absoluyte toestemminge der oudsten vande naestgelegene

dorpen Dolatacq, Vevorangh, item Taccarejangh, ende in aensien van wel 850 persoonen die uit voorschr. dorpen expresselijck tot assistentie van onsen gouverneur in 't exerceeren van voorschr. rechtveerdige executie aldaer mede verschenen waren, boven en behalven de inwoonderen van Pangoya selfs. Voorts weder het bevel als opperhoofden van Pangsoya gegeven den broeder ende soon van den gemassacreerden Taccomay met een stricte aenmaninge aende Pangsoiers openbaerlijck gedaen, voorschr. twee persoonen tot voorschr. (fol. 618) qualite geëligeert, als haeren oudsten en opperhooffden t'erkennen ende gehoorsaemen; 't welck sij alle na te comen solemnelijck belooft hebben, soo dat dese zaecken met goede ordre tot een gemeene ruste onser onderdanen in dat quartier geëffectueert is.

Gemelten zijn Ed. derwaerts reysende, hadde en passant aengedaen 't eylandt Lamey, en 't selve als noch gepeupleert bevonden met 63 zielen soo vrouws als manspersoonen ende kinderen, die haer seer demoedichlijck thoonende met versoeck den tegens hun luyden ontsteecken toorn mochte gestilt, sij in nu genaden aengenomen, ende haerlieden goedertierentlijck gepermitteert worden doch op dat lant te moogen possessie houden, de verwilderinge wech te ruymen en behoorlijck aenplantinge van rijs als andersints tot haer sustentement en Comps. gerieff te doen. Beloovende dat haer doorgaens in obediëntie thoonen, haer tot allen tijden ende vrijwillich ten dienste van de Comp. des noodich sijnde laten gebruycken, ende haer doorgaens den gouverneur van Tayouan in sijn ordre ende beveelen om d'selve promptelijck naer haer vermogen naer te comen gesubmitteert houden zouden [...] ende insiende sedert dat 't selve bij ons vijandelijck aengetast van 't meerendeel der inwoonderen ontbloot, bij de Chinesen in pacht genomen, seer verargert geworden was, heeft gemelten zijn Ed. voors. inwoonderen haer versoeck geaccordeert met restrictie dat al voorens een preuve van haer weldoen genomen hebbende als dan daerinne wijders zoude werden gedisponeert.

Luydende het Joernael specifice daervan gehouden als volght: (fol. 619) [...] Vrijdach den 27en dito. Inbarcquerende in een champan met d'Eerwaerdige predicanten Junio en Levio nevens den cap.n Jan Jeuriaensz., verzeylende daer mede nae 't eylandt Lamey omme inspectie van desselfs plaetse te nemen ende d'inhabitanten aldaer tot volcoomen gehoorsaemheyt te reduceren, off andersints nae bevindinge van zaecken ten uyttersten te procederen [...] met 45 coppen te volgen, omme des t'aenzienelijcker ons intent in effect te brengen. Ende quamen met dito champan die morgen omtrent negen uyren aen 't eylandt Lamey, alwaer van de sergeant Jan Barentsen verstonden hoe d'inhabitanten aldaer noch sterck waren 18 mannen, 19 vrouwen, 14 jongens, 12 meyskens: t'samen 63 zielen

daeronder negen zuygende kinderen. [...] Hebbende voorschr. sergeant verscheyde malen aengeweest, hij wilde in haer faveur aen ons schrijven wij haer doch in genade wilden aennemen, met beloften haer voortaen gehoorsaemelijck te comporteren. Waerop goetgevonden d'inhabitanten t'insinueren (alsoo tot het vluchten al bereets stonden) haer gesamentlijck met mannen, vrouwen ende kinderen, in den tijt van een uyr op genade ende ongenade bij ons te verschijnen omme ten dienste van d'Generaele Comp^e. op desselfs saecken gedisponeert te worden. Als naer behooren met desen last commandeerde den Eerwaerden predicant Junio nevens voorschr. sergeant omme hier zulcx uyt onse naeme aen te zeggen welcke oock alle in voorschr. tijt haer ontrent onse pagger lieten vinden, (fol. 620) daervan zes mannen bij ons quamen die hun seer demoedichlijck aenstelden ende uyt alder namen versochten wij wilden haer begaene faulten doch niet langer bedencken. Sij trachten haer gewillichlijck onder onse gehoorsaemheyt te submitteren ende t'allen tijden zeer ijverlijck tot des Comp^s. dienst te laten vinden die sijlieden gesamentlijck vertrouwden met dit eylandt de cultiveren daeraen den besten dienst doen conden, soo nochthans, dat lijff, leven, zandt en landt des Comp.^es was ende blijven zoude. Waerop in consideratie namen hoe dit eylandt nu een jaer langh van de Chinesen die 't selve in pacht genomen hadden seer verwildert [...] was, dat daertegens voorschr. inhabitanten nu al eenige velden omme rijs ende tarwe te planten op des sergeants aenzeggen gereet gemaeckt hadde op hoope bij ons haer gecommitteerde faulten zouden gepardonneert werden. [...]

Wij vonden [goet] haer op 't voorschr. eylandt te laten verblijven ende aenzeyde dat een preuve van haer gehoorzaemheyt zullen nemen ende den tijt afwachten, off oock in 't aenplanten van allerley aertvruchten haer soo neerstich zullen comporteren als aen ons beloofft hebben te doen, met welcke antwoorde haer d'inhabitanten seer verblijt hielden, thoonden haer t'onser aenwesen seer gedienstich [...].

(On 1 December 1637, Governor Jan van der Burgh returned from Pangsoya with the complete contingent of soldiers, consisting of 140 men, who had accompanied him there since his departure from Tayouan on the 26^th of November last.)

fol. 617: On his arrival in that village he had ordered the arrest of the conspirators of the murder of Chief Taccamey, who was chosen as headman by the General Company in accordance with the wishes of the inhabitants. After they were publicly indicted on a charge for this murder, the three killers were sentenced to the death penalty, to serve as an

example to other criminals. These murderers were decapitated with the emphatic permission of the headmen of the neighbouring villages Dolatock, Verovorongh and Taccareyang, in the presence of the inhabitants of Pangsoya, by over 850 people from the mentioned villages who had been invited by the governor to assist him with the execution of the aforementioned just punishment. Furthermore, the Pangsoyans were admonished in public and told that the brother and the son of the massacred Taccomay succeeded him as their chiefs, and that these two persons, once elected to this position, should be obeyed and recognised by them as their elders and headmen. They solemnly pledged to accept this, so that these matters have been effectuated in good order with general peace among our subjects in these quarters as a result.

On his journey there His Honour had also visited Lamey and found it still populated by 63 souls, women, men as well as children, who behaved very humbly and prayed that the incensed wrath might be stilled and that once the Company had shown mercy on them, they might be graciously allowed to stay on the island and clear the overgrown and neglected farmlands and start again on the cultivation of rice and other crops for their own maintenance as well as for the benefit of the Company. They promised to always show their obedience and that at all times they were willing to comply with the Company's call for assistance and that they would submit themselves to the governor of Tayouan as to promptly obey all his orders and commands as best as they could. [...] His Honour – being aware of the fact that since our attack had stripped the island of most of its inhabitants and had been leased by the Chinese, it was increasingly overrun by weeds – complied with the request of these inhabitants on the condition that first they had to prove their good behaviour before a further decision could be taken.

The following journal was kept during that journey: (fol. 619): [...] On Friday the 27th ditto the Reverends Junius and Levio, together with captain Jan Jurriaensz set sail on a sampan to Lamey so as to visit and subdue the inhabitants to complete obedience or, if necessary, to proceed as he might feel necessary considering the local conditions. They were accompanied by 45 men in order to be able to execute these orders in the best way possible, and arrived the next morning at about nine o'clock with the sampans at the island Lamey. Upon arrival they were informed by Sergeant Jan Barentsen that there were still 18 men, 19 women, 14

boys, 12 girls, a total of 63 souls, including nine infants. These inhabitants have visited him several times asking him if he could not implore me by letter on their behalf to restore them to favour, on the promise that from then on they will behave very obediently. We agreed to tell the inhabitants (who were already about to flee away) to appear all together within the hour, men, women and children so as to make an unconditional surrender so that the General Company could decide this matter. We commanded Reverend Junius together with the mentioned sergeant to go and deliver the message to them in our name, and indeed at the arranged time they came to the entrance of the stockade. (fol. 620) Six men came forward and in the name of the others requested us very humbly to forget about their former mistakes. They will try to submit themselves to obedience and at all times are willing to devote themselves to be of service to the Company, they are convinced that they can be most useful by cultivating the island. In any case their bodies and lives, as well as the sand and the land would now and forever belong to the Company. Considering that the island since it has been leased out to Chinese tenants for over a year, has become overgrown and that at the same time some of the inhabitants, on the recommendation of the sergeant, already have cleared and made ready some fields for growing rice and wheat, as they hope that we will pardon the faults they have committed. [...] We responded that we allowed them to stay on the island and that we shall try out their obedience and wait and see whether they will behave themselves diligently in the cultivation of crops as they have promised us to do. The inhabitants appeared to be very glad with this answer and showed themselves much obliged.

83. Original missive Governor Jan van der Burch to Governor-General Anthonio van Diemen
Tayouan, 12 December 1637.
VOC 1123, fol. 913-921.
FORMOSA UNDER THE DUTCH, p. 165.[50]

1638

84. Resolution.
Tayouan, 19 January 1638.
VOC 1128, fol. 521.

(On 19 January 1638 a resolution was taken in the Zeelandia Council to send an expedition to Pimaba in the east once again, to discover the alleged goldsites. After a first attempt to sail to that distant place a year earlier had not been successful it was decided to travel over land on this occasion.)

85. Extract from the Dagregister of Johan Jurriaensz. van Linga, Captain of the Zeelandia garrison on his voyage to Pimaba, 22 January-12 February 1638.
VOC 1128, fol. 556-568.

fol. 557: [22 januari 1638] Op huyden den capiteyn Johan van Linga met 130 soldaten in drie joncken verdeelt naer de quartieren van Lonckiouw om aldaer conform sijne ontvangene instructie [...] te landen ende voorts over de Lonckjouwsen bodem naer Tawaly ende Pymaba te marcheeren.
(Op 24 januari landde Van Linga met zijn manschappen in de baai van Lonckjouw. De volgende dag marcheerden zij naar Dolaswack waar zij een ontmoeting hadden met:) den Lonckiousen vorst, sijnde vergeselschapt met sijnen soone, broeder ende eene swyte van omtrent vijftig mannen, alwaer wij stille hielden ende ons crijchsvolck in slachordre gestelt hebben. Wanneer ons neffens den vorst weynich nedersetten, ende naer eeniche discours gemelte vorst met sijnen broeder uyt den naem van onsen Ed. Hr. gouverneur gegroet is, ende hem verder angesecht hoe wij met onse bijhebbende crijchsmacht van onsen welgemelten Hr. gouverneur gesonden wiert om op sijn versouck Tawaly met onse wapenen tot redelicheit te brengen, vertrouwende dat sijn persoon ende eenige vande sijne, item provisie voor ons volck tot op des viants boodem sall contribueren, soo als noch onlangs door den tholck Samsiacq onsen Ed. Hr. gouverneur heeft laeten weeten dat sijn rijs ende gerst daertoe al bereyt hielt ende naer onse comste (fol. 558) verlangende bleeff. Waerop dito vorst in antwoort gaff dat hij sich over de weldaet van onsen heer gouverneur t'hemwaerts verplicht hielt. Wat verder sijn persoon, sijn volck ende de proviesie voor de onse

anginck, daerin soude hij in gheen gebreecken blijven, maer 't selve conform sijn beloften voor desen an den capitein als andere gedaen, laten uytvallen. Hietende meteen ons ende ons bijweesende volck hertlick willecommen. [...]

Met den avont commen wij in dito dorp Dolaswack, sijnde van dito inwoenderen aldaer wel gewilt. Het crijchsvolck wiert stracks in drye haerer wachthuysen verdeelt, ende met starcke ordre (opdat er ghien ongeregeltheyt soude gebruyck werden) daer binnen gehouden, ende logierde ons den geseyden vorst tot sijnen huyse [...].

(De vorst vroeg Van Linga of hij een dag langer wilde blijven.) Middelerwijle wilden hij sijn volck, die soo hier ende daer in verscheyden dorpen woonachticht sijn, onse praesentie ancondigen, opdat sij haer op morgen ende op overmorgen (versien met lijfftochten soo voor ons als voor haer selffs) bij onse macht souden laeten vinden. [...]

Den 26 dito: [...] den vorst heeft ons ende sijn volck, onse soldaten met cost ende dranck naer haere wijse wel onthaelt.

Den 27 dito: [...] neemen wij (neffens den regent, sijnen broeder ende andere onderdaenen van Doloswack ons vertreck naer Bangsoer [...] commen omtrent 11 uyren aende oostsijde deses eylants op de seecant [...]. Van hier marcheeren wij voort [...] noortwerts.

(De manschappen kampeerden op het strand:) [...] hier sijn noch verscheyden inwoenderen uyt de Lonckiouwse quartieren tot bevorderinge van de begonnen tocht bij ons verscheenen. [...]

(Op 28 januari passeerden zij de bergdorpen: Karradey, Tarodas en Matsaer 'die onder Lonckjouw ressorteerden' (fol. 559) en overnachtten in Luypot. Door de regen waren de paden overal moeilijk begaanbaar. De volgende dag trok men verder langs de dorpen Ballicrouw en Parangoy:) Alhier dienden ons den vorst van Lonckiouw an, hoe dat d'inhabytanten van 't dorp Patsaban dat neutrael is, geveynsde ende ghiene oprechte vrienden met haer sijn. Oversulcx versocht hij, wij wilden gemelte dorp gewapender hant angriepen, ende tot redelicheit brengen. Hiervan bij ons de redenen ondersocht sijnde, seyden sij. allenich dat dese luyden vaels ende niet oprecht sijn, sonder nochtans haere begaene misdaet tegens den Lonckiousen stant te connen anwijsen. Over welck voorstel naer verscheyden bedenckinge den vorst als volcht geandwort is: dat t'ons niet redelick dachte ende ooc onse consientie niet toeliet, iemant te beorlogen die daer toe ghien weetlicke redenen gegeven hebben. Maer haerluyden tot redelicheyt ende vrientschap met den Lonckiousen vorst ende sijne ondersaeten te brengen, daertoe wisten wel goeden raet, ende was desen dat den vorst één van sijne ondersaeten naer Patsaban soude affsenden

ende laeten haer uyt des capiteyns naeme anseggen, hoe wij met onse bijhebbende criechsmacht (onder geselschap der Lonckiousen vorst ende sijne ondersaeten) tot hier toe verscheenen sijn. Soo sij nu tot onse gunste ende der Lonckiousen vreede genegen sijn, souden sij haere regenten geaccompagniert met lijfftochten (voor ons leeger) op strant onder haer dorp laeten vinden. Ende in gevalle sij dit verwerpen, meynen wij met recht (diewijle sij den vreede affslaen) haer te moogen beoorloogen. Dat beviel de vorst met sijnen broeder wel, ende seyde dit redelijck te wesen. Weshalven stracx eenen boode met bovenstaende last naer gemelte dorp gesonden. Omtrent 11 uyren commen voor dito Patsaban dat gelijck de voorige in 't geberchte ligt ende van ons niet gesien can werden. Alwaer neergeslaegen ende onsen versonden boode uyt voorseyde dorp ingewacht hebben.

Cort op den middach compt den bovengeseyden boode wederom, rapporterende dat den regent desselven dorps met enige van de sijne versien, met lijfftochten in corten sich bij ons te transportieren sall - wij wilden slechts een weenich tijts stil leggen ende sijne comste, die soo haest (gemerckt sij over die lijfftochten onder haer nog beraeden moesten) niet geschieden can, inwachten. Waerop andermael een boede derwaerts gesonden wiert om haer an te seggen, soo sij genegen waeren afftecommen dat moesten sij in corten doen, soo niet, souden ons gemoveert vinden een ander middel bij der hant te nehmen, also wij om harent willen hier niet lange wilden vertoeven. Middeler wijle wiert het quartier soo voor ons als die Lonckiouwers, van dito Lonckiouwers gemaackt, also van gevoelen bleeven aldaer te moeten vernachten. [...] Weynich achter de sonnenonderganck compt den regent van dito dorp met eenige van die sijne, sijnde versien met acht leevendiche verckens, eenich drooch hertevleys, ende zeven potten met massecau dat alles soo onder ons volck als de Lonckiouwers uytgedeelt is. Sij scheenen vreesachtich ende versaecht te sijn, doch wat angetrocken ende getracteert sijnde, verthoonden haer als doen wat blijgeestiger, wanneer hem met advijs van den Lonckiousen vorst anseyden dat 't ons wel geviel diewijle hij ende eenige van die sijne met lijfftochten voor ons volck afquame, waermede hij onse gunste verworven hadde ende wilden haer ooc onsen vreede (gelijck wij alle redelicke luyden tot noch noyt geweygert hadden) niet affslaen maer in onse gunst anneemen, dat hem wel geviel, ende hielden sich daermede vergenoecht.

Met raet ende goetvinden van den meergeseyden Lonckiouschen vorst is haer verder voorgestelt dat wij t'ons wel wilden laeten gevallen, wanneer sij van nu voort als getrouwe bontgenooten tegens des Comps. ende des

Lonckiouwsen staet, haer comportierden, ende soo sij daervan in gebreeke bleven souden sij niet minder als andere onwillige in onse ongunste commen te vervallen. Dat scheen haer ooc an beyde sijden wel te gevallen, ende seyden sij oprechtelijck tegens onsen ende des Lonckiousen staet haer te willen anstellen. Seyden verder haer met een redelick getael onder ons volck op morgen te willen verthoonen, ende alsoo die van Tawaly dat ooc gelijck sij seggen haere vianden sijn, gewaepender hant helpen angrijpen (dat achter niet en volgt is). Waerop geantwoort hebben, soo sij daertoe lust hadden, wij wilden haer wel onder ons geselschap anneemen; andersins hadden tot voltreckinge onsens voorneemens, met die hulpe van Godt, volck genoech. Hierop hebben haer tot danckbaerheyt der genootene lijfftochten ende teyken van vrientschap met twee blauwe cangans (fol. 560) eenige corallen ende weynich taback begifftight, waermede sij met contentement des nachts weder naer hun dorp vertrocken sijn.

De redenen ende insichten waerom wij hier desen halven dach vertoefft hebben is geweest eensdeels om den Lonckiouwsen vorst tot contentement met dit dorp te brengen, anderdeels omdat 't ons geraetsaemst docht ghien vijanden maer alle vrienden achter den rugge te laeten, opdat in voorvallene saecken 't sij in wederkeren deses tochts ofte toecomende tijden, onse nootwendicheyt van hun becoomen mogen.

[30 januari] Des morgens [...] marcheerden [...] voort naer Tawaly, die van Patsaban volgen niet gelijck sij op gesteravont belooft hadden. Onse bijwesende Lonckiouwers waeren in 't geheel omtrent die 400 à 500 mannen sterck.

Twee uyrren achter middach comen wij voor 't dorp Tawaly dat stracx angetast, stormender hant ingenomen, geheel affgebrant, ende in den gront geruïneert is. Met sonnenonderganck trecken naer verrichtinge onser saecken weder uit dito dorp ende slaen ons leger an die reviere die dicht langs dito dorp uit 't geberchte in see loopt ende omtrent tot die knie diep is. Gemelte dorp lach in 't hangen van 't geberchte, ende was aen die een sijde daer wij in mosten soo met een steenen als bambousen pagger omvangen, d'welcke poorte sij ooc tegens ons incomste meynden te beschermen; die sij echter naer weynich chargeeren verlaten hebben, ende vluchten sij hooger haer dorp in. Dit dorp was eerst aen den voet van 't geberchte met goede partie huysen versien, daernaer omtrent tien voeten hooger op wederomme met andere partije huysen, gelijck straeten, dat alsoo voort hooger ende hooger tot in bovenste van dito dorp geduyrt heeft. Dito hoochten tusschen der geseyde straeten waeren alle met platte steenen op geseth ende omtrent acht à tien voeten hoogh, invoegen haer 't

selve als een borstweeringe gedient heeft. In alle welcke opclimmende verhoeginge sij haer dapper geweert, ende defensie gepresenteert hebben, sulcx dat wij haer met gewelt ende sterck aentrecken, daeruit gedreven (ende eyndelinge haer dorp ons in geruymt) hebben, dat stracx bij ons angestecken, ende tot den gront affgebrant is. Daer waeren verscheyden huysgesinnen in haere huysen gevlucht die alle met schieten ende branden van dito huysen in onse handen gevallen sijn. In d'veertig hooffden ende omtrent zeventig gevangens rapporteerden ons de Lonckiouwers dat sij becomen hadden.

Doch naderhant wert ons door meester Marten die wij in Pymaba, gelijck volgen sal, gelaten hebben[de] bericht dat hij conform sijn ontfangen last, den regent van Lonciou tot lergeeren der gevangene Tawaliers naer veel aenhoudens verweckt, ende dito gevangens in den maent Junij weder te huys gebracht heeft, welck weder kerende gevangens hij verclaert dat 104 persoonen in 't getal geweest sijn. Acht à tien van de beste kinderen verhaelt hij dat noch om redenen onder den Lonckiousen vorst gelaeten heeft, daerbij comen negen kinderen die in Tayouan geweest, ende in april met een joncke wederom teruggegesonden sijn, sulcx dat 't getal der gevangen sonder feylen 120 menschen geweest is.

Wij hebben 16 gequetsten onder onse soldaeten gehat, waervan twee onderwegen ende ooc soo veel in Tayouan gestorven sijn. Onder die van Lonckiouw sijn ooc zes gequetsten geweest daervan ooc één gestorven is.

Gemelte dorp heeft omtrent in 250 à 300 huysen bestaan. Dat hier niet meer als honderd strijtbare mannen, conform 't bericht der Lonckiouwers den jare verleden aen mij gedaen, in souden geweest hebben en compt in mijn gelooff niet. Haere huysen sijn op de Lonckiouwse maniere doch den meestendeel met platte steenen (gelijck schaliën) bedeckt, invoegen den geworpen brant dito steenen dack, weynich off ghien schade doen can, maer dewijle dat gemelte dack op bamboesen gelegcht wert, die van langer hant door haer vier stoken wel gedroocht sijn, soo heeft 't vier dat wij daer onder hielden stracx gevat ende deste eer gemelte bambousen affgebrant, sulcx dat dito steenen dack dat op voorschreeven bambousen sijn stoonsel heeft, nedergevallen is. Ooc waeren de meeste huysen boven in den vorst met stroo dicht gemaeckt, dat wij ooc angesteecken, ende in diervoegen 't geheele dorp tot niet affgebrant hebben.

De inwoonderen deses dorps waeren gefatsoeneert ende gearmeert gelijck die van Lonciouw met piel ende boogh die sij veel hebben. [Het] is bij haer het snelste ende defensivste geweer; daerbij hebben sij pycken ende schilden, alles in conformite met die van Lonckiou. [...]

Ultimo dito: [...] één van onser gevangene vrouwen die out ende de
moeder van den Tawalischen regent was, soo men ons bericht, is van
onsen capiteyn (neffens twee kinderen die sij seyde dat haer in den bloede
bestonden) om redenen gelergeert ende met een cangang ende een armosijn
begifftight. Haer wert bericht dat sij die veltvluchtige Tawaliers soude
gaen aenseggen, soo sij tot onse gunst ende vrientschap genegen sijn, soo
mosten sij haer bij ons voor Lowaen laten vinden, wanneer haer wel
weder in genade anneemen wilden.

Verscheyden inwoonderen (neffens haeren regent) van Lowan die dese
gerucht verstaen hadden, sijn alhier bij ons (brengende een vercken tot
schenkagie) verscheenen, die 't gedaene soo sij seyden wel geviel ende
souden selffs daertoe soo 't noch ongedaen was geholpen hebben. Alhier
voor Tawaly soude in sulcken weer als doen was wel vaertuych connen
houden ende te lande comen.

Omtrent 9 uyren [...] hebben wij oock neffens den Lonckiousen vorst ende
omtrent vijftig van de sijne (die (fol. 561) naer veele anhoudens daer toe
bewillicht was) onse reyse naer Lowaen angevangen. Die van Lowaen
omtrent twintig mannen sterck, hebben ons ooc met haer geselschap tot
voor haer dorp geaccompagniert, onse soldaten alhier secret naergetelt
sijnde, bevont noch 106 gelitgangers sterck te sijn, waermede voorts in
Godts naeme naer Lowaen ende Pymaba gemarcheert sijn. Onsen wech
was gelijck vooren langs de seecant [...].

Halffachtermiddach commen onder dorp Lowaen [...], des avonts hebben
den regent van dito dorp Lowaen voorgeslagen dat 't ons wel soude
gevallen soo eenige van de sijne sich als onsen gesante naer Pymaba sich
wilden transporteren om haer luyden onse comste ende die redenen der
selver antecondigen. Waerop dito regent tot antwoort gegeven heeft dat sij
met die van Pymaba maer gedissimulierde, ende ghiene oprechte vrienden
sijn, weshalven haer 't selve uyt vrese van gedoet te werden niet dorsten
ondervinden. Maer was genegen met sijn volck gewapenderhant op
morgen tot voltrecking onses voorneemens sich onder onse criechsmacht te
vervoegen om also gearmiert haer luyden de redenen onser comste
ruchtbaer te maecken, waermede ons gerust hielden.

Verder onsen Chineesen tolck, Tangwa genaemt, die meermaels daer
geweest is, voorgestelt sijnde sich met geschencken an den regent van
voorseyde Pymaba op morgen diende te vervoegen, om alsoo de redenen
onser comste hem ruchtbaer te maecken. Die ooc uyt vreese van gedoot te
werden (soo hij seyde) 't selve affgeslaegen heeft, ende conformierde sich
met 't gevoelen van bovenstaende regent, invoegen d'expeditie van onsen
gesante achtergebleven is. [...]

Des nachts commen d'ingesetenen van Lowaen in redelijck getal bij ons sijnde in meyninge op morgen vroech gewapender hant neffens ons naer Pymaba te vertrecken, om ons dessein tot effect te helpen. Bringen twee levendiche verckens, eenich droch hertevleys ende acht calebassen met dranck, hebben sij voor ons volck meede gebracht; dat alles onder de soldaeten uytgedeelt is tot recompens van haer gebrachte lijfftochten. Als ten teycken van vrientschap sijn haer luyden drie cangans, eeniche toback ende twee bosch crallen vereert, waermede sij ten vollen gecontenteert geweest sijn.

Februarius anno 1638. Primo dito: [...] neffen die van Lowaen die omtrent 150 mannen sterck waeren ende den Lonckiousen vorst met de sijne naer Pymaba. In 't optrecken wirt ons van die van Lowaen angedient hoe sij geïnformeert waeren dat die van voorseyde Pymaba met haere bontgenooten geresolveert sijn ons gewapenderhant in 't velt te willen tegen trecken. Daerop wiert geantwoort, soo sij daertoe inclineren, sullen haere comste gewillich inwachten.

Des middachs te één uyren sijn wij voor dito Pymaba wel angecommen. Dito inhabitanten des geseyden dorps vonden wij gewapent dicht voor haer dorp in 't velt, waertegens wij soetjens in slachorde gemarcheert sijn, sij deinsden ende weeken achterwerts. Eyndelinge hielden wij stil ende sonden onsen Chineesen tolck Tangwa genaemt, met volgende informatie an die van Pymaba: te weeten dat hij den regent ende inhabitanten van dito Pymaba soude anseggen hoe door ordre van den Ed. Heer gouverneur ende den oppersten regent der Hollantsen standt deses eylants ende anclevende van dien, den capitein in Tayouan met sijne bijhebbende criechsmacht herwaerts angesonden is. Wesende niet sijn beveel haer gewapenderhant antegripen, maer den vreede ende gunste te presenteren om welcke redenen wij ooc in april anno passato met één onser joncken alhier geweest sijn, ende doenmaels door haerde winden ende groote seebaeren ons genootsaeckt vonden de rede onverrichter saecken te ruymen, ende sonder obtinuee onses voorneemens weder naer Tayouan te keren. Sulcx dat als nu door welgemelte Heer gouverneurs ordre, de voiagie tot Lonckiouw te waeter, ende wijders met dese macht tot hiertoe te lande angevangen is.

Den Chinees wiert verder geïnstitueert in geval dito regent quam voor te wenden, dat sij beducht waeren 't mochte met haer uytvallen gelijck 't met die van Tawaly uyt gevallen is, weshalven in sorge stonden ende ons niet vertrouwen dorsten, dat hij dan in antwoort haer soude dienen, hoe die van Tawaly an den Lonciousen vorst, sijnde onsen bontgenoot, ende ooc selffs met verachtlicke redenen streckende vilipendentie van ons respect,

dat wij niet lijden connen, merckelicke orsackt hadden gegeven; sonder dat, ten waere noyd geschiet. Met welcke bovenstaende ordre den Chinees Tangwa naer (fol. 562) d'inhabitanten van Pymaba, die niet vert van ons voor dito dorp in haere wapens stonden gemercheert is; ende bleven wij op onse plaetse met goede wacht ende ordre den versondenen Chinees, die sij stracx in haer dorp leyden, ingewacht.

Seeckeren ingeseetenen van dito Pymaba, compt onderentusschen omtrent ons leger, doende teycken ofte wel iemant sprecken wilde, waertegen eenige van onse bijwesende Lonckiouwers ende den Chieneesen tolck Dickop derwaerts gegaen sijn. Gemelte persoon was een man van cleyne conditiën, ende vraegden soo hier ende daer naer ondienstige saecken. Eyndelick wenden hij voor ('t sij dan ter goeder trouwe ofte wel bedriegelijck), hoe datter veele ingesetenen van Pymaba in die aldaer staende ruichten daer ons leeger dicht an lach, haer verborgen hielden (dat ooc daer nae waer bevonden is), die ons wellicht hinder ende naedeel mochten aandoen. Weshalven 't hem geraden docht, wij souden daer opbreecken ende op het vlacke affgebrande velt dat daer dicht bij was neederleggen, alwaer merder ruymte ende beter uytsicht was. Over welck voorstel ons bedachten, ende meynden dat sulcx wellicht mocht geschieden, omdat sij onse macht op dito afgebrande vlacke velt uyt haer dorp als van haere wachthuysen die sij doch eene utermaeten hooch hebben, pertinent souden connen affsien. Weshalven dito inwoender van Pimaba wiert angesecht dat wij voor sijne insinuatie an ons danckbar sijn, maer wel verseeckert waeren dat onse mede gebrachte criechsluyden wiens getal niet weynich was, ende ooc in dito ruichten neederlaegen, die van Pymaba wel souden tegenstaen, waermede hij weder terugge gekeert is.

Middelerwijle verschijnt seeckeren Chinees uyt geseyde dorp, die aldaer omtrent die twee jaeren geweest is, rapportierende hoe sijluyden onsen tolck die als gesante in Pymaba van ons gesonden was, aldaer behouden ende wel onthaelt hadden. In wiens plaets sijluyden hem eens herwerts te commen gelicentiert hadden, ende soude den anderen tot sijne wedercomste aldaer vertoeven. Hij verhaelde verder dat op gisteren die tijdinge van Tawaly aldaer angecomen was, weshalven d'inhabitanten van verscheyden dorpen onder haer staende bij malcander vergaedert sijn, ende waeren den geheelen nacht uyt vrese van onse comste binnen haer dorp in de wapens gewest. Oock seyde hij dat den meesten hoop met ghien kleyne sorch omvangen was. Invoegen de vrouwens met haere goederen merendeels bosswerts in, all gevlucht geweest sijn.

Desen Chinees hebben wij ooc naer weynich ondersoeck van 't gene ons noodich docht weeder gelargeert, ende naer 't dorp gesonden, opdat wij

door 't weederkeeren van onsen tolck in 't begonne werck mochten commen te besoigneeren. Weynich tijts hiernaer wiert van den regent van Pymaba die sich in 't dorp verhielt, een gecommitteerde neffens den weederkeerden Chinees an ons gesonden, seggende van haeren regent bemachticht te sijn met den Hollantsen capiteyn van vreede te tracktieren, blijvende ondertusschen op één plaets buyten ons leeger hem daertoe angeweesen vertoeven. Wanneer wij naer weynich bedenckens wederomme een gecommitteerdens derwerts gesonden hebben met berichtinge dat hij den gecommitteerde met beleefftheit soude anseggen, wanneer den regent uyt Pymaba persoonlick hier verscheene dat sich als dan den capiteyn ooc in eygen persoon bij hem vertoonen sal. Waermede dito gecommitteerde nach weynich discoursen opstont ende sich naer Pymaba getransporteert heeft; haer leeger stont geduyrich dicht bij hun dorp in de wapens.

[...] Naer 't weeder keeren van desen gecommitteerde compt den regent van dito Pymaba genaemt Magol personlick geaccompagniert met vier à vijf van de sijne buyten ons leeger op bestelde plaets als voeren is angeroert, versoeckende dat den Hollantsen capitein sich ooc in eygen persoone bij hem aldaer vertoonen will. Daerop gevolcht is dat wij ons persoonlick sijnde vergeselschapt met vier musquetiers ende den trompetter, die opblies ooc, derwaerts getransporteert hebben. Welck geluyd der trompette hem wonder docht, ende sagen sijne omstanders vreemt toe. Aldus bij dito regent gecommen sijnde, setten ons neffens geseyde regent ende den Lonckiousen vorst ter needer. Met weynich clappussen, pinang ende stercken dranck sijn wij van hem begifticht, dat in 't tegendeel met arack die noch weynich hadden gerecompenseert werden.

Wanneer verder met dito regent van vreede handelinge getracteert is ende seyde den regent, off sij ons wel conform ons voorstel door den Chinees Tangwa an haer gedaen gelooven mochten, ende off 't selve ongevalst bij ons onderhouden sall werden. Waerop hem geantwoort is, dat wij luyden sijn die Godt vresen, van wiens ons loegens, bedriegerij ende valscheyt verboden wierdt, weshalven an onse sinceriteyt ende belooften niet te twijfflen hebben, te meer ons van haer tot noch ghien hinder noch afronten (daer in meynen dat continueeren sullen) angedaen is. Dat die van Tawaly van ons aengetast ende beorloogt sijn, daertoe hebben sij ons mercklicke redenen gegeven; sonder dat waer 't selve niet geschiet. Alles in conformite gelijck wij meynen onsen Chienesen tolck den regent sal angecondicht hebben. Op welcke bovenstaende reden dito regent naer weynich bedenckens sijnen hoet ofte mutse treckende een weynich naer 't fatsoen van een croone, die ten deele met gout doch seer dun gelijck

pampier, bedeckt was van sijn hooft nam, ende stelde deselve met volgende redenen op ons hooft, seggende: 'wanneer uwe woorden waerachtich sijn, gelijck wij vertrouwen, jae soo sal desen hoet die mij van mijnen voorouderen geerft is, wiens opliggende goudt sij van het affgelloopene dorp Lynau (gelijck volgen sal) tot buyte becommen hebben, een teycken des verbonts sijn, waeran de mijne bemercken sullen dat wij des Compagnies bontgenooten ende ghij onse vrienden gewoerden sijn'. Waerop in tegendeel onsen hoet genommen ende den selven (fol. 563) in gelijcke form op des geseyden regent sijn hooft gestelt hebben, seggende in effecto: 'het bovenste decksel mijns lychaems, dat bij ons niet kleyn, maer in grootachtinge genomen wert, is den regent ende heer over den ommeslach van Pymaba vereert, waeruyt mijne bijweesende crijchsluyden als andere ondersaeten ooc sullen affmeten dat wij die van Pymaba in vreede ende vrientschap angenomen hebben'. Hiermede wert den vreede getroffen, die an beyde seyden met handtgeven bevesticht is. Wanneer verder ½ [el] roet flouwel tot confirmatie van den gemaeckten vreede an dito regent behandicht is, dat hem wel geviel ende accepteerde 't selve gewillich. Naer weynich vertoeven dat ten teycken van vrede eens gedroncken was, nempt dito regent sijn affscheyt, ende transporteerde sich met dito hoet van ons becomen op 't hoofft naer sijn volck, die noch gewaepent voor dito dorp (naer gissinge omtrent 500 à 600 sterck) in ordre stonden. Tegens den avont compt meergemelte regent met eenige van die sijne neffens onsen Chineesen tolck Tangwa, die sij 't sedert onse ancomste gehouden hadden, wederom bij ons. Vier à vijf clappussen ende weynich stercken dranck wiert voor ons medegebracht. Ons wert van den Chinees bericht dat hij gemelte hoet ende het roode flouwel op sijn huys gehangen hadde, waermede hij an sijne ondersaeten te kennen gaff dat den vrede tusschen hem ende den Hollantsen stant getroffen was.

Naer weynich gehouden discoursen tusschen ons ende den regent van Pymaba, item den Lonckiousen vorst, versocht dito regent wij wilden ons criechsvolck den aenstanden nacht doch niet in sijn dorp laeten commen, op morgen wilden sij ons selffs binnen leyden. Waerop hem geantwoort is, dat sich daervan wel buyten sorch stellen mach, alsoo onse soldaeten soo subject sijn, dat deselve sonder onsen wille haer niet verreppen connen. Dat hem wel geviel, ende versochte hij wij wilden ons neffens twee à drie van d'ons met hem in 't dorp transpoorteeren, ende t'sijnen huyse vernachten. Waertegens tot antworde gegeven is, dat wij ons over sijne belefftheyden verplicht hielden ende soude daertoe wel geneegen sijn, maer die wijle t'bedencken stont, dat onse bijhebbende crijchsluyden door ons affweesen wellicht, 't sij in haere tuynen ofte velthuysen, eenige

ongeregeltheeden mochten anrichten, dat ons niet lieff soude sijn. Weshalven 't ons raetsaemst dunckt dat sich ons persoon (om alle misverstanden voor te commen) dese nacht in 't leeger verblijft, ende op morgen gelijcker hant conform sijn versoeck, binnen haer dorp trecken, dat hem recht dochte, ende liet sich 't selve well gevallen. Hij nam voorts sijn affscheyt alsoo 't doncker wert, ende vervoegde sich bij sijn volck, dat noch voort 't dorp in d'wapens stondt. Onsen tolck Tangwa transporteerde sich ooc neffens den regent binnen dito dorp ende vernacht aldaer.

Achter den regent ende de sijne haer vertreck, sijnde alreits doncker geworden, resolveerden wij (om considerabile redenen, alsoo den wilden hoop niet te vertrouwen is) met ons leeger op te brecken, ende een ander quartier (dat bij dage affgesien was) in te neemen, alwaer wij ons met beyde compagnies (stellende d'inwoenderen van Lonckiou ende Lowaen tusschen beyde), in slachordre elck in sijn gelitt, neergelecht hebben. Wij hielden stercke ende goede wacht. [...].

Den 2ᵉ dito: des morgens [...] compt den regent van Pymaba omtrent één uyre op den dach, hebbende sijnen becomen hoet van gisteren op sijn hooft, in ons leeger. Versoeckende wij wilden ons met ons crijchsvolck neffens den vorst van Lonckiouw ende de sijne in hun dorp transporteren. Maer die van Lowaen versocht hij dat buyten mochten blijven, alsoo sij van outsher vianden waeren geweest, ende dienvolgende wellicht eenige onlusten mochten veroorsaecken, te meer omdat sommige alriets in den verleeden nacht in het dorp geweest ende seeckere corallen, die bij haer in groot achtinge sijn, geeyscht hadden. Hierover bij ons den Lonckiousen vorst ende den regent van Lowaen beraeden sijnde, vonden goet tot voorcomminge van ongenuchten, dat die van Lowaen souden buyten blijven ende onse comste aldaer inwachten, oftewel naer dat haer behaegde wederom naer huys keeren, dat sij annamen ende hebben haer alsoo weeder naer hun dorp getransporteert.

Wie breecken met slaende trommels ende vliegende vendels met ons leeger op ende marcheeren naer hun dorp. Den regent nam mij bij mijne rechter, ende den Lonckiousen vorst bij de slincker hant, marcheerden alsoo voort naer dito dorp. D'inwoendern stonden an beyden sijden onse passagie dicht onder hun dorp in haere wapens, daer wij tusschen door, wel op onse hoede sijnde, met goede ordre gemercheert hebben. Den regent leyden ons tot sijnen huyse, daer hij ons naer hare wijse wel onthaelt heeft. Ons crijchsvolck wert an beyde sijden des geseyden regents huys in ordre gestelt, die ooc lijfftochten van d'inwoenderen genocht toegebracht is, doch den stercken dranck wert onder ons volck op den hals geweert.

Daer ontstont onder d'inhabitanten, ick en weet niet waerom, eenen oploop dat stracx door haeren regent weder geslist is; hij bestraffte haer verder over den grooten toeloop, die sij omtrent ons deden, ende gelast dat sich elck van hier in sijne wooninge transportieren soude, dat sij ooc gedaen ende achtervolcht hebben.

Dus verdt gecommen sijnde hebben hem met eenige blauwe cangangs, crallen, ½ goude laecken, ende een stucx sweert flouweel ende twee armesijnen begifticht. Wanneer naer verscheyden discoursen ondersocht is wat volckeren tot sijn gebuyren hier omtrent was hebbende, ende ofte deselve met hem in vrede ofte orloge stonden; waerop hij in antwoort gaff dat aldaer omtrent verscheyden dorpen ende volckeren woenachtigt sijn, die de sommige met haer in vreede ende d'andere in oorlooge staen, ende verhaelden hij verder naer soet ondersoeck, hoe dat noordewerts (fol. 564) van Pymaba, sijnde omtrent 3½ dachreysens (voor haer) seeckere reviere bij haer Danau genaemt, daer bij eenige dorpen liggen die sij 't eene Ranginas ende 't ander Radangs hieten, wiens grootte niet minder als Pymaba is. Dese luyden hebben vaertuych, sijnde vloegel prauwen, daer souden noch verscheyden dorpen hier omtrent liggen die sij niet en kennen. In dese dorpen seggen sij dat goudt is, dat dito reviere Danau die uyt 't geberchte compt soude opwerpen. De redenen die sij van 't bovenstaende geven sijn als volgt: dat sij over eenige jaeren seecker dorp (omtrent dito reviere), genaemt Lynau, hebben affgeloopen, alwaer sij eenige plaeten gouts (sijnde van 't selve daer des regents hoet mede bedeckt is), doch seer dun, onder haere slaapmatten gevonden ende mede t'huys genomen hebben. Uyt welcke luyden sij bericht sijn, dat gemelte reviere 't gout soude opwerpen, doch in wat vorm 't sij, in 't groot ofte cleyn getal, weten sij ons niet an te seggen. Ofte dese luyden dito gout uyt gemelte reviere selffs opsammelen, dan ofte sij 't gewapender hant van haere vianden becomen, weeten sij ooc niet.

Ondersocht sijnde om wat redenen met dese luyden in oorlooge staen, ende ofte sij door onsen middel met haer niet connen bevredicht werden, ofte andersins den orloch anteseggen, alsoo wij van opinie sijn die den vreede affslaet met goet recht den oorloogh mach angedaen werden. Waerop hij eerstelick in antwoort diende, dat dese luyden van outsher nict wetende waerom haere vianden gewest sijn, weshalven sij daerin continueerden. Wat verder den vredehandel anginck, daer was niemant soo stout in Pymaba die onderstaen dorst als een gesant sich derwaerts te transporteren, behalven dat sij luyden malcander in haere spraecke ooc niet verstaen connen, over sulcks 't selve hem wel dacht.

Hierop voort ondersocht sijnde ofte sij dan genegen waeren den oorlogh hun an te doen, soo wilden wij ons onder hun geselschap tot dempinge haerer vianden (gelijck met die van Lonckiouw ende andere onse bontgenooten gedaen hadden) wel laeten gebruycken. Dat scheen hem wel te gevallen, ende seyden naer weynich beraet dat sijn volck als noch voor d'onse te schrupelioes was, ende vresen sij dat haer op den wech van ons ontrouwicheyt soude angedaen werden; oversulcks dorsten sij dese reys met ons niet optrecken. Wanneer hem verder voorhielden dat sij onse getrouwicheyt uyt 't gene wij den Lonckiouwsen vorst (gelijck hij weet) te gevalle gedaen hebben behoorde af te meten; waertegen hij weederom in antwoort gaf, wanneer sij soo lange met ons verkeert ende ommegegaen hadden, gelijck die van dito Lonckiou gedaen hebben, dan souden sij niet minder in alle voorvallende saecken als die van Lonckiou bevonden werden.

Meermaels hem voorstellende dat den tijt als nu geschapen was (diewijle wij met onse crijchsmacht tot hier verschenen sijn), om dese sijne vianden door onse wapens tot redelicheyt te brengen; ende soo hij an onse getrouwheyt twijffelende was, wij wilden wel eenige van d'onse als ostagiers tot onse weedercomste in sijn dorp laten verblijven. Waerop geantwoort heeft, dat sij dese reys met ons souden optrecken, was voor haer (om redenen gelijck vooren) als een onmoegelicke saecke. Maer wilden wij eenige van d'onse op ons vertreck naer Tayouan in sijn dorp laeten blijven, dat souden hem wel gevallen, ende wilde denselven met cost ende dranck wel onthaelen. Doch iemant van de sijne in teegendeel met ons naer Tayouan te gaen dorsten sij uyt vreese van water dat wij over moeten niet bestaen.

Naer 't afflaeten van dese discoursen is an hem ondersocht, ofte niet van dito gout hadde dat sij van 't dorp Lynau ende andere haere vianden gehaelt hebben. Op welcken voorstel hij in effecto andwoorde, jae, daervan te hebben. Wanneer verder versochten hij wilde gemelte goudt eens verthoonen ofte 't selve met 't onse één gestaltenisse hadde, presenteerde hem ondertusschen seeckere Japansche munte (bij dito Japanderen Cupang genaemt) dat hij besach ende seyde 't sijne soo dick niet te wesen maer vrij wat dunder, hij wilden 't ons wel verthoonen, maer diewijle sijn gantsch huys vol volck was, schaemden hij sich daervoor. Naer weynich discoursen hielden andermael an hij wilden dito gout slechts sien laeten, ofte daervan vercoopen wij souden 't selve t'sijner eeren meedraegen ende bewaeren, andersins hadden wij in Tayouan gouts genoch gelijck hij gesien hadde. Wanneer hij opstont gaende naer seeckeren aldaer staende knaster seggende 't selve te willen kriegen, doch

bedachte sich ende keerde onverrichter saecken (met dese woorden) wederomme, dat hij met dito goudt medelijden hadde, sulcx dat 't selve niet ten verschijn gecommen is, ten fine wij ooc om consideratiën van dito goudt affgelaeten hebben.

Hij verhaelden verder hoe dat omtrent een dach ofte wat meer reysens van Pymaba, seecker dorpiën licht, wiens name mij ontgaen is, dat met haer ende de gouthebbende luyden in vreede is. Dese ingesetenen secht hij dat van dito goudthebbers somwijlen eenich goudt truckeren, van waer sij ooc wel somtijts weynich connen becomen. Hierop hebben wederom tot vervolch onser goede meyninge hem voorgestelt dat den wech door dito dorp dat haer ende onse vrienden sullen sijn, naer gemelte gouthebbers geopent was, 't sij dan van daer één gesante derwerts te senden, ofte wel gewapenderhant den marsch, naerdat sich die gelegentheyt vertoonen sal, selffs anvangen. Sij wilden slechts met ons optrecken ende den wech anwijsen, ende die route van dien; dat dan een boode naer dito dorp wilde affverdigen die weynich gouts voor ons opcochte, wij wilden 't selve betaelen ende sijne comste buyten 't dorp inwachten. Waerop als volght geantwoort heeft: dat sij met ons souden optrecken dorsten sij om voorig gegevene reden haer niet ondervinden; dat sij oock onse wechwijsers naer dito dorp souden sijn, dorsten sij mede (diewijle men ons tot noch voor een vremt volck hielt) van schaemte halven niet onderstaen; een boode derwaerts te sende, daertoe souden die sijne, gemerckt wij noch (fol. 565) (soo nuyw ende) in haer dorp sijn, ghien lust hebben, behalven dat den wech vert is, ende dan noch te bedencken stont ofte wat sullen becommen ofte niet; maer van langer hant als twee à drie persoonen van d'onse daer bleven, verseeckerde hij ons van 't selve.

Verder gevracht sijnde ofte omtrent dese goudthebbende luyden ghien Spaniargden sich verhielden, aen wien sij gemelte goudt mochten vercoopen. Daervan seyden sij haer leven niet gehoort te hebben, noch waer 't selve vertiert wert. Naer alle welcke bovenstaende vragen ende andworden, hebben wij ooc om considerabele redenen affgelaeten ende niet meer daervan gediscouriert, te meer wij alriets één monster van dito gout an den voorseyden hoet, ende noch seecker cleyne pertie becomen hebben.

Ondersocht verder wat wapens dese luyden omtrent die reviere Danau hebben, item ofte haere macht groot ofte cleyn is; secht dat sij neffens haer met schilden, houwers, pyl ende booch, ooc sommige met pijcken gewapent sijn. Wat 't gestaltenisse van 't volck an gaet, sijn groot van posture, ende in ghien cleynder getal als die van Pymaba, 't souden ooc naer haer seggen redelicke crijchsluyden weesen.

Op alle bovenstaende berichtinge ende hoop van de gewenste gout mynerael te becommen, hebben conform onse ordre goetgedacht den persoon van meester Meerten alhier, neffens een soldaet, ende een Guseratte die haer dienen sal, item seeckeren Chienees die hier twee jaeren geweest is ende haer spraecke soo hij secht redelijck verstaet, te laeten verblijven. Den regent angedient sijnde dat tot bevestiging der gemachten vrede twee persoonen van d'onse wilden hier laeten, ende dieselve over twee maent commen weederhaelen, geveelt hem wel, seggende dat d'selven in sijn huys souden gefoureert ende met cost ende dranck genoch besorght werden.

Twee à drie jongelingen, sijnde van den regent sijn maechschap, hebben mede gesien dat haere pronckpluymen (gelijck sij draegen) an d'ondercant vier vingeren breet rondt om haer hooft met dergelijcken dun gout bedeckt was.

Tegens den avont gemerck in onse saecken, soo wij meynden, niet meer te verrichten (ende in dito dorp te vernachten ongeraetsaem) was, hebben opgebroecken ende buyten dito dorp gemarcheert. Den regent geleyden ons selffs an mijne rechterhant tot buyten 't dorp in 't velt, alwaer hij affscheyt nam, ende, naer dat hem van getrouwichheyt tegens des Compagnies staet vermaent was, item dat sich als onse oprechte bontgenooten met die van Lonckiou ende Lowaen draegen most, (dat hij gewillich annam) weeder terugge gekeert is. Wij marcheerden voort, en leegeren an seecker reviertien in 't vlacke veldt, daer den nacht vertoefft hebben. Den verckens die alreets in Pymaba voor ons gedoot sijn, hebben sij tot hiertoe gebracht die soo wel onder d'Lonckiouwers als d'onse uytgedeelt hebben.

Het dorp Pymaba is redelick groot ende licht niet op 't geberchte gelijck die van Lonckiou doen, maer op vlack ende effen velt, haere huysen sijn met stroe gedeckt ende rontom met bambousen dicht gemaeckt, soo is ooc gemelt dorp met wassende bamboesen omvangen, alles in conformité gelijck Synckan, ende daer omtrent gelegene dorpen, behalven dat haere huysen soo goet ende groot niet en sijn. Sij hebben ooc redelijck veel soo clappus als pynangboomen, binnen dito dorp. Daer souden naer onse gissinge ende 't bericht van seeckeren Chinees die daer gelijck boven, twee jaren geweest is, meer als 1000 strijdbaere mannen in sijn. Dese luyden sijn redelijck sterck van lychaem ende gearmeert neffens die van Lonckiou, sijnde pijl ende booch, item pycken, sommige van omtrent 15 andere van 18 voeten lanck. Men bericht ons dat sij goede ende defensive crijchsluyden sijn. Eene derselver inhabitanten sijnde des regents dienaer

was boven gewoente seer groot ende groff van lychaem, sijn grootvader, seyden sij, soude eene pijcke van dertig cattie swaer gevoert hebben.

Daer souden noch zes à zeven dorpen die daer omtrent gelegen sijn volgens 't bericht van dito Chinees onder haer commando staen waervan sij alriets eenige crijchsluyden bij haer vergaedert hadden.

Drie Februarius: Meester Maerten die met ons op gisteren tot hier gecommen was, ende sich den verleedenen nacht over sijn aenstaende besoignes met ons beraden heft, keert naer becoomene extract uyt onse instructie concerneerende sijn bevoolen saecken (neffens een soldaet, genaemt Isack, persoon die hem tot geselschap dienen sal, item een Guseratte ende seeckeren Chinees die daer als boven twee jaeren geweest is) wederom naer Pymaba. Op sijn affscheyt is een chargie met zes musquetiers gedaen. De Heere geve dat sijn bevoolen saecken naer wensch moegen uytvallen!

Wij marcheeren voort tot voor Lowaen ende rusten aldaer an een waterbeeckien. Alhier commen d'inwoonderen kleyn ende groot bij ons. Drie levendige verckens, eenige coeckies van mily gebacken ende ooc stercken dranck hebben sij ons toegebracht. Den regent van dito Lowaen versouck wij wilden ons met onsen macht in sijn dorp transporteeren. Hij wilde aldaer naer vermoegen ons onthaelen, dat wij omdat gemelte dorp soo hooch op 't gebeerct ligt, met beleftheyt affgeslagen hebben, seggende dat wij danckbaer waeren voor haer beleftheyt ons bewesen, maer sijn genegen onse reys op staende voet naer Lonckiou (fol. 566) an te vangen. Daerop hij verder versochte, wij wilden dan een brieffien an meester Maerten, die in Pymaba was, schrijven, dat denselven haer uyt onsen naeme quam te besoucken. Gemelte brieffjen wilden sij dito meester Merten selffs te handen stellen, dat wiert hem vergunt ende in 't werck gestelt.

Den regent van 't dorp Tawalij dat op 30en passato bij ons stormenderhant ingenomen ende affgebrant is, liet alhier door den regent van Lowaen (in welck dorp sich verhielt) versoecken ofte hij bij ons om van vrede te tracteren verschijnen mocht; dat hem met communicatie van den Lonckiousen vorst ingewillicht ende toegestaen hebben. Waerop hij neffens eenige van de sijne bij ons verscheenen is, ende versoeckten sij naer weynich discoursen, dat sij in onse gunst ende vrientschap (neffens die van Lonckiou ende daer omtrent gelegene volckeren) mochten angenommen werden.

Waerop als volght haer geantwoort hebben: 'dat wij voors. dorp Tawalij hebben affgelopen ende geruïneert, is allenich omdat ghij voor desen trouwloes ende onminlick met die van Lonckiou onse bontgenooten

gehandelt hebt. In den jaer verleeden hebt ghij ooc tot vilipendentie van ons respect (als die van Lonciou op onse macht haer beriepen) wel stoutelijck derven seggen, wij souden slechts met haer ancommen, ghij wildet ons met gelicke spise wel versadigen. Welck verachtelicke ende stoute redenen wij om ghienige oorsaeck lijden willen, maer trachten allewege, gelijck nu geschiet is, sulcx met de wapens te revengeeren. Wat voordeel nu onse comste U toegebracht heeft, weeten wij (maer ghij) best. Doch gelickerwijs door het swert den chrijch volvoert wert, even alsoo verwerfft men door een oprechte herte ende lijfflicke tonge den vrede. Sulcx dat U ooc onse gunste niet affslaen, maer inwilligen willen, opdat alle dese werelt weet dat wij die wrevelmoedige met onse wapens bestrieden ende die nederiege in vreede anneemen connen'.

Op welcke bovenstaende redenen den regent geandwoort heeft, dat hem 't gepasseerde leet was, ende sulcke stoute onwetende worden waeren bij haer onbedachte jongelingen geschiet, dat hij niet remediëren cost. Allenich versoechten hij, wij wilden slechts in genade anneemen ende op haer voorige plaetse wederom laeten bouwen. Sij wilden haer tegens den Compagnies staet, item met die van Lonckiou, oprechtelijck ende seer minnelijck draegen. Op welcke bovenstaende voorstel ende andwoorde, wij met advijs van den Lonckiousen vorst haerluyden weeder angenommen ende den vrede met hantgeven bevesticht hebben, mits dat sij een kleyn Clappus ofte Pynang boomtien met eerde in een treesel ten teycken dat sij haer lant an d'Hoochmoegende Heeren Staaten ende den Ed. Heeren Bewinthebberen der Vereenichde Oostindische Compagnie hebben opgedragen, ons souden ter hant stellen. Dat beloofden hij in gevalle enich in sijn dorp, dat wij geheel hadden geruïneert te becomen was.

Daer wiert verder bij den regent ondersocht, hoe veel dooden sij wel gehadt hebben, item wat getal gevangens bij die van Lonckiou wech gevoert sijn. Waerop hij antwoorden 't getal der dooden niet te weeten, maer datter omtrent 120 menschen werden gemist. Naer welck bovenstaende discours ende vermaen van trouw ende oprechticheyt tegen des Compagnies ende Lonckiousen stant hebben wij omtrent twee uyren achter de middach weder opgebrocken ende onsen marsch achtervolcht.

Tegens den avont legeren ons an seckeren waeterbeckiën sijnde omtrent halffwegen Lowaen ende Tawalij alwaer des nachts vertoefft hebben, gemelte drie verckens van Lowaen becomen sijn ons van de Lonckiouwers tot hier naergedraegen, die gedoodet ende onder 't volck uytgedeelt hebben.

Vier Februarius: [...] naemen voor der sonnen opganck [...] ons vertreck, ende passerden in corten het verbrande dorp Tawaly [...]. Omtrent halff

achtermiddach commen voor 't dorp Patsaban alwaer [...] vernacht hebben. Dese luyden van onse comste verwitticht sijnde hebben cost ende dranck genoch (gelijck voor desen in 't heen gaen) affgebracht. Invoegen haer bedancken moeten [...].

5e dito: [...] wij marcheeren [...] voort naer 't dorp Luypot, onderwegen hebben noch seecker dorpsvolck dat in 't geberchte licht, met twee levendige verckens, eenich drooch hertevleesch, ende stercken dranck ons in gewacht. Dat wij affsloegen ende danckten haer voor haere beleefftheyt, doch sij hielden an wij souden 't selve accepteeren. Sij wilden 't ons tot Luypot, sijnde een dorpien dat niet vert was, naerdraegen. Sulcx wert angenomen ende sijn sij met ons tot voor dito Luypot gemarcheert.

fol. 567: 't Was omtrent 11 uyren als wij voor geseyde Luypot verscheenen sijn. Alhier hebben wij in onse oude quartier dat noch stont, wat gerust en de geseyde twee levendiche verckens gedoot ende onder 't volck uytgedeelt. Des achtermiddachs omtrent twee uyren breecken weeder op. [...] Met den avont commen voor 't dorp Matsaer, alwaer ons neergeslaegen ende vernacht hebben [...]

6e dito: des morgens [...] marcheerden [...] weder voort [...] comen in 't dorp Bangsoer, van waer naer weynich rustens voorts naer Dolaswack, [...] d'inwoonders hielden haer over onse comste seer verblijt. [...]

7e dito: [...] dewijle ons volck van 't marcheeren vermoeyt was, hebben geresolveert dese dach hier te verblijven. D'inwoenders hebben nae haer vermoegen ons onthaelt.

8e dito: [...] resolveerden wij naer onse joncke te vertrecken, ende hebben naer veel bedenckens hoe 't met de becommene gevangens van Tawalij, die onder de Lonckjouwers berustende sijn, handelen sullen. Eyndelinge goetgedacht zes à zeven van de fijnste kinderen uit te kiesen, ende naer Tayouan mede te voeren, 't sij dan den Ed. Heer gouverneur d'selve in Tayouan onder de officieren geliefft uyt te deelen, ofte wel met de joncke die in April om meester Maerten naer Pymaba gaen sal weederom te senden.

Den vorst van Lonckiou wiert mede angesecht in gevalle bij sijn gemelte Ed. heer gouveneur verstaen wiert, dat geseyde gevangens van Tawaly soude gelergeert werden, dat hij sich 't selve ooc onderwerpen most ende gemelte gevangens uyt sijn lant wederom te huys senden, waermede hij sich conformierde ende seyde 't selve sich te willen onderwerpen.

Omtrent acht uyren neemen wij ons vertreck uyt Dolaswack, den Lonckiousen vorst geleyden ons persoonlijck met eenige van de sijne naer onse joncke. [...] Met der sonnen onderganck commen bij onse joncke in de baye van Lonckiouw. [...]

9ᵉ dito [...] begeven ons naer genommenen affscheyt van den Lonckiouwsen vorst die sich seer dienstich aan d'Ed heer gouverneur gebiet, omdat hem met chrijgsvolck tot dempinge der hoochhertige Tawaliers gesecundeert hadde, met onsen joncken buytengaets in see [..].

fol. 557: [22 January 1638] Today captain Johan van Linga and 130 soldiers embarked in three junks for a trip to the Lonckjouw region and, in accordance with his instruction, to land in the Bay of Lonckjouw and march via Lonckjouw territory on to Tawaly and Pimaba.
(On 24 January Van Linga and his men landed in the Bay of Lonckjouw. The next morning they set out and in Dolaswack they met:) [...] the ruler of Lonckjouw, accompanied by his son, and a suite of about fifty men. We stopped and our men were positioned in battle array. We then sat down beside the ruler for a while and after some civilities we gave, in the governor's name, his kind regards to the mentioned ruler and his brother. Furthermore, we explained to him that we, together with the army, had been sent by our lord governor upon the ruler's request to subject Tawaly with our arms. In return we expected that he and some of his men, would supply provisions for our men until they reached the enemy's territory. This expectation was based on the fact that the interpreter Samsiack recently had told the governor that the ruler was looking forward to our arrival, and to that end he was keeping enough rice and millet in store. (fol. 558) Whereupon the ruler replied that the governor's kindness much obliged him and that neither he, nor his people would in any way fail to help us out with the victuals. He would ensure that everything was accomplished according to the earlier promises he had made to the captain and others. He bade everyone of us heartily welcome. [...]
In the evening we arrived in the village of Dolaswack [which was located in Lonckjouw territory], much to the joy of its inhabitants. The men were split up in three of their guardhouses, and with stringent rules (to prevent irregularities from happening) they were kept inside. We spent the night at the ruler's own house. [...].
(The next day the ruler asked the men if they would be willing to stay in Dolaswack for another day.) Meanwhile he wanted to inform his people, who dwell here and there in several villages, about our presence so that they could, amply provided with victuals, join the army tomorrow and the day after tomorrow. [...]

The 26th ditto: [...] together with the soldiers and his people the ruler entertained us well with drinks and food according to his customs.

The 27th ditto: [...] together with the regent, his brother and other subjects we left Dolaswack for Bangsoer. [...] At about eleven we arrived at the eastcoast of this island [...]. From there we proceeded with our march in a northern direction [...]. *(The men camped on the beach)* here some more inhabitants of the Lonckjouw region joined us to participate in the expedition. [...]

(On 28 January they passed the mountain villages: Karradey, Tarodas en Matsaer 'which were subject to Lonckjouw' (fol. 559) *and the night was spent in Luypot. Everywhere the paths could only be passed with great difficulty. The rocks were particularly slippery because of the rain. Nowhere along the shore was an appropriate landing for junks to be seen. The next day the men continued along the villages Ballicrouw and Parangoy:)* [...] There we learned from the ruler of Lonckjouw, that the inhabitants of the neutral village of Patsaban, were nothing more than feigned and unfaithful friends of his people. Therefore he requested us to attack that village in order to subject the people with our arms. When we investigated the reasons for this request a little more deeply, they only told us that the inhabitants of Patseran were malicious and disingenuous, without really being able to prove any offences perpetrated against Lonckjouw. Thus, after considering the ruler's proposal, we answered him in the following way: that we thought it was not reasonable and that our conscience would not tolerate that we should wage war against people who haven't given a clear reason for doing so. However, we did know how we could counsel them to unite Patsaban with Lonckjouw. If the ruler would send one of his men to Patsaban to announce in the name of the captain that we with our expedition army, together with the Loncjouw regent and his subjects had arrived here. Should they be willing to subject themselves to our protection and to conclude peace with Lonckjouw, their headmen should meet us at the beach and supply our men with some victuals. But if they should renounce our peace proposal we would consider it to be our right and duty to raise arms against them. The regent of Lonckjouw and his brother seemed to like this and they agreed to send a messenger over to the mentioned village.

At about eleven we reached Patsaban which, like the other villages, is situated in the mountains, so that we could not see it. There we took a

rest and waited for the messenger to return. Shortly after noon he came back, reporting to us that the regent would soon send us some provisions together with some of his subjects. He asked us to wait for a while because he needed some time to arrange for that.

Whereupon a messenger was again sent to anounce to them that if they were willing to come down to meet us they had to do so right away, however if they did not show up themselves then we would be compelled to employ other means, because we did not intend to stay there any longer for their sake. In the meantime the men from Lonckjouw were making up quarters for us all, as we felt that we had to stay for the night. [...]

A little while past sunset the regent of Patsaban came down with some of his men, presenting us with eight living pigs, some dried venison and seven pots of *massecau*, all of which was divided among our men as well of those of Lonckjouw. The villagers seemed to be quite timid and frightened, but after we had welcomed them in a kind manner and talked a little, they seemed to become somewhat more cheerful. When we told the regent, on the advice of the ruler of Lonckjouw, that we were pleased that he and some of his subjects had come down to meet us and had supplied us with some victuals for our men, and that in doing so he gained our confidence and that we also were willing to offer them peace and grant them our favour, which he surely (just like all sensible inhabitants had done before) would not reject. The regent and his followers accepted our words.

With the advice and agreement of the mentioned Lonckjouw ruler, we also proposed to the people of Patsaban that we would be satisfied if they would, from that time on, behave like loyal allies of the Company and of Lonckjouw. However, we added that should they fail to meet expectations we would respond in a way similar to that taken against other disobedient villages, which also seemed to please both sides. They answered that they sincerely wanted to be united in peace with the Company as well as with Lonckjouw. Furthermore they said that the next day they wanted to appear before us with a sufficient number of their people, and also that they wanted to assist us in the assault against those of Tawaly, (which however in the end was not performed) who they counted to be their enemies as well. To this statement we replied that if they wanted to, they were welcome to accompany us, although we (with God's help) had

enough men at our disposal to carry out our plan. Hereupon as a sign of friendship and expression of our gratitude for the provisions we had received, we offered the men of Patsaban two blue *cangans*, (fol. 560) a few beads and a little tobacco. That night they contentedly returned to their village with these presents.

The reason for our half-a-day stopover there can partly be attributed to the fact that we intended to reconcile the ruler of Lonckjouw with the village of Patsaban and partly because we deemed it expedient to leave no enemies but only friends behind us, so that should the occasion arise, either on the way back or in the future, we may have any necessities supplied by them.

On 30 January at daybreak [...] we marched on [...] to Tawaly but those of Patsaban did not follow us as they had promised us yesterday evening. Lonckjouw accompanied us with about four- or five hundred warriors.

At two in the afternoon we arrived at the village of Tawaly, which was quickly taken by assault, burnt to the ground and completely ruined. At sunset, long after this was over, we left that village and camped with our men beside the knee-deep river that runs along that village from the mountains to the sea. Tawaly was situated high up on a mountain slope and was, on the side where we had to enter, surrounded by strong enclosures of stone and bamboo. At first, the villagers thought they could defend the gate and prevent us from entering but after a few charges they left it and fled higher up in their village. At about ten feet above the first group of houses built at the foot of the mountains, another row of houses was situated, just like streets that run parallel to each other, and so each level went on, higher and higher up to the top of that village. On the heights in between the mentioned streets flat stones, being about eight or ten feet high, were erected that served the defenders as parapets. In all of these ascendant elevations they bravely resisted and defended themselves so courageously so that we had to drive them out with force and assaults. After they had finally vacated Tawaly, we set it afire and reduced it to ashes.

Several families had fled into their houses, but during the shooting and the burning down of their houses they fell into our hands. The Lonckjouw warriors reported that they had seized over forty heads and about seventy prisoners, although afterwards we were informed by [junior surgeon], master Maerten Wesselingh, whom we had left behind in Pimaba (as will

be seen from the following story), that when he, following up our instructions, induced the ruler of Lonckjouw to set the captives from Tawaly free, and escorted them home in June, the number of prisoners actually turned out to be 104. For specific reasons, Wesselingh left eight or ten of the smartest children in charge of the Lonckjouw ruler, in addition to these another nine children had been sent to Tayouan, who in April were sent back home in a junk. Consequently the number of prisoners taken in Tawaly unquestionably must have amounted to 120 people.

Sixteen of our soldiers were wounded in the fight, of whom two died on the journey while another two succumbed back in Tayouan. Of our Lonckjouw allies six men were wounded and one of them died.

The mentioned village of Tawaly, had consisted of 250 or 300 houses, so it seems unlikely that it did not have more than a hundred warriors as the people of Lonckjouw had told me the preceding year. Their houses were constructed in the same way as those of Lonckjouw but their roofs were mostly covered with flat stones (like slates), with the result that when fire is thrown, the roof will not easily become damaged. However, because the roofs were supported by bamboo canes which, due to the long-term burning of fire in the houses, were well dried, the fire that we lit underneath immediately set the bamboos on fire. Consequently the stone roofs, which were shored up by the bamboos, collapsed. In addition, the nooks of the roofs of most houses, had been filled up with straw, which we also set afire so that the whole village was burnt to the ground.

The inhabitants of that village were dressed up well and armed in a similar way as those of Lonckjouw, often with bows and arrows. This is the fastest and most defensive weapon they fight with. In addition they have spears and shields like the people of Lonckjouw. [...]

The 31st of January [...] one of our captives, being an elderly woman and, as we discovered, the mother of the regent of Tawaly, was (together with two children whom she said belonged to her kin) released by our captain for good reasons and was endowed with a *cangan* and an *armozijn*. She was told to announce to the fugitive people of Tawaly, that if they were favourably disposed towards seeking our favour and friendship, all they had to do was to meet us near Lowaen, upon which we were willing to restore them to our favour.

Several inhabitants of the village of Lowaen, including their regent, who had heard about the affairs appeared before us and presented us with a pig. They told us they were pleased with what we had done to Tawaly and said they would have been willing to assist us if it still had to be done. In the weather conditions we endured, it would be possible to find a landing spot at Tawaly for our vessels.

At about nine o'clock [...] we, together with the Lonckjouw ruler and about fifty of his men, (fol. 561) who only after strong demands were willing to accompany us, set out on our journey to Lowaen. The party from Lowaen, being about twenty men, have led us on the way to their village. When we unobtrusively counted the number of our Company soldiers, it was found that our ranks still counted 106 men. In God's name we proceeded, along the shore, on to Lowaen and Pimaba [...].

In the afternoon we arrived near Lowaen. [...] As evening fell we suggested to the regent of that village that we would be pleased if some of his men could go to Pimaba to act as our envoys and announce the object of our imminent arrival to the inhabitants. The regent replied that because his people maintain only feigned and not honestly friendly relations with Pimaba they did not dare to go there for fear of getting killed. However he was willing to join our armed force together with his warriors so as to make known to the people of Pimaba the reasons of our coming. This offer we accepted.

Thereupon we asked our Chinese interpreter Tangwa, who had been to Pimaba several times, whether he would be willing to go there on the following day with some presents for the regent of that place in order to notify him the reasons for our coming. But he also rejected our request out of fear (as he said) of getting killed and made similar objections as those made by the regent of Lowaen. As a result of these refusals the delegation of an envoy did not take place. [...]

During the night a considerable number of armed inhabitants of Lowaen came to us, bringing along two pigs, a little dried venison and eight bottle gourds filled with liquor for our men, in order to depart with us to Pimaba the following morning and to assist us in carrying out our intended plan. After the presented provisions had been distributed among the soldiers, the natives were favoured with three *cangans*, some tobacco and two strings of beads, by way of compensation for the victuals they

had given and also as a sign of friendship, with which they were completely satisfied.

February first Anno Domini 1638. *(The men continued the march)*, besides those of Lowaen who were about 150 men strong and the ruler of Lonckjouw with his men. During the advance the men from Lowaen told us that they were informed that those of Pimaba together with their allies had decided to go to battle against us in the fields, so we answered that if Pimaba would be included to do this we would be ready and waiting for them.

At one o'clock in the afternoon we arrived at Pimaba. The inhabitants were found to be in the fields in front of the village armed and ready for battle, whereupon we positioned ourselves in battle array and slowly marched towards them. This made them recoil and retreat. Finally we halted and sent Tangwa, our Chinese interpreter, to tell them the following: the regent and inhabitants of Pimaba should be instructed that the Honourable Lord Governor, the supreme regent of the Dutch nation on this island and the surrounding islands, had sent the captain of Tayouan together with his armed force to that place. He (the captain) had not received orders to assault them with arms but to grant them peace. For that reason in April one of our junks had already been here at Pimaba but due to strong winds and high waves, it had been forced to return empty-handed to Tayouan. Consequently this time by orders of the mentioned lord governor this force had been sent out first by ship to Lonckjouw and had travelled onwards from there overland until the present location.

The Chinese interpreter furthermore was instructed how to act if the regent would suggest that they were afraid of the same thing happening to them as had happened to Tawaly, and consequently thought they could not trust the Dutch. The interpreter had to answer that the people of Tawaly had brought it upon themselves because they had insulted our ally the regent of Lonckjouw as well as ourselves with defamatory talk in an intolerable manner. If they had not done this, we never would have punished them as we did. With this order the Chinese Tangwa (fol. 562) went to meet the inhabitants of Pimaba, who stood, quite near to us, drawn up in battle array in front of their village. We at our position, lined up in order, standing guard while waiting for the Chinese, who was immediately guided into the village, to return.

In the meantime a certain citizen of Pimaba came towards our army, indicating that he wanted to speak with someone, whereupon some of the men from Lonckjouw in our company, together with the Chinese interpreter Dickop went to meet him. The mentioned person, who was a simple man, initially inquired about some irrelevant matters. Then he pretended (either in good faith or mendaciously) that many more Pimaba warriors kept themselves hidden in the bushes near to where our army was positioned (which later on indeed proved to be true), who might do us harm. Therefore he deemed it advisable if we would leave that place and pitch our camp nearby at the flat burnt off fields were our men would have more space and a better view. After we had considered his proposal for a while we thought they possibly wanted us to do this because they could easily size up clearly everything that happened in the open burnt off fields from their village and from the top of their extraordinarily high watchtowers. Thus we expressed our gratitude to the mentioned inhabitant of Pimaba for the information he gave us, and assured him that our force, that consisted of a considerable number of soldiers who kept themselves hidden in the bushes as well, would be perfectly capable of withstanding the men from Pimaba. The man rejoined his fellows.

Meanwhile a certain Chinese appeared out of the mentioned village who had lived there for about two years. He reported that the villagers had welcomed our interpreter, whom we had sent to Pimaba as our envoy and who had been received there safely. In his place they had permitted him to come over. They would keep the other one [Dickop] in Pimaba until his return. He told us that the news of the devastation of Tawaly the day before had reached Pimaba, whereupon the people of several other villages subordinate to Pimaba had assembled. Out of fear of our coming they had stayed up the whole night standing guard. He said that most of the men were very worried, and consequently the women had already together with all their belongings fled into the woods.

This Chinese, after we had made a few necessary inquiries, was sent back to Pimaba, so that we, after the return of our interpreter, would be able to confer on the matter taken in hand. Somewhat later the regent of Pimaba, who remained in the village, sent out a delegate who came to us together with the returning Chinese interpreter. The envoy of Pimaba told us the regent had authorized him to negotiate for peace with the Dutch captain. He awaited our reply at an indicated spot slightly away from the

place were our men were positioned. After we had contemplated everything for a while we again sent someone to tell the envoy with courtesy that when the regent of Pimaba would come to us in person, then the captain also would personally turn up to meet him at the appointed place. After a brief conversation this envoy went back to Pimaba. Their army was still lined up in arms near the village.

[...] After the return of this envoy the regent of Pimaba, named Magol, personally accompanied by four or five of his men, went to the fixed place outside our camp as mentioned before, requesting the Dutch captain also to show up in person. Whereupon we personally, accompanied by four musketeers and the trumpeter who was sounding his trumpet, went to the arranged place. That trumpet sound seemed miraculous to him, and his attendants watched it with amazement.

Thus having reached the regent, we sat down next to him and the ruler of Lonckjouw. He presented us with some coconuts, some pinang and some liquor, and in return we offered him some of the arrack of which we still had a little on hand. Afterwards we negotiated with the regent about the conditions for a peace treaty. He asked us whether they could trust us in accordance with what the Chinese Tangwa had put forward to them and whether we would fully observe the proposals. Whereupon we replied to him that we are people who live in the fear of the Lord, who has forbidden us lies, deceit, and treachery, so that he should not doubt our sincerety and promises, the more so because we had not so far suffered any nuisance nor opposition (which we expect to continue) from them. Those from Tawaly, against whom we had waged war, had given us important reasons for doing so and without those causes it would never have happened. We said all this in conformity to what we felt our Chinese interpreter had [already] announced to the regent. After having considered our words for a while, the regent took his cap off his head, which slightly resembled a crown because it was partly covered with a very thin layer of gold, like paper, and placed it with the following words on my head: 'when your words are trustful, like we trust, yea may this hat, which I have inherited from my ancestors, and which is covered with gold they once took as loot from the conquered village Linauw (which will come up below) serve as a sign of our union through which my people will find out that we have become the Company's allies and that you have become our friends'. Upon which I, for my part, took off my hat and put it

(fol. 563) in the same way on the head of the mentioned regent by saying: 'the upper most cover of my body which by our people is held in high esteem, is presented to the regent and lord of Pimaba and its surroundings. From this my accompanying men-at-arms and other subjects will also gauge that we have concluded peace and friendship with Pimaba'. Herewith the peace, that from both sides was endorsed by shaking hands, was concluded. Furthermore the regent was presented with half a yard of red velvet as a means of validating the confirmed peace, which he accepted willingly and which greatly pleased him. After we had stayed there for a while and had taken a drink to the declared peace, the regent took his leave, with the hat he got from us on his head, and returned to his people who (being at a guess about five- or six hundred men strong) were still standing lined up. At nightfall the mentioned regent came back together with some of his men and the Chinese interpreter Tangwa, who had stayed with them since our arrival, presenting us with four or five coconuts and some liquor. The Chinese told us that the regent was displaying the hat, together with the piece of red velvet, on the front of his house by which he indicated to his subjects that peace was concluded between him and the Dutch state.

After we had deliberated for a while with the regent of Pimaba and the ruler of Lonckjouw, the regent asked us whether we would not want our men to stay in their village for the coming night and that he intended to welcome me into Pimaba tomorrow. To which we replied that he did not need to bother about that, because our soldiers are subjected to such a degree to my authority that they would not move without our permission. He liked that answer and asked if we together with two or three of our men would not like to come and stay the night in his house. We answered him that his politeness much obliged us and that we would be willing to do so, yet we should consider that, during our absence, our attendant men-at-arms might cause some irregularities or damage to their gardens or storehouses in their fields, something which would greatly grieve us. Therefore we would consider it to be most sensible if we in person (so as to avoid all misunderstandings) would stay with the army and that we, to comply with his request, would enter his village together with him in the morning. He agreed with that and because it was getting dark he returned to his people, who were still standing lined up in arms in front of the

village. Our interpreter Tangwa also went with him to spend the night in Pimaba.

After the regent and his retinue had left, as it had already become dark, we decided (for certain reasons, as we did not trust that bunch of savages) to strike the camp and to move to another spot that we had discovered during daytime, where both our companies (placing the inhabitants of Lonckjou and Lowaen in between) each ranked in battle array, camped for the night. We maintained a strong and good vigil. [...].

The 2nd ditto. In the morning [...] at about one o'clock the regent of Pimaba, who was wearing the hat he yesterday was presented with, came to meet us in our camp. He invited us together with our men and the ruler of Lonckjouw and his people into his village, but the men of Lowaen were asked to wait outside, because they had formerly been enemies, so that their presence could easily lead to some friction. The more so because the night before some of the men of Lowaen already had entered into Pimaba and had demanded certain beads that are greatly valued by them. When we consulted the ruler of Lonckjouw and the regent of Lowaen about this, they agreed, in order to avoid disturbances, that it would be better that the men of Lowaen should stay outside the village, either to await our return or to go back home, which they decided to do and so they returned to their own village.

We broke camp and with drums beating and colours flying the army marched to Pimaba. The regent took me by my right hand and the ruler of Lonckjouw at his left hand, thus we marched on into his village. The inhabitants stood lined up in arms on both sides near the village, while we passed them marching in good order and well on the alert. The regent guided us to his house where we were given a warm welcome according to their customs. Our men, who also got enough provisions from the villagers, were ordered to line up along both sides of the regent's house, but liquor was forbidden to them on threat of the death penalty.

At a certain moment among the crowd of villagers a kind of riot occured, I do not know why, but the regent immediately settled the dispute and reproved his people for the great rush of people coming towards us. He ordered all of his subjects to return to their houses, which they actually did.

Then we offered him some blue *cangans*, some beads, half a yard of cloth embroidered with gold thread, a piece of black velvet and two

armozijnen. Meanwhile we discussed a little with him what peoples were his neighbours and whether he counted them to be friends or antagonists. He replied that several villages inhabited by people who belonged to different nations were to be found in that area and that he considered some of them to be friends but others enemies of Pimaba. After we had continued our inquiry a little further, he told us after some prodding that north of Pimaba, (fol. 564) at about a three and a half days' march away (that is to them), there was a certain river named Danau in the local language. Along the banks of that river a few villages were to be found. One of them was named Ranginas by them and another Radangs, both being of about the same size as Pimaba. These people owned outrigger prahus. In that area several other villages were to be found with whom the people of Pimaba were not familiar. In these villages, situated at the sides of the Danau River, gold was said to be found. It was yielded by the river which came down from the mountains. As proof of that story they said that several years ago they had conquered a certain village named Linauw, situated near that river where, under the villager's sleeping-mats, they had discovered a few plates of gold (like the gold that covered the regent's cap but even thinner) which they had taken home. From those people they had learned that the mentioned river exposed the mineral to the surface, but they could neither tell the quantity nor in what form. Neither did they know whether those people of Linauw themselves collected the gold out of the river or whether they obtained it by force from their enemies.

We made inquiries about the reasons why Pimaba considered these people to be their enemies and whether they could not be pacified through our mediation or whether war should be waged on them with our support as we do believe that we rightfully may take up arms against those nations not accepting our peace proposal. The regent at first answered as follows: From time immemorial, they had considered the people of Linauw to be their antagonists thus they merely continued to do so. As far as the peace negotiations were concerned, apart from the fact that they could not understand their language, there was not one person to be found in Pimaba who would dare to go there as an envoy.

We further investigated whether the Pimaba would be prepared to wage war against Linauw and intimated that we would be willing to deploy our force (just as we have done for Lonckjouw and our other allies) at their

service in order to subjugate their enemies. Although initially he seemed to be rather pleased with that proposal, after some deliberation about the matter, he said that he feared that his men would still harbour too many suspicions towards our soldiers. They might be afraid that on the way they would suffer faithless acts and therefore they would not dare travel together with us. When we replied that they could well judge our faithfulness by the assistance we have given to the ruler of Lonckjouw (as he must be well aware) on several occasions, he replied by saying that if his men had been in our company for as long as those of Lonckjouw had done, then they surely would have felt the same as those of Lonckjouw had experienced.

Several times we put before the regent that now the time had come (because we had appeared in Pimaba with our army) to subject his enemies by force of our arms. In case he doubted our faithfulness we would be prepared to leave some of our men as hostages behind in his villages until our return. Thereupon he replied that it would be impossible for them to go on the march with us this time, but that he would be pleased if we would leave some of our men behind in his village when we left for Tayouan. He would see to it that they would lack nothing and that they would be entertained well with food and drinks. However none of his men dared to go with us back to Tayouan because they feared the water that we would have to cross.

On finishing this discussion we asked him if they did not have any of the mentioned gold they obtained from Linauw or their other enemies. He answered this question by saying that indeed they did. Whereupon we requested him to show us some of the mentioned gold and if it looked similar to the gold we knew of. In the meantime we showed him a certain type of Japanese coin (named *koban* by the Japanese). After he had taken a look at it he said that the gold he had mentioned was not quite as thick and that he was willing to show it to us, but that as his whole house was crowded with people he would feel embarrassed about doing so. Having spoken with him for some time we again insisted that he should just show us the gold, or sell it to us. We would carry it along and keep it in his honour, as he very well knew that we already possessed enough gold in Tayouan. At a certain moment he got up and went to a hamper which stood in the room, saying that he would get it, but then he seemed to change his mind and he returned empty-handed by saying: that he felt pity

for the gold. Thus he did not produce the gold for our inspection and this made us decide that, for various reasons, we had better leave the matter alone.

He further told us that at about one day's march away from Pimaba, a certain small village was situated, its name has slipped me, that kept friendly relations with Pimaba as well as with the people possessing gold. According to the regent these inhabitants sometimes barter a little gold from those gold-owners so that once in a while his people also acquire a little bit. Hereupon we, by means of showing him our good intentions, proposed that - because the road to the gold-possessors, now seemed to be open via this village, which being friendly to them also will be friendly to us - we either could send an envoy or if the occasion should occur, we could start an armed expedition. We would be very much obliged if they either could accompany us and point out the way to the friendly village, so that from there a delegate could be sent to these villages who could purchase some gold for us (for which we gladly would pay) while we would be waiting outside the village. He replied as follows: they did not dare to accompany us on the march for the reasons he had given before, and that they also were afraid to guide us to this village out of embarrasment, because they still considered us to be strangers. His people would even refuse to send out an envoy, not only because of the great distance or because of the uncertainty of whether they could get some gold, (fol. 565) chiefly because the Dutch were still seen as newcomers in their village. However, if we could leave two or three of our men behind, he assured us that this could be done at some time in the future.

When we went on to ask him if any Spaniards were staying in the neighbourhood of those gold-possesing peoples, to whom they could sell their gold, he replied that none of them had ever heard about anything like that. After having posed all the mentioned questions, we for several reasons decided to stop bringing up this subject, the more so because we had already received a sample of ditto gold on the regent's hat and another small set as well.

Having inquired about the size of their armed force or what weapons the peoples who live near the Danau River possess, the regent told us that they, just like them, use shields, choppers, bow and arrow and that some of them are armed with pikes. As far as their appearance is concerned they are of a tall stature and they are capable of bringing about an equal

amount of armed men in the field as Pimaba. Furthermore they are considered to be quite able warriors.

As a result of everything stated above and in the hope that we will get some of the desired mineral, we, conforming with our instructions, have decided to leave master Maerten Wesselingh in Pimaba together with a soldier and a Gujarati Company slave to serve them, and also a certain Chinese who lived here for two years and who claims to reasonably well understand their language. When we announced to the regent that, as a sign of the concluded peace we intended to leave two persons behind in his villages until we returned after two months, he seemed to be pleased. He said that they were welcome to stay in his house and that he would see to it that they were supplied with enough food and drink.

We have seen two or three young men, who belonged to the regent's own kin, wearing ornamental feathers on their heads, which below were covered with a four fingers wide band of thin gold plates.

At dusk we realised that, as far as our own matter was concerned, we could not accomplish anything more (and that it was not expedient to stay over for the night) so we left and marched to a place outside of the village. The regent himself saw us off holding me by my right hand far into the fields, where he bade us farewell. He returned to his village after we had urged him to be faithful to the Company's state and reminded him that he should behave himself as we expect our true allies to do and maintain good relations with the people of Lonckjouw and Lowaen (which he agreed to). We marched forth for a while and spent the night camping in the open field near a small river. They carried the pigs, that had already been slaughtered for us in Pimaba, and the meat was then distributed among the men of Lonckjouw as well as our own men.

The village of Pimaba is quite large, and is not located in the mountains like the villages of Lonckjouw, but built in the open field. Their houses that are covered with thatched roofs are surrounded by bamboos while the entire village is also hedged in by a fence of bamboo plantings, very similar to Sincan and the other villages situated in that area, with the exception that the houses of Pimaba are not as large or neatly constructed. Also within the village quite a number of coconut and pinang trees are growing. At our rough estimation, and according to the Chinese who has lived there for two years, Pimaba could bring about a thousand able-bodied men into the field. The people are fairly strongly built and they

carry the same arms as the men of Lonckjouw: bows and arrows and pikes, between fifteen and eighteen feet long. We were told that they are able and defensive warriors. One of these inhabitants, the regent's servant, was of an exceptionally large and coarse stature. His grandfather was said to have handled a thirty catty heavy pike.

According to the Chinese, another six or seven villages, situated in that neighbourhood, were subordinated to the command of Pimaba. Some of their warriors already had been called in by them.

On 3 February surgeon Maerten, who yesterday had accompanied us so far, and with whom we spent last night deliberating about his forthcoming duties, returned to Pimaba, after we had handed over to him an extract of our instructions concerning his orders. He is accompanied by a soldier named Isack, a Gujarati [slave] and a certain Chinese who has already spent two years in this neighbourhood. Upon his farewell six musketeers fired a salute; God grant that everything will be carried out in compliance with our request.

We continued our march back to Lowaen where we took a rest in front of the village near a small stream. There the local people, young and old, came to present us with three live pigs, some cookies baked of millet and also some liquor. The regent of Lowaen, invited us to bring our complete force into his village, so that he could entertain us according to his ability. As the village was situated high up in the mountains, we politely rejected his request by saying that we were grateful for the courtesy they had rendered us but that we intended to immediately depart on our journey to Lonckjouw. (fol. 566) Furthermore he asked if we would send a note to master Maerten who had remained in Pimaba, to invite him to come over and pay a visit to Lowaen on behalf of us. They were willing to deliver that note to master Maerten themselves, which we agreed to.

The regent of Tawaly, whose village we had taken by assault and burnt down on the 30th of last month, asked us by means of the regent of Lowaen (in whose village he was staying) if he would be allowed to come and negotiate for peace with us. His request was approved of, and the ruler of Lonckjouw communicated our permission to the regent of Tawaly. Whereupon he, together with some of his people, appeared before us and requested after some discussion, that he (just like those of Lonckjouw and the neighbouring peoples) could be confirmed as an ally into our favour and friendship.

We responded to him in the following way: 'We have ruined and reduced the village of Tawaly to ashes only because you had behaved faithlessly and in a hostile manner to our Lonckjouw allies. A year previously, in order to slander our good name and respect, you had the cheek to say (when Lonckjouw appealed to our might) that if we would show up to attack their village you would serve us with the same sauce. This contemptuous and vile reasoning we certainly do not want to suffer but we will always try, as happened this time, to take revenge by taking up arms. What advantage our arrival brought to you we do know, but you will understand even better yourself. However, likewise war is waged by means of the sword, peace just as well can be gained by the heartfelt wish, or a kind verbal petition, for it. Thus we do not intend to refuse your proposal. On the contrary we want to accept it, so that all the world will know that we will fight those inhabitants who are hostile our arms, but we will always pardon the submissive ones'.

The regent replied that he regretted what had happened and that those bold thoughtless remarks had been shouted by some of the ignorant youths of his village, something which he had not been able to repair. The only thing he requested was that we should show mercy for them and that we would allow them to rebuild their village on the former site. They were willing to behave themselves openly and obediently towards the Company's state as well as towards those of Lonckjouw. To this proposal we responded that, according to the advice of the ruler of Lonckjouw, we had already agreed to accept them as our allies and afterwards we had confirmed the peace by shaking hands, on the condition that they would present a little coconut or pinang tree to us planted in a pot as a sign that they had subjected their land to the High and Mighty Gentlemen of the States General and to the Honourable Lords and directors of the United East India Company. He promised to do this if only he could find a plant and pot in his village which had been completely devastated by us.

Furthermore, we asked the regent how many people of Tawaly had died in the battle and also how many prisoners had been carried off by Lonckjouw, to which he answered that he did not know the number of deaths but that about 120 people were missing. After this conversation we urged them to behave both faithfully and sincerely towards the Company as well as to Lonckjouw, and at about two o'clock in the afternoon we broke camp and continued on our march.

At nightfall we encamped beside a small stream about halfway between Lowaen and Tawaly where we spent the night. The three pigs that we had received from the inhabitants of Lowaen were slaughtered and divided among the men.

On 4 February, [...] before sunset we took [...] our leave and soon passed by the burnt down village Tawaly [...]. At about halfway through the afternoon we arrived at Patsaban, where [...] we passed the night. These people who had been notified of our arrival, brought (just as they had done on our outward journey) enough food and drink, for which we had to thank them [...].

The 5th ditto, [...] we marched [...] on to Luypot, along the way some mountain people awaited us to offer two live pigs, some dried venison and a little liquor. We thanked them for their courtesy and turned down their kind offer but they insisted we should accept it and they would carry it for us to Luypot, being a little village that was not situated far away, to which we agreed, and they accompanied us on our march to Luypot.

fol. 567: At about eleven o'clock in the morning we arrived in Luypot, were we rested for a while in our old quarter, which was still standing. The two pigs were slaughtered and divided among the men. At about two o'clock in the afternoon we continued the march. [...] At nightfall we arrived in front of the village Matsaer, were we spent the night. [...]

The 6th ditto, in the morning [...] we marched on [...] until we came to the village of Bangsoer, from there, after a short rest we went on to Dolaswack, [...] which was reached a little after sunset. The inhabitants of that village were very pleased at our arrival. [...]

The 7th ditto, [...] because our men were very fatigued by the long march, we decided to stay over for the day. The villagers of Dolaswack entertained us in their own way.

The 8th ditto. [...] We resolved to depart for our junk, and considered for a long while how we could best deal with the captives from Tawaly who had remained in Lonckjouw. Finally we thought fit if we would select six or seven of the most promising children and take them with us to Tayouan. Then the Honourable lord governor can decide for himself whether he will divide those children among the officers at Tayouan [to serve in their households] or send them back with the junk that will sail to Pimaba in April to pick up master Maerten.

In the event that His Honour the governor would decide that the captives of Tawaly should be released, the ruler of Lonckjouw was notified to obey and see to it that the mentioned prisoners would leave his land and return to their home country. He agreed to act in conformity with the governor's wish.

At about eight o'clock we took our leave from Dolaswack, and the ruler of Lonckjouw together with some of his warriors personally saw us off to our junk. [...] At sunset we reached our junk in the Bay of Lonckjouw. [...]

The 9th ditto. [...] After we bade farewell to the ruler of Lonckjouw, who has proved to be very obliging to the Honourable lord governor because he and his warriors had assisted us in teaching the haughty people of Tawaly a lesson, we boarded the junk and sailed off to sea. [...]. *(On the 12th of February 1638 the expedition force returned to Tayouan.)*

86. Note or memorandum of the names of the villages and surrounding fields made on behalf of the States General and on the orders of Governor Jan van der Burch, by Junior Merchant Maerten Wesselingh.
Pimaba, 10 February 1638-20 August 1639.
VOC 1131, fol. 841-844.

fol. 841: Lolon, Ripos, Lappalappa, Backingan, Poenoch: Dit sijn vijff cleyne dorpen benoorden Pimamba op de vlacte gelegen uyt geseyt Backingan ende cunnen dese vijf dorpen 300 weerbare mannen uytleveren.

Moronos, Marangtip, Pinabaton, Tammalaccouw, Micabon, Bouer: Dit zijn bredelijcke dorpen om de west van Pimamba gelegen allegader mede op de vlackte ende cunnen dese dorpen 450 weerbare mannen uytmaecken.

Tarouma, Luwan, Tawalij, Sappien, Lavabicar, Kinaboulouw, Patciabal: Dit zijn seven groote dorpen want met de anderen weynich min als 2000 man uytleveren cunnen.

Pimamba: Alwaer mijn residentieplaetse is mach uytleveren 800 weerbare mannen.

fol. 842: Kinadouwan, Tollerekan, Boenoch, Saboeco, Sayman, Terrowatil, Coroloth, Toebuirij, Massisij, Caradalan, Poltij, Dadileij, Laboean, Tebutte Kedan, Coelalouw, Parriwan, Sagedeu, Caberokan, Erapissan, Tocobocobul: Dit sijn dorpen in 't hooge geberchte gelegen waervan men uyt de sommige 2½ dach moeten reysen eer men op d'vlacte comen can,

ende uyt de sommige 1 à 1½ dach naerdat het weder sich betoont, dese tegenoverstaende dorpen verclaeren d'inhabitanten in alle quartieren dat se met den anderen 10.000 weerbare mannen uytleveren connen.

Carreware, Bieris, Barikil, Tadangis, Sappiat: Dit sijn de vijff dorpen geweest benoorden Pimamba aen de zeecant gelegen, maer zijn door die van Pimamba voor 't optreck van het leger gemassacreert. Dat veroorsaeckt de Pimambaers nu heel tot op een weynich naer aen den Danauw, 't welcke niet meer als 16 mijlen weechs om de noort van Pimamba is, reyssen connen.

fol. 843: Cavadouw, Cobiongan, Durckeduck, Tolckebos, Tallassu, Bommelit, Poetscenoch, Borroborras, Tarracway, Sappide: Dit zijn tien dorpen soo vooraen in 't geberchte aen de westzijde van Formosa gelegen sijn, waer onder de jongste drie der Lonckjouwer toecomen ende zijn in dito drie Lonckjouwse dorpen niet meer als 300 weerbare mannen, doch d'andere seven naerdat d'selve hebbe cunnen sien ende van d'inhabitanten gerucht wort, zouden dito dorpen niet minder als 5000 man uytleveren.

Doloswack, Rackij, Bangsoor, Cattangh, Touresatsa, Carradeij, Dawadas, Matsar, Lupot, Perromooij, Talanger: Dit zijn dorpen die den Lonckiouwer toecomen, waervan de sommige vooraen in 't geberchte ende eenige op de vlacte gelegen zijn, doch zijn onder dese dorpen drie die niet meer voor handen, want gemassacreert, van honger verloopen ende uytgestorven zijn, te weten Talanger, Perromooy, Carradey. De resterende dorpen soo noch voorhanden mogen met den anderen ontrent 800 weerbare mannen uytbrengen.

Linauw, Tacciraya, Palan, Ullebecan, Rabath, Daracop: Dit zijn de zes vermaerde goutrijcke dorpen soo de Compagnie noch bekent, ende naerdat van alle quartieren soo daer ontrent leggen verclaert wort, soo soude daer ontallicke menichte van menschen in wesen. Dat oock geloof geven want de Pimambaers met alde omleggende dorpen soo crachtich niet en sijn dat een voet lants van haer winnen cunnen, gelijck oock dickwils wanneer ontrent de mercken quam, persoonlijck gesien ende beoogt hebbe.

fol. 844: Dese bovenstaende dorpen connen in 't geheel uytbrengen 19.650 weerbare mannen.

fol. 841: Lolongh, Ripos, Lappa Lappa, Backingan, Poenoch: These are the five small villages situated in the plain north of Pimaba. The mentioned Backingan, together with these other places can yield 300 able-bodied men.

Moronos, Marangtip, Pinabaton, Tammalaccouw, Nicabon, Bouer: These are spacious villages situated also on the plain, westward of Pimaba that can produce 450 fighting men.

Tarouma, Lowaen, Tawaly, Sipien, Lavabicar, Kienaboulouw, Batsibal: These are seven large villages because all together they can bring in little less than 2000 men to the field.

Pimaba: which is my residence can bring in 800 able-bodied men.

fol. 842: Kinadauan, Tollerekan, Boenoch, Saboeco, Sayman, Terrowatil, Coroloth, Toebuirij, Massisij, Caradalan, Poltij, Dadiley, Laboean, Tebutte Kedan, Coelalouw, Parriwan, Sagedeu, Caberokan, Erapissan, Tocobocobul: These are villages located high up in the mountains. From some of them one has to travel 2½ days before one can reach the plain and from some others it takes about 1 or 1½ days depending on the weather conditions. About the above mentioned villages the inhabitants of the other regions testify that all together they are able to bring in 10,000 fighting men.[51]

Carreware, Bieris, Barikil, Tadangis, Sappiat: These used to be five villages that were situated to the north of Pimaba at the seashore but the inhabitants were massacred by Pimamba sometime before the Company expedition force reached Pimaba last January. This renders it possible for the people of Pimaba to travel almost right to the Danau River, which is situated no more than 16 miles north of their village. (fol. 843)

Cavadouw, Cobiongan, Durckeduck, Tolckebos, Talasuy, Bongelit, Poetckenoch, Borboras, Tarracway, Sappide: These are ten villages situated in front of the mountain range stretching out on the western side of Formosa. Three of them belong to the ruler of Lonckjouw (those being the last ones that became part of his area) and they can bring in only 300 able-bodied men, but the other seven villages, as far as I have been able to see, and also as is claimed by the inhabitants, can together bring no less than 5000 men to the field.

Dolaswack, Backij, Bangsoer, Cattangh, Touresatsa, Carradey, Dawadas, Matsar, Luypot, Perromooy, Talanger: These are the villages that belong to the ruler of Lonckjouw; some of them are situated in front of the mountains and some others are located on the plain. But among them three villages: Talanger, Perromooy and Carradey, no longer exist because the people have been either massacred or died of starvation and

consequently have become extinct. The remaining villages together are able to bring in about 800 fighting men.

Linauw, Tacciraya, Palan, Ullebecan, Rabath, Daracop: These are the six renowned goldowning villages so far as the Company knows. According to what has been testified from all quarters in the neighbourhood, those places contain an innumerable number of people. We attach credence to this because the inhabitants of Pimaba together with all its surrounding villages are not strong enough to gain one single foot of land from them, as I have often seen and witnessed when I came near to the boundary markers of the Pimamba region.

fol. 844: The above-mentioned villages on the whole can conscript 19,650 able-bodied men.

87. Report by Merchant Cornelis Fedder to Governor Jan van der Burch on his inspection of the results of the missionary work in the villages of Soulang, Mattouw, Sincan, Bacaluan and Tavocan.
Tayouan, 8 February 1638.
VOC 1128, fol. 459-461.
DRZ, I, pp. 402-405; FORMOSA UNDER THE DUTCH: pp. 160-163; ZENDING, III, pp. 160-168.

88. Dagregister Zeelandia, 7 May 1638.
VOC 1128, fol. 473. Summary.
DRZ, I, pp. 417-418.

(On 7 May Governor Van der Burch received a missive from Junior Merchant Maerten Wesselingh, who reported that gold apparently could be found in a certain village named Tiroo, near Linauw, and that he was planning to visit that place soon. The inhabitants of Pimaba proved to be quite willing to assist him and his people. Thanks to the concluded peace Wesselingh could travel freely through the whole region from Lonckjouw as far as Linauw. The inhabitants of Pimaba and its neighbouring subordinated villages had promised to submit themselves to the Company.)

89. Resolution.
Tayouan, 7 September 1638.
VOC 1128, fol. 544-545

Dat [...] de groote dorpen Soulang omde noort ende Tapouliangh om de suyt gelegen, op der inhabitanten versouck ende de grote hoope die men heeft van den Waeren Eeuwigen Godt veel sielen toegebracht te worden, den sieckentrooster Pieter Jansz (jongst van 't schip gecomen) in Soulangh Hans Oloff sal toegevought worden; item den sieckentrooster Adriaen Bastiaensz [...] in Tapouliangh bij Willem Egbertse sal worden geleyt, ende den assistent ... van de fluyt *Broeckoort* gelicht, welcke hem presenteert omme in dat religie werck meede gebruyckt te worden sal dien sieckentrooster Merkinius in Baccaluan bijgevougt.

Den edelman Radout, sijnde den broeder vande regent in Pimamba welcke door onse ordre in Pimamba bij den ondercoopman Marten Wesseling ontrent een maent geleden vandaer herwaerts gebracht is, soo omme den provisionelen gemaeckte vreede te solemniseren, als dat denselven onsen handel en wandel gesien hebbende naer sijn wederkeren aldaer den Nederlantschen naem te meer te verbreyden, versouct als nu licentie om met sijn swite te mogen vertrecken; dat hem toegestaen wort ende geordonneert is Mr. Marten met denselven weder derwaerts te gaen, onder 't geleyde van zes soldaten die hem tot versekeringe [...] in Pibamba brengen sullen, wesende den gem. ondercoopman bij den gouverneur met een schriftelijcke instructie versien [...].

The large villages Soulang, situated to the north of Tayouan, and Tapouliang, situated in the south, will get extra teachers at the request of their inhabitants, in the hope that the true Almighty God will gain many a convert's soul: Pieter Jansz who recently disembarked on Formosa, will be assigned as catechist to Hans Oloff in Soulang and catechist Adriaen Bastiaensz [...] will be sent to Tapouliang to assist Willem Egbertse. Furthermore an assistant, who recently arrived with the flute *Broeckoort*, and who asked to be employed in the missionary work, will be assigned to catechist Markinius in Bacaluan.

The nobleman Redout, the brother of the regent of Pimaba, arrived according to our instruction about a month ago accompanied by Junior Merchant Maerten Wesselingh in order to validate the provisionally concluded peace and to take a look at our doings and dealings in Tayouan so that after his return to Pimaba he may propagate the Dutch reputation

over there. Upon requesting his leave with his suite, we granted permission and ordered Master Maerten to again go with him to escort him back [...] to Pimaba in the company of six soldiers. To that purpose the mentioned junior merchant was equipped with an instruction written by the governor.

90. Extracts taken from the Zeelandia Castle Resolution-books, concerning the resolutions on the island of Lamey, taken in the Formosa Council.
VOC 1170, fol. 592-593. Extract 7 September 1638.

> fol. 592: Soo wort oocq insgelijcx eenstemmich goetgevonden ons garnisoen van 't eylant Lamey te lichten omde naevolgende consideratiën: dat de Comp. maer honderd realen 's jaers voor de pacht is genietende [...] (fol. 593) dat de pachter echter noch claecht daeraen comt te verliesen, sulcx in 't aenstaende gemelte pacht noch minder soude gelden, dat ons volck meest sieck sijn door de swaere dampen welcke aldaer vallen. Dat de 19 Lameyers, 12 vrouwen ende acht kinderen daer resterende haer gehoorsaementlijck aenstellen ende belooft hebben nooyt tegens onsen staet te opposeren daervan bij desen gelegentheyt een preuve sullen nemen. [...].

fol. 592: So is also unanimously agreed to remove the garrison from Lamey out of the following considerations: the Company only earns one hundred reals a year for the rent [...] (fol. 593) nevertheless the tenant complains that he incurrs losses on it, such that the next year the rent certainly will yield even less. Most of the time our men are falling ill which is caused by the evil vapours that occur at that place. On this occasion we shall put to the test whether the remaining Lameyans (19 men, 12 women and eight children) do behave very obediently as they have promised to never again revolt against our state.

91. Extracts from the Dagregister Zeelandia, concerning Lamey.
VOC 1170, fol. 621. Extract 30 September 1638. Also in: VOC 1128, fol. 493.[52]
Published in: DRZ, I, p. 436.

fol. 621: Op dato retourneert van Pimaba per Chinesen joncq over Lonckiou en 't eylandt Lamey de zes soldaten welcke op 9en deses den ondercoopman Marten Wesselingh tot conduyt en geleyde van den Pimabaeschen edelman Radout mede gegeven zijn, raporterende conform 't schrijvens van dito Wesselingh ontvangen in dato aen de heer gouverneur gedirigeert, niet alleen op sijn aenlangen aldaer wel onthaelt was geweest, maer oock dat de Pimabase sonderling contentement, dat haeren voornoemden edelman Radouth alhier genooten hadde en aengedaen was.

Per voorschreven joncqe verschijnt insgelijcks van 't eylandt Lamey den sergiant Jan Barentsen aldaer als opperhooft tot dato deses gelegen. [...] hebbende op sijn vertreck het houte wambays toegeslooten, 't geschut begraven en aen d'inhabitanten, mannen, vrouwen en kinderen sterck sijnde, serieuselijck gelast dat nooyt gedoogen zoude iemandt binnen 't voors. houte wambays te laten comen, maer in contra t'onser wedercomste soodaenich trachten te mainteneren en te transporteren als op zijn vertreck aldaer gelaeten hadden sulcx alsoo in dier vougen beloofft hebben naer te comen.

fol. 621: On this date the six soldiers who on the 9th of this month departed with Junior Merchant Maerten Wesselingh to accompany the Pimaba nobleman Redout, return in a Chinese junk from Pimaba over Lonckjauw and the island of Lamey. In accordance with the content of the letter received by Wesselingh to the lord governor, the soldiers report that upon arrival in Pimaba they not only received a good welcome but that the people of Pimaba were exceptionally contented with the favourable reception their lord Redout had enjoyed during his stay at Tayouan.
Sergeant Jan Barentsz also arrived on the same junk. Until this date the sergeant was the commander of the men on Lamey. [...] He reports that on his departure he had buried the guns, and had closed up the wooden stockade, and had seriously instructed the inhabitants, men, women and children, never to let anyone enter the wooden stockade but, on the contrary, to see to it that until our return everything will be maintained in exactly the same way as how we left it. This they promised to do.

92. Resolution.
Tayouan, 4 October 1638.
VOC 1128, fol. 455-456. Summary.

(On 4 October the Council decided, in order to prevent the continuation of the troubles with Vavorolangh, to send ensign Thomas Pedel together with 25 men to the village to deliver a letter from the governor to the village elders. On the 14th they returned at the castle together with four village elders who had come over to Tayouan to discuss the matter with the Company authorities.)

93. Resolution.
Tayouan, 18 October 1638.
VOC 1128, fol. 547-548.

Den vaendrich Thomas Pedel ende ondercoopman Joannes vanden Eynden, op heden van Vavorolangh wederkerende, brengen mede vijff vande outsten der inhabitanten van Vavorolangh, item een Chinees aldaer resiederende, die haer aenstonts excuserende dat wilden ten goeden duyden sij luyden op onse eerste ontbiedinge niet waeren verscheenen: de Chineesen hadden haer onse meeninge niet wel getranslateert etc. Versochten wijders demoedelijck uyt aller name der Vavorolangers dat men haer gelieffde mede een aenpaert in haer velden te geven daer sij luyden vrij sonder eenig beleth mochten jagen, ende harttenvleesch tot onderhout van haer dorp distribueren; item dat de cuylen op 't voorgeven van den gouverneur mochten werden afgeschaft ende met stricken te setten de Chinese vergunt wierde te jagen. Welck voorstel bij den gouverneur ende raedt in achtinge genomen sijnde, hebben daerinne geconsidereert dat door het vergunnen van cuylen te maken wel eyndelijk tot niet worden soude; ten anderen dat de harten die in geseyde cuylen gevangen worden, de vellen seer bloedich bevindenende, dienvolgende ons die helft soo veel in Jappan niet haelen sullen, als wel vande vellen daer vande hartten in stricken gevangen sijn. Sulcx om toecomende jaer beter vellen in Jappan aen de marct te brengen, als mede dat de harten ende hinnen, inden besten tijt weeder mogen aenteelen, soo wordt eenstemmich bijde vergaderinge goetgevonden dat men de jagers bij onse openbare placcaten sal injungeren niemant sal vermogen eenige cuylen te maken maer met stricken de hartten te vangen op peene van arbitrale correctie. Insgelijck sal niemant langer mogen jagen als tot ultimo April ten eynde dito hinnen weder inden

maenden May ende Juny bequamelijck ende sonder de minste verhinderinge (fol. 548) mochten voortteelen ende wanneer geoordeelt werdt dan jaerlijcx d'hartenvangst sal connen bestaen, daer andersints het jagen in voors. twee maenden toegelaten worde consequentelijck de jacht jaerlijck moeten verminderen door dien de geseyde hinnen in desselfs maenden met jongen bevonden.

(The Vavorolangers are allowed, as a means of maintaining their own village, to use a third part of their fields for the hunt for themselves only. The Chinese are only allowed to hunt from November to April on the other two thirds part. These hunting grounds will be marked by border poles. The governor ordered the inhabitants of Vavorolangh that whenever he should ask for them, they have to appear at once before the government.)[53]

Ensign Thomas Pedel and Junior Merchant Joannes vanden Eynden, returned from Vavorolangh today, bringing along five of the elders of that village and a Chinese who is residing over there, who immediately made their excuses for the fact that they did not gather upon our first summons to come to Tayouan, they told us that the Chinese had translated our message incorrectly. Furthermore, on behalf of the whole of Vavorolong, they humbly asked whether the Company would allow them a part of their fields where they could hunt freely without any hindrance in order to distribute the venison for the provision of their village. They also asked the governor to forbid the Chinese huntsmen to catch deer in pits but only to allow them to hunt by means of snares. Governor and Council gave the proposition some careful thought and, in view of the fact that the permission of making pits eventually would result in extinction [of the deer], and in the second place because the skins of the deer caught in those pitfalls turn out to be so blood-soaked and damaged that in Japan we will not even fetch half the price of the skins of deer caught in snares. Thus in order to be able to provide the Japanese market with better quality skins in the following year, and in order to enable the deer and hinds to breed during the best time of the year, the Council unanimously agreed that the hunters will be ordered by public decree to use only snares and that nobody will be allowed, on arbitral penalty, to dig holes to make pits for catching deer. Likewise nobody will be allowed to hunt after the 30th of April so that the hinds can safely breed during the months

of May and June (fol. 548) under which circumstances the deerhunt can take place every year.

94. Original missive Governor Jan van der Burch to the Amsterdam Chamber.
Tayouan, 18 November 1638.
VOC 1128, fol. 361-377. Extract fol. 373-375.

fol. 373: [...] den onderkoopman Marten Wesselingh volgens onse ordre aldaer laetende omme sich weyders van de verhoopte goutmineraele t'informeren ende ons daervan over Loncqieuw advijs te geven. 't sedert heeft sich gemelten ondercoopman tot in Augustij daeraenvolgende in Pibamba onthouden, ende onderwijlen sijn wedervaeren ons bij gelegentheyt over Loncqieuw geadviseert, daerop wij hem dan wijders hebben geordonneert omme met de gevouggelijcxte middelen, tot het gewenscht desseyn te geraecken, want hebbende ons bij verscheyde missiven geadviseert dat deses goudtrijcke dorpen genaemt: Linau, Rabath, Rangenas, Sakircia, Ellebeen ende Tiroo, in 12 dagen reysens met een crijgsmacht van 200 soldaten conde besocht worden. Daertoe onse sobere gelegentheyt alhier niet en presenteerde, soo hadde een middel geraemt dat met hulpe van den Pimambaer als in een ambassade na Linauw, dat het grootste ende naestgelegene dorp was, soude verreysen ende onsen vrede haer aenbieden; dat uyt sich selven op een ander wijse onderstaen hadde met 130 inhabitanten van Pimamba bij de handt te nemen, doch ontrent Linauw comende moste de vlucht nemen door dien d'Linauwers gewapenderhandt soo sterck op haer aenquamen, dat soo niet hadden connen loopen souden er eenige doodt gebleven hebben. Naderhandt heeft 't selve andermael onderstaen om bij de Linauwers te comen doch is even gelijck als vooren gevaren. Onderwijlen hebben gemelten ondercoopman herwaerts ontbooden nevens den edelman Radout (broeder zijnde van de Pimambasche regent) (fol. 374) omme met den anderen t'overleggen hoe met die van Linauw in gespreck comen mochte. Hier sijnde slouch gemelte Marten Wesseling voor, dat met een troupe van vijff soldaten nevens een redelijcke vereeringe aen de Linauwers, op voorige wijse mochte gesonden worden. Wanneer dan ontrent haer quamen ende de Pimambaers de vlucht namen, soude hij met de vijff medegegevene soldaten blijven staen ende haer eenige coraeltgens als andertsins toeworpen, waermede meende dat haer furie soude zijn gestudt ende hem dan soude gehoor geven. Sulx wij achten van alte quaden gevolge te sijn, door dien hem met vijff mannen te swacq achten, soo een menichte

gewapende wilden te wederstaen die alreede de vlucht van haren vijant voor oogen siende, haer niet anders souden connen inbeelden off de victorie was aen haer sijde, ende dan niet conde considereren dat hij van onsentwegen gesonden was om haer den vrede aen te bieden, maer eerder te gelooven hadde dat wij haere vijanden assisteerden omme de Linauwers alle mogelijcken affbreuck te doen, waerdoor wij de nederlage crijgende, souden alle onsen luyster bij den brutalen hoop verliesen off ten minsten eenen grooten cracq crijgen, dat geensins op soo een lossen voet diende geperpetreert te werden. Redenen waeromme hem geordonneert hebbe, sulx den broeder des regents van Pimamba oock gelast is de saecke daernaer aen te stellen, ende te verrichten datter één gecommitteert van Linauw in Pimamba bij gemelten Wesseling comen sal off dat persoonelijck onder suffisante ostagiers derwaerts verreysen sal, ende die van Linauw onsen vrede aenbieden alsoo des Comp.ˢ constitutie niet lijden wil sulcx met reputatie van aensienlijcke crijgsmacht geschieden can [...].

D'gestaltenisse van de bovengeroerde ses goudtrijcke dorpen adviseert ons gemelte ondercoopman, dat het gout aldaer overvloedigh bij alle d'inhabitanten van mans, vrouwen en kinderen gedragen werdt om den hals, armen, vingeren, om 't lijff, beenen ende theenen. De mans laten hare mutsen, hantvatten van geweer, hasegaeyen als andertsins daermede beslaen. De Chineesen souden oock d'inhabitanten voor desen groote quantiteyt goudt affgehaelt hebben, dan wanneer sij vermercten het geseyde goudt waerd was, hebben egeene Chineesen niet langer aldaer willen gedoogen, waerdoor voors. Chineesen aen d'onse souden hebben bekent gemaect. Echter hebbe tot noch toe niet connen vernemen hoe sich het gout aldaer opdoet ende sijn d'oppiniën daervan verscheyde. D'één secht dattet de Reviere Danau opwerpt (fol. 375), andere sustineeren dat den harden regen 't goudt van 't geberchte affdringt, den darden meent dito goudt uyt het geberchte gegraven wordt ende 't selve met ayren op doet, dat wel 't beste soude wesen als daer achter conde comen, 't seeckerste sal ons eyndelijck den tijdt leeren [...].

fol. 373: [...] Upon our orders Junior Merchant Maerten Wesselingh stayed in Pimaba in order to make inquiries about the hoped-for gold mineral, and to advise us via Lonckjouw. Since then Wesselingh, who lived in Pimaba until August, informed us about his experiences via Lonckjouw. Thereupon we sent him orders that he should try to reach his aim with the best possible means. In his letters he wrote that the gold-rich villages named: Linauw, Rabath, Rangenas, Sakircia, Ellebeen and Tiroo, could be reached with a force of two hundred soldiers after a twelve day

journey. Because of the limited condition here in Tayouan it would be impossible to send out an expedition force, we therefore devised a plan that with the assistance of the regent of Pimaba, he should travel to Linauw, the largest and nearest of those villages, and offer them peace. Wesselingh himself had already tried to do this together with 130 inhabitants of Pimaba. But when they came near that village they had to run away because the armed warriors of Linauw came running towards them. If they had not run away, surely some [of Wesselingh's company] would have been killed. He tried again another time to get near to the people of Linauw, but the outcome was the same. Meanwhile we summoned the junior merchant and the nobleman Redout (the regent of Pimaba's brother) to join us (fol. 374) in order to confer with them how to enter into conversation with the people of Linauw. Maerten Wesselingh suggested that he would again travel to Linauw as before but this time with five soldiers and with a considerable present for the villagers. When the Linauw warriors would come towards them, and the Pimaba men would scramble away he, together with the five soldiers who accompanied him, would stand still and throw some little beads or other trinkets to them. In that way Wesselingh meant to soothe their anger after which they might listen to him. Some plan however! We are of the opinion that this would only lead to mischief, because we deem him and five men far too weak to hold off such a crowd of armed savages who, when they see their enemies [from Pimaba] running away, will only think that they are the winning side, and certainly will not understand that he has been sent especially to offer them peace. On the contrary they will most likely believe that we are assisting their enemies to harm the people of Linauw. If beaten we shall lose our reputation among this impudent mass, or it will at least be badly damaged. This should not be carried out in such an ill-considered way. Therefore we ordered him as well as the regent of Pimamba's brother to see to it that one delegate from Linauw will be sent to Pimamba to meet Wesselingh, or that he himself in exchange of sufficient hostages will go to Linauw to make peace with them. Under the present conditions the Company does not have the power to reach these objectives with a substantial army. [...].

About the site of the above mentioned six gold-rich villages this junior merchant informs us that plenty of gold is worn by all inhabitants, men, women and children. They wear it around the neck, arms, fingers as well

as around their bodies, legs and toes. The men cover their caps, hilts of
their weapons, assegai and other gear with gold. In the past the Chinese
are said to have collected a large quantity of gold but since they
discovered the real value of the gold, the inhabitants did not tolerate any
Chinese staying in that area anymore, for which reason the Chinese have
revealed this to us. Wesselingh however did not discover yet in what
shape the mineral is deposited and the opinions differ on this. Some say
that it is thrown up by the Danau River (fol. 375) while others believe that
heavy rains erode it from the mountain slopes, a third opinion says that
the gold is dug up from the mountains and that it is found in veins in the
earth. It would be useful if this can be discovered, only time will tell.
[...].

95. Resolution.
Tayouan, 25 October 1638.
VOC 1128, fol. 550-551.
See also Collectie Sweers 1. East India letters, extracts and acts, 1620
to 1674 (1640), fol. 191-194.

fol. 550: [...] Op gisteren schrijvens becomen hebbende uyt Vavorolangh
van onsen resident aldaer leggende, hoe van d'Vavorolangers bericht was
dat d'inhabitanten tien Chineesen, op de velden jagende omcingelt hadden,
daervan zeven gequetsten ende drie met pijlen doodtgeschooten waren,
doch niet wetende wat natie sulckx gedaen hadde. Welcke geruchten wij
niet alleenlijck gehoordt maer oock uyt desselfs gequetste Chinesen
volcomentlijck verstaen hebben, bij d'inhabitanten geschiet te wesen.
Alleenlijck difficulteerden off die van zee, off wel eenige jonge
manschappen van Vavorolangh dit vermelte feyt gepleegt hadden, ons
oock gebleecken sijnde dat alle de jagers van de Vavorolangsche velden
geretireert ende tot Wancan gevlucht waren. Saecken van al ten quaden
gevolge ende tegens den welstandt van de Generaele Compagnie strijdich,
ende redenen waeromme die oock dienen met d'alderrigourste straffe
voorgecomen te worden, dewijle alle onse bondtgenoten dorpen op dese
wrevelmoedige natie siende hieraen geen exempel gestatueert wierde,
lichtelijck t'avondt ofte morgen, tot dit boos feyt mede soude vervallen,
ende de saecke van een quader tot een arger soude geraecken. Sulckx
omme daerinne te voorsien is op de propositie van den gouverneur
goetgevonden, sijn Ed. in persoon, met eene crijchsmacht van ... soldaten
derwaers sal vervougen, mede nemende soo veel inhabitanten als van

Sincan, Bacluangh, Mattau, Soulangh ende Tirosen door domine Junio sal connen geprest worden, omme met deliberatie van den Raedt de quaatwillige, 't sij met minne ofte onminne, in handen te becomen ende daervoor soodanigh exempel te statueren (fol. 551) als Sijn Ed. den Raedt tot maintenue van Comp.ˢ respect ende voorstandt van haer Ed. goet recht sullen vinden te behooren. [...].

fol. 550: [...] Yesterday we received a letter from our resident posted at Vavorolangh, that he had been informed by the villagers that some inhabitants had entrapped ten Chinese who were hunting in the Vavorolangh fields. The result was that seven Chinese were wounded and that three were killed by arrows. These rumours were confirmed by the wounded Chinese themselves who told us that these acts of violence had been committed by natives but that it was difficult to know with certainty whether the offenders had come from the sea or whether some of the young fighting men of Vavorolangh were responsible. We also learned that after the incident all the hunters had left the fields of Vavorolangh and run off to Wancan, that being of ill consequence and in opposition to the General Company's interests. For this reason such attacks need to be prevented in the future under the threat of severe penalty. If our other allies believe that this rancorous nation will not be taught a lesson they may easily commit such evil deeds themselves and such behaviour will go from bad to worse. Thus on the proposal of the governor the Council agreed that an expedition force, consisting of ... soldiers, commanded by His Honour in person, will leave for Vavorolangh, and that as many inhabitants of Sincan, Bacaluan, Mattouw, Soulang and Tirosen as possible will be recruited by Reverend Junius to join that army. After some debate in the Council it was agreed that the target will be to capture, willingly or unwillingly, the malefactors so as to inflict such a punishment (fol. 551) as His Honour and the Council consider necessary for the maintenance of the Company's reputation. [...].

96. Dagregister kept by Governor Jan van der Burch during his expedition to Vavorolangh with an armed force of 210 soldiers to punish its inhabitants.
Vavorolangh, 27 November-4 December 1638.
VOC 1128, fol. 501-509.
DRZ, I, pp. 442-448.

97. Missive Governor Jan van der Burch to Governor-General Anthonio van Diemen.
Tayouan, 4 December 1638.
VOC 1128, fol. 402-417.[54] Extracts.

fol. 407: [...] Op d'incomste van de jacht die althoos door d°. Junio is gevordert ende weder gedebourseert in drijmael 's jaers aen alle kinderen der inhabitanten, ider een cangangh tot cleedinge te vereeren ten respecte de jonge jeucht neerstich soude te schoole comen ende inde waere leere Jesu Cristij mochten onderwesen worden, de kinders in alsulcker voegen d'ouders niet contentement onthoudende die se andersints in hare velden soude meenemen ende aldaer tot den dienst gebruycken. Soo wordt door gem. Junio so oock somtijts aende ouders eenige weynige cleetgens vereert aen dengeenen welcke haer in dit Goddelijcke werck ijverig thoonen, dat de kinderen vermanen neerstich ter schoole te gaen, dat haer selfs geerne tot het gehoor van Gode, [...] inde kercke laten vinden [...] met soodanige vermaninge als door gem. Junio dagelijcx onderwesen werden, die oock somtijts de outste vande dorpen doet tracteren met spijse ende dranck om haer te meer te courageren ende tot dit goede werck te genegender te maken [...].

fol. 415: [...] Wat succes onse gedane tocht naer Vavorolangh gesorteert heeft resteert U Ed. bij desen gecommuniceert te worden, hoe namentlijck wij in persoon nevens den crijcsmacht van 200 Nederlandtsche coppen, tot d'straffinge der gem. Vavorolangers in de Riviere Poncan verscheenen sijnde, hebben d'eersten deses 's nachts, een expresse Chinees derwaerts gecommitteert, ende d'oorsaecke onser compste aende outsten van Vavorolang geadviseert hoe van haer begeerde dat ons de rebellen, die nu onlangs seven Chinesen soo als opper velden met onse permissie waren jagende, gequetst ende drie doot geschooten hadden, soude ter handt stellen omme daer aen een exempel te statueren, als met den anderen tot voorcominge van onlusten ende mainctuyre vanden getroffen vreede souden vinden te behooren, de gem.ᵉ outste tot dien eynde uyt Vavorolangh ontbiedende, met in 't gemoet te trecken ons te bewelcomen. Sulcx dat drije derselver 's anderen daech inden avondt bij ons in 't leger verschijnende haer andermael onse meeninge wel serieuselijck voorgehouden hebbende, doen soo verde quamen dat sulcx belofde naer te comen; alleenlijck difficulteerde dat d'persoonen niet soude connen bestellen, door dien gevlucht waren maer dat haere huysen ende goederen conden aenwijsen, waermede ons (fol. 416) welgevallen mochte doen ende diergelijcke.

Donderdachs 's morgens met gem. macht in 't dorp Vavorolang treckende gecombineert met ongeveerlijck 1400 inhabitanten van Mattouw, Soulangh, Sincan, Bacaluan, als andere, hadde wel expresselijck, op lijffstraffinge doen verbieden, dat egeene onser onderdanen, de geseyde Vavorolangers soude beschadigen voor ende aleer daer toe ordre van ons bequame sulcx oock alsoo effect gesorteert is. Soo wierde de geseyde Vavorolangers oock wel gewaerschouwt dat egeen pijlen op de minste onser inhabitanten en quame te schieten, off soude andersints haer d'oorloch aendoen, ende d'huysen in brandt steecken. Waerop wij tot ongeveerlijck de middach treynerende wierde gehouden om ons de quaadtwillige ter handt te stellen, brachten ons enige Chinese rocken toe die se de jagers uytgeschut hadden, maer van persoonen ende goederen conden ons niet aenwijssen, door vrese dat t'avondt ofte morgen, haere huysen van de geïntresseerde mochte verbrandt worden. Sulcx vermerckende, dat ons met een praetgen trachten tot den avondt traynerende te houden, omme haer voordeel des te beter af te sien, resolveerden wij vijf à zes huysen inden brandt te steecken, laetende d'vordere straffe met de repremende tot haer beter comportemente, in stato verblijven, daertoe lastgaven om een eynde van saecke te crijgen. Dan de Vavorolangers dit siende, schooten met pijlen op de Sincanders, dat ons dede en veroorsaeckte de gantsche strate, daer ongeveerlijck 150 woonhuysen ende 200 rijshuyskens stonde, door den brandt te vernielen wanneer oock de vijff oudsten met ons gevangen mede namen.

De Sincanders cregen van haer drije hooften ende verscheyde wierde door onse muscettados gequetst daerentegen hadden wij maer drije gequetste Sincanders, Gode sij loff, dat dese tochte sonder quetsinge ofte dodinge van enich Nederlander soo wel uyt gevallen is. 't Sal sonder twijffel den schrick onder d'inhabitanten baren ende de wrevelmoedige Vavororlanders tot beter verstandt doen brengen, dat gedogen sullen de Chinesen opper velden te jagen of andersints soude 't voorwaer de Comp.ᵉ in 't opsamelen der hartevellen jaerlijckx veel comen te verscheelen ende dese natie souden haer eyntlijck al te onverdragelijck aenstellen dat met alle mogelijcke middelen in tijts moet voorgecoomen worden. Sulcx dat wij de gelegentheyt waergenomen hebben, desen tocht bij de handt te nemen, wanneer zes scheepen van Japan alhier waren aengelangt ende dat (fol. 417) het oude volck voor de verlossinge noch desen dienst conden presteren [...].

fol. 406: *(Governor Van der Burch refers to the resolution of 18 October that was taken to guarantee the safety of deer-hunters and to prevent the occurence of further disturbances in the fields of Vavorolangh.)*

fol. 407: [...] The revenues from hunting collected by Reverend Junius have been used, three times a year, for providing all the native children with a *cangan* on the condition that the youngsters all diligently come to school and be educated in the true teachings of Jesus Christ. In that way, by presenting the children with a little bonus, the parents, who no longer benefit from their children's labour in the fields, will be rather contented. Likewise, every now and then Rev. Junius presents some textiles to those parents who show themselves pious Christians and urge their children to attend school, and who go to church themselves [...], and listen to Junius' admonitions everyday. Sometimes Junius also treats the village elders to food and drinks to encourage them to continue on the new road they have taken and to make them the more accessible for the propagation of the Gospel [...].

fol. 415: [...] The successful outcome of the punitive expedition to Vavorolangh needs to be communicated to Your Honour now: I myself went with an army of 200 Dutch soldiers with the purpose of punishing the mentioned Vavorolangan malefactors. As soon as we arrived at the Poncan River, on the first of December, we sent a Chinese to that village in order to explain to the Vavorolangh elders the reason for our arrival and that we wanted them to turn in the suspected rebels who had recently wounded seven Chinese who were hunting in their fields with our permission, and had killed three of them. We wished to make certain the offenders would receive an exemplary punishment. In order to prevent further disorder and to guarantee the peace we concluded with them, the village elders, were invited to come over from Vavorolangh and meet us on the way. They complied with this, because three of them appeared in the camp the next evening. After we had explained our intention to them once more in a serious way, they promised to follow up our order, except that they could not immediately turn in the suspected persons because they had run off. However they could point out their houses and goods to us (fol. 416) with which we could take any action. On Thursday morning we entered the village of Vavorolangh with our force, together with about 1400 inhabitants of Mattouw, Soulang, Sincan, Bacaluan, and other settlements, who were forbidden expressly, on pain of corporal

punishment, to harm the mentioned Vavorolangians unless they were ordered to do so. This order was obeyed. In addition, the Vavorolangians received a warning not to shoot arrows at any of our allies, or we would wage war on them, and set their houses afire. We were kept waiting until the afternoon for the delivery of the culprits but [the outcome was] that they brought us some of the Chinese coats which they had stolen from the Chinese huntsmen, but they were not able to point out the persons or their belongings, for fear that at night or the following morning their houses would be set afire by the persons concerned. When we noticed that they tried to keep us in suspense until the coming evening, and thus win some time to their own advantage, we decided to burn down five or six houses, refraining from further punishments for the time being in order to improve their behaviour. However, when we gave the order for those houses to be set on fire the Vavorolangians began to shoot arrows at the Sincandian allies. This forced us to set fire to the entire street, about 150 dwelling houses and about 200 rice storage sheds, and captured five village elders. The Sincandians seized three enemy heads in the fight and several Vavorolangians got wounded by our musketeers, while on our side only three Sincandians were hurt. Praise the Lord this expedition was carried out successfully without one Dutchman being hurt or killed. Undoubtedly this has frightened the inhabitants and will force the revengeful Vavorolangians to come to their senses and tolerate the Chinese to hunt in their fields. Unless we succeed in this the Company will seriously fail to get the required number of deerskins and, additionally, this nation would behave too intolerantly which at all times needs to be prevented through all possible means. Consequently we used the opportunity to carry out this punitive expedition at the moment when six ships from Japan had arrived here in Tayouan, so that we could (fol. 417) deploy the old hands of the garrison one more time shortly before they were be replaced [by new arrivals] [...].

1639

98. Missive Governor Jan van der Burch to Governor-General Anthonio van Diemen.
Tayouan, 9 January 1639.
VOC 1130, fol. 1323-1343. Extract.

fol. 1323: [...] Hiervorens verschijnen alhier den 6ᵉⁿ deses, darthien Vavorolangers, nevens één der oudtsten, welcke wij den 18ᵉⁿ december passato op der gevangenen versouck hadden gelargeert, audientie aenden gouverneur solliciterende. Binnen comende vraegden d'oorsaecke haerder verschijninge, begonde den gemelten oudtsten sijn rapport te doen, seggende hoe dat hem de gouverneur op sijn instantelijck versouck na Vavorolangh hadde gelargeert (fol. 1324), alwaer comende hadde niet alleen d'oudtsten maer oock alle de jonge manschappen op de gewoonlijcke vergaderplaetse bijeen doen roupen. Alwaer in 't midden op een verheven pleck haer hadde aengecondicht de behoudenisse van haere persoonen ende goederen, bij aldien hun alt'samen onder de gehoorsaemheyt vanden Nederlantschen staet oprechtelijck willen begeven. Ja presenteert den gouverneur onsen vader te wesen, mits dat wij hem oock als gehoorsame kinderen sullen obediëren, de Chinesen op onse velden vrij ende vranck te laten jagen, sonder de minste verhinderinge aen te doen, maer alle hulpe ende vaveur bewijsen, daer sulcx van nodig mochte wesen. Wanneer dat bij een ijder van goeder harten wort nagecomen, soo sal ons dorp niet alleenelijck tegens alle onse vijanden worden geprotegeert, maer oock ijdereen sijn goet behouden, gerustelijck sullen met onse vrouwen ende kinderen den rijs ende geers mogen planten, maeyen ende in onse huyskens opsamelen, met verheven stemme uytdruckende wat oyt meer gewenscht hebben, ende waeromme en souden wij Vavorolangers ons niet gewillichlijck den Nederlantschen staedt onderwerpen om soo een vreedtsamich leven te mogen leijden. Daerentegen verclaerde haer gewaerschouwt te hebben ingevalle enige jongemanschappen in hartneckicheyt wilden persisteren (fol. 1325) soo, verseeckerde haer gesamentlijck, niet alleenlijck dat het geheele dorp in d'assche sal worden geseth, daer door van rijs ende goederen sullen sijn ontbloot, maer sullen ten rove van onse vijanden worden gegeven, die ons achtervolgen, dooden, ende onse kinderen niet sullen sparen opdat over onse hoofden triumphe ende feest soude mogen houden. Sulcx soo alle haer gehoorsaemlijck wilden aenstellen, beloften souden doen dat de Chinesen ongemolesteert

sullen laten jagen, wel gedachtich sijnde soo die eenige overlast aengedaen wierde sulcx den gouverneur persoonlijck soude wesen gedaen. Waerop verclaerden dat alle de Vavorolanders, generalijck ende een ijder in 't bijsonder opper maniere van een strootgen te breecken, swoeren datse haer niet meer soo vermetel sullen aenstellen, maer gewillichlijck den Nederlantschen Staet onderworpen. Wijders hadde haer verhaelt de goetaerdicheyt der Nederlanderen humeuren, hoe dat de vier overste, nevens Tziecka opperste der Chinesen, niet alleenlijck en hadden in 't leven behouden maer bovendien noch eerlijck getracteert. Waerop oock met verheven stemme hadden uytgeroupen: 'soo wij Vavorolangers soodanige victorije over onse vijanden hadden vercregen als den gouverneur (fol. 1326) gedaen heeft, wij souden se alle hebben gedoodt, ende over de hoofden triumphe gehouden'. Daerop verclaerde dat alle d'Vavorolangers tot verwonderinge met blijtschap hadden uytgeroepen, nu de outsten noch in 't leven gelaten waren, waren se te meerder verobligeert, oprechter danckbaerheyt te bethoonen, ende straffe van varckens aenden gouverneur te geven tot een teecken dat hun haer faulten hertelijck leet waren, belovende andermael deselve met een goet ende gehoorsaem leven te beteren. Daerop wijders goetvonden alle de goederen te restitueren welcke de quaetwillige vande Chinesen in 't jagen opper velden gerooft hadden, ende nevens hem in Tayouan te brengen omme door den gouverneur weder gerestitueert te worden aen den geenen die daertoe gerechtich soude wesen. Sulcx nu met 13 outsten hier gesaementlijck gecomen waren, omme te versoucken dat haer gecommitteerde faulte gratieuslijck mochte vergeven ende den vorigen vrede de novo soude worden getroffen.

't Gepasseerde in dier vougen vanden voors. oudsten van Vavorolangh verhaelt ende overgetolckt wesende, (fol. 1327) hebben wij haer daerop gedient, off alle d'outsten 't voors. rapport wel hadden begrepen, ende oock gesint waeren den Nederlantschen Staet gewillichlijck t'onderwerpen ende wat dat doen souden, ingevalle enige wrevelmoedige t'avont ofte morgen van dese resolutie quamen af te wijcken, ende onder 't een off ander pretext de Chinesen overlast aendeden.

Beloofden daerop ter goeder trouwen sij luyden met alle man op soodaniche misdaders souden vallen, ende den gouverneur in Tayouan toebrengen omme daeraen soodanige straffe t'exerceren als sijn E. soude vinden na rechten te behooren. Sulcx om den vrede te bondiger t'arresteren, hebben wij in presentie vanden Raedt deses comptoirs Tayouan haer schuldich debvoir andermael willen te verstaen geven, op dat kiesen mochten wat in desen te doen ofte te laten hadden.

Dat gedogen mosten de Chinesen binnen acht dagen op de Vavorolantsche velden quamen jagen, ende niet alleenich geen hinder aendoen, maer oock desnoots sijnde alle vruntschap bewijsen, waer sulcx van node mochte wesen; dat haer vijandelijck sullen aenstellen tegens de geenen die de Chinesen eenigen overlast (fol. 1328) aenquamen doen, ons deselve in handen leveren omme daerover de rechtvaerdige straffe te decerveren, sulcx als den gouverneur met de outsten der verenichde dorpen soude vinden te behooren.

Ende opdat de Vavorolangers, soo wel als d'inhabitanten onser verenichde dorpen, mochten weten qualijck gedaen ende tegens den Nederlantschen staet verlopen te hebben, soo sal van nu aff haer onttrocken blijven de preëminentie die haer den gouverneur voor desen gegeven hadde van één derde der velden te behouden waerop de gem.ᵉ Vavorolangers alleen mochten jagen, dat nu door voors. gecommitteerde oppositie, weder aen de Comp.ᵉ vervalt, ende dienvolgende oock gedogen sullen de Chinesen op voors. wijse, sonder d'minste verhinderinge, aldaer mede te laten jagen.

Dat d'voors. Chinese plunge met hun medegebracht door den coopman Hambuangh aen de Chinesen die daertoe gerechtich sijn vandage t'haerder presentie sullen worden gerestitueert, ende verclaeren t'haerder leetwesen bij eenige quaatwillige, soo een boose actie gedaen te sijn, waervooren de (fol. 1329) Chinesen na desen niet te vresen hebben, alsoo wij oudtsten belooven de Chinesen tegens alsulcke quaedtwillge te beschermen; dat wanneer den gouverneur enige quaedtwillige den oorloch wil aendoen, sij luyden gesaementlijck, oock t'allen tijden, volvaerdicht sullen staen, omme hem in voorvallende saecken t' assisteren. Ende omme d'Vavorolanders haer actie seeckerder te mogen bespeuren, soo verstonden wij dat de twee Nederlanderen welcke voordesen in Vavorolangh gelegen hadden, haer weder derwaerts souden transporteren, die wij d'outsten recommandeerden vruntlijck te bejegenen ende wel tracteren, opdat se daer door onse gunste te meer capteren mochten.

Alle 't gunt voorschr., is de gemelte outste Vavorolangers wel duydelijck te verstaen gegeven, ende beloofden volwaerdich hetselve gewillich na te comen. Waerop wij haer gesamentlijck met eede, op haer wijse, bevorderden den Nederlantschen staet gehouw ende getrouw te wesen als eerlijcke ende oprechte bontgenoten schuldich ende gehouden sijn te doen. Sulcx ter vergaderinge van onsen Rade, den gem. vreede aldus andermael is gearresteert, ende de gevangenen (fol. 1330) daerop oock gelargeert geworden, ende hebben de outsten uyt aller namen der gehoorsame Vavorolangers, naer 't sluyten deser vrede noch geproponeert off wij niet verstonden dat die causa movens van dese onlusten geweest sijn, niet

behoorden aen die gehoorsaem gebleven waren, te restitueren alsulcke
goederen die door den brandt haere huysen ende rijs verlooren hebben, ten
tijde wanneer de quaetwillige quamen straffen, ende sij haere eygen
huysen niet hebben willen aenwijsen. Ten eynde d'onnosele souden
worden geexcuseert, sulcx haer toegestaen hebben met goede redenen de
restitutie te vorderen, omme d'gehoorsame recht te doen, ende de
quaatwillige haere straffe te meerder mochten gevoelen ten eynde daeraen
een beter exempel soude worden gestatueert tot schrick van alle
booswichten, ende haer namaels te wagten van diergelijcke vijandelijcke
actie tegens Comp.ˢ staet meer aen te nemen. 't Welck sonder twijffel al
enich goet baren sal, sulcx dat de hartevellen vanghst in voorige terme
alweer sijn voortgangh heeft, daer het ons oock omme te doen was, ten
eynde de Comp.ᵉ, inden vellenhandel niet soude worden vercort. [...].

fol. 1323: [...] A little while ago, on 6 January, thirteen Vavorolangians,
besides one of the elders who we had taken captive and who later on (on
the 18ᵗʰ of December of the previous year) was released at his own
request, appeared at Tayouan asking for an audience with the governor.
When, upon their entering, we asked them the reason for their arrival, the
mentioned headman reported that the governor, on his repeated request,
had agreed to let him go to Vavorolangh. (fol. 1324) Upon his arrival he
had not only summoned up the elders to come to the usual place of
assembly, but also the young warriors. There, on a somewhat elevated
spot in the middle he had announced that if they wished to keep their
belongings and lives they must collectively and honestly submit
themselves to the Dutch State: 'The governor has promised to be like a
father to us [the Vavorolangians], on condition that we behave like
obedient children and that we will let the Chinese hunt freely on our
fields, without impeding them in any way, but assisting and helping them
whenever it is necessary. If everybody meets his commitments true-
heartedly then our village will not only be protected against our enemies
but everybody can also keep his belongings and continue to make a living
peacefully while we men together with our women and children may plant
and reap rice and millet and store it in our little sheds.' The headman
raised his voice and asked 'what else do we wish', and 'why they
shouldn't we Vavorolang people not be willing to voluntarily submit
ourselves to the Dutch State so we may lead a peaceful life?'. Conversely
he also mentioned that he had warned them that if some young men

persisted in opposing the Company's power (fol. 1325) then, not only would the entire village be reduced to ashes, so that: 'we will be stripped of our rice and goods but, moreover we will be abandoned to the plunder of our enemies who will hunt and kill us, and will not spare our children, and celebrate their victory showing off the heads they have taken'. They should all behave obediently and promise not to molest the Chinese hunters anymore, keeping in mind that if the huntsmen are caused any inconvenience, the governor would regard that as a personal affront. To this the Vavorolangians declared according to their custom, altogether as well as each individually, themselves willing to break a little piece of straw to swear an oath that they will no longer oppose but will submit themselves willingly to the Dutch State. The headman had also told his audience about the kind-heartedness of the Dutch, that not only had the lives of the four village elders and that of Chinese headman Tziecka been spared, but in addition they also had been treated well. Thereupon in a loud voice he had exclaimed: 'if we Vavorolangians had won such a victory over our enemies as the governor has (fol. 1326) won over us, we would have killed all of them and celebrated our triumph with the heads of the defeated'. He told us that thereupon all Vavorolangians had cried out with joy: 'now that the headmen had been spared, they felt even more indebted to show true gratefulness by presenting the governor with pigs he had demanded by way of punishment, showing that they sincerely regretted their former offences and promising once more that they intended to mend their ways'. They also agreed to return all the goods the offenders had taken from the Chinese deer hunters, and offered to see to it that those belongings were delivered in Tayouan to the governor who then could return them to the rightful owners. To that purpose the thirteen headmen had come to Tayouan together in order to request pardon for the committed mistakes and the reinstatement of the formerly concluded peace.

After everything had been told by the mentioned Vavorolangh elder, and had been interpreted (fol. 1327), we asked if all of the headmen had sufficiently understood the report and if they really intended to submit themselves voluntarily to the Dutch State and what they would do if some of their subjects would ignore the decree and again cause inconvenience to the Chinese.

To that question, in good faith, they all together promised to retaliate to such an offence by catching the offenders and surrendering them to the governor in Tayouan so that they may be punished in the way His Honour considers to be just. Whereupon, in order to conclude a decisive peace we, in the presence of the Tayouan Council, have resolved to teach them their duties once more. To that end we made them decide whether they wanted to obey the governor or not.

Within eight days the Vavorolangians would have to tolerate the Chinese who came to hunt in the Vavorolangian fields. Not only should they not cause any trouble but they also had to extend their friendship to those Chinese if they had problems. Additionally, they would have to take armed action against any adversaries who might somehow inconvenience the Chinese, (fol. 1328) and hand them over to us so that the governor together with the headmen of the allied villages can decide about the rightful punishment.

In order to make the Vavorolangians as well as the inhabitants of our united allied villages aware of the offences some Vavorolangians have committed against the Dutch State, their former privilege, entitling them to a third part of their fields as their exclusive hunting territory, which had been granted to them by the governor, will be abolished from now on. As a result of the committed antagonistic acts these fields will belong to the Company so that the Vavorolangians must tolerate the Chinese huntsmen on all their fields.

All stolen Chinese goods which the headmen returned to us today, will be returned to the rightful Chinese owners by merchant Hambuangh, in their presence. Meanwhile the Vavorolangian headmen have to declare with regret that some malicious subjects committed that offence, which (fol. 1329) the Chinese will no longer have to fear, because we, the headmen, promise that we will protect the Chinese against those evil-minded people and that at all times we will be ready to assist them if necessary. In order to keep an eye on their actions, we thought it best to send over the two Dutchmen, who had been stationed in Vavorolangh earlier, and urge the village elders to treat them in a friendly way, so that they may gain our favour again.

After everything mentioned above was clearly repeated to the Vavorolangian headmen, they promised to comply with everything. Thereupon they together took an oath that they in their own way would

take care to be true and loyal subjects of the Dutch State as honest and sincere allies, as they are obliged to be. Consequently the mentioned peace was concluded once more and the prisoners (fol. 1330) were released. Afterwards the elders, on behalf of all obedient Vavorolangians proposed that with our agreement the offenders who had caused the irregularities should replace the goods and belongings of the obedient and innocent villagers, which got destroyed in the fire when their houses were ruined and their supplies of rice were lost when we came to their village to punish the actual offenders. The only transgression these villagers had made was to refuse to point out the houses of the guilty ones. In order to excuse the innocent we allowed them to ask for restitution in order to do justice to the obedient and to punish the evil-minded people. Thus a bitter lesson could be taught to scare all villains who afterwards will take care not to undertake any more antagonistic actions against the Company's power. This undoubtedly will lead to better results so that the deerhunt can be continued as before. In fact the expansion of the trade in deerskins is the real aim, so that the Company may not suffer loss in this matter. [...].

99. Original missive Governor Jan van der Burch to Governor-General Anthonio van Diemen.
Tayouan, 12 March 1639.
VOC 1130, fol. 1405-1417. Extract.

> fol. 1408: [...] [Op 16 februari] is mede den ondercoopman Maerten Wesselingh over Lonckieuw naer Pimamba gesonden omme door hem te meerder vande Louansche gelegentheyt te vernemen, ende inde Pimambasche spraecke wat ervaren sijnde, in 't aenstaende saysoen ons te dienen dat bij de goudthebbende lieden te rechte connen comen, soo U Ed. verstaet de vordere gelegentheyt met een aensienlijcke crijchsmacht sal worden ontdect. [...].

fol. 1408: [...] On 16 February Junior Merchant Maerten Wesselingh was sent to Pimaba over Lonckjouw with the order to investigate the situation of Lowaen, and being somewhat acquainted with the language of Pimaba, he may see to it that in the coming season we will be able to get in touch with the gold owning people, if Your Honour agrees, that region should be explored further with a considerable military force. [...].

100. Extract Dagregister Zeelandia, 18 March-4 November 1639.
VOC 1131, fol. 664-739.
DRZ, **I, pp. 452-484. Summary.**

(On 20 March two letters were received in Tayouan (dated 1 and 2 March) from Junior Merchant Maerten Wesselingh in Pimaba. He reported that he had safely arrived in Dolaswack on 27 February and that he had found the 1600 rock-goat skins and the other pelts which the ruler of Lonckjouw had promised to deliver to the Company. The inhabitants of Taccabul, a mountain village that had recently upon their own request made peace with the Company and who formerly had been adversaries of Lonckjouw's ruler also had agreed, upon Wesselingh's recommendation, to conclude peace with Lonckjouw. Those from the pacified village of Lowaen had, during Wesselingh's absence, raided Talangar and beaten to death all its inhabitants except for two persons who had managed to escape. Eventually the village of Lowaen, as soon as the Company can dispose of enough soldiers, needs to be punished for this offence. Wesselingh finally asked if about 20 or 25 cangans could be sent to Pimaba, for distribution among those inhabitants who had assisted him on the way. On the 12th April another letter written by Wesselingh on 10 April arrived in Tayouan with the news that he had travelled to 'Pyuma' where he had arrived safely on 5 April. His sudden departure caused some fear among the people of Pimaba that the Company might send a punitive expedition to them and to Tawaly. To Wesselingh's disappointment the amount of bartered moose and rock-goat skins was very limited. He thought that was due to the fact that there had been a lack of the highly favoured little jackets as trade goods, while a surplus of cangans had spoiled the market. Because most of the rice had been lost in a fire it had become very scarce. On 25 April Wesselingh travelled again to Linauw together with 600 Pimaba warriors in search of the gold sites. However, upon reaching Linauw his allies, who greatly feared the men of Linauw, interpreted the singing of the birds and their dreams as bad omens. As a result nothing could be done with them anymore and nothing was accomplished. On different occasions people from a certain village named Backingan, came to Pimaba, on behalf of Kinadauan, another village situated high up in the mountains at about five days' march away

from Pimaba, and invited Wesselingh for a visit. They seemed to be very willing to conclude peace with the Dutch authorities.
On 15 May another letter from Wesselingh, written in Tevorang the 14ᵗʰ, reached Tayouan. He wrote that he would not take a shortcut through the mountains to Pimaba, because the inhabitants living in the mountains at about two days' march away from Tayouan, were reputed to be hostile towards the Company. Therefore he had decided to take the southern road via Tapouliang and Lonckjouw.)

101. Extract Dagregister Zeelandia, 27 March 1639-24 January 1640. Collectie Sweers 7, fol. 25-51.
See also DRZ, I, pp. 485-505; FORMOSA UNDER THE DUTCH, pp. 176-179; ZENDING, III, pp. 189-193.

102. Journal or dagregister by Junior Merchant Maerten Wesselingh on the expedition to the east coast of Formosa, via the central mountain range, 11-21 May 1639.
VOC 1131, fol. 835-840.

fol. 835: Adij dito 1639. Op vandaech vertrock nevens den sergeant Jurriaen Smidt uyt Tayouan naer Baccluan alwaer des avons arriveerden, naemen oock aldaer onse rustplaetse.

12 ditto. In de morgenstont namen de reys wederom aen ende gingen uyt Baccluan door het dorp Maguiam naer Tevourangh, daer oock den avont wechbrachten want wat ver om gaen was. Hier vraegde de Nederlanderen nevens de Chinesen, mitsgaeders de inhabitanten die aldaer resideren, off geen passagie over 't hooge geberchte en wisten. Waerop dat antwoorden van neen, als alleenlijck twee cleyne dorpen dewelcke vooraen in 't geberchte lagen genaemt Cannacannavo ende Leywan. Dit verstaen hebbende resolveerden met den anderen dat het wederom om de suydt tusschen het hooger ende het lager geberchte door wilden laten staen, tot soo langh dat jewers een openingh vonden daer door conde comen, gelijck oock geschiet is.

13 ditto. Naemen ons afscheyt in Tevourrangh ende marscheerden doen voorts tot ontrent drie uren des aftermiddags wanneer doen bij een cleyn dorp quamen genaemt Duckeduck. Dit dorp siende ende gewaer wordende gingen daer binnen omme te vernemen ofter ooc wat nieuws conde comen te hooren. Dan daer binnen comende, verstonden gants niet, want verclaerden dat in 't hooge geberchte noyt niet geweest waeren. In dit

dorp bleven des nachts door oorsaeck moede ende van 's morgens aff (fol. 836) in de son gemarcheert hadden.

14 ditto. Vertrocken uyt Duckeduck naer Cleyn Tackrian, daer mede laet op den dach quamen, in dit dorp vonden een Chinees dewelcke, naer dat wat gerust hadden, ondervraegden off in 't geberchte gants niet bekent en was, hierop antwoorden van ja. Dit hoorende seyde: 'wel dat is goet, maer hoe worden die dorpen doch genoemt, die wel bekent sijn?', antwoorde: 'Cawado, Kinadauan ende Bunoch', ende hierop sprack [ik]: 'die dorpen sijn mij seer wel bekent, ende ick bidde U dat doch eens met mij derwaerts gaen wilt, want U lieden daer wel voor betaelen sal'. Den Chinees antwoorde dat het geerne doen wilde, dan hadde partije vellen die in Sincan moste leveren, waerom 't oock niet geschieden conde. Echter beloofden dat des anderen daegs, 's morgens tot in het dorp Tarrequan convoyeren wilde, daer meer Chinesen waeren, ende lach ditto dorp dichter bij het pat dat opgaen mosten. Dit verstaende waren wel tevreden, bleven bij die Chinees dien nacht over [...].

15 dito. Marcheerden met den Chinees naer het dorp Tarrequan. Wij hadden dien dach een seer moyelijcke mars omdat dicwils door verscheyde revieren mosten. In het dorp gecomen sijnde, gingen wat sitten ende naer dat weynig gerust hadden begosten naer Chinesen te vernemen, dan vonde geen. Waerover ons bij d'inhabitanten begaeven ende versochten of derselver ons in het voorste dorp die vooraen in 't geberchte lach wilden convoyeren. Waerop dat antwoorden, het waere alsnu (fol. 837) tegens haer wet, want met haer rijs om in te halen besich waren, soodat het voor dien tijdt niet geschieden conde. Wij bleven hier des nachts want dien daech niet verder mochten.

16 dito. Vertrocken van daer naer Tapouliangh, alwaer twee Nederlanderen vonden die mede naer alle gelegentheyt vernamen, dan costen ons geen bescheyt geven, wij bleven dien nacht echter aldaer om op den aenstaende morgen des te frisscher te mogen wesen.

17 dito. Vertrocken uyt het dorp Tapouliangh door Vorovorongh ende Dolatock tot Cattija. Hier stuyten de rijs, door oorsake volck uyt het geberchte vont daer mede spreken conden. Ick nam de lieden ende brachten se terstont tot een Chinees in huys daer se wel tracteerden. Voorts vraechden haer naer haer dorp, hoe genoemt wierde ende off 't hoogh in 't gebergte lach. Hierop antwoorde haer dorp heet Tolocobos ende lach ontrent een dach reysens van daer. Dit hoorende seye: 'wel, op morgen soo willen wij met U lieden naer U dorp vervougen, want niet en twijffelen off sult ons wel verder helpen dat overcomen mogen'. Sij gaven tot antwoort dat ons tot aen het naeste dorp wel brengen wouden, maer

verder en dorsten 't niet bestaen. Wij waren met de lieden tervreden ende dancten Godt dat soo veel openingh becomen hadde.

18 dito. Naer gedaen maeltijt gingen naer 't hooghe geberchte marcheren. Den wech was seer steenich ende moyelijck om gaen, echter omtrent (fol. 838) drie uren des achternoens arriveerden aldaer. Wij bevonden dito dorp seer groot van steen opgebouwt, veel volcx ende van lijftochten soodanich versien dat een lust om aen te schouwen was. Wij bleven 's nachts in dito dorp rusten ende wierde naer lants costuyme wel getracteert.

19 dito. 's Morgens vroech versochten seer vrundelijck op de outsten dattet haer wilde gelieven volck ter beschaffen die ons tot in het naeste dorp convoyeren mochten, alsoo den wech niet en wisten. Hierop gaven tot antwoort: 'Wij sullen met alle man nevens U lieden gaen soo ras slechts wat gegeten hebben, ende U lieden aldaer segourlijck brengen.' Dit hoorende bedancten haer seer ende gaff aen de principaele outste een cleyne vereeringe. Ontrent negen uren trocken aen het marcheren 't gebercht op. Desen mars duerden wel twee uren eer dat op 't hoogste van dito berch quamen. Boven sijnde keken uyt dan sagen niet als een seer groot dorp ontrent noorden van ons genaemt Cobeonggar. Welck dorp naerdat van een ider verclaert wierde 1000 weerbare mannen uyt souden connen leveren. Ick geve 't selver oock gelooff want naerdat sien coste soo was dito dorp wel helfte groter als 't ander, daer uytgetrocken was. Ontrent vier uren des achtermiddachs arriveerden in Culalou, daer mede wel onthaelt ende getracteert werden. Wij bleven hier 's nachts door oorsaecke niet verder mochten. (fol. 839)

20 ditto. In den morgenstont deden d'oudste een cleyne schenckagie ende versochten meteen off ons met volck wilden accommoderen die ons over 't voirdere geberchte mochte helpen. Sij gaven tot antwoort van 'Ja', dan deyden daerbij 'gij meugt alsoo lieff hier blijven, als derwaerts gaen'. Waer was het dat sij het wel deden maer echter docht haer dat het voor ons een onmogelijcke sake was. Ick badt slechts dat gaen wilde, want althoos voor regen bevreest waren. Wij cregen eyntelijck gehoor, soodat terstont aen 't marcheeren trocken, dien berch aff ende doen wederom eenen anderen grooten berch op ende weder ten laetsten ofte dien berch ten eynde wesende, quamen aen een seer machtigen hoogen berch. In 't opgaen was dito berch dicht met ruychte bewassen soo dat het padt door dien meest steen seer slim om gaen was. Dito berch was oock altijt met een nevelachtige lucht betrocken dat seer qualijck quamp want daerdoor barvoets gaen mosten. Op 't jongste doen seer langh geclommen ende eyndelijck boven gecomen waeren, vonden dien bergh vray effen dat een lust om sien was, oock waren daerboven veel plasschen met water dat soo

hier ende daer tusschen de clippen uyt quam dringen. Dit water was soo uyttermaten cout dat het onmogelijck was een halven dronck daer van te doen off de tanden die randen die kilden een mensch soodanich dat pas in een quaertiers uyrs weder terecht commen conden. Desen berch was oock seer vol van campherhout bomen die sulck een reuck van haer gaven dat schier niet verdueren (fol. 840) costen. Boven was dito berch off toegemetselt was want de tacken van de campherhoute als andere bomen soodanich in den anderen gevlochten waeren dat ons van dien gantschen dach geen son begaen conde. Ontrent drie uren gingen die berch wederom aff ende waeren doende tot doncker avont eer dat daer aff quamen. In 't opgaen was dito bergh noch beter als in 't affgaen, want aen d'ander sijde uytermaten stijl was. Op desen berch hebben de see oost ende west van ons gesien. Wij logeerden 's nachts in de velthuysen Lawabicar dat seer wel bekent was, want rede aen den oostsijde van Formosa waren.

21 dito. Een weynich naer middernacht trocken wederom aen 't marcheren, de bocht uyt somtijts door de revier heen. Wij hadden een seer helderen maen dat ons wel quam, souden 't anders niet durven bestaen hebben. Met het aencomen van den daech waren op 't strant daer niet seer langh vertoufden maer vervolgden ons terstont naer Tawalij, daer 't heetste van den daech lieten over gaen. Naer den middach ontrent drie uren vervouchden ons naer Pimaba. Met het ondergaen van de son passeerden Luwan ende een weynich voor middernacht geraeckten in Pimaba, Godt Lovende ende danckende voor dat ons soo genadelijck die weghe hadden laten volbrengen. Wij vonden ons volck oock cloeck ende gesont dat ons soo veel te meer verheugden.

fol. 835: Today, on 11 May 1639, Sergeant Jurriaen Smidt and I left Tayouan for Bacaluan where we arrived in the evening time and where we spent the night.

12 ditto. In the morning we left Bacaluan and travelled on by way of the village Maguiam to Tevorang, where we also stayed over for the night because the distance was too great to reach the next village before dark. Here we inquired after the Dutchmen and Chinese stationed over there as well as the inhabitants if they knew a passage through the high mountains, which was answered in the negative. They only knew two hamlets named Cannacannavo and Leywan, situated at the foot of the mountain range. Whereupon we resolved to again take the southern route, leading through the high and lower mountains, which we would follow all the way until we discovered a way through, which indeed eventually was discovered.

13 ditto. We took our leave from the people of Tevorang and marched on until we came to a small village named Duckeduck at about three o'clock in the afternoon. We entered that village to see if we could get any information. Upon entering the village we learned nothing because the inhabitants themselves had never gone up into the high mountains. Because we were quite tired after a long march in the sun, we stayed over for the night. (fol. 836)

14 ditto. We left Duckeduck for Little Taccareyang, where again we arrived late. After we had taken a rest we questioned a Chinese and asked him if he knew his way around in the mountains. He answered affirmatively whereupon I said: well that is good but do you happen to know the names of those villages? He replied: 'Cawado, Kinadauan and Boenoch'. Thereupon I said: 'I am quite familiar with [the names of] those villages and I beg you to take me there for which I am very willing to pay.' The Chinese answered that he would gladly bring us there, but that he had to deliver a parcel of skins in Sincan first. However he offered to accompany us to Tarroquan the next morning where we would meet with more Chinese. That village was situated closer to the path we had to ascend. We were quite satisfied with that prospect and spent the night at his place. [...].

15 ditto. We marched with the Chinese to the village of Tarroquan. That day we had a very difficult march because we had to cross several rivers. After our arrival in the village, we sat down, rested for a while, and then started to look for some Chinese. When we did not meet any we addressed the inhabitants and asked if they could not guide us to the nearest village situated in the mountains. (fol. 837) They told us that, because they were at the moment busy with the rice harvest, it was against their law to do so before they had accomplished that task. We slept the night in Tarroquan because we were not allowed to leave that same day.

16 ditto. We went on to Tapouliang, where we met with two Dutchmen who we questioned about the local situation but they could not give us any relevant information. We stayed over so that we could leave the next day being well rested and fit for the road.

17 ditto. We left Tapouliang and passed through Verovorongh and Dolatock to Cattia, where we interrupted our journey because we met people from the mountains with whom we could communicate. I

immediately brought them to the house of a Chinese where we treated them well. In the meantime I asked them about their village, how it was named and whether it was situated high in the mountains. They replied that their village was named Talacobos and that it was situated at about a day's journey from there. Upon hearing this we said: 'Well we are willing to accompany you tomorrow to your village because you will undoubtedly assist us further to find the right passage through the mountain.' They answered that they were willing to bring us to the nearest village but that they could not direct us any further because they did not dare to go there. We were quite satisfied with their offer and thanked the Lord for the offered opportunity.

18 ditto. After breakfast we marched into the high mountains. The road was very stony and it was difficult going. At about (fol. 838) three o'clock in the afternoon we arrived in Talacobos. We discovered that it was a very large village built of stone and densely populated. It was so well supplied with provisions that it was a pleasure to see. We reposed in that village and were welcomed very hospitably according to their customs.

19 ditto. In the morning we asked the elders in a friendly way whether they could provide some people to guide us to the nearest village because we did not know the way. They replied: 'As soon as we have finished our meal, we shall all accompany you and see to it that you arrive there safely.' We thanked them for their kindness and presented the principal headmen with a few gifts. At about nine o'clock we started to climb the mountain and it took us about two hours before we reached the highest point. High up from the top we saw only one very large village located to the north of us which was named Cobeonggar. Each of our guides confirmed that the village could bring in about 1,000 fighting men, which I heartily believe because it seemed to be twice as large as the one we had left that morning. At about four o'clock in the afternoon we arrived in Culalou where we were welcomed very warmly. We stayed for the night because the villagers wouldn't hear of us going any further. (fol. 839)

20 ditto. The next morning we offered the headmen some presents and we requested them to provide us with some men to guide us further into the mountains, They answered: 'Yes', and added: 'Yet we would prefer you to stay here.' The truth was that they were willing to assist us but they believed that it would be impossible for us to move on into the highlands. I only told them that we wanted to go because we feared the rains. They

finally agreed so that at once we started the march down hill. Afterwards we climbed another high mountain, and having passed over that one we at last arrived at a very mighty high mountain. The entire mountain was wrapped in mist, its slopes were covered with brushwood, and the rocks on the ground were quite slippery. Because we had to walk barefoot the path was extremely difficult to ascend. We climbed for a long time until at last we reached the top. We discovered the mountain to be quite level and a true treat for the eye. Up there a lot of pools were to be found filled with water that at places welled up through the rocks. This water was extremely cold so that it was even impossible to take a sip of it without suffering a stab of pain in the teeth and gums so much that it took one at least a quarter of an hour to get over it. This mountain was also densely covered with camphor trees that gave off such a strong smell that it could hardly be endured, (fol. 840) Above, it seemed as if that mountain was bricked up because the branches of the camphor wood as well as other trees were so much intertwined that the entire day we did not get any sunlight. At about three o'clock in the afternoon we again went downhill but it took us until well past dusk before we got down. That mountain was easier to climb than to descend as its slope on the other side was extraordinarily steep. On top of this mountain we saw the sea to the east as well as to the west of us. That night we stayed in the field cabin of Lawabicar, where we found ourselves to be on familiar ground, as we had already reached Formosa's eastern side.

21 ditto. A little after midnight we continued on our journey and marched out of the bight, and every now and then waded through the river. If we had not been as lucky as to have such bright moonlight, we would not have dared to venture so far that night. At dawn we arrived at the beach, where we stayed only for a short time in order to proceed on to Tawaly, were we rested in the heat of the day. At about three o'clock in the afternoon we set out for Pimaba. At sunset we passed Lowaen and a little before midnight we reached Pimaba, giving praise and thanks to the Lord, whose mercy helped us to accomplish the journey. To our great joy we encountered our men who we had left behind in Pimaba in good health.

103. Short Memorandum and instruction by Governor Jan van der Burch for Sergeant Jan Barentsz, departing with the junk of Samsiack to Lamey.
Tayouan, 15 May 1639.
VOC 1131, fol. 621-623; VOC 1170, fol. 636-637. Extract.

fol. 637: [...] Wijders met haer in discours raeckende sult opmerckinge nemen hoe haer gevallen soude soo wij eenige Lameyers uyt Sincan haer mede bij voegende off dat sij lieden die liever sagen geëxcuseert, wel lettende op de antwoorde die hier op sullen geven.

Ten anderen sult inspectie nemen off noch alle in 't leven sijn die daer gelaten hebt, insgelijcx ons rapporterende off daer eenige kinderen 't sedert geprocureert sijn; item off niet liever bij haere vrienden naer Batavia souden verreysen dan aldaer te verblijven en sulcx meer wat Ued. noch daerbij soudet connen voegen; dat gevoegelijck van Ued. als van een ander vallen sal, vermits aldaer over de twee jaren gelegen hebt ende met haer promptelijck spreecken cunt ende sij tegens Ued. vrij sijn daeromme oock Ued. gesonden wort. [...].

(After inspection of the island and the stockade the sergeant should address the remaining inhabitants:) fol. 637: Next you will find out while talking to them how they would respond to the plan to let some of the Lameyans who are living nowadays in Sincan, return to their island or if they would prefer that we would just leave the situation as it is. You have to carefully consider their answers. Subsequently you will check if all those you left there are still alive; you also will have to report us whether any children were born lately and also whether the islanders would not prefer to go to their kin in Batavia and live with them or whatever you may deem useful to ask, because you have been stationed there for over two years and you have a good command of their language and they behave uninhibitedly towards you, which is why we have sent you. [...]

104. Extracts taken from the Zeelandia Castle Resolution-books, concerning the resolutions on the island of Lamey, taken in the Formosa Council from 2 June 1636 to 27 February 1645.
VOC 1170, fol. 581-600. Extracts 16 and 23 May 1639.

fol. 593: 16 Mey. Soo proponeert den gouverneur wijders seer noodich te wesen dat het eylandt Lamey gevisiteert wort omme ons te versekeren off d'inhabitanten continueren in 't gehoorsamen van den Nederlantsen staet ofte oock daer plantinge van rijs, groenen gember, geerst, parthije jonge clappusplanten bevorderen soo als jongst belooft hebben. Waer op goetgevonden wert de sergeant Jan Barentsen daertoe te gebruycken, welcke op gem. Lamey twee jaeren gelegen heeft en van d'inwoonders bemint wort. [...].

fol. 594: 23 Mey. Vindende aldaer 19 Lameyers, 12 vrouwen ende tien kinders, sijnde twee kinderen meer geprocureert 't sedert dat aldaer jongst geweest was, ende is seer vrundelijck op haer manier onthaelt geworden. [...] Hadden haer de verpachtinge van 't eylant Lamey aengesecht ende dat den Chinees Samsiack aldaer admiteren soude, dat gaerne naecomen wilden ende sulcx meer als haer den gouverneur souden willen te laste leggen.

Rapporterende wijders hoe de Lameyers haer redelijck gecomporteert hadden in 't zaeyen van rijs, geerst, ende groene gember, dan claegden over de Pangsoyers die haer somtijts eenige overlast quamen aen te doen in 't ontvreemden van haere clappessen, waerop hem na Pangsoya hadden getransporteert ende aen de oudsten aldaer uyt onse naeme clachtigh gevallen die belooft hadden sulcx na desen voor te comen, daer die van Lamey wel mede tevreden waeren. [...]

Wijders hadde hij de Lameyers voorgehouden off niet wel genegen soude wesen na haer vrunden te vertrecken die op Batavia in goeden doene waeren, daer op treurich saegen ende begonden te wenen, antwoordende: 'als ons sulcx den (fol. 595) gouverneur belast soo moeten wel, maer verhoopen ons soo te comporteeren dat al sulcq voornemen sal afgebeden worden'.

Uyt alle 't welck blijct dat haer obedient aenstellen ende niet apparent sij dat bij aentelinge des Comp^s. staet souden vervremt worden, ten respecte dit getal weynich is. Maer sal desselfs continuatio tot meerder verseeckeringe strecken om van anderen natiën niet gepriveert te worden, te meer dewijle die van Pangsoya haer sulcx soude trachten te beletten, die andersints selfs daer veel nae staen souden, soo door ons in balance niet wierden gehouden.

fol. 593: On 16 May the governor proposes further the need to again inspect the island Lamey to ascertain whether the inhabitants continue to obey the Dutch state and if they are making progress with the cultivation of rice, green ginger, millet and a set of young coconut palms just as they recently promised us to do. It was resolved to send Sergeant Jan Barentsen to Lamey for that purpose, who has been stationed on the island for two years and is well-liked by the people. [...].

(On 23 May Sergeant Jan Barentsen returned from Lamey:) He encountered 19 Lameyan men, 12 women and ten children, so that two more children had been procreated since his last visit, and was welcomed in a very friendly manner according to their custom. [...] He had announced to them that the island would be leased out to the Chinese Samsiack and that they should not refuse him admittance, with which they gladly complied just as they comply with whatever the governor may order them to do.

Furthermore he reported that the Lameyans had taken good care of the sowing of rice, millet and green ginger but that they had complained about the Pangsoyans who sometimes came to bother them and steal their coconuts. Thereupon the sergeant had crossed over to Pangsoya to complain about that in name of the Company to the elders of that place. These then promised to refrain from further raids, much to the satisfaction of the islanders.

Also he asked the Lameyans whether they were perhaps willing to join their kinsmen who were so well off living in Batavia, to which they reacted very sadly, looking very dejected. Bursting out in tears they answered: 'if the (fol. 595) governor orders us to do so we must go. We hope to conduct ourselves in a such an irreproachable way that he will be dissuaded from that purpose'.

From everything it becomes clear that they behave very obediently and that it would seem that further procreation will not alienate them from the Company because their number is so small. On the contrary the continuation of their growth in numbers will only provide them more security so that they will not be deprived of their position on the island or harmed by other nations, even more so because the Pangsoyans are eager to gain influence over the island which, if we did not keep them in balance, they would surely try to do.

105. Dagregister Zeelandia, 14, 22 June 1639
VOC 1131, fol. 664-739. Summary.
DRZ, I, pp. 466-467.

(On 14 June Permonij, a nobleman and brother to the 'oranckay' or ruler of Pimaba, Redout, who himself had visited Tayouan before, arrived at the castle together with eight servants. He merely came, upon his own wish, for sightseeing. On 22 June a letter was delivered from Wesselingh in which he asked Permonij to immediately return to Pimaba because the villagers did not accept his absence any longer.)

106. Account of the proceeds derived from hunting and the expenses of Reverend Robertus Junius in the Tayouan accountbooks.
[Tayouan], 30 September 1639.
VOC 1131, fol. 649-658.
FORMOSA UNDER THE DUTCH, pp. 167-173; ZENDING, III, pp. 173-188.

107. Orders and instructions from Governor Jan van der Burch for Junior Merchant Maerten Wesselingh and Sergeant Jurriaen Smith during their stay in Pimaba and on the way to Kinadauan and Boenoch.
Tayouan, 30 September 1639.
VOC 1131, fol. 845-848.

fol. 845: Wat ordre van tijt tot tijt aen den ondercoopman Maerten Wesselingh gegeven is, omme door onsen getroffen vreede met die van Pimamba aengegaen in Linauw residentie te crijgen can bij onse instructie aen gem.ᵉ Wesselingh den 26ᵉⁿ Junij ende 29ᵉⁿ Julij daeraenvolgende verleent, ten principalen vernomen werden. Doch wat devoiren daertoe sijn aengewent en is noyt soo verde geraeckt dat met d'selve in gespreeck van vrede is gecomen. Sustineerde hij Wesselingh sulcx t'ontstaen door puyre verbaestheyt van de Pimambaers, die al hoewel met macht ontrent de grensen van Linauw tot drije distincte reysen verscheenen waren, niet derffden den gem.ᵉ Linauwers verwachten, maer aenstonts haer met gefingeerde beuselingen excuseerde, seggende qualijcken gedroomt off de vogelen niet wel gesongen hadde, dat dan niet goets bedieden ende dien volgende vruchteloos weder gekeert zijn.

Soo en hebbe insgelijcx gem.ᵉ Pimambaers op ons serieus begeeren niet
getracht t'onderstaen de Linauwers per forma van een ambassade toe te
senden met een vereeringe uyt onsen name, omme onder ostagiers met
haer in gespreeck te comen. (fol. 846) Apparent door vreese dat niemant
derfde d'eerste te wesen, excuserende haer oock dat door oncuntheyt van
de Linauwse spraecke metter niet te rechte conde comen etc. Sulcx dat 't
sedert twintig maenden herwaerts in Pimamba niets wijders verricht is, als
dat gem.ᵉ Maerten Wesselingh sich in de Pimambasche spraecke geuseert
ende door experiëntie ondervonden heeft warachtich te zijn dat de
Pimambasche spraeck vande Linausche verre te differeren compt ende
dienvolgende ons voorgedragen van seeckere natie uyt 't geberchte (bij
westen Pimamba in een dorp genaemt Backingam gelegen) verstaen te
hebben dat die van Kimadauwan ende Boenoch groote vruntschap met die
van de om de noort gelegene dorpen onderhouden, welcke dorpen naer
men rucht met de goutrijcke lieden in contract van vreede gecomen sijn,
ende wert daer bij gevoucht dat d'inhabitanten een spraecke als de
Linauwers spreecken, sulcx hij Wesselingh sustineert warachtich te wesen
te respecte het vrunden zijn, ten minsten malcanderen eenichsins verstaen
moeten.
Om dan des Compagnies limyten soo verre uyt te breyden als bij alle
mogelijcke industrie geschieden can, dat oock niet te duchten is
d'inhabitanten op Formosa het minste leet de Nederlantsche natie zal
worden aengedaen dat wijders ons van d'Ed. Heer gouverneur- Generael
ende Heeren Raden van Indiën bij haer Ed. missive geordineert worden
[...] (fol. 847) soo veel doenlijck sij, [...] met de zes goutrijcke dorpen (de
Compagnie noch onbekent) in alliantie ende vreede treeden mogen, off ten
minsten dat met die van Linauw, sijnde d'hooffstat van gem.ᵉ zes dorpen,
in gespreeck connen comen omme soo wijders naer gelegentheyt van
saecke vorder te geraecken ende vernemen wat vruchten 't voors. eylant
Formosa meer sij geevende.
Omme dan bij te brengen wat doenlijck zij, hebben wij met advijs van den
heer commissaris goetgevonden den ondercoopman Maerten Wesselingh
weder naer Pimamba t'ordineren omme sich wijders in desselfs spraecke
t'exerceren, met d'inhabitanten aldaer goede correspondentie
t'onderhouden, ende vorders te verrichten dat alle d'hertenvellen,
steenboxvellen ende elantshuyden over Lonckjouw in Tayouhan
segourlijcken mogen worden gevoert, soo als 't gepasseerde jaer
gevouglijcken heeft connen geschieden, daeraen contentement genomen
hebben. Wijders gelasten wij den voors. sergeant Juriaen Smit,
jegenwoordich in Pimamba wesende, hem, nevens negen cloucke soldaten

tot dieneynde van hier affgeveerdicht, naer 't dorp Kimadauwan off Boenoch transporteren zal, ende de outsten aldaer van onsentwegen begroeten haer d'onderstaende cleenicheeden uyt onsen name vereeren ende voorts t'onderstaen wat van dese spraecke die (fol. 848) de Linausche tale gelijckens leeren can, hem bijvougende den soldaet welck in 't schrijven wel ervaeren is omme alles aen te teeckenen ende hun proffijt daermede te doen. De resterende acht soldaten connen somtijts naer Pimamba gesonden worden omme ons van 't gepasseerde aldaer te dienen, ende soo noodich sij datter een jongen geleyt wort om de spraecke te leeren, can sulcx van hier geschieden. Ordonerende gem^e. Juriaen wijders aldaer tot onse naerder rescriptie te verblijven, met d'inhabitanten goede correspondentie t'onderhouden alle goede debvoiren in 't leeren der spraecke aen te wenden opdat door perfecte annotitie tot meerder licht geraecken mogen. Blijvende niet te min den ondercoopman Wesselingh in Pimamba gerecommandeert alle goede debvoiren te contribueeren wat dat tot openinge vande Linauwse gelegentheyt gedijen can, [...].

fol. 845: From time to time orders had been given to Junior Merchant Maerten Wesselingh authorizing him to take advantage of the peace concluded with the inhabitants of Pimaba and to settle at the village of Linauw, as can be seen from the instructions given to him on 26th June and 29th July.[55] Wesselingh reported that, no matter how hard he had tried, all his attempts to carry out these orders had failed and he had never succeeded in communicating with them about peace. He blamed the men of Pimamba for this as on three different occasions when he had appeared at the border of the territory of Linauw with them, they had fled out of sheer terror. They did not even dare to await the mentioned men of Linauw, but immediately cleared off, under several false pretences, like they had had bad dreams, or the singing of the birds did not sound right which they read as being a bad omen. As a result we had to return without having accomplished anything.

Consequently the warriors of Pimaba neither complied with our serious request, to send on our behalf a present to the people of Linauw by means of an embassy, nor did they attempt, by exchanging hostages, to start talking to them. (fol. 846) Apparently they were all afraid to take the lead. They also used their ignorance of the language of Linauw as an excuse, saying they would never be able to carry out an assignment. Consequently, during Wesselingh's twenty months stay in Pimaba, nothing has been implemented yet, except that he has mastered the local

language. However, he personally found out that the language of Pimaba differs greatly from the one spoken in Linauw. Yet he had heard from a certain nation situated in the mountains to the west of Pimaba in a village named Backingan, that the people of Kinadauan and Boenoch, maintain friendly ties with northern villages, which (it is said) have concluded peace with the gold-rich peoples. Furthermore, the inhabitants of those northern villages were said to speak the same language as those of Linauw, which seems likely to Wesselingh who is of the opinion that if they are friends they at least should be able to communicate with each other somehow.

In order to extend the Company's boundaries as far as possible on the island, so that we do not have to fear the Dutch Nation will be harmed by the Formosan inhabitants in the slightest way, the Honourable lord Governor-General and the Gentlemen Councillors of the Indies have sent orders that, if possible, we [...] (fol. 847) should try hard to enter into an alliance and peace negotiations with the six gold-rich villages (still unknown to the Company as yet). At least we should try to make contact with the people of Linauw, the principal village of the six we have mentioned, so as to be able to make inquiries about their situation and about what other fruits the land of Formosa produces.

In order to accomplish what possibly can be done we, on the advice of the Commissioner Nicolaas Couckebacker, have decided to send Junior Merchant Maerten Wesselingh again to Pimaba with the aim of acquiring further skills in the language and of maintaining good relations with the inhabitants. He should furthermore see to it that all the deer-, rock goat- and elk-skins are transported over Lonckjouw and delivered safely in Tayouan just as it was satisfactorily done in the past year. Furthermore we order Sergeant Jurriaen Smith who is presently stationed in Pimaba, to set out accompanied by nine stout soldiers as an envoy to the village of Kinadauan or to Boenoch. On our behalf Smith will pay his respects to the chiefs over there and present them with some gifts. He also will have to try and find out if he could learn that language which is similar to the language spoken (fol. 848) in Linauw. We will send a soldier with him who happens to be experienced in writing, so that he can note down the words, to his profit. The remaining eight soldiers can be sent to Pimaba every now and then to account for what is happening there. If it is necessary to station a boy over there to learn the language, then this can

be done from here. We further instruct the mentioned Jurriaen Smith to stay there until he receives further orders, and to maintain good relations with the inhabitants, and to stake everything in learning the language so that, thanks to good note-taking we will gain more insight. Nonetheless Junior Merchant Wesselingh himself will be recommended to do whatever he can to contribute in opening up ties with the Linauw region.

108. Original missive Governor Jan van der Burch to Governor-General Anthonio van Diemen.
Tayouan, 4 November 1639.
VOC 1131, fol. 424-547.[56]
See also FORMOSA UNDER THE DUTCH, **pp. 179-182;** ZENDING, **III, pp. 194-200.**

109. Extract from the report of Commissioner Nicolaas Couckebacker on his mission to Tonking and his visit to Formosa.
On board the *Rijp*, **8 December 1639.**
VOC 1131, fol. 222-315.[57]
See also FORMOSA UNDER THE DUTCH, **pp. 182-183;** ZENDING, **III, pp. 200-203.**

fol. 281: [...] Belangende d'inwoonderen van Formosa, soo Christenen als heydenen zijnde, die haer onder de subjectie ende gehoorsaemheyt van de Hoog Moogende Heeren Staeten Generael hebben begeven, thonen haer behoorlijcke obediëntie ende princepaelijck die van Sinckan, Baclouangh, Soulangh, Mattou, Tavocan, Tevourangh, Tapouliangh ende meer om de noordt gelegene dorpen, gelijck mede de dorpen om de zuyt op de vlacte gelegen. Die van 't hooge geberchte hebben haer eenigen tijt moediger ende stouter (door dien hooch ende in huysen van steen gebout woonen) gelaten, doch siende ende gewaer werdenende de Nederlanders dagelijcx in ende over 't geberchte reysen ende inde dorpen frequenteren, beginnen (zoo men seyt) tammer ende vrunthouder te worden, ende souden eeniche van voors. dorpen soo om de zuydt ende noord van Tayouan gelegen naer dat mij mogelijck is te vernemen geweest ontrent de 24.450 weerbaere mannen uytmaecken connen, ende sijn: Lalongh, Ripos, Lappa Lappa, Backingan, Poenoch. Dit sijn cleyne dorpen benoorden Pimamba op de vlacte gelegen, uyt geseyt Backingan ende cunnen de vijf dorpen 300 weerbare mannen uytleveren.

Moronos, Marangtip, Pinabaton, Tammalackouw, Micabon, Bouer: dit zijn redelijcke dorpen leggende onder aen de voet van 't geberchte op de vlackte dicht bij Pimaba zulcx dat met een halff cartouw van daer connen geschooten werden, zijn bevolcqt met 450 weerbare mannen.

Tarouma, Tawalij, Sappien, Lavabuar, Kienabanlouw, Patciabol: dit zijn groote dorpen, want met den anderen ongevaerlijck 2000 mannen cunnen te velde brengen.

Pimamba: alwaer des ondercoopman Wesselingh zijne residentie plaetse is, zijn aldaer ontrent 800 weerbare mannen.

fol. 282: Kinadouwan, Tollerekan, Boenock, Sabouco, Sayman, Terowatil, Coroloth, Toebinrij, Massisij, Carradalam, Poleij, Dadil, Laboan, Tebuttekedam, Coulalouw, Parriwan, Sageden, Caberokan, Erapissan: deese dorpen leggen in 't hooge geberchte waervan men uyt de sommige 2½ dach moeten reysen eer men op d'vlacte comen can, ende uyt de sommige 1 à 1½ dach na dat het weder sich vertoont. Dese tegensstaende dorpen verclaeren d'inhabitanten dat se met den anderen 10.000 weerbare mannen connen uytmaecken.

Cavadouw, Cabiongauw, Durekduck, Tolckebos, Tollessu, Bongelijt, Poetckenoch, Toccobocubul, Tarracway, Sappide, Borroboras: Dit zijn elff dorpen soo voor in 't geberchte aen de westzijde van Formosa gelegen, waer onder de jongste drie den Lonckjouwer toecomen, ende zijn in dito drie dorpen niet meer als 300 weerbaere mannen, doch d'andere naer dat van d'inhabitanten gerucht wort, souden niet minder als 5000 man uytleveren, t'samen maeckende: 5300.

Doloswack, Backij, Bangsoor, Gattangh, Touresatsa, Tawadas, Matsar, Lupodt: Dese dorpen staen onder jurisdictie van den Lonckjouwsen vorst, de sommige voor in 't geberchte ende eenige op de vlacte, mogen met den anderen ontrent 800 weerbare mannen uytbrengen.

fol. 283: Takaraijan, Pandandel, Galirolurongh, Vorovorangh, Narariangh: Dese dorpen leggen bij suyden Tanckoya sijn bevolckt met weerbaere mannen ontrent: 1450.

Netnee, Sengwen, Tarakeij, Jamick, Keersangan: Deese vijf dorpen worden in 't generael geheeten Dolotocq, leggen almede om de zuyt naer 't geberchte, cunnen te velde brengen 1200 coppen.

Pangsoya, Salomo, Tangenij, Tavoulangh: Dese vier dorpen leggen ontrent twee daghen reysens van Tayouan naer de zuyt, soo aende zeecant als naer 't geberchte, cunnen uytleveren 750 weerbare mannen.

Sinckan, Bacelouangh, Soulangh, Mattouw, Tavakan: Dese dorpen leggen alle noordelijck van Tayouan het verste ontrent een dach reysens, sijn bevolckt met ontrent weerbare 1400 mannen.

Maeckende t'samen 24.450 coppen.

Volgen nu die geene waer aff de seeckere quantiteyt haerder weerbare mannen niet hebben cunnen vernemen, als te weeten: Tapouliangh, Sourioriol, Sotenauw: dit sijn dorpen leggende oostelijck, stijff een dach reysens van Tayouan inde 't laege geberchte.

Sopourareij, Sonavaheij, Sora Karakeij, Valatogan: dese dorpen leggen naerder aen 't geberchte.

Tidikiangh: leyt noch naerder 't geberchte ende bestaet in drie à vier dorpen.

fol. 284: Kaseija: bestaet in acht à tien dorpen ende is van Tidikiangh, een dach reysens dieper in 't geberchte.

Terourangh, Teijnewangh, Sigit: dese drie leggen een groot dach reysens oostelijck van Sinckan ende sulle in één getrocken werden.

Tagobul, Taracwan: dese leggen oostelijck van Tevourangh één à twee dagen reysens dieper in 't geberchte.

Dorcko: sijn twee dorpen tusschen Mattou ende Tirosen.

Tirosen: leyt ½ dach reysens N.O. aen van Dorcko.

Taroukij: is een ½ dach reysens noordelijcker.

Dalivou, Tosavangh, Valaula, Dovaha, Arrissangh: noch soo verre oostelijck van daer onder 't geberchte.

Vouvorolangh, Vasikan, Gilem: dese dorpen leggen westelijck van Dalivou na de zee toe, doch Gilem een weynich hooger, hebben onlangs versocht datter eenich van ons volcq mochte gesonden werden, sijn seer gehoorsaem.

fol. 281: Among the inhabitants of Formosa, Christians as well as heathens, those who have submitted themselves already in allegiance to the High and Mighty Gentlemen of the States General and show considerable obedience are principally those of Sincan, Bacaluan, Soulang, Mattouw, Tavocan, Tevorang, Tapouliang and some other villages situated to the north, as well as the villages situated in the southern part of the western plain. The villages situated in the high mountains have behaved themselves for some time more courageously and audaciously, (because they were dwelling high and dry in their stone houses), but, since they noticed and realized that Dutchmen were travelling up and down the mountains and also frequent the villages, they have become (as said) somewhat 'tamer' and more friendly. As far as I have been able to find out the following villages, situated to the north as well as to the south of Tayouan, can possibly bring about 24,450 able-bodied men into the field.

Lolongh, Ripos, Lappa Lappa, Backingan and Poenoch are small villages situated on the plain to the north of Pimaba, except for Backingan. These five villages can raise 300 able-bodied men.

Moronos, Marangtip, Pinabaton, Tammalaccouw, Nicabon, Bouer are fair-sized villages located on the plain at the foot of the mountains close to Pimaba, at half a cannonshot distance. They are inhabited by 450 able-bodied men.

Tarouma, Tawaly, Sippien, Lavabicar, Kienaboulouw, Batsibal are large villages, because all together they can bring about 2,000 warriors into the field.

Pimaba, where Junior Merchant Wesselingh is residing, houses about 800 able-bodied men.

fol. 282: Kinadauan, Tollerekan, Boenoch, Sabouco, Sayman, Terrowatil, Coroloth, Toebuinrij, Massisij, Caradalan, Poltij, Dadiley, Laboean, Tebutte Kedan, Coulalouw, Parriwan, Sageden, Caberokan, Erapissan: These villages are situated in the high mountains. It takes 2½ days before one can reach the plain from some of these villages, but from some it only takes 1 or 1½ day, according to the weather conditions.

According to the inhabitants these villages represent a strength of some 10,000 able-bodied men.

Cavadouw, Cobiongan, Durckeduck, Tolckebos, Talasuy, Bongelit, Poetckenoch, Taccabul, Tarracway, Sappide, Borboras: These are eleven villages located at Formosa's western side in the promontory. The last three, that are subject to the ruler of Lonckjouw, consist of only 300 able-bodied men. According to the inhabitants the others can bring into the field no less than 5,000 men. All together this amounts to a number of 5,300 men.

Dolaswack, Backij, Bangsoer, Cattangh, Touresatsa, Tarodas, Matsaer, Luypodt: These villages fall within the jurisdiction of the ruler of Lonckjouw. Those are situated in promontories, and some in the plain can bring altogether 800 able-bodied men into the field.

fol. 283: Taccareyang, Pandandangh, Galirolurongh, Vorovorangh, Narariangh: These villages, situated south of Tancoya at the western side of the island, are inhabited by about 1,450 able-bodied men.

Netne, Sengwen, Tarokey, Jamick, Keersangan: These five villages, generally called Dolatock, are also situated in the south close to the mountains and can bring 1,200 men into the field.

Pangsoya, Salomo, Tangenij, Tavoulangh: These four villages situated at about a two day's journey to the south of Tayouan, situated by the sea as well as near the mountains, can raise 750 able-bodied men.

Sincan, Bacaluan, Soulang, Mattouw, Tavakang: These villages all are located within one day's journey to the north of Tayouan and are inhabited by about 1,400 able-bodied men.

Altogether a total of 24,450 men.

Now we continue with the names of those villages of which we have not been able to gather information about the number of able-bodied men:

Tapouliang, Sourioriol, Sotenauw: These are villages situated in the promontory at about a one day's journey eastward of Tayouan.

Sopourareij, Sonavaheij, Sora Karakeij, Valatogan: These villages are located nearer to the mountain range.

Tedackjangh: is situated even closer to the mountains and consists of three or four villages.

fol. 284: Kaseija: consists of eight or ten villages and is subject to Tedackiangh. It is situated at about one day's journey deeper into the mountains.

Tevorangh, Teijnewangh, Sigit: These three places are situated at about a little more than one day's journey to the east of Sincan and will be consolidated into one village.

Tagobul, Taracwan: these are situated to the east of Tevorangh at about a one or two day's journey further into the mountains.

Dorko: consists of two villages between Mattouw and Tirosen.

Tirosen: is situated at a half day's journey northeast of Dorko.

Tarokey: is located at a half day's journey further to the north.

Dalivo, Tosavangh, Valaula, Devoha, Arrissangh: the same distance as above to the east, at the foot of the mountains.

Vavorolangh, Vassican, Gielim: these villages are situated to the west of Dalivo towards the sea, but Gielim is somewhat more elevated. They behave obediently; recently they requested if some Company men can be sent to be stationed over there.[58]

110. Dagregister Zeelandia, 16 December 1639.
Collectie Sweers 7, fol. 42. Summary.
DRZ, **I, pp. 488-489.**

*(On 16 December Sergeant Jurriaen Smith left Tayouan for Pimaba with
ten soldiers and special orders for Wesselingh. He was sent with a small
force, reinforced by volunteers from Pimaba as well as from its
subordinated village Moronos, to Palangh (a village which belongs to the
Linauw region) with the purpose of inviting those people to conclude
peace with Pimaba, through mediation of those of Moronos who happen
to speak more or less the same language as those of Palangh.)*

1640

111. Missive Governor Joan van der Burch to Governor-General Anthonio van Diemen.
Tayouan, 28 January 1640.
VOC 1133, fol. 177-198. Extract.

fol. 177: [...] Bequamen schrijvens uyt Wancan van den vendrich Thomas Pedel daerbij verstonden hoe die van Davolee, een dorp ontrent 15 mijlen van Vavorolangh gelegen, de Chinese jagers uyt de Vavorolansche velden gejaecht, tien chiampans in de gront gehauwen, ende twee derselver dootgeslagen hadde. Welcke moetwilliche oppositie wel gewenscht hadde promptelijck met een aansienlijcke crijschmacht sulcx te straffen dat het andere tot een exempel gedient soude hebben. Dan vermits de [...] retour schepen daernaer niet conde ophouden is 't selve tot naerder gelegentheyt in stato gebleven. Onderwijlen vonden goet tot stuttinge desselfs actie den capitain Jan Juriaensz met twintig soldaten naer Vavorolangh te senden, met ordre de outsten te waerschouwen dat haer niet alleenlijck onder die van Davolee en comen te vermengen maer oock trachten uytter velden te helpen, aengesien in macht bij die van Vavorolangh niet te vergelijken zij, off dat andersints daerinne zullen versien. Doch is bevonden de Vavorolangers onschuldich te zijn ende haer onvermogen verclaert hebbende, is soodaniche wrevelmoediche actie op reeckeninge van die van Dovalee gebracht, in meeninge t'zijner tijt de straffe te laten gevoelen. Doch beginnen 't hooft in 't schoot te leggen, ende seggende door de Chinesen abusijvelijck daertoe verleyt te zijn. Sulcx dat de saecke bij d'outste van Vavorolangh zal worden gedirigeert, dat eerstdaechs twee derselver bevelhebberen van Davolee ons zullen toecomen om desselfs gecommitteerde faulte met die gevougelijckste middelen te beslechten. [...].

fol. 177: [...] We received a letter from Wancan from ensign Thomas Pedel, from which we learned that the inhabitants of Davolee, a village situated at about a 15 miles distance from Vavorolangh, had chased away Chinese huntsmen from the Vavorolangian fields, beaten two of them to death, and destroyed ten sampans. We had preferred to punish this wilful revolt immediately with a considerable expedition force to teach them a lesson. Yet since we could not delay the ships bound for Batavia any

longer, we had to postpone that action. In the meantime we decided, to prevent things in that area going from bad to worse, to send captain Jan Jurriaensz with twenty soldiers to Vavorolangh. He was ordered to warn the chiefs of Vavorolangh not only to mess around with Davolee but to try to chase them out of their fields. Which should not be too great a problem for them as the force of Davolee can hardly measure up to that of Vavorolangh. However, it has become clear that the Vavorolangians have convincingly proven their innocence on this occasion; the mentioned vindictive action can solely be attributed to Dovalee. Therefore we agree that they will receive their just punishment in due time. However they already started to knuckle under, indicating that they had been seduced by the Chinese into committing that serious error. Consequently this case will be left to the elders of Vavorolangh, who will see to it that soon two of the chiefs of Davolee will come to us to make up for the mistakes as we shall see fit. [...].

112. Missive President Paulus Traudenius to Governor-General Anthonio van Diemen.
Tayouan, 20 March 1640.
VOC 1133, fol. 147-162. Extract.
FORMOSA UNDER THE DUTCH, p. 184; ZENDING, III, pp. 204-205; DRZ, I p. 495.

fol. 150: [...] Wat aengaet den stant der inhabitanten hier te lande, staet (Gode sij loff) noch als vooren in goede forme, connen niet anders bespeuren ofte bethoonen haer te wesen gehoorsaeme subjecten van den Nederlantschen staet, eenlijck die van Dovalee daer d'Ed. Heer gouverneur saliger in sijne missive van dato 28 Januarij passato van geschreven heeft, dat haer vrij wat insolent mettet dootslaen van twee Chinesen ende 't jagen van eenige andere uyt de Vavorolangsche velden hadden aengestelt. Welcker voorseyde Dovaleers doenmaels in meeninge bleven (soo ons die in Vavororlangh) door haere outsten uyt te wercken versekerden hun herwaerts om haere faulten te beslechten souden hebben getransporteert, dan sijn tot noch toe niet verschenen. Ondertusschen laten oock niet naer, noch somwijlen haeren wrevelmoedichen aert in 't slaen ende wechjaegen der Chinesen jagers uyt de Vavorolangsche velden te toonen, 't welck (fol. 151) in dese conjecture vermits d'onvermogentheyt van eenige macht te connen uytmaken, alsoo met conniventie moeten

voorbij laten gaen, tot dat de sake geboren sal sijn om haerer misdaet naer merite in aenstaende te straffen.

Comende dan vorders tot de gelegentheyt van Pimaba ende Linau, mitsgaders d'apparentie om tot de gewenschte goutmynerale te geraken, soo sullen U Ed. dienen hoe dat op 16e December passato d'Ed. Heer Van der Burch saliger den ondercoopman Wesselingh per missive hadden geordonneert seker dorp genaemt Palangh dat sijne Ed. was aengedient, te wesen nuyterale vrunden met die van Linau, ende kennende haere taele, den vrede aen te bieden. Edoch gemerct, ondervont d'Ed. Heer gouverneur saliger sulcx abusivelijck door den sergeant was aengedient, ende dienvolgende die van Pimaba als d'ander omleggende dorpen verclaerden de Palangers niet één woord soude connen vertaelen, oversulcx niet genegen derwaerts te gaen (als U Ed. bij ons dagregister breder gelieft te beoogen). [Wesselingh] heeft sulcx niet connen effectueren, maer is met een aensienlijcken macht van Pimabaers als d'andere omleggende inhabitantten nevens 12 soldaten om haer voor te gaen, naer Linauw verreyscht in meeninge omme t'onderstaen off met de gevouchelijkste middelen tot minnelijck accoort met deselver conde comen. Dan ontrent haer dorp verschijnende rescontreerden een groot deel derselver Linauwers aenwien hij Wesselingh met sijn geweer neder te leggen, als andere vrundelijcke actiën te bethoonen dese sake in 't werck stelden, doch greep bij deesen brutale menschen geen plaets, maer wierpen met stenen ende sloegen (onder reverentie gesproken) op haer achterste pertijen, invoegen tot geen gehoor te bewegen waeren. Welcken volgende, gem.e Wesselingh staende dese affronten hem niet te lijden, met de Pimabaers haer vijantlijck heeft aengetast, 't welck soo courageuselijck gesuccedeert is, dat tusschen de 400 à 500 hoofden en de negen gevangens, soo vrouwen als kinders, van de geseyde Linauwers hebben becomen. Hebbende dese victorie, waervoor den Almoogenden gelooft sij, in de oogen der omleggende dorpen onuytsprekelijck groot geweest naer voorschr. Wesselinghs verclaringe, als U Ed. bij seecker vertoogh door hem aen d'Heer gouverneur saliger gedaen hier nevens in copia gaende gelieve te beoogen.

Gem.e Wesselingh blijft in gevoelen men door dese gevangens vrouwen ende kinderen met goet tractement aen deselver te doen, ende haere taele te leeren, sal connen uytwercken, om door cleene middelen tot het effect van deser langh verhoopte sake te comen. [...].

fol. 152: Ontrent 14 maes swaerter gout dat op den touts 18 à 21 carraet haelt, ende bij desen hier nevens gaet, heeft voorseyden Wesselingh op sijn aencomste dato 3 February passado alhier aengebracht, dat door den

Pimabaers in den jongsten tocht vande Linauwers ter buyte becomen was, met verclaringe geroerde Linauwers grote platgeslagen stucken gouts om haeren hals op de borst ende de armen dragen, invougen daer uyt te concluderen staet wel eeniche quantiteyt aldaer te becomen sal sijn, doch de seeckerheyt hiervan wil ons den tijt leeren. [...]

Den 10e stantij is voors. Wesselingh bij den Raet wederom derwaerts afgevaerdigt met mondelinge orders van den Ed. Heer gouverneur saliger bij alle doenelijcke debvoiren te trachten om de gevangene Linauwsche vrouwen haere tale te leeren ende onderstaen, doch in alle schijn off daer geen werck van maecten maer alleen discours wijse, in wat vougen 't gout bij haer gevonden wort ende soodanigen quantiteyt; mitsgaders off men niet minnelijck verdrach in plaetse van de waepenen te gebruycken dese luyden tot onser devotie ende alliantie soude connen trecken. 't Welck vernomen hebben dat dan bij gelegentheyt 't selve promptelijck per een expresse dit soude laten weten, omme naerder daerop te resolveren, ende eene instructie waernaer sich soude hebben te reguleeren [...].

fol. 150: [...] As far as relations with the inhabitants are concerned, praise the Lord, everything is still well and we can notice that they show themselves obedient servants to the Dutch State. Only those of Dovalee, about whom His Honour the late governor has written you in his missive of 28 January, have behaved insolently by beating to death two Chinese and chasing away others from the Vavorolangian hunting fields. According to those of Vavorolangh some of the Davolee headmen would be sent over to us in Tayouan to account for the committed mistakes, but so far they have not yet appeared. In the meantime they continue their spiteful behavior by beating and chasing off Chinese hunters from the fields of Vavorolangh. (fol. 151) Because under the present circumstances we are unable to mobilize some troops we have to turn a blind eye until the time is right to punish the culprits for their crimes.

Broaching the subject of Pimaba and Linauw, and the likelihood that we may lay our hands on the desired gold, we inform Your Honour that on 16 December the late Governor Van der Burch ordered Junior Merchant Wesselingh to go to a certain village named Palangh to conclude peace with them, because His Honour had been told that those villagers were neutral friends of the people of Linauw and also could speak their language. However it became clear to His Honour that this information had been erroneously reported by the sergeant, because the people of Pimaba and its surrounding villages explained that those of Palangh would

not be able to translate one single word into the Linauw language and they therefore were not inclined to go there (for further details please refer to our journal.[59]When as a result that plan was not effectuated, Wesselingh went to Linauw instead with a considerable force of Pimaba men, and allies of the neighbouring villages as well as twelve Company soldiers in order to lead them, with the intention of reaching an agreement with them by peaceful means. When they appeared in front of Linauw and came upon a crowd of villagers, Wesselingh, by putting his weapons down on the ground and making other friendly gestures, indicated that he came with peaceful intentions. However this fell on deaf ears to those savage people who started throwing stones and (if you will forgive me for saying) displayed their behinds while making beating gestures, so that they were not willing to listen. Not willing to suffer this affront Wesselingh together with his Pimaba braves so courageously charged the enemy that he was able to take about four- or five hundred heads and nine captives (women as well as children) of the mentioned Linauw people. According to Wesselingh's account addressed to the late governor, which Your Honour can read for yourself as we are sending you a copy, this victory, God Almighty be praised, has made an incredibly profound impact on the inhabitants of the surrounding villages. Wesselingh remains of the opinion that by treating the captured women and children well, and learning their language he may be able to reach our aims step by step. [...]

fol. 152: About 14 mas of gold which on the balance weighed 18 or 21 carats will be sent to you together with this missive. Wesselingh has delivered that gold sample to us, upon his arrival in Tayouan on 3 February last. The people from Pimaba had captured it from Linauw during their last raid on that village. He explained that the mentioned villagers of Linauw wear large flat beaten pieces of gold on their chests and around their arms, from which it can be concluded that at least some quantity of gold can be found there, but time will tell if this is indeed so.

The 10th of this month Wesselingh again was sent out by the Council with a verbal instruction from the Honourable late governor to exert all his strength to try to learn the Linauw language from the imprisoned women and to make inquiries, talking seemingly as if he was not really interested, how and in what quantities gold is found among them and if it would not be possible to somehow make their people our devoted allies

instead of having to use violence. It had been agreed with him that, as soon as he finds out more, he would inform us immediately by express messenger, so that we could draw up a resolution and send him instructions on how he should proceed in this matter. [...].

113. Missive Governor-General Anthonio van Diemen to President Paulus Traudenius.
Batavia, 13 June 1640.
VOC 1134, fol. 329-372. Extracts.

fol. 362: [...] Seer gaerne hebben gelesen den goeden toestandt, ende accressement van onse onderdanen d'inhabitanten op Formosa, 't is vreughdigh dat soo goede progresse in 't aennemen van 't Christengeloove gedaen worden. Dominee Junius heeft veel debvoiren daer te lande en wenschten tot continuatie resolveren conde, daer echter niet in geforceert can worden, dewijle sijnen (fol. 363) verbonden tijt geëxpireert is. Verhopen nae desen middel te becomen om een bequaem predicant derwaerts te schicken, Markinius ende andere dienen nae merite getracteert, ende aengehouden, mitsgaders daerentegen die geen lust hebben haer inde tale te oeffenen, herwaerts gesonden, want van de sulcke geen dienst getrocken can worden [...].

Vervolgende de comportementen der inwoonders, sien die van Dovola hun te buyten gaen, daerin continuerende dienen gestraft, ende dat aensienelijck, soo haest die macht 't selve sal lijden. 't Ongeval 't welck d'insolente Linauwers aengetroffen, ende dat ontrent 4 à 500 hooffden verloren hebben, is smartelijck, edoch maeckt onse groote reputatie. God geve door de becomene gevangene acces tot de goudtmijne, nu soo lange nagespeurt, becomen mogen. Gestadigh moet daernae getracht worden, waertoe den persoon van Marten Wesselingh een seer bequaem instrument is, ende aengehouden dient, [...] blijve dese saecke te voorderen ten hooghsten bevolen. De 14 maes swaerte gout van Paccan hebben doen smelten, ende hout daar een 18 caraet, in Batavia waerdigh 11 realen silver, den reael gout, wenschten 14 picols van dat gout becomen moghten, [...]

't is niet apparent desen jare extraordinarie macht nae Tayouan (fol. 364) sullen schicken tot straffe van de rebelsuchtige, als om vordere extentie te doen ende den Spaengaert van dat lant te jagen. [...]

fol. 366 [...] Wij connen niet bedencken de Comp.ᵉ van de resterende veertig overgebleven brutale menschen op Lamey, den minsten dienst toe

te comen staet maer wel t'sijnder tijt bij multiplicatie swarigheyt. Weshalven onder dien off d'ander gevoeglijcke pretext, off des niet wesen willende, per force deselve lichten ende nae Batavia senden sult. [...].

fol. 362: [...] With great pleasure we read about the good relations with, and the increase of, our Formosan subjects. It is also very good to see the progression of the propagation of the Gospel and their conversion to the Christian faith. Reverend Junius has many duties to fulfill so it would be desirable if he could decide to extend his service. However, because his contract (fol. 363) has expired we can not force him to stay on. We do hope we can soon find a way to send another capable minister there. Markinius and the others ought to be paid according to their merits and, if possible, kept in the Company's service, but those who show no pleasure in learning the local languages, should be sent elsewhere, as they are of no use. [...].

Coming to the behaviour of the inhabitants, we see that those of Davolee transgressed the limit. If they continue to do this they should be severely punished as soon as we have sufficient soldiers to carry it out. The adversity the insolent Linauw people met with, and the fact that they lost about four or five hundred heads, is very unfortunate, yet it contributes to the Company's great reputation. God willing, we will eventually gain access to the long-searched for gold sites. The exploration should be continued steadily. Maerten Wesselingh's service definitely needs to be extended, as he happens to be quite a capable instrument in this matter. It is a case of the utmost priority. The sample of 14 mas Formosan gold was melted into a nugget of 18 carat which in Batavia was valued at 11 silver reals for one real of gold. We wish we could receive another 14 piculs of that Formosan gold. [...]

It is unlikely that we shall be able to send this year an extraordinary force to Tayouan (fol. 364) to punish the rebellious inhabitants as well as to enlarge the Company's territory and drive the Spaniards off the island. [...]

fol. 366 [...] We do not think that the Company will derive any benefit from the remaining forty savage people on Lamey. On the contrary, in time, once they have multiplied again, new troubles can be expected. Therefore under some kind of proper pretext or, if that is impossible, you should evacuate 'per force' and send them over to Batavia. [...].

114. Extracts from the Dagregister Zeelandia, concerning Lamey.
VOC 1170, fol. 622.[60] Extract 8 August 1640.

> fol. 622: Op dato is bij den raedt geresolveert den sergeant Jan Barentsen met 13 à 14 soldaten naer Lamey te senden om aldaer voor eenigen tijt te remoreren, en die inwoonders haer doen te vernemen om in 't eerste van 't Noordermousson de resterende inwoonderen volgens d'ordre van d'Ed. heer Generael daervan te lichten.

fol. 622: On this date the Council resolved to send Sergeant Jan Barentsen together with 13 or 14 soldiers to Lamey to stay there for a while and find out about the whereabouts of the inhabitants so that he can remove the remaining islanders from Lamey by the next northern monsoon, on order of the Governor-General.

115. Extracts from the Dagregister Zeelandia, concerning Lamey.
VOC 1170, fol. 622. Extract 30 August 1640.

> fol. 622: 30en dito. Vertreckt van hier naer 't Goude Leeuws eylandt per een jonckjen ende 11 Nederlanders den sergeant Jan Barentsz met instructie [...] de vervallen pagger te herstellen [...] ende daertoe de assistentie van die inwoonders aldaer remorerende versoecken, sal ten eynde hunne gelegentheyt aff sien hunne cultiveringh voorcoomen ende dat eylandt t'zijner tijt zuyveren moogen [...].

fol. 622: On the 30th ditto, 11 Dutchmen and Sergeant Jan Barentsz depart in a little junk to the Golden Lion Island with instructions to repair the dilapidated stockade. For that purpose they should ask the inhabitants for assistance who, by involving them in this work, could be drawn away from their own interests and in this way further cultivation of their lands can be averted so that when the time has come the island can be cleared easily. [...]

116. Extracts taken from the Zeelandia Castle Resolution-books, concerning the resolutions on the island of Lamey.
VOC 1170, fol. 596. Extract 9 October 1640.

fol. 596: 9 October. Mede door zijn Ed. vertoont hoe d'Ed. heer Generael bij missive van den 13^{en} Junij sij schrijvende dat niet verstaen de Comp. van de resterende veertig Lameyers den minsten dienst maer ter contrarie bij multiplicatie wel swaricheyt toe te comen staet, dienvolgende haere achtbaerheden 't selve in consideratie gegeven wesende ende dat achtervolgende resolutie vanden 8^{en} Augustij passado om desselfs doen te vernemen den sergeant Jan Barentsen derwaerts met 13 à 14 soldaten gesonden zij doch tot noch geen tijdinge becomen hebben.

fol. 596: 9 October. His Honour has explained to the Council that the Honourable lord Governor-General wrote, in his missive of 13 June, that he is not at all convinced that the Company will derive any benefit from the remaining forty Lameyans, but on the contrary that their multiplication only will lead to future troubles. Therefore the councillors, after considering this matter, had decided to, by the resolution of 8 August last, to send Sergeant Jan Barentsen to Lamey with 13 or 14 soldiers to size up the situation there, but we have not yet received any news.

117. Extracts from the Dagregister Zeelandia, concerning Lamey.
VOC 1170, fol. 622-623. Extract 23 October 1640.

fol. 622: het Comp.^s jonckjen met den sergeant Marten Mayer meede brengende een missive van den ondercoopman Marten Wesselingh dicterende in substantie dat soodra aen Lamey gecoomen den sergeant Jan Barentsen aldaer remorerende zijne Ed. missive overhandicht, ende de mondelinge gerecommandeerde ordre gecommuniceert hebbende, in tegendeel vande selven verstaen hadde de Lameyers met een troupe van zeventig soldaten genoegsaem in handen souden te becoomen wesen, alsoo daer 17 huysgesinnen waeren, hebbende ider huys twee deuren die op 't onversienste beseth mosten worden doch moste noch (fol. 623) twee maenden daermede gewacht worden, als wanneer door de coude in hunne wooningen blijven slaepen. [...].

fol. 622: On 23 October, Sergeant Marten Mayer arrived here with the Company's junk delivering a missive from Junior Merchant Maerten Wesselingh who tells us in essence that as soon as he had landed in Lamey he had delivered His Honour's missive to Sergeant Jan Barentsen who is staying there. After Mayer had communicated Barentsen the orders which had been commended to him orally, he learned on the contrary that with a contingent of seventy soldiers the remaining Lameyans could easily be obtained, because there were only 17 families. All of their houses have two doors that can be secured by surprise but according to Barentsen (fol. 623) that should be postponed for another two months when due to the chill weather the Lameyans will be sleeping indoors [again].

118. Missive Reverend Robertus Junius to Governor-General Anthonio van Diemen.
Tayouan, 23 October 1640.
VOC 1134, fol. 112-115.
FORMOSA UNDER THE DUTCH, pp. 184-188; ZENDING, III, pp. 206-213.

119. Original Missive Governor Paulus Traudenius and the Formosa Council to the Amsterdam Chamber.
Tayouan, 5 November 1640.
VOC 1136, fol. 961-962.
DRB 1640-1641, 6 December 1640, pp. 113-116.

120. Extracts taken from the Zeelandia Castle Resolution-books, concerning the resolutions on the island of Lamey. 30 November and 20 December 1640.
VOC 1170, fol. 596-597. Extracts.

> fol. 596: 30 November [...], item voornemens bleven achtervolgende d'ordre van d'Ed. heer Gouverneur-Generael medio december aenstaende de resterende Lameyers van 't Goude Leeuws Eylant te lichten, de welcke alweder tot de 60 personen stercq geworden, ende een redelijcke macht omme deselve gevoechlijck in handen te crijgen van noode zal zijn [...].
> fol. 597: 20 December, [...] d'Ed. gouverneur draegt den raedt voor dat den tijt omme de inwoonders van 't Eylant Lamey te lichten volgens 't schrijven van den sergeant Jan Barentsen, op dat eylandt met eenige

soldaeten garnisoen houdende verschenen ende de volle maene, waerbij 't selve gevoechlijck geschieden can, op handen is. Soo hebben eendrachtelijck verstaen 't selve tegen maendach aenstaende onder den manhaften capiteyn Jan van Linga de welcke van de gelegentheyt vermits voor desen tot suyveringe van dien dat eylandt bekent, ende gefrequenteert met zestig coppen te laten effectueren. [...].

fol. 596: 30 November. [...] On the orders of the Honourable lord Governor-General, we also intend to carry out in the middle of the next month of December the deportation of the remaining people of the Golden Lion Island, who again have increased to some sixty persons. To that purpose a reasonable force is required so as to be able to properly get hold of them.

fol. 597: 20 December. The Honourable Governor presents the Council with the news that, according to the writing of Sergeant Jan Barentsen, the time had come to deport the inhabitants of Lamey and that the full moon, when this could happen best, is at hand. So it was resolved unanimously that next Monday the stout captain Jan van Linga, who visited the island before and is acquainted with the local circumstances because he commanded the former assault and mopping-up operation, will execute that duty together with sixty men.

121. Extracts from the Dagregister Zeelandia, concerning Lamey. 27 December 1640.
VOC 1170, fol. 623. Extract.

fol. 623: [...] vertreckt van hier met twee joncquen ende zestig Nederlantse soldaten achtervolgen de resolutie van den 20en stantij naer 't eylandt Lamey den capp.tn Johan van Linga omme d'inwoonderen volgens d'ordre van d'Ed. heer Gouverneur-Generael ende raden van India van dat eylandt te lichten.

fol. 623: According to the resolution taken on the 20th of this month captain Johan Jurriaensz and sixty Dutch soldiers set sail to Lamey in two junks, to deport the inhabitants of the island, on the orders of the Honourable lord Governor-General and Council of the Indies.

1641

122. Original missive Governor Paulus Traudenius and the Formosa Council to Governor-General Anthonio van Diemen.
Tayouan, 10 January 1641.
VOC 1134, fol. 103-111. Extract.
See also DRB 1640-1641, pp. 175-176.

fol. 105: [...] Soo als op 20^{en} December passato bij ons geresolveert was den capiteyn Johan van Linga met 60 coppen naer 't eylandt Lamey tot becominge ende suyveringe der resterende inwoonderen te seynden, soo hebben 't selve op 27^{en} daer aenvolgende met twee joncquen effect laeten sorteeren, den 2^{en} stantij retourneert alhier over landt wederom voorn. cappiteyn Van Linga, rapporteerende hoe medebrengende was 38 Lameyse inwoonderen, te weten acht mans, 13 vrouwen ende tien jongens ende zes meysgiëns die met de joncque op dato voorschr. binnengaets verscheenen, welcke inwoonderen bij nacht beset, ende in sijn gewelt becomen hadde. In 't begin van 't beset sijn drie dooden (vermits vluchtende wierden, gelijck alle trachteden te doen), blijven leggen, ende noch twintig in 't bosch wech geraeckt, die meest in vrouwen ende kinderen bestaen. Omme dan deselve mede in handen te becomen, soo heeft den cappiteyn aldaer bij den sergeant Jan Barentsz 16 mannen laeten verblijven, mitsgaders een vrouwe die haer dochterken in de furie op 't aengrijpen van 't volck miste, ende seer schreyende was, dit is gedaen op hoope dat de veltvluchtige bij d'onse, ende vervolgens uyt hun selven bij hunne mackers naer Tayouan comen souden. Sijn der Godt loff, daerin soodanich uytgevallen dat gem. Van Linga, over sijne betoonde vigilantie, ons goet genougen ende insonderheyt d'Ed. Compagnie soo getrouwe goeden dienst gepresteert heeft.

Aengaende de besendingge onder den ondercoopman Marten Wesselingh met de 15 soldaten van Pimaba naer de Goutrijcke dorpen, hebben 't zedert sijn vertreck noch geen tijdinge vernoomen; willen vertrouwen ende Godt Almachtich bidden, 't selve ten besten uytvallen laeten, [...].

fol. 105: [...] On 20 December last year the Council resolved to send captain Johan van Linga with sixty men to Lamey to clear the island of its remaining inhabitants. This was carried out on the 27th with the use of two junks. Captain Van Linga returned on the 2nd of this month overland,

reporting that he had managed to run in 38 inhabitants from Lamey, namely: eight men, 13 women, ten boys and six girls. They all arrived later that day on the junk. They had been rounded up and taken by force at night. When the occupation started, three people got killed (while they tried to escape as most of them attempted to do) and another twenty people, being mostly women and children, managed to run off into the bush. In order to get hold of them still, the captain ordered Sergeant Jan Barentsz to remain behind with 16 men. One woman from the island, who was crying her heart out because she had lost her little daughter in the midst of the fury that followed the rounding up of the people was left behind as well, with the intention that she can convince the runaways to surrender themselves to willingly join their fellow islanders in Tayouan. Praise the Lord, everything turned out so successfully and Van Linga has shown himself to be a vigilant and faithful man who, much to our pleasure, has served the Company so faithfully and well.

As far as the journey of Junior Merchant Maerten Wesselingh with 15 soldiers to Pimaba and the 'goldrich villages' is concerned, since his departure we have not received any message from him yet. We pray to God Almighty, that it will turn out for the best, [...].

123. Missive Governor Paulus Traudenius to Governor-General Anthonio van Diemen.
Tayouan, 22 January 1641.
See also DRB 1640-1641, pp. 248-249; DRZ, II, p. 4.

(Junior Merchant Wesselingh had returned from his last journey to the 'goldrich villages' with a few more samples of gold. This time he was treated everywhere in a friendly way by the aboriginal people.)

124. Extracts from the Dagregister Zeelandia, concerning Lamey.
VOC 1170, fol. 624. Extracts 1, 10 and 23 February 1641

fol. 624: Primo februarij, [...] is mede geresolveert den vendrich Marten Meyer op Lamey daer mede aen te schrijven dat ingevalle de gevluchte ende aldaer verblevene Lameyers in der minne op zijne vrundelijcke insinuatie niet verschijnen ende resolveren in Tayouan hun residentie te nemen, dat zich met de gevoechelijckste middel met assistentie van de Pangsoyers achtervolgens d'ordre van de Ed. heer Gouverneur-Generael,

't zij met wil ofte onwil, doot ofte leven, de selve zal soecken in handen te crijgen, herwaerts te brengen ende dat eylandt geheel van die natie te suyveren.

10en dito, Comt alhier wederom binnen 't Canael van Lamey ten ancker des Comp. jonck *Tamsuy* mede brengende een briefken van den coopman Marten Wesselingh dickterende in substantie hoe dat op 2en deses in Dolaswacq wel aengecomen, den regent uyt den name van d'Ed. heer gouverneur begroet ende denzelven aengedient hadde zijnde niet wel tevreeden onse bondgenooten soo mishandelde en 't schiedtgeweer vande Quinamsche joncque in handen houwende was, het welcke eyndelijck naer weynich sporrelinghe den voors. Wesselingh ter hant gestelt ende met voors. joncque in Tayouan gecoomen is. [...]

23en dito, des avonts laet comt alhier het Comp.s jonkjen met den sergeant Jan Barentsen van Lamey hebbende achtervolgende onse ordre (op den 15en passato hem aengeseyt) de huysinge aldaer zijnde gedemolieert, 't garnisoen gelicht ende herwaerts gebracht. [...].

fol. 624: On the first of February 1641 [...] it was also decided to write to ensign Marten Meyer on Lamey that in case the runaway Lameyans, even after trying to convince them to come over to us in the most friendly way, do not appear or decide to come and take up their residence in Tayouan, he should employ every possible means, if necessary with the help of the Pangsoyans, to seize them nolens volens, dead or alive so as to comply with the order of the lord Governor-General to bring them hither so that once and for all the entire island will be cleared of that nation.

The 10th ditto. The Company junk *Tamsuy* anchors here in the Canal coming from Lamey and bringing us a note from Merchant Maerten Wesselingh reporting to us that on the 2nd of this month he had arrived safely in Dolaswacq, where he had greeted the regent of that village in name of the lord governor and also had made clear to him that he was not happy with the way in which the people from Dolatock had molested the Companys' allies, especially the fact that they kept the guns of a junk from Quinam, which finally were handed over to Wesselingh and transported by him to Tayouan.

The 23th February. Late in the evening the Company's junk with Sergeant Jan Barentsen on board comes here from Lamey. According to the orders we have given him on the 15th, he has demolished the buildings and left with the garrison.

125. Missive Governor Paulus Traudenius to Governor-General Anthonio van Diemen.
Tayouan, 17 March 1641.
DRB 1640-1641, pp. 264-268; DRZ, II, pp. 4-6.

(Junius, upon his request, had gone on leave to Batavia. He personally reported to Governor-General Anthonio van Diemen that there were about 4000 to 5000 converts among the Formosans. Maerten Wesselingh 'the adventurer' had again made a journey to the renowned gold villages. He had found the two Company-soldiers left behind in Daracop to be in good health. Although they had been treated well, the inhabitants had been rather curious about the true reason for their long-term stay. A woman who had been sent along to act as interpreter had told everyone that they were only after gold and other riches. Thereupon the chief of Daracop had asked all his subjects to contribute something so that soldier Adriaen Watermondt had received three baskets filled with deerskins, beads, shells, etc. as well as two headbands and three thin plates of gold. Although he had refused to accept the gifts, he had left the baskets hanging under the roof of the chief's house until Wesselingh's return. Upon his arrival, Wesselingh had reprimanded the villagers and explained to them that the Company wanted nothing but their friendship and that they should submit themselves and their lands to the Dutch State. By means of a symbolic confirmation he only requested each village to present two baskets in which a small coconut and a pinang tree were planted. When his wish was granted by the villagers, he accepted the baskets on the condition that they would behave themselves loyally. They, in their turn, could from now on count on the Company's protection. In return he presented the headmen with some gifts like textiles, beads and needles, for which they gratefully thanked him.)

126. Extract from the dagregister Tayouan, about the first 'Land Day' held on Formosa.
Tayouan, 11 April 1641.
VOC 1170, fol. 638-639. Summary.
DRZ, II, pp. 1-3.

(On 11 April 1641 a 'Land Day' or assembly was held in Saccam. Twenty-two headmen and elders appeared from the six villages situated to the north of Tayouan: Sincan, Tavocan, Bacaluan, Soulang, Mattouw and Tevorang; another twenty headmen appeared from the eight villages situated to the south: Pangsoya (which actually consisted of six villages) Taccareyang, Sorriau, Netne, Verovorongh, Pandandangh, Tapouliangh and Cattia.)[61]

127. Missive Governor-General Anthonio van Diemen to Governor Paulus Traudenius.
Batavia, 26 June 1641.
VOC 865, fol. 196-221. Summary.

(Anthonio van Diemen wrote that he had learned from the letters as well as from what was reported to him orally by Reverend Junius, about the good and loyal conduct of the indigenous peoples of Formosa, and the progress of Christianity among them. [...]
He also understood that those of Davolee and their associates continued to behave offensively and rancorously and therefore agreed that: 'notwithstanding that at the moment they seem to keep themselves quiet, their offences need to be corrected as a warning for others'. Their punishment was postponed because the Company on Formosa could not dispose of a sufficient military force. [...] He furthermore reported that 35 Lameyans, men, women as well as children had arrived in Batavia. He was very pleased about this and hoped that the Chinese on Lamey would manage to seize the remaining islanders, who in due time should also be sent to Batavia.)

128. Missive Reverend Robertus Junius to Governor-General Anthonio van Diemen.
Tayouan, 21 October 1641.
VOC 1140, fol. 210-213. Extracts.

(Reverend Junius had paid a visit to Batavia. After leaving the city, on 15 May he returned in Tayouan on 21 July. In a letter to Governor-General Van Diemen he revealed his intentions concerning his work on the propagation of the Gospel in Soulang:)

fol. 210: [...] voorneemens sijnde soo haest het exploict dat eerstdaegs op Davola aengelegt zal worden volbracht, is met mijn gantse familia op te breecken ende mij in Soulangh (dat het grootste ende volckrijckste dorp is) te transporteren [...].

Niet tegenstaende alhier mijne huyshoudinge was, hebbe daerom niet naergelaeten den dienst des Heeren in onse dorpen (excepto Mattou ende Tevorangh, daer de groote affwaeteringe in haere revieren, ons niet toelieten te comen) weeckelijcx waer te nemen. Sijnde 't seedert mijn arrivement alhier niet alleen veele soo bejaerde op de belijdenisse haeres gelooffs als jonge kinderen, door den christelijcke doop, Christij gemeynte ingelijft, verscheydene (om het lichtveerdich verlaeten van mans ende vrouwen, dat hier veele geschiet te revenieeren) in den houwelijckse staet naer Christij instellinge inde volle vergaederinge bevesticht maer oock die in verschillen ende querellen gevallen waren, geapaiseert ende wederomme vereenicht.

Alsoo omtrent haere dooden (die in haere huysen te begraven gewoon waeren) noch verscheyden heydense superstitiën onderhielden, hebbe alle doenelijck devoir aengeleyt om van haer te vercrijgen, dat op een publijcke plaetse omtrent onse kercke (gelijck in onse landen de gewoonte is) begraven mochten werden, dat die van Xincan hebben toegestaen (sijnde een groote plaetse daer toe bequaem gemaeckt omtrent onse kercke, daer al eenige begraven sijn) ende eerlange hoope in de andere dorpen aengenoomen sal werden, daermede veele heydensche opiniën ende costuymen sullen verdwijnen.

Den Sabbath wort in alle onse dorpen alsnoch seer solemneelijck geviert, verscheynen des Sondachs in een groot getal. Drie ende somtijts viermael, sal weeckelijcx in haere taele gepredickt connen worden, sijnde nu alhier twee proponenten in haere taele soo verre geverseert. Verhoope selve (soo mijne crachten het willen toelaeten) des Sondaegs dienst te doen, voor den

middach in Soulangh, ende na de middach in Mattouw (sijnde twee dorpen niet verre van den anderen gelegen) soodat maer in twee plaetsen te weten in Tavocan ende Tivurangh des Sondaegs het woort Godts voorgelesen sal worden.

De schoolen gaen oock noch onverhindert voort. Veele sijn der die tamelijck lesen, ende eenige die redelijck schrijven connen, worden alsnoch (gelijck voordesen) tweemaels des weeckx inde Catechetische vragen geëxcerceert. Dese verhoopen wij t'sijner tijt de rechte vruchtdraegende boomen in des Heeren acker sullen sijn.

Die twee jongelingen die met mij op Batavia geweest, die van U Ed. vijff realen ijder maendelijcx sijn toegeleyt, hebben haer tot noch toe neerstich gequeeten, vaceeren geheel in 't institueeren van haer compatriotten, soo dat van haer in toecomende goede diensten (fol. 211) te verwachten hebben. Veele sijnder nevens dese die haer lantsluyden gestadich onderwijsen, dat de cranckbesoeckers seer verlicht, hebbende nu maer ten princepaelen het opsicht over het wercq te nemen, willende de onderwijsinge veel liever vande haere ontvangen als van de onse, die nu ende dan wat gemelijck sijn, als sij het geene haer geleert wort, niet wel connen begrijpen. [...]

[...] Naer het vertreck van den *Walvisch* neempt den Ed. Heer gouverneur voor, die van Davole ende Vavorollangh met de wapenen te (fol. 212) besoecken, dat wij oordeelen gants nodich, alsoo seer vilipendeeren ons gesach in dit geweste, bij alle middelen trachtende dese ende geene van onse gealligeerde van ons aff te trecken. Het schijnt dat die twee distincte reysen in welcke dat die van Vavorollangh aengetast sijn, soo veel noch niet heeft geopereert, dat het hooft inden schoot geleyt ende obdientie betracht hebben. Daeromme op een harder, seveerder, ende aensienlijcker maniere moeten gestraft werden, sullende in toecomende omsichticher sijn, om haer niet soo lichtvaerdich tegens den standt van onse princepaele te opponeren.

Successive heeft UE te verwachten den heerlijcken standt ende treffelijcke voortganck van dit geestelijck gebouw onder dese Formosanen. Ued. gelieve te vertrouwen het aen ons niet mancqueeren sal, off alle doenlijcke devoiren tot winninge van veele zielen, ende voortplantinge van 't Christendom alhier geadhibeert sullen werden, [...]

Sijn E. heeft onlangs op het haelen van de hooftbrieffkens in onse dorpen een placcaet geëmaneert, dat verhoope soo veel sal effect sorteren, dat daer maendelijcx voor desen zes à zeven hondert brieffkens wierden uytgedeelt, duysent ende meer naer desen uytgegeven sullen worden.

Desen jaere hebben onse Formozanen eenen treffelijcken ooghst in haere *pagie* gehadt, dat haer seer wel compt, alsoo veele seer arm sijn, ende oock helpt tot voorderinge onser saecke.

Hoe den coopman Wesselingh met sijn bijhebbende geselschap (die in Pimaba aen 't oosteynde van Formoza, eenigen tijt geleden ende inde taele redelijcke ervarentheyt becomen hadde) omgecomen, ende van eenige dorpen daer omtrent dootgeslaegen is, sal Ued. sonder twijffel wijdloopich van den heer gouverneur genotificeert worden, [...]

Alle andere dorpen, soo oostelijck als westelijck van Formoza, blijven als vooren seer gehoorsaem, uytgenomen Davola, Vavorolangh ende daeromtrent, die eerlange straffe voor haere misdaet ontfangeh sullen. [...].

fol. 210: [...] As soon as the punitive expedition against Davolee, that will soon be undertaken, has been accomplished, I intend to move with my entire family to Soulang (the largest and most densely populated village on the island). [...].

Although I was living in Sincan I have never failed to perform the Lord's service in our allied villages every week (except for Mattouw ende Tevorangh which, due to the heavy flow of the rivers, we were not able to reach). Consequently since my arrival many people, adults as well as children, have been confirmed and having been baptized they have joined our Christian congregation. Several people (in order to keep those men and women from committing adultery too rashly, a form of misconduct that happens here all too often) were publicly confirmed in the state of holy matrimony in front of the general meeting of the village council, while others who got involved in marital troubles and quarrels were appeased and reunited with each other.

They still practised various pagan superstitious customs concerning their deceased (whom they used to bury in their houses). I have exerted every effort to have them bury the dead in a public cemetry near to our church (as is the custom in our country). Those of Sincan already have agreed to do so on a large acre made ready to that purpose. Already a few have been buried there. Before long I hope that the other villages will also adopt this custom, which will put an end to so many heathen opinions and customs.

The observance of the Sabbath is now solemnly practised in all our villages, and on Sundays many people attend the services. Furthermore a

large number can be taught the catechism in their own language, three or sometimes even four times a week. At the moment two ordinands have made a lot of progress in learning the local language. For myself I hope (if my strength allows me) to perform the Sunday service in Soulang in the morning and in the afternoon in Mattouw (these two villages are not situated far from each other) so that only the two villages of Tavocan and Tevorang on Sundays have to manage by reading the Gospel aloud (with an ordinand).

The schools also continue steadily and many pupils have learned how to read rather well while some of them can write. As before, they are instructed twice a week in answering questions of the catechism so we do hope that in time they will become the fruit carrying trees on God's acre.

The two youngsters who have accompanied me to Batavia and who each receive five reals a month from Your Honour, behave very diligently and are completely engaged in instructing their compatriots, so we expect good services from them in the future. (fol. 211) Besides these two there are many more to be found who steadily teach their fellow countrymen and who greatly help out the catechists who now only need to concentrate on supervision. Moreover the pupils prefer being taught by their compatriots above our own catechists, who can sometimes be rather impatient when the people do not immediately comprehend what is told to them. [...]

(The ordinand (proponent) Agricola has gained enough knowledge in the Sincan language to communicate well with the inhabitants. From now onwards he will take up his residence in Sincan from where he will also spread the Gospel among the people of Tavocan.)

[...] After the departure of the *Walvisch*, His Honour the Governor, intends to take up arms against the people of Davolee and Vavorolangh (fol. 212), which we consider to be necessary because, by making use of all possible means and by dragging our name through the mire, they attempt to subvert the Company's authority and to pervert our allies. It seems to be apparent that the two occasions when we punished Vavorolangh before, did not result in getting them to knuckle under and making them obedient. Therefore we do feel that this time we need to teach them a serious lesson, to prevent them from opposing our power so lightheartedly in the future.

Your Honour can expect the excellent state and perfect progress in the building of this religious edifice among the Formosans. I beg Your Honour to trust that we will employ all possible means to gain new souls and to propagate the Christian religion. [...]

His Honour has recently issued a proclamation which hopefully will effectuate that, instead of the six- or seven hundred head tax-notes that used to be handed out every month [to Chinese traders, fishermen and hunters allowing them to stay in the villages], henceforth a thousand or more will be issued.

This year the Formosan inhabitants reaped an excellent harvest from their rice paddies. This is a great benefit to them as many of them are very poor and at the same time, it is also advantageous to the achievement of our goal.

How merchant Wesselingh (who had resided in Pimaba, on Formosa's east coast for some time and who had been able to master the local language quite well) was beaten to death, together with his company, by men from some villages situated in that area, will undoubtedly be reported *in extenso* to you, by the governor.

All the other villages, located to the east as well as to the west of Formosa, remain very obedient, except for Davolee, Vavorolangh and others around there, who before long will be served their deserved punishment. [...].

129. Missive Governor Paulus Traudenius to the Amsterdam Chamber.
Tayouan, 30 October 1641.
VOC 1140, fol. 214-216. Extract.

fol. 214: [...] Den eersten Februario lieten den coopman Marten Wesselingh onder behoorlijcke instructie wederom naer Pimaba ende naer de goutrijcke dorpen vertrecken, dewelcke sijne reyse van tijt tot tijt over landt tot een halve dach reysens toe aen Kelangh genomen; doch heeft niet connen vernemen waer 't gout minerael ten principalen is vallende, rescontrerende wel eenige luyden die weijnich dun geslagen gout tot hun acroutement hadde, ende oock daervan een monster gebracht heeft. Ende wanneer d'selve vraechde waer 't voors. minerael vandaen quame, wesen hem naer seecker geberchte alwaer een persoon woonde die dat minerael soo dun clopte, rapporteerende daer oocq geenen wech na toe, nochte

onmogelijck te comen was. 't Schijnt de luyden daer geen vreemde natie hebben willen, gelijck ons blijckt bij seecker rapport door den Chinees Thosim gedaen dat de Castiliaenen in Kelangh jaerelijcks à vier realen swaerte silver, den reaal swaerte goudt negotieeren, het welcke d'inwoonderen van 't geberchte Cauwelangh selffs in Kelangh brengen, ende bij haer verscheyden reysen door haere padres onderstaen is, omme daer naer toe te reysen, doch sijn noyt weder gecomen maer telckens op den wech doot geslagen. Waeruyt dan naectelijck blijct niemant omtrent haere woonplaetsen gedoogen willen.

Meer geroerden Wesselingh is inde maent September omtrent de dorpen Tammalaccou, Nicabon, Kipos, Kimabaton, Bacanca, Lappelappen ende Depoij tot reparatie van des Comp.es huysinge in Pimaba bambousen gaen hacken, seer schelmachtich van de inwoonderen van Tammalaccau, nevens noch twee soldaten ende den tolck Paise doot geslagen, waeraen de Comp. (alsoo een goet instrument tot dat wercq was), veele comt te verliesen. [...]

Den 10en April passato, lieten generaliter alle opperhooffden der dorpen om de noort ende zuyt des casteels Zeelandia gelegen, aen Saccam verschijnen ende hun affvraegen off niet genegen bleven de Generaele Compagnie onder ons gouverno (alsoo d'Ed. heer gouverneur Johan van der Burch in den Heere ontslapen was) ende ick in desselffs plaetse ware gesurrogeert in alles, gelijck voor desen, te gehoorsaemen ende getrouw te wesen. Waerop alle blijdelijck antwoorden, 'jae'. Zulcx U Ed.ts staet op Formosa in gewenschte termen toeneemt, ende tot in Tamsuy om de noort ende voorts de geheele zuyt bevredicht blijft, excepto eenige rebelsuchtige (sijnde die van Davole ende Vavorolangh die eerstdaechs voornemen aensienelijck te straffen, als mede die van 't dorp Tammalacouw daer den coopman Wesselingh doot geslagen (fol. 215) sij, ende voorts te ondernemen wat op Formosa meer valt, ende principalijck de ontdeckinge der goutmijnen als vooren seggen een eynde te maecken.

De aenplantinge der Christelijcke religie ende schoolen onder de jeucht inde dorpen Zinckan, Matouw, Bacalowangh, Soulangh, Tavocan, Tivorangh etc. nemen hart toe. Veele worden er gedoopt ende op de Hollantsche wijse in 't openbaer inde kercken getrout. Ende sal dat wercq metter tijt, wanneer de oude luyden (die hunne superstitiën noch niet wel vergeten connen ende in 't heymelijcke opereeren) te mets uyt de werelt geraecken, van groote consideratiën werden. Verclaeren oocq nooit jaeren voor desen soo vruchtbaer als nu onlangs gehadt te hebben, waeruyt bespeuren, Godt de Heere hun beeter als in voortijden segent, dat hun dapper in haer geloove stijft. Veele van de aencomelingen sijnder die soo

treffelijck reden van haere geloove, den doop, ende de heylige
sacramenten weten te geven dat menige Nederlander, Godt betert, soude
beschamen. Tot uytvoeringe van dit loffelijck werck is den Ed. Robbertus
Junius een seer bequaem instrument. Den selvigen sijnen tijt was
geëxpereert, heeft een keer naer Battavia gedaen ende heeft d'Ed. Heer
Generael sij Ed. noch twee jaeren te continueeren aengenomen. [...].

fol. 214: [...] On the first of February we again sent merchant Maerten
Wesselingh, provided with proper instructions, to Pimaba and the villages
rich in gold. He occasionally made explorations as far north as half a
day's journey from Quelang but he has not been able to find out where
the gold can actually be found. He only met some people who were
wearing a few thin gold plates, from which he brought us a sample.
When he questioned them about the origin of that gold, they pointed to
some mountain, where a person was living who beat the mineral in as
thin a shape as the piece they were wearing. However they also informed
him that no road led to that place nor could anyone go up there. It would
seem the inhabitants do not permit any stranger to enter their territory, as
is confirmed by a report given by a certain Chinese named Thosin, who
told us that the Castilians in Quelang bartered an amount of silver every
year, worth four reals, for one real of solid gold, which was brought by
the inhabitants of the Cauwelangh mountains to Quelang. On several
occasions, Spanish fathers had traveled to that site, but none of them had
ever returned because they had all been beaten to death by those mountain
people. From this it becomes clear that they will not allow anyone to
come anywhere near to their dwelling places.
In the month of September, Wesselingh had gone off to the villages
Tammalaccouw, Nicabon, Kipos, Pinabaton, Bacanca, Lappa Lappa and
Depoij in order to cut bamboo which was necessary for repairing the
Company's house in Pimaba. Over there, he, two soldiers as well as the
interpreter Paise were treacherously beaten to death by the inhabitants of
Tammalaccauw. In him, the Company has lost a great asset as he was a
capable instrument in the realization of our aims. [...]
On the 10th of April, we invited all the chiefs of the villages situated to
the north as well as to the south of Zeelandia Castle, to appear at Saccam.
We asked them if they were willing to remain obedient and loyal to the
General Company as well as to our government (because the Honourable
Governor Johan van der Burch had passed away I had been appointed as

his successor). They answered whole-heartedly: 'yes'! Consequently Your Honour's state of affairs on Formosa has been expanded considerably to a point as far north as Tamsuy, while the entire south also is pacified, except for some rebels (like Davolee and Vavorolangh, who we intend soon to punish effectively, as well as those from Tammalacouw who murdered merchant Wesselingh). (fol. 215) Furthermore we intend to explore what other advantages the Company can gain on Formosa, principally to achieve a definitive result in the exploration of the gold mines.

The propagation of the Christian religion and the establishment of schools for the youth in the villages of Sincan, Mattouw, Bacaluan, Soulang, Tavocan, Tevorang etc. continues to progress. Many young people are baptized, after having made their confession of faith, and many have been married in the church in the Dutch manner. This eventually will have far-reaching results when the old people who are not able to forget their superstitions and who continue to practise them in secret, will have departed from this world. The inhabitants declare that never before they have got such a good harvest as the last one, from which they infer that this time, the Lord blesses them more than before, which greatly strengthens them in their faith. Many of the prospective Christians are so capable at explaining the creed, their baptism as well as the Holy Sacraments, that it would bring a blush to the cheeks of many Dutchmen. The Honourable Rev. Robbertus Junius has proven himself to be an extraordinary instrument in this praiseworthy endeavour. After a visit to Batavia, he has, although his contract had already expired, signed up with His Honour the Governor-General, to serve the Company for another two years. [...].

130. Missive Governor Paulus Traudenius to Governor-General Anthonio van Diemen.
Tayouan, 6 November 1641. Original missive missing. Summary.
See DRB 1641-1642, pp. 55-63; DRZ, II, pp. 6-9.

(On the 'Land Day', that took place in Soulang on 11 April 1641, the headmen of 42 villages in the neighbourhood of Tayouan formally submitted themselves to the Company and Governor Traudenius. As a seal of friendship every headman was presented with a black velvet waistcoat

and a cane. The Formosans complained about disturbances carried out by Chinese at several places. Traudenius promised to take action against such misbehaviour. The next day, on 12 April, the headmen of the villages situated near Wancan, like Dorcko and Tirosen, appeared. After the ceremonial part of the meeting, just before they returned to their villages, all chiefs were treated to a meal. In March, Junior Merchant Maerten Wesselingh, had traveled from Pimaba to Supra in order to conclude a treaty with the headmen of seven north-eastern villages: Patcheral, Matdakij, Tangosaupangh, Wouwe, Caratoet, Silaetoe, and Tatock. After some other journeys to the north and a short visit to Tayouan, Wesselingh (at the beginning of May), again returned to the east coast. In order to conclude peace on behalf of the VOC-authorities in Tayouan with the inhabitants and to try to convince them to start growing rice, he travelled on foot from Lonckjouw to Pimaba. However on 12 September 1641 a soldier from Pimaba brought the message to Tayouan that Wesselingh, together with two soldiers and an interpreter, had been murdered by inhabitants of the villages of Tammalaccauw and Nicabon, both situated at two miles distance from Pimaba. The inhabitants of Pimaba did not know why they were murdered but they said they always feared the violence of those two neighbours. Traudenius planned a punitive expedition with the purpose of punishing the rebels in Vavorolangh, the murderers of Tammalaccauw and the ruler of Lonckjouw, who had turned out to be disobedient.)

131. Missive Governor Paulus Traudenius to Governor-General Anthonio van Diemen.
Tayouan, 17 November 1641.
VOC 1140, fol. 226-230.
See DRB 1641-1642, pp. 97-101; DRZ, II, pp. 9-10.[62]

132. Missive Reverend Robertus Junius to Governor Paulus Traudenius.
Soulang, 10 December 1641.
VOC 1140, fol. 232.

Naerdat wij den 6[en] deeser van Ued. ons afschijt genomen hadden, sijn alhier wel met onse familie den 7[en] aengelangt, Godt geve het tot Sijns Naems glorye ende deesen armen menschen salicheyt gedijen mach.

Omtrent den avondt verschijnt alhier den Chinees van alle Dovaleesche dorpen uytgesonden, refereert dito Dovaleers zeer te inclineeren tot den vreede, oversulcx te verlangen afte comen, ende met UE daervan te handelen. Daerom seer ernstelijck versochten een rottinck opdat daermede bevrijt mochten werden voor de Tarokijers ende Tirosenners die anders lichtelijck de handen aen haer mochten leggen, dat haer niet hebbe connen weygeren op dat segour ende buyten alle dan hier bij Ued. mochten verschijnen. Secht oock dertig persoonen van de hare gebleeven te sijn ende dat zeer vervaert waren voor de paerden diese voor verslindende dieren hebben aengesien.

Gisteren zijnde Maendach comen wederom twee Chineesen met twee pijlen, die hier neffens gaen, van die van Zamkin ende Kalakiou affgesonden, twee dorpen noordelijcker als Gilim gelegen, hielden aen als boven om een rottangh, ende dat genegen bleeven met Ued. van een vreede te contracteeren. Ditto Chineesen verhaelden dat de Vavorolangers maer eenen verlooren hadden, ende seer vervaert waren, souden mede met die van Gielem verschijnen. Sij namen aen te effectueeren dat alle die den vreede versoecken t'samen sullen afcoomen, opdat de eenen machte weeten, wat den anderen wort opgeleyt, daertoe twintig dagen van doen hebben; soo dit dorp aendoen sal (Godt mij gesondtheyt verleenende) met haer bij Ued. mij vertonen.

De leraeressen sijn gisteren zeventig sterck uyt Mattauw na Tirosen volgens UE. ordre, vertrocken, heeden 56 uyt Soulangh ende morgen of overmorgen sullen se volgen uyt Baccaluan, Sinckan ende Tavakangh, dat veel goets dit ons geestelijck werck toebrengen sal.

De Sincanders hebben de hoofden ende de appendentiën van dien begraven, vandage hebben wij se hier beginnen te versamelen, soo dat binnen weynich dagen geene in alle de dorpen meer gevonden sullen worden. [...].

After we, on the 6th of this month bade farewell to Your Honour, we all arrived safely in Soulang. God willing, we will be able to propagate the Gospel and lead these poor people into salvation.

At about evening time a Chinese appeared here in Soulang, sent on behalf of all the villages of Dovalee. He reported that the Dovaleese, were inclined to conclude a peace treaty. Therefore they were willing to come over for negotiations, and seriously requested a [Company's] cane that would serve them as a means of safe conduct so that they would be set free from the people of Tarokij and Tirosen whom they feared might grab

them. We thought we could not refuse their request as it enables them to appear safely and unconcerned before Your Honour. The Chinese also reported to us that thirty people of Davolee got killed in the action and that they had been terrified of the horses which they took for predators.

Yesterday, being a Monday, again two Chinese arrived over here, bearing two arrows [as safe conduct] which I send Your Honour along with this letter. They have been sent as emissaries on behalf of those from Zamkin and Kalakiou, two villages situated north of Gielim. Like those of Dovalee, mentioned above, these inhabitants of Zamkin and Kalakiou also asked for a Company cane and were willing to enter into a peace contract. These Chinese told us that the Vavorolangians, had only lost one person in the battle, but were scared by our force and planned to appear before the Governor and Council, together with those of Gielim. Moreover they intended to effectuate that all those villages that were asking for peace, would come together to Tayouan so that they all will know the peace conditions of each other. The journey will take them about twenty days and when, on the way, they pass by Soulang (God willing) I shall accompany them in order to jointly appear before Your Honour.

Yesterday, according to Your Honour's orders, the priestesses,[63] being seventy in number, left from Mattouw to Tirosen. Today another 56 will depart from Soulang and tomorrow and the day after tomorrow those of Bacaluan, Sincan and Tavakang will follow. A measure that undoubtedly will have the desired effect on the missionary work.

The Sincandians have buried the heads and bones [they had captured in the past]. Today we started to gather them here [in Soulang] so that within a few days their war trophies will have been made to disappear. [...].

133. Missive Governor Paulus Traudenius to Governor-General Anthonio van Diemen.
Tayouan, 22 December 1641.
VOC 1140, fol. 256-259. Extract.

> fol. 256: [...] Soo als voors. schepen op 18[en] November passato van dese reede vertrocken waeren sijnde het weeder seer paysibel, soo resolveerden den tocht naer Davole ende Vavorolangh (conform Ued. welgegevene ordre) bij der handt te nemen ende alle praeparaten daertoe vereyschende vaerdich te maecken.

Alles claer sijnde vertrocken den 20en dito met een crijchsmacht van 280 militaire persoonen, honderd zeevaerende als ambachtsluyden, mitsgaders eenige officieren, tesamen omtrent 400 Nederlantsche coppen, sijnde in 74 Chineese champans geïnbarcqueert, welcke champans oock stijff met 300 Chineesen gemant bleeven. Derwaerts, den 21en dito, jegen den avont arriveerden in Wanckan, waer vandaen de gantsche macht bij den anderen hebbende, in den avontstont reys vorderden en quamen des anderen daechs, sijnde den 22e inde riviere Poncan en de rusteden wat aen het Geuse bosjen. Des nachts voeren van dito bosjen ontrent twee mijlen boven 't selve d'rivier op, alswaer tot aen de morgenstont stil bleve leggen, als wanneer ons te lande begaven, maeckende van partije champans die op 't landt haelden een wagenbrugh, waerinne eenige victualie als ammunitie van oorloge met twintig cloucke soldaten beset lieten verblijven. Dit alsoo versorcht wesende, namen 150 Chinesen mede, omme onse vivres, ammunitie van oorloge als andere nootwendicheden te dragen, latende de resterende Chinesen bij de champans ende d'onse verblijven.

Jegens den middagh den 23en dito hebben door eenige inwoonderen tijdinge van den Ed. Robertus Junius becoomen die ons liet weten hoe met d'inwoonderen van onser bondtgenooten dorpen op de marsch was. Soo begaeven ons jegens den middach met den gantschen treyn mede aen het marcheeren. Inden avontstont quamen bij do. Junio ende onse 15 ruyters die over landt waeren gereyst, sijnde ende bevindende bij voorn. Junio ongeveer de 1400 inwoonderen van diverse dorpen, te weten Soulangh, Mattau, Zincan, Bacaloangh, Tavocan, Tivorangh, Dorcko, Tapouliangh, Tilosan ende Tavocan, ende d'inwoonderen op haere wijse armeert ende geproviandeert, naemen dien nacht onse rustplaetse ontrent een cleene poel ofte rivierke van versch water, separeren d'inwoonderen over 't rivierken van ons.

Des morgens vrouch, sijnde den 24e dito, begaven ons wederom op de wech naer Davole, alwaer naer den middach, hebben noch een rivier gepasseert, sijn gecoomen. Wat rescontre aldaer met den vijant hebben gehadt ende hoe ontrent dertig coppen vanden vijant door onse crijchsluyden soo te voet als te paerde ter neder gevelt ende door d'inwoonders als dan 't hooft sijn affgeslagen, becomen hebben, hebben wij God danck niet één mensch gequetst veel min verlooren dan alleen eenen Soulanger 't hooft van haer affgehouwen. Insgelijcks hoe het dorp, sijnde redelijck groot t'eenemael verbrant hebben, ende alle haere vruchtboomen affgehouwen ende als doen een nacht aldaer gerust ende des anderen daechs, wesende den 26en dito, vandaer na Vavorolangh met de

gantsche macht (excepto 1200 inwoonderen die wederom sonden, alsoo meer schade als voordeel ons toebrachten) verreyst.

Ende wat ons doente aldaer sij geweest, namentlijck hoe hetselve mede t'eenemael, uytgesondert twee à drie parcken om consideratiën, in de assche gelegt hebben, ende één der outsten die bij ons verscheyden maelen quam, gerecommandeerd dat ons de drie Nederlandsche hoofden die van de onse becoomen hadden, beneevens de moordenaers in Tayouan souden toebrengen ofte dan wederom stonden te coomen. Ende doen van daer wederom onse marsch naer 't Geusebosjen hebben ondernoomen, item van daer vertrocken, in Wancan wel aengecoomen ende over Soulangh te water om verscheyde poincten aldaer, tot voordeel van 't geestelijck gebouw, den inwoonderen voor te stellen ende gelasten. [...]

Wij willen niet dubiteeren ofte desen gedaenen tocht sal de rebellige Davolianen ende Vavorolangers wel cleyn ende nedrich maecken ende sal oock niet alleene een schrick maer oock groote gehoorsaemheyt inde hierom leggende dorpen veroorsaecken gelijck al gereede een exempel (fol. 257) daervan hebben becoomen, als U Ed. uyt dit brieffken van d°. Junio aen ons gedirigeert hiernevens in copia gaende, gelieve te vernemen, wanneer d'inwoonderen van Vavorolangh ende Davolee, mitsgaders andere om de noort gelegene dorpen bij ons coomen te verschijnen sullen, het beste ten meesten dienste vande Generaele Compagnie met hun saecken uyt te wercken d'aviso. [...].

fol. 256: [...] As soon as the ships, that had been lying in the roadstead, left on 18 November last, and the weather turned out to be rather fair, we resolved that the right moment had come after all the necessary preparations had been made, to set out (according to Your Honour's orders) on the punitive expedition to Davolee and Vavorolangh. On 20 November we left with an army of 280 soldiers, a hundred sailors as well as artisans, besides some officers. These men, all together being about 400 Dutchmen, embarked in 74 Chinese sampans that were already manned by over 300 Chinese crew-members, and set sail to Wancan where they arrived on 21 November a little before the evening. The same evening the entire force then left to continue the voyage. The next day, on 22 November, we reached the Poncan River. Having rested there for a while near the *Geuse* grove,[64] we sailed during the night two miles up stream to a spot were we remained berthed until daybreak. Then we disembarked and from some sampans, that were hauled ashore, we constructed a bridgehead, in which we stored some provisions and

ammunition, and left twenty sturdy soldiers as guards. When this was carried out we took 150 Chinese along to carry our belongings like the provisions and ammunition, leaving the remaining Chinese to stay with the sampans and our guards.

In the afternoon of 23 November we received a message by the Hon. Rev. Robertus Junius, in which he informed us that he was on his way together with the warriors of our allied villages. Whereupon we, together with the entire party, set out on our march. At dusk we met with Rev. Junius and the 15 horsemen who had taken the land route. Junius was accompanied by about 1,400 inhabitants, armed and victualled according to their own customs, from the allied villages: Soulang, Mattouw, Sincan, Bacaluan, Tavocan, Tivorangh, Dorcko, Tapouliangh, Tilosan and Tavocan. That night we camped near a small freshwater pool or creek, and we ordered our troops of inhabitants to spend the night on the other side of the stream.

Early the next morning, 24 November, we set out for Davolee, were we arrived in the afternoon having crossed another river. There a clash ensued and about thirty of the enemy were slain either by our men on foot or on horseback, while their heads were seized by our allied inhabitants. The Lord be praised that none of us died or got hurt, except for one man from Soulang who was decapitated. Their village, which was of a considerable size, was reduced to ashes and all their fruit trees were chopped down. After we had spent the night over there, the next day, 26 November, we set off, with the entire army (save for the 1,200 allies who, instead of helping us out, had caused us only trouble, so we had ordered them to return to their villages). From there we continued to Vavorolangh that also was burnt down completely, except for two or three quarters that, for certain reasons, were saved from the fire. One of the elders, who came to meet us several times, was told that the Vavorolangians should return the three heads of the Dutchmen to us in Tayouan, which they had seized in the past, and deliver up the murderers as well, or we would return with our army one more time. Subsequently we took our leave and marched back to the *Geuse* grove and from there we sailed back to Wancan. Following this we continued with the sampans for Soulang in order to proclaim and explain several articles to advance the inhabitants. They also were urged to profess their religion. [...] Unquestionably this expedition will have humiliated the rebellious people

of Davolee and Vavorolangh so that it will not only cause fear in the surrounding villages but it will also turn them into more obedient subjects. We already have some proof of this, (fol. 257) as Your Honour can read in Junius' note written to us on 10 December. We will send you a copy, in which he is writing when the inhabitants of Vavorolangh and Davolee, as well as other villages situated in that area north of Tayouan, will show up at Zeelandia Castle, to work out their business in the best possible way for the well-being of the General Company. [...].

1642

134. Missive Governor Paulus Traudenius to Governor-General Anthonio van Diemen.
Tayouan, 7 January 1642.
VOC 1140, fol. 264-273.
See DRB 1641-1642, pp. 109-111; DRZ, II, pp. 11-12.

135. Missive Governor Paulus Traudenius to Governor-General Anthonio van Diemen.
Tayouan, 16 March 1642. Summary.
See DRB 1641-1642, pp. 146-153; DRZ, II, pp. 12-14.

(On 11 January 1642 Governor Traudenius left Tayouan as commander of 353 men (225 Company soldiers, 110 Chinese and 18 servants from Java and Quinam) on a punitive expedition to the east-coast. The aim was to punish Tammalaccauw for the murder of Maerten Wesselingh and to further investigate the alleged gold-sites once again. On 12 January the troops disembarked in the Bay of Lonckjouw. The next day the men began to march northwards and on 22 January they were welcomed in Pimaba. They learned from the villagers that the inhabitants of Tammalaccauw had killed Wesselingh in a drunken fit. The following day the whole army set off to Tammalaccauw, together with the Pimaba warriors who had been ordered to assist the Company forces in the reprisal action. On 24 January, on their way to the hostile village, they ran into an ambush of a great number of Tammalaccauw warriors. In the subsequent fight, however, a lot of these adversaries were wounded and 27 were killed. The next day, the village, situated high up in the mountains, was destroyed, even though the enemy put up stubborn resistance. After a short rest in Pimaba the men continued their march along the beach in a northern direction. On 4 February they passed Sibilien, but because rice or other provisions were scarce in that village, they marched on. One soldier was swept away in a fast-flowing river and drowned. When they crossed a deep gorge located in between mountain ranges they suddenly were greeted by about 400 armed warriors from eight of the largest mountain villages. The invitation to follow the mountain people to their dwellings

was politely turned down. Soon after, when the soldiers were crossing a river, they were suddenly attacked by the same men, but the musketeers managed to drive them off. Afterwards the men of Sibilien told them that the mountain people had intended to kill all the Dutch. On 7 February it was decided to return to Pimaba first. From there they could set out on the return voyage overland via the Tacabul mountains. The next day the expedition army was welcomed by chief Roringh of Vadan, who proved to be happy with the recent Company victory over his enemies and requested that two Dutchmen stay behind in his village to learn the language. Back in Pimaba five commissioners from Tammalaccauw came to negotiate for peace. This was granted to them on the condition that from then on they were considered to be subjected to Pimaba. On 23 February the Company expedition force returned in Tayouan.

Meanwhile on 14 February some of the headmen of Vavorolangh had come to Zeelandia Castle to hand over the skulls of Junior Merchant Hans Ruttens and two of his company, who, in the preceding year, had been beaten to death in the Vavorolangh fields. They were again accepted as subjects of the Company and the States General, on the condition that they would obey the following eight articles:

1. Confession of guilt.

2. Promise never again to undertake anything to the disadvantage of the Company or its allied villages.

3. Murderers had to be delivered up to the Court of Justice.

4. Taking up arms against other villages without the governors' permission was forbidden.

5. Formosan allies were obliged to always assist Company-servants who visited their villages with food, lodging etc.

6. Formosan allies were obliged to show up if they were summoned up by the Company.

7. They should not allow Chinese hunters, without Company permits, into their fields.

8. They themselves were allowed to hunt in their fields on the condition that they would obey the Company rules.

On 23 February the contract was signed by Traudenius in the presence of the Vavorolangh delegates. It was determined that if one of the articles should be violated more than two times, the whole village would be held

responsible. In that case every family would have to pay a fine of ten bundles of unpolished rice or five deerskins to the Company.)[65]

136. Missive Secretary Christiaen Smalbach to Governor Paulus Traudenius.
Pimaba, 1 April 1642.
VOC 1140, fol. 286-288.

Den 28en passado ben met den edelman Parmonij, sijn bijhebbende volq ende zes Chineesen in 't dorp Pimaba met gesontheyt aengelangt ende mij ten huyse vande E. Comp. begeven, alwaer d'onse met gesontheyt (excepto den corporael Jan Duversie, die 's avonts voor onse compste overleden is, neffens Jacob Boeij geheel sieckelijck ende Hendrick Jansz Bleecker die een quaat been heeft) voor mij gevonden hebbe.

Naer weynich tijts is den cappiteyn Radout bij mijn in 's Comp.s huys om te ontvangen gecomen, dien naer vriendelijcke groetenisse volgens U.E. gegevenen instructie uyt den naem van U.E. verders aengedient hebbe hoe tot onderhoudinge van vruntschap U.E. volgens haere jongst gedaene beloften, om een opperhooft weder in Pimaba te zeynden mij derwaerts gesonden hebben, niet twijffelende dat hem zulcx, neffens d'andere outsten des dorps aengenaem ende niet mishaechelijck wesen sal. Item dat uyt handen van sijn broeder Parmonij een pack cleeren met sijn toebehooren van hoet, hemden, cousen, schoenen ende anders meer van U.E. wegen te ontfangen hadde. Waerop antwoorde hem mijne compste seer lieff ende aengenaem sij, ende dat sich tegens U.E. over den aen zijnen broeder ende de bijhebbende Pimabaers in Tayouan gedaene weldaden als oock vande overgesondene schenckagie ten hoochsten bedancte gegeven heeft, soude oock verders van 't selve, 't welcq conform van voorgem.e instructie hem meer voorgehouden hebbe [...] inderdaet naercomen ende achtervolgen. [...]

't Huys 't welck van U.E. tot bewaringe van Comp.es goederen op strant tegens de compste der joncke maecken te laeten mij gelast is, hebbe bij aencomste (doch seer slecht ende voor den regen onbewaert) alreets gemaeckt ende partije goederen daerin voor mij gevonden ende 's daechs daeraen door de Tawaliers, die ons goet over den wech brachten, volcomentlijck decken, 't restandt der vellen, aldaer brengen ende den kennip door de Pimabase wijven, also 't tegens haer wet is, van de mans gedragen te werden, voorts brengen laeten, dat alsoo te deeser tijt in Comp.s huys des gelt, 't sij dan met het comen der joncke daer de omleggende dorpen seer naer verlangen ende fijn goet verwachtende sijn,

niet meer berustende, noch voor de pannen, potten, porceleyn ende wat des meer is, can verruylt ofte verseth werden.

Die van Pima seggen wel expresselijck, soo geene goede cangans, fijne Lanckins, van die geele coraelen, die de Chineesen Chitiatso noemen, ende bij de Pimabaers alsoo hoogh geëstimeert sijn dat met vier à vijf stucks dito's onder hun een nederlach volcomentlijck goetdoen ende betalen can, schoone blauwe, roode, lichtgeele, bruyne, orangie ende somtijts weynich swarte ditos; alsmede fijne roode, licht donckerblauwe ende swarte bruyne cangans, gelijck voor mijn vertreck onder 't volck uytgegeven is, met de verwachte joncq niet en compt, sijluyden in 't minste niet reujelen noch haere vellen daertegens versetten wilden. Ja, dorsten wel naer root dubbelt damast, armozijnen, cousen, Hollantse schoenen, costelijcke hemden ende diergelijcke meer om te reujelen vraegen, alsoo door den gedaenen tocht sijluyden als oock d'omleggende dorpen met goet overvloedich ende soodanich versien sijn dat te verwonderen is. De pannen, potten ofte porceleijne schootels, sijn in 't minste niet voor vellen ofte kennip te versetten. Jae, wilden haer qualijck voor 't goet op strant te draegen daermede contenteeren ofte betaelen laeten.

Alhier in 't dorp mede een groote siecte van hitsige coortsen (fol. 287) onder de inwoonders, dat twee: drie: vier: à vijf persoonen op eenen dach wechsterven.

Item groot mancquement van rijs ende geerst (die door U.E. gedaenen tocht meest verconsumeert is) dat tot onse eygen lijffs nootruft ofte onderhout voor 't betaelen aen goet yets becomen connen. Deshalven bij den cappiteyn Reduyt neffens sijnen swaeger, den regent Toea, dat in d'aenstaende tijt d'inwoonders haere velden meer besayen ende rijckelijck vruchten daervan trecken sullen (opdat bij geval jaerlijcks soodanigen tocht van U.E. geschiet, sijluyden niet gans tot arme luyden geraecken mochten, […] voorgehouden, die 't selve naer te comen vastelijck belooft hebben.

Met het aencomen der joncke sijn bij Sr. Wesselingh zaligers tijt voordesen om de Comp.ˢ goederen van strant in Pimaba te brengen, die van Tawalij op ontbooden, 't welck van mij oock naer oude costuyme achtervolcht werden, sal tot dien eynde dan met rijs, soute vis, Hollants vleys ofte speck om sijluyden die rijckelijck van eeten sijn te besorgen diende versien te wesen, alsoo gelijck boven geseyt, alhier weynich te becomen is.

Verders sijn de alhier omleggende dorpen, noch in goede vreede ende eenicheyt met malcander, excepto die van Tawalij die tegens het dorp Paddeijn, 't welck ½ dach gaens boven 't dorp Luypot in 't geberchte

licht, uyt oorloogen geweest sijn, ende drie hooffden van daer gehaelt hebben. Item hoe die van Madaan ofte Vadaan daer Hendrick Jansen Bleecker, neffens Jacob Boeij volgens U.E. last op den 27en Februarij passado tot onderhoudinge van vruntschap geweest ende van den regent Roron ende anderen haer dorpsvolcq bejegent sijn, is bij 't neffensgaende dachregister naerder te sien.

Den regent Toea, die de suster van den cappiteyn Redut heeft ende bij naest meer als den gem.e Redut onder dese inwoonders gevreest werdt, heeft onder andere discoursen bijgebracht dat niet weet wat U.E. in haere aenwesentheyt soude te quade gedaen hebben, daer door minder als sijne swagers den cappiteyn Redut ende Parmonij bij U.E. conde geacht werden, alsoo gem. sijne swagers van U.E. met cleederen, hemden, cousen, schoenden etc. sijn vereert worden, hij daertegens als een outsten des dorps niet ontfangen, ende bij de inwoonders alhier in verachtinge gebracht wierdt, soo heeft oock den Redut voornoemt, dat bij U.E. sijns swagers Toeas halven te gedencken op mijn versocht, twijffelde niet U.E. naer bekende goedadicheyt daer in versien soude.

Die van Tammalacouw hebben een nieuw dorp 't welcq sij Pinassoen noemen, tusschen 't oude Tammalaccouw ende Morronos in 't hangen van 't geberchte, gelijck Tawalij, te bouwen aengevangen ende heeft den regent Redut eenen van de Tammalaccouwers, die den tolck Michiel 't hooft affgeslaegen, tot een opperhooft daerover gemaeckt, alsoo 't selve tegens U.E. expres bevel is, doe U.E. ordre waer naer mij te reguleeren hebben, sal daer over inwachten. [...]

Op morgen met den dach [...], sal mij in den naeme Godts tot vervorderinge mijner aenbevoolen reyse, naer Lolongh, Supra ende Vadan met de soldaten Adriaen Jansz Watermondt ende Jan Huybertsen op den wech begeven, Godt Almogenden wil ons sijne genade verleenen, dat deselve tot Sijns Naems eere ende ten dienste der E. Comp. uytvallen ende strecken mach.

Groene ende geele cangans, item groene coraelen ende cleene pannen, sijn alhier niet gesien. Middelmatige ditos pannen met twee ooren, daer alhier noch maer één van berustende is, item ditos met één oor, daervan noch 69 stucx in voorraet sijn, sijn wel getrocken.

fol. 288: Chineesen toeback ende partije zijde diende, van alderhande coleuren, oock wel een weynich te hebben om bij de regenten soo hier als daer, wanneer in haere dorpen hun te besoecken come, een draet vier à vijf te geven, item sout ende groote oude spijckers, eenige slooten soo van Chineesen als Vaderlandtse, dienen hier nootwendich te wesen, alsoo niet eene verslooten camer noch kiste alhier is. [...]

Den cappiteyn Redut ende swaeger Toea, neffens den edelman Parmonij
doen U.E. haeren onderdanige ende hartelijcke groet toewenschen. [...].

On the 28th of the last month I arrived with the nobleman Parmonij, his
retinue and six Chinese, safe and sound in Pimaba. I made my way to the
Company's house were I found our men in good health, except for
Corporal Jan Duversie, who had died the evening before my arrival,
Jacob Boeij who lay ill and Hendrick Jansz Bleecker who suffered from
an infected leg.

After a while captain Redout came to visit me in the Company's
residence. I welcomed him as instructed in a friendly manner on behalf of
Your Honour. Subsequently I announced to him that I had been sent by
Your Honour with the purpose of maintaining friendly relations,
according to the recently made promises to appoint a Company resident to
his village once again. I told him that without doubt he and his men
would be pleased with my arrival and that, on behalf of Your Honour, his
brother Parmonij would present him with a complete costume and
accessories like hat, shirts, stockings, shoes and so on. He replied that
indeed he was very pleased with my arrival and that he was very grateful
for the gift he had received from Your Honour and for the way in which
his brother and his company had been welcomed in Tayouan.
Furthermore he promised to meet with and follow up every demand
which, according to my orders, I presented to him. [...]

The house which you ordered me to construct to serve as a beach storage
place for the Company's trade goods before the arrival of the junk, I
found had already been constructed (but in a very poor way and without
good protection from the rain) with a party of merchandise stored in it for
me. These commodities were covered up completely by the remainder of
the skins, that were brought in the next day by some inhabitants of
Tawalij, who also helped us out by carrying our goods on the way to
Pimaba. Also used to cover the commodities was the hemp, that we had
taken in by the Pimaba women, as it is against Pimaba customs that men
should carry it. Therefore, the current situation in the Company's
warehouse is, that there is no merchandise to be found, not even any sign
of the pans, pottery, porcelain and suchlike, that would normally be ready
for barter and sale, as the inhabitants await the arrival of the much longed
for junk which they expect to bring in fine goods.

Those of Pimaba told me explicitly that they were hoping for delivery of quality *cangans*, *lanckins*, or a certain kind of yellow beads, that are named *Chitiatso* by the Chinese, that are esteemed highly by them, so much so that four or five of those beads can settle and pay off a charge of manslaughter. They also wanted the fine blue, red, light yellow, brown, orange and perhaps a few black beads; as well as fine red, slightly dark blue, and black brown *cangans*, like those that were distributed among our guests from Pimaba before we left Tayouan. Unless commodities of this type were delivered by the expected junk, they will simply refuse to barter anything, nor will they exchange any of their deerskins. To my amazement they even dared to ask me for double red damask, *armozijnen*, stockings, Dutch shoes, precious vests and the like for bartering; because of the recent expedition they, as well as the surrounding villages, really are abound in everything.[66] It is not possible at all to exchange the ordinary pans, pots or porcelain dishes for deerskins or hemp. They were even reluctant to accept such merchandise as payment for carrying goods to the warehouse on the beach for us.

Over here in the village an epidemic of hot fever is rampant (fol. 287) among the inhabitants, so that two, three, four or even five people die every day. Also due to a considerable lack of rice and millet (most of which was consumed by the men during Your Honour's recent expedition) it is quite difficult for us to obtain enough for our subsistence or nourishment by bartering any of our goods. Therefore we advised captain Redout, besides his brother-in-law the regent Toea, that the inhabitants from then on should sow their fields so that they may reap an abundant harvest, so that if Your Honour will send an expedition every year they would not take the risk of being reduced to beggary. [...] To this they responded that they certainly would meet with our request.

Upon the arrival of the junk, the late Sr. Wesselingh used to invite those of Tawaly to carry the Company's goods from the beach into Pimaba. This old custom will be continued by me, and they will be rewarded for that with rice, salted fish, Dutch salted meat and bacon so as to provide these people with an abundance of food, because as mentioned before, they are suffering from a lack of provisions.

Furthermore the surrounding villages are still maintaining peaceful relations with each other, except for those of Tawaly who waged war against the village Paddeijn, which is situated in the mountains at half a

day's journey north of Luypot, and seized three heads from there. The same goes for those of Madaan or Vadan, which Hendrick Jansen Bleecker, and Jacob Boeij, according to Your Honour's orders, on the 27th of February visited in order to maintain friendly ties. How they were received by regent Roron and the other villagers, Your Honour can read in the appended dagregister.[67]

The regent Toea, who is married to the sister of captain Redout, and who is dreaded almost more by the Pimaba inhabitants than Redout himself, has put forward openly that he does not know what he, during Your Honours' presence, had done to offend Your Honour, and what would be the reason why he is held in less esteem than his brothers-in-law captain Redout and Parmonij. After all they were presented by Your Honour with clothes, shirts, stockings and shoes, while he on the contrary, although he was a member of the village elders, did not receive anything and as a consequence was despised by the inhabitants. Therefore Redout, who did not doubt that Your Honour will kindly grant his wishes, requested me to tell Your Honour to also remember his brother-in-law Toea.

Those of Tammalacouw, like Tawaly, started to built a new village which is named Pinassoen, located against the mountain slopes between the former Tammalaccouw and Moronos. The regent Redout has appointed someone of Tammalaccouw as chief, the same person who beat off interpreter Michiel Paise's head. Because this runs contrary to Your Honour's explicit orders, I am awaiting Your Honour's instructions of what action to take. [...]

Tomorrow at dawn [...] I shall, in the name of the Lord, embark on my projected trip with the soldiers Adriaen Jansz Watermondt and Jan Huybertsen to Lolongh, Supra and Vadan. May God Almighty have mercy upon us, that this journey will be accomplished in this Glory of the Lord and be beneficial to the Honourable Company.

Green and yellow *cangans*, as well as green beads and small pans are here not in demand at all. But medium size pans with two ears, of which only one is left, as well the same type with one ear, of which we still have 69 in store, do find a market over here.

fol. 288: We ought to have some Chinese tobacco and a supply of silk of various colours over here, as to be able to every now and then present the regents of the villages we are visiting with about a thread of four or five. The same goes for salt, large old nails as well as Chinese or Dutch locks,

which we need because we do not dispose of one single room nor any chest that can be locked of. [...]

The captain Redout, his brother-in-law Toea, as well as the nobleman Parmonij send Your Honour their humble and sincerest regards. [...].

137. Missive Secretary Christiaen Smalbach to Governor Paulus Traudenius.
Pimaba, 26 April 1642.
VOC 1140, fol. 289-291.

Op den 13ᵉⁿ dito 's avonts ben eerst van Madaan ofte Vadaan wederom in Pimaba geretourneert, alwaer tot mijn leetwesen de joncke (op gisteren alhier gearriveert) alreets van den wal gecort in zee naer 't eylandt hier tegenover leggende sijn cours nemende onder seyl gesien, ende de goederen van U.E. voor Pimaba gesonden in Comp.ˢ huys op strant lach, bevonden ende volgens inleggende memorie [...] eensdeels ontvangen ende overgenomen hebbe.

[...] Maer alsoo in mijne aencompste van Madaan door die neffens den tolck Anthonij achtergelatene soldaten ben bericht, dat hij vendrich Smith bij sijne aencomstte in Pimaba over die in 't Compagnies huys aen olij ende asijn mitsgaders ander weynich hebbende vivres, 't welck voor mijn eygen gelt betaelt, zuyr ende swaer uyt Tayouan over den wech te draegen geworden is, met sijne bijhebbende soldaten, onder 't spreecken 't selve te meer vrij aentasten soude, t'samen verconsumeert heeft, dat oock niet een droppel olij noch asijn, 't welck te deser tijt soo wel voor ons eygen als de Chinesen mede gebrachte siecken ten hoochsten mancqueert, alhier te vinden noch overgebleven is. Vermeyne alsoo hij vendrich Smith, sijn preceance hier in soodanich selffs overgenomen heeft, dat d'selve veel meer als wellicht in mijne presentie geschieden mochte, volbracht is, derhalven hooch ende demoedich versouckende ben U.E. mij in mijne geringh durenden tijt, met diergelijcke besendingen aenstaende, oversien ende verschoonen wil.

Alsoo ten tweeden onder anderen bij den regent Redout als andere opperhooffden mitsgaders den gemeenen man mijn persoon soodanich in disrespect ende cleynachtinge gebracht heeft, dat het selve ten dienste der E. Comp.ᵉ streckende aen sijluyden te volbrengen versocht hebbe, in 't minste niet volbracht ende naergecomen is, dieshalven met gewelt, gelijck bij 't [...] dachregister te sien is, uytbreecken moeten.

Den regent Reduyt versouckt reverent ende ootmoedich U.E. gelieve voorgem.ᵉ vendrich Smith herwaerts aen niet meer te zeynden, alsoo voor desen tusschen hem ende Sr. Wesselingh zaliger alweege oneenicheyt aengericht hadde, ende oock des halven door 't aenschrijven van voors. Wesselingh zaliger van U.E. hieruyt om in Tayouan te verblijven gelicht is. (fol. 290) U.E. gelieve seeckerlijck te vertrouwen, dat het voors. ende principael van den regent Redout den vendrich aengaende hem door fenijn ofte misgunste van mijn niet naer geseyt werdt, maer inderdaet ende waerheyt door den tolck Anthonij in mijn presentie als van de gestoolene pannen hem Redut om weder te restitueeren vermaent hebbe, ten antwoorde (als meede dat van gem.ᵉ Smith aen seeckere persoone drie stuckx van ditos middelmatige pannen geschoncken waeren die niet ten voorschijn brengen conde), gegeven heeft, wat last genoemden Smith tot het verschencken der pannen gehadt heeft, sal bij U.E. ten besten kennelijck sijn.

Hadde den vendrich Smith in 't besoucken der dorpen, sijne last om de goederen op 't strandt leggende, voor den regen ende dieven gepreserveert gehouden, soude beter geweest zijn oock meerder eere daer van gedraegen, ende wellicht geen quaat been gehaelt hebben.

Die alhier van Comp.ᵉˢ wegen berustende ende bij mijne aencompste voorgevondene goederen sijn conform mijn op den eersten deses aen U.E. gedaene missive overgenomen ende […] voor mijn vertreck naer Vadaan op strant in Comp.ˢ huys gebracht ende bij de alhier doenmaels remorerende soldaeten tot haerder verantwoordinge achtergelaeten. […]

De groote isere pannen à 25 reaal 't cento waervan hier alreets eenige noch in voorraeth ofte voorhanden sijn, sijn gans niet getrocken, deshalven te wenschen waer U.E. van 't halff slach à 14 Reaal 't cento in meerder quantiteyt herwaerts aengesonden hadde.

De bruyn blauwe Lanckins à twee M.ˢ ider, hadden wel gedient wat fijnder van stoff te weesen, dan onder de Pimabaers extraordinaire fijne ditos, die ons volck als mede de Chineesen geruylt hebben, berustende sijn. Dieshalven oock dese niet aensien wilden, seggende die cangans te deser tijt eens soo fijn te sijn als de Lanckijns, daer voor desen de cangangs slecht ende de Lanckijns fijnder van stoff sijn geweest. Doch alsoo geen andere hebben, verhoope dat te sijnder tijt onder de omleggende dorpen voor vellen, was, rijs, ende kennip etc. wel sullen verseth werden.

Belangende de bruyn blauwe cangans, waeronder noch partie swarte (daer niet van te raecken is) mede loopen, sijn fijn ende sullen d'selve t'haere, met Godt de Voorste, rijckelijck connen opbrengen.

Het waere te wenschen geweest U.E. 25 à dertig stucx ditos fijne lichtblauwe cangans, item geheel fijne Lanckijns, neffens alderhandt sorteringe van corael (excepto groen) daer al haer vraegen naer is, mede overgesonden hadde, haer alsdan verseeckert houden mocht, dat in 't aenstaende jaer meer dan 700 à 800 stuckx elantshuyden, item harte ende steenbocxvellen, mitsgaders rijs, kennip, boonen, was ende andere alhier vallende fruyten in grooten quantiteyt uyt deese plaetse conde lichten ende naer Tayouan vervoeren laeten.

Van de 158 bossen Chinees corael weet niet wat seggen sal, alsoo niet één bos blau, lichtgeele ende swarte, die alleenich hier getrocken sijn, daeronder is. De ijsere hoecken, item oude spijckers, daertegens de kennip te deser tijt wel getrocken is, sijn niet so abondant als de gelegentheyt wel vervorderde met de besendinge der joncke alhier gecomen, dan in alles cleyn ende groot de stucken van dese hoecken 28 sijn.

De Chineesen hebbe volgens U.E. gegeven mondelinge ordre in Supra gebracht, ende in die aldaer leggende bergen ende cloven om 't beste daeruyt te trecken aenwijsinge gedaen, maer alsoo sij seggen, [...] aldaer niet te verwachten is, sijn wederom tot Pimaba achter aengevolcht, doch op den 20^{en} deses, d'één van hen luyden in Lolangh overleden, ende alsoo alhier niet meer te verrichten hebbe, doe de selve met den neffens gaenden soldaet Lieve Drapiou wederom op naer Tayouan senden.

De Chineesen sijn voorneemens op d'één ofte andere sijde des geberchts Tacabul, in 't geberchte noch meer ondersouckinge te doen, dieshalven den soldaet Lieve Drapiou dat sich haerent halven niet ophouden, maer op 't spoedichste sijne reyse naer Tayouan aen U.E. te vervorderen.

In Supra ben bericht dat acht dagen voor mijn compste (fol. 291) die van Supplien, Pallan, Dorcop, Vadaan etc. om vellen tegens sout te ruylen geweest sijn.

Den regent Ronduyt ende Toea, hebbe volgens U.E. aen vendrich Smith gegeven, ende mij mondelinge achtergelaete missive, een cleyne schenckagie gedaen, waervoor aen U.E. hun ten hoochsten sijn bedanckende.

De luyden vande omleggende dorpen comen rijckelijck aen om te ruylen, maer willen de Lanckins daer van U.E. het monster seynde, inderdaet groff sijnde, niet aensien. Deshalven veel wederom gaen laeten moeten.

Het Comp.^s huys dient gans vermaeckt ende van buyten met heele bambousen beseth te wesen, dan men daer binnen voor de dieven vast niet bergen noch voor de menichte van ratten, die de canassers daer de roode moussous in leggen bij mijne absentie van onder doorboort ende verscheyde stucken te schanden gemaeckt hebben. Dieshalven in de

onverslootene oude kisten, is beter bewaringe gedaen, ende moet noch vreesen dat door lanckheyt van tijt oock daer door graven sullen.

Ick versoucke mede hoochlijck U.Ed.ᵉ gelieve des ouden regents Toea, wegens het pack cleeren eens te gedencken, dan als den selven somtijts beschoncken is, het dorp op en neer loopende veel geraes daervan maecken doet, dat den regent Reduyt dieshalven selffs voor hem bevreest is, ende volgens eerstgedaene missive aen U.Ed. daervan te gedencken, versocht heeft. Traen, keersen ende londt, item weynich olij van olijven ende asijn voor sieck ende suchtige te geven, daervan alles hier niet als voor desen bij Sr. Wesselingh zaligers tijt, met het besenden der joncke gecomen is, hadde mede verwachtende geweest, ende dat daerom bij U.E op mijn vertreck niet versocht hebbe is mijne onwetentheyt, also mij wat hier mancqueerde niet bekent was, toe te schrijven.

Wegens de christal de montangie ende andere mij meer volgens instructie van U.Ed. gelast is, sal met den eersten in de oostwaerts leggende geberchten van Pima, item het geberchte van Pallan, daer die van Pima seggen vallen doet, ondersoucken ende U.Ed. daervan met d'eerste hieraenvolgende missive rapporteeren.

Wegens het dorp Pinassoroo ofte Nieuw Tammalaccauw, die met haer bouwen van huysen volgens mijne voorige aen U.E. gedaene missive tot dato stil gehouden, ben U.E. ordre daermede over verwachtende.

De soldaten Adriaen Watermont ende Jan Huybertsen die haeren tijt, neffens de mijne, tegens aencomende verlossinge ten vollen geëxpireert is, versoecken hoochelijck dat in de maendt van September, gelijck selffs, mede doen opcomen mogen. Tot dien eynde mijns geringen oordeels, wel dienen soude eenige bequame persoonen voor eerst in Supra om met die van Vadaan, die daer dickwils comen, in kennisse te geraecken gelecht wierden, die als dan bij 't opcomen van geseyde Adriaen ende Jan Huybertsen in Vadaan verder resideren connen. [...].

On the evening of the 13ᵗʰ ditto, I at last returned again from Vadan, or Madan as it is sometimes known, again in Pimaba. To my regret, I learned that the junk (that arrived here yesterday) had already set sail for the little island, situated opposite of Pimaba. The merchandise that was sent to Pimaba by Your Honour, was found to be in the Company's warehouse on the beach, seen and approved of as being according to the supplied account [...], and partly received by me.

(Upon inspection of the trade goods, delivered by the junk commanded by Ensign Jurriaen Smith, Smalbach discovered that 12 pans, exactly those

which were the most in demand (of 14 reals for a hundred pieces), were missing and that also some salt had been taken away by the inhabitants. He complained about that to the regents Redout and Toea. To his regret Smalbach had not been able to return earlier from Vadan but he also thought that the junk had been ordered to set sail to the island first and to call at Pimaba afterwards.)

[...] However, upon my arrival from Vadan, I was informed by the interpreter Anthonij as well as the men who had stayed behind in Pimaba, that when ensign Smith arrived in Pimaba he had told his accompanying soldiers to make free with the oil and vinegar, as well as the few other remaining provisions stored in the Company's house. These items I had bought at my own expense, and they had been carried with great difficulty all the way from Tayouan overland. Consequently there was not a drop of oil or vinegar, which was taken along especially for our invalids as well as for those taken in by the Chinese and which at the moment we all badly need. In my opinion, and regarding this matter ensign Smith, has acted in rather a headstrong way, something which would never have happened if I personally had been present. Therefore I submissively beg Your Honour if you would spare me future problems and skip the sending of such delegations during the short period that I am stationed here.

Secondly, the ensign's lack of respect caused me such humiliation among regent Redout and the other chiefs as well as the ordinary villagers that my attempts in implementing the Company's policy regarding these people lead to nothing. As a consequence this, as becomes clear from the dagregister could easily result in violence.[68]

The regent Redout reverently and respectfully requests Your Honour not to send the above mentioned Ensign Smith again, because it was Smith who sowed discord between himself and the late Sr. Wesselingh. Also Your Honour, upon a letter written by the deceased Wesselingh, decided to recall Smith to Tayouan. (fol. 290) Your Honour can be sure that the things mentioned before, particularly with respect to regent Redout's opinion about the ensign, were not dictated to him out of venom or envy on my part, but indeed are true. When the interpreter Anthonij, in my presence, admonished Redout to attend to the restitution of the stolen pans, the regent replied that he would not be able to return all the mentioned pans as it had been Smith himself who had given away three

medium sized pans to a certain person. Your Honour will know best how to judge if Smith's behaviour was pursuant to his instructions.

It would have been better if ensign Smith, during his visit to the villages had followed his orders to guard the merchandise on the beach against thieves as well as the rain. This probably would have gained him credit instead of harming his reputation as his removal of the merchandise has done.

The Company goods I came upon when I arrived have been transferred to me, and I accounted for them in my missive to you written on 1 April. Before I left for Vadan I saw to it that they were properly stored in the Company warehouse on the beach and left to the responsibility of the soldiers who remained in Pimaba at that time. [...]

The large iron pans of 25 reals for a hundred pieces, of which we still have some in store, are not at all in demand so it would be advisable if Your Honour could send a larger quantity of the medium size ones of 14 real for a hundred pieces.

It would have been better if the brown blue coloured *lanckins* of two mas apiece, would have been of a somewhat finer fabric because some people in Pimaba already have extraordinarily fine quality *lanckins* which they had earlier bartered from the Chinese as well as of some of our own folk. That's why they had not even bothered to take a look at the ones we offered them for sale, telling us that these *lanckins* were hardly any better than the ordinary *cangans*, whereas the *lanckins* used to be of a far better and more delicate fabric. However, because we do not have any other merchandise I do hope that in due time these *lanckins* can be bartered to the surrounding villages for skins, wax, rice, hemp etc. The brown and blue *cangans*, among which we still have a party of black ones that we are not able to sell, are delicate and God willing, they will yield a considerable sum there.

It would be desirable if Your Honour had ordered the despatch of about 25 or thirty pieces of the same delicate lightblue coloured *cangans*, as well as some truly fine *lanckins*, besides some different assortments of beads (except for green coloured ones) that are in high demand. If you can do this we may be able to obtain over 700 or 800 moose-skins, deerskins, and rock-goat skins, as well as rice, hemp, beans, wax and other fruits in large quantities for transportation to Tayouan.

I do not really know what to say about the 158 bundles of Chinese beads in strings, whereas not one of them is blue, light yellow or black, the only colours that are in demand here. The number of angle irons, and old nails brought by the junks, which nowadays can be traded for hemp, is hardly sufficient for the local needs. Moreover there are 28 of small and larger size hooks.

According to the orders given by Your Honour orally, I have taken the Chinese to Supra and its mountains and gorges to investigate what they can best yield us. However they did return to Pimaba, because as they said there was nothing to expect. Unfortunately the 20th of this month one of them died in Lolangh, and because there is nothing else for them to do here, I will send them together with the soldier Lieve Drapiou back to Tayouan.

The Chinese intend to carry out some more explorations on one side or another of the Tacabul mountains, therefore in order not to detain soldier Lieve Drapiou on their behalf, we permitted him to leave to Tayouan on his own, to be able to report to Your Honour soon.

In Supra I received the news that eight days before my arrival, (fol. 291) inhabitants of Supplien, Pallan, Dorcop, Vadan etc. had appeared over there to barter skins for salt.

The regents Redout and Toea were presented with some gifts, according the order given verbally by Your Honour to the ensign Smith and the missive he left for me, for which they render their thanks to Your Honour.

The people of the surrounding villages come in large numbers to barter, however they refused to even take a look at the *lanckins*, of which indeed Your Honour did send us rather a coarse sample. Therefore we were forced to let them go again without any *lanckins*.

The Company's warehouse needs a complete overhaul and the walls on the outside need to be covered by whole bamboo canes because inside nothing can be stored safely against thieves, nor from the multitude of rats, which during my absence managed to eat through the baskets from underneath and badly damaged the red *moussous* that were stored in it. Therefore I have stored these textiles in the old unlocked chests, although it is to be feared that in time the rats will be able to gnaw their way through these as well.

I seriously request Your Honour again (as I already did to you on behalf of Redout in my first letter) to remember the old regent Toea with a costume, because he roams around, whenever he is under the influence of alcohol, in the village making a racket, to such an extent that the regent Redout is frightened by it. Whale or cod-liver oil, candles and taper, as well as a little olive oil and vinegar for the sick and needy, have been not supplied by the junk since the time of the late Wesselingh. Because at the time of my departure, I thought that everything had been provisioned, I did not ask for supplies, so this deficiency also can be attributed to ignorance of my part.

Concerning the rhinestone and other duties that I have to look into upon Your Honour's orders, at the first opportunity I will travel to the mountains situated to the east of Pimaba and the mountains of Pallan where, according to the inhabitants of Pimaba, that mineral is supposed to be found, and make the necessary inquiries in order to inform Your Honour about it in my next missive.

The people of the village Pinassoroo or New Tammalaccauw who, as I wrote to Your Honour in my previous letter, I ordered to stop building houses and to first await Your Honour's permission. I am expecting Your Honour's orders about this case.

The soldiers Adriaen Watermondt and Jan Huybertsen whose contracts (like mine) are running out, seriously do request (like myself) if they, in the next month of September, can be relieved and summoned up to Tayouan. In the meantime, in my humble opinion it would be beneficial to the Company if some able man could be stationed in Supra in order to establish contacts with the inhabitants of Vadan who often come there, so that he, after the return of the mentioned Adriaen and Jan Huybertsen, may continue to reside there. [...].

138. Missive Governor-General Anthonio van Diemen to Vice-Governor Paulus Traudenius.
Batavia, 28 June 1642.
VOC 866, fol. 332-351. Summary.

(fol. 343: Governor-General Anthonio van Diemen expressed his disappointment about the results of the expedition to the northeastern part of the island (in January and February 1642), commanded by Traudenius. In his

own words Van Diemen called it 'like having been to Rome without having seen the Pope', because the men had been so close to the supposed gold-sites in the Cauwelangh mountains, near to the villages Takelis or Lilauw, Cauwelangh as well as about three or four others. Although they had come so close, more out of fear than from lack of provisions, the Company soldiers had left without 'having seen the Pope', that is without having investigated those places thoroughly. Van Diemen already knew how tremendous a loss the death of Wesselingh meant to the Company, because Wesselingh on his own had dared to take many more risks to explore this long hoped-for mineral than the entire expedition army.

Van Diemen was informed that inhabitants of the Cauwelangh mountains travelled to Quelang and that they bartered gold for four weights of silver, but that they did not allow any stranger to enter into their villages. In the Tayouan dagregister[69] it has been noted down (at the entries of 18 June and 9 August 1641), that a certain Chinese Thosim had reported that people from the Cauwelangh mountains did come down to Quelang twice a year in order to offer their gold for sale. He also reported that each time they came, they brought along an amount of gold that weighed about 3000 reals. According to this man also some silver could be obtained from them. Furthermore it was said that small amounts of gold could be found on a beach at the mouth of a certain river that ran into the sea near Takijlis or Lilouw. At that place, where gold was eroded down with the stream it could be found on the beach, the inhabitants gained small quantities while using little baskets and wooden trays. This collected information could well be an indication that gold-lodes were to be found in that area, therefore the time had come to find out the truth about it once and for all.

fol. 344: *The Governor-General was dissatisfied with result of the mentioned expedition undertaken by Traudenius. According to him Traudenius had pursued unsuitable tactics towards the local inhabitants. Although he had an entire army at his disposal, he had failed to force the villagers to submission because he did not inflict any punishment or maintain strict discipline. Batavia urged the Tayouan government to take firm action against all inhabitants whenever they failed to meet with their obligations as that was the only way to make the Formosans respect and fear the Company's authority.*

Van Diemen called the reprisal action against Tammalaccouw (to revenge the massacre of Wesselingh) as inadequate as the expeditions undertaken against Vavorolangh and Davolee (in November and December of the preceding year) (fol. 345) Likewise the Tayouan authorities had refrained from punishing the disobedient ruler of Lonckjouw who, according to Batavia, had deserved the death penalty because during the last expedition, among other things, he had failed to supply the Company men with provisions and even had threatened to kill some of them. [...]

The Governor-General also had been informed that in many of the villages located near Tayouan, superstitious practices still occurred. He hoped that the newly appointed judicial administrators would be able to take measures against this. Even worse was the conduct of the priestesses or old witches, who although they had been banished from their own villages, still managed to carry out some pagan influence on the people. This resulted in the fact that the propagation of the Gospel suffered harmful consequences, therefore Van Diemen ordered them all to be transported to Batavia. [...]

fol. 347: Although the island Bottel [Botel Tobago], situated eastward of Pimaba, was very small, the High Government approved of its exploration. Also it definitely needed to be depopulated, and the islanders had to be transported over to Batavia. It was still expected that the remaining people on Lamey would all be brought over to Batavia so that soon the island would be entirely depopulated. In Batavia the Lameyans as well as other Formosans were quite in demand as they, if only they were guided well, had a reputation to be keen and hardworking. Because the indigenous Formosans in that way could be beneficial to the Company, Batavia ordered Tayouan, whenever anyone would act obstinately, to inflict a punishment on them by sending them over to Batavia. [...]

fol. 351: The High Government ordained the Governor and Council of Tayouan no longer to permit Chinese to frequent Formosa without having the disposal of a Company licence. It was also ordered not to allow any more Chinese to settle themselves among the inhabitants in the Formosan villages.)

139. Instruction from Governor Paulus Traudenius to the Captains Hendrick Harroussé, Johan van Linga, Commander Pieter Baeck and the other officers of the ships *Wijdenes*, *Zantvoort*, *Waterhont*, *Kievit*, *Waeckende Boey*, the junks *Goede Hoop*, *Goede Fortuyn* and the pilot boat on the expedition to Quelang.
Tayouan, 17 August 1642.
VOC 1140, fol. 309-312. Extract.

fol. 312: [...] Ofte het geviele eenige inwoonders van het landt, waermede de Spanjaerden bevredicht zijn ende het gout soo gesecht wert, van handelen, 't sij dan voor ofte na de veroveringh bij U liedens verscheenen, soo zult deselve vrundelijck bejegenen ende met haer in vrede trachten te treden, omme dan haer een weynich te onthaelen, soo geven U liedens bij desen meede eenige weynige cleynicheden die des noodich sijnde, ende daer voordeel mede connende doen, haer uyt des Comp.ˢ naeme moocht vereeren, [...].

fol. 312: [...] At any time some indigenous peoples, who happen to be pacified with the Spaniards in Quelang and who, it is said, barter gold from them, (before or after the conquest of the Spanish settlement) would appear before you, you should treat them in a friendly way. Moreover you should try to enter into peace negotiations, to that purpose you have to entertain them a little for which we have provided you with a few trinkets which, you could turn to account by offering them to those people on behalf of the Company. [...].

140. Missive of the Quelang Council to Governor Paulus Traudenius.
Quelang, 28 August 1642.
VOC 1140, fol. 292-294. Extract.

fol. 293: [...] De Chineesen uyt Tayouan mede genomen om ons wat te rechte te helpen soo in 't landen als in de belegeringe, waren vervaert om ons den wech te wijsen, maer mosten die selffs soecken, als oock van gelijcken de Tamsuyers dewelcke, soo sijluyden ons geseyt hebben, op den 23ᵉⁿ dito met duysent coppen en negen van haer vaertuych aen d'oversijde van 't vaste landt gecoomen waeren volgens hare beloften aen ons gedaen, maer geen vervarschinge mede gebracht, ende conden ons geen voordeel doen met haer pijl en booch, presenteerden om d'inwoonders soo veel affbreuck te doen als mogelijck is, off dat ons mochte helpen ende

sijluyden hare genegentheyt t'ons waerts wilden thoonen, daerop voor antwoort gegeven hebben sulcx mochten doen, naer haer welgevallen. [...].

fol. 293: [...] The Chinese that came along with us from Tayouan in order to offer some help with the disembarkation and the siege of the Spanish settlements in Quelang turned out to be too frightened to show us the way, so that we had to find our own way. The same happened with the inhabitants from Tamsuy who, as promised, on the 23rd of August landed with a thousand men in nine of their vessels on the opposite side of the mainland of Formosa. However, they had not taken sufficient provisions along, and they were of no use with their bows and arrows. They proposed to do as much damage as possible to the local inhabitants [allies of the Spaniards] and asked us how they could assist us as they wanted to show us their loyalty. We answered that they were free to do what they liked. [...].

141. Missive Captain Hendrick Harroussé to Governor Paulus Traudenius.
Quelang, 4 September 1642.
VOC 1140, fol. 313. Extract.
See also FORMOSA UNDER THE DUTCH, p. 189; ZENDING, III, p. 215.

> fol. 313: [...] D'inwoonders van hier ofte Kimpouliers hebben peys gemaect met de Tamsuyers in ons presentie, de selve hebben ons heeden oock haeren vruntschap aengebooden dat niet refuseerden maer belooft assistentie te doen bij alle gelegentheden, als sij ons maer onderdanich wesen wilden, haer sullen houden als broeders uyt den naeme des heeren Prince van Orangien ende d'E. heeren Bewinthebberen der Vereenichde Oostindische Compagnie. Vorders wat aenlangt het gout dat hier ontrent valt, heeft weynich om 't lijff. [...].

fol. 313: [...] The inhabitants from this place or 'Kimpouliers' in our presence did conclude peace with those from Tamsuy. At present they also offered us their friendship, which we accepted, promising, for our part, to lend them a hand on all occasions if they only would behave themselves submissively. Then we, on behalf of the Prince of Orange and the Directors of the United East India Company, were willing to consider

them to be our brothers. Furthermore, as far as the gold is concerned, there's nothing in it in this area. [...].

142. Missive Captian Hendrick Harroussé to Governor Paulus Traudenius.
Quelang, 6 September 1642.
VOC 1140, fol. 314-315. Extract.

fol. 315: [...] D'inwoonders Quimpauliers sijn op gisteren met de vlagge, die haer lieden vereert hebben in teecken van vrientschap met haer te houden, ende sij luyden met ons wederom verscheenen, rapporteerende dat haer sullen transporteren met vrouwen, kinderen en ommeslagh uit 't dorp staende op d'overzijde van 't canael, daer sij voor desen gewoont hebben, maer sijn noch bevreest hoe wij luyden haer alle verseeckeringe belooft hebben ende vrientschap bewijsen maer 't moet mettertijdt coomen die alles sal leeren. [...].

fol. 315: [...] Yesterday the local inhabitants, *Quimpauliers*, returned with the flag we gave them as a sign of our mutual friendship, informing us that they, men, women as well as children together with all their belongings, intended to move their village from the present site across the water where they used to live. However they also expressed their fear that we would fail to keep our promise to offer them protection and friendship. Something which time will tell. [...].

143. Resolutions taken by Field-Commander Johannes Lamotius c.s.
Quelang, 14 September-7 October 1642.
VOC 1140, fol. 301-302. Resolution 14 September 1642.

fol. 301: [...] Alsoo men bij ervaerentheyt bevindt dat in nieuwe geconquesteerde ende veroverde plaetsen veele quade inbreucken, misusen ende onordentlickheden onder 't volck comen te gheschieden, tot groote schade ende nadeel van gem. plaetse, 't welck alhier mede begint in swangh te gaen, soo is 't dat mede (omme all 't selve voor te comen en goede ordere te statueren) in raede goetgevonden ende geresolveert wert dat men bij forma van edictie de naervolgende poincten, peenen ende straffen, verbieden ende den volcken publiceren sal.
Eerstelijck dat noch hoge, noch laege officieren, soldaeten, ofte bootsgesellen, sullen onderstaen haer aende oversijde van 't canael te

transporteren, ofte comen in der inwoonderen dorpen, haer huysen, tuynen ende aencleven van dien, sonder speciale last ende consent (fol. 302) daertoe verworven te hebben.

Ten anderen dat niemant deselvige inwoonders, ergens ofte op eenige plaetse bejegenende, in geenderhande maniere sal bekrencken ofte trachten van 't haere te priveren, opdat egeene redenen van clagen mogen hebben, vermits haer onder ons gehoorsaemheyt ende defensie hebben begeven.

Van gelijcken sal oock niemant der Chinesen tuynen, huysen, mitsgaders alles wat deselvige ende haere persoonen is raeckende in geenderleije maniere onderstaen te beschadigen, dit alles op lijff straffe. [...].

fol. 301: [...] Because experience has taught us that in newly conquered places often misconduct and irregularities occur among the people that will bring about a lot of damage, it was agreed and resolved upon (in order to prevent this from happening and to put things right) issuing out a decree in which the following orders, points, fines and punishments will be made public.

First, neither high - nor low ranking officers, soldiers as well as sailors, will transport themselves across the water, or visit houses, gardens or the like in the indigenous villages, unless special orders are given (fol. 302) for that purpose.

Secondly, while dealing with these inhabitants somewhere, no one is allowed to harm them in any way, or to try and deprive them of what is theirs, so that they will not have the slightest reason for complaints, since they have obediently subjected themselves to us and our protection. Likewise no one will cause damage to the gardens, houses or anything else that belongs to the Chinese or their families, on pain of corporal punishment. [...].

144. Instruction from Captain Hendrick Harroussé for Helmsman Symon Cornelissen, on his journey on the *Goede Hoope* along the Formosa Coast to the Danau River to explore a certain bay on the eastern coast and to investigate if gold can be found in that area. Quelang, 15 September 1642. VOC 1140, fol. 322-323.

fol. 322: [...] ingevalle dat voorn. Bay ende haven ontdect (daeraen wij niet en twijffelen), sal daer in loopen, trachtende met alle uyterlijcke middelen

ende minne de inwoonders te spraecke te comen ende sooveel mogelijck te vernemen naer de gout-minerale ende in wat maniere die wegen ende passagie zijn bergachtig, clippich ofte anders hoe verre ofte het met cleyne vaertuygh op te varen, ofte te voet moet gemarchieert worden, ende opdat des te beeter tot ons voorneemen soude comen, soo werden Ulieden tot behulp ende assistentie mede gegeven twee inwoonders Quimpouliers die daer toe sult employeren soo om met het volck aldaer te spreecken, als opsoecken van de passagie.

Nu tot het ooghwit ende deseyn gecomen zijnde, sult op 't spoedigsten trachten over landt met een brieff te adviseren van U wedervaeren, daertoe één van dese inwoonders ofte alle beyde die de wegh weeten, condt gebruycken ende trachten soodrae als doenlijck is met de jonck van gelijcke herwaerts te spoedigen ende selfs raport aende overheyt te doen. [...].

fol. 322: [...] If you discover the mentioned bay and harbour (which you undoubtedly will), then you will sail into it. There you will, with the use of all outward appearances and in an amicable way try to communicate with the local inhabitants so as to learn as much as possible about the gold mineral, in what way we would be able to reach the sites and if the roads are mountainous, rocky or otherwise. Also you should try to find out if it would be somehow possible to reach those places in small vessels or if it would be better to go there on foot. In order to facilitate our aim in the best possible way you will be assisted by two local inhabitants or 'Quimpauliers' who you should employ both as interpreters and guides.

When you have reached the objective you should try to inform us about your experiences by overland letter as quickly as possible. To that end you can send one of these local inhabitants (or both of them) who are familiar with the roads. Likewise, you should as soon as possible hasten to come over in the junk and bring a report to this government in person. [...].

145. Dagregister Field-Commander Johannes Lamotius on the expedition to Quelang and Tamsuy, 13 September-12 November 1642. VOC 1146, fol. 658-678. Summary.
DRZ, II, pp. 19-44.

(On 20 September the headmen of the nine villages of Tamsuy appeared before Lamotius and his Council in Quelang. They were willing to transfer their land to the Company and they requested to become allies of the Dutch. Two days later, on the 22nd, the chiefs of the villages Kijmaurij, Tapoureij, St. Jago, Talebeouan and Torockjam did the same. On 23 September headman Palijonnabos of Kijpatou and chief Siasou of the village Pinorouan, both situated near the mouth of the Tamsuy River, also came to subject themselves. Interpreter Alonce told the field-commander that 15 villages were situated along and near that river. All the villages together could bring about 4,000 able-bodied men in the field. On 25 September Lamotius left with his army of 528 men on the expedition to Saint Laurens Bay.)

146. Resolution taken by Field-Commander Johannes Lamotius c.s. The village of St. Jago (or Olim Kiwamioan), 28 September 1642. VOC 1140, fol. 305. Summary.[70]

(Following up orders received by the Honourable gentlemen the Governor-General, his councillors as well as His Honour the Governor of Tayouan, Lamotius and his expedition army left Quelang on 25 September to march (accompanied by a few vessels that sailed to St. Jago) to the supposed gold sites. During the expedition the men discovered the roads to be extraordinarily difficult, so much so that it took them three days to reach St. Jago (which distance could be covered by the inhabitants in one day). Furthermore some of the men, as well as quite a number of slaves, had to be left behind on the way as they were completely exhausted and unable to continue the march. The situation became more and more distressing. When the field-commander addressed some of the people of St. Jago to make inquiries about the conditions of the roads situated further south from St. Jago to Cabalangh and on to St. Lourens Bay, he found out that the roads they were taking were still much better than those routes. Those roads seemed to be impossible to take for Europeans who also had to

carry their rifles and other luggage. Moreover, apart from other obstacles, they had to cross three large rivers at least, which could not even be crossed without a vessel by the indigenous peoples, who go around nude. If it actually took them over two days to get there, it would take us, even supposing we could walk there at all, over six days to do so. Consequently, after due consideration, the field-commander together with his principal officers unanimously resolved that it would be sensible to return to Quelang. For the time being it would be impossible to make the journey overland. Further explorations had to be undertaken with a vessel.)

147. Missive Governor Paulus Traudenius to Governor-General Anthonio van Diemen.
Tayouan, 5 October 1642.
VOC 1140, fol. 455-485.
See also FORMOSA UNDER THE DUTCH, p. 189; ZENDING, III, pp. 215-216; DRZ, II, p. 15.

148. Dagregister of Field-Commander Johannes Lamotius on the expedition to Quelang and Tamsuy.
VOC 1146, fol. 666-677. Summary of October 1642.
DRZ, II, pp. 29-41.

(On 1 October the army arrived back in Quelang. On 7 October a Company soldier together with interpreter Alonce returned from a four day journey to the villages situated near Tamsuy. The purpose of their visit was to barter provisions in exchange for some cloth, bracelets, earrings made of glass and copper as well as other trinkets. They had managed to obtain 23 chicken, two pigs, some limes, bananas, sugarcane and sweet potatoes. They reported that they had been welcomed in Kipangas, Kiliessouw and Madamadou. Everywhere they were welcomed warmly, but when the inhabitants had offered them raw salted fish, the Dutch soldier had refused it by saying that raw fish did not agree with him. As a result they had cooked it and offered as many fresh fruits as the two men could eat without asking anything in return. The people had been very curious and said that never before any Dutchman or other European had paid a visit to one of their villages. The soil seemed to be fertile and

the local people were provided with enough rice and other food. It was contrary to their custom to eat chicken.)

149. Resolution taken by Field-Commander Johannes Lamotius c.s. Quelang, 7 October 1642.
VOC 1140, fol. 307-308.

fol. 307: [...] dewijle men bevindt ende bespeurt dat d'inwoonders van Kimaurij ende bijsonderlijck die van St. Jago, hun niet en draegen ende bethoonen als zij in d' opdraginge van hun lant ende begevinge onder onse gehoorsaemheyt bij contracte aengenomen ende belooft hebben. Als namentlijck die van St. Jago ten tijde wij met de armade aldaer verschenen waeren, op onse begeerte ende versoeck ons niet behoorlijck hebben versorght van eetwaeren, waerinne zij hun gantsch onwilligh ende traegh betoonden, sulcx dat men 't selve bij naer per force ende met dreygementen moesten soecken te becomen, niet tegenstaende dat men 't selve met comptanten op staende voet ten alderdierste betaelde 't welck alsdoen (omme hun de maete ten alderuytersten welke meeten ende in 't minste geen oorsaecke van (fol. 308) miscontentement te geven) ongemerct lieten doorstaen, bovendien hun vande Ed. veltoversten belast ende bevolen sijnde (gelijck oock beloofden te doen) om met veertig à vijftig mannen te volgen ende victualie van rijs, visch, ende andre eetwaeren voor 't volck mede te nemen, ende onderweygen aen zijn Ed. ofte 't volck te vercoopen oftte verruylen, ten eynde de soldaten ende andere geen swaeren last van victualie beneffens hun geweer over d'ongemackelijcke wegen senden behoeven te dragen, hebben zij 't selve niet naergecomen, maer gelijck als verachtelijck in den windt geslagen ende contrarie hunne gedane belofte moetwillens versuymt ende gestaeckt hebben, sulx datter niet één man van haer 't leger gevolght is.

Oock mede soo veel van Kimoureij ende Tapoureij als St. Jago, hebbende insgelijcks bij contracte belooft ende wel duydelijck als één van de principaelste poincten gespecificeert omme soo wanneer eenige slaven offe andere van ons quamen wech te loopen ende 't selve tot haerder kennisse gecomen sijnde, dat zij alsdan terstont deselve wech gelopenen leevendigh ofte doodt naer dat sich de saecke toedraeght, weeder (om seecker redelijck daer toe gestelt loon), in onse handen leveren ende brengen souden, 't welcke zij van gelijcke niet naergecomen, maer seeckeren slaeff genaemt Jan Pilet alhier neffens andere in de conquest van dese plaetse becomen en inde mayoors huysinge gebruyct (wel geweeten hebbende dat deselve wech gelopen was) sedert sijn wechloopen tot nu toe opgehouden,

gespijst ende gevoet hebben, alle 't welcke eene al te groote schaede, nadeel ende inbreucke voor dese plaetse soude veroorsaecken. Wert derhalven mede bij gem.ᵉ Ed. heer Veltoversten geproponeert ende den Raedt in deliberatie gegeven, of niet nodich ende dienstigh soude zijn een exemplare straffe aen d'voors. ongehoorsaeme inhabitanten die hunne trouwe beloften ende verbondt hierinne gebroken ende contrarij hunne schuldigen plicht, gedaen ende betoont hebben, te statueren. Alsoo genoeghsaem blijct dat deselve met geen sachte redelijckheyt te bewegen zijn, maer met harde sporen bereden moeten werden, op dat sulcx ofte diergelijcke schadelijcke factiën niet verder commen in te wortelen, mitsgaders met wat middelen ende op hoedanige wijse men 't selve aenvangen ende beginnen zal.

Den Raedt de propositie van zijn Ed. gehoort ende voorders geconsidereert ende overwogen hebbende, wat swaerigheden ende nadeel uyt 't voorverhaelde soude mogen comen te resulteren, is van advijs ende resolveert dienvolgende dat men eenige van de principaelste uyt d'voorn. dorpen, tot 10 à 20 toe, alhier ontbieden ende terstont in apparentie stellen sal, omme naer gedane examinatie ende ondervindingen van saecken tegens de principaelste belhamels ende oprockenaers sonder conniventie sodanich te procederen als men bevinden sal te behooren.

fol. 307: [...] It has been perceived that the inhabitants of Kimaurij and particularly those of St. Jago, do not behave in the way they promised after transferring their lands to the Company, and submitting themselves into obedience, and concluding peace with us. When we arrived with our armada in St. Jago, the inhabitants did not comply with our request to supply us with the necessary provisions. On the contrary, even though we offered to pay them cash at a very fair price, they were quite sluggish and unwilling, so that we almost had to threaten them before we received anything. In order not to arouse their suspicions or cause any (fol. 308) ill-feelings we allowed them to get away with it. Furthermore when the Honourable field-commander ordered St. Jago to send about fifty people along with supplies like rice, fish and other food (which they promised to do) which they could sell or barter en route, so that the soldiers did not have to carry a heavy load of provisions besides their weapons over the difficult roads. They did not meet with the request but brushed it aside as being a contemptuous request, and maliciously broke their pledge so that none of them followed the army.

The people of Kimoureij and Tapoureij just like those of St. Jago, have entered into a contract with the Company, in which they promise to observe the articles of that agreement. Especially the principle point that, as soon as it will come to their attention, they will deliver up, dead or alive, our runaway slaves or other deserters. For this they will be presented with a reasonable reward from the Company. However, they did renege on their promises. Although they knew that a certain slave named Jan Pilet (whom we, besides others, acquired during the conquest of Quelang) who served in major Harroussé's household had run off, they nonetheless offered him food and shelter. All this may cause great damage, disadvantage and subversion to the Company's authority in this place.

Consequently the field-commander proposed that the Council should deliberate whether it might not be necessary to enact an exemplary punishment on the mentioned disobedient inhabitants who have broken our pact and acted unfaithfully. It became clear that nothing would be accomplished by using moderate means, and that in order to avoid such harmful factions from growing deeper we had to dig our spurs into them, and therefore we should look into ways to deal with this problem.

The Quelang Council, having taken notice of the His Honours' proposition, and after careful consideration of any possible adverse consequences, resolved that about ten or twenty of the leading figures of these villages should be invited to come over to the fortress and to apprehend them as soon as they arrived so that after interrogation we could proceed against the principal rogues and agitators in such a way as we believe necessary.

150. Dagregister of Field-Commander Johannes Lamotius on the expedition to Quelang and Tamsuy.
VOC 1146, fol. 666-671. Summary of 7-11 October 1642.
DRZ, **II, pp. 31-44.**

(On 7 October the runaway slave, who used to serve Major Harroussé, was at last delivered up by inhabitants and at once sentenced to death as an exemplary punishment. Furthermore twelve men of St. Jago were taken into custody. The next day Lamotius sent envoys to Kimaurij to invite some of the principal headmen of that village to come over to the fortress,

but they fled into the mountains. Captain Boon was sent over and he managed to take six captives. On 9 October all captives were sentenced and it was decided that as a deterrent six men out their midst were to be hanged in retaliation for their disobedience, unruliness and subordination. The six who were put to death in public on 10 October were: Pantochan, son of the village elder of Sint Jago; Sisinjan, chief of Kimourij and Taporij; Tamorij Alonce inhabitant from Sint Jago; two inhabitants of Kimourij and another man from St. Jago. After the sentence was carried out the remaining captives got permission to return to their villages. They were told that if they would return to the fortress with the Prince's flag they would again be restored to favour. The loyal interpreter Theodore was proclaimed chief of the villages Kimourij and Taporij. The next day, being 11 October, Field-Commander Lamotius left Quelang with a part of his army to occupy Tamsuy. A small fortification would be erected there on the foundations of the demolished Spanish fort.)

151. Instruction from Field-Commander Johannes Lamotius to Lieutenant Thomas Pedel, commander of Tamsuy and his Council.
Tamsuy, 10 October 1642.
VOC 1146, fol. 679-680.
DRZ, II, pp. 45-47.

152. Missive Major Hendrick Harroussé to Field-Commander Johannes Lamotius.
Quelang, 19 October 1642.
VOC 1140, fol. 320-321. Extract.

fol. 320: naerdat U.E. met bijhebbende macht op den 11en stantij naer costy vertrocken was, is uyt het dorp van St. Jago, Mattey die daegs te vooren door U.E. met sijn companyeros uyt de gevanckenisse gelargeert ende ten dien eynde derwaert gesonden sijnde, nevens vijf principaelen hier aengecomen, welckers ongehoorsaem ende wederspannicheyt, die U.E. in 't gemelte haer dorp betoont hebben, item niet naergecomen waeren 't geene belooft ende beswooren hadden. Sulcx haer voorhielden dat tot dien eynde de executie aen de haere gedaen, en andermael wanneer sulx meer gebeurde, met meerder de selve gang (als noch sien conden) gaen soude, waerdoor de schrick soo veer onder haer gecomen is dat se, alhoewel de principaelste sijn zoon selfs geëxecuteert zijnde, sonder meer van de selve

te mentioneren, ons tot nieuwe vrundschap versochten. Sulx naer all het gene volgens d'articulen waernaer hun te reguleren hadden, voorgehouden sijnde, hebben deselve op haer versoeck wederomme als vrunden aengenomen ende Mattey nevens twee anderen vande vijf principaelste als hoofden gestelt. [...]

Die van Kimaurij ende Taporij bevinden nu wel het vluchten haer seer schadelijck [is], want reede van rijs soo benodight sijn dat se niet alleen naer St. Jago, Tamsuy ende andere plaetsen gegaen sijn om te coopen, maer dagelijcks hier voor rijs ende padie tot onser conserfatie visch te coopen bringhen, door welckers noot (veel straffer dan eenich swaert sijnde) sal ongetwijffelt de ingenomen boos-ende hertneckigheyt van dien brutaelen hoop niet alleen geweecken, maer sal haer door vreese tot meerder ontsach aen ons verbinden.

Op gisteren ontrent den middagh is ons U.E. sijne aengenaemlijck in dato 14 stantij per drij Tamsuyers wel geworden, waerinne gesien hebben den 11en des nachts voor Tamsuy Godtt Loff ten ancker gecomen waeren, exempt het jacht de *Waeterhondt* bij welckers tardement ende ongestadich weder U.E. sich tot opmaecken van 't fort seer swack bevonden, edoch dat door de hier gedaene executie de inwoonders door vreese de billicke gehoorsaemheyt heeft doen onderwerpen, hope U.E. vordercomende tot eer ende voordeel continueren sal. [...].

fol. 320: After Your Honour had left Quelang with your men on the 11th of this month, Mattey from St. Jago, whom Your Honour, together with his retinue, had set free from prison and sent back to his village the preceding day, appeared again, as well as five of his principals. We confronted them with the earlier disobedience and insubordination they had displayed to Your Honour, besides their failure to meet with everything they had pledged to do when they had concluded the agreement with the Company. If they again misbehaved themselves then we would inflict punishment on them once again, [in the same way as we had done to the others]. This frightened them so much that, although the chief's own son was among the executed they, without even referring to this, requested the establishment of new friendly relations. We complied with their request and proclaimed Mattey, besides two more of the five principals as headmen. [...]

Those of Kimaurij and Taporij now experience that their escape did them a lot of harm because they are now already in serious need of rice, for the purchase of which they not only go to St. Jago, Tamsuy and other places

but they even come here every day to barter fish for rice. Their need for food is a more severe punishment for them than by any sword. Undoubtedly it not only will neutralise the bias, anger and obstinacy of that savage crowd, but their fear, will inspire awe in them and link them closer to our authority.

It must be quite agreeable for you to hear that we received Your Honour's letter of the 14th of this month, yesterday at about noon, delivered by three men from Tamsuy. From which we learn (God be praised) that Your Honour safely anchored on the Tamsuy roads, except for the delay of the yacht *Waterhondt*, which caused troubles with the construction work of the fortress. Still I hope that Your Honour will be pleased to know that the punishment that was ordered by Your Honour by means of a sanction resulted in the inhabitants' subjection and hopefully this achievement will continue to be beneficial to Your Honour. [...].

153. Missive Field-Commander Johannes Lamotius c.s. to Governor Paulus Traudenius.
Tamsuy, 26 October 1642.
VOC 1140, fol. 316-319. Extracts.

fol. 316: [...] D'inwoonders van Quimaurij, Taporij ende St. Jago, hebben in 't eerste ende in d'overdraginge van hun landt ende submissie onder onse gehoorsaemheyt groote dingen belooft, doch door wijse van doen, hadden hun gantsch ongehoorsaem ende wederspannich bethoont niet tegenstaende wij haer met alle billijckheyt bejegenden, ende met een sacht lijntgen sochten te trecken, gevende haer de maete ten alderruymste vol ghenoch, 't welck alles niet en heeft mogen helpen, derhalven wij genootsaeckt waeren (om een exempel te statueeren ende ontsach te maecken) ses van de principaelste belhamels te straffen ende op te hangen, d'andere hebben 't hooft inde schoot geleyt, ende om vergiffenisse gebeden, ende sijn oversulx wederom in genade aengenomen.

Wij twijffelen niet, ofte gem.[e] inwoonders sullen haer voortaen gewillicher ende gehoorsaemer aenstellen nu sij sien dat het ons ernst is ende lichtelijck daermede doorgaen 't welck hun oock wel serieuselijck gewaerschout ende voorgehouden hebben. [...]

fol. 318: Alhier hebben mede een Cagiaender gevonden die ontrent zeven jaeren geleden van de Spangiarts wegh gelopen is ende tot nu toe hier ontrent bij de inwoonders gewoont heeft, den welcken doch niets goets tot voordeel van de Compagnie soude bewercken, deshalven hem met de

jachten costij gesonden hebbe, alsoo dit landt nootsaeckelijck van alsulcken schadelijcken gebroedsel, soo veel als mogelijck is, dient gesuyvert te werden eer men ruste ende volcomen gehoorsaemheyt van d'inwoonders sal connen erlangen. Den 20en deser wert ons per missive van den Mayoor Herrousee geadviseert dat d'inwoonders van St. Jago, Kimourij ende Taporij door den schrick van de voorige gedane straffe aen eenige van de haere hun nu vrij wat gevoeghlijcker ende gehoorsamer aenstellen, [...]

Ons comt nu op 't laetste te voren ende werden sekerlijck bericht dat den tolck Alonce (die wij op den derden deser met eenige goederen ende comptant van Quelangh naer de naeste dorpen van Tamsuy gesonden hadden, omme eenige verversinge te ruylen) meest alle de voors. goederen ende comptanten in sijn eygen beurse gesteecken ende d'inwoonders op onse namen alle 't geene dat hij den 7en ditto in Quelangh medebrachte om niet afgedwonghen, 't welck mede vrij wat turbatie onder d'inwoonders gebaert heeft. Waer 't dat wij sulx wat eerder hadden geweeten, wij souden hem sijn welverdiende straffe hierover niet onthouden hebben. 't Bedroeft ons hartelijck, dat ons desseyn om van hier te lande naer Tayouan te marcheren door 't verbijzeylen vande *Waterhondt* ende andere intervallen gebroken is. Alsoo wij uyt alle omstandigheden bespeuren dat nu den rechten tijt gebooren is omme dese gantsche custe van hier tot Tayouan onder onse gehoorsaemheyt ende devotie te brengen, want ons niemant van de inwoonders soude derven tegenstaen maer liever, bij maniere van spreecken, op de handen dragen doordien haer onse inneminge ende veroveringe van de Spangiaerders fortressen op Quelangh, ende dat bij exemplare straffe vande ongehoorsame inwoonders van St. Jago ende Kimourij gestatueert hebben een groote schrick ende vreese is aengejaeght 't welck hem over 't gantsche lant verspreyt heeft. [...]

fol. 319: [...] 't garnisoen alhier verblijvende sullen hun met des Comp.s cost, waermede wij haer redelijck ende ten vollen (exempt eenige arack) voor zeven maenden versien sullen laten, moeten behelpen, sonder dat se eenige besondere toevoeringe van verversinge van de inwoonders te verhoopen hebben als alleene 't geene sij selfs met visschen ende jagen connen becomen, gelijck wij selfs mede tot noch toe hebben moeten doen, alsoo deese inwoonders neffens andren daer wij geweest sijn gantsch armelijck leven ende qualijck een hoen ofte ander vee in hun dorp te sien ofte bevinden is, gelijck wij selfs ondervonden hebben.

Voor dese inwoonders heeft 't garnisoen in 't minste niet te vresen ende sullen veyligh genoeg mogen jagen ende visschen (soo hun anders de lust daertoe streckt ende gereedschap hebben), alsoo wij bevinden dat d'selve

inwoonders niet dan armhertige menschen ende gants geen chrijchsluyden zijn. [...].

fol. 316: [...] The inhabitants of Kimaurij, Taporij and St. Jago initially made a lot of promises to us about transferring their lands and subjecting themselves to our authority, yet in their behaviour they showed themselves very disobedient and rebellious, notwithstanding we treated them with fairness and tried to nudge them in the right direction with gentle pressure. Therefore we were compelled (in order to set an example and to fill them with awe) to punish six of the principal rogues by hanging them. Indeed as a result of this the others knuckled under and begged us for mercy, so we were able to restore them to favour.

We do not doubt that the mentioned inhabitants from now on will behave themselves more willingly and obediently, because they can see that we are serious and may easily continue to behave like this for which we have seriously warned them. [...]

fol. 318: Here we came upon somebody from Caganayan[71] who, about seven years ago, ran off from the Spaniards in Quelang and who has lived among the inhabitants ever since. However because he will not be of any use to the Company, and because this land should be cleaned of such harmful scum as much as possible before law and order can be created, we resolved to send him over to Your Honour aboard one of the yachts. On the 20th of this month we received a missive from major Harroussé, in which he informed us that the inhabitants of St. Jago, Kimaurij and Taporij, for fear of the punishment that was inflicted on some of them earlier, at present behave themselves in a more decent and obedient manner, [...].

Recently it also was put forward to us that a certain interpreter named Alonce (whom on the third of this month of October we sent from Quelang to Tamsuy with some merchandise as well as some cash, in order to barter it for certain provisions) had pocketed the money and the other goods. Moreover he, on our behalf, had forced the inhabitants to hand over everything without payment with which he returned to Quelang on the 7th. His actions certainly caused severe anger among those people. If we had known about this extortion before, he would have have received just punishment.

To our regret we failed to carry out our plan to march all the way from here to Tayouan, due to the drifting by of the *Waterhondt* and some other

troubles. As we have noticed from all the circumstances the time has come to subject the entire coast from Tamsuy to Tayouan to our authority, because then not one of the inhabitants would dare to resist us anymore. On the contrary, they would all prefer, as it were, to be devoted to us because of our conquest of the Spanish settlements on Quelang. Furthermore the exemplary punishment we inflicted on the disobedient inhabitants of St. Jago and Kimaurij caused enormous fear among them and the news about that event got around the whole island. [...]

fol. 319: [...] The garrison, which is stationed over here, will just have to manage as best as it can with the Company's rations and we have provided the men with sufficient food for seven months (except for some arrack). They will not have to expect a lot of refreshments from the indigenous peoples, apart from what they are able to get for themselves by fishing and hunting, something which we used to do ourselves as well because the inhabitants of this place, and the other places we visited in this area, live in poverty. In their villages poultry or other livestock is hardly to be found, as we found out ourselves. [...].

The garrison does not have to fear anything from these inhabitants and they will be able to go hunting and fishing safely (if they would feel like it at all and if they would use the proper equipment) because we do find that those inhabitants are nothing but poor people, and not being warriors at all. [...]

154. Interrogation of a certain Castilian named Domingo Aguilar, on the order of Governor Paulus Traudenius and carried out by representatives of the Formosa Council, in the conquered fortress Quelang concerning the location of the gold deposits on Formosa.
Quelang, undated [October 1642].
VOC 1140, fol. 445-447.

> 1. Hoe sijn naem is, waer van daen, hoe oudt van jaren, ofte oock getrouwt ende hoe lange in Quelangh sijn plaetse gehadt heeft ende of 't in dienst van den Coninck ofte een vrij persoon is ende oock eenige kinderen heeft?
> Antwoort: Domingo Auguilair, van Tafcale, oudt nae sijn ondthoudt 38 jaren, getrouwt met een Formosaense vrouwe, ende aldaer in 't jaer van anno 25 gecoomen eer het casteel begonnen was, was een vrij persoon

ende in 14 jaren niet in dienst van den coninck geweest, heeft geen kinderen, maer een creado.

2. Off hem oock bewust is, ofte eenige kennisse heeft dat op Formosa goudt valt, ofte eenige goudtmijnen voor handen sijn ofte ontdeckt mochten connen werden?

Secht Ja ende in Torraubouan te vallen, ende is een uytwerpsel uyt het geberchte in zee, maer 't welck met het seewaeter een tegenspoelinge maeckt, ende alsdan naderhandt gevonden wert, sijnde 't selve sandt alsoo geschept met backen ende al gestadich spoelende naderhandt op de grondt blijft zitten.

3. Waer en hoe verre de selve van Quelangh gelegen ende hoe die plaetsen genaempt sijn?

Omtrent veertig Spaensche mijlen Tarraboan, Amadola ende voorts op strandt.

4. Off voorn. plaetsen van daer te lande connen ofte te water met eenich vaertuych besocht werden?

Secht met cleyn vaertuych moeten besocht werden alsoo door seeckere inwoonders genaempt Parockaron, seer wreevelich volcq, geen passagie te lande verleendt wert.

5. Off die passagie te lande moeyelijck is ende hoe veel dagen daer mede souden doorgebracht werden eer aldaer souden aencoomen?

Secht een seer moeyelijck ende steyle passagie is, ende soude in 15 dagen connen voleyndt werden.

6. Welcke passagie men aldaer toe souden gebruycken en of hij daer ontrent wel geweest heeft ende aldaer goudt gesien bij eenige inwoonders ofte wilden ende ofte oock des inwoonders spraecke kent?

Secht wanneer goedt ende bequaem weder is wel te waeter can besocht werden, ende andersints 't selvige te landt moet geschieden inde maenden April, May, Junio, Julius ende Augusto, maer de wilden gaen niet anders als inde maenden April, Augustij, Januarij ende Februarij. Secht aldaer selfs geweest is ende 't sandt in sijn mondt gehadt ende alsoo het goudt uyt gevonden, ende is den wech van Quelangh eerst op St. Jago zeven mijlen, ter zee is inde goede tijdt wel te reysen maer te lande moeyelijck. Van St. Jago tot Cabelloan tien mijlen te waeter dicht aen 't landt, maer te lande mede moeyelijck, van Cabelloan tot St. Lourenzo tot Manin zes mijlen can mede te waeter ende te lande besocht werden. Van Manin tot een witte sandt strandt zes mijlen waer alreede goudt valt. Van daer tot Taraboan zes mijlen, ende aldaer is de grootste quantiteyt. Verclaert 't selve persoonelijck tot St. Lourenso te lande ende voorts tot Tarraboan alles te waeter besocht heeft, ende secht de spraecke volcomentlijck te

kennen. Waerover de gouverneur ofte padres hem nooyt hebben willen
laeten nae Manilha vertrecken, als alleenich over vijf jaren waer, ende
daer niet meer als zes maenden geremoreert heeft ende voorts nae Iloco
ende daer nae nae Kakeyen vertrocken ende eyndelijck weeder door 't
bidden ende smeecken der padres over drie maenden geleeden in Quelangh
geretourneert is.

7. In wat forme het goudt aldaer is, berchachtich, sandich, ofte oock tot
platen gesmolten ofte andersints bereyt?

Secht door 't affwaeteren in de revieren wanneer petjens affvloeyen 't
selve sandich ende wanneer 't hardt regent ende hart wayt in stucken
gevonden wordt ende selffs daervan om sijn hals gedragen heeft [...].

8. Offe het goudt bij de inwoonders in eenige estime ofte waerdije
gehouden wert ende van haer wel can gehandelt worden?

Secht nu in estime is door de Spaengiaerts ende Chinesen maer eerst
soodanich niet, costende nu een reaal swaerte zes reaal, voor dees tijdt
ende eerst twee reaal goudt een reaal silver, daer na gelijck geweest ende
daernae een reaal goudt twee reaal silver ende eyndtlijck tot prijs als
boven.

9. Wat waeren ende goederen men aldaer moet brengen, om goudt weder
in plaetse daer vooren te becoomen ende hoe dat de prijse van tijdt tot tijdt
verhoocht is?

Secht de waeren die daer moeten gebracht werden om met de wilden te
handelen sijn ijsere pannen, gesoute visch, ijser om ploegen te maecken,
Chineese rocken van cangans, ende kennippe lijwaeten, sout, cleyne
coopere bellen ende schellekens, ende oock eenige coopere armringen,
ende dick getrocken fijn silverdraet, oock realen van 8en, ronde (fol. 446)
dicke copere armringen met slange becken, oock eenige platte zee
hoornen, eenich gecouleurt groen ende geel courael, ijsere parrings, ende
eenige gemaeckte flitzen om harten te schieten, ende secht door de
graegicheyt der Chineesen ende Spaengiaerts, soo hooch in prijs
geclommen is.

10. Off haer de inwoonders oock met eenich goudt 't sij in haer hair, om
de hals, armen ende beenen ofte andersints haer lichaem cieren, ende op
wat voor maniere het aldaer bij haer gedragen wert?

Secht haer met eenige platen goudt, tuschen silvere ingevoucht alleenich
op de borst vercieren, maer de vrouwen cleyne stucken aende vingers
dragen 't welcq alsoo hangende haer tot wanneer vrolijcq sijn tot cieraet
verstreckt ende aldaer mede vrolijckheyt bedrijven.

11. Off hij al wel verseeckert is, dat soodaenige ornamenten van goudt ende niet van eenich cooper soude gemaeckt sijn, ende waer bij hij sulcx seeckerlijck weet?

Secht seeckerlijck sulcx te weten alsoo verscheyde maelen 't selve op den toetsteen, daertoe bij hem hebbende geprobeert heeft ende dat aldaer geen coper valt maer dat nae de Chineesen aldaer cooper, ende Castiliaenen silver gebracht hebben, 't selve wel bij haer vermengt wert, doch dat hetselve meest bij de Chineesen geschiet.

12. Op welcke tijdt van 't jaer het selffde best ende bequaemst is te ondersoecken, dan off tot allen tijden can besocht werden.

Refereert sich aen 't 6ᵉ articul.

13. Off de wilden waermede de Spaengiaerts in vreede sijn met voors. inwoonders wel handelen ende eenich goudt daer vooren becoomen, ende hoe de handelinge tusschen haer geschiet.

Alleenich eenige inwoonderen van Kimaurij ende omdat de andere niet vertrouwen ende vijanden sijn met deselve noch ende de handelinge geschiet met de goederen als boven in 't 9ᵉ articul verhaelt staet.

14. Alwaer 't schoon dat de voors. inwoonders noch vijandich met haer waeren off die selve plaetse met geen macht van volcq te bemachtigen soude weesen ende hoe 't selve met bequaemheyt soude connen geschieden.

Secht also hij daer ontrent bekent is, met één à twee persoonen daer seeckerlijck gaen can ende dat deselve plaetse met macht aentastende d'inwoonders daervan wel te dwingen soude sijn, maer oordeelt beeter met vrientschap 't selve soude geschieden.

15. Off hij oock eenige kennisse gehadt heeft dat van onse Nederlanders om de Oost van Formosa sijn, ende off het verre daer noch van daen is daer het goudt valt.

Secht ja, ende noempt een Duytsman seggende genaempt Adriaen, die in Vadan lecht, ende oock eenige brieven van onsen gouverneur aldaer gehadt heeft, ende dat eenen Balthasar de Columbe seecker brieff van de Taraboanders hadde becoomen, die aldaer van Adriaen Waetermondt verlooren bij haer gevonden is, ende oock bij den gouverneur in Quelangh gebracht is ende bij voors. Balthasar gelesen. Van inhoudt sijnde om eenige vellen voor de Comp.ᵉ aldaer op te coopen ende dat ontrent 1½ dach reijsens te waeter daervan het goudt mede valt, dat hij meynt indien in seeckere bergen, hem bekent, gegraven wierdt, groote quantiteyt goudt soude te becoomen zijn. Heeft in alle de dorpen Sibilien, Vadan, Talaroma, ende andere aldaer omleggende geweest is, ende verscheyde varckens geruylt. Secht een schelmachtich volq te sijn, ende oock kennisse

te 'hebben dat ons volcq aldaer met macht geweest is ende seecker Hollander in een reviere verdroncken, ende dat de Chineesen, ende andere swarten onse bagagie gedragen hebben, ende naderhandt selfs Adriaen heeft willen opscherpen om hem van daer te lichten off het leven te benemen.

16. Wanneer het nu seecker is ende de aengeweesene plaetsen gevonden sijn goudt te geven wat quantiteyt hij wel vermeynt men daer jaerlijcx soude connen becoomen?

Secht gesamenlijck in 't generael uyt Taraboan 1 picol swaerte ende met de witte strandt 1½ picol wel soude connen opgebracht werden.

17. Waerom eerst in Quelangh wegens den coninck soo grooten macht van 1400 coppen sterck aldaer geweest is, ende tegenwoordich ende weynich daervooren met soo cleyn guarnisoen versien bleeff?

Antwoordt dat eerstelijck de macht aldaer gebruyckt is om de inwoonders tot devotie te brengen ende dat in 't eerste door de veranderinge des luchts groote sterfte geweest is ende allenskens soo verslapt.

18. Wat insichten heeft de coninck gehadt om 't selve landt te vermeesteren?

Alleenich omdat aldaer eenige Japanders ende Chineesen frequenteerden, om deselve tot Christenen te brengen maer niet om eenige negotie.

19. Waerom over eenige jaren ettelijcke blancken gemassacreert sijn?

Antwoordt dat de selve (alsoo onder haer rijs mancqueerde ende aldaer quamen te handelen) door schelmachtich verraedt gemassacreert sijn, gelijck hij selfs verclaert doen in Cabellan mede was om rijst te coopen.

20. Waerom hij aldaer, alsoo kennisse van goudt hadde, geen groote middelen vergadert heeft, nademael hij aldaer soo bekent met de inwoonders geweest is ende daertoe bequame gelegentheyt gehadt heeft, oock wel geweten in wat estime 't selve bij de Spaengiaerts ende andere natie is?

Omdat daer noyt geen licentie toe vande gouverneur gehadt heeft ende door schroom 't selve niet heeft willen ondervinden om dies wille dat niet gesuspecteert soude werden van groote rijckdom ende daerdoor 't leven namaels soude comen te verliesen. (fol. 447)

21. Off hij niet genegen blijft om alhier te verblijven ende sijne behulpsaemheyt tot het selve te becoomen te thoonen wanneer een goet tractement genieten mach?

Secht ja, ende niet wel genegen is om naer Batavia met de andere Spaengiaerts te vertrecken, alsoo in groote haet bij haer is, maer bereyt ons in alles te dienen, excepto dat niet anders mach gebruyckt werden als in soodaenige geleegentheyt ende dat van slagen mach geëxcuseert werden.

22. Waerom soo lange jaren hier in dese quartieren gecontinueert heeft ende herwaerts gecoomen is, ende wat hem bewogen heeft te trouwen met een Formosaense vrouwe?

Secht wanneer een cleyne jongen van twee jaren oftte daer ontrent out was in Mexico gecoomen is, ontrent tot sijn 15 à 16 jaren daer verbleven, voor jongh bootsman van daer in Acquapulco gecoomen, ontrent een maendt aldaer sijnde sieck geworden weder naer Mexico geretourneert is, daer in de tijdt van twee jaren een ongeluck gecreegen hebbende ofte een nederlage gedaen, is gevangen naer de Manilha gevoert ende aldaer vijf jaren op de galije voor soldaet gedient, ende van daer in Quelangh sijn resterende tijdt in de dorpen als vrijman, excepto vijf jaren in conincxdienst geweest is, ende daerinne alles ondersocht ende bij experiëntie bevonden.

23. Waer vandaen sijn vrouwe geboortich is ende oft bij de inwoonders eenige vrientschap daer door geniet, alsoo seer voor haer in 't overgaen des fortresse geintercedeert heeft.

Antwoort van St. Jago geboortich te sijn, secht van den overste van Taparij's vrientschap is, die hier in Quelang geweest sijn, genaempt Kilas sa Romana sijnde den broeder van sijn vrouws vader ende daer door geniet hij voor sijn eygen een sulpherberch met een clooff daer seer goeden sulpher valt.

1. What is his name, where is he from, how old is he, is he also married, and since when has he been residing in Quelang, as a free man or in the service of the king of Spain, does he have any children as well?

Answer: Domingo Aguilar, of Tafcale,[72] according to his memory he is 38 years of age, he is married to a Formosan woman, and he arrived on the island in the year A.D. 1625, before the castle was built,[73] he was a free man and had not been in service of the king for fourteen years, he did not have any children but a *creado*.[74]

2. Does he know whether any gold can be found on Formosa, or whether there are any goldmines or whether they may possibly be explored?

He says yes, and that the gold deposits are to be found in Tarraboan, and that it concerns erosion from the mountains into the sea, and that the gold can be found at a certain spot where the seawater meets with a counter current. It is shovelled up with sand in a bin in which, after continuous rinsing, the mineral remains on the bottom.

3. Where and at what distance is this site situated from Quelang, and how are those places named?

The places are named Tarraboan and Amadola and are situated on the beach at about forty Spanish miles from Quelang.

4. Can the mentioned places be reached by land or only by sea with a vessel?

He says that they have to be visited with small craft, because no passage is granted over land by a certain rancorous people named Parockaron.

5. Is that route overland difficult and how many days would it take to reach that place?

He says that it is a very hard and precipitous route, and that it would take about 15 days to accomplish that journey.

6. What road should we take there and had he been there himself, whether he had seen any gold at that place in the hands some inhabitants or savages, and also if he mastered their language?

He says that when it is fair weather the place can be visited by sea, otherwise it can be reached via land but that has to be accomplished during the months April, May, June, July and August, but the savages themselves only go there in the months of April, August, January and February. He tells us that he himself has been to that place and that he, putting some sand into his mouth, had managed to gather some gold out of it. The first part of the road, from Quelang to St. Jago is seven miles, which is easy to reach by sea in the right season, but very difficult to accomplish overland. From St. Jago to Cavalangh is ten miles and can be accomplished by sea remaining close to the shore, but again it is very hard to make that journey by land. The six miles from Cavalangh to St. Lourens to Manin can be covered by water as well as by sea. From Manin onwards one reaches a white sandy beach after about six miles where gold may already be found. The distance from there to Tarraboan, where one comes across the largest quantity of gold, is another six miles. He stated that he personally had travelled by land to St. Lourens and from there on had continued to Tarraboan by sea. He affirms that he has mastered the local language, as a result of which neither the governor nor the *padres* ever permitted him to leave for Manila, except for one time, five years ago, when he stayed there only for six months after which he continued to Iloco and afterwards to Caganayan.[75] But he had returned to Quelang three months ago, because of the begging and pleading of the fathers.

7. In what shape can the gold be discovered there, in the rocks, in the sand, or is it already beaten in plates or wrought in some other way?

He says that it is deposited in the rivers by the drainage, flowed down by little streams within the sand. When it rains heavily or during a gale one can come across somewhat larger nuggets. He used to carry one such piece around his neck. [...]

8. Do the inhabitants themselves value the gold and do they barter it?

He says that nowadays, contrary to former days, it is valued because of the value attached to it by the Spaniards as well as by the Chinese, and that a nugget of gold with the weight of one real at present amounts six reals of silver, while before two reals of gold were valued at one real of silver. Then the value was equal for a while, but afterwards one real of gold came to be valued at two reals of silver until the price reached the present level as mentioned above.

9. What merchandise should one carry over there, in order to exchange it for gold and what price increases have taken place?

He says that the commodities that should be taken over there for bartering purposes with the savages are iron pans, salted fish, iron to manufacture ploughs, Chinese coats made of *cangans*, hemp cloth, salt, little copper bells, as well as some copper bracelets, some quality silver wire, reals of eight, round (fol. 446) thick copper bracelets with snake's heads, as well as some flat seashells, some coloured green and yellow beads, iron machetes, and some slings to employ for deer hunting. Because of the eagerness of the Chinese and the Spaniards to obtain gold, the prices had increased.

10. Do the inhabitants embellish themselves with some gold, either in their hair, around the neck, arms, legs or elsewhere on their bodies, and in what way do they wear these adornments?

He says that the men adorn themselves with some plates of gold, worn only on the breast in between some silver ones, but that women do wear little pieces of gold around their fingers which dangle in a certain way, so that they are used to wearing these adornments when making merry, to add to the gaiety.

11. Is he able to say with certainty, that such adornments, indeed are manufactured of gold and not of copper, and why is he sure about that?

He says he knows for sure because on several occasions he tested the material with a touchstone he carried along with him. Moreover, no

copper can be found there, although the Chinese import copper and the Castilians bring along silver. Only the Chinese sometimes mix these with gold.

12. What time of the year would the most appropriate period to explore that particular part of Formosa, or can it be visited at all times of the year?

He refers himself to the 6th article.

13. Do the savages with whom the Spaniards maintain peaceful relations, trade with the mentioned inhabitants, have they ever managed to obtain any gold, and how does the bartering takes place?

Only some inhabitants of Kimaurij have done so because they do not trust the other peoples and see them as enemies. The trade is carried out with the merchandise mentioned in article nine.

14. If the mentioned inhabitants were still their enemies, would they not be able to conquer that place by force with an army and in what way could that best be undertaken?

He says that he himself is not familiar with that place, but that first he could go there accompanied by one or two persons, but that the mentioned place surely could be subjected by force although it would be better if that would happen in a friendly way.

15. Did he know that our Dutchmen are staying on the east-coast of Formosa, and at what distance are the gold-sites situated from their places of residence?

He says yes, and mentions the name of a Dutchman called Adriaen,[76] who is residing in Vadan, and who received some letters from our governor, and also says that a certain Balthasar de Columbe got hold of a letter given to him by the people of Tarraboan, which had been lost by Adriaen Waetermondt at their village and had been found by them. This intercepted letter, which was then delivered to the Spanish governor in Quelang and read by the mentioned Balthasar, dealt with the following contents: Watermondt proposes to buy some deerskins for the Company in Vadan. Furthermore he states that at a distance of about 1½ day journey by sea, gold is to be found. He thinks that if digging should be undertaken in certain mountains, well known to him, a considerable quantity of gold could be found. He has visited Sibilien, Vadan, Talleroma, and all the surrounding villages and he has bartered several pigs. According to Watermondt the inhabitants are a villainous nation.

When a Company army had visited that area one Dutchman drowned in a river.[77] On that journey the luggage had been carried by Chinese and other 'blacks', and afterwards Adriaen himself had urged his superiors to discharge him and permit him to leave Vadan or otherwise he would commit suicide.

16. When we will be ascertained that gold can be found at the indicated places, what quantity could be mined annually, in his opinion?

He says that yearly all together one *picul* of gold can be got from Tarraboan as well as another 1½ picul from the white sandy beach.

17. Why was the royal Spanish force in Quelangh originally so strong with 1,400 men, while at present (already for some time), it is only occupied by a small garrison?

Domingo Aguilar answers that the force was used for subjugating the inhabitants, but because of the changes in the air many people had died. Consequently the garrison gradually became depleted.

18. What reasons did the king have for the conquest of the mentioned place?

Only because some Japanese and some Chinese used to frequent the place. The conquest was made in order to convert them to Christianity but not because of the trade.

19. Why were several white men massacred a few years ago?

He answers that, because they suffered from shortage of rice, they went there to barter, and that they were murdered because of treachery. At that time he himself was sent out as well to buy rice in Cavalangh.

20. What is the reason for the fact that, although he knew about the gold, he did not manage to accumulate a fortune himself, especially since he became acquainted with the inhabitants he must have had a good opportunity to do so, the more so because he must have been aware how much it is valued by the Spanish as well as by any other nation?

Because the governor never licensed him to do so, and because of diffidence he never dared to find out. He did not want to become suspected of owning great riches, and as a consequence lose his life. (fol. 447)

21. Would he be willing to stay on in Quelang in order to enter Company service and enjoy a good salary and help us out?

He says yes, and confirms that he is not quite willing to leave with the remaining Spaniards to Batavia, because he is despised by them, but that

he surely is willing to serve us well and assist us with everything if he is not beaten.

22. Why did he continue to live in these parts for so many years, for what reason did he come to this region anyway and what moved him to marry a Formosan woman?

He says that he arrived in Mexico when he was a small boy, about two years old. He stayed in that country until he was about 15 or 16 years old. Then he went, in the position of young boatswain, to Acapulco. After about a month he became ill and returned to Mexico City. Two years later he met with misfortune as he had committed manslaughter, and consequently he was transported as a prisoner to Manila, where he was condemned to serve a five-year sentence as a soldier on the galleys and subsequently in Quelang. Since then he lived as a freeman in the villages. Everything he had explored and found out about the situation in northern Taiwan he learned through his own experience.

23. What is his wife's place of birth, do the villagers extend friendship to him because of his marriage, since he made every effort to intercede between them and us at the time of the surrender of the fortress?

He answers that she originates from St. Jago, and that she belongs to the kin of the headman of Taparij: Kilas sa Romana, who himself had come to Quelang,[78] and who is the brother to his wife's father, and because of these family ties he possesses the ownership of his own sulphur mound and a gorge in which a spring with good quality sulphur is to be found.

155. Original missive Governor Paulus Traudenius to the Amsterdam Chamber.
Tayouan, 3 November 1642.
VOC 1140, fol. 448-454.
FORMOSA UNDER THE DUTCH, pp. 191-192; ZENDING, III, pp. 220-222.

156. Articles and conditions presented by Field-Commander Johannes Lamotius and the Quelang Council to the inhabitants of Formosa who have accepted these rules and are willing to be united under Company protection.
Quelang, undated [10 November 1642].[79]
VOC 1146, fol. 713.

Eerstelijck dat sij aen de Nederlanders hun lant gewillichlijck ende bereyt sijn op te draegen, ende sulcx metterdaet zullen doen blijcken, ende voorts de selve natie gehouw ende getrouw te blijven, nu ende ten eeuwigen dagen.

Dat geen wapenen teugens ons ofte imandt van onse geallieerde vrunden ende bontgenoten, nochte tegens den geenen alwaer wij ende sij jegenwoordich mede vereenicht sijn en sullen aenneemen ofte gebruycken, om geenderley oorsaecken maer ter contrarij alle hulpe, faveur ende bijstant met goet ende bloet te bethoonen ende specialijck ingevalle eenige van onse ofte van onse geallieerde met hun jachten, joncqen ofte andere vaertuych op haere strant quame te vervallen ende te verongelucken dat sij alsdan de selve hunne leven, goederen ende vaertuych getrouwelijck sullen helpen bergen ende ter naester plaetse van ons garnisoen ofte fortressen te helpen brengen.

Dat soo wanneer een prince vlagge met een siap ofte merck gelijck haer mede gegeven is, in haer dorpen wert verthoont, hunne outsten ende oversten terstont aen 't casteel op 't eylandt Quelangh zullen verschijnen omme t'aenhooren ende naer te coomen, soodanige ordre ende last als hun bij de respective overicheden aldaer sal werden gegeven.

Dat mede in gevalle onse jagers ofte imant van onse geallieerde bontgenooten in ende ontrent haere plaetsen mochten comen te verdwaelen sij d'selve wederom sullen terechte brengen, sonder eenige hinder ofte impechement te doen ende ter contrarie alle wechgeloopen ende gevluchte swarten ende andere, 't sij vrije ofte lijffeygenen, die sij souden mogen vernemen, terstont ende sonder te vertoeven soo metter minne als met gewelt, ende in cas van groote oppositie der selver hooffden ofte coppen aen 't vers. Quelangh ofte elders alwaer die thuys hooren sullen brengen, waer voor hun een redelijcke recompense sullen doen.

Dat insgelijcks gehouden sullen sijn, soo wanneer wij met eenige inwoonders in oorlooge quamen te geraecken ons met een gantsche macht t'onser eerste requisitie te comen assisteeren, t'welcken wij insgelijcks tegens haere vijanden tot hun bescherminge sullen doen, behoudelijck dat

den oorloch in reeden bestaet ende met kennisse bijder handt genomen wert.

Eyndelijck dat alle de naeste gelegen dorpen eens ter weecke, ende de veerste eens in de veertien daegen, alhier met aert- ende boomvruchten, als mede met hoender eyeren, vis, groot ende cleen beestiael op den passer om te venten zullen verschijnen, welcke goederen hun in redelijckheyt affgecocht ende met gelt, cleeden ofte andere waeren ten dancke sullen betaelt ende voldaen werden.

Eyndelijck ende ten laesten alsoo dese articulen tot ende op approbatie van onse hooge overicheyt geslooten ende beraempt sijn, soo sullen d'inwoonders ofte hooffden van dien, alle veranderinge, verminderinge ende vermeerderinge welcke niet anders als in redelijckheyt bestaen sal, mede gehouden sijn aen te nemen, ende te accepteeren gelijck dese bovenstaende articulen mede gedaen hebben.

First, that they will voluntarily offer their land to the Dutch, and that they will actively demonstrate their fidelity and allegiance in all eternity.

That they will not raise up arms against the Company or any of our allied friends, nor for any reason whatsoever, against those with whom we, as well as they themselves, are presently at peace with, but that on the contrary they will offer them all help, support and assistance, especially if some of our people or allies run aground or are wrecked with their yachts, junks or other craft on their beaches, when they will have to loyally assist in rescuing the people from drowning as well as salvaging the goods and the vessels and see to it that everything is brought to one of our nearest fortresses or garrisons.

Whenever a Prince's flag together with a seal or identifying mark, similar to the one which has been given to them, is shown to them in their villages, their elders and headmen should immediately show up at the fortress on the island of Quelang, in order to be informed of any order or commission that the authorities wish to give them, and any obligations they must fulfill.

That also if any of our huntsmen or one of our allies, should get lost in or near their places, they will have to see to it that he is brought back safely; but on the contrary that they will immediately bring in all runaway 'blacks' and other fugitives, whether freemen or slaves, whom they might run across, either with or without the use of force. And if such people show strong opposition they are allowed to bring the runaway's head to

Quelang or elsewhere, for which the Company will give them a reasonable recompense.

That also they must assist us with their entire force, whenever we enter into war with some rebellious inhabitants. Likewise we, in our turn, will assist and protect them against their enemies, if the war is based on reasonable arguments and is undertaken after serious consideration.

That the people of all neighbouring villages once a week, and those of the most remote places once in fourteen days, will appear at the market over here to sell earth- and tree fruits, hens eggs, fish, as well as large and small livestock. For their merchandise they will receive a proper price either in cash or in textiles or other goods.

Finally and at last, that these articles will be drawn up and concluded with the approbation of our High Government [at Batavia]. Therefore the inhabitants or their headmen will have to undertake and accept all adjustments, reductions or increases, provided that every change is implemented for good reasons in the same way as the here mentioned articles have been formulated.

157. Extract of the missive from Field-Commander Johannes Lamotius to Governor Paulus Traudenius, dealing with the punishment of rebels.
Vavorolangh, [27 November] 1642.
VOC 1141. fol. 141.

Op gistere een wijle naer den middach comt ons U.E. missive van den 21en deser per onse soldaten alhier in Vavorolangh (alwaer wij des voormiddaechs met onse chrijchsmacht wel aengecomen waeren) wel ter hant, ende verstaen daer uyt dat de drije Favorolangers ende twee Chineesen uyt Wancan aen U.E. gesonden, aldaer wel aengecomen ende in goede verseeckeringe genomen waeren om parate executie daermede te doen.

Wij hebben mede op onse aenkomste in de mondt van de reviere Poncan drie Vavorolangers, die voor desen den coopman Hans Ruttens ende sijn geselschap soo schandelijck vermoort hebben, ende aldaer van eenige hooffden off cappiteyns van geseyde Vavorolangh in onse handen gelevert, stante pede (naer dat wij van alles wel bericht waeren) in praesentie van ses Vavorolangers aen een pael gebonden de rechter hant affgecapt, voorts

geharquebuseert, de coppen affgeslagen, ende op staecken gestelt, laetende de lichaemen daer bij leggen ende aldaer verblijven.

Alhier comende (gelijck oock in voors. Poncan, 't Geusebosien ende dicht voor 't dorp alwaer de principaelste ons gemoeten) hebben de geseyde inwoonders ons vertoont ende met vele redenen bewesen dat sij niet schuldich en waren aen de ongehoorsaemheyt nochte rebellie door anderen begaen. Maer hebben oock twee van de aldaer principaelste cappiteyns ende rebellen opgehitst [die] ende een grooten aenhangh gemaeckt hebben, beneffens seven Chineesen die alhier lange gewoont ende uytermaten veel quaets voor de Compagnie hebben gebracht, in onse handen gelevert, ende daer beneffens aengewesen de huysen ende goederen van d'andere moetwillichen die gevlucht ende wechgeloopen waren. Thoonende hun voorts willich ende bereyt om de geseyde gevluchte rebellen als mede de moordenaers van Gielim ende andere moetwillichen met allen ernst ende vlijt te vervolgen ende, soo 't hun mogelijck is, in onse handen (om gestraft te werden) te leveren 't welck tot noch toe door hun onvermogen, ende dat hun parthije te sterck was, niet en heeft connen geschieden. Oock hebben ons van coste ende dranck volcomentlijck versorcht ende de tafel voor onse aencompste gelijck als gedeckt gehadt, sulcx dat wij tot soodanigen resolutie om de ontschuldige met de schuldige te straffen, niet en hebben connen comen.

De voorschr. cappiteyns ende seven Chineesen, hebben mede op staende voet, sonder langh beraet, doen onthalsen, hunne huysen ende goederen, beneffens 't geenen dat van de gevluchte moetwilligers bevonden, t'eenemael geruyneert ende verbrant, waermede wij noch niet voornemens sijn op te houden ende uyt te scheyden maer sullen hun onse macht ende voirdere straffe noch wel beter doen gevoelen.

Wij sijn van voornemen heden ofte morgen, als wij ons volck wat vervarscht ende 't lichaem een weynich gesterckt hebben, met de macht naer Gierim te marchieeren ende deselve onse wapenen te doen gevoelen, ende soodanich te straffen dat voortaen weynich lust sullen hebben, hunne ooren meerder op te steecken nochte eenige moetwille aen d'onse te betoonen, gelijck wij vertrouwen dat die van Vavorolangh mede niet en sullen doen, alsoo sij selffs bevinden ende nu eerst ter deegen beginnen te bemercken, dat wij daer niet mede gecken, ende de Chineesen ende andere quade oprockenaers, hun niet dan al te schadelijck sijn ende ten bederve soecken te brengen. […].

Yesterday in the afternoon, a while after we had safely arrived with the army in Vavorolangh, we received your missive of the 21th of this month,

delivered by some of our soldiers. From this we learned that the three Vavorolangians and two Chinese from Wancan, whom we had sent over to Your Honour, had arrived safely and were taken in custody right away so that summary execution could be put into effect.

Also upon arrival in the mouth of the Poncan River, we have executed three Vavorolangians, who committed the horrible murder on merchant Hans Ruttens and his company and who were handed over to us by some of the headmen or captains of the mentioned village Vavorolangh. After we had been informed extensively about everything the prisoners were at once tied to a stake and their right hands were chopped off in the presence of six Vavorolangians. Next they were shot dead and subsequently their heads were cut off and put on poles while the bodies were left to rot.

When we arrived over here, the mentioned inhabitants did their best to prove that they were not guilty of disobedience but that others had revolted, just like they did in the mentioned Poncan, the *Geuse* grove and in front of the village (where the headmen themselves came to meet us). We learned that the rebellion had been instigated by two of the principal captains, who had incited the rebels and had gathered a great following, and furthermore seven Chinese who had already been living in that village for a long time and who have caused a lot of harm to the Company. These culprits were all extradited to us. The houses and belongings of those, who had committed mischief but who had managed to escape, were handed over as well. In that way the people of Vavorolangh showed their willingness to prosecute the mentioned runaway rebels as well as the murderers from Gielim, and also the other malicious inhabitants, with the necessary seriousness and application and if possible to hand them over to us so they can receive their just punishment. Yet they had not been able to do this until now because of their weakness and because the rebels were too strong. Also they gave us a warm welcome and provided us very well with food and drinks so that we, so to say, found a generous table set for us. Therefore we could not take the decision to punish the innocent people together with the guilty ones.

The mentioned captains and the seven Chinese we ordered to be beheaded on the spot, without long consideration. Their houses and belongings, besides everything belonging to the runaway rebels, were burnt down and destroyed completely. We intend to carry on with this punishment until all

of them have personally experienced our power and punishment even better.

As soon as our men have rested and been properly fed, we intend to continue the march to Gielim today or tomorrow. There we will raise arms against the inhabitants and punish them in a such a way that never again will they dare to behave themselves in such a rebellious fashion, or harm our people. Likewise, we do believe that those of Vavorolangh will refrain from further disobedience as well. At the moment they have experienced personally that we do not stand for any nonsense, and that the Chinese and other agitators will bring them nothing but ruin. [...].

158. Missive Governor Paulus Traudenius to Governor-General Anthonio van Diemen.
Tayouan, 4 December 1642.
VOC 1141, fol. 142-145. Extract.

fol. 142: [...] Dat wij 18en deses met den Raadt hebben geresolveert dewijle het volck dat bij den anderen hadden redelijck frisch ende gesont waren, ende vischteelt op handen is, wanneer men om champans ten hoochsten verlegen valt, de tocht naer Vavourolangh, Davolé, Gillim ende andere om de noort gelegene dorpen tot straffe van dien rebelligen ende brutaelen hoop als omme verder te sien ende te vernemen off men van daer tot in Tamsuy over lant soude connen comen, mitsgaders de omherleggende dorpen tot redelijckheyt 't sij bij wegen van minne ofte met gewelt van wapenen te brengen, bij der handt te neemen als U Ed. breder bij onse resolutie in dato 18en November daer over genomen ende hier bij gevoecht gelieven te vernemen, daertoe ons gedragen.

Naerdat alles wat tot den tocht gerequireert wierdt vaerdich ende claer gemaeckt was, soo is den Ed. Johannes Lamotius op 20en deses met een macht van 680 coppen g'imbarcqueert in 75 champans. [...] Den 21ste des namiddachs verschijnt alhier uyt Wancan een champan sijnde door geseyden Ed. Lamotius in aller ijl affgevaerdicht, medebrengende onder behoorlijcke verseeckeringe ende wacht drie inwoonderen, te weeten twee van Vavorolangh ende één dito van Gierim, sijnde regenten ofte outsten van dito dorpen, één dito boven de drie was bij den Ed. Lamotius omme in verscheyde gelegentheden te dienen verbleven. Dese luyden waren in Wancan gecoomen omme herwaerts hun te transporteren, ende ons alweder omme naer ouder gewoonte, te meer de geruchten hadden dat wij op de been waren, met praetjens (sonder de moordenaers mede te brengen)

die hun wel expresselijck niet alleene meenichmael mondelingh maer oock met brieffkens in 't Chinees gelast hadden te brengen, ende sonder met deselve te verschijnen te paeyen. Ende alsoo dese schelmen haeren ouden zangh met deselve te willen brengen heugen, soo hebben geresolveert die, na behoorlijcke (fol. 143) genomen examen ende confessie van qualijck gedaen ende jegens de hooge overheyt gepecceert te hebben, tot exempel van alle andere booswichten, die soo hier ende daer op 't landt noch berusten, jae onder den duym van onse nieuwe genaemde Christenen selffs soo wij vertrouwen noch veele zijn, met de coorde te straffen datter de doot na volght. De executie is den 25en tot schrick van veele alhier zijnde Chineesen gesienet ende volbracht, sal ontwijsselijck veel goets onder de Formosanen veroorsaecken, dat Godt gunne. [...].

fol. 142: [...] Because the soldiers are quite fit and healthy and because the fishing season is approaching when all sampans will be needed, the Council resolved on the 18th of this month, to undertake the expedition to Vavorolangh, Davolee, Gielim and other villages situated to the north of Tayouan, in order to punish those rebellious and impudent hordes. Also the men had to try and find out whether they could continue their journey overland to Tamsuy from there. Furthermore on their way they had to try to pacify the villages along the route, either in a friendly way or with force, as Your Honour may read in detail in our resolution from that date, added to this letter, according to which we have acted.[80]

After everything was made ready for the journey, the Honourable Johannes Lamotius left on the 20th of this month[81] with a force of 680 men, embarked in 75 sampans. [...] In the late afternoon of the 21st, a sampan from Wancan appeared in Tayouan, that had been sent in great haste by Lamotius.[82] It carried under guard three inhabitants: two from Vavorolangh and one from Gierim, all regents or elders of those villages. These people had come to meet Lamotius in Wancan, together with another headman who was ordered by Lamotius to stay behind to assist him with other matters. They had been on their way to Tayouan in order to carry out their earlier ploy of attempting (without handing the murderers over to us) to put us off with fair speeches even more so because they had heard the rumor that we were on our way. Notwithstanding we had ordered them several times verbally as well as by notes written in Chinese to bring in the murderers. Instead of complying with our wish they tried to appease us with fair words. In order to give

these rogues something to remember that will make them stop singing their old tune we resolved, after examination and careful consideration and (fol. 143) after they confessed their criminal behaviour and their offences committed against the Company's high government, that they would be punished by getting the rope.

The death sentence was carried out in Tayouan on the 25th, in the presence of many terror-struck Chinese who are dwelling in this place. Undoubtedly this severe action will serve as a deterrent for all other villains, of whom too many are still to be found at places, yeah, even among the newly converted Christians, and will have a most positive effect on the indigenous Formosans.[83] [...]

159. General Missive, Batavia, 12 December 1642.
VOC 1138, fol. 1-116.
Formosa, pp. 200-209. See also DRZ, II, pp. 15-16.

160. Resolutions taken by Governor Paulus Traudenius and the Formosa Council.
Tayouan, 15 December 1642-8 January 1643.
VOC 1146, fol. 692-696. Resolution 18 December 1642.[84]

fol. 692: Alsoo den vorst van Loncquiouw als mede sijnen broeder ende insonderheyt sijnen zoon mitsgaders hunnen voorderen aenhangh niet geschroompt hebben haer verleden jaere, wanneer den tocht langs de oostcandt van Formosa ondernamen ende door sijn lant ende dorpen mosten passeeren, seer impertinent aen te stellen, ons niet alleene weygerende lijfftochten (die door 't sneuvelen van eenige onser joncken verongeluckt waeren) maer daer en boven oock verscheyden andere nootwendicheden die hun te vooren voor onse compste g'injungeert waeren te beschaffen, sulcx sijluyden hun niet als vrunden maer ter contrarie bijnaer als vijanden aenstelden; dreygende naer ons vertreck (soo als eenige wijn ende arack met gewelt d'onse hadden affgenomen ende hun volgesoopen), den opperstierman Simon Cornelissen ende sijn bijhebbendt geselschap den cop aff te houwen; doende wijders soo veele vilanie aen d'onse als mogelijck was; item dat mede (fol. 693) desselfs onderdaenen seeckere vier Chineesen (die met onse licentie brieffkens omtrent Pangsoya visten), seer schelmachtich vermoort ende hun voorts in alle saecken seer ongehoorsaem aengestelt hebben. Soo heeft d'Ed. heer gouverneur Paulus Traudenius den raat des Casteels Zeelandia collegialiter bij den anderen

vergadert hebbende haere Ed. dese vuyle proceduyren voorgehouden ende met eenen aengewesen hoe wel hadde vereyscht parate executie, maer alsoo bijnae tot Pimaba eer sulcx verstonden met d'macht vooruyt waeren gemarcheert, soo en conde het selve als doen niet wel geschieden, gelijck oock om vescheyde consideratien zulcx op de wederom comste niet heeft connen bijgebracht werden. Oversulcx haere meergem. Ed.ˢ voordragende (ten aensien voors. vorst, den broeder ende zoone soo door brieven als bij monde door Chineese tolcken hebben doen insinueeren, dat hun bij ons (omme eenige saecken te vereffenen) aen 't casteel te vervoegen, hadden dat echter niet gedaen hebben ende ongehoorsaem gebleven sijn, ofte men dienvolgende niet en behoorde (dewijle onse macht met d'Ed. veltoverste Johannes Lamotius eerstdaechs uyt Wanckan alhier verscheenen is ende wederom tot vertreck vaerdich sijn) een redoutabele chrijchsmacht derwaerts tot straffe derselver uyt te setten. Op allen 't welcke bij haere Eds. rijpelijck ende met aendacht geleth ende gespeculeert wesende is eendrachtelijck ten dienste van de Generaele Compagnie goetgevonden ende gearresteert om desen rebelligen ende ongehoorsamen hoop tot redelijckheyt, nedricheyt ende t'onser devotie te brengen, noch heden onse macht van ontrent de 300 Nederlantsche coppen, inde jachten *Waeckende Boeye*, *Nachtegael* ende 't quelpaert de *Bracq* mitsgaders de groote lootsbooth die al op gisteren met 42 coppen per den coopman Johannes van den Eynden derwaerts vooruyt vertrocken is, nevens twee des Comp.ˢ joncken te laeten embarcqueeren ende d'selve onder 't commando vanden Ed. Lamotius voornᵗ. naer Pangsoya alwaer het wel ende een vlacke strant om te landen is, te verseylen ende costij gecomen sijnde den oorlooge met behulp van de Pangsoyers ende Tamsuyers, onse onderdaenen die wij door den coopman Van der Eynden hebben doen iniungeeren hun veerdich te houden den Lonckjouwer aen te doen ende van alle canten soo veele mogelijck te bespringen. Ende d'wijle voors. vorst aende oostcandt van Formosa sijn uytvlucht can nemen, soo is meede goetgevonden den regent van Pimaba door den schrijver Christiaen Smalbach, die den 15ᵉⁿ stantij over 't geberchte van Tacabul derwaerts vertrocken is, te laeten waerschouwen ende gelasten dat sich met sijn volck langs de oostcant van Formosa, omtrent de cloove van Calingit tegen den 20ˢᵗᵉ ofte den 22ᵉⁿ deser sullen vinden laeten. Alwaer een compagnie Nederlantse soldaten rescontreeren sal, omme alsoo den meergeroerden Lonckiouwsen vorst ende sijnen aenhangh, soo wel vande oost als westcust, in sijn landt te vallen ende te benarren ende hem ende de sijne 't sij levendich ofte doot in handen trachten te becomen.

Door sijne E. mede voorgedragen wesende hoe nu eenighe jaeren
herwaerts, ende insonderheyt dagelijcx gewaer geworden sijn, hoe
schadelijck de menichte der remoreerende Chineesen de Generaele
Compagnie in de dorpen om de noort ende zuyt verre van ons gelegen
sijn. Die niet alleene hunne groote proffijten vande inwoonderen trecken
maer de Nederlantsche natie daerenboven odieux bij haerlieden, onder
verscheyden pretexten, weten ende soecken te maecken. Ende dat meer
ende waerachtich is, practiseeren (gelijck voorleden jaere ondervonden
hebben), sommige Chineesen d'inwoonderen wijs te maecken wij t'haeren
gebiede staen. Sulcx leert ons mede d'experiëntie niet alleen, maer dienen
d'inwoonderen (siende vande Chineesen bedroogen werden) ons sulcx selfs
aen ende leveren (fol. 694) de Chineesen (die hun altijt ten quaden geraeden
hebben), in onse handen over. Blijckende alsoo claerlijck uyt alle
omstandicheeden de meergeroerde Chineesen gants schadelijck
instrumenten voor de Comp^e. op Formosa. Ende dat noch meer zij, dat zij
luyden haer volcomen domicilium aldaar hebben, sijnde oock veele
derselver met inlantsche vrouwen getrout daerbij oock kinderen
procreerende, dominerende voorder naer hun welgevallen, ende willen dat
de inwoonderen (alsoo ons tot een Bulleback hebben gebruyckt)
gewillichlijck naergecomen ende achtervolcht hebben. Soo is meede bij
sijn Ed. ende den Raadt voornoempt (naer verscheyden cavilatiën ende
overlegh van saecken, als insonderheyt siende op de welgegeven ordre, die
ons d'Ed. heer Gouverneur-Generael ende heeren Raden van Indiën, dit
verleden zuyder mousson dienaengaende hebben gelieven te geven ende
omme dese schadelijcke inconveniënten tijdelijck te prevenieeren,
geresolveert tot gerustheyt ende welvaeren deser opluyckende republijck,
allen ende een ijgelijck onder onse jurisdictie op Formosa sorteerende,
d'selve bij placcaete te interdiceeren ende affigeeren, dese naervolgende
articulen te gehoorsaemen namentlijck:
Voor eerst ende ten principaelen soo en sullen egeene Chineesen 't sij van
hooge qualiteyten ofte wat conditiën, die soude mogen wesen inde
noordelijcke dorpen, dat is boven Mattau, ende Tirosan haer woonplaetse
ofte domicilium (het sij oocq onder wat pretext het soude mogen wesen)
voortaen meer nemen op de verbeurte van lijff en goet maer bij aldien
aldaer soecken hunnen handel met d'inwoonderen t'exerceeren zullen
gehouden wesen een pascedul in Tayouan (die voor en maendt duyren
ende daerenboven een reaal van 8^en betaelen sullen), te haelen. Dit verstaet
sich voor een handel chiampan in de welcke haere residentie sullen
houden, ende hunnen handel volgens den tijt die haere brieffken mede
brengen drijven, gehouden zijnde alle maanden een nieuw briefken te

haelen. Wie contrarie bevonden wert, sal voor de eerste reyse verbeuren sijn chiampan met alles datter in is ende daerenboven vijftich realen van 8^{en} aende Comp. betaelen, voor de tweede reyse sullen deselve daerenboven aenden lijve gestraft werden.

Ten tweeden soo en sullen oock egeene Chineesen, 't sij van wat conditie die sijn, in de zuydelijcxste dorpen (dat is van Tavocan tot het zuyteynde van Formosa toe) vermoghen hunne residentie te houden. Maer bij aldien genegen blijven aldaer hunnen handel naer gewoonte t'exerceeren dat sulcx met chiampans, offe soo geraden vinden te lande, gehouden sullen sijn te doen ende dat op conditie ende peene als hiervooren claerlijck en vervaeth staeth.

Ten derden soo en sullen egeenige joncken, 't sij groote ofte cleene, 't sij bij oosten ofte westen Formosa in eenige havenen ofte bayen vermogen te loopen ende handelen, sonder onsen expressen passe van hier te hebben, daer en boven oocq betaelen zullen thien realen van 8^{en}. Wie contrarie bevonden sal werden gedaen te hebben ende sulcx niet achtervolcht, sal voor de eerste reyse betaelen een hondert realen van 8^{en} in contant ende d'jonck ende d'ingeladen goederen verbeuren, voor de tweede mael sullen alle de Chineesen daer en boven aen den lijve gestraft werden naerdat bij den Raet sal werden verstaen.

Ten vierden [...] so sullen om verscheyde goede consideratiën de Chineesen die inde dorpen Soulangh, Mattouw, Sincan, Baccolouangh, Tavocan, Tirosan ende Teyvorangh, (alwaer onse residenten hebben) haer sijn onthoudende tot naerder ordre van de Ed.e heer Gouverneur-Generael ende Ed. heeren Raden van India mogen verblijven. d'Andere Chineesen die in de voorsz. noordelijcke (fol. 695) ende zuydelijcke dorpen niet vermogen haer cedem te nemen, staen toe aen Saccam, Tayouan, ende eenige oocq in onse naest gelegen dorpen haer woonplaetse te mogen nemen, mits betaelende alsulcke gerechticheden als daer toe staen ende sal een maent naerde publicatie deses sich een ider hiernaer hebben te reguleeren, als wanneer dese articulen gelden ende ingancq nemen sullen. Item dat op niemant hiervan ignorantie pretendeere, soo is meede geresolveert desen te doen publiceeren ende ter plaetsen daer 't behoort, in de dorpen om de zuydt ende noort gelegen, te doen affigeeren.

fol. 692: Considering that the ruler of Lonckjouw, as well as his brother, his son and all their other followers, did not hesitate to behave very impudently when we made the expedition to the east coast of Formosa in January last, and had to pass through his land and villages; that they not only refused to provide us with supplies (which we needed very much as

some of our junks got wrecked) but that they moreover failed to present us with other requirements, which we had ordered them to furnish to us before our arrival; that they did not act as friends but almost acted in a hostile manner, threatening after we had left (when they had taken some wine and arrack by force and had drunk themselves senseless) to decapitate senior helmsman Simon Cornelissen and his company; that they furthermore acted as villainously as possible (fol. 693) and that things had even gone so far that some subjects of the Lonckjouw ruler had treacherously murdered four Chinese (who were in possession of Company permits entitling them to fish in the neighbourhood of Pangsoya); and finally, considering that they had behaved themselves with brazen insolence in everything, Governor Paulus Traudenius invited the Council of Zeelandia Castle to assemble.

He presented all the excesses committed by Lonckjouw to the gathered councillors and indicated that those disobedient acts actually called for summary execution, but because they had only discovered the seriousness of the matter when the expedition had already progressed almost as far as to Pimaba, he had therefore not been able to carry these punishments out properly, and for several reasons it had not been wise to do this either on the way back. On that account Traudenius proposed to the councillors (the more so because this ruler, his brother and his son had been urged several times, by letters as well as orally by Chinese interpreters, to come over to the castle, in order to settle the various disagreements, but had not accepted this invitation and had continued their disobedient behaviour. Therefore the governor asked the councillors if the moment had not arrived (the more so because field-commander Lamotius had just returned with his men from Wancan, and was ready to depart again) to send an expedition army out there. After careful consideration of the matter the Council unanimously resolved, to the benefit of the General Company, to dispatch our force of about 300 men in order to teach these rebellious hordes a lesson in humility and to subjugate them. As a result of this that same day the troops embarked on the yachts *Waeckende Boeye*, *Nachtegael*, the *quelpaert* de *Bracq*, as well as two Company junks and the large pilot-boat, that had already gone ahead the previous day with 42 men with merchant Johannes van den Eynden. [The fleet] set sail, under the command of the Honourable Lamotius with Pangsoya as its destination, where they might easily land on the flat beach. Merchant Van

der Eynden was instructed to order our subjects, the people from Pangsoya and Tamsui, to prepare themselves to join the Company troops in the fight against the subjects of the Lonckjouw ruler, and to press the enemy from as many sides as possible.

In order to prevent this ruler to escape in the eastern direction, it was also agreed to instruct the secretary Christiaen Smalbach, who departed on the 15th of this month via the Tacabul mountains to Pimaba, in order to summon the regent of that place to come with his warriors to the Calingit gorge, and see to it that they will reach that spot on eastern coast, on about the 20th or the 22nd of this month. There they will meet a company of Dutch soldiers to help them attack the Lonckjouw ruler and his followers from the eastern as well as the western side and to press him hard and to get hold of him and his people dead or alive.

His Honour also presented the Council with the fact that over the past several years it had become clear how much damage was done to the General Company by the multitude of Chinese living in the remote Formosan villages situated to the north as well as to the south of Tayouan. At present the unpleasant consequences of the dealings of these Chinese is experienced every day. They not only know how to exploit the inhabitants but they also know how to disgrace the Dutch nation among the villagers by telling them all kinds of lies. Likewise we found out last year, that some Chinese led the inhabitants to believe that we planned to take away their lands from them. Such is the situation as it was discovered not only by ourselves but also by the inhabitants, who (whenever they learn that they have been cheated by any Chinese) should inform us about it. In such a case they should surrender (fol. 694) those cheats (who always play tricks on them) to us. From everything it becomes clear that the Chinese turn out to be rather harmful to the power of the Company on Formosa, many of them are married to indigenous women, by whom they beget children. Furthermore they easily wield power over the villagers, desiring them to fulfill their wishes. Something of this indeed was achieved, especially when they pictured us as bogeymen. To that end, after thinking over all kinds of hair-splitting subtleties and after careful considerations, the Council, taking also into account the order given to us last southern monsoon by the Honourable Governor-General and the Councillors of the Indies, to promote the peace and prosperity of this awakening republic, it was resolved, in order to

prevent any setbacks, to command everyone subjected to the Company's jurisdiction to obey the following articles:

Firstly and principally no Chinese (of whatever rank or position) will be allowed for whatever reason to be domiciled in the villages located north of Mattouw and Tirosen, on pain of the seizure of their goods. Those who trade with the inhabitants must be in the possession of Company permits (valid for one month, to be obtained in Tayouan for one real of eight). This entitles them to trade in the area for the period of one month with a sampan, which at the same time may serve as their accommodation. Thus they are obliged to come over to Tayouan every month to be issued a licence. Whenever someone is caught trading without such a Company note, the first time his sampan together with everything in it will be confiscated and he will have to pay the Company a fine of fifty reals of 8th. The second time the offender will receive corporal punishment.

Secondly no Chinese, of whatever position, will be allowed to reside in the southern villages (i.e. from Tavocan to the southern tip of Formosa). However if they would like to continue trading over there, they are permitted to practise their business from aboard a sampan or, if they prefer it, to trade overland, but they will be obliged to comply with the above condition and may be submitted to fines as explained above.

Thirdly, no junks, no matter whether they are large or small, will be allowed to call at any bays or harbours on the eastern or western coasts of Formosa, for trading purposes without our special licence, at the price of ten reals of 8th. Those who are found not complying with the rules must, on the first occasion, pay a fine of a hundred reals of 8th in cash together with the confication of the junk and all goods aboard. If any Chinese offenders are caught for a second time, they will be given corporal punishment as the Council deems best.

Fourth, [...] for several good reasons, the Chinese who are residing in the villages Soulang, Mattouw, Sincan, Bacaluan, Tavocan, Tirosen and Tevorang, (where also Company residents are stationed) have to await further instructions from the Governor-General and the Councillors of the Indies. Those Chinese who are not allowed to live in the mentioned other northern (fol. 695) and southern villages are permitted to take up residence in Saccam, Tayouan and some of the other villages situated close in the neighbourhood, on condition that they pay the fixed charge. This

regulation will take effect a month after its publication. In order to ensure that nobody will pretend to be ignorant of this measure it was also decided to publish this decree and promulgate it in all villages situated to the north as well as to the south.

161. Missive Governor Paulus Traudenius to Governor-General Anthonio van Diemen.
Tayouan, 26 December 1642.
VOC 1146, fol. 687-691. Extracts.

fol. 687: [...] Den 6en deser lopende maent arriveerden alhier uit Tamsuy vier Chineese joncken. [...] Met dito joncken bequamen een brief uit Quelangh van de capiteyn Harousé ende een dito uit Tamsuy van de luytenant Pedel dicterende ten principaelen als volcht:

Dat 't sedert den Ed. veltoversten vertreck van daer ende sijn jonghsten aen ons gedirigeert, d'inwoonderen van St. Jago (die over de costij gedane executie voor 't vertreck van voors. veltoversten onder den anderen gerebelleert hadden) om vergiffenisse comen bidden waeren, met belasten voortaen sulcx niet meer te willen onderstaen ende hun als gehoorsaeme kinderen te draghen ende hadden deselve (ten aensien vanden Ed. Lamotius beloften voordesen aen haar gedaen) voor goede luyden in genade aengenomen. Dat inwoonderen van Kumaury (door dien meest van d'onse leven moeten) hun geheel stil ende modest hielden.

Dat hij geresolveert was de principaelste van alle omleggende dorpen onder onse gehoorsaemheyt resorterende achtervolgende recommandatie van Lamotio, in 't corten aen 't casteel te ontbieden omme haere promtitude daarbij te vermercken. [...]

fol. 688: Dat die van de dorpen Piennorowangh, Moron ende Senaer van wegen hare outsten aende Compagnie hun dorpen ende landt met eenige cytroenen, orangeappelen, ende pisangh boomen opgedragen ende zijluyden hun deselve artijckelen (door Lamotius daar gelaeten) voorgedragen ende hun daar mede geconfirmeert hadden. [...]

Op den 14en stantij soo retourneert den Ed. Veltoversten Johannes Lamotius met de bijhebbende macht van de noort, hebbende op den uyttocht ende wederkeeren de naar genomineerde dorpen ende cleyne vlecken met den viere verteert ende voirder soo veel affbreucke gedaen als hebben connen bijbrenghen, zijnde de voorsz. plaetsen met naemen als te weeten Vavourolangh, Gierim, Sarbon ofte Samlin West, Toickera West, Gierim ofte Lauhab, Oost Toickera, Salamoet, Balobeys ende out Davole.

Ontrendt ende in voorsz. dorpen hebben d'onse, soo lange den tocht geduyrt heeft (soo die ons in handen gelevert als die geattrappeert sijn) dartich persoonen van 't leeven ter doot gebracht, wesende 11 Chineesen ende 19 inwoonders van vooren aengeroerde dorpen. Wij willen verhoopen dese actie wat goets bij desen brutaelen hoop veroorsaecken ende andere tot schrick ende exempel dienen sal, dat Godt gunne.

Voirder om de noort van voorsz. dorpen hadden wij gaarne (conform onse mede gegeven instructie) gesien voorn. Lamotio om de noortoost gelegen dorpen ende andere plaatsen, als mede omme den wech om tot Tamsuy over landt te comen te ontdecken hadde vereyscht. Doch heeft vermits ten eynde vande tale ende onkuntschap vanden wegh waeren niet connen bijgebracht werden, weshalven genootsaeckt wierden wederom te retourneeren.

D'opperhoofden van vooren meergenoemde dorpen hebben d'onse gelast ende doen aenzeggen binnen weynige dagen in Tayouan aen 't Casteel moesten verschijnen, dat belooft hebben te willen achtervolgen. Tot noch toe hebben niemant vernomen. Wanneer paresceren sullen (dat duchten uyt vreese noch wel wat aenlopen wert) sal ons den tijt leeren. [...]

fol. 689: Soo als den 14en deser den Veltoversten Lamotius van de noort gekeert was, soo en hebben geenen tijt, dewijle deselve costelijck valt, onnuttelijck willen door laten slippen ofte versuymen. Maer naardat het volck wat gerefriseert waren, soo resolveerden den 18en dito 't naarvolgende: Eerstelijck alsoo den vorst van Loncquiauw alsmede sijnen broeder ende insonderheyt sijnen zoon, mitsgaders hunnen voirderen aenhangh haar verleden jaar niet geschroomt hebben, wanneer den tocht langhs de oostcant van Formosa ondernomen hun seer impertinentelijck ende ongehoorsaem als doen ende oock naderhandt doorgaens soo met vier Chineese visschers die ontrent sijn landt onder onse passe waren visschende doot te slaen als andere insolentiën meer aen te stellen, een redoutable chrijchsmacht van 300 militaire persoonen onder 't commando van d'Ed. Lamotius tot straffe der voorsz. rebelligen hoop te water tot Panghsoya ende voorts over Panghsoya te lande derwaerts te largeeren. [...].

fol. 687: [...] On the 6th of this month four Chinese junks arrived here from Tamsuy, [...] with those junks we received a letter from Quelang written by capitain Harroussé, and one from lieutenant Pedel at Tamsuy with the following contents: Since the departure of the field-commander from the north, and since his previous letter, the inhabitants of St. Jago who had revolted on account of the executions by Lamotius just before his

departure, had come to Quelang to beg for pardon. They confirmed that they would never again act with such rebelliousness and that from now on they would behave themselves like obedient children. Subsequently they had been granted mercy according to the promises made to them by Lamotius. We also learned that the people of Kimaurij (who depend largely on us) behaved very quietly and modestly.

Harroussé intended, as recommended by Lamotius, to invite to the fortress all the principal headmen of the surrounding villages subjected under the Company's authority, in order to see how promptly they react. [...]

fol. 688: The elders of the villages Penorowan, Moronos and Senaer on behalf of their inhabitants had come over to transfer their villages and land to the Company offering us some lemons, oranges as well as banana trees. Thereupon we had presented them with the articles (left behind by Lamotius) and confirmed them as our allies. [...]

On the 14th of this month Field-Commander Johannes Lamotius returns with his army from the north having burnt to ashes and damaged the following villages and small hamlets: Vavorolangh, Gielim, Sarbon or Samlin, West Toickera, West Gielim or Lauhab, East Toickera, Salamoet, Balobeys and Old Davolee. During the entire journey, in and near the mentioned villages, our men killed thirty people (some of whom who were turned in to us by the inhabitants). Eleven of them were Chinese, 19 people were inhabitants of the mentioned native villages. Hopefully, God willing, this action will have a positive effect on these insolent groups and will be a deterrent to other villages.

Furthermore, we hoped that the villages situated to the northeast as well as the inland road to Tamsuy would have been explored by Lamotius and his men (according to his instruction). However, due to the lack of knowledge of the route as well of the language of the inhabitants in that area, this could not be accomplished, and consequently the men had to return.

We ordered the chiefs, of the villages mentioned earlier, to appear at the castle in Tayouan within a few days. Although they promised to comply with our wish, we have not yet seen any of them. Time will tell when they will eventually appear (which, out of fear, probably will take a while. [...]

fol. 689: As soon as Lamotius had returned from the north and once the men had rested, we resolved to send on the 18th a considerable expedition army of 300 soldiers under Lamotius' command by sea to Pangsoya, and from there overland to Lonckjouw. [...] There are several reasons for taking this action. Firstly because the ruler of Lonckjouw as well as his brother, his son and followers behaved very insolently and disobediently towards us last year when we undertook the expedition to the east coast of Formosa. In addition, they continued to act in an aggressive and illegal way by killing four Chinese fishermen who were in possession of Company licenses and fishing legitimately somewhere in the rulers' territory. They have also committed other offences, and it seemed sensible to lose no time in punishing them. [...].

162. Extracts from the Dagregister Zeelandia, concerning Lamey. VOC 1170, fol. 625-627. Extract 28 December 1642.

fol. 625: Dat in Tamsuy in seecker Chinees huys een Lameits meysken gevonden hadde die aldaer wel twee jaeren geweest en met den Chinees getrouwt was, de welck nu met bewillinge vanden Chinees mede herwaerts quam omme daerover bij sijn Ed. gedisponeert te werden. [...]
Soo verstonden mede op dato van den coopman Samsiack dat de Chinesen die op Lamey de pacht hadden en costij woonden met d'inwoonderen te spraeck gecoomen en een dito in Pangsoia gecoomen was. Waerover aen een Chinees die derwaerts vertrock een ordonnantie op den coopman Van den Eynden gepasseert is dat denselven ongemolesteert costij soude gaen laeten omme alsoo bij gelegentheyt de resterende te beter tegelijck in handen te becoomen.

fol. 625: In Tamsuy (in the south), in a certain Chinese house, a girl from Lamey had been found, who had resided there for two years and was married to a Chinese. With the consent of her husband she had come to Tayouan so that His Honour could pass judgement on this matter.
On the same date we were also informed by merchant Samsiack that the Chinese to whom Lamey is leased out to and who are living on the island had entered into conversation with the remaining islanders and also that one Lameyan had come over to Pangsoya on his own. On account of this, we sent an order to merchant Van den Eynden in Pangsoya by a Chinese

messenger, telling him to let the Lameyan go unmolested in order to await the right opportunity to catch the remaining Lameyans.

163. Dagregister kept by Lieutenant Thomas Pedel in the newly constructed fort Anthonio, Tamsuy, 5 November 1642-8 May 1643.
VOC 1145, fol. 308-349. Summary of November 1642-January 1643.
DRZ, II, pp. 93-133.

(On 16 November some inhabitants of Penorowan came to subject themselves to the articles issued by Lamotius in Quelang. They reported that they had come down to buy rice from the villages Senaer and Kijpatauw, because it was not their custom to grow rice as those from Tamsuy did. The next day three men from Warou came to subject themselves and on 21 November two men from Senaer, among them chief Kaekielach, did the same. On 7 December chief Tanquoy of Madomadou transferred his land to the Company. On 15 December the lieutenant Pedel returned from an inspection tour to Ritsyock, Madamadou, Ratsecan, Kattia, Kienasodouaen, Cibocan, Penorowan, Tokojan, all situated to the north of Tamsuy. He reported that many headmen of those villages who already had subjected to the Company, and had been in Quelang where they had received a Prince's flag, told him that they had only done so out of fear. Consequently Pedel read the articles drawn by Lamotius to them again and once more urged them to comply with the Company rules. He also had offered the principal headmen several gifts. He learned how bitter they were about the barbaric treatment they had received from Lamotius. Yet they assured Pedel that they had nothing against Harroussé or himself. Although Pedel managed to buy some gold, the inhabitants seemed quite unwilling to sell it. However, by January 1643 more and more inhabitants knew how to find their way to the fortress. Some of them came in their prahus to trade small amounts of ginger, sugarcane, and pattates for cash or tobacco.)[85]

1643

164. Original missive Governor Paulus Traudenius to Governor-General Anthonio van Diemen.
Tayouan, 12 January 1643.
VOC 1146, fol. 735-736. Extracts.

fol. 735: [...] Op 3en deses retourneert van de tocht naer Loncqiauw bij der hant genoomen de Ed. Lamotius met de bijhebbende crijchsmacht. [...] 't Is dan Ed. Heer sulx dat d'onse gecombineert sijnde met ontrent 300 à 400 Pangsoyers (die wij gelast hadden mede te gaen), ongeveer de veertig coppen ende zeven gevangenen soo mans, vrouwen en andere jongelingen hebben becomen, ende vijf dorpen dat de principaelste sijn door den viere met alles wat daerinne, soo van rijs, milje, oubijs ende andere aerdvruchten, mitsgaders cleeden en diergelijcke meer, bij ofte ontrent is geweest, vernielt ende t'eenemael geruïneert. Onder voorz. dooden is meede geweest den vorst sijn soon, dat een slimmen schelm die veel quaets dede was. Den vorst en sijnen broeder met hunnen aenhangh is het ontvlucht. Soo gerucht wert souden in een dorp Tipoul, ontrent Pimaba in 't hooge geberchte gelegen, hun onthouden. Dito dorp ende de gelegentheyt desselfs, also d'onse voor desen daer sijn geweest, blijft ons volcoomen bewust. Binnen weynige dagen sullen twee compagniën soldaten van 100 à 200 man derwaerts schicken omme den vorst t'achtervolgen, in handen te becoomen ende die van Tipoul (die hun gebercht hebben ende oock tegens die van Pimaba kanten) na behooren te straffen.
fol. 736: [...] Dat de Loncqiauwers als mede de Bacoloanders van hier verseynden, oordelen een goede saecke te sijn. Sal grootten schrick onder de Formosaenen causeren also sijluyden bijnaer liever willen sterven als van hun lant vervoert te werden en wanneer eenige nu jegens den staet coomen te vergrijpen sullen soo veele derwaerts schicken als doenelijck wert sijn.

fol. 735: [...] The 3rd of this month the Honourable Lamotius and his accompanying force returned from the expedition to Lonckjouw, [...] it so happened that our men allied with about three to four hundred people from Pangsoya (whom we had ordered to accompany him) hunted about forty heads and took seven prisoners, men, women and youngsters. Five

villages, being the most important ones, have been completely destroyed by fire with everything in it like rice, maize, yams, and other crops as well as cloth etc. The son of the ruler was among the dead, a devious rascal with evil ways. The ruler together with his brother and their accomplices has escaped. It is rumoured that they are in Tipol, in the mountains near Pimaba. As our people have been there before, this village and its situation is well known to us. Within a few days we will despatch two companies totalling one to two hundred soldiers to pursue and capture this ruler and to mete out an appropriate punishment to the inhabitants of Tipol (who are hiding themselves and are also opposing the people of Pimaba). [...]

fol. 736: It is our opinion that it will be desirable to exile the people of Lonckjouw as well as those of Bacaluan. It will strike fear into [the hearts of] the Formosans as they would rather die than be banished from their land. In case some of them defy our authority, we will send away as many of them as possible.

165. Extracts taken from the Zeelandia Castle Resolution-books, concerning the resolutions on the island of Lamey.
VOC 1170, fol. 598. Resolution 30 January 1643.

> fol. 598: Soo is meede geresolveert omme achtervolgende des Ed.en heer Generaels ordre 't Goude Leeuws Eylandt t'eenemael vande inhabitanten te suyveren. Ten aensien het weder sich paisibel [toont], met des Comp. joncke de *Goede Hoop* ende tien soldaeten onder den vaendrich Jurriaen Smith per instructie morgen naer Pangsoya te verseylen omme aldaer gecomen wesen, nevens den proponent Andreas Merkinius, 25 à 30 Pangsoyers te nemen ende sijn keer naer Lamey te doen. Die inwoonders met minne, sonder bloetstortinge, in handen te becomen ende tot ons te brengen ofte andersints bij onminne daermede soodanich naer gelegentheyt te handelen dat den staet van de Generale Comp.nie daervan verseeckert blijven.

fol. 598: It was also resolved, in accordance with the order of the Honourable lord Governor-General, to completely cleanse the Golden Lion Island of its inhabitants. Now that the weather was fair, ensign Jurriaen Smith was instructed to sail to Pangsoya in the Company's junk *Goede Hoop* with ten soldiers, and having arrived there, to meet with

ordinand Andreas Markinius and assemble 25 to thirty people from Pangsoya. With this small party he should set sail for Lamey, capture the inhabitants in a peaceful manner, without bloodshed, and bring them here or, if peaceful means were not possible, to take appropriate measures to ensure the common good of the Company.

166. Extracts from the Dagregister Zeelandia, concerning Lamey. VOC 1170, fol. 625-626. Extracts 11, 16 February 1643.

fol. 625: Den 11en Februarij dat naer 't becoomen van zijn Ed. ordre achtervolgende d'zelve met 44 Pangsoyers (die willich bevonden) sich naer Pangsoya getransporteert ende den vendrich Juriaen Smith aldaer op primo deser gerescontreert hadde, als wanneer naer boort gevaeren en met vaertuych naer Lamey overgesteecken. Daer des anderen daechs, sijnde den 2en, 's morgens aengelant waeren, gaende den vendrich met de twee bijhebbende soldaten vooruyt naer landt, en ondertusschen dat besich waeren met de Pangsoyers te landen, quamen den vendrich tegemoet drie van de cloeckste inwoonderen die van de Chinees vande onsen haer comste al verwittight waeren. Dat soodrae de Pangsoyers vernamen twee van de drie Lameyers de vlucht namen, wijsende op haeren hals meenden als doen dat souden moeten sterven. Den eenen, Tamarissa genaemt, hielt stant en omhelsden de voorschreven Pangsoyers, van wien wederomme wel getracteert wierden. Beloovende de resterende inhabitanten voor den dach te doen comen en om sulcx in 't werck te stellen largeerden den selven wederomme, als wanneer den (fol. 626) vendrich persoonelijck met den Lameyer Pieter sich (omme hun te noodigen) het boswaert in transporteerden, doch vernamen niemandt.

16en dito. Op dato compt den vendrich Juriaen Smith van Lamey aen 't casteel, [...] rapporteerende dat soo op den 2en deser aen Lamey gearriveert en aen landt met twee soldaeten gegaen was, hem drie inwoonders bejegent hadde, waermede vande te spraecke gecoomen en met d'onse omme den vreede aen te gaen. Maer uyt hun minen bespeuren conden wel genegen waeren, blijvende echter altijt buyten d'onse haere handen, tot dat eyndelijck eenige Pangsoyers mede aen landt en met haer (als vooren) in spraecke gecomen waren, de vlucht genomen hebben, wijsende op haere halsen en roepende: 'nu moeten wij sterven en de Pangsoyers sullen ons van 't leven beroven', als wanneer uyt vreese gesamentlijck in bosschade de vlucht namen, sonder dat deselve naderhant wederom gesien heeft, offte te voorschijn gecoomen sijn. Onmogelijck wesende door de onnatuyrlijcke dichte ruychte d'selve te vervolgen offte

op te zoecken, onaengesien de Pangsoyers sommige daegen hun devoir
daertoe gedaen. Waer over eyndelijck geresolveert hadde soo veel
doenelijck de ruychte aff te branden en sijnen wech achtervolgende ordre
van d'Ed. heer gouverneur wederom herwaerts te nemen.

fol. 625: The 11th February, in accordance with His Honours' instructions
we went to Pangsoya with 44 Pangsoyans (who had been willing to come)
and met with ensign Juriaen Smith the first of this month. Having
embarked we crossed to Lamey. On arrival on the 2nd the ensign escorted
by two soldiers led the way ashore. While we were occupied in
disembarking the Pangsoya warriors, the ensign was met by three of the
more courageous of the islanders who had already been informed of our
arrival by the Chinese. The moment they saw the Pangsoyans, two of the
men of Lamey fled pointing at their necks to indicate that they thought
they were going to be killed. Only one, called Tamarissa, remained and
embraced the Pangsoyans by whom he was well treated.[86] He promised
to bring out the rest of the inhabitants. To enable him to do this we
released him. Moreover, (fol. 626) the ensign personally, together with the
Lameyan Pieter, entered into the woods (to invite the Lamey people to
come out), but encountered no one.

On the 16th, ensign Juriaen Smith returned to the castle from his trip to
Lamey, [...] reporting that after he had arrived at Lamey on the 2nd of
this month and had gone ashore together with two soldiers, he had run
across three inhabitants. They had talked with them and as far as could be
understood from their behaviour, they seemed willing to make peace with
us, but still kept out of reach. However, when finally some Pangsoyans
also came ashore and spoke to them, they fled, pointing at their necks and
crying out: 'Now we are about to die, the Pangsoyans will take our life'.
Full of fear they all fled into the bushes and were not seen again and did
not even show themselves later. The extraordinary thickness of the
undergrowth made it impossible to chase them, let alone to find them,
even though the Pangsoyans really tried for several days. Therefore it was
finally decided to burn as much as possible of the undergrowth and return
to Tayouan according to the order of his Excellency the governor.

167. Instruction from Governor Paulus Traudenius to President Maximiliaen Lemaire.
Tayouan, 25 February 1643.
VOC 1146, fol. 793-797. Extract.
See also FORMOSA UNDER THE DUTCH, pp. 190-191; ZENDING, III, pp. 218-220.[87]

fol. 794: UE. sullen [...] de gerechticheyt die d'inhabitanten van de om de zuyt gelegen dorpen desen jare op ons verleden aenseggen aen de Compagnie gewillichlijck, namentlijck ider gesinne tien bossen padie hebben gecontribueert, in gewoonte houden en gelijck bij ons geschiet sij doorgaens aenmanen hunne landen ruymer als t'haren propren behoeve beplanten. (fol. 795) Door de geresene ongehoorsaemheyt der dorpen om de noort als Favorolang etc. daer de wapens opgevolcht, sulcx alle verdestrueert sijn, is van dese erkentenisse niets gecomen. Dat hervadt dient, en opdat geen tweespalt onder de Formosaen resultere, geseten buyten onse nieuw genoemde Christenen en degeene niet appelleeren waeromme meer van des Heeres gonste verbastert sijn als dese, soo achten geraden 't sal oock dienstich wesen. Niet jegenstaende den predicant Junius ende sijnen geestelijcken nasleep gevoelen de saecke t'immatuyr om haere tederheyt 't sij dat gecommitteerde of persoonelijck UE. met communicatie van 't collegie d'inboorlingen van Xincan, Bacolangh, Tavacan, Mattouw, Soulang etc. [...] doet aenmaenen of selfs injungeeren hunne landen wat ruymer als voor desen t'haeren noodtruft gedaen hebben met rijs etc. besayen, mitsgaders jaerlijcks erkentenisse in conformite als de zuydelijck gelegen vlecken (dat een cleenties doch de gemackelijcke luyicheyt raeckende is), aen den heer contribueeren. Tegen gem. Juni en dies overeencomende gevoelen hebben, dit staende zaysoen aende E. heer Generael geschreven, d'ordre hebt per eerste gelegentheyt ontweyffelijck te gemoeten ende daer in UE. nader te reguleeren. Echter 't voorstaende en onse meeninge te beginnen schoon dat gelijck qualijck connen sien haer E[s]. in Battavia hier inne met Junio congvenieerden alsoo de saecken van soo groote emporte niet, en dan wel te redresseeren sijn. Aen de oostcant van Formosa sal dit weynich beschieten als alleene omtrent Pimaba die doch almede soms schaars van rijs sijn, hun meest behelpende met milie, paddadeses, oebesen en andere aerdtvruchten, des niet te min sal UE. (wanneer in de maent van April onse joncquen met behouvende crameriën ten gerieve van de inhabitanten derwaerts demitteert) dese saecke al sachkens bevorderen en daermede opsiende hoeft instrueeren den Piemaër hiertoe op de gevoechelijcke maniere adverteert en aenmaent, wij willen

verhoopen niet alleen Pima maer bij gelegentheyt andere daer door sullen aengeport werden ende hunne velden vlijtich omcappen, uytbreyden en besaeyen sullen. [...]

Tot onderhoudinge van vrundtschap (hoe wel te lande van dien cant gelijck persoonelijck bij laetste gedaene tochte ondervonden hebbe), tot de geruchte goutmijne niet geraecken connen sal echter nodich sijn nevens den schrijver Smalbach drie à vier bequame soldaten van goeden inborst te resideeren gelecht werden, opdat den inwoonder nu onder tucht ende gehoorsaemheyt van de Compagnie gereduceert bij afwesen van dienaeren niet en verwildere en den ouden fleur volge dat noch bij wijllen qualijck genoech is in te houden daer op UE. dan te letten hebbe.

D'oorlogen om de Noort in Vavorolangh, Gerim etc. als mede om de zuyt in 't rebellich vorstendom van Loncqiauw desen jaere aengerecht hebben onder de gedweëge, veel goets en grooten schrick veroorsaeckt. Wij twijffelen niet of sullen in corten afcomen om versoeninge als wanneer haer een straffe sal sijn over de gepleechde moetwil, ijder huysgesinne vijf hartevellen jaerlijckx te contribueeren aengesien door de waepenen hunne velden verdorven en onvruchtbaer gemaeckt soo dat van rijs gefrusteert en den selven ingevolge te voorderen noch ontijdich zij. Doch naer 't desen als weder naer behooren sijn nedergeseeten met de voorgenoemde zuyderlijcken dorpen haer contributie en erkentenisse evenaren ende dewijle dan soo om de zuyt als noort den oorlogh een eynde genomen heeft, sulcx aen de westcant weynich meer te verrichten overich sij, alleenelijck dat ontdeckinge geschiede van de passagie tusschen Bettgierim en Tamsuy om de noort, mitsgaders de 17 à 19 dorpen daer gerucht te leggen, 't sij bij wege van minne ofte met gewelt onder 's Compagnies gebiet ende gehoorsaemheyt geredigeert werden. Soo willen UE. hoochelijck belasten ende recommandeeren, wanneer den tijt occasioneert ende gelegentheyt toelaet, 't selve voorsichtelijck bij der hant te doen nemen. [...] Oock bij tijde selfs en door andere ondervonden hoe onmogelijck het sij te lande om de oost als west van Formosa tot de goutmijnen te geraeken dewijle vande constitutie van tijt tot tijt g'informeert sijn geworden wanneer, namentlijck in April, de voyagie dient aengevath dien tijt nadert, ende de saecke een eynde vereyscht soo sullen UE. wanneer den stierman Sijmon Cornelisz., tot Bottels ontdeckinge voor eenige dagen uytgesonden van sijn voyagie retourneert, 't quelpaert de *Brack*, de twee lootsbooths en Compagnies joncqen *Quelangh* en *Hoope* claermaecken en vaerdich houden om soo draa 't saysoen twijffelt deselve met 150 militaire persoonen, die Tayouans guarnisoen sonder gevaer gevouchelijck sal derven connen, derwaerts

onder behoorlijcke ordre afsteecken. Gedenckende de twee Japanderes die lange daer gefrequenteert hebben ende met sijn Formosaensche vrouwe den Castiliaen Domingo Aguilaer die ontrent Quelangh in de dorpen ruyme jaren geremoreert van alles kennisse ende naeckte declaratie dier wegen gedaen heeft op eene van voors. vaertuych derwaerts te largeren omme als tolck ende guide bij gelegentheyt te dienen. [...].

fol. 794: Your Excellencies [...] will continue to levy the excise that the inhabitants of the villages situated in the south have voluntarily contributed this year to the Company, following our request, to wit ten bundles of paddy. You will also continually admonish them - as we have always done - to plant their fields more extensively than is necessary just for their own use. (fol. 795) Because of their rebellion, some villages in the north like Vavorolangh etc. have been destroyed by force of arms so that no tribute could be given. This situation should be redressed. In order not to create discord with those Formosan people not belonging to our new Christians, and so that they do not ask why they are not as much in the Lord's favour as the others are, we consider it advisable and also profitable, although Reverend Junius and his spiritual followers think it is too early because of its delicate nature, that a delegate or Your Honour, carrying a message from the Council, admonish or even instruct the local people from Sincan, Bacaluang, Tavacan, Mattouw, Soulang etc. to grow more rice in their fields than they have been doing, for their own consumption. This increase will enable them also to supply a yearly tribute to their lord, in the same way as the hamlets in the south are doing (which does not amount to much, but is easily neglected out of laziness). I have written to the Honourable General this season that you have orders to meet with the aforementioned Junius, and those who agree with him, without fail at the first opportunity to come to an arrangement. However, Your Honour will make a start with our aforementioned plan, because we think it is hardly conceivable that Their Excellencies in Batavia will agree with Junio in this matter, since it is not very important and can easily be undone. In the eastern parts of Formosa it will not yield much, except around Pimaba, and even there shortages of rice occur, so that they have to make do with maize, potatoes, yams and other fruits of the earth. Nevertheless, Your Excellency (when dispatching our junks in April with the necessary merchandise for the local population) should pursue this matter carefully. You will instruct the supervisor to encourage and

admonish the people of Pimaba appropriately, so that we may hope that not only Pima, but also in due course other villages will be stimulated to expand their fields by deforestation and sow them more extensively. [...]

In order to maintain our friendship (although it is impossible to go overland from there to the alleged goldmines as we found out personally during the last expedition) it will yet be necessary to quarter three or four soldiers of good moral character over there besides the clerk Smalbach, lest the inhabitants, who are now under the rule of the Company, become lawless and follow their old original habits in the absence of Company's servants. Such a situation can sometimes be difficult to prevent and should be carefully watched by Your Excellencies.

The wars we waged in the north, in Vavorolang, Gielim etc., as well as in the south, in the rebellious principality of Lonckjouw, have produced positive results and have inspired terror in the hearts meeker inhabitants. We do not doubt that they will come shortly to ask for reconciliation. As punishment for their mischief every household will have to contribute five deerskins yearly since they cannot give rice because their fields have been destroyed. However, as soon as they have settled down again they will pay their tribute in the same way as the southern villages. Now that the war in the south as well as in the north is over, nothing much is left to be done in the western region, except to discover the passage between Dorenap and Tamsuy-in-the-North and to bring the 17 to 19 villages that are rumoured to lie there under the Company's rule either peacefully or by force. We therefore strongly order and recommend that you carefully undertake this task as soon as time and the opportunity permits. From personal experience and that of others we are aware of the impossibility of reaching the goldmines overland either from the east or from the west. From time to time we have been informed of the best time for the journey to be undertaken, to wit in April. While this date is approaching, and this question needs to be resolved, Your Excellencies, as soon as steersman Simon Cornelissen, who was sent to explore Bottel [Tobago] a few days ago, returns from his journey, will prepare the *quelpaert* de *Brack*, the two pilot-boats and Company's junks *Quelangh* and *Hoope* and keep them ready with clear instructions to sail with 150 of the military that Tayouan's garrison can easily spare, as soon as the season breaks. Remember to send there on one of those ships to serve as interpreter and guide if needed, either the two Japanese who over a long period of time

have regularly visited the region or the Castilian Domingo Aguilar and his Formosan wife who has lived for a long time in the villages near Quelang and has told us everything about that place.

(Traudenius advised that the lieutenant Pieter Boon should act as commander on the intended expedition).

168. Dagregister Zeelandia 25 February-15 November 1643.
VOC 1145, fol. 266-424. Summary.
DRZ, II, pp. 49-210.

(On 13 February an expedition to the small island Bottel Tobago was undertaken with the pilot boat. Although some people were seen from a distance and several presents were placed in front of one of the three villages, no direct contacts with the islanders could be made. On the 18th the men left the island, taking along three or four pigs and two curiously made proas. A shot was fired out of the pilot boat at three inhabitants who were seen standing on the mountain, and one of them was hit.
Merchant Johannes van der Eynden, who on 15 March had been sent on an expedition to the south, reported that he had met with a chief of Pangsoya, one of Netne and some of the surrounding villages, as well as with five refugees from Lonckjouw on 18 March in the village of Cattia. He had learned that about thirty men and a greater number of women and children were dwelling at about three miles south of Pangsoya. Earlier, on several occasions, they had tried to assault the ruler of Lonckjouw, but at present they no longer knew where he was residing. The headmen of Pangsoya invited them to come and live in their own village but the Lonckjouw refugees on their part preferred to stay at the place where they had already been settled down for a while, because the cult of their idols was different to that of Pangsoya. Van der Eynden, on behalf of the Company, explained to the other headmen that, whenever some refugees or mountain people came down to one of their villages they were obliged to announce it at the castle. The people of the mountain village Bebabehey and its' surrounding settlements, seemed to be willing to submit themselves to the Company. Because they did not dare to come over on their own, they had to wait for some men from Tapouliangh who would come to fetch them. On 16 February 87 men, women and

schoolchildren from Tapouliangh, Swatalauw as well as Verovorongh departed to Soulang to get baptised there.)

169. General Missive, Batavia, 7 March 1643.
VOC 1141, fol. 384-389.
See also FORMOSA, p. 210; DRZ, II, pp. 16-17.

170. Resolutions taken by President Maximiliaen Lemaire and the Formosa Council in Tayouan, 1 March-9 October 1643.
VOC 1145, fol. 425-468. Resolution, 21 March 1643.
See also for 16 April, 11 September, and 25 September FORMOSA UNDER THE DUTCH, pp. 191-192; ZENDING, III, pp. 220-222.

> [...] Soo is mede g'arresteert dat men d'inwoonderen der om de noort gelegen dorpen Soulangh, Xincan, Mattauw, Bacoloangh, Tivorangh, etc. tot het aenplanten, vergrooten ende cultiveeren van haere rijsvelden annimeeren ende volgens alle redelijckheyt provisioneel ende tot naerder ordre van d'Ed. heer Generael te verstaen geven dat voortaen hunne saecken soodanich derigeren (gelijck d'inwoonderen in de dorpen om de zuyt remorerende) gewillichlijck ende prompt doen omme aen de Comp. (ten aensien hun landt onder onse bescherminge in vreede besitten) jaerlijcx ider huysgesin tot erkentenisse eenigen rijs leveren [...].

[...] It has also been decided to encourage the inhabitants of the northern villages of Soulang, Sincan, Mattauw, Bacaluan, Tevorang, etc., to grow rice and to enlarge their rice fields and until further notice from His Excellency the General, to instruct them in all reasonableness for the time being to see to it (as the people living in the southern villages do voluntarily and without delay) that every household pay a tribute of some rice to the Company (because they enjoy peaceful ownership of their land under our protection) [...].

171. Verbal or Narrative of the most important events compiled from successive pieces of advice of the factory Tayouan 22 March 1643-20 March 1644, Batavia [April] 1644.
DRB 1643-1644, pp. 144-148.

172. Dagregister Zeelandia 25 February-15 November 1643.
VOC 1145, fol. 284. Summary of March 1643.
DRZ, II, pp. 67, 68.

(On 28 March President Maximiliaen Lemaire returned to Zeelandia after having paid a visit to the minister's house in Sincan. There he had personally asked the inhabitants of Soulang, Mattauw, Bacaluan, Sincan and Tavocan whether they were willing to follow up the Company's decision taken on 21 March and to pay recognition with an annual tribute of rice to the Company in return for their protection. To this they replied that they willingly agreed to do so.)

173. Missive President Maximiliaen Lemaire to Ordinand Andreas Merquinius.
Tayouan, 31 March 1643.
VOC 1146, fol. 548.

UE. missive van den 26en stantij deser hebben wel ontfangen, waer op oock al weederom geantwoort hadden dan alsoo voor 't vertreck van den boote den Chinees Taycon benevens twee bevelhebbers van costi met één der hooffden van 't dorp Pagewangh en UE. schrijvens van 28en stanty die onderschepte, hebbe deselve weeder in getrocken ende desendaerop geadresseert.

Met de voors. persoonen hebben verscheyde reedenen, nopende de gelegentheyt eeniger dorpen in 't geberchte ende d'opdracht derselver aen d'Compagnie, gehadt. Verseeckeren ons genoechsaem, soo de hostiele procedueren (die soo nu en dan aen de Chineesen als jegens ander dorpsvolck met ons in vruntschap sittende hebben gepleecht) willen pardonneeren ende eenen Neederlander om hun herwaerts te brengen met seynden, dat die van Sotimor, Talesien, Popenongh, Belangssit ende andere daer ontrent gelegene plaetsen meer, haere outsten om met ons te accordeeren gewillich aen 't Casteel zullen affseynden. 't Welck om tot ons ooghwith te geraken ende in dat gewest vreedich te mogen blijven, hun geaccordeert ende den Pagewanger wel onthaelt, een cleet met een rottangh toegestaen hebben. Dienvolgens ende om dat in die sprake ervaren sijn, gaet met hun derwaerts Samuel Minnes ende den voors. Chinees taycon. UE. versorge deselve met eenige hooffden van de dorpen aldaer verstterckt ende in 't gaen en keeren soodanich verseeckert werden dat hun geen onheyl onderwegen van één ofte d'ander aengedaen wert,

waeraen wij oordeelen bijsonder gelegen is ende UE. 't selve ten
hoochsten bevolen laeten. [...].

We received Your Excellency's letter of the 26th of this month in good
order and we also had already prepared a reply. However, before the
departure of the boat we intercepted the Chinese *taycon* and two
principals from your place together with one of the heads of Pagewangh
with Your Excellency's letter of the 28th of this month. Therefore we
cancelled our first letter and send you the following letter instead.
We had several talks with the aforementioned persons regarding the
situation of some villages in the mountains and their submission to the
Company. They have assured us that if we would forgive them their
hostile acts (committed from time to time against the Chinese and people
from other villages who are living in friendship with us) and would send
a Dutchman with them over there, the peoples from Sotimor, Talasuy,
Potlongh, Belangssit and other nearby places, would willingly send their
principals to the castle in an attempt to reach an agreement. In order to
reach our goal and maintain peace in that region, we agreed and treated
that man from Pagewan well, awarding him some cloth and a baton. With
the aforesaid purpose, and because they are well versed in that language,
Samuel Minnes and the aforementioned Chinese *taycon* will accompany
them. Your Excellency is requested to see to it that they are secured by
some heads of the villages there, that their journey is safe and no harm
whatsoever is done to them by anybody. This we regard as extremely
important and your highly recommended duty.

174. Dagregister Zeelandia 25 February-15 November 1643.
VOC 1145, fol. 284. Summary.
DRZ, II, p. 75.

*(On 13 April the headmen Tarimlauw, Tivolang, Tapatouloy and
Tamaparingh of the four villages Talasuy, Podnongh, Vordngil and
Paynos, situated in the mountains eastward to Tapouliangh, showed up in
the general meeting at Zeelandia Castle. On behalf of their people they
dedicated their lands to the Company. Furthermore they agreed to donate
a yearly tribute of rice, just like the inhabitants of Tapouliangh and
Pangsoya had already promised to do.)*

175. Missive Sergeant Christiaen Smalbach to President Maximiliaen Lemaire.
Tawaly, 19 April 1643.
VOC 1146, fol. 517-518.

Op den 30^{en} deser affgelopen maent martij ben eerst binnen Pimaba nevens mijne bijhebbende wel aangelangt ende d'onse in goeden welstant gevonden, en naer dat de groetenisse van UE. aen den cappiteyn Redut, neffens d'andere ouderlingen deses dorps gedaen, hebbe d'selve voorgehouden, hoe U Ed. ten hoochsten misnoecht, dat soo hartneckich ende ongehoorsaem zijn, ende op de jongst gedaene ontbiedinge, als den Lonckjouwer beoorloochden, niet mede te velde verscheenen sijn. Item, alsoo nu eenige jaeren herwaerts onder den Hollantschen staet in vrede ende eenicheyt geleeft hebben, oocq noch voortaen doen zullen ende voor al haere vijanden door onse macht beschermt blijven, dieshalven tot schuldichen plicht der genootene weldaden van haere overheyt, mede gelijcq de zuydelijcke dorpen ontrent Pangsoya ende dier plaetsen alreets doen, soodanigen padij als bij U Ed. goet gevonden werdt, aenstaende mede opbrengen mosten. Wat hierop geantwoort hebben U Ed. bij 't neffens gaende dachregister te beoogen.

De dorpen Borboras, Taccabul en Callingit hebbe in passant, volgens instructie UE., last om haere wooningen om leech omtrent Pangsoia te maecken aengedient. Belooffden hoochelijck 't selve te achtervolgen. d'Oorsaecq dat het noch niet geschiet en was, hebben UE. bij vooraengeroerde dachregister claerlijck te sien.

Die van 't dorp Tipol hebben tot diversche reijsen bij mij om vreede te vercrijgen ende een woonplaetse te geven aengehouden, 't welcq hun eijndelinge tot UE. naerder ordre toe gestaen ende vergunt hebbe, [...].

On the 30th of last March I arrived safely with my party in Pimaba and found our people in good health. After conveying Your Honour's greetings to captain Redout and the other principals of this village, I told them that you were highly displeased over their stubbornness and disobedience and over the fact that they did not show up when we summoned them during our war against the Lonckjouw people. Moreover, as they have been living in peace and unity under Dutch authority for the past few years, and will continue to do so, being protected from all their enemies by our might, therefore it is their duty to repay the benefits that are bestowed on them by their masters by

furnishing as much paddy as Your Honour deems fit, as the villages in the south around Pangsoya and other places are already doing. Their answer can be read by Your Honour in the daily journal that I am sending along.

In passing I have ordered the villages Borboras, Taccabul and Calingit in accordance with Your Honour's instructions to build their houses below, near Pangsoya which they have promised to do. The reason they had not yet done so, Your Honour can read in the aforementioned daily journal.

The people of the village Tipol have urged me repeatedly for peace and for a place to live, which I have finally granted them until further notice by Your Honour, [...].

176. Dagregister kept by Sergeant Christiaen Smalbach.
Pimaba, 22 March-19 April 1643.
VOC 1145, fol. 294-300. Summary.
DRZ, **II, pp. 78-84.**

(On 25 March Smalbach went from Pimaba to Borboras to ask chief Patlalun why he still had not moved down into the lowlands near Pangsoya with his people, as he had promised to do. Patlalun explained that the villagers of Borboras had not yet rebuilt their village in the lowlands and started tending crops, because they first had to await the time of the millet harvest. If they did not first reap the harvest from their old fields they surely would suffer starvation during the next northern monsoon season. Upon Smallbachs' warning not to wait too long in carrying out the Company's orders, he agreed to start already with clearing the new place. The next day Smalbach went on to visit Calingit. Cappangh, the headman of that village, responded almost in the same way as chief Patlalun had done. Back in Pimaba chief Redout promised to see to it that his people would deliver as much rice as possible to the Company. Because rice seemed to be rather scarce over there at the eastern part of Formosa, Smallbach asked the inhabitants to start tending more fields. On 7 April three men from Tipol came to meet Smallbach in Pimaba and agreed to do everything the Company wanted them to do if only the hostilities committed against them by those Pimaba and Tavaly could be brought to an end. The following day an inhabitant of Serus informed the sergeant that his village was destroyed and furthermore that

his people had been enslaved by those Vadan. Later on Smallbach was informed by Redout that he had been told by the chief of Supra that Company soldier Jan Huybertsen, who had been stationed in Vadan and who had fallen ill, probably had been beaten to death by some of the headmen of Vadan.)

177. Missive Governor-General Anthonio van Diemen to President Maximiliaen Lemaire.
Batavia, 23 April 1643.
VOC 867, 220-233. Summary.

(fol. 221: […] Governor-General Anthonio van Diemen was very pleased to learn about the conquest of the Spanish settlement on Quelang, the incorporation of Tamsuy, and the further performances carried out by Field-Commander Johannes Lamotius against the rebellious northern inhabitants. He expressed the hope that this would raise so much fear among those rebels, that the Company would in the future no longer have to inflict such a severe punishment. […]
fol. 225: […] He ordered that the island Bottel should be visited again when the opportunity arose, this time with a considerable force, so that this island could be depopulated. The islanders could either be transported to Tayouan or to Batavia. The High Government had been informed of the existence of another island named Malebriga or Tatachel, situated in front of Formosa's northeastern coast at about two miles from the place were the goldmines were supposed to be situated. It was said to be possibly populated by Spanish. President Lemaire was ordered to find out the truth about this matter and, if possible, to see to it that those people might be transported as well.)

178. Resolution taken by President Maximiliaen Lemaire and the Formosa Council.
Tayouan, 27 April 1643.
VOC 1145, fol. 441-442.

D'hoofden der inwoonderen van Calingit, Barboras ende Tacabul op 25en deser in comp. van den soldaet Willem Claesz. van Ceulen (comende door de Cloove van Calingith uyt Pimaba herwaerts alhier) ende heden in raede verscheenen wesende, versocht (fol. 442) hebbende (op onsen voor desen

gedaene insinuatie ende annimatie) dat haer inde leechte een plaetse omme te resideeren mochte aengewesen werden. Daertoe voorstellende seeckere bequame vlackte omtrent vier à vijff mijlen besuyden Pangsoya, hun wijder excuserende sulcx eerder souden versocht hebben ten waere haere rijs ende geerstvelden noch ongeïnt ende groen gestaen hadden, hetwelcke bij den President ende den Raedt (denselven collegiael vergadert wesende) aengehoort ende het versouck in consideratie gecomen sijnde, is verstaen 't selve billick te wesen ende hun toe te staen, mits dat hun dorp in 't viercant ende met rechte straete maecken, dat die plaetse daertoe mogen occuperen ende dat men sulcx, op dat d'inwoonders daer ontrent hier van kennisse mogen hebben, domine Marquinio aenschrijven sal, 't selve hun alomme bekent te maecken.

Uyt de missive van den resident Smalbach (op 25en deser door den genoemden Willem Claesz herwaerts gebracht) gesien sijnde, hoe die van Tipol dewelcke nu jonghst met ons in oorloge geweest sijn, diversche maelen, mits in alles de Compagnie behoorlijck souden subjecteren, aen hem om den vreede ende een verseeckerde woonplaetse in 't laeghe gesolliciteert, item haer sulcx tot naerder gelegentheyt ende onse ordre aende Tipolse reviere te woonen mede provisioneel toegestaen hadde; soo is geresolveert den voorschreven Smallbach op morgen per den genoemden soldaet in ordre wederomme aen te schrijven dat haere residentie aldaer sullen vermogen te blijven houden, mits dat binnen den tijt van 14 dagen ende langer niet naer de gedaene insinuatie sullen gehouden wesen sulcx persoonelijck ten hoove aen ons te coomen versoecken, ofte dat bij faulte van dien nergens geen verseeckerde plaetse hebben sullen. [...].

On the 25th of this month the heads of the inhabitants of Calingit, Barboras and Tacabul, accompanied by the soldier Willem Claesz. from Cologne (having arrived from Pimaba through the gorge of Calingit) were present at the council meeting. They requested (fol. 442) (in accordance with our suggestion and prompting) to be allocated a place to live in the valley, and proposed a suitable stretch of land about four to five miles south of Pangsoya. They apologised for not having made the request earlier, but their rice and barley had not yet been ready to harvest. The president and Council (holding a joint meeting) listened to their request and after some deliberation considered it reasonable to allow them to use that piece of land, on condition that they would built the village as a square with streets that ran straight. In order to make this known to the

people living there it was decided to write to Reverend Marquinio [ordering him] to widely announce this decision.

In the letter from the resident Smalbach (delivered on the 25th by the aforementioned Willem Claesz.) we read that the people of Tipol who were at war with us until recently, had repeatedly asked for peace and a safe place to live in the valley, on condition that they would subject themselves completely to the Company, and that he had permitted them for the time being and until further notice from us, to live near the River Tipol. Therefore, it was decided to send word to this Smallbach tomorrow, through the aforementioned soldier, that we would allow them to continue to reside there provided that within 14 days and not a day longer after being instructed they would come to the Council to make this request in person, and if they failed to do so then they would have no safe place anywhere.

179. Missive President Maximiliaen Lemaire to Sergeant Christiaen Smalbach.
Tayouan, 28 April 1643.
VOC 1146, fol. 514-515.

fol. 514: [...] Dat den Tipolder op sijn versoeck ende onse approbatie bij provisie vreede toegestaen ende aende mont van de riviere Tipol plaetsen om te woonen aengewesen hebt, laten ons wel gevallen, soo bij aldien eenige van de voornaemste ende die machte hebben, om met ons te handelen uyt hun dorp, naer dat haer de weet daer van is gedaen, 't selve (gelijck behoort) aen 't casteel in veertien dagen comen versoecken. Als wanneer hun vrijelijck moget verseeckeren alles wel ende t'haren besten sal afflopen, dan soo sulcx naerlaten, ende in dien tijt om 't voorscr. niet en verschijnen, blijft alles ongedaen ende sult haer insinueeren dat hun voor onse formeele vijanden houden ende steets vervolgen sullen. 't Welck hun onsentweegen soodanich aenseggen moet, dat beweecht werden datelijck met brenger deses herwaerts te comen dat verhoopen willen alsoo volgen sal.

Die van 't gebercht Taccobul sijn aen 't Casteel geweest ende is hun vergunt besuyden Pangsoya aende zeekant haer ter woone needer te mogen slaen. d'Excusen over haere tardance gedaen sijn aenneemelijck ende voor sufficant. Aengesien eenige aende oostcant in 't geberchte leggende aen UE. versoekende om in de leechte te mogen wonen, sult uyt onsen name sulcx toestaen ende gelegentheyt daer toe aenwijsen, gelijck met die van

Labicar geschiet is, dat voor gedaen approbeeren. Niemant sult toestaen eenige oorloge jegens sijne vijanden aen te vangen ofte die te gaen bespringen, maer daer van besocht werden mogen haer mannelijck weeren ende soo veel als connen sien te vermeesteren. d'Ongelijcken die hun dies aengaende geschieden hebben ons te verwittigen, waer inne naer behooren met gelegentheyt sullen versien dat den inwoonders daer ontrent in te scherpen hebt. Soo sult oock naerstich vernemen ofte het also inderdaet ende waer is dat den persoon van Jan Huybrechtsen in Vattan gelegen hebbende, niet sijn eygen doot gestorven, met stocken doot geslagen soude sijn, als UE. journael aengeteeckent, ende ons 't selve t'sijner tijt advijseren opdat daerover de behoorlijcke correctie mogen laten doen.

D'excusen vande Pimabaers hebben weijnich om 't lijff, sulcx daer over oock maer tamelijck genoegen. Wat naer desen op haere belooffde groote verbeteringe, die wel observeeren ofte anders sullen straffen te verwachten hebben volgen sal, willen in aenstaende verneemen. De toesegging, die sij ende andere dorpen daer om haer hebben gedaen van nevens de zuydelijcke dorpen ontrent Tapouliang jaerlijcx in rijs aen de Compagnie recognitie te doen, is een goede sake. Bij alle wegen ende discoursen dient hun in die devotie te houden ende dat wij daer over ten vollen vergenoegen ende noch meer sullen doen als daer van d'effecten ontmoeten. [...].

fol. 514: [...] We approve the fact that you have provisionally allowed the headman of Tipol and his people peace and allocated them a place to live at the mouth of the River Tipol, based on their request and our consent. So, if some of their most important people, authorised to deal with us, appear at Zeelandia Castle within fourteen days after notification to make the request, you can assure them that everything will turn out well for them. However, if they fail to comply and do not appear within the prescribed time everything will be cancelled and you will make clear that we will consider them as our formal enemies and will hunt them down them relentlessly. This you must tell them in our name in such a way that they will be prompted to immediately come down here accompanied by our messenger. We hope this will indeed happen.

People from Taccabul in the mountains came to the castle and have been permitted to settle on the coast south of Pangsoya. The excuses for their tardiness were considered acceptable and sufficient. [If villages] situated in the east in the mountains ask to be allowed to settle in the valley, you will grant permission in our name and allot them a place as was done in

the case of the Labicar people, which was sanctioned by us. No one will be allowed to start a war against their enemies or to ambush them, but if they suffer an attack, they are allowed to defend themselves vigorously and try and take as many prisoners as possible. The injustices they suffer in these cases must be brought to our attention, and we will take appropriate action. This you must make clear to the inhabitants. You must also do your best to find out if it is true that Jan Huybrechtsen, who was stationed in Vadan, did not die of natural causes, but was beaten to death with clubs, as Your Honour wrote in his journal. Please advice us in due time so that we can mete out a fitting punishment.

The excuses of the Pimaba people are poor and we are not very satisfied with them. We want to be informed of the outcome of their vow of significant improvement, which they will have to keep or else be punished. The promise they and their surrounding villages made to pay a yearly tribute in rice to the Company, in the same way as the southern villages around Tapouliang, is very welcome and they should by all means be encouraged to continue to do so. We will make it worth their while and will do even more for them when we see the results.

180. Extract from the Dagregister kept by Provisional Captain Pieter Boon on the exploration expedition to the goldmines.
Quelang etc., 28 April-11 May 1643.
VOC 1145, fol. 353-358.[88] Summary.
DRZ, II, pp. 137-142.

(On 28 April captain Boon and his men, having sailed in a junk from Quelang, found a landing spot on Formosa's northeastern coast. The next day the soldiers marched to Taraboan where they were welcomed by the headmen who expressed their wish to conclude peace with the Company. The people of Tarraboan were willing to assist Boon. On 31 April, upon Boons' request, one of the chiefs went to the remote village of Talleroma and some of the places situated nearby, in order to offer the villagers peace and friendship on behalf of the Company. Meanwhile all inquiries made into the alleged gold-sites led to no result. On 5 May Boon and his men left Tarraboan. Before their depature the chief confessed to Boon that although some people from Cavalangh had told him earlier to distrust the Company-men, the Dutch were now most welcome to his village whenever

they wished to come and trade. Domingo Aguilar's wife [who accompanied the expedition army as interpreter] offered to stay behind in the village in order to see whether she could find out anything more about the gold. Afterwards the soldiers passed by Sakiraya where the people donated them some pigs. In the evening Talleroma was reached but because the inhabitants of that village proved to be very unwillingly to assist the men in any way, the captain and officers thought it unwise to spend the night over there. The 6th of May some rivers had to be crossed and a very steep and rocky road had to be climbed. That night camp was pitched in Pisanan were the men were treated reasonably well. The next day a visit was paid to Vadan, where the army stayed for the night. Boon understood that one of the headmen had already left the villages with most of his followers, so the captain ordered the posting of extra guards. On the 8th the army continued to Soupra where some food was offered to them and the next day they marched on to Tackerij. On 11 May Boon and his men reached Pimaba.)

181. Copy missive Captain Hendrick Harroussé to President Maximiliaen Lemaire.
Quelang, 7 May 1643.
VOC 1146, fol. 486-489. Extract.

fol. 486: [...] Naerdat de inwoonderen van St. Jago in november laestleden gerebelleert ende corts daeraen weder onse vruntschap versochten, en vermits die van Kimaurij op 28en Januario meest door honger gedrongen en door vreese dat de wechgeloopen Cageianen uyt Tamsuy aengehouden hadden, insgelijcx die uyt de dorpen van Cabelan door den quaden wech en ongestuymich weder haer geheel van ons vervreemt hadden, hebbe om enige derselver off gem.e Cageianen te attrapperen alle practicable devoiren aengewent. Ende soo haest het weder toeliet den luytenant met 25 soldaten tot twee verscheyde maelen ontrent halff wegen van St. Jago gesonden, maer is telckens naer dat een seer periculeuse gladde klipachtige wech gemarcheert waeren, vruchteloos gekeert. Edoch door 't animeeren van Domingos Aguilaers huysvrouw sijn eenige van gem.e inwoonderen van Kimaurij die haer dus lange in St. Jago onthouden hebben (meer door vreese dan van een goede genegentheyt) hier geweest. Zulcx merckende en vermits ons seeckerlijck gerapporteert was de wechgeloope Cageianen haer bij hun onthielden, hebbe met eenige der principaelen in arrest te nemen het soo verre gebracht dat ons reede op eergisteren vier van verseyde

Cageianen gebracht ende binnen zes dagen noch twee, die in Cabelan sijn gaen halen, belooft hebben toe te brengen. En soo het mogelijck is dat wij den principael van gemelte dorp en eenige van St. Jago die haer naest een wijl tijts seer trouweloos gedraegen hebben, becomen connen, sullen achtervolgens UE. sijnne missive (als aen de becomene Cagianen) soodanige straffe statueeren dat het de Comp.ᵉ tot dienste ende een ander ten voorbeelde strecken sal. [...].

fol. 486: [...] The inhabitants of St. Jago in November last year had rebelled and shortly afterwards again begged for our friendship, just like the people of Kimaurij had done on 28 January, mainly driven by hunger and fear because they had accommodated Caganayan Company slaves who had run away from Tamsuy. The same goes for the inhabitants of the villages of Cavalangh who became alienated from us on account of the bad roads and bad weather. We have employed all practical means to capture some of those fugitives, or some of the Caganayans. As soon as the weather conditions improved we sent the lieutenant and 25 soldiers half way to St. Jago on two occasions in an attempt to make such a capture. However, having marched over very dangerous, slippery and rocky roads, he returned without results on both occasions. Then, being urged by the wife of Domingo Aguilar, some of the inhabitants of Kimaurij who had remained in St. Jago came to us (more out of fear then friendship). Noticing that, and because we were assured that the fugitive Caganayans were staying with them, we arrested some of the more important ones, thus having four of the aforesaid Caganayans delivered, with the promise of getting another two, who are in Cavalangh, and having them delivered as well. If we succeed in capturing the principal of the aforementioned village and some from St. Jago, who have been acting treacherously for some time, we will – in accordance with Your Excellency's letter – mete out such a punishment to them (and the captured Cagians) to the benefit to the Company and as an example to others. [...].

182. Missive Sergeant Christiaen Smalbach to President Maximiliaen Lemaire.
Pimaba, 9 May 1643.
VOC 1146, fol. 519-521.

Op den 15[en] deser loopende maendt May 's achtermiddaegs is mijn U Ed.[e] missive van den 28[en] passado, door thoonder deses Willem Claesen, van Ceulen wel geworden. Daeruyt verstaen hebbe, hoe U Ed.[e] dat den Tipolder op haer versoecq den vreede tot U Ed.[e] naerder ordre toegestaen ende een woonplaetse aen de Tipolse reviere aengewesen contentement genomen heeft, oock soodanich verblijven sal, soo eenige van sijluyden naer behooren 't selve aen 't Casteel binnen 14 dagen comen te versoecken.

Hierop hebbe datelijcq naer Mornos gesonden, ende den man die van eerst aff haerentwegen te tracteren bij mij geweest (fol. 520) is, ontbieden laten. Dien naerdat 's morgens bij mij verscheenen het bovenaengeroerde, volgens UE. missive, voorgehouden ende cito naer Tipol om d'outsten aldaer 't selve aen te dienen, affgesonden hebbe met expresse last bij aldien geener van hun mede naer Tayouan gaen wilde, dat alles doot en te niet sijn sal, ende sijluyden op alle plaetsen, als onse openbaere vianden dootgeslaegen ende vervolcht werden sullen.

Den 7[en] 's avonts is geseyde Mornosser met eenen vande principaelste uyt Tipol, Assiro genaempt, neffens twee van haere Banserans binnen Pimaba bij mij gecomen. Geseyde Assiro vermelde hoe de Tipolders soo seer bevreest waeren dat geen van haer naer Tayouan gaen wilde, maer sijn geresolveert d'één om de zuyt, d'ander om de noort, west ende oost in andere dorpen te vluchten, dieshalven hij om het dorpsvolcq bijeen te houden, derwaerts gaen wilde, ende UE. om vreede ende vergiffenisse te bidden, verhoopende U Ed. sijne beloften om weder haerwaerts comen te laeten, niet te min als bij die van Callingit ende Borboras gedaen, mede houden sal. 't Welcq hem ten hoochsten verseeckert ende dat daer voor in 't minste niet bevreest zijn zal.

Dese meergenoemde Assiro is onse natie seer toegedaen ende heeft groot ontsach onder de Tipolders, diens halven mijns weynich oordeels goet sijn soude, soo UE.[e] gelieffde dat tot opperhooft van dito dorp uyt UE. naem gestelt werde, mij heeft sich oocq mede aangeboden een velt voor de Comp. te maecken daerin jaerlijcx rijs sal gesayt werden.

Die van Pimaba geven noch weynich gehoor, hoe wel haere outsten eensdeels goet sijn, hebben doch gans geen ontsach onder haer volcq, dan

als jongst vertrocken ben naer Tipol, hebbe swaerlijcq soo veel man die mijn over den wech brachten bemachticht werden connen.

Derhalven de outsten nochmaelen bij mijn ontbooden ende U Ed. laaste missive getoont, ende expres uit UE. naem voorgehouden bij aldien 't selve meermaels gebeurde, dat als dan gewis verseeckert sijn zullen dat het eens voor al met hun uyt ende te niet weesen zal, daerop vrij te letten ende hun voor te sien hadden. Antwoorden dat onder hun volcq soodanich ontsach maecken ende daerop slaen zullen, soo lange als 't hout bij den hant hebben, op dat diergelijcke niet meer geschiet.

Die van 't dorp Tawalij, doen mede van gelijcken, alsoo dat niet eenen man daeruyt bemachticht werden connen, ende wanneer noch mede gaen, laeten één onderwege sitten ende loopen wech, 't welcq 't alder argste is. Ick sal den tijt noch een weynich aensien ende soo daerin continueeren, den oppersten dat bij U Ed. selffs verschijnen moet, opstueren.

Jegenwoordich comt den tijt dat de geerst geinnet werdt, waermede beginnen ende toesien sal hoeveel ider inwoonder ofte dorpsvolcq uyt haer eygen believen aen d'Ed. Comp.ᵉ tot recognitie opbrengen werdt.

Ick hadde wel gesien dat U Ed.ᵉ met een letterken mochten aengeroert hebben, hoe veel bossen rijs een ider gesin opbrengen moet, dan den rechten thiende te nemen, can desen volcq niet ingeprent werden, dan sij bij nacht den rijs van 't velt wechnemen ende nimmermeer voor onsen oogen brengen souden. Derhalven beter is dat een gewis getal van bossen hun te geven opgeleyt wierde, dese Pimabase bossen sijn ongelijck grooter als de Pangsoise, dan uyt één deser bossen wel vier à vijf connen gemaeckt werden. [...]

fol. 521: [...] Soo sullen daer oocq eenige inwoonders wesen die wel stoutelijck durven seggen, wilden wij pays met hun maecken was goet ende wilden wij oocq niet, gaven weynich daerom, souden 't maer recht uytseggen. [...].

On the 15ᵗʰ of this month of May in the afternoon I received from Willem Claesen from Cologne Your Excellency's letter of the 28ᵗʰ of last month. I understand that [my decision] to grant the Tipol headman and his people their request for peace until your further notice and to allocate them a place to live on the River Tipol, met with Your Excellency's approval. Also that you will maintain this [decision] if some of them duly appear at the castle within 14 days to make this request personally.

Upon hearing this I immediately sent someone to Moronos, to summon the man who has been their negotiator from the beginning. (fol. 520) After

he had appeared before me in the morning I explained to him what was written in Your Excellency's letter and sent him straight to Tipol to convey this to the elders there. I also made it very clear that if no one wanted to go to Tayouan, everything will be nullified, and that they will be killed and hunted down as our declared enemies, wherever they might be.

On the 7th in the evening the aforementioned man from Moronos came to me in Pimaba together with one of the principals of Tipol, by the name of Assiro, as well as two of their *Banserans*. Assiro told me that the people of Tipol were so frightened that none of them wanted to go to Tayouan and that they were planning to flee in all directions, some to the south, others to the north or west or east, to neighbouring villages. In an effort to keep the villagers together, he proposed to come [to the castle] and to beg Your Excellency for peace and forgiveness, hoping that Your Excellency would still keep his promise and let him return, as you did with the people from Calingit and Borboras. This I assured him solemnly and told him not to be afraid.

This Assiro is very devoted to us and is highly respected among the people of Tipol. Therefore, in my humble opinion, it would be a good thing if it pleased Your Excellency to appoint him chief of this village in your name. He also promised to bring a field under cultivation to grow rice every year for the Company.

The people of Pimaba are not yet very obedient, although their principals are on the whole adequate, they do not command any respect among their people. When I travelled to Tipol the other day, it was almost impossible to muster the men needed to take me there, so I once again summoned the principals and showed them Your Excellency's latest letter. In your name I made it clear that if assitance was again withheld they could be sure that our patience would be exhausted and that they should [always] be aware of that. They replied that they would instil respect into their people and use their sticks to hammer it home lest it should occur again.

The people of the village of Tawaly behave themselves in the same way. We can not get anyone of them [to accompany us]. And even when they come, they leave along the way and flee, which is even worse. For the moment I will wait and see and if they persist I will send the head [to the castle] to appear before Your Excellency in person.

Now is the time that the millet is going to be harvested. They have already started and I will pay attention to how much of it the individual inhabitants or the village people as a whole will give to the Company as tribute of their own free will.

I would have wished that Your Excellency had mentioned in a letter how many bundles of rice every household was to pay, because it is impossible to get across to them that we must have our rightful tithe and they will take the rice from their fields during the night and keep it hidden from us. It would be better therefore if we ordered them to deliver a fixed amount of bundles. The bundles here in Pimaba are much bigger than the ones in Pangsoya, one of these being equal to four or five of those [from Pangsoya].

fol. 521: *(Just as Smalbach had finished his letter four small boats anchored in the bay of Pimaba. Helmsman Jan Oloffsen immediately came ashore to meet Smalbach and to deliver the message that Captain Pieter Boon and his men had already passed Vadan and Supra and that they were marching along the beach. He expected them to arrive in Pimaba soon. Because the army was suffering from a serious lack of provisions, Boon had occasionally ordered the inhabitants to offer the soldiers some rice. Those who did not observe this request could expect to be punished.)*
There will be some inhabitants who have the audacity to say that if we wanted to make peace, it was all right with them, but if we did not, they could not care less and that this was their honest opinion.

183. Missive Governor-General Anthonio van Diemen to President Maximiliaen Lemaire.
Batavia, 9 May 1643.
VOC 867, fol. 275-282. Summary.

(fol. 280: [...] The High Government in Batavia did not want to revoke its decision that the Formosans had to pay a contribution of paddy to the Company. The objections raised by Reverend Junius on this matter were seen to be unfounded. Although it would take some time to start off the payment, the subjects had to know their sovereigns and pay tribute to them. Junius' other objection, concerning the sending away to Batavia of the pagan priestesses was also seen to be quite absurd. The Governor-General was of the opinion that Junius flattered these old crones far too

much. The Tayouan government would get orders on how to deal with the people of Lamey who were living in Sincan. Those of that nation who had been among the first to be taken to Batavia and who were divided among some Dutch households to learn the Dutch language and to be apprenticed to a trade, proved to be very able. The same counted for those people of Lonckjouw who also had been sent over to Batavia. As a result it became apparant that they were much more useful to the Company away from their country, then they had been on their island. The Governor-General suggested that Formosa instead could partly be populated by people originating from elsewhere. The reported progress (fol. 281) made in the conversion of the Formosan heathens seemed to be considerable. However, the High Government was anxious to know if the positive messages covered up the truth. The Governor-General feared that as long as the Formosans were only taught in their own language, no progress would be made. Therefore the Company had to ensure that they would also be instructed in the Dutch language which was the only way to really win their regard. Van Diemen thought it rather strange that the Company made so much effort for its employees to learn all the different Formosan languages. This might have been worth the effort if there had been one general Formosan language. But since that was not the case (almost every single village on the island had it's own language) the Company had to act accordingly, no matter if this would lead to some retardation of the progress of conversion at first.

Governor-General and councillors were pleased to hear that Christiaan Smalbach had again been sent to Pimaba, in order to act as a resident and to make sure the inhabitants remained obedient. However, because of the riotous life the Company men were known to lead over there, Batavia feared that the inhabitants would take a dislike to the Company as a result. Van Diemen approved of the order drawn up by the Formosa Council, that strictly forbade Company men to cause the inhabitants any inconvenience, for example by extorting goods or provisions from them in an improper way. Lemaire was instructed not to be too considerate towards the rebels of Vavorolangh and of other places. In order to make them turn to the Company he indeed should treat them gently and in a friendly way to begin with. However those who refused to listen, or who were hiding rebels, had to be persecuted and routed out completely. President Lemaire's proposal that all the Company's Formosan subjects

had to be convened once a year for a general meeting at the castle or in Saccam, was received rather well by the High Government. Further orders about this would soon be sent to Tayouan.)

184. Resolution taken by President Maximiliaen Lemaire and the Formosa Council.
Tayouan, 11 May 1643.
VOC 1145, fol. 445.

Aengesien wij op gisteren door het schrijven dato 3^{en} deser van den resident Christiaen Smalbach uyt Pimaba verneemen hoe den provisioneelen capiteyn Pieter Boon, naer 't verrichten van sijnen last in ende omtrendt Tarraboangh, voornemens is om over Pimaba langhs 't geberchte van Taccabul herwaerdts te keeren ende ordre versoeckt wat in passant met sijne bijhebbende crijchsmacht noch gedaen begeeren. Soo geeft den president Maximiliaen Lemaire den raadt, collegialiter vergadert sijnde, in bedencke dewijle sulcx met weynich costen ende moeyten nu gevoechelijck can geschieden, ofte men twee vliegen met eene klap te slaen, niet en begeerde den vorst van Loncqiouw, schoon reede goet gedeelte van sijnen plaetsen geruyneert hebben, echter (hoewel anders verhoopt hadden) noch soodanich niet schijnt aengetast te wesen dat hem den reguel van de Comp.^e met aen 't casteel te comen en reconsiliatie te versoecken voegen wil, ofte wel die van Sotimor met haere adherenten dewelcke nu eenigen tijt herwaerts onse onderdanen in de zuydelijckste dorpen met alderhande vijantlijcke proceduyren besprongen ende gewelt aengedaen hebben, één van beyden met de gem. chrijchsmacht den oorloghe aen te doen ende aen haer ten exempel van andere aensienlijcke straffe met onse wapenen te statueeren. Op alle 't welcke aendachtelijck geleth sijnde, is naer verscheyde debatten op dese twee poincten gehouden, eyndelijck eenstemmich goetgevonden, gemerckt gemelten Boon 't geberchte van Taccabul overcomende 't landt van Loncqiouw achter ofte besuyden hem laet leggen ende aldaer sonder weeder te rugge te keeren, dat den soldaet die reede moey ende math sal sijn in dit warme aemachtighe weder al te seer matteeren soude, dat men voor present den Loncqiouwer daervan excuseeren ende den meergemelte Boon in ordre aenschrijven sal, te meer dewijle dit voorhant ende inden wech opgenoomen can werden, dat hem met onse voorschreven macht ende wapenen jegens die van Sotimor ende d'omliggende plaetsen van haere complicen weynden ende haer op 't rigoureuste den oorloghe aendoen sal, alles doot slaende, gevangen nemende, verbrandende ende ruyneerende dat

hem voor ende in handen compt, opdat zij ende de resteerende dorpen in 't
geberchte, hierdoor tot onderdanicheyt van den Neederlandtschen staeth
gebracht ende wij behoorlijcke kennisse ende acces van den Swatelauschen
wech naer Pimaba, die cort ende in vijf dagen van Saccam tot daer gedaen
can werden, mogen becomen. Waer aen achten de Comp. om de oostcant
van Formosa te gevoechlijcker te frequenteeren ende in devotie te houden
besonder gelegen is.

Yesterday we were informed by a letter of the 3rd of this month from the
resident Christiaen Smalbach in Pimaba that provisional captain Pieter
Boon, having completed his task in and around Tarraboan, was planning
to return through Pimaba along the mountains of Taccabul. He inquired if
we had any orders for him and his troops to carry out on the way.
Therefore president Maximiliaen Lemaire asked the council, sitting in
joint session, to consider – while it can now be easily accomplished
without much expense or difficulty and to kill two birds with one stone –
ordering this force to attack either the ruler of Lonckjouw who, although
we had already destroyed a good many of his strongholds, does not
appear to be so impressed that he will obey Company's rule to come to
the castle and request a reconciliation. An order could also be given to
attack the people of Sotimor and their accomplices who for some time
now have molested our subjects in the south with all kinds of hostile acts.
By severely punishing either of them with our arms, they would be made
an example of, and it would serve as a warning to others. Having
considered all this and after several deliberations on these two points, it
was finally decided unanimously to leave the people of Lonckjouw alone
for the time being because Boon passing through the mountains of
Taccabul will have already passed this place. As a result of this it would
be too demanding for the already tired and exhausted soldiers to go back.
It was decided to send Boon written instructions – especially because this
could be done on the way – to turn his force and weapons on the people
of Sotimor and neighbouring places and their accomplices and to
mercilessly wage war on them, slaying them, capturing them, burning and
destroying everything they could lay their hands on. In this way the
people of Sotimor and the other villages in the mountains will be
subjected to Dutch authority. At the same time we will gain knowledge of
and access to the Swatalau road to Pimaba which is short and can be
covered in five days from Saccam. This is considered to be very

beneficial to the Company in order to get more easily to the eastern part of Formosa and to keep that region under submission.

185. Resolution taken by President Maximiliaen Lemaire and the Formosa Council
Tayouan, 19 May 1643.
VOC 1145, fol. 446.

D'heer president den Raadt des Casteels Zeelandia voorgedraegen hebbende hoe op 17ᵉ deser ons, nevens missive van den 9ᵉⁿ stantij van den Pimabaschen resident Christiaen Smalbach, seeckeren Assiro, hooft van Tipol, aen 't casteel verscheenen zij omme achtervolgende onse insinuatie den vreede uyt den naem van 't selve dorp te versoecken ende te bevestigen dat oock voornemens waeren in der besten formen te doen ende hem (omdat Smalbach ons aenschrijft de Hollanders seer geneegen is, ende veele onder sijn volck vermach) met het Bevelhebbersschap rottingh ende cangan te vereeren. Doch des anderen daechs naermiddachs, hem tot dien eynde ontbiedende, verstonden naer de visserijen uyt wandelen was, sulcx genootsaeckt waeren de saecken tot des anderen daechs uyt te stellen, als wanneer één van sijn volck rapporteerde, die sijn Ed. voor sich liet comen, dat den selven met sijn broeder uyt vreese (om dat eenige swarten in de kettingh hadde sien arbeyden ende dat meijnde men hem oock soodanich soude tracteeren) stilswijgens waeren vertrocken, ende haer geweer tot den tolck Kimptingh hadden laeten staen, sulcx dat haere compste vruchteloos is uytgevallen. Allen 't welcke bij haere Edˢ. in consideratie genoomen wesende, is verstaen ende goetgevonden (om 't selve te hervatten) den voorschreven verbleven Tipolder met een cangans te vereeren ende goet tractement laeten aendoen ende den selven, noch heden ofte morgen, met onse advijsen aen Smalbach te largeeren ende den selven daerbij aen te schrijven dat haer andermael op de gevouchelijckste maniere insinueert, dat weldoen sullen ende haer in 't minste geen hinder daerover van ons en sal toecomen, dat gem. Assiro ofte iemandt anders ten eynde als vooren aen 't casteel verschijnt, twintich dagen naer d'eerste insinuatie ofte anders dat vijanden verclaert blijven.

The president informed the Council that the 17th of this month a man called Assiro, head of Tipol, had arrived at the castle – carrying a letter from our resident in Pimaba, Christiaen Smalbach, dated the 9th of this month – in order to ask for peace in the name of his village in accordance

with our suggestion. He intended to formally grant him that request and to present him with a baton [as symbol] of power and a cangan (because Smalbach had written to us that he was dedicated to the Dutch and enjoyed great authority over his people). However, when he was summoned the next afternoon for that purpose, we heard that he had gone for a walk to the fisheries so that we were forced to postpone it to the next day. Then one of his people, summoned by His Excellency, reported that he and his brother had departed secretly out of fear (because they had seen some blacks working in chains and thought that they were going to be treated the same), having left their weapons with the interpreter Kimptingh. Their arrival had thus been in vain. All this being considered by Their Excellencies, it was decided (in order to go through with our objective) to present the aforesaid man from Tipol who had stayed behind, with a cangan, to treat him well and to send him today or tomorrow to Smalbach with our instructions. Smalbach is ordered to tell them in an appropriate manner that we will treat them well and will not give them any trouble when the aforementioned Assiro or someone else appears at the castle within twenty days after being told to do so, or else they would continue to be regarded as enemies.

186. Missive President Maximiliaen Lemaire to Sergeant Christiaen Smalbach.
Tayouan, 19 May 1643.
VOC 1146, fol. 515-516.

fol. 515: [...] Soo is ons oock [...] wel geworden UE. missive van den 9ᵉ deser, benevens Assiro, hooft van Tipol, die soo uyt U lieden schrijvens verneemen op onse insinuatie herwaerts quam om de vreede uyt den naem van 't selve dorp aen ons te versoecken ende te bevestigen, dat oock voorneemens waeren in der bester forme te doen ende hem, omdat ons aen schreeff de Hollanders seer genegen is en veele onder sijn volck vermach, met het bevelhebberschap rottangh ende cangan te vereeren. Dan des anderen daechs naer middachs hem tot dien eynde ontbiedende, verstont naer de visschereijen uyt wandelen was, sulcx de saken tot 's anderen daechs uytstellen mosten, als wanneer ons door één van sijn volcq die voor ons lieten comen aengedient wert denselven met sijn broeder, uyt vreese om dat eenige swarten in de kettingh hadde sien arbayen ende dat meynde men hun oock soo danich soude tracteeren, stilswijgens waeren

vertrocken en haer geweer dat d'tolck Kimtingh hadde laten staen, sulcx dat dier halven haere compste vruchteloos is uyt gevallen. Echter om 't selve te hervatten, hebben den brenger deses met een cangangh vereert, goet tractement laten aendoen, ende wat voornemens waeren met gemelten Assiro ende noch gesint sijn te doen, soo twelijck retourneert, aengeseyt. Dat belooft heeft haer alles op 't beste voor te dragen welcken volgens, om de saken aen weeder zijden genoech te doen, hebben in 't raden goet gevonden UE. aen te schrijven dat haer aendermael op de gevoechelijckste maniere insinueert dat wel doen sullen ende haer in 't minste geen hinder daer over van ons en sal toecomen, dat gemelten Assiro ofte iemant anders, ten eynde als vooren aen 't casteel verschijne, twintich dagen naer de eerste insinuatie die hun onsent halven sult doen, ofte anders dat vijanden verclaert blijven. Dat wel ter herten neemen mogen ende met een geringe moeyten connen weeren, hiertoe genegen sijnde con 't haer een Nederlander van daer tot convoy mede geven die dan met haer wederom van hier daerwaert keeren sal. 't Papier dat ontbooden hebt, gaet in handen van brenger deses, voors. gebleven Tipolder die per Chinees in Tapouliangh hebben laten convoyeeren ende soo van de inwoonders, opdat geen onheyl en ontmoet, van dorp tot dorp hebben g'ordonneert, sal werden versekert tot dat (fol. 516) [in] Tipol ofte Pima comt.

De recognitie soo d'inwoonders inde suydelijcke dorpen aen de Comp. jaerlijcx betaelen is thien bossen voor ijder huysgesint dat die van d'oostelijcke dorpen, vermits hunne bossen vrij grooter sijn, met vijff van d'haere sullen moeten voldoen. 't Welck ongevaer den anderen reeckenen slaen ende jegens November ofte als haeren oest ingesamelt is, te voorderen hebt. Thiende en begeert de Compagnie niet van 't selve, nog is 't vermaen geweest, ende soude d'inwoonders al te lastich vallen, die niet gesint sijn booven reeden te belasten.

De regenten Redut, Thoya ende verdere outsten van Pimaba die ons hebben doen groeten cont uyt onsen naem met gelijcken congratuleeren ende haer, als oock die van Tavalij, aendienen soo niet gedienstiger en sijn de Compagnie en haere dienaers in het een en ander voorvallende de behulplijcke hant te bieden, als nu eenigen tijt herwaerts hebben gedaen, dat de vaderlijcke vermaninge in scherpe correctie sullen veranderen, daerop wel letten mogen hun die 't eeniger tijt t'ontmoeten staet. [...].

fol. 515: [...] We duly received Your Excellency's letter of the 9th of this month which arrived with Assiro, head of Tipol who, as we understood from your writings, came here to ask for peace in the name of his village. We intended to grant him that formally and to present him with a baton

and a *cangan*, because you wrote that he was very devoted to the Dutch and enjoyed great authority among his people. However, when we summoned him the next afternoon for that purpose, we heard that he had gone for a walk to the fisheries so that we had to postpone the proceedings until the next day. That day we were informed by one of his people, whom we had summoned, that he and his brother had secretly departed, leaving their weapons with the interpreter Kimtingh, because he had seen some blacks working in chains and feared that we would treat them the same. Their arrival had therefore been in vain, but in order to continue our efforts, we have presented the bearer of this letter with a *cangan*, treated him well, and told him what our intentions were with regard to Assiro, and that we still intended to negotiate peace as soon as he returns, which he promised to convey to the best of his abilities. Thereupon, in order to satisfy both sides, the council has decided to instruct you to tell them once again in an appropriate manner that we will treat them well and will not harm them in the least if the aforementioned Assiro or anyone else appears at the castle twenty days after the first notification that you will give them in our name. Otherwise they will continue to be regarded as enemies. They should be well aware of this and should know that problems can be avoided without much difficulty. If they want to, you can put a Dutchman at their disposal as an escort, who will return with them from here. The paper you asked for has been handed to the bearer of this letter, the man from Tipol who had stayed behind, whom we had escorted by a Chinese to Tapouliang and then ordered the inhabitants to do likewise from village to village, so that no harm might befall him, ensuring his safe journey (fol. 516) to Tipol or Pimaba.

The yearly tribute the inhabitants of the southern villages are paying the Company, is ten bundles per household. The eastern villages, because their bunches are considerably bigger, will have to pay five, which we think is about the same. These will have to be collected in November or when they have harvested their crops. The Company does not require tithe, nor did we request them to do so, as it would have been too difficult for the inhabitants, whom we do not want to burden unreasonably.

To the regents Redout and Toea, and the other principals of Pimaba who have sent their respects, you can return our compliments. You should

inform them that if they are not more obedient and will not lend a helping hand to the Company and its servants if needed, as they have done for some time, our fatherly admonitions will be replaced by severe punishment. They should be well aware of what might be in store for them. [...].

187. Missive Sergeant Christiaen Smalbach to President Maximiliaen Lemaire.
Pimaba, 19 May 1643.
VOC 1146, fol. 521-522. Extracts.

fol. 521: [...] Die door vermoeytheyt als met quade beenen beladen, ende van den cappiteyn Boon tusschen Supra ende Pimaba achtergelatene zes soldaten ende des barbiers jonge, sijn den 14en deses voormiddaechs, naer 't vertreck van den cappiteyn, drie gedraegen, nevens vier andere (fol. 522) die noch weynich bijgaende waeren, door die van 't dorp Daracop hier gebracht.

Den 17en dito comt den tolcq Antonij met de twee siecken uyt Vadaan alhier, dat nu alle bij malcanderen ende geene meer achter waeren, waer van den eenen, Martinus Ewoutsen genaempt [...], gevraecht hoe sich die van Vattan tegens hun hadden gedraegen. Rapporterende dat hun geen dronck waeter geven, noch veel min over den wech brengen wilden, derhalven hun hoe sieck ende kreupel oock waeren, naer Serus begeven hebben. Van welck Serussers 's anderen daegs op Supra en verder door die van Daracop ende Pimabaers binnen Pima gebracht. [...]

Op de beloften die de Pimabaers aen de cappiteyn om haer in toecomende beter als gedaen hebben tegen d'onse te gedraegen, sal wel letten. Dan ick noch weynich beteringe speure derhalven den regent Redut voorgestelt dat die van Pimaba vrij aenseggen mochte, bij aldien in 't oude continueeren, icq aen U Ed. om in Tipol te gaen woonen versoucken soude. Hier over sijn seer verbaest geworden, hebben gebeden dat sulcx niet doen mocht, sij souden alles naercomen gelijck belooft hadden. [...]

Den cappiteyn Redut versoeckt Ued. gelieven acht à tien man soldaten, gelijck bij Sr. Wesselingh zaligers tijt geschiet is, alhier een tijt langh leggen om de quade Pimabaers te vervolgen ende met toedoen van de onse uyt te roeyen. [...].

fol. 521: [...] The 14th in the morning, after the departure of the captain, the six soldiers and the barber's boy who were left behind by captain

Boon between Supra and Pimaba because of exhaustion and weakness of the legs, have been brought here by some people of Daracop. Three of them were carried while the other four (fol. 522) just about managed to walk.

On the 17th of this month the interpreter Anthonij arrives from Vadan with two sick men, so that no one was left behind. When one of them, called Martinus Ewoutsen, was asked how the people of Vattan had treated them, he answered that they had not even been given one sip of water, and had flatly refused to take them down the road, so that they, sick and lame as they were, had gone to Serus. The next day people from Serus had taken them to Supra, and those of Daracop and Pimaba had taken them further to Pima.

I will pay close attention to the promises made to the captain by the Pimaba people to improve their behaviour towards us from now on. I do not see much improvement and therefore I have told the regent Redout to notify the people of Pimaba that if they were to continue in their old ways, I would ask Your Excellency's permission to go and live in Tipol. This made them very anxious and they begged me not to do that, saying that they would fulfil all their promises.

Captain Redout requests Your Excellency to station eight to ten soldiers here temporarily, as was the case during the late Mr. Wesselingh's time, in order to deal with the Pimaba people who misbehaved and to exterminate them with our help.

188. Resolution taken by President Maximiliaen Lemaire and the Formosa Council.
Tayouan, 21 May 1643.
VOC 1145, fol. 447.

Den heer President den Raet des casteels Zeelandia bij den anderen vergadert hebbende communiceert haer Eds. hoe sijn Ed. gisteren avont een missive uyt Tapouliangh van den 20en May toegecomen was, waerbij de proponent Andreas Marquinius advijseert hoe den provisioneelen capiteyn Pieter Boon, met zeven soldaten geaccompangieert, den 19en deser 's avonts in Tapouliangh gearriveert was, latende de meeste macht in Netne, omme te vernemen werwaerts den aenstaenden tocht soude geschieden. Het welcke verstaen hebbende, hadde gerapporteert den tocht naer Sotimor niet wel met volcomen respect soude connen uytvoeren,

alsoo sijnne crijchsmacht bij den anderen versamelt hebbende ('t welck sonder verloop van eenige dagen almede niet soude connen geschieden) want bij troupen van tien ende twintig in 't getal hier ende daer sijn achter gebleeven, geen dertig bequame persoonen soude connen uytmaecken. Ten aensien d'selve al te samen (door de langhdurige reyse) afgemat ende door gebreck aen coussen ende schoenen haere voeten geweldich beschadigt sijn, [...] is op het voorstel van sijn Ed. geresolveert den meergeroerden Marquinio op stondt aen te schrijven, dat sich gem. capiteyn met sijne bijhebbende macht op 't alderspoedichtste herwaerts aen transporteert. [...].

Mr President having convened the Council of castle Zeelandia, informed Their Excellencies that yesterday evening he received a letter from Tapouliangh dated the 20th of May in which the ordinand Andreas Marquinius writes that provisional captain Pieter Boon accompanied by seven soldiers arrived in Tapouliangh on the evening of the 19th of this month, having left his main force in Netne, in order to hear where he had to lead his campaign. After being told [his destination] he said that he would not be able to carry out this campaign to Sotimor completely according to plan, because having assembled his troops (which could not be done in a few days as they straggled all along the way in groups of ten and twenty) they would not even amount to thirty able persons. Because of the fact that they are all exhausted (caused by the long journey) and their feet are in a very bad state through lack of socks and shoes, [...] it has been decided at the suggestion of His Excellency to immediately write to Marquinio that the aforesaid captain and his accompanying force should proceed to Tayouan without delay. [...].

189. Missive Captain Hendrick Harroussé to President Maximiliaen Lemaire.
Quelang, 23 May 1643.
VOC 1146, fol. 489-491. Extract.

fol. 490: [...] Met des inwoonders vaertuygen van Tarraboan is hier voor acht dagen Domingos Aguilaers vrouwe, die door den cappiteyn Boon den 7[en] stantij op sijn vertreck naer costij aldaer gelaten was, in Cabalan ende van daer over landt op gisteren hier gecomen ende gerapporteert, naerdat gem.[e] cappiteyn met bijhebbende chrijchsmacht lange naer de goutmijne gesocht hadt, van daer over lant naer Pimaba vertrocken was. [...]

De inwoonderen van St. Jago en Cabalan, die 't sedert het vertrecq van gem.^e cappiteyn tot dieversche reyse ontboode hebbe, betoonen als noch haer seer ongenegen om van hier te comen, insgelijcx die van Kimaurij welcke meestendeel weder in haer dorp gecomen waeren. Beginnen haer andermael, door vreese, om dat ons kennelijck is sij de Cagejaenen aengehouden ende gespijst hebben, omtrent halff wegen St. Jago in 't bos te begeven, dienvolgende soo sijn van meyninge als met woorden ende toedoen van Domingos Aguilaers vrouwe en met de redelijckheyt niet te regeeren sijn, alle mogelijcke middelen aen te wenden om haer en die van St. Jago soo seer te vervolgen, schaede ende affbreuck te doen als met deses garnisoens volck sonder perijckel en nadeel van de Comp. eenichsints connen gedaen werden. [...].

fol. 490: [...] With boats of the inhabitants of Tarraboan, Domingo Aguilar's wife (who had been left there by captain Boon on his departure on the 7th of this month) came to Cabalan eight days ago. From there she arrived here yesterday overland. She reported that the captain and his force, having searched for the gold mine for a long time, had departed for Pimaba overland. [...]
The inhabitants of St. Jago and Cavalangh, whom I have summoned several times since the departure of the captain, are still very reluctant to come here. Also the people of Kimaurij, who for the most part had returned to their village, are starting to move into the woods about halfway from St. Jago out of fear because it is known to us that they have accommodated the Caganayan Company slaves and fed them. Therefore it is our plan – if they cannot be controlled by words through the help of Domingo Aguilar's wife or by reason – to use all possible means to persecute them and the people of St. Jago, to cause them as much harm as can possibly be done by our garrison without danger or detriment to the Company.

190. Missive Lieutenant Thomas Pedel to President Maximiliaen Lemaire.
Tamsuy, 28 May 1643.
VOC 1146, fol. 503-506. Extract.

fol. 505: [...] Diernevens senden wij UE. per de lootsbooth de twee realen min een sesje (alsoo niet meer conde becomen) swaerte gout, costende

11¾ reaal swaar gelt, hetwelcke ick voor desen inde dorpen Kitsjock ende Vatsican van de inwoonders hebben geruylt, ende ernstelijck vernomen off geen meer hadden, waerop antwoorden van Jaa, maer dat niet minder wilden geven als tien reaal à 56 stuyvers de reaal swaerte. Vorder hebbe haer curieuselijck ondervraecht waer 't gout haelden ofte van wien sij het verhandelen, seyden dat sij 't van de inwoonders van Tarraboangh ruylden 't geene sij hebbende, maeckende soo veel cromme sprongen eer sij van dit weynich gout conden scheyden, dat belachelijck was ende hadde groote moeyte eer dat conde becomen. [...]

Alsmede de over den gedaenen tocht om d'inwoonders haere dorpen, wegen, paden, revieren t'visiteeren ende haere humeuren en conditiën aff te speculeeren, ende alsoo ernstelijck te vernemen ofte eenige seeckerheyt van de goutmijne conde verstaen ende off d'inwoonders quantiteyt hadden, alle 't welcke hebbe gedaen ten meesten dienste van de Comp. Doordien de wilden haer landt niet eerder aen ons begeerden op te draegen voor en aleer dat ick hun eerst hadde comen besoecken, dat dan daernae doen souden wat wij begeerden, [...], dat sij 't seedert altijts gedaen hebben ende beeter gehoorsaem geweest als d'andere dorpen daer ick niet geweest ben, maer wert UE. ordre van mijn persoon altijts in en bij 't fort te houden ende geen inwoonders daerinne te laeten comen, volcomentlijck achtervolcht. [...].

fol. 505: [...] Herewith we send Your Excellency with the pilot boat the two reals, minus a sixth (because we could not get more), weight of gold, costing 11¾ heavy reals, which I bartered with the inhabitants of the villages of Kitsjock and Vassican. I inquired if they had more and they answered yes, but they would not sell for less than ten [silver] reals at 56 five-cent pieces per real weight. I also made extensive inquiries as to where they got the gold, or from whom they bought it. They told me that what they had, they had exchanged with the people of Tarraboan, making all sorts of excuses lest they had to part with even this small amount of gold, it was really ridiculous and it took a lot of trouble to get it. [...]

Also [I send you the report] on the expedition to explore the villages, roads, paths and rivers and to find out as much as possible about the character of the inhabitants and their circumstances and to make serious inquiries in order to find out the facts out about the gold mine and if the inhabitants had a lot of gold in their possession. All that I have carried out, serving the best interests of the Company, because the savages did not want to yield their land to us before I had visited them, and only after

that would obey our wishes. [...] This they have indeed done since then and they have been more obedient than the other villages that I had not visited. I have however scrupulously obeyed Your Excellency's order to always stay in or near the fort and not to allow the inhabitants to enter it.

191. Missive President Maximiliaen Lemaire to Captain Hendrick Harroussé.
Tayouan, 6 June 1643.
VOC 1146, fol. 481. Extract.

fol. 481: [...] Desen dient tot geleyde vande nevensgaende twee Nederlanders, den Japander Jasinto ende eenden Kimaurier, [...]. Den vers. Japander, vermits aldaer vrouw ende kinderen heeft, de inwoonders taele promtelijck spreeckt, de Nederlanders toegedaen, bejaert ende van goet leven is, hebben op sijn ernstelijck versoeck in dienst van de Compagnie genomen, om voor tolcq als andersints costi gebruyckt te werden, [...].
De Kimauriër Bartholomeus die met Pieter Boon als tolcq mede naer Tarroboangh geweest, ende ons over Pimaba toegecomen is, hebben goet tractement alhier aengedaen, hem met twee cleetjens vereert ende gerecommandeert de Comp. in alle voorvallen onder de inwoonders aldaer de hant te bieden, ende naer UE. commando te luysteren. Dat belooft heeft te doen. [...].

fol. 481: [...] This serves as a safe-conduct for the two Dutchmen, the Japanese Jasinto and someone from Kimaurij. On his urgent request we have taken this Japanese into the employ of the Company, to be used as an interpreter or in another capacity at your post, because he has wife and children there, speaks the local language fluently, is devoted to the Dutch, is old and leads a good life.
The Kimaurij man Bartholomeus, who accompanied Pieter Boon to Tarraboan as an interpreter and came to us via Pimaba, has been well treated here. He was presented with two pieces of cloth and instructed to lend the Company a helping hand in questions pertaining to the local people and to obey Your Excellency's orders, which he promised to do. [...].

192. Missive President Maximiliaen Lemaire to Captain Hendrick Harroussé.
Tayouan, 10 June 1643.
VOC 1146, fol. 482-483. Extract.

fol. 483: [...] De huysvrouwe van Domingos Aguilar die ons bericht wert aldaer en op voors. tocht goeden dienst gedaen heeft, sult met d'eerste Nederlants vaertuych herwaerts laeten comen, opdat alhier wederom bij haer man, dien seer naer verlangt, mach geraecken. [...].

fol. 483: [...] The wife of Domingo Aguilar – who we were told has rendered excellent service over there and during the expedition – you will send back with the first Dutch ship, so that she can be reunited here with her husband who is eagerly longing for her. [...].

193. Missive Captain Hendrick Harroussé to President Maximiliaen Lemaire.
Quelang, 11 June 1643.
VOC 1146, fol. 496-497. Extract.

fol. 497: [...] Theodoor, principael van Kimaurij, die alleen causa movens van 't wechloopen der selver indios ende Cagiaenders is geweest, ende daerover hem als noch schou van ons houdt, heeft verscheyde maelen sijn leetwesen ons laeten aencundigen ende doen bidden dat al zulcx hem mochte vergeven sijn, wel genegen was weder in 't fort te comen. Daerop wij hem weynich antwoorde hebbe laeten weten maer echter soo vertrouwe, vermits nieuwers heen en weet ende ons sijnne genegentheyt gerapporteert is, dat sich in weynich dagen op genade bij ons vervougen sal. Soo UE. believe, dat hem dan naer costij schicken ofte hier wat in apprehentie houden, ende om dat apparentelijck sijn faute met goede dienste verbeteren sal (als dan wel gedwongen sijnde) weder largeeren connen, [...].

fol. 497: [...] Theodoor, principal of Kimaurij, who alone was the reason for the 'Indians' and Caganayan Company slaves fleeing, and who is therefore still afraid of us, had his regrets conveyed to us on several occasions and had begged to be forgiven, saying that he was willing to come to the fort. We have not answered him, but we trust that he will give himself up and cast himself on our mercy before long, because he

has nowhere to go and we have been apprised of his whereabouts. If it pleases Your Excellency we can send him to you, or else we will keep him prisoner here for some time until we can release him, because he clearly intends to redress his faults through rendering good service (being forced to do so anyway), [...].

194. Missive Sergeant Christiaen Smalbach to President Maximiliaen Lemaire.
Pimaba, 13 June 1643.
VOC 1146, fol. 522-525. Extracts.

fol. 523: [...] Aengaende de Tipolders hebbe den Assiro, neffens haere outsten, bij mij ontbieden laeten, maer daer is niemandt gecomen, den Assiro excuseerde hem, door groote sieckte niet comen coste. D'anderen seyden tegens haeren wette te wesen van daer te vertrecken voor dat haeren geerst ingehaelt hadden, ende hoe dickwils oocq stuerde, ende met veel dreygementen om haere velden in brant te steecken te laten, als niet quamen, aenseggen liet, creegh voorige antwoort, ende baden om uytstel, dierhalven patienteeren mosten. Den 5en dito sijn meergem. Tipolders naementlijck Hardip, sijnde de broeder vanden wechgevoerden oppersten Kacko, dien de bevelhebbersschap naer UE. goetvinden ten naesten soude toecomen, Ikenau, Dingelau, Drigau ende Hellemont jonge, neffens meer andere alhier verscheenen, dien UE. laetste vermaen ende waerschouwinge voorgestelt ende dat datelijcq sullen resolveren wat doen ofte laeten wilden, alsoo den Duytsman al acht dagen langh naer haer gewacht ende niet langer ophouden conde, maer op morgen aen sijn Ed. naer Tayouan affseynden wil. Gaven tot antwoort dat hun binne drie daegen claer maecken ende derwaerts vertrecken wilden, 't welcq hun noch maelen toegestaen, met conditie dat sij ter genoemder tijt quamen ofte niet, den Duytsman evenwel wechsenden soude.

Den opperhoofden van Pimaba hebbe naer UE. groetenis, daervoor hun ootmoedich bedancken, hoedat in 't toecomende sich tegen ons volcq met heen en weer helpen over den wech, soo wel zuytlijcq als noortlijck, beter bethoonen mosten, gelijck noch tot dato gedaen hebben, opdat geen clachte bij U Ed. verder comen mochte daer door genootsaect wierden haere vaderlijcke goetheyt in scherpe correctie eenmael te veranderen ende sij t'sijnder tijt het uyteynde daervan te verwachten hadden, voorgehouden. Dienden daerop dat haeren mogelijcke vleijt dagelijcks aenwenden, gelijck selffs sien coste, maer hadden geen gehoor onder 't volcq meer, als hun

de regent Redut iets seyde, antwoorden: 'wat is aen U blinde gelegen, wat wilt gij doen, gij cont immers niet sien ende de Hollanders leggen alle sieckelijcq ter coye, wat geven wij om U', doet alsoo een ider wat selffs wil. Eenen halven dach gaens van hier oostwaerts aen de zeecandt genaemt Rengenas, bouwen sommige uyt Pimaba sonder mij te kennen ofte te vraegen een dorp, 't welcq genouch te beletten stondt, ende alles voor te comen was, hadde maer een maendt lancq tien à 12 soldaten bij mij leggen.

De omleggende cleyne dorpen die somtijts ten dienste van den E. Comp. met het aenbrengen van bambousen ende rottangh die tot vermaecq van 't huys ende packhuys, dat aende eene zijde geheel ingevallen is, van doen hebbe, (fol. 524) willen mede naer die van Pima niet meer luysteren, ende wil icq iets gedaen hebben moet sij door de Duytschen aenpressen laeten, maer alsoo niemant hebbe die derwaerts senden can, moet alles leggen laeten als 't is.

Den oppersten van Tawalij, Sowangh genaemt, hebbe tot vijf à zes reysen om UE. last, gelijck die van Pimaba, aen te dienen bij mij ontbieden laeten maer is soo stout dat niet verschijnen wil. Seyt hebbe ick wat te seggen bij hem comen sal, 't welcq mij onmogelijcq is. Verder hebbe den selven uyt UE. naem aenseggen laeten, dat gelijcq Tipol, Pimaba ende andere omleggende dorpen gedaen hebben, met sijn dorpsvolck in 's Compagnies velt eenen dach zullen comen wercken, icq sal se met cost ende dranck versien, maer die daer compt is niemandt. Daertoe rucht de andere zuytlijcke dorpen op, dat op mijn ontbieden niet verschijnen zullen, seggende ick en deuge niet, de Hollanders deugen niet ende diergelijcke meer. Soo hebbe oocq eenen stoel met drie cussens in Tawalij bij hem staende gehadt, welcken stoel hem den cappiteyn Boon in sijn vertrecq belast dat in Pima soude brengen laeten, doch 't selve niet achtervolcht.

Den soldaet Adriaen Firmenoys bericht hoe in 't herwaerts comen, sijnde ontrent drie daegen naer des cappiteyns vertrecq, 's Comp.ˢ huys vol pijlen, bogen ende hassagayen staende gevonden heeft, waermede desen booswicht vemeynt, soo den cappiteyn iets anders tenderen wilde sich vijantelijck te betoonen ende te defendeeren. Wanneer hem nu deses alles voorgehouden werdt, sal naer sijne gewoonte 't selve gesamentlijcq denegeren, gelijcq verscheyden reyse daer hem de luyde die goet affgenomen heeft present gebracht hebbe in mijn jegenwoordicheyt gedaen heeft, om desen nu voor te comen, laet bij U Ed. rijper oordeel berusten. [...]

Den 20ᵉⁿ May passado is den edelman Permonij (alias Paulus genaempt) uyt Vadaan alhier aengelangt, medebrengende zeven vrouluyden hooffden,

die uyt het dorp Pisanan, 't welcq onse vrunden sijn ende voor twee jaeren den E. heer gouverneur Paulus Traudenius met zijne bijhebbende macht, ende nu in 't verbij trecken den cappiteyn Pieter Boon ende sijn volcq veel goet gedaen ende met cost ende drancq onthaelt hebben, gebracht heeft. Daerop seer verstoort geworden ben, hem Permonij, neffens sijne broeder Redout voor mij comen laeten, ende hun luyden gevraecht, wie daertoe last gegeven hadde uyt oorloogen te gaen, naer de mael het van onsen Ed.e heer president expres verboden is. Redut antwoorde dat het buyten sijn weten was ende wil sijnen broeder, hoe blint oocq is, bij naer doorstooten. Permonij antwoorde dat door den regent Redut daertoe gebracht sij, die hem geseyt dat den cappiteyn Boon bij sijn vertrecq uyt Vadaan, op Pisanan te gaen oorlogen consent gegeven heeft, 't welcq groote leugens sijn. Die hooffden liet voor mij coomen, ende belaste dat d'selve dadelijcq ter plaetse daer gewoon sijn te bergen, brengen souden ende naer haere wetten geen dansen, springen noch eenich getier daer over te maecken sullen, 't welcq naer gecomen sijn ende de Pimabaers, dat het bij U Ed. qualijcq sal genomen werden, een groote vreese aengebracht heeft. Dit is het getal der hooffden die sij gehaelt hebben: (fol. 525)

Vadaan: dertig coppen.

[Pisanan]: zeven ditos.

Supra: vier ditos.

Saccareya: drie ditos.

Somma: 44 ditos.

Den 27en May heeft den edelman Callocalle op mij versocht dat hem consent geven wil op Lonckjouw te gaen oorlogen 't welcq hem vergunt, alsoo noch niet anders weet onsen vijant is.

Den 4en Junij is voorgenoemde Callocalle van Lonckjouw wederom gecomen, medebrengende een mans hoofd, rapporteerende hoe op den 1en deses in de sant bay naest bij Lonckjouw gecomen is alwaer een geheel dorpsvolck van des Lonckjouwers slaeven, nevens twee Chineesen, die eenen cnasser met cangangs om vellen van de omleggende dorpen te ruylen, bij hun gehadt hebben, voorgevonden. Dito volcq heeft hunluyden toegeroepen dat van UE. vreede vercregen hadde, souden maer vrij bij hun comen, 't welcq de Pimabaers niet gelooven wilden, sijn met hun aen 't vechten geraeckt, hebben sommige gequetst ende eenen het hooft affgeslaegen.

Den 9en dito sijn de inwoonders van 't dorp Darcop bij mij verscheenen, claegende over eenen Pimabaer, Alibanbangh genaempt, die sich in 't dorp Saccarey ophout ende de dorpen Supra, Saccareya ende Pallan opruct, dat op mijn ontbieden niet verschijnen, noch met de Hollanders iets te doen

hebben zullen. Neemt de luyden daer selffs root hont hair, schulpen ende meer anders aff ende de wijle hem de Daracoppers het selve niet geven wilden, dreygt hij dagelijcks dat met die van Vadaan comen, de Daracoppers dootslaen ende het dorp in brant steecken wil.

Versoucken derhalven dat U Ede. gelieve een Duytsman in haer dorp te leggen, op dat voor dit volcq bevrijt sijn mochten. Dit soude niet ongeraden wesen, alsoo aldaer de beste elants huyden vallen ende door hun luyden aen die van Batsilaer tegens hout verruylt werden, welcke proffijten de Comp.e als dan genieten cost.

De outsten van Pimaba hebbe aengesecht dat eenich volcq naer 't dorp Saccreya stuyren zullen ende den Alibanbangh opbrengen, maer can 't selve van hun niet vercrijgen, seggen tegens haere wet te wesen haer eygen volcq gevangen te nemen ende Duytse daer naer toe te senden. Hebbe niemandt die gaen can. [...]

De Pimabaers neffens de omleggende dorpen, brengen redelijcke vellen te ruylen, dat alsoo van dit jaer eene goede somma bijeen vergaderen zal.

Den Tipolder Hardip presenteert sich aen, den Lonckjouwer levendich in handen gevangen te crijgen ende U Ed. te brengen. [...].

fol. 523: [...] Regarding the people of Tipol, we have summoned Assiro and their principals, but no one showed. Assiro asked to be excused, he could not come because of serious illness, the others said that it was against their law to leave before they had harvested their millet. However often we sent for them, and threatened to burn their fields if they did not come, they gave the same answer and asked for respite, so that we had to be patient. On the 5th of this month some of the Tipol principals, to wit Hardip, brother of the deported principal Kacko, who, with Your Excellency's approval, has the first claim to command, Ikenau, Dingelau, Drigau, Hellemont the younger, and some others appeared. I conveyed Your Excellency's latest admonition to them and a warning and told them to make their minds up without delay, as to what they wanted to do. Because the Dutchman had already been waiting for them for eight days and could not be kept here any longer, but should be despatched tomorrow to His Excellency in Tayouan. They replied that they wanted to make preparations to leave within three days. This was allowed, making it clear that the Dutchman would be sent on his way whether they had arrived at the appointed time or not.

I have conveyed Your Excellency's kind regards to the principals of Pimaba, who have thanked you humbly. I have instructed them to show

more willingness in future than they had done so far in helping our people on their journeys, either going south or north, so that no further complaints would reach Your Excellency. Otherwise his fatherly benevolence would have to give way to severe punishment, which they certainly could expect in due course. Their answer was that every day they did their utmost, as we could see ourselves, but their people did not obey them anymore. Whenever their regent Redout spoke, they replied: 'Why trouble yourself, blind man, what do you want, you cannot see, can you, and the Dutch all lie on their bunks ailing, what do we care about you'. And so everybody does whatever he feels like. Half a day's walking from here to the east, at a place on the coast called Rengenas, some people from Pimaba are building a village, without asking or informing me. This could effectively be prevented or stopped, if only I had ten or twelve soldiers stationed here for one month.

The little villages in the neighbourhood, with which we sometimes have dealings, when they supply the Company with bamboo and rattan for the repair of the house and the warehouse (which has completely collapsed on one side) (fol. 524) also refuse to obey the people of Pimaba. When I want something done, they have to be forced by Dutchmen, but as I have no one to send over there, I have to leave everything as it is.

I have summoned the principal of Tawaly, called Sowangh, five or six times to convey to him, as I did to those of Pimaba, Your Excellency's instructions. However, he is insolent and refuses to come, saying that if I had to tell him something, I should come to him, which I cannot possibly do. Moreover, I did let him know in Your Excellency's name that he had to come and work with his people for one day in the field of the Company, as did Tipol, Pimaba and other villages around here, and I would provide them with food and drink. But nobody showed up. He is also inciting the other villages in the south not to appear when summoned, telling them that I was no good, the Dutch were no good and things like that. I also had left behind a chair with three cushions with him in Tawaly and on his departure captain Boon had ordered him to have that chair delivered to Pimaba, but he has not complied.

The soldier Adriaen Firmenoys has reported that on his way here, about three days after the departure of the captain, he found the Company's house full of arrows, bows and assegais. The miscreant had the intention, in case the captain had planned something else, to resist and defend

himself. When he is confronted with all this, he will deny everything as usual, as he did several times in my presence, when confronted with people whom he had robbed. In order to prevent this, I am awaiting Your Excellency's more mature judgement.

On the 20th May the nobleman Permonij (alias Paulus) arrived here from Vadan, bringing with him the heads of seven women taken from the village of Pisanan. The people of Pisanan are our friends; two years ago they treated the Honourable Governor Paulus Traudenius and his force to food and drink as they have also done just recently when captain Pieter Boon and his people passed through their village. This has made me very angry and having summoned Permonij and his brother Redout, I asked them who had given the order to go to war, when it had been expressly forbidden by our Honourable President. Redout answered that it had been done without his knowledge and he had made an attempt to stab his brother, even though he is almost blind. Permonij answered that the regent Redout induced him to do it by saying that captain Boon on his departure from Vadan had given permission to go to war against Pisanan, which is a gross lie. I made them bring those heads and ordered them to take them straight to the place where they are usually stored, without dancing, leaping or celebrating according to their laws. They have obeyed these instructions and were very frightened that Your Excellency would take it very badly. Following is the number of heads they took (fol. 525):

Vadan: thirty heads.

[Pisanan]: seven ditto.[89]

Soupra: four ditto.

Sakiraya: three ditto.

Total: 44.

On 27 May the nobleman Callocalle requested my permission to go to war against Lonckjouw, which I granted, because they still are our enemies as far as I know.

On 4 June the aforementioned Callocalle returned from Lonckjouw, bringing the head of a man. He reported that when he arrived in the sandy bay near Lonckjouw on the first of this month, he encountered the whole slave population of Lonckjouw and two Chinese with a basket with *cangans* to trade for skins in the neighbouring villages.

These people cried out that Your Excellency had granted them peace and that they could freely come to them. The Pimaba-men did not believe them and got into a fight, wounding some and cutting off one head.

On the 9th of this month the inhabitants of the village of Daracop came to me, complaining of a man from Pimaba called Alibanbangh who is staying in the village of Sakiraya and is inciting the villages of Soupra, Sakiraya and Pallan not to appear when summoned by me and to have no dealings with the Dutch. He is also robbing them of *red dog's hair*, shells and other things and when the Daracop people refused to hand it over, he threatened to come back with people of Vadan to slay the Daracop population and burn their village.

Therefore I call upon Your Excellency to station a Dutchman in the village of Daracop in order to get rid of people like this. This is all the more advisable because the best elk-skins are to be found there, which are traded with those of Batsilaer for wood, the profit on which can then go to the Company.

I have told the elders of Pimaba to send some people to the village of Saccreya to arrest this Alibanbangh, but I could not make them obey. They say it is against their law to take their own people prisoner and that I should send a Dutchman, but I have no one who can go. [...]

The inhabitants of Pimaba and of the neighbouring villages bring reasonably good skins to trade, so that this year we will gather a good amount. Hardip from Tipol has offered to capture the ruler of Lonckjouw alive and to deliver him to Your Excellency. [...]

195. Missive Anthonio van Diemen to President Maximiliaen Lemaire.
Batavia, 23 June 1643.
VOC 867, fol. 454-473. Extract.

(Governor-General Anthonio van Diemen emphasized that the Company's aim should be that all recent territorial conquests made on the island should be turned to profit instead of becoming a burden to the Company's account. To that end he urged president Lemaire and his councillors to make every effort to do so. Particularly the inhabitants had to be made to realize gradually that they had to recognize their lord and sovereign and that they, as a sign of their loyalty, had to pay tribute to their protector.

With this in mind the High Government by no means intended to do away with the already levied tithe on the paddy. Governor and Council of Tayouan received orders, to take care that in every village the tributes would be collected properly and moreover that all those who were unwilling to pay should be admonished.

Van Diemen disagreed with the Reverend Junius, who had raised objections to the tributes, as the Company simply needed some profits to counterbalance its enormous expenses. Furthermore the Governor-General was at variance with Junius' opinion about the deportation of the pagan priestesses or sorceresses to Batavia, as the High Government was of the opinion that those evil women, instead of being tolerated among the Formosans, had to be rooted out completely.

The exiles from Lonckjouw had rendered good service in Batavia. They had proved to be as industrious and active as the earlier deported Lameyans and all of them were already apprenticed to a trade. Van Diemen wished that more people of Lonckjouw could be put to work in that way in the future, whereupon he urged the Zeelandia Council to send all those who deserved a punishment, if possible as many women as men, over to Batavia.

As concerned the Lameyans who were living among the Sincandians, the Governor-General was of the opinion that the [baptized] girls, when they had reached the nubile age, should rather marry Dutchmen than Sincandians. On the understanding that those Company employees who were striving to marry a Formosan girl would be confronted with the Company's orders, that is: when they marry such a girl, at the same time they will marry the country, consequently they will have to stop thinking of ever returning to the Netherlands. Van Diemen regretted the fact that he learned that the Lameyans usually lead a more pious life when they were living among the Sincandians than they would do when they were living among Dutchmen, and urged Lemaire to have all offenders brought to justice. The Lameyan boys and young lads, although they had to get permission when they wanted to get married, had to be apprenticed to a trade and put to work into the Company's service just as in Batavia. During their apprenticeship the Company had to add a little sum to the boys for their maintenance.)

196. Missive Captain Hendrick Harroussé to President Maximiliaen Lemaire.
Quelang, 25 June 1643.
VOC 1146, fol. 497-499. Extract.

fol. 499: [...] Theodoor, principael van Kimaurij, die de wechgeloope Cagiaenders opgeruyt, aengehouden ende met al sijn gevolgen (op den 8ᵉⁿ Februario onder schijn van in Cabelangh rijs te gaen haelen, naer St. Jago wech geloopen is geweest, heeft sich voor vier dagen op genade bij ons begeven ende om vergiffenise gebeden, zulcx onaengesien hebbe hem tot U Ed. nader ordre in apprehentie genomen, soo UE. believe dat hem met alle de pampieren tot sijnen laste beleyt met de eerste gelegentheyt naer costij senden ofte hier eenige maenden dat ons wel het raetsaemste dunckt in apprehentie behielden, ende dan vermits de schricq onder de hier ontrent woonende inwoonderen groot genouch is, over het voorbidden van sijn volck, gelijcq dagelijcx doen, met vertrouwen de Comp.ᵉ in alles getrouwlijck ende gedienstich wesen zal, weder largeerde, vertrouwe niet anders ofte sal dan zijn begaene faulte met goede dienste weder soecken te verbeteren ende om de genegentheyt van de inwoonderen tot ons te trecken oocq wel het dienstichste wesen zal.

Naer St. Jago ende Cabalan, die ons altoos hebben laeten weten dat bevreest sijnde ende onse vrunden waeren, maer hier niet dorsten comen, hebbe den Japander, vermits Theodoor de principaelen seer beschuldicht, om deselve mede te brengen op gisteren derwaerts gesonden, maer soo haest als hooren zullen, dat Theodoor hier gevangen is, vreese dat niemandt sal connen meebrengen.

Domingos Aguilaer's vrouw die present in de dorpen van Tamsuy om rijs ende anders te coopen is gegaen, sal met de eerste presenterende gelegentheyt UE. toegesonden werden.

fol. 499: [...] Theodoor, the principal of Kimaurij, who had incited the fugitive Caganayans and given them shelter, and who had run away on the 8th of February to St. Jago with his followers, pretending to go and get some rice from Cavalangh, surrendered to us four days ago and begged for forgiveness. Notwithstanding that, I have taken him into custody until Your Excellency's further notice. If it is Your Excellency's wish to have him sent to you at the first opportunity together with all the documents pertaining to his case, or – what is advisable in our opinion – to keep him in detention here for a few months and then – seeing that the

fear of the inhabitants living around here is strong enough – release him at the praying of his people, which they are doing every day, trusting that he will be in all instances a loyal and obedient servant to the Company. I am completely convinced that in that case he will try to make up for his mistakes by rendering excellent service and that it will also serve to win the affection of the inhabitants.

Yesterday I have sent the Japanese to St. Jago and Cavalangh, settlements which have always maintained that they were our friends, but were afraid and did not dare to come to bring us their principals because Theodoor was bringing serious accusations against them. I fear, however, that as soon as they hear that Theodoor is detained here, it will be impossible to bring anyone.

The wife of Domingo Aguilar, who at the moment has gone to the villages of Tamsuy to buy rice and other goods, will be sent to Your Excellency at the first available opportunity.

197. Missive Captain Hendrick Harroussé to President Maximiliaen Lemaire.
Quelang, 7 July 1643.
VOC 1146, fol. 500. Extract.

> fol. 500: [...] De Japander die wij naer de dorpen van St. Jago ende Cabalan om de principaelen gesonde hebbe is wederom gecomen, ende heeft ons gerapporteert dat de principaelen hem gesecht hadde onse vrunden waeren, maer hier ontrent het fort niet comen dorsten. De vreese is in de selve met het apprehendeeren van Theodoor soo groot geworden dat soo lange deselve in apprehensie sidt, daer dagelijcx met groote belofte van hem wel te comporteeren van sijne vrienden het voorloopen aff hebbe, niemanden van gemelte principaelen sal hier durven verschijnen. [...].

fol. 500: [...] The Japanese we have sent to the villages of St. Jago and Cavalangh to bring their principals has returned, reporting that those principals had told him that they were our friends, but that they did not dare to come to the fort. Their fear has increased so much after the arrest of Theodoor - of which we are reaping the fruits as can be seen by his friends making solemn promises daily that they will behave - that as long as he is in detention, none of the aforesaid principals will dare to appear. [...]

198. Missive Captain Hendrick Harroussé to President Maximiliaen Lemaire.
Quelang, 10 July 1643.
VOC 1146, fol. 501. Extract.

fol. 501: [...] De vrouwe van Domingos Aguilaer die wij, vermits ongenegen is naer costij te vertrecken, niet gewaerschuwt ende op presente gelegentheyt veel min gedacht ende dierhalve verloff gegeven hebben, is in Tamsuy om rijs te coopen gegaen ende sal binnen twee à drie dagen op haer wedercompste tegen toecomende gelegentheyt om UE. toegeschickt te werden. Dierhalve UE. ordre sullen naercomen ende voortaen in 't fort verblijven. [...].

fol. 501: [...] We did not warn Domingo Aguilar's wife to come over to Quelang before, nor on the present occasion, because she was unwilling to leave for Tayouan. Therefore we permitted her to go to Tamsuy to buy rice. When she has returned, which will be in about two or three days, we will follow your instructions and keep her at the fort so that she will be sent over to Your Honour on the first possible occasion. [...].

199. Missive Captain Hendrick Harroussé to President Maximiliaen Lemaire.
Quelang, 22 July 1643.
VOC 1146, fol. 501-502. Extract.

fol. 502: [...] De inwoonderen van St. Jago ende Cabelan blijven als noch ongenegen om hier te comen ende de vrouwe van Domingos Aguilar die van Tamsuy weder gecomen is, werdt alhier tegens toecomende gelegentheyt in 't fort gehouden.

fol. 502: [...] The inhabitants of St. Jago and Cavalangh are still not willing to come here. The wife of Domingo Aguilar, who has returned from Tamsuy, is being kept at the fort until the first opportunity for sending her over to Tayouan.

200. Resolution taken by President Maximiliaen Lemaire and the Formosa Council.
Tayouan, 29 July 1643.
VOC 1145, fol. 455.

Alsoo den Ed. heer Generaal in sijne Ed.^{ts} missive dato 9^{en} Mey jongstl. [...] ons expresselijck ordonneert dat waar de recognitie aen de Compagnie jaarlijcx te contribueeren onder den Formosiaen, staande onder ons gebiet, noch niet is ingevoert, dat men die daar met den eersten in 't werck stellen sal, ende dat Cornelis van der Linde om naar Pimaba te vertrecken gereet is, die sulcx mede dient te weten ende per instructie opgegeven, soo draecht d'Ed. President Maximiliaen Lemaire, den Raadt bijeen vergadert hebbende, voor, aengesien de jonghste recognitie in bossen padie betaelt is, dat vermits de ongelijckheyt van de bossen een seer onvaste reeckeninge maeckt ofte het niet geraden ende beter soude sijn dat men een seecker gewicht van suyveren padie, getal van hertevellen ofte elandtshuyden raemden om voortaen egaliter in alle dorpen hem daernaer voor soo veel mogelijck te reguleeren als wel de recognitie in bossen padie te laten voldoen die in d'eene plaets grooter ende d'ander cleender sijn dat metter tijt crackeel ende confusie geven soude, den Raadt voorscr. propositie wel ingesien ende overwogen hebbende, vinden om verscheyde redenen eenstemmigh goet dat ijder huysgesin voortaen sal opbrengen twintig cattij suyveren padie sijnde ruym soo veel als thien bossen dito van voorleden jaere hebben uytgebracht, ofte in plaetse van dien vier stucx hartevellen cabessa ofte twee stucx elandtshuyden naer 't de luyden gelegen compt te geven ende dat men 't selve in alle dorpen alsoo sal sien in te voeren 't welck ons dunckt wel de naeste middel tot gerustheyt aen allen zijden te wesen.

The Honourable General has expressly ordered us in His Excellency's letter dated 9 May, that wherever the presentation of a yearly tribute to the Company has not yet been introduced among the Formosans under our authority, this should be done immediately. Moreover, Cornelis van der Linden, who should also be informed and be instructed accordingly, is ready to leave for Pimaba. Therefore the Honourable President Maximiliaen Lemaire, having convened the Council, has suggested to them – because the latest tribute was paid in bundles of paddy, which on account of the difference in size resulted in diverging calculations – if it would not be better and advisable to set a fixed weight of pure paddy, and

of deer- and elk-skins in order to have equal rules for the villages as far as possible, or if it would be better to continue to have the tribute paid in bundles of paddy, that are big in one place and small in another, which will produce quarrels and confusion in due course. Having deliberated on this proposal the Council has unanimously decided on several grounds that from now on every household will provide twenty catties of pure paddy, being amply more than the yield of the ten bundles of the past year, or instead four deerskins *cabessa* (of the best quality) or two elk-skins, whatever suited them best. This will be introduced in all villages which, in our opinion, will be the best way to ensure peace on all sides.

201. Instruction from President Maximiliaen Lemaire to the corporal of the cadets Cornelis van der Linden in Pimaba.
Tayouan, 30 July 1643.
VOC 1146, fol. 566-568. Extracts.

fol. 566: Dewijle den schrijver Christiaen Smalbach op den 13en deser in Pimaba is overleden, ende dat de Bevelhebbers van die plaets aen ons ernstelijck versocht hebben, weder een bequaem borst aldaer mocht werden gelecht, soo is in Raade verstaen uwen persoon daer toe te gebruycken soo om haer hier in te voldoen, die natie daer met in beter devotie te houden, de cleene negotie tot gerieff van de inwoonders aldaer te vervolgen als jegens November aenstaende de toegeseyde recognitie in suyvere padie als hartevellen van d'inwoonders te vorderen [...].

Die van Tipol jongst met de wapenen tot redelijckheyt gebracht, hebben op haer versoeck bij provisie toegestaen, dat beneden aen de mont van de Tipolse Reviere haere woonplaetse mogen nemen gelijck oock reede gedaen hebben, mits gehouden bleven dat versoeck aen ons alhier te comen vernieuwen ende de vrede te versoecken dat tot noch toe op verscheyde termijnen die hun gegeven sijn niet geschiet is, sulcx dat als willen noch formele vijanden sijn, echter om de vrede te voeden ende den Formosaen in sijn onverstandt eenichsints tegemoet te comen soo sult den Tipolder onsenthalven ernstlijck aenseggen dat wij wel mogen lijden ende in 't minste daer niets tegen hebben dat sij hun tegenwoordige woonplaetse blijven occupeeren, dan dat weten moeten willen se vreedich blijven woonen, dat door eenige van haere voornaemste de vreede ende bevestinge van haer woonplaetsen alhier aen ons moeten comen versoucken, als wanneer buyten alle swaricheyt zullen zijn, waer toe hun ernstelijck aenmaenen ende dat sulcx nu met het retourneren van Adriaen

Watermondt ende d'andere Nederlanderen bequamelijck soude connen geschieden, haer verseeckerende alle beleeft onthael bij ons sal aengedaen werden.

Die van Calingit, Barboras ende Tacabul sijn naer langh aenporrens eyndelijck soo verre gebracht dat inde leechte sijn comen woonen, waertoe hun hier aen 't casteel zijnde, op haer versoeck bequame plaetse omtrent vier (fol. 567) à vijff mijlen besuyden Pangsoya is aengewesen, wij en hebben 't sedert daer niet meer van vernomen, echter willen niet twijffelen ofte zullen haer ter voorschr. plaetsen neder geslaegen hebben, in 't passeeren van dien wech cont daer naer naerstich vernemen ende t'sijner tijt laeten weten wat daer van zij.

Aen Christiaen Smalbach hadden op sijn vertreck jongst derrewaerts bij instructie belast dat die van Pima ende alle de daer omtrent gelegene dorpen staende onder onse gehoorsaemheyt, souden uyt onse naeme bekent maecken dat soo wilden doen blijcken gehoorsaeme subjecten van onsen staet te wesen dat in november aenstaende, gelijcq de zuydelijcke dorpen omtrent Tapouliangh hun voorleden jaere rede voorgegaen waeren, mede recognitie aen de Compagnie souden moeten doen; dat naer ons voors. Smalbach heeft aengeschr. soo in Pima, Tipol als elders liberalijck is geconsenteert ende belooft t'sijner tijt op te brengen, doch wat ende wat quantiteyt te contribueren hebben is noch noyt claer uytgedruckt, dat nu in Rade gearresteert ende ider huysgesin op twintig cattij suyveren padie ofte vier stucks hartevellen cabessa ofte wel twee stucx elantshuyden gestelt is, hebbende een ider sijn vrije wille te geven wat liefts begeert te missen, Ulieve sult sich daernaer promptelijck reguleeren ende in 't begin van November sulcx vorderen ende sonder eenich omsien ofte naerder ordre te verwachten behoorlijck in 't werck stellen, daer op ons verlaeten zullen.

Dan om U des te meer van haere meyninge in desen te verseeckeren, soo cont haer uyt onsen naeme aenseggen dat van Smalbach lange voor desen gaerne gehoort heb, dat wel genegen sijn nevens de zuydelijcke dorpen, voortaen mede jaerlijcx aen de Compagnie recognitie in padie als anders op te brengen dat zulcx een goede saecke is, dat hierbij bethoonen oprechte subjecten van onsen staet te wesen ende dat zulcx haer rijs gewas ingesamelt hebbende hun sult cunnen afvorderen. Uyt haere antwoort hierop sult U genoech van haeren wille connen verseeckeren ende opdat dese invorderinge van recognitie met ordre mach toegaen, soo zult ider dorp sijn huysgesinnen opnemen ende met de outste van ider dorp overleggen wat ider gesin te geven, verdraegen mach den rijcken hooger ende den armen leger als de gem.ᵉ twintig cattij, stellende echter moet de reeckeningh dooreen genomen voor ider gesin de geseyde twintig cattij

behouden ende die geen rijs en hebben mogen vier stucx hartevellen cabessa ofte twee stucx elantshuyden in plaets geven waerop te letten hebt. Egeene inwoonders zult op den wech eenige overlast doen met stooten, slaen ofte eenige victualie aff te dwingen gelijck voor desen wel dapper in swangh heeft gegaen maer hun in tegendeel alle vruntschap bewijsen ende UE. yets gebreeckende sulcx voor cangangs ofte coralen ruylen. Echter 't geene U uyt eygen wille vereeren is een ander ende moocht vrijelijck aennemen. U volck zult hier toe houden ende als herrewaerts comen, ofte die elders naer toe schickt hun zulcx wel scherpelijcq verbieden, opdat dieswegen geene clachten ons voorcomen mogen ende dat d'inwoonders van onse natie in een beter gevoelen mogen geraecken als om diergelijcke oorsaecke tot noch toe sijn geweest daer goede achtinge op te nemen hebt.

In Pimaba gecomen sijnde sult de outsten datelijck bij den anderen versamelen, haer onsentwegen groeten ende aencundigen dat vermits de doot van Smalbach op haer versoeck UE. persoon, om de saecken aldaer als gem. Smalbach gedaen heeft behoorlijcq waer te nemen, derrewaerts hebben geschickt, dat niet en twijffelen ofte sult met den anderen (fol. 568) wel gedient sijn ende dat bij haer in alles naer onse ordre beter als voor desen sullen schicken, daer eenigen tijt herrewaerts naer passelijck genoegen ingenomen heb, ende dat zulcx nu moeten sien in alle voorvallen te verbeteren off zullen geen vrunden connen blijven.

Die van Pima ende Lonckjouw sijnde tesamen in vijantschap, hebben den anderen soo nu als dan met de wapenen bestooct soo dat somtijts eenige van wedersijden gesneuvelt sijn; die van Pima haer revengie te soecken hebben met cleene troupen, sonder dat verstaen zulcx buyten ons consent vermogen te doen, hun naer Lonckjouw begeven ende somtijts een hooft met gebracht, meenende hun dingen wel gedaen hadden; dat haer ten tijde van Smalbach, gelijcq uyt de brieven hem aengeschreven sien cont, verscheyde maelen heb verbooden, echter noch jongst tegens onse expresse ordre gepleecht is. UE. zult niet alleene die van Pima maer oock alle andere dorpen daer over te seggen hebben, insinueeren egeene de minste oorlooge onder wat pretext ende tegens wie het sij en hebben aen te vangen dat ons zulcx toecomt te doen. Sij stil sitten ende thuys blijven zullen. Geschiet haer ongelijcq, 't selve aen ons te claegen hebben, dat wij daerinne voorsien ende de rechtschuldige naer behooren daerover wel straffen sullen, ofte ten waere omtrent haer dorpen ende inde rijsvelden bestoockt wierden, als wanneer hun mannelijck daer jegens stellen, ende al dootslaen mogen dat hun vijantlijcq voorcompt.

UE. sij ten besluyte gerecommandeert omsichtich in alle voorvallen te gaen, ende soo veel doenelijcq op 's Comp.ˢ dienst allerwegen behoorlijck

te letten, item met eenen christelijcken wandel d'inwoonders ende U volcq voor te gaen opdat daerdoor gesticht ende in beter devotie mogen gehouden weerden. [...].

fol. 566: Because the clerk Christiaen Smalbach has died in Pimaba on the 13th of this month and the principals of that place have urgently requested us to station another competent person there, the Council has decided to employ your person in that capacity to comply with their request, to keep those people under control, to continue the small-scale trade for their benefit and this November to collect the promised tribute in pure paddy and deerskins [...].

We have provisionally granted the request of the inhabitants of Tipol, recently subdued by force of arms, to take up residence in the lowlands at the mouth of the River Tipol, which they have already done. However, they will still be obliged to appear here to make that request once again and to ask for peace, which has not yet happened although they were given several deadlines. Under the circumstances we can formally regard them as enemies, but in order to cherish peace and to accommodate to the ignorant Formosans, you will solemnly notify the Tipol people in our name that we will accept and not oppose their continued stay in their present domicile, but that we must know that if they want to continue to live in peace. Some of their principals will have to come here and ask for peace and approval of their domicile. Only then can they avoid difficulties. You should strongly urge them to do this, saying that it could be easily carried out when Adriaen Watermondt and the other Dutchmen return, and assuring them that they will all be welcomed with due respect.

After much prodding we finally got the peoples of Calingit, Borboras and Taccabul to live in the plains. Having shown up here at the castle with their request we allocated them an appropriate place about four (fol. 567) or five miles south of Pangsoya. Since then we have not heard from them but we do not doubt that they have taken up residence there. When you pass that way, you may make inquiries and let us know in due course.

We had instructed Christiaen Smalbach on his latest departure to notify the people of Pimaba and all other villages in that region that in order to fall under our authority in our name, and that if they wanted to prove to be loyal subjects of our state, they also had to pay tribute to the Company this coming November, following the example of last year by the southern villages around Tapouliangh. Smalbach had written us that this was

readily agreed by Pima, Tipol and other places and that they had promised to pay this in due time, but it had never been made clear what and how much they had to contribute. This has now been settled by the Council and fixed at twenty catties of pure paddy or four deerskins *cabessa* for each household, giving them the choice of what they can part with more easily. We trust that you will promptly take all necessary steps in this regard, start collecting at the beginning of November and settle this business effectively without reverting back to us or awaiting further instructions.

In order to be even better informed of their opinion in this case, you can tell them in our name that we were pleased to hear from Smalbach that they were willing – like the villages in the south – to pay a yearly tribute of paddy or another commodity to the Company. That this is a good thing, showing that they are loyal subjects of our state, which is the basis for levying this after having harvested their rice crops. From their reaction you can sufficiently judge their opinion. Moreover, in order that the collecting of tribute may be carried out fairly, you will make a list of the households of every village and deliberate with the principal of each village what each household can contribute, the rich ones more and the poor ones less than the aforementioned twenty catties. However, you must stick to the average amount of twenty catties for each household, while those that do not have rice are allowed to give four deerskins *cabessa* or two elk-skins instead. This you should keep in mind.

On the road you will not molest any of the local people by pushing or hitting them, nor will you extort provisions from them – which had been the general practice in the past – but on the contrary you will behave in a friendly manner towards them, and if you need anything you will trade it for *cangans* or coral. What they present to you of their own free will is, however, another matter and you are allowed to accept it. You will also force your men to comply and forbid them [to act like that] when they come here or when you send them elsewhere, so that we do not receive any complaints in this regard and the local people will hold us in higher esteem than they have done until now for that reason. This should have your attention.

Having arrived in Pimaba, you will assemble the elders without delay, greet them in our name and notify them that because of the death of Smalbach we have sent you there at their request, to take good care of all

matters, like the aforementioned Smalbach had done before. That we do not doubt that they (fol. 568) will get along well together and that they will comply with all our instructions better than they have done before, over which we have only been moderately satisfied until now. That they will have to improve in all respects, otherwise we cannot continue to be friends.

The peoples of Pimaba and Lonckjouw are at war, carrying out armed attacks on each other with occasional casualties on both sides. To take revenge the people of Pimaba have gone to Lonckjouw in small parties, although they were allowed to do so without our permission, sometimes bringing back a head and thinking that they had done the right thing. During Smalbach's time we had prohibited this on several occasions, as can be seen in the letters we wrote him, but still it has been perpetrated the other day in contravention of our express orders. You will instruct not only Pimaba but also all other villages under your command, not to start even the smallest war under any pretext and against whatever enemy. That is our prerogative, they should take no action and stay at home. If they are wronged, they must complain to us, we will deal with it and mete out a fitting punishment to the offender, unless they are attacked near their villages or in their rice fields, then they are allowed to defend themselves in a manly way, and kill all the enemies.

Finally you are recommended to exercise caution under all circumstances and to keep in mind as much as possible the service to the Company in all its aspects. You and your men should also set an example for the local people of a Christian way of life, so that they will be uplifted and be kept in better devotion. [...].

202. Missive President Maximiliaen Lemaire to ordinand Andreas Merquinius.
Tayouan, 2 August 1643.
VOC 1146, fol. 549-550. Extract.

fol. 549: Tot ons leetweesen hebben uyt de confessie vande inlantse vrouwe Roemack, door onse ordre voordesen in hechtenisse genoomen, verstaen ende volcomentlijck gesien dat sij haer twee kinderen in hoerdom geprocureert seer schandelich om 't leven gebracht ende in 't velt bij haer hamadongh, beyde noch levendich sijnde, begraven heeft, ende sulcx bij Caesar van Winschooten ende eenige outsten van Tapouliangh

ondervonden is. Oversulcx dewijle de saecke soo claer legt, ordeelen wij met d'voors. outsten die moorderesse den doot waerdich te wesen ende authoriseerden UE. dienvolgende met approbatie van onsen Raede opsichte deses den misdadigster 't sij met onthooffden ofte andersints naer de gelegentheyt best presenteeren sal, ter doot te brengen opdat eenmael die Godt verdrietende gruwelen onder den Formosaen mach uytgeroeyt ende exempel gestatueert werden, gedenckende tot spectackel van dien soo veele inhabitanten van de omherleggende dorpen te vergaderen als mogelijck is. Van 't succes sullen per eerste gelegentheyt advijs verwachten. Uyt het schrijven van d.° Junio hebben verstaen dat zes persoonen vande zuydelijcxste dorpen met ons noch onbevreedicht in handen becoomen hebt, dewelcke hun als spions op den wegen souden onthouden hebben, die wij UE. ordineeren met den eersten segour door d'inwoonderen herwaerts laet brengen mits dat voor haere moyten betaelt sullen werden. [...].

fol. 549: To our regret we learnt and were completely convinced by the confession of the native woman Roemack, who was arrested on our orders some time ago, that she has shamefully murdered her two children who were the result of her fornication, having buried them while still alive in the field near her *hamadongh*, which was found out by Caesar van Winschooten and some principals of Tapouliangh. Because this case is completely clear we find in common with the aforesaid principals this murderess deserving of a death sentence. Therefore we authorise you, with the approval of the Council, to execute this criminal by decapitation or in another manner that fits the occasion, so that these god-forsaken atrocious crimes will one day be rooted out and an example is set for the Formosans. Do not forget to assemble as many people from the villages in the region as possible to watch this spectacle. At the first opportunity we shall be expecting a letter of what has been accomplished by it. In the letter from Reverend Junius we read that you have captured six persons from the most southern villages, that are not yet at peace with us, who are said to have roamed the roads as spies. We are ordering you to have them brought here safely as soon as possible by local people, who will be paid for their troubles. [...].

203. Dagregister Zeelandia. Entry 5 August 1643.
VOC 1145, fol. 266-424. Summary.
DRZ, **II, pp. 178-179.**

(On 5 August a letter was received from Ordinand Merquinius from Tapouliangh together with five captives from the village of Paginwan he had sent to Zeelandia Castle to be punished for attempting to pillage the Swatalauw villages. However those robbers had been caught by the inhabitants. Governor and Council ordered them to be deported to Batavia.)

204. Missive Corporal of the cadets Cornelis van der Linden to President Maximiliaen Lemaire.
Pimaba, 19 August 1643.
VOC 1146, fol. 594-597. Extracts.

fol. 594: Op den 11en dito deeses ben met mijn bijhebbende volck des omtrent 18 glaesen in 't dorp Pyma wel aengecomen ende hebbe alhier de drie Duytsen beneffens den Duytschen jonghen noch in goeden doene gevonden, ende alhier een weynich geweest sijnde bennen beyde opperhoofden soo Redut als Toboe in onse wooninghe gecomen ende hebben mijn wellecom geheeten, die naer vriendelijcke groetenisse de groedt van UE. hebben gedaen, waer voor mij hartelijck bedanckt hebben, ende hebbe haer voorts aengesecht, alsoo naer 't overlijden van Christiaen Smalbach aen de Ed. Heer hadden doen versoecken dat gaerne weder een goedt borst in steede wilden hebben. Weshalven U Ed. ende sijnen bijhebbenden Raadt mijn daertoe geordineert hadden, om met haer in vreede ende eenicheyt te leven, waer in seer wel tevreeden waeren ende ick hebbe haer doen meteen belast dat mosten alle d'outsten van d'omleggende dorpen souden doen vergaeren in Pijma in des Compagnies wooning om aldaer mijn becoomene last ende U Ed. grondighe meyninghe aen te hooren, waernaer hun voortaen souden hebben te reguleeren. 't Welcke hebben belooft te doen ende sijn alsoo gekeert ider naer sijn wooninghe en hebben 't dien selven avondt inder cundt gedaen.
Op den 12en dito hebbe des Compagnies goederen ontfanghen die alhier noch sijn berustent geweest in presentie van alle bijhebbent volck [...], oock hebbe hier een canasser met cleijne Chineese coralen gevonden, die niemandt weet waer vandaen compt dan dat Smalbachs moeten weesen, ende ick gants geene in des Compagnies kisten en vinde en sal

genootsaeckt weesen om ten dienste van d'Ed. Compagnie aen te tasten
om soo aen bamboesen soo als aen rottangh ende anders te reuijlen, aen 't
maecken van 't huys ofte elders wat het soude mooghen weesen [...]. [...]
Den 14en dito sijn d'opperhoofden van Pijma als andere omleggende
dorpen in des Comp.s huys verscheenen, die doen vriendelijck van U Ed.
hebbe gegroet waervoor mijn hebben bedanckt ende naer alle vriendelijckst
onthael, den last van U Ed. volgende mijn instructie te verstaen gegeven.
Hebbe door den tolck Anthonij ende haer in 't generael alles grondigh te
verstaen gegeven ende wel ernstelijck aengemaendt dat bij aldien haer
selven als trouwe bontgenooten wilden betoonen hier geene fauten aen sijn
en mosten als den gesetten tijt soude gecomen sijn ofte anders in plaets
van vruntschap d'ongenade van U Ed. souden te verwachten hebben. Waer
op liberaelijck hebben geandtwoordt dat aen haer gants geene faulte
weesen sal ende middelertijt willen haer volck daertoe oock wel vermanen
ende aenporren souden, dan klagen van dit jaer weynich rijs ofte padie
sullen connen opbrenghen alsoo door den overvloedighen regen al haer
velden wech gespoelt ende verdorven sijn, maer belooven soo veel als
mogelijck sijn sal in vellen te vergaderen.
Wat aengaet den oorloch belooven oock meede haer stil ende gerust te
houden ende dat niet sonder mijne kennisse uytgaen en sullen, [...].
fol. 595: [...] Op den 6en dito in 't passeren van 't vlack landt tuschen
Pangsoya ende Barboras soo hebbe ick neerstigh vernomen off die van
Barboras ende Tackebul als Calingit oock waeren affgecomen naer haer
voorighe belofften. Welcke des avondts recht contrarij bevonden hebbe,
alsoo den selven avondt in Barboras gecomen ende aldaer een weynich
vertoefft hebbende, sijn d'opperhoofden met haer tween bij mij gecomen
die naer onse gewoonelijcke groetenisse hebbe van U Ed. hebbe gevraecht
door wat reeden met sulcke valscheyt om begonden te gaen ofte dat den
geck met d'Ed. heer begonden te scheeren. Waerop in antwoort becomen
hebbe dat soohaest haer geerst ende haer ander gewas van 't velt hadden
alsdan haer naer de vlackte souden begeven. Waer op haer weder ten
andtwoordt hebben gegeven dat nu verscheyden maelen sulcx belooft
hadden dat vrij mosten gelooven soo wanneer den geck met U Ed.
begonden te scheeren dat haer sulcx qualijck vergaen soude ende in plaets
van vruntschap de ongenade van UE. souden hebben te verwachten,
waerop in antwoort becomen hebbe als booven soo haest haer mogelijck
is hun met gemeenderhandt daer naetoe vervougen souden. [...]
Den 7en dito, hebbe haer andermael aengemaendt. Waerop belooven als
booven ende ben doen benevens acht Barborassers vertrocken naer
Tacabul, alwaer omtrent ten 18 glasen ben gearriveert ende hebbe naer een

weynich rustens d'opperhoofden bij mijn gecomen, ende hebbe haer als d'anderen hebbe voorgehouden. Die spreecken als booven verhaelt ende en hebben oock geene ontschuldingh dan alleen die van Callingit alsoo dat opperhoofft in Tayouan soude geweest sijn ende haer niet voorgingh. Hebbe haer gevraecht soo anderen qualijck voeren oock wilden qualijck voeren, waerop geen andtwoordt gaven anders als booven dan dit eyndelijck hebben belooft soo haest haer gewas van 't velt hadden als dan haer naer de leeghte voeghen souden [...].

Den 8en dito sijn van Takabul naer Callingit benevens 11 inwoonders die ons overwech brachten alsoo door den reeghen de weechen qualijck ganghbaer waeren ende ben dien avondt gecomen inde clooff van Calingit waervan daen een Pimabaer naer boven hebbe gestuyrt om d'opperhoofden te roepen, die naer een schoot met een musquet des avonts omtrent de vier glaesen bij ons sijn gecomen. Doch het rechte opperhoofft was absent die den selven nacht hebbe doen roepen ende hebbe aldaer dien nacht vertoefft.

Den 9en dito alsoo die van Callingit uyt oorlooghen waeren hebbe naer mijn vrundelijck versoeck die van Takabul soo verre gebracht dat met mijn nae Batsibal sijn gegaen alwaer ontrent middagh ben gearriveert, [...] 's avonts omtrent 20 glaesen soo is het opperhoofft van Callingit bij ons gecomen onder Batsibal, die naer de groetenisse van UE. hebben gesecht waerom dat alsoo voordeesen in Tayouan is geweest ende aldaer aen d'Ed. heer President belooft hadde (fol. 596) om op 't vlacke landt te komen timmeren, met sijn dorpsvolck ende als noch op sijn oude plaetse was blijven woonen, waerop in antwoordt gegeven heeft dat wel in Tayouan was geweest maer hem niemandt iets vermaent hadde dan allenelijck den Capiteyn Pieter Boon. Waer antwoorden 't selve belooft hadde, maer alsoo alhaer velden bereyt waeren, dat daerdoor verlet waeren, dan soo haesst haer gewasch souden te huys hebben als dan sijn voorighe belofften nae soude comen.

Den 10en dito in 't passeeren van den wech naer Tawalij, soo sijn wij die van Tawalij ontmoet, in de clooff van Kinebelou die uyt oorlooghen wilden gaen op een dorp genaemt Lieupot die voor een maent een hooft van haer genomen hadde ende de tweede stemme van Tawalij tot ter doot toe gequest hadden. Ende waerop haer in den name van UE. hebbe gelast weder te keeren ende naer desen niet meer uyt oorloghen gaen souden buyten onse kennisse 't welck belooft hebben. Ende sijn daerop des anderen daechs getorneert. Oock soo hebbe d'opperhooft genaempt Scogan mede voorgehouden van den thienden die in November op soude moeten

brengen 't welck mede mildelijck beloofft hebben soo veel als mogelijck is naer te comen.

Den 11en dito ben vertrocken naer Pijma ende ben omtrent middach gecomen onder Tijpol alwaer mijn d'opperhoofden ontmoet sijn met cost ende drancq. Ende ons seer vriendelijck onthaelt ende alle vruntschap beweesen hebben, die naer een weynich vertoefft had aengeseyt hebben den last van U Ed. Waerop ten antwoordt becomen hebbe dat één van haer outsten uyt jaghen was; dat soo haast den selven thuys gecomen soude sijn als dan met alleman in Pijma soude comen om aldaer te samen te spreecken.

Den 16en dito sijn alhier de twee opperhoofden in Pijma gecomen, die door den tolck Anthonij hebbe moeten laeten haelen. Ende hebben haer uyt den name van U Ed. gegroet ende vorders mijnen last door den regent Redut van U Ed. volgende mijne instructie grondich te verstaen gegeven. Waerop naer een weynich beradens in andtwoordt becomen hebbe, dat benevens Adriaen Watermondt ende d'anderen sonder eenich uytstel naer Tayouan wilden gaen om aen d'Ed. Heer president haer landt op te draghen ende als dan in een vast verbandt te treeden. Wat aengaet den tienden belooven mede als goede onderdanen t'sijner tijt op te brenghen.

Wat aengaet haere timmeragie is noch gants niet. Woonen noch heel woest den eenen hier den anderen daer, uyt oorsaeck dat soo veel te doen hebben gehadt met het bouwen haerder velden dat noch geen rechte huysen en hebben maer belooven soo haest de noorde mousson kompt om leech ende aen de revier te sullen timmeren. [...]

Den 19en dito ondertusschen soo en isser hier niet voor gevallen dan dat hier eeniche persoonen van Soepera sijn geweest waer door haer opperhoofden hebbe ontbooden. Het opperhoofft Redut ende sijnen broeder Toeba doen U Ed. ootmoedigh groeten, [...].

fol. 594: On the 11th of this month I arrived with my men around 18 bells safely in the village Pimaba and found the three Dutchmen and the Dutch boy there in good health. After a short while both headmen, Redout as well as Toboe, came to our house to welcome me. Having greeted them, I conveyed your best wishes to them, for which they thanked me. Thereupon I have informed them that because after the death of Christiaen Smalbach they had made the request to the Honourable [president] to have a competent person in his place, Your Excellency and the Council had appointed me to live with them in peace and harmony, about which they were very pleased. At the same time I instructed them to assemble all the

principals of the neighbouring villages in Pimaba in the Company's residence to receive my orders and Your Excellency's well-founded views, to which they had to comply in future. Having promised to do this they returned to their respective homes and have made this known the same evening to everyone.

On the 12th of this month in the presence of all my men I received the Company's goods that had been stored here [...]. I also found a basket with small Chinese beads the origin of which no one knew, except that it may have belonged to Smalbach. Because I could not find any in the Company's cases, I will be compelled to use these in the service of the Honourable Company, to trade for bamboo, rattan, etc., for the repairs of the house and other necessary things [...]. [...]

On the 14th of this month the principals of Pimaba and other, neighbouring, villages came to the Company's house, whom I have greeted amicably in Your Excellency's name, for which they thanked me. After this very friendly welcome I have explicitly made clear to them, through the interpreter Anthonij, all the orders you instructed me to make known to them. I have seriously admonished them that if they wanted to prove themselves as loyal allies, they should not be in default when the time came, because then they would have to reckon with Your Excellency's disfavour instead of his friendship. Without restraint they replied that they would certainly not fail and that in the meantime they would admonish and urge their people. They were, however, complaining that they would not be able to produce much rice or paddy, because the heavy rain had washed away all their fields and ruined them, but they promised to gather as many skins as possible instead.

Regarding the war they also promised to keep quiet and would not march without my knowledge, [...].

fol. 595: [...] On the 6th of this month, passing through the plains between Pangsoya and Borboras, I have enquired if the peoples of Borboras and Taccabul as well as Calingit had indeed come down in accordance with their promises. In the evening it was clear that this had not been the case. That same evening I arrived in Borboras and after some time the two principals came to me together. After the customary greetings from Your Excellency I asked them what reasons had prompted them to such dishonesty, and if they wanted to make a fool of His Excellency. They answered that as soon as they had harvested their barley and other crops,

they would move to the plain. I retorted that they had made that promise several times now and that they could rest assured that if they tried to make a fool of His Excellency, they would be sorry and could be sure of Your Excellency's disfavour instead of your friendship. Their answer was the same as before, as soon as possible they would all go there. [...]

On the 7th I once again admonished them, and got the same promise as before. Thereupon I departed with eight men from Borboras for Taccabul, where I arrived around 18 bells. After a little rest the principals came to me, whom I addressed in the same way as I did the others and getting the same answers. They also had no excuse, other than blaming the people of Calingit, because their chief had been to Tayouan and should not have gone before them. I asked them if they thought that two wrongs made a right, to which they had no answer other than before, but in the end they promised to descend to the plain as soon as they had harvested their crops [...].

On the 8th we [departed] from Taccabul to Calingit with 11 local people who accompanied us because the roads were barely passable owing to the rain. That evening we got as far as the gorge of Calingit from where I sent someone from Pimaba up to summon the principals, who, after having fired a musket, arrived at about four bells at night. Their real principal, however, was absent and I had had him called that same night that we spent over there.

On the 9th, because the people of Calingit had gone to war, on my friendly request I managed to persuade the men from Taccabul to accompany me to Batsibal, where we arrived round about noon. [...]. Around 20 bells in the evening the principal of Calingit came to see us just outside Batsibal. I welcomed him in Your Excellency's name and then asked him why they were still living in the same place, although he had been to Tayouan and had promised the Honourable President (fol. 596) to build [their homes] with his people in the plain. He answered that he had indeed been to Tayouan, but nobody had given him any orders, except [later] captain Boon, to whom he had made this promise. But as their fields were ready to be harvested, they were unable to go right away, but would comply as soon as their crops were gathered in.

On the 10th on our way to Tawaly, we met the men of Tawaly in the gorge of Kinnebelouw. They intended to go to war against the inhabitants of a village called Luypot, who had taken the head of their people and

wounded the second in command of Tawaly so seriously that he died. I have ordered them in the name of Your Excellency to return home and in future not to go to war without our knowledge. They promised to do that and returned the next day. I also informed their principal, called Scogan, about the tithe they had to pay in November. He generously promised to obey as best as they could.

On the 11th we departed for Pimaba and around noon we were near Tipol, where the principals came to meet me with food and drink, welcoming us very amicably and showing their friendship in every respect. After some time I conveyed to them Your Excellency's instructions. I was told that one of their principals had gone hunting and that as soon as he had returned they would all come to Pimaba for talks.

On the 16th of this month the two principals arrived in Pimaba[90], who had to be sent for by the interpreter Anthonij. After greeting them in Your Excellency's name, I then thoroughly conveyed to them my orders through the regent Redout in accordance with Your Excellency's instructions. After some deliberations they answered me that they intended to travel to Tayouan without delay together with Adriaen Watermondt and the others, in order to dedicate their land to the Honourable President and to enter into a permanent alliance. They also promised to pay the tithe in due time as loyal subjects.

Regarding the building [of houses], nothing had been done as yet, they are still living roughly and scattered, because they have been so occupied with cultivating their fields that they still have not got proper homes. They have promised, however, that as soon as the northern monsoon arrives, they will come down and build [their houses] near the river.

On the 19th. Nothing has happened in the meantime, except that some people from Soepera came here, through whom I have summoned their leaders. The headman Redout and his brother Toea send Your Excellency their humble greetings, [...].

205. Extracts taken from the Zeelandia Castle Resolution-books, concerning the resolutions on the island of Lamey, taken in the Formosa Council.
VOC 1170, fol. 581-600; VOC 1145, fol. 459. Resolution 21 August 1643.

fol. 598: Den president Maximiliaen Lemaire den Raedt des casteels vergadert hebbende, is mede verstaen dat men de resterende jonge Lameyers, jongens ende meysgens in Sinckan ende elders woonachtich, volgens des Ed. heer Generaels schrijven, met gelegentheyt aen 't casteel trecken ende ambachten leeren ende oock onder de benodichde Comps. dienaren als fatsoenelijcke vrije luyden verdeelen, mits dat d'eerste drije jaeren voor cost en cleeren dienen ende die om zijnde, zes realen van 8ten 's jaers daer en boven genieten sullen, ende die alreets bij Duytsen wonen ende de drij jaer daer bij geweest sijn sullen van primo Januarij aenstaende boven de cost en cleeden 6 realen van 8ten voortaen genieten ende die noch geen drij jaeren gedient, sullen haeren tijt affwachten als wanneer die recognitie mede te verwachten hebben ende blijven oock haere meesters ende meesteressen, van 't begin aen, gehouden deselve soo veele doenlijck in christelijcke religie op te laten trecken, ten (fol. 599) eynde de schandelijcke sustinue van dat stichtelijcke onder den Formosaen als Nederlander opgerocken mach werden.

fol. 598: President Maximiliaen Lemaire, having assembled the Council, has decided that, in accordance with the Honourable General's letter, the remaining young people of Lamey, both boys and girls who are now living in Sincan and elsewhere, will be brought to the castle to learn a trade and to be distributed among the employees of the Company and decent free citizens. The first three years they will work just for their food and clothing and after that period they will earn six pieces of eight on top of that. The ones who are already living with Dutch people and have been doing so for three years will, starting from January the first, earn 6 pieces of eight besides their food and clothing, and the ones who have not yet served for three years, will wait for that time, when they too will receive this payment. Their masters and mistresses will be obliged from the first day to educate them as much as possible in the Christian religion so that (fol. 599) the shameful renunciation of all piousness among Formosans and Dutchmen alike will be halted.

206. Note of the visitation and the examination of the inhabitants of Sincan, Soulang, Mattouw, Bacaluan and Tavocan by the Reverends Junius, Bavius, Van Breen, and by deputies Cornelis Caesar and Nicasius de Hooghe.
Tayouan, 4 October 1643.
VOC 1146, fol. 585; VOC 1143, fol. 775-780.
FORMOSA UNDER THE DUTCH: pp. 195-196; ZENDING, III, pp. 229-230.

207. Original missive the Formosa Church Council to the Amsterdam Classis.
Tayouan, 7 October 1643.
Gemeente Archief Amsterdam, Archief Classis Amsterdam, 379.
FORMOSA UNDER THE DUTCH, pp. 192-195; ZENDING, III, pp. 223-228.

208. Resolution taken by President Maximiliaen Lemaire and the Formosa Council.
Tayouan, 9 October 1643.
VOC 1145, fol. 468.

Den Loncquiousen vorst broeder, Cayloangh genaemt, op sijn versoeck aen 't casteel bij ons ter audiëntie verscheenen sijnde ende versocht hebbende dat nevens sijnne complicen daarmede van desselfs broeder sigh langen tijt geseppareert hadde ende die successive hem noch toegevallen waaren, sijnnen sedem in de leechte omtrent Pangsoia mochte nemen. Welck versoeck den president den raadt van Formosa voorgestelt hebbende ende ondervonden wesende dat den voorsz. Cayloangh sijnnen broeder in sijn onbehoorlijckheden doorgaans tegen, met den oorlogh sich niet gemoeyt, oock in den jonghsten niet present ende aen 't Casteel in goeden aensien geweest is. Soo is op 't voordragen van sijnne gem. Ed. geresolveert dat men op desselfs versoeck, om voors. consideratiën ende de goede getuygenisse die van hem gegeven wert denselven ommtrent Pangsoia plaatse wijsen ende hem als hooft over sijn mede te brenghen Lonckiouwers ende die hem naerdesen noch toecomen mochten stellen sal, mits dat hem alle lasten nevens de jaarlijcxse padie recognitie volgens andere Formosaenen te onderwerpen heeft, op hoope (waartoe dan oock onderleyt dient dat door dien middel den broeder met één van beyden 't zij met het vossen vel, ofte gewelt) te becomen sal sijn. Soo is mede verstaen

dat men die van Pottelong sijnde een dorpjen in 't geberchte gelegen, op haar versoeck toestaen sal in de leechte bij die van Netne te moogen coomen woonen.

The brother of the ruler of Lonckjouw, called Caylouangh, appeared at the castle seeking an audience during which he requested permission to take up residence in the plains near Pangsoya, together with his followers, who also had distanced themselves from his brother and one after another had sided with him. The president has put this request before the Council of Formosa and having experienced that this Caylouangh had generally resisted his brother's misconduct, had not participated in the war, also not in the latest one, and having always been held in esteem at the castle, it was decided on recommendation of His Excellency on the basis of the aforementioned reasons and the positive testimony on his behalf, to allocate him a place near Pangsoya and to appoint him as head over the Lockjouw people he was taking with him and the ones who would join him later, on condition that he would submit to the same conditions as the other Formosans, including paying paddy as a tribute and hoping (which he has to be told) that in this way it will be possible to capture his brother either by cunning or by force. It was also decided to grant the people of Potlongh, a small village in the mountains, their request to come and live in the plains near Netne.

209. Original missive President Maximiliaen Lemaire to Governor-General Anthonio van Diemen.
Tayouan, 12 October 1643.
VOC 1145, fol. 213-262.[91] Extracts.
See also FORMOSA UNDER THE DUTCH, pp. 196-197; ZENDING, III, pp. 231-233.

fol. 213: [...] Naar dat den capiteyn Boon met drie joncquen, 't quel de *Brack* ende de groote lootsboot gemant met 197 Nederlandtsche - ende 39 Chineese coppen den 21en Meert verleeden van hier over Tamsuy ende Quelangh nae Taroboan, tot 't opsoecken van de langh geruchte goudtmijnne, uytgeset hadden, is den selven met alle de voors. vaartuygen den 2en April daar aenvolgende in Quelangh wel gearriveert en, vermits 't herde weeder, niet voor den 12en dito nae sijn geprojecteerde plaatse connen vertrecken. Ontrent Taroboan comende vonden aldaer ende de

gantsche cust langhs groote berninge en geen gelegentheyt om te anckeren
ofte te landen, eyntelijck tot den 28en dito. [...] Van waer ongevaar vijf à
zes mijlen noordelijcker aengemarcheert, des anderen daechs in 't dorp
Taroboan gecomen sijn, met hun ende d'omleggende dorpen op hoope
door vruntschap beeter tot de kennisse van 't gout geraecken soude pays
gemaeckt hebben. Die hun naar veel moeytens ende eenige dagen dralens
brachten ter plaatse daar sij 't gout soo seyden, in de maent Augusto
soecken, ende als dunne vlieskens ofte hamerslagh van ijser inde revieren
vinden, (fol. 214) niet dervende ons volck de cloove verder in brengen, uyt
vreese van de bosloopers (een quaat volck dat als katten de clippen op en
affclauteren ende door haech en hech weeten te breecken), hunne vijanden,
besprongen te werden. Doch hebben ons volck noch daar ter plaatse
nochte vrij hooger dat sonder d'inwoonders de cloove opclommen, d'aerde
openende, gansch egeen apparentie van gout gevonden. Sulx vastelijck te
gelooven staet door voors. Taroboanders ofte bedroogen sijn, ofte dat den
oorspronck waar het gout valt, dat volcomen met U Edt. soude
sustineeren, selfs niet en weeten. Want anders te geloven staet hun met de
gemelte vlieskens niet genoegen souden. Wijders verclaarden voor
aengetoogen inwoonders dat tusschen de reviere Iwatan ende Papouro, als
't hert geregent heeft ende de revieren sterck affgeloopen hebben, mede
eenigh sandtgoudt langhs de strandt te vinden is, maar dat het principaelste
goudt valt in 't dorp liggende op voors. revier van Papouro een mijl
noordelijcker als Taroboan, presumeerende 't goudt aldaer bij hun in 't
geberchte uyt d'aarde gegraven wert, also 't selve in stucken als
boontiens ende halve leeden van vingers wel hebben becomen. Dogh en
can men van Taroboan tot die plaatse overlandt niet comen, maer soude te
water moeten geschiën; dit is 't voornaemste geseyden Boon van het goudt
vernoomen ende ons gerapporteert heeft, sonder dat ons can verseeckeren
wat quantiteyt goudt dat gewest jaarlijcks uytgeeft. Dan uyt alle
omstandicheeden is (onses oordeels) vastelijck te besluyten, den
oorspronck goudt rijck ende van emporte zij, dienvolgens oock wel
meriteert daarom moeiten ende costen soo lange wert aengewent, totdat
men ten principaelen comt, want 't goudt dat de rivieren uytgeeven is van
hoogen alloy ende behout met weynich ofte geen verlies (geraffineert
sijnde) ruym twintig caraet gelijck U Edt. bij dees nevensgaande acht
maes, die in Tarraboan voor acht cangans, makende ongeveer acht reaal
genegotieert sijn, claerlijck sult connen sien. Waarvan om proeve te
neemen vijff maes geraffineert dat soo veel caraet behout, ende de rest,
opdat Ued. daarvan behoorlijcke inspectie moght nemen, gelijck het inde
riviere (fol. 215) valt gelaaten hebben; 't stuckien met 't gatiën is bij

d'inwoonders off Chineesen gesmolten met cooper (soo schijnt) vervalst
ende geen staet daarop te maacken.

Gemelten Boon sijne saecken als booven verhaelt verricht ende affscheyt
van de principaelen in Taroboan genomen hebbende, is nae Pimaba
vertrocken, meynende aldaar (bevoorens ordre daartoe gestelt hebbende)
de gantsche maecht in 's Compagnies vaartuygen te scheepen ende ons
alsoo te water weederom langhs de zuyt van Formosa toe te comen. Dan
doordien de zeynen die aen landt gedaen bij voors. vaartuygen niet
vernoomen wierden, sijn deselve eenige dagen vooraff leedigh alhier
verscheenen, sulcx de macht die reede seer vermoeyt was, haeren mersch
voorder over landt hebben moeten neemen; die met onse ordre om die van
Sotimor ende de daar ontrent gelegen vijantlijcke dorpen met de wapenen
exemplaar te straffen, onderschepten. Maar aengesien de meergem. maght
door de langhdurige reyse ende soodanigh affgeslooft was, dat niet langer
voort conden, ende met troupen van 15 à 20 man, sonder langer in ordre
te connen mercheeren, aenquamen, is ons desseyn tot naarder gelegentheyt
in staet gebleeven; dat eerstdaechs, de revieren wat affgeloopen sijnde,
voornemens sijn te hervatten, werdende ons hoope gegeven langhs die cant
eenen wech sullen openen, die ons van Saccam in vijff dagen tot Pimaba
brengen sal, ende meenichte van dorpen ons onderdanich sullen connen
maecken; dat een gewenschte saacke soude wesen, ende naar desen 't
succes daarvan te verwachten hebt. [...]

fol. 227: [...] 't Zeedert 't vertreck van den Gouverneur Traudenius hebben
sich de saacken in Quelangh met d'inwoonders maer passelijck
toegedragen, die van St. Jago blijven opstinaat: seggen wel goede vrinden
met d'Hollanders sijn, maar en willen aen 't casteel niet comen. Die van
Kemaurij, onder pretext dat in Kabelangh souden gaen rijs (fol. 228)
coopen, sijn gesamentlijck met vrouw en kinderen derwaarts verloopen,
ende daar 't meerendeel van 't voorleden noorder mousson verbleven,
doch met de comste van onsen macht naa Taroboan gedestineert weeder
gekeert, hebbende haar dorp weederom met nieuwe huysen herbouwt,
waeruyt te besluyten staet dat haar voortaen naar ons willen schicken. De
oorsaacke van haar wechloopen schuyven op één van hun bevelhebbers,
die aen 't ophouden van de wech geloopen Panpangers meede schuldich
sijnde lange heeft geabsenteert eer te voorschijn dorst comen. Naarderhant
verscheyden maelen geinsinueert sijnde is van selffs op genaade ende
ongenaade in 't casteel gecomen, biddende ootmoedelijck vergiffenisse
over sijn misdrijff, met belofte dat voortaen alles dat men hem beval
gehoorsamen ende sijn volck oock daartoe houden soude, welcke saacke

ons per missive alsoo gecommuniceert sijnde, hebben ordre gegeeven op hoope sijn beloften presteeren zal, denselven te largeeren. [...]

In Tamsuy hebben haer d'inwoonders soo ons den luytenant Thomas Pedel successivelijck heeft geadvijseert beter ende gehoorsaemelijck aengestelt, doende voor een geringe schenkagie van cangans met 't aenbrengen van bambousen tot reparatie vande fortificatie als anders alles dat hun op geleyt is geweest, soo dat het een beeter aert van volck, als in Quelangh en daar ontrent schijnt te weesen, [...]

fol. 229: Niet tegenstaande verleeden jaere door onse gedaene tochten aen die van Vavourolangh ende Loncqiouw met onse wapenen aensienelijcke straffe zij geschiet, soo blijven echter hertneckich ofte schreupeleus, soo men 't dan wil noemen, om aen 't casteel den vreede te comen versoecken, waartoe naar uyt alle omstandicheeden connen vermercken, wel geneegen souden sijn. Die van Tipol hebben 't hooft inde schoot gelecht ende naer langh draelens hun gecommitteerdens om den vreede te soliciteeren ende dat omlaech aen de mont van de rivier Tipol mochten woonen gesonden; dat hun mits gehouden blijven naar den genomen voet recognitie in padij ofte vellen te betaelen en alles te doen dat de Compagnie haar verder compt op te leggen, vergunt ende toegestaen is. Den schrijver Christiaen Smalbach, die in Pimaba eenigen tijt herwaarts sijne residentie wegen de Compagnie gehadt heeft, is den 13en julij aldaer overleeden, in wiens plaetse op 't versoeck vande Pimabaers als om 't gesach van de Compagnie aen dien cant te mainteneeren met behoorlijcke instructie weeder (fol. 230) derwaarts geschickt hebben, den corporaal van d'adelborsten Cornelis van der Linden, voorheenen in Vavourolangh 's Compagnies saecken met reedelijck fatsoen waargenomen hebbende, willende vertrouwen aldaer van gelijcken sal doen, dat t'sijner tijt Ued.t geadviseert wert die van Pima ende de daar ontrent gelegen dorpen, naar ons voors. Smalbach zaliger, bij sijn leeven ende nu gemelten Cornelis van der Linden advyseert hebben, gewillichlijck geconsenteert de gestelde erkentenisse jaarlijcx op te brengen. [...]

fol. 257: [...] De gecommitteerdens van Vavourolangh ende Gierim sijn om des gelijcks te doen reede inde reviere Poncan gecomen, van waar te dien eynde vrijgeleyde dat hun toegesonden is, versocht hebben, vreesende apparent alsoo den droogen tijt begint te genaecken hun anders haest wederom bijcomen soude, [...].

fol. 213: [...] After captain Boon with three junks, the *quel* de *Brack* and the large pilot-boat, manned by 197 Dutchmen and 39 Chinese, had been dispatched on the 21st March from here via Tamsuy and Quelang to

Tarraboan to search for the much talked of goldmines, he arrived safely
with all ships on the 2ⁿᵈ of April in Quelang. Because of bad weather he
could not leave earlier than the 12ᵗʰ of that month for his destination.
Approaching Tarraboan there was a lot of surf all along the coast and no
opportunity to anchor or to go ashore, until finally on the 28ᵗʰ. [...] From
there they marched five or six miles north. The next day they arrived in
the village of Tarraboan and made peace with it and with the
neighbouring villages, hoping to find out more about the gold through
friendship. Only with much difficulty and after dragging their feet for
several days they took them to the spot where they said they searched for
gold in the month of August, finding it like thin skins or chips in the
rivers. (fol. 214) They did not dare to take us further into the gorge, for
fear of being ambushed by the savages in the forest, an evil people who
clamber up and down the rocks like cats, and break through fences and
hedges. However, neither on that spot or higher up in the gorge, where
they climbed without the local people, did our men, after digging, find
any sign of gold. It seems to be certain, therefore, that they were
deceived by the people of Tarraboan or that they themselves did not know
where the gold could be found, which would tally with Your
Excellency['s opinion], because otherwise they would not be satisfied with
only chips of gold like that. The local people also told them that small
grains of gold could be found on the beach between the rivers Iwatan and
Papouro when after heavy rainfall the rivers had been swollen. But the
gold is mainly found near a village on the river Parrapoure, one mile
north of Tarraboan. They think that the inhabitants are mining the gold in
the mountains there, because they have obtained pieces of the size of
beans or half finger-joints. However, it is impossible reach that place
from Tarraboan by land, the journey must be made by water. These are
the most important things Boon has found out about the gold and reported
to us. He could not tell us how much gold is mined yearly in that region.
But to all appearances it can be concluded that (according to us) it must
be a rich vein. Therefore it will be worth while spending time and money
until our main objective is achieved, because the gold found in the rivers
is of a high alloy, more than twenty carats, with no or hardly any loss
after refining. Your Excellency can see this clearly by means of the
sample of eight mas we have sent with this letter, that we traded in
Tarraboan for eight *cangans*, the equivalent of about eight reals. We have

refined five mas as a test, which maintained its carats, while we left the rest as it was found in the river, (fol. 215) so that Your Excellency can examine it properly. The piece with the hole in it has been falsified by local people or Chinese by melting it together with copper and cannot be valued.

Having carried out his task as reported above and having said goodbye to the principals of Tarraboan, Boon left for Pimaba. He intended to embark his force there in the Company's ships (having given orders to that purpose beforehand) and to sail back round the south of Formosa. However, the signals from the shore were not seen by the ships, so that they arrived here empty a few days earlier, and the force, already very tired, had to march on overland. We intercepted them with orders to punish the peoples of Sotimor and neighbouring hostile villages by force of arms as an example. But the men were so exhausted by the long journey that they could not go on much longer, and were arriving in groups of 15 to twenty men, unable to maintain marching order. Therefore we left our plans till another opportunity presented itself. But it is our intention to resume this plan soon, when the rivers are somewhat lower. We are hopeful that we can clear a way on that side that will take us from Saccam to Pimaba in five days, while subjecting many villages. This will be a desirable thing and you may expect our success in this venture in due course. [...]

fol. 227: [...] Since the departure of Governor Traudenius relations with the inhabitants of Quelangh have not been too good. The people of St. Jago continue to be obstinate. They claim to be good friends of the Dutch, but refuse to come to the castle. The people of Kimaurij had run away to Cavalangh with their wives and children, pretending to go and (fol. 228) buy rice there. They stayed there for much of the past northern monsoon, but on the arrival of our force destined for Tarroboan, they returned and have rebuilt their village with new houses. From that we have concluded that they will obey us in future. We put the blame for their running away on one of their leaders, who remained absent a long time before he dared show himself, because he was guilty of harbouring the fugitive *Panpangers*. After being urged several times he came of his own free will to the castle casting himself on our mercy, humbly begging for forgiveness and promising to follow all our orders and to force his people to do the same. When these developments were reported to us by letter

we gave orders to release him in the hope that he would keep his promises. [...]

Lieutenant Thomas Pedel has notified us on successive occasions that the inhabitants of Tamsuy are behaving themselves well and obediently, fulfilling for a small gift of *cangans* all the tasks they were given, like bringing bamboo for the repair of the fortress etc. They seem to be a nation of a better disposition than those of Quelang and neighbouring places, [...].

fol. 229: The peoples of Vavorolangh and Lonckjouw have been severely punished by force of arms in last year's expeditions, but they still are too obstinate, or maybe it is better said fearful to come and ask for peace at the castle, although apparently it is obvious that they prepared to make peace. The Tipol people have finally given in and after much delay have sent their representatives to ask for peace and for permission to come down and live near the mouth of the River Tipol. We have given permission on condition that they will pay tribute in paddy or skins on the same footing as before and that they will fulfil every task the Company assigns them. The clerk Christiaen Smalbach, who had been stationed in Pimaba by the Company some time ago, passed away there on the 13th of July. On the request of the Pimaba people and in order to maintain the authority of the Company in those parts we had dispatched – with proper instructions – the corporal of the cadets Cornelis van der Linden, who formerly promoted the interests of the Company in Vavorolangh in a decent manner. We expect him to do the same over there and will inform Your Excellency about that in due course. The late Smalbach, when he was still alive, and now the aforementioned Cornelis van der Linden have both informed us that the people of Pimaba and neighbouring villages have consented of their own free will to yearly pay the stipulated tribute. [...]

fol. 257: [...] Representatives of Vavourolangh and Gierim have arrived at the River Poncan, from where they asked for a safe-conduct, which we have sent them. Apparently they are afraid now that the dry season is approaching that we would again pay them a visit, [...].

210. Missive Reverend Robertus Junius to President Maximiliaen Lemaire.
In Pangsoya in the house of schoolteacher P. Barentsz., 21 October 1643.
VOC 1146, fol. 603-605.[92]

211. Missive President Maximiliaen Lemaire to Anthonio van Diemen.
Tayouan, 19 November 1643.
VOC 1145, fol. 193-202. Extracts.

fol. 195: [...] D'acht dorpen Cleen Davolee, Dalivo, Jorijs, Douvaha, Voulala, Deusouvan, Tavoupoul ende Vasican, noordelijck van Mattauw gelegen ende lange met ons in vruntschap gestaen, hebben, nevens d'andere haere gebueren, mits jegens haere vijanden mogen beschermt werden, gewillichlijck de geraemde recognitie van padie te sijner tijt belooft op te brengen. Drie gecommitteerdens wegens die gemeente van Vavorolangh, bestaende ongevaer noch in honderd huysgesinnen te weeten van de goede ende die steets de Nederlanders gefavoriseert hebben, wesende de rechtschuldige met haere adherenten inde noordelijcke dorpen verstroyt, sijn den 16en deser aen 't casteel geweest ende met de Comp.e vereenicht, mits haer onderwerp ende de reede gestelde erkentenisse benevens andere dorpen haere gebueren jaerlijcks te contribueeren ende vorders alles te doen dat de Comp.e haer op te leggen compt.
Seecker Chinees rover, Kimwangh (alias Saccalau) gent., voor desen met eenige joncqjens naer gerucht werdt hem in de Piscadores en op de noortwest cust van Formosa onthouden hebbende, soude hem, naer ons meermaels gerapporteert is, acht joncquen in de reviere van Betgierim begeven, sich aldaer neder geslaegen, ende hem met sijn bijhebbende Chineesen, benevens Betgierim selffs noch Girim, Out Davole, Cleen en Groot Samlo, Dalivalou, Tavocul, Valabaus ende Darou Karra Karra onderdanich gemaeckt hebben, Jae heeft noch eenige weynige daegen herwaerts uyt hongersnoot ende om rijs voor sijn volck op te soucken, die van Vasican affvallig gemaeckt met haer 't dorp van Dalivo aengevallen ende 't selve wel halff affgebrandt, doch soude met schande gestut ende geretireert wesen. Omme waerinne nae behooren te voorsien, zijn voornemens naer 't depecheeren van de scheepen in 't begin van december een tocht te waeter (fol. 196) derwaerts te laeten geschiën, [...].

fol. 195: [...] The eight villages Little Davolee, Dalivo, Jorijs, Douvaha, Voulala, Deusouvan, Tavoupoul and Vassican, situated north of Mattouw and being our friends for a long time have, together with other neighbours, willingly promised to pay the stipulated tribute of paddy in time, provided they be protected against their enemies. Three representatives of the community of Vavorolangh – now consisting of about a hundred households, namely the good ones that have always been favouring the Dutch, the guilty ones and their accomplices being scattered over the northern villages – have been to the castle on the 16th to be reconciled with the Company, consenting to pay the already stipulated tribute yearly just like their neighbouring villages and to furthermore perform all duties the Company may assign them.

A Chinese pirate called Kimwangh (alias Saccalau), who was rumoured to have been around in the Pescadores and on the north-west coast of Formosa with a few junks, had proceeded, according to several reports, with eight junks to the river of Dorenap and had taken up residence there, subjecting with his Chinese force not only Dorenap, but also Gielim, Old Davolee, Little and Great Samlo, Dalivalou, Tavocul, Valabaus and Darou, Karra Karra. Only a few days ago driven by hunger and trying to find rice for his people, he even made the people of Vassican defect and together with them attacked the village of Dalivo, burning half of it down, but he was checked and had to make a shameful retreat. In order to be able to take appropriate measures we intend to undertake an expedition over sea (fol. 196) in the beginning of December after the dispatch of the ships, [...].

212. Missive President Maximiliaen Lemaire to Governor-General Anthonio van Diemen.
Tayouan, 9 December 1643.
VOC 1145, fol. 203-210. Extract.
See also FORMOSA UNDER THE DUTCH, p. 197; ZENDING, IV, p. 1.

fol. 208: [...] *(Chinese handelaren wordt de toegang tot de noordelijke en zuidelijke dorpen ontzegd)* willende in 't alderminste niet twijffelen ofte den inwoonder sal hierdoor meer ende meer tot ons gewennen ende om 't geene hem gebreeckt selffs in Tayouan ter merckt comen, ofte soo ons zulcx ontschiet sulen hem jaerlijcks in Tapouliangh om de zuyt ende Soulangh om de noort twee à drie maenden met de vereysschende

coopmanschappen in trocq van vellen ten dienst moeten sijn, als wanneer de Comp.ᵉ met der tijt de proffijten die den Chinees dus lange getrocken heeft oocq staen toe te vallen.

Mitsgaders gesien ende gehoort hebbende de clachten die d'inwoonders van Mattauw, Soulangh, Baccoloangh, Sincan ende Tavocan over den Chinees wegen 't bestaen van haere naest gelegen velden doen, soo is om de selve daerin contentement te geven ende den Chinees daer door op Zaccam te trecken verstaen dat men 't gebruyck van vers. velden van nu aff hun noch een jaer sal laeten genieten ende dat als dan gehouden sullen sijn die te verlaeten.

Wijders geconsidereert hebbende hoe naedeelich den voors. Chinees 't gemoet van de inwoonders is, ende dat ons deselve in de voors. dorpen (daer tot U Edts. naerder ordre te woon te moogen blijven gelicentieert sijn) ons somtijts spel berockent, soo comen om Formosa van dat slim gedrocht te suyveren niet verbij aen U Edt. te solliciteeren dat d'selve van daer nae Saccam gewesen mogen werden, waerdoor ons meerder gunst toegebracht ende Saccamme te beter gepeupleert werden sal, dese voors. poincten ende noch andere meer daervan om niet te langh te sijn ons aen de resolutie gedraegen, hebben om reedenen hier boven aengeroert alsoo ten dienste van de Comp. gearresteert ende goetgevonden, vastelijck verhoopende U Ed.ᵗ die voor wel gedaen opnemen ende oordeelen zult.

Aengesien die van Sotimor met haeren aenhanck ruym een halven dach reysens oostwaert van Tapouliangh ende voor desen met ons in vruntschap staende, niet afflaaten van dagelijcx d'onse in de zuydelijckste dorpen viantelijck te coomen bestoocken ende hoofden te haelen soo is in Raede ten hoochsten noodich geacht vermits de wegen droogh ende de revieren redelijckerwijs te passeeren sijn, eerstdaechs een tocht met 150 coppen derwaerts te doen, soo om d'selve exemplaerlijck te straffen als den corten wech nae Pimaba daervan voor desen hebben geadviseert doenelijcq sijnde te ontdecken, ende de dorpen onderweege leggende ons onderdanich te maecken, [...].

fol. 208: [...] *(Chinese inhabitants of the island were reported to continuously tarnish the Company's reputation in the eyes of the Formosans. On various occasions that instigation had caused disturbances. Therefore, in order to improve the image of the Company among the Formosan subjects, it had been decided to forbid the Chinese to continue their commercial activities in the northern and southern villages (except in some special cases for important reasons) the more so because the Company only gained about 400 reals a year from the*

licences:) in this way the local people will undoubtedly be getting used to us more and more and will come in person to the market in Tayouan to buy the things they need. If, contrary to expectation, this does not happen, we will have to supply them every two or three months per year in Tapouliangh in the south and Soulang in the north with the needed commodities in exchange for skins. In due course the Company will gather in the profits that have until now gone to the Chinese.

Having heard the complaints of the inhabitants of Mattouw, Soulang, Bacaluan, Sincan and Tavacan directed against the Chinese and arising because of the existence of adjoining fields, it was decided, in order to satisfy them and to make the Chinese move to Saccam, to allow them the use of those fields for one more year, after which time they will be obliged to vacate them.

Furthermore, having seen how harmful the Chinese are with regard to the local people and that they sometimes play dirty tricks upon us in the villages mentioned above (where they are licensed to live until further notice by Your Excellency) we cannot but ask Your Excellency, in order to rid Formosa of those evil monsters, to be allowed to order them to Saccam. This will be more beneficial to us and will make Saccam better populated. These points and some others, for which we refer to the resolution in order not to be too lengthy here, we have approved and decreed, for the reasons mentioned before and for the good of the Company, trusting that Your Excellency will consider it rightly done.

The people of Sotimor and their following, living more than half a day's travel east of Tapouliangh and until now having been friendly towards us, do not stop making daily hostile attacks on our people in the most southern villages and hunting heads. Therefore the Council has deemed it highly necessary, now that the roads are dry and the rivers are passable, to undertake an expedition with 150 men, in order to punish them as an example to others and also, if possible, to discover the shortcut to Pimaba we mentioned earlier, subjecting all villages on the way.

213. Dagregister Zeelandia 12 July 1643-20 March 1644. Summary of January 1644.
ARA, *Survey of microfilms of archival data kept in foreign archives* **486, Collectie Gijssels. (The manuscript is kept in the Landes bibliothek Karlruhe, Germany.)**
DRZ, **II, pp. 211-236.**

(On 21 December a letter was received from Merchant Johannes van den Eynde from Swatalauw. He reported that on 17 December, during the march in the mountains on the way from Taccareyang to punish rebellious Pangnangh, his men had run into an enormous crowd of about 3000 warriors from all the rebellious villages of the area. Immediately several smaller groups attacked the expedition army and in that way they succeeded in preventing the Company soldiers and their Taccareyang allies to enter the village of Pangnangh. Upon learning this bad news it was decided in the Formosan Council to send another contingent of sixty men. Van den Eynde was advised that if it seemed that his men would again be defeated because the rebels were in the majority, then he had to come up with some trick in order to outfox them and take revenge for the earlier defeat. In a next letter, that was delivered at the castle on 30 December and that was written by Van den Eynde two days before, he reported that the army had reached Sotimor, but it had been impossible to climb the steep road that led into that village. Moreover because many warriors had been seen on the heights being ready to throw down stones, he had decided to withdraw to Swatalauw.)

1644

214. Extract missive President Maximiliaen Lemaire to Governor-General Anthonio van Diemen.
Tayouan, 15 January 1644.
DRB 1643-1644, pp. 28-29.

(During the expedition over Tamsuy to Sotimor a bloody encounter occurred, in which seventy people were killed; 21 Dutchmen, several Chinese, 'blacks' [Company slaves] and more than forty Formosans. This defeat was due to a misjudgement of the situation by the Company troops.)

215. Dagregister Zeelandia 12 July 1643-20 March 1644. Summary February-March 1644.
ARA, *Survey of microfilms of archival data kept in foreign archives 486, Collectie Gijssels.*
DRZ, II, pp. 211-236.

(On 1 February 1644 a resolution was passed in the Council that, if the High Government of Batavia would agree, two 'Land Days' or general assemblies of village headmen would be held in Saccam; one on 21 March for the northern villages and one on 18 April for the southern and eastern villages.
On 16 February about 75 men under the command of captain Pieter Boon boarded the junk Brack, *to set sail for the island Bottel [Botel Tobago or Lan Yü]. Two days later the junk anchored in front of three coastal settlements located on the eastern side of Bottel. The next day some islanders were seen, who had fled into the mountains upon the arrival of the Dutch, whereupon the Company soldiers went ashore carrying a white flag. Ensign Jurriaen Smit soon managed to meet with one of the warriors with whom he exchanged coats, indicating that he wished to meet him again the next day. On 20 February eight or ten islanders came down and offered captain Boon a goat; in return some textiles were presented to them. Subsequently another group, of about twenty, also came to meet Boon and his company. These warriors wore a lot of silver ornaments,*

Spanish reals, bracelets of silver wire etc. Some of them were seen wearing golden rings in their ears or silver plates on their caps, while others were carrying weapons with silver butts. However the next day none of them showed up again and the captain, who had been ordered to capture three or four inhabitants and bring them over to Tayouan, thought of a way how to force the people to come down to the beach. Boon and his men finally managed to lure some islanders down by holding some cangans out to them and afterwards tried to carry three or four men aboard the junk. However because these men defended themselves fiercely, only two were captured, while one was hurt in the struggle and another man mortally wounded. Before leaving on the 24th, the Company men went to see the villages situated on the western side of Bottel but they did not meet with any people. The next day they sailed back to Tayouan via Pangsoya and Lamey.

On 3 March the Zeelandia Council decided that senior merchant and resident Cornelis Caesar was to be sent over to Verovorongh, together with merchant Johannes van den Eynde. They had to investigate whether they could get the people of the remote villages of that area, situated high up in the mountains, to come down and settle in newly established villages on the plain. If these mountain people were within reach for ministers and teachers this would be beneficial to the progress of Christianity.)

216. Resolutions, Tayouan, 29 March-11 Augustus 1644.
VOC 1147, fol. 467-476. Resolution 29 March 1644.
See also FORMOSA UNDER THE DUTCH, pp. 197-203; ZENDING, IV, pp. 2-12.

fol. 468: [...] soo is mede tot accomodatie van onse garnisoenen *[in Quelang en in Tamsuy]* ende allen daer ontrent ingesetenen, g'arresteert dat men den Chinesen ende allen anderen die daer toe genegen sijn, vrijstellen, vergunnen ende toestaen sal, dat hun aldaer met landtbouwerije, visschen, het raffineren van swavel ende allen handelingen (gelijck hier op Tayouan wert gepleecht) in voorsch. plaetsen van Tamsuy ende Quelangh vermogen sullen t'erneren ende derwaerts te gaen ende keren, mits dat alle imposten hooftgelt etc., (gelijck in Tayouan gebruyckelijck sij) egeene uytgesondert dragen sullen ende in genen delen bij d'inwoonderen in de dorpen gaen handelen, maer wel dat d'inwoonderen bij hun onder 't domineren van onse casteelen, verkeren

ende toegelaten handeldrijven sullen mogen. Insgelijcx dat niemandt van daer naer China, ofte van China costij met off sonder coopmanschappen sal vermogen te varen dan met onse expresse ordre ende consent, als wanneer van alles dat uyt- ende invoeren thienden betaelen zullen, gelijck dan oock doen sullen van d'inbrengende goederen alle die gene die al gerede passen tot exercitie van hunnen swavelhandel van China derwaerts verleent zij; alles op de penaliteyten in onse voordesen g'emandeerde placcaten vervaeth, ende in toecomende daer op noch te stellen etc. [...].

fol. 468: [...] It has also been decided for the convenience of our garrisons and all inhabitants there that the Chinese and all others who are willing to do so, will be licensed and permitted to make a living in the aforesaid places of Tamsuy and Quelang through farming, fishing, the refining of sulphur and all other occupations that are practised here in Tayouan, and that they are allowed to travel to and from there, provided that they pay all excise-duties, poll-taxes etc. that are customary in Tayouan, without exception, and that they will not go out to trade with the local people in their villages, but that the villagers will be allowed to come to trade with them under the supervision of our castles. Furthermore, no person will be allowed to sail from there to China, or from China to there, with or without merchandise, except on our express orders and with our permission, in which case they will pay tithe on everything that is imported or exported. This also applies to the goods imported by all those who have already been issued passes to exercise their sulphur-trade with China there; all this [will be enforced by the] penalties that are included in the proclamations promulgated earlier and those that are yet to be determined etc. [...].

217. Missive Corporal Cornelis van der Linden to President Maximiliaen Lemaire.
Pimaba, 29 March 1644.
VOC 1147, fol. 505-506. Extract.

[...] Alsoo nu den tijt niet toelaet om d'Ed. heer te schrijven nae behoren door de compste vande jonck, alsoo ick grote moeyte hebbe gehadt om 't volcq te crijgen die 's Comp. goederen nae de jonck moesten dragen dan verhope door de hulp van Godt op den gesetten tijt met d'opperhooffden deser dorpen in Tayouan te zijn als wanneer ick d'Ed. heer in alles ter

dege sal rapport doen. [...] Uyt d'Ed. heer zijn schrijvens verstae dat hier, wanneer het d'Ed. heer mochte goetvinden, noch wel een troupiën volck mochte gesonden werden, 't welcq wel soude van node wesen, soo d'Ed. heer niets nodich daer door geliefden te laten doen, dat soo lange in Tayouan bleven tot den landtdach gehouden was, alsoo ick anders wellicht de inwoonders niet en zoude connen bewilligen om naer Tayouan te gaen, alsoo gants geen vertrouwen meer op onse natie hebben. Wat de schortingh daervan is can niet weten. Edoch en clagen niet anders dan alleen vande tocht van Tipol ende haer oude praetgiens, 't welcq ick haer soo veel als mogelijck is uyt den zin stel.

Wat aengaet de tocht naer Calonoij hebbe ick op den 7en voorleden met de Pimers op den wech geweest maer alsoo ons den regen overviel heb ick door onwillicheyt der Pimers niet connen uytrechten. Alsoo claechden dat haer niet mochelijck was om 't geberchte op te comen door de gladicheyt van de wech, die sij seggen dat meestal clare keysteen is die se niet connen passeren ende also ick haer niet en conde bewilligen om met mij te gaen, soo hebbe ick weer moeten naer Pima keren alwaer den 8en zijn aengecomen. Vorders hebbe ick altijt getracht om mijnen last te volbrengen maer en heb het niet connen doen, door den langhduurigen regen die wij alhier 't sedert den 5en dito tot den 26en hebben gehadt.

Aengaende den oudsten in 't dorp Tipol, die heefft hier in Pima op den 13en deses geweest om hem te verantwoorden. Doch om hem en andere niet te laten [billijken] soo hebbe ick hem door aenraeden van den regent weer ongemolesteert laeten gaen alsoo goede beloften van beterschap dede, ende belooffden in haest benevens d'anderen te timmeren op haere aengewesene plaetse ende verhoope in corten (fol. 506) tijt d'Ed. heer volcomen hier van rapport te doen. Wat aengaet de twee oudsten uyt Oudt Tammalaccouw, blijven noch als voren, dan en can icq daer noch niet in doen alsoo den regent heel sieck is, waerom ick met haer sal wachten tot ick in Tayouan geweest ben, soo sij haer stil houden om alhier geen beroerte te maken onder de dorpen.

D'Ed. heer verhaelt in sijn missive van 't dorp Sapien, 't welcq een dorp is gelegen achter Tawaly in de clooff in 't geberacht ende zijn door den coopman Marten Wesselingh saliger al voor vijff jaren met de Comp.e verenicht geweest maer stellen haer nu heel rebel, ende hebben op den 24en dito verleden een vrouw het hooft affgeslagen van 't dorp Bavabijkaer ende begint soo d'één voor d'ander naer de pijpen vast te stellen. [...].

[...] Time does not allow me to write to Your Excellency properly because of the arrival of the junk. I have had much trouble in finding

people to carry the Company's goods to the junk. I hope with the help of God to be in Tayouan together with the heads of these villages on the appointed date, and then I will give Your Excellency a detailed report on everything. [...]

From Your Excellency's letter I understand that with Your Excellency's permission it may be possible to send a small party of men here, which would be very welcome, if Your Excellency did not have an urgent task for them that would keep them in Tayouan until after the Land Day, because otherwise I might not be able to persuade the inhabitants to go to Tayouan, as they have no confidence left at all in our nation. I do not know what has caused this, but they are complaining incessantly about the expedition to Tipol and are repeating their old stories, which I am trying to refute as much as I can.

Regarding the journey to Calonoy, I went on my way on the 7th with the men from Pimaba, but we were caught in the rain and could not accomplish anything on account of the obstinacy of the Pimaba people, who were complaining that it was impossible to climb the mountains because of the slipperiness of the road that according to them mainly consists of bare rock and had therefore become impassable. As I could not persuade them to go on with me, I had to return to Pimaba, where I arrived on the 8th. Since then I have constantly tried to carry out my task, but was unable to do so because of the incessant rain we had from the 5th until the 26th.

The principal of Tipol was here in Pimaba on the 13th to justify himself, but in order not to condone his behaviour and that of the others, I have released him unmolested on the recommendation of the regent, because he seriously promised to make up for his actions and pledged to quickly build his house together with the others on the location that was allocated to them. I hope to inform Your Excellency in detail about this soon. (fol. 506) Concerning the two principals of Old Tammalaccouw the situation is the same as before, but I cannot do anything about it because the regent is very ill. Therefore, so long as they remain quiet I will wait until after I have been in Tayouan, lest it will cause unrest in the villages.

In his letter Your Excellency mentions the village Sipien. This village is situated beyond Tawaly in the gorge in the mountains and was already allied with the Company by the late Marten Wesselingh five years ago. However, they are behaving in a very rebellious way now and on the 24th

they cut off the head of a woman from the village of Lavabikaer and so one after the other they are starting to get obstinate. [...].

218. Instruction from President Maximiliaen Lemaire for Captain Pieter Boon, leaving with the yacht *Breskens* and the junk *Diemen* to Tamsuy.
Tayouan 9 April 1644.
VOC 1147, fol. 481-485. Extract.

fol. 483: [...] Uyt de jongste advysen van de vrunden in Tamsuy verstaen wij hoe de landsaten weynich aen de casteelen comen, insonderheyt de geene die onder Kelangh sorteeren, dat heel ongerijmpt compt ende met de kleene aldaer aenwesende macht niet can geremedieert werden. Echter verstaen niet alleen dat sulcx promptelijck behoorde te geschieden maer oock dat gelijck hier gepractiseert is, jaerlijckse recognitie in vellen sullen moeten betaelen. Evenwel om haer hiertoe te brengen soude niet gaerne al te straffe middelen gebruycken, maer liever bemercken dat alleen door 't aensien onser gewapende troupen tot ons oogmerck mochten werden gebracht. Dieshalve sal U Ed. aldaer onder de vrunden onderstaen ofte in Julij aldaer een troupe van 70, 80 à 100 coppen senden ende hun daer met aller wegen inde dorpen selffs, ofte wel op een andere gevouchlijcke (fol. 484) manier sonder gewelt te doen gingh versoecken met goede woorden ende 't gesach van soo een aensienelijcke macht niet souden tot soodanigen redelijckheyt te brengen sijn als de dorpen hier naest ontrent gelegen, gebracht bennen. Wij achten 't doenelijck 't advijs van ginder sullen verwachten ende t'zijner tijt dan daer op verder letten. Ondertusschen is 't niet verbooden met de middelen die daer hebben op dit stuck de gelegentheyt toelaetende met voorsichtichticheyt te letten, gelijck geduyrent UE. aenwesen oock naerstelijck vernemen sult, wat ende hoeveel dorpen ons aldaer voor protecteurs erkennen, hoe groot van huysen dat sijn, wat ende hoeveel dorpen tusschen Tamsuy ende Dorenap (anders door quaat gebruyck voor desen bij ons Betgilem genaempt) noch onbevreedicht leggen, ende offte door hun selffs ofte eenige meerder macht geregeert werden, insgelijcks oostwert aen van Tamsuy in ende langhs het geberchte condt mede doen, waer aen de Comp.ᵉ in deese gelegentheyt van toeloopende dorpen eenen merckelijcken dienst geschieden sal. [...].

fol. 483: [...] From the latest reports from our friends in Tamsuy we understand that the natives hardly ever come to our castles, especially

those under the authority of Quelang. This is very strange and cannot be remedied with the small force present there. We have decided not only that this should be done without delay but also that they will have to pay a yearly tribute in skins, as is already customary here. However, to bring that about, you should preferably not use too harsh methods. We would rather like to see that they were persuaded just by the sight of our armed troops. Therefore will Your Excellency make enquiries with our friends if they could send a force of seventy, eighty or hundred men to visit all the villages themselves in July, and thus bring about with kind words or in another suitable (fol. 484) way without the actual use of force. A considerable force like that will make them reasonable just as has been done in the villages here. We deem it right to await the reports from there and will have a further look at it in due course. In the meantime, it would not be a bad idea during Your Excellency's stay there, to pay careful attention under the present conditions to the issue of which and how many villages acknowledge our patronage, how many houses they have, how many villages between Tamsuy and Dorenap (formerly by mistake called Betgilem) are not yet at peace with us and if they are governed by themselves or by some higher power. You can do the same east of Tamsuy and along the mountains, so that the Company will be done a considerable service through the joining of villages.

219. Order and instruction from President Maximiliaen Lemaire for Ensign Hendrick Jacob Baers, subaltern Chief in Quelang.
Tayouan, 9 April 1644.
VOC 1147, fol. 489-490. Extract.

fol. 489: [...] Soo sult met allen vlijdt ende neersticheyt betrachten dat d'inwoonders ende landtsaten daer ontrent in goede devotie ende gehoorsaemheyt onderhouden werden, ende met de selve vrundelijck handelen ende ommegaen (onvermindert nochtans 't gesach van den Comp.ᵉ).
Soo ons den Capp.ᵉⁿ Harousé op sijn aencompste van daer heeft weten te seggen, souden de verseyde landtsaeten ende besonderlijck de Kimaureesen gantsch seer tot den Japancen tolcq Jasinto Quesaijmondonne genegen sijn, ende meest alles doen wat vande Compagnie door hem geseyt offte gebooden wert, derhalven sal Ulieve voors. Japander in behoorlijcke achtinge nemen, wel tracteeren ende geen onlusten sonder reeden aendoen,

op dat hij 't geene hem wegens d'Comp.ᵉ den inwoonders belast des te gewilliger ende met te beter genegentheyt tot den Nederlandtsen staet uytvoeren ende bewercken mach. [...].

fol. 489: [...] You will exercise the greatest care and diligence to keep the inhabitants and the natives in that region devoted and obedient and you will deal with them in a friendly manner (without prejudice to the authority of the Company).

After his return captain Harroussé has told us that the natives, and in particular the people from Kimaurij, are very fond of the Japanese interpreter Jasinto Quesaymondonne, carrying out almost anything he tells or orders them to do on behalf of the Company. Therefore you will hold him in esteem and treat him well, not giving him cause for resentment without reason, so that he may execute with even more willingness and devotion to the Dutch state all instructions by the Company regarding the local people. [...]

220. Missive President Maximiliaen Lemaire to Lieutenant Thomas Pedel.
Tayouan, 9 April 1644.
VOC 1147, fol. 496-498. Extract.

> fol. 498: [...] Twee jaeren nae den anderen hebben de Formosanen voor yder huysgesin tot recognitie betaelt 20 catty affgestampten padie, dan alsoo bemerckt hebben dat hun sulcx eenichsints discommodeerde ende dat liever hertevellen gaven, daar oock vrij beter met gedient sijn, is op de vergaderinge van jongsten landtdagh voorgestelt ende geapprobeert dat voortaen yder huysgesin in plaets van padij, twee elandtshuyden, ofte vier hertevellen cabessa, ofte acht dito barigos ofte 16 pees jaarlijcx betaelen sal, waar toe costij den inwoonder meede gebracht dient, soo ons wilt verseeckeren van oprechte gehoorsaemheyt dat met den anderen ijverlijck te bemercken hebt. [...].

fol. 498: [...] For the past two years the Formosans have paid twenty *catty* of threshed paddy for each household as tribute. We have, however, noticed that this inconvenienced them somewhat and that they preferred to pay in skins. Because this suits us better too, we have during the meeting of the latest Land Day proposed and approved that in future every

household will pay us annually instead of paddy of two elk-skins or four deerskins *cabessa* (of the first quality), or acht *bariga* (of middle quality), or 16 *pee* (of the lowest quality). The people in your region will have to be made to do the same in order to make sure of their honest obedience, which we together will have to do our best to bring about. [...]

221. Dagregister Zeelandia 20 March-11 August 1644.
VOC 1148, fol. 281-351.
DRZ, II, pp. 237-300. Extracts.

(On 21 March 1644 the assembly or 'Land Day' of the northern villages had taken place. The 'Land Day' for the southern and eastern villages was to be held in Saccam on 19 April.)[93]

222. Resolution Tayouan, 11 April 1644.
VOC 1147, fol 469-470.

fol. 469: [...] Gemerckt dat den Zuydelijcksten landtdach begint te genaecken soo draecht sijn Ed. mede voor offte men denselven niet in forma, gelijck met den Noordelijcksten geschiet is, behoorden te houden ende hun lieden gelijcke poincten voor soo veel als met den anderen gemeenschap hebben voor te dragen, soo is mede verstaen alsoo niet anders hebben connen bemercken, ofte alles is aensienelijck met goet respect ende voornaementlijck tot goet genoegen van d'inhabitanten toe gegaen, dat men om eenparige regeringhe onder den Formosaen ende bij veranderinge geen alteratie te maken daer mede op gelijcken voeth niet alleen nu maer oock jaerlijcx continueren zal.

Ende also ondervinden datter verscheyden vorsten die menichte van dorpen onder hun hebben op 't landt van Formosa sijn, ende naer desen noch apparendt meer te verschijnen staen, soo werdt g'arresteert dewijle d'selve vrij meerder seggen als d'ordinarie oudsten over haere onderdaenen (fol. 470) hebben, dat men omme haere macht allenskens te besnijden op seeckere geraemde articulen, met den vorst van Lonckjouw, die nu over sijn misdrijff weeck is ende remis versoeckt op den aenstaenden landtsdach, sodanich sal soecken te handelen als wij oordelen dat hier naer met andere vorsten mede behoorde te geschieden, de natuyre onser landen crijgen ende de Compagnie nuttelijckst is.

fol. 469: [...] In view of the fact that the Southern Land Day is approaching, His Excellency proposed that this meeting be held in the same form as the northern one, and that the same points should be presented there in so far as those were applicable to both. Seeing that everything had proceeded in good order and generally to the contentment of the inhabitants, it was also decided, in order to create an uniform rule for the Formosans without making alterations every time a change in the circumstances occurs, to continue this not only now but every year.

We have observed that there are several rulers on Formosa who control a multitude of villages and we will undoubtedly discover more later. Therefore it was decided, because they have much more power over their subjects (fol. 470) than the average principal in his village, in order to gradually reduce this power to certain fixed regulations, to deal with the ruler of Lonckjouw, who is now repentant over his misconduct and is asking for amnesty at the coming Land Day in such a manner as we think would be appropriate for all other rulers as well, so that they will become like our own lands which will be most profitable to the Company.

223. Resolution, Tayouan, 16 April 1644.
VOC 1147, fol. 470-471.

> fol. 470: [...] Ende alsoo vermerckt wert datter dagelijcx veele cleenicheeden uyt China ende eenige buytenplaetsen van Formosa (bij den Chinesen en den inwoonder getrocken) aengebracht werden, offte men dienvolgende niet volgens sijn Edts. ooghwit ende redelijckheyt soo van 't eene als van 't ander tot vergrotinge van gemelte incompsten thienden behoorden te heffen; 't welck bij haere Eds. in consideratie gecomen ende wel overwogen zijnde soo is eendrachtelijck verstaen ende geresolveert dat den Chinees van primo May aenstaende gehouden sal wesen van alle de swarte suyckeren, Chineese caersiëns, toebacq, aracq, olij, traen, allerley smeer, offte veth, Formosaense rottangh, coralen, als andere diergelijcke coopmanschappen ende cramereyen meer die hier in 't quartier en onder den inwoonder gesleten werden, voor 't inbrengen voortaen den gerechten thienden aen de Compagnie [te voldoen].
>
> [...] Aengesien den Chinesen voor desen om goede consideratiën in de Noordelijcke (fol. 471) ende Zuydelijcke dorpen, die verre van de handt gelegen zijn, den handel verboden was, die voornemens waeren t'sijner tijt tot accomodatie van den Formosaen ofte selffs ofte door de Chineesen te laeten geschieden, gelijck sulcx op den Noordelijcksten landtdach aen de

bevelhebberen oock ten dele beloofft hebben, dan bij naerder overlegginge vermerckt zijnde dat het selve, vermidts den groten ommeslach dier saecke, niet wel als met veel residenten hier en daer te leggen door ons sal connen geschieden, 't welcq behalven ons soo met een cleijtgien te venten gelijck den Chinees niet en weten te behelpen de Comp. vrij lastich souden vallen, soo is mede geresolveert omme d'inwoonderen hun gerieff soo veele doenelijck te doen hebben, ende onse voorsz. beloften dies aengaende te presteren dat men in de Noordelijckste dorpen als Favorolangh, Tirosen, Dorcko ende Tevorangh, onder gelimiteerde conditiën ende d'opsichte van den politijcq, als andere residenten daer omher leggende, bij provisie om een preuve daer aff te nemen zes, acht, à tien Chineesen naer dat gem.ᵉ dorpen groot zijn, met bewillinge van d'inwoonderen den handel ende het resideren aldaer toestaen zal mits dat voor haere admissie almede tot vergrotinghe van 's Comp. incompsten een redelijcke somma gelts jaerlijcx betalen zullen.

fol. 470: [...] Seeing that a lot of small goods are daily being brought in from China and remote places on Formosa (for the use of the Chinese and the local people), it was suggested that in accordance with His Excellency's intention and out of fairness, a tithe should be levied on those goods so as to increase our revenue. After careful consideration by the councillors it was unanimously approved and decided that the Chinese from May 1ˢᵗ will be obliged [to pay] the Company tithe on the import of all black sugar, Chinese candles, tobacco, arrack, oil, fish-oil, all kinds of fat, Formosan rattan, beads and all similar merchandise and other cheap goods that are peddled in these parts.

[...] For good reasons the Chinese have until now been forbidden to trade in the northern (fol. 471) and southern villages situated in remote areas. We intended to undertake this trade to accommodate the Formosans ourselves or hire the Chinese for that purpose, as we more or less promised the principals during the Northern Land Day. However, after further deliberation it became evident that because of the many cumbersome tasks it could only be done by stationing residents in many places. This would be difficult for the Company and besides we could not make a profit like the Chinese by peddling pieces of cloth. Therefore, to accommodate the local people as much as possible and to fulfil our promises, it was decided to provisionally allow in northern villages like Vavorolangh, Tirosen, Dorko and Tevorang, and under strict conditions and supervision of the

political administrator and other local residents for test purposes, six, eight, or ten Chinese, according to the size of the villages, to live and trade there with the approval of the inhabitants. This would be permitted provided they pay a reasonable amount of money annually for their permission and to increase the Company's revenues.

224. Compendium from the daily annotations by Captain Pieter Boon on his voyage to Tamsuy and Quelang.
Quelang etc, 10 April-7 May 1644.
VOC 1148, fol. 300-309.
DRZ, II, pp. 256-263.

(On 6 May the headmen of eight villages situated near Tamsuy, who had earlier concluded a treaty with the Company drawn up by Johannes Lamotius, came to the fortress.[94] They were urged to observe the articles and rules as formulated in that treaty. The Compendium is followed by a very detailed interview with Theodore, inhabitant and headman of Kimaurij, who provided Boon with a list of all the villages around Quelang and Tamsuy with the names of the chiefs and the number of fighting men.)[95]

225. Missive Lieutenant Thomas Pedel and Junior Merchant Johannes van Keijssel to President Maximiliaen Lemaire.
Tamsuy, 10 May 1644.
VOC 1147, fol. 506-509. Extract.

fol. 508: [...] Om de landtsaten van dit gewest tot sodanighe jaerlijckse recognitie te brengen als die van costij nu twee jaeren achter den anderen aen de Compagnie betaelt hebben zal niet eerder mogelijck zijn voor en aleer door 't verdestrueren ende vernietigen van haere dorpen ende rijsvelden getempt zijn. Dus langh als voornemelijck voor drie dagen (al d'oudsten van d'omleggende dorpen hier ontboden zijnde, daer van maer eenige voor den cappiteyn sijn verscheenen die hier de meeste part in acht à tien maenden niet hebben willen comen) sijn daermede gedreyght. 't Welcke hun inbeelden en laten voorstaen (om dat soolange gedreyght) niet gemeent en wert doch nu hebben weder gelijck aen den veltoversten Lamotius en ons in meenich reysen hebben gedaen opnieuws veel toegeseyt ende belooft de Comp.ᵉ in alles te gehoorsamen. Sulcx schijnt

soo haest eenich vaertuych hier vernemen (door vreese van gemelten veltoverstens troupen veroorsaeckt) haer gewoonte te zijn, want deselve niet langer nacomen als den tijt dattet vaertuygh hier is. Dies UE. tegens Junij offt Julij een troupe herwaerts zeynden, vertrouwe tot devotie ende tegens toecomende jaer de recognitie sal connen ingevoert werden [...].

fol. 508: [...] It will not be possible to get the inhabitants of these parts to pay the same yearly tribute as the people in your region have already been paying the Company for the last two years until they have been tamed by destroying and ruining their villages and rice fields. They have long been thus threatened, and especially three days ago (all the principals of the neighbouring villages having been summoned here, of whom only a few actually appeared, most of them not having wanted to come for the last eight or ten months). But (because we have been threatening them for so long) they were convinced that we did not mean it. Now they have again made all kinds of promises, as they did to Field-Commander Lamotius and to us many times, and have undertaken to obey the Company in all respects. This seems to be their practice whenever they see a ship (out of fear caused by the troops of the field-commander), but they are only docile as long as the ship is here. Therefore, if Your Excellency would send some troops over here in June or July, we are confident that they will be obedient and that next year the tribute can be introduced. [...].

226. Missive President Maximiliaen Lemaire to Lieutenant Thomas Pedel.
Tayouan, 7 June 1644.
VOC 1147, fol. 499-504. Extracts.

fol. 501: [...] Met den Kimourier Theodore hebben gecontracteert, dat hij met sijn dorpsvolcq in Quelangh op strandt bij 't fort de Comp.ᵉ soo veel van de beste smeecoolen sal leveren als die jaarlijcx vorderen sal. In den prijs sijn niet wel eens. Den selven heefft voor thien van de neevensgaande opgehoopte tonnebalies geëyscht twee reaal van 8ᵉⁿ swaer gelt, dat hem gaarne wilden geven, dan gemerckt zij niet seecker wiste ofte daeraen behouden conde blijven, hebben 't aen sijn ondervindinge gerefereert aen 400 balien tot soodanigen prijs als die geven can, 't zij min ofte meer en can voor eerst ende tot naarder ordre geen quaet, meerder quantiteyt

begeerende sullen die tijdelijck genoech opeysschen. Omdat de tot noch toe becoomene coolen maar schelfferingen, ende nergens nae vande beste bevonden sijn, soo hebben hem onderwesen, 't welcq oock aengenomen heeft te doen, dat moet sien langs de cloven daar de coolen jegenwoordich in groeven ende mijne te comen, 't welcq met ons opinieeren met eenige steenen affte breecken genoechsaem als connen geschieden als wanneer gestadich goede ditos ende meerder quantiteyt te becomen sal sijn [...].

Wij blijven voornemens soo geen emportanter saeck ons sulcx beleth, van jegens 't uytgaan des zuydermoussons een compagnie soldaten ofte twee derwaerts te senden, om den Formosaen in dat gewest tot beter ordre ende gehoorsaemheyt als jegenwoordich zij te brengen, het daar voor houdende dat sonder exemplare straffe hunne beloffte nu tweemaels gedaen ende 't gene meer van haar begeeren weynich acht slaen sullen. [...]

fol. 503: [...] Op 't versoeck van vooraengetogen Theodoor hebben toegestaen dat de slechste soorte van de roode Chineese coraelen, in handen van den vendrich Jacob Baers, hem ende den fiscael met den eersten weder ter handt gestelt sullen werden. D'andere die bij hun de costelijckste geacht werden, als mede den jongen, sult tot naerder ordre in verseeckeringe houden, ende hun hoope geven dat met 't eyndigen van dit mousson ordre verwacht om de reste hun mede t'overhandigen.

Gemelten Theodoor hebben alhier geduyrent sijn aenwesen wel onthaalt, van 's Comp.^ies intentie costij nae vermogen wel onderricht, in 't Bevelhebberschap geconfirmeert, met een rottangh van ontsagh ende een roodt damaste cleet vereert, 't welcq alles danckbaerlijck onder beloffte van in alles de Comp.^e behoorelijcke gehoorsaemheyt te bewijsen geaccepteert heefft. Van gelijcken gaat hier nevens voor Don Lucas, 't welcq hem ter handt stellen cont ende van onsentwegen mits voors. gehoorsaemheyt beloovende, hem in sijn ampt confirmeeren, met gelegentheyt sullen denselven eens hier verwachten, [...].

fol. 501: [...] With Theodore from Kimaurij we concluded a contract that he with his people every year, upon our order, will deliver a quantity of excellent coals on the beach at Quelang near to our fortress. However we still disagree with him about the price. For ten barrels (the ones that are sent along) he asked two heavy reals of 8^th, which we are willing to pay him but, as we understood, they were not quite sure if they would be able to meet with that amount, we have left it to him to decide whether he can come up with four hundred tubs, be it a little more or a little less, for which we will pay him a price such as we are able to offer him, because

for the time being it can do no harm. If we want a larger quantity of coals, we will order them in time. Because the coals we did receive, turned out to be of a rather poor quality, and mostly slack, we instructed him to see whether he could search in the gorges where the coals are to be found in pits and mines. In our opinion, the coals can be mined quite easily by breaking off some larger stones. He responded that he was willing to do this, therefore we expect to receive a considerable amount coals of a better quality, in that way. [...].

We still intend, if no other more significant affair prevents us from doing so, to send at the end of the season of the southern monsoon, one or two companies of soldiers thither in order to subject the Formosans in that region to better order and obedience than they at present can be brought to. We do not expect they will comply with any request from us without exemplary punishment, the more so because they have already twice given us their promise to submit themselves to our authority. [...]

fol. 503: [...] Upon the request of the mentioned Theodoor, we have agreed that the poorest quality red Chinese beads, which happen to be in the hands of ensign Jacob Baers at the moment in Quelang, will be returned to him as well as to the fiscal on the first possible occasion, whereas the other beads, that happen to be the kind of beads most valued by the inhabitants, will be kept by you until you receive further instructions from us.[96] The same counts for the boy, who you will have to keep in your charge until further notice.[97] In the meantime you will have to give them hope that at the end of this monsoon season you will expect orders to also hand over the other beads to them.

We have treated the earlier mentioned Theodoor well during his presence over here and we have instructed him to the best of our ability about the Company's policy and intentions. We confirmed his position as a commander by presenting him with a cane as a symbol of his authority and a cloth of red damask, which he accepted with considerable gratitude, promising us that he will be obedient to the Company in everything. We sent you the same gifts intended for Don Lucas that you, on our behalf, can hand over to him, on condition that he will promise to be obedient. Subsequently you can confirm him in his office. When it suits him we will expect him to pay a visit to us in Tayouan in due time. [...].

227. Resolution, Tayouan, 14 June 1644.
VOC 1147, fol. 472.

fol. 472: [...] dat de saken eniger malfacteurs uyt Tavocan lange in hechtenis geseten ende onderwijle noch eenige andere Formosaense delinquanten van de Noordelijcke dorpen daerbij gecomen, item in Soulangh volgens het schrijven van den politijcq Sr. Cornelis Caesar noch verscheyden civijle saken af te handelen zijn; soo is mede verstaen op het voordragen van meer aengetogen heer President achtervolgende onse voordesen genomen resolutie dat men omme alles soo 't geen halssaecken bevonden werden finalijck aff te handelen ende ter executie te stellen naer Soulangh noch heden committeren sal den Ed. Pieter Anthonisz. Overtwater, den fiscael Adriaen van der Burgh, den cappiteyn Pieter Boon ende den eersten clercq Nicolaes Hornecker.

fol. 472: [...] that the cases of some malefactors from Tavocan, who for a long time have been in custody (while in the meantime some other Formosan delinquents originating from the Northern villages were added to them), still need to be settled. Moreover, according to what was written to us by political administrator Sr. Cornelis Caesar, in Soulang several civil cases still have to be concluded. Therefore, as proposed by the lord president, the Council confirm the resolution passed before and decided to delegate without delay the honourable Pieter Anthonisz. Overtwater, fiscal Adriaen van der Burgh, captain Pieter Boon and senior clerk Nicolaes Hornecker to Soulang in order to conclude everything completely, capital offences excluded.

228. Missive Ensign Hendrick Jacob Baers c.s. to President Maximiliaen Lemaire.
Quelang, 15 June 1644.
VOC 1147, fol. 510-511.

't Sedert den 10en may dat den cappiteyn Pieter Boon van Tamsuy met het jacht *Breskens* vertrocken is alhier niet sonderlinghs voorgevallen als dat de inwoonders van St. Jago den 20en boven voors. drie personen hier gestuert hebben om voor haer oudsten vrijgeley en consent te hebben om met mij te spreken wegens haere begane fauten die geschiet zijn bij den Ed. heer veltoversten Johannes la Motius ende den Ed. mayoor Hendrick Harousé. 't Welck ick haer luyden vrij hebbe geconsenteert om te comen

ende beloofft oock weder haerder straeten te laten gaen tot naeder ordre van UE. [Ick] hope niet dat UE. 't selve qualijck sal affnemen.

Ende alsoo sijn den 31en dito als boven verschenen van St. Jago twee oversten met acht particuliere personen, de namen van de twee overste sijn aldus op Christen genaempt Franciscus Marrisch ende Martijn Marrauguis. Ick hebbe haer luyden affgevraecht wat haer begeren was, welcke ten eersten antwoordt gaven: weder vrede ende alliantie met de Ed. Comp.e ende zij U Ed. begeren wilden doen. [Zij] wisten seer wel haere groove faulten die zij luyden bij den Ed. veltoversten ende ten tijde van den Ed. heer mayoor Hendrick Harouse hadden gedaen, doch begeerden genade, wilde alles naercomen dat U Ed. offte yemandt van U Ed. daertoe gestelt zijnde ten dienste van de Ed. Comp.e te gelasten heeft, alse maer in genaden mochten aengenomen werden. Ick hebbe haer luyden met alle ernst voorgehouden waerom als dan achterbleven doen den Ed. cappiteyn hier sijnde ende van U Ed. uytgestuyrt was, dat se voor hem niet quamen verschijnen. [Zij] antwoorden datse niet hadden derven comen vermidts sij luyden voor desen niet bij den mayoor Hendrick Harouse hadden geweest. Vorders vraechden waerom datse Bolij, sijnde overste van St. Jago niet met gebracht hadden. Sij antwoorden so Bolij vrij geley mochte hebben om hier te comen, sij daer nae toegaen souden om hem te halen, 't welcq zij deden.

Alsoo is Bolij met 12 oudsten op den 6en Junij alhier geweest, begerende genade, ick hebbe haerluyden beloofft 't selve U Ed. aen te dienen ende Bolij een cleen brieffken gegeven tot een waer teycken dat alhier om pardon is gecomen.

Bolij begeerden zijn rottingh weder die hij bij den Ed. heer veltoversten Johannes La Motius tijden weder gestiert hadden, welcke ick hem tot uytstel gestelt hebbe tot naerder ordre van Ued. offte het opperhooft dat Ued. ten eenigen tijden hier naer dese quartieren quame te stuyren ende dat zijn rottangh met de vlagge bij U Ed. in Tayouan was berustende.

Ick hebbe den oversten, te weten Bolij, met des Comp.es wapenen wel scherpelijck gedreyght, ingevalle hij tot enigen tijden 't sij wanneer dat 't oock mochte, eenigen last van U Ed. comen ende liet op ontbieden ten eersten moste comen verschijnen. Waerop hij zijn rottingh weder begeerde, 't selve met alle vlijt naer te comen. Hierop verwachte U Ed. ordre ende last. [...].

Since the 10th of May, when captain Pieter Boon departed from Tamsuy with the yacht *Breskens*, nothing unusual happened here except that on the 20th of the mentioned month some inhabitants from St. Jago sent three

persons to request us permission and safe-conduct for their headmen to come to this fortress to speak to me about the offences they have committed in the past, at the time when the Honourable lord Field-Commander Johannes La Motius and the Honourable major Hendrick Harroussé stayed in the north. I gave the elders my consent to come to see me and promised them that afterwards they can return freely to their settlements, until I receive further notice from Your Honour. I do hope Your Honour does not consider that I have acted rashly.

Also, that on the 31th of May, two headmen appeared from St. Jago accompanied by eight private persons. The two headmen are named in the Christian way: Franciscus Marrisch and Martijn Marrauguis. Upon my question as to the purpose of their visit, they replied that they again wanted to conclude peace with the Honourable Company and that they wanted to comply with everything Your Honour desired. They said that they were aware of the bad mistakes the people of St. Jago had committed during the presence of the Honourable field-commander and the Honourable lord Major Hendrick Harrousé but that now they begged for mercy. They confirmed that they really wanted to observe everything Your Honour, or any person appointed by Your Honour to exercise supervision over them, wanted them to do in service of the Honourable Company, if only they could be restored to favour. Thereupon, in all seriousness, I confronted those people with the question of why they stayed behind when the Honourable captain was sent here on behalf of Your Honour, instead of appearing before him. They replied that they had not dared to come because they had not met with major Hendrick Harrousé before. I also asked them why they had not brought Bolij, the chief of St. Jago, along. They told me that as soon as Bolij is assured safe-conduct from me they would go to their village to collect him. They then set out to pick him up.

Eventually Bolij, accompanied by twelve elders, arrived here on the 6th of June. Upon their request for forgiveness I promised them that I would make a petition to Your Honour on their behalf, so proving that he did come here to appeal for pardon, I presented Bolij with a short note.

Bolij desired to again receive his cane, that had been presented to him by the Honourable lord Field-Commander Johannes Lamotius in person, but I told him to be patient because we had to await further orders from Your Honour, or from the commander who might at any time be sent over to

this area, and that in any case his cane and flag were kept by Your Honour at the castle in Tayouan.

I did threaten this chief Bolij that the Company would raise up arms against St. Jago at any time if he and his people do not immediately meet with any order he receives from Your Honour, or obey any summons to appear. He thereupon asked again for his cane, [promising that] he diligently will observe any order. We do expect to receive Your Honour's opinion and orders about this matter. [...].

229. Missive Corporal Cornelis van der Linden to President Maximiliaen Lemaire.
Pimaba, undated [June 1644].
VOC 1147, fol. 511-513.

[...] So gelieve U Ed. te weten hoe dat alhier tusschen den 8 ende 9en Junij ontrent middernacht eene groten brandt is aengesteken van d'inwoonders waer van het gehele dorp op vier huysen nae, die een weynich in de bambousen stonden, tot de gront toe is affgebrandt. Dan en connen noch niet weten van wie het gedaen is. Waer onder 's Comp.s logiement mede is verbrandt, soo dat ick alhier grote schade aen 's Comp.es goederen daerdoor hebbe geleden so van den brandt alsmede van de Pimers die een parthije daervan gestolen hebben. Wat aengaet des Comp.es goederen die hier na den brandt noch bevonden zijn, gaet in desen de memorie daervan. Voorders van mijn ofte mijn volcq en hebben oock weynich offte niet daervan behouden, alsoo wij genen tijt hadden, want den brandt in 't vaeste huys van des Comp.es logiement gesteken was ende ondertusschen dat wij met het boscruyt doende waren, om 't selve te versorgen. Dat wel bewaert was voor schade, also ick vreesde dat het selve mede in den brant mochte raken ende dat door den slaech yemandt van de inwoonders mochte verongelucken, als wanneer het met ons niet wel en soude hebben gegaen. So is des Comp.es logiement soo haestich in den brandt geraeckt dat wij qualijck tijt hadden om ons ende des Comp.es goederen, die wij metterhaest noch uyt den brandt ruckten, want ick selve noch so lange in 't huys was dat mijn volck de sporten van 't venster mosten stucken houwen om daer buyten te geraeken, want mij den brandt so na was dat ick uyt de deur niet conde geraken. Ende ondertusschen dat ick in 's Comp.es logiement doende was, so is den brandt oock in 't packhuys geraeckt waerin ick 's Comp.es vellen ende padiebergh, waerbij een cleynen thoren stont daerop ick mijn cantoor met mijn pampieren hadde,

also ick doende was met schrijven om een man met mijn dachregister op te stuyren. 't Welck door (fol. 512) haestheyt des viers alle verbrandt is, ende alle de padie die ick van de Ed. Comp. hebbe genoten ende aen de cant van 190 elandtshuyden, die ick alhier weer getrocquen hadde waeronder 39 stucx waren die ick op den 28 April alhier berustende gehouden hadde. Aengaende d'inwoonders en hebben ons gantsch geen adsistentie gedaen in den brandt, maer hebben ter contrarie ons wel een partheye goet ontstolen, waeronder een canasser was daer in ick alle de coralen ende de witte cangans in hadde gedaen, alsmede noch een deel andere goederen die een persoon op den naem uyt den brandt te dragen naer Reduts packhuys maer ginck daermede een ander wech. Alhoewel daer een soldaet bij was die mede een dracht goet hadde doch en conde hem niet achterhalen, sodat ick niet te recht kan schrijven wat verbrandt ofte gestolen is. Oock soo sijnder een parthije pannen gestolen, waervan ick een deel weer bekomen hebbe. Ende naer dien ick haer grote dieverie bemerckte, so soude ick vermoeden dat het nergens om gedaen is dan om eenich goet van ons te hebben. Want hier alreets vreemde praetgiens gaen, also ick den jongen Josias uyt hadde gestuyrt op den 10en deser om water te doen halen, so verhaelde hij mijn in presentie van mijn bijhebbende volcq hoe dat hem van een man gevraecht was off hij den brandt in 's Comp.es logiement gesteken hadde. Waerop den jongen hem antwoorde, so den brandt van hem gecomen waer hoe dat het dan quam dat het andere huys eerst soo veer verbrant ende van daer in ons huys gecomen was. Waerop den voorseyden Pimer hadde geantwoordt, dat het waer was dat den brant van 't ander huys in 't onse was gecomen. Ende vorder, so seyt den jongen, dat den voorseyden met een lachende mont soude hebben geseyt dat de Pimaer gaerne den slach van 't boscruyt hadden gehoort. Waeruyt wel staet te sustineeren waer vandaen ons dit ongeluck is gecomen want d'Pimers, jonck noch out, niet meer mentie van den brandt en maeckte dan off daer een bos stro waer verbrandt geworden. Aengaende de pannen die noch behouden zijn, hebben alle in den brandt geweest sodat daer weynich goets meer aen is, oock waeren der al een deel van gestolen die ick met behulp van den regent weder gecregen hebbe. Vorders belooft den regent te zullen vernemen nae 't geen daer noch meer gestolen is, 't welcq hij beloofft alle weder te beschicken soo haest hem mogelijck is, want hij seyt vier à vijff verspieders uyt te hebben die overal na vernemen.

[...] Op den 26en april soo hebbe ick hier een briefken gekregen van de soldaet Isaecq Sepmans waerin hij anders niet schrijfft als dat zijn (fol. 513) order streckt om te reysen tot Tawalij. Op den 28en dito, soo ben ick met

twee soldaeten nae Calonet gegaen om den soldaet Jan Jansz. Emandus volgens de Ed. heer sijn ordre in 't dorp Calonet te brengen om aldaer de Perreyouanse spraeck te leren ende zijn dien avont in Tipol gecomen. Den 29en dito zijn voort gemarchieert naer Tawalij alwaer op den middach sijn gecomen ende hem Sougan sijne faulten doen voorhouden wegens drie hoofden die zij op den lesten meert van 't dorp Orkoudien hadden gehaelt tegens d'ordre van d'Ed. President al hoewel sij voordesen ter contrarie wel goede beloften hadden gedaen dat niet meer souden oorlogen voor dat d'Ed. heer 't selve souden belasten. Maer vragen niet veel daerna off ick haer wat segh off niet, waer op ick haer heb voorgehouden wat haer in toecomende wellicht daervoor mocht overcomen, maer lachen daerom, waerop ick hebbe stilgeswegen. Den 30en dito sijn voortgegaen nae Batsibal alwaer ick den nacht hebbe gerust. Den 31en sijn gegaen na Calonet ende sijn ontrent den avont aldaer gecomen alwaer rottingh ende bambousen claer waren om 't huys te maken. Den oversten May Hebucq verstaen als dat een Hollander in Barboras was die daer vellen reulden, waer op ick een brieff naer Barboras heb geschreeven om te weeten wat zijn doen daer mocht wesen. Vorders so heb ick het erff laten slechten om des Comp.es logiement op te stellen. Den 2en dito so sijn oock hier gecomen enige inwoonders van de hier ontrent gelegen dorpen, die mede quamen om te arbeyden. Ontrent den avondt so heb ick weder bescheyt gecregen van Isaack Sepmans die mij schrijft dat hij door ordre van de Ed. heer President ten dienst van Dirck Segerman was uytgestuyrt.

[...] Your Honour will have to know that over here, on the evening of the 8th to the 9th of June, at about midnight, a large fire was started deliberately by one or some of the inhabitants. As a result the complete village burnt down, except for four houses that stood a little apart in the midst of a grove of bamboos. Unfortunately we do not know anything yet about the perpetrator. Because the Company's lodge was also lost in the fire, and also because the people of Pimaba stole a lot, I suffered a great loss from the Company's merchandise. Herewith I send you a list of those commodities that remained undamaged after the fire. Very few of my own belongings, or those of my people could be saved. Because the fire was started in the permanent Company's house we hardly had time to secure anything as we were busy moving the gunpowder. We managed to save it, because I very much feared that it might catch fire and the resulting explosion would kill some of the villagers (if that had happened then things would have looked bad for us). The Company's lodging house

caught fire so rapidly that we hardly had time to hurriedly pull ourselves
and some Company goods out of the fire. For myself, I remained so long
in the house that my men had to hack away the bars out of the window so
that I could still escape through it as I could no longer pass through the
door since the blaze had come too close. As I was busy in the Company's
lodging, the warehouse, in which I stored all the Company's deerskins as
well as the heap of paddy, also caught fire, as well as the little tower that
stood next to it in which I had my office and in which my papers were
kept. I had just been busy finishing my journal, so that in time it could be
delivered to Your Honour, but because (fol. 512) of the suddenness of the
spread of fire everything was destroyed. The same goes for all the paddy
I received from the Honourable Company, as well as about 190 elk skins
that I already had managed to barter from the inhabitants (including 39
pieces that were deposited here already on 28 April). The inhabitants of
Pimaba did not render any assistance to us during the fire. On the
contrary, they managed to steal some merchandise, including a basket in
which I kept all the beads and the white *cangans* as well as some other
commodities that I myself ordered to be carried to safety to regent
Redout's storehouse by a certain person who went elsewhere, in spite of
being accompanied by a soldier who was carrying some goods as well,
but who was unable to catch up with him. Consequently I am not able to
write down with certainty what was lost in the fire and what was stolen.
Also a set of pans was stolen, of which I got back a part. After I
discovered the considerable theft these people of Pimaba had committed
during the fire, I suspect them to having started this fire for the sole
purpose of obtaining some commodities from us. The more so because
there were rumours of this. On the 10th of June I sent out the servant boy
Josias to fetch water, who afterwards, in the presence of my men, told me
that a certain man of Pimaba had asked him if it was he who started the
fire in the Company's lodging house. To which the boy had replied that if
he was the one who had committed arson, how would it be possible that
the other house was almost burnt down first before our house caught fire.
Whereupon the mentioned Pimaba man had answered that it was true that
the flames had spread from the other house to ours. The boy said, that
this man thereupon said laughingly that the Pimaba people would have
loved to hear the explosion of the gunpowder. From this it becomes
rather clear whom we have to thank for this disaster. The more so

because the people of Pimaba, neither young nor old, mentioned the fire again, as if only a bundle of straw had been burned in the fire. As for the pans that were saved, they have all been in the fire, so they are no longer good. Some were stolen, but I have retrieved these through the help of the regent. Furthermore the regent promised to search for the other stolen goods and that he will see to it that everything is returned to us as quickly as possible. He told me that he had sent out four or five spies to find out about everything. [...]

On the 26th April I received a note from soldier Isaacq Sepmans in which he wrote nothing more than that he was ordered (fol. 513) to travel to Tawaly. Thus according to your orders I went on 28 April, with two soldiers to Calingit in order to accompany the soldier Jan Jansz. Emandus to the village of Calingit, where he will be stationed with the purpose of mastering the Perreyouan language. That same evening we reached Tipol from where we marched on to Tawaly and where we arrived in the afternoon of the 29th. In Tawaly we confronted [headman] Sougan with the offences he had committed: three heads had been captured on the last day of March in the village of Orkoudien against the orders of the Honourable president, whom they had promised not to wage war anymore against any village without having received strict orders from himself to do so. They hardly responded to my words, whereupon I informed them what in the future might happen to them if they continued to behave so disobediently. To this they only laughed a bit, and I kept silent. On the 30th April we went on to Batsibal were I spent the night. On the 31st we went on to Calingit and arrived there at about evening time. In Calingit we found canes and bamboo poles ready for the construction of the Company's house. From headman May Hebucq we learned that there was a Dutchman staying at that moment in Borboras who was bartering deerskins with the inhabitants. Whereupon I sent a letter to Borboras as to find out who this Dutchman might be and what he was doing over there.[98] Furthermore I had a plot cleared so that the Company's lodging house could be built on that site. On the second of May some people from the surrounding settlements arrived in the village. They came to assist us with the construction work. In the evening I received a message from Isaack Sepmans [in Borboras], who wrote to me that he had been sent out upon the Honourable president's orders to assist Dirck Segerman.

230. Missive Lieutenant Thomas Pedel c.s. to President Maximiliaen Lemaire.
Tamsuy, 4 July 1644.
VOC 1147, fol. 513-520. Extract.

fol. 517: [...] t Zedert het vertreck van den capiteyn Boon is den schrick onder de Tamsuyers sodanich ontstaen en door Don Lucas ten principalen bewerckt den voorneemsten bevelhebber der reviere, genaempt Gommon, welck twe malen met de Comp.^e verbondt heeft gemaeckt ende nu 't sedert 10 maenden daer weynich op gepast had, ons op den 20^{en} passato drie dagen langh andermael tot een nieuw verbont te maecken heeft versocht met presentatie van 1494 reaal van achten in couralen, tot teken van zijn getrouwheyt (als sijn vorige gebroke beloften maer mochten vergeven zijn), in versekering te geven, nae dat sulcx drie dagen langh (vermidts op 't ontbieden van gemelten cappiteyn hier niet gecomen was) affgeseyt hadden. [Wij] sijn, vermidts 't geheel Tamsuy nae hem luysterde en hier geen andere aparentie was om de recognitie in te voeren, provisioneel tot U Ed. approbatie in vrundtschap getreden, latende ons gemelte couralen als per nevengaende memorie haer lieden getaxeert, onder conditie dat hem voortaen naer behooren comporteren sou, ende anders doende met verlies van zijn leven aen de Comp.^e te vervallen, waer mede het so veer brachten dat van de presente maent geheel Tamsuy belooft heefft de recognitie in vellen gelijcq costij gebruyckelijck is aen de Comp.^e te voldoen. Ten welcken eynde de nevensgaende memorie hebbe gemaeckt wat dorpen de Comp.^e voor haer protectiën erkennen. Item hoeveel huysen der in, wat spraeck men spreeckt, insgelijcx de zielen ende waer gelegen zijn. Schoon dit jaer alles soo niet ten eersten volgen zal, so sal echter wel connen bespeurt werden off de gedane belofften ten goede is geschiet.

Theodore, die hem de reyse van costij seer bedanckt, so haest in Quelangh sal gecomen zijn, als den vaendrager Jacob Baers diesaengaende aenschrijve, sal datelijck insgelijcx den fiscael de couraelen becomen en het kool graven bij de handt nemen, so dat U Ed. met d'eerste gelegentheyt (also denselven insgelijcx voor den smith hier mede noch een weynich gerecommandeert hebben) een monster ende hoe alles insgelijcken met Don Lucas, die U Ed. seer doet bedancken, succedeert te verwachten heeft.

Gemelten Theodore wert de recognitie dewijl door U Ed. (so hij seyt daerover hem niet gerecommandeert is) tot U Ed. naerder ordre niet gevoordert. Die van St. Jago comen dagelijcx door vrese gedrongen om vrientschap te maken, doch nademael het redelijck is eerst tot recognitie

verstaen, blijven tot der tijt sulcx beloven en blijck van doen onbevredicht. Insgelijcx d'inwoonders van Cabalan ende van de reviere Lamcan die niet eer voor aleer gelijck U Ed. voornemens is, tegen 't uytgaen van dese mousson met de macht die U Ed. believe te zeynden daertoe te brengen zijn. Want soo veer met deselve gecomen is, doch voornamentlijck die van Lamcan dat d'inwoonders die door de Comp.ᵉ bevredicht zijn (fol. 518) sonder verlies van hun leven daer niet comen mogen. [...]

Den sergiandt Reynier Ibels, van Groningen ende Monica van La Mey, dienstbode van den luytenandt, welck met den anderen begerich sijn inden houwelijcken staet te treden versoecken derhalven een ider in 't bijsonder dat UE. het gelieve te abbroberen en dat sij den naesten daer in mochten bevesticht werden.

fol. 517: [...] Since the departure of the captain Boon the inhabitants of the Tamsuy region are living in great fear. Don Lucas managed to get the principal headmen of that area, named Gommon, who has already concluded an alliance with the Company on two occasions but who, for a period of ten months, did not seem to care much about it, although recently, on the 20th of June, for three days in a row he requested conclusion of a new agreement with the Company. Moreover he wanted to entrust to us his beads valued at 1494 reals of 8th as a sign of his loyalty (if only his former broken promises could be pardoned). For three days we rejected his offer, because he had not appeared when he was summoned up by captain Boon. However, finally we accepted his proposal because all inhabitants throughout the Tamsuy area listen to him and because there is no other opportunity to introduce the taxes and get the people to pay them. Thus we agreed to provisionally conclude a treaty of friendship with him until we receive Your Honour's approbation for it. He left us the mentioned beads that were estimated by them as you can see from the memorandum included in this letter, on the condition that from now on he would behave himself in accordance with the agreement.[99] We warned him that if he should fail to do so he surely would be risking his life. As a result within the present month of July all the Tamsuy villages have promised to pay the taxes to the Company by means of deerskins as is the custom in Tayouan. The included memorandum was drawn up especially to register those villages that do recognise the Company to be their protector, as well as how many houses they contain, what languages the people speak, how many souls are living

in them and where they are situated.[100] Although not everything may be accomplished this year, the agreement will enable us to find out if the promises that have been made will be carried out properly.

Ensign Jacob Baers writes that Theodore, who thanks him very much for his trip to Tayouan will, as soon as he has arrived in Quelang, see to it that the fiscal will receive the beads. Subsequently he will start with the coal mining, so that Your Honour can expect a sample to be sent to you on the first possible occasion (as we have recommended him as well as the smith again to be a little quicker). You can therefore expect that a sample will be sent to you, delivered by Don Lucas, who also expresses his gratitude to Your Honour.

The mentioned Theodore will not immediately have to pay the taxes, until further notice from Your Honour because he says that you have not ordered him to do so. Those of St. Jago come to us daily in fear asking for peace with the Company; yet because it is reasonable that they first agree on payment of taxes [before we accept them to conclude an alliance with us], we told them that until they promise us to do so we will not allow them to become pacified with the Company. Likewise we shall deal with the inhabitants of Cavalangh and the Lamcan area, who can only be brought to pay after the end of the present monsoon season, when, according to Your Honours' intentions, they will be visited by our troops. The situation has deteriorated so much that they (and principally those from Lamcan) do not tolerate any of the inhabitants that have already been pacified with the Company, to enter their territory, (fol. 518) without risking their lives. [...]

Sergeant Reynier Ibels, from Groningen, and Monica van La Mey, servant girl of Lieutenant Pedel, both desire to get married. Therefore each of them do request that Your Honour kindly give them your approval so that they can soon enter into matrimony.

231. Dagregister Zeelandia 20 March-11 August 1644.
VOC 1148, fol. 281-351.
DRZ, II, pp. 237-300. Summary.

(On 21 June substitute political administrator Joost van Bergen returned in Tayouan from an expedition to the villages of Tevorang, Tarroquan, Liwangh and the mountains situated to the northeast of Sincan. On 6 May

he reached Tevorang and learned that 25 pagan priestesses were still practising their idolatry. The people of Liwangh proved to be willing to provide the Company with a yearly tribute and requested if some Dutch and Chinese could come to live in their village. In that village the lower part of their houses was built of stone, while the upper part was constructed of wood with a straw roof. On 11 May Van Bergen reached Kannekanevo which was appeased with Talipangalangh as well as with the villages Nackanwangh (or Great Tackapul) and Tapangh. On the 15th, before he returned to Tayouan, he visited the settlements Wangh, Tivora and Apaswangh and managed to appease them with their neighbours. On 24 May the ruler of Lonckjouw's son appeared before the Council of Zeelandia Castle. He very humbly requested peace in his father's name who due to his indisposition was not able to come himself. This was granted to him on condition that all the articles as they were formulated at the Land Day would be obeyed by the ruler and his people. Furthermore the peace treaty could only be concluded at the castle on the condition that his father would come over himself. Likewise the ruler's brother Caroboangh, chief of Catsiley, a village of about 60 houses situated at about 1½ days journey south of Pangsoya, paid a visit to Tayouan to subject himself to the Company. He was presented with a silver mounted cane.)

232. Resolutions, Tayouan 11 August-14 November 1644.
VOC 1148, fol. 212-255. Resolution, 22 August 1644.

fol. 214: [...] Conform d'advijsen op 15en Januarij verleden, door den President ende Raad des eylandts Formosa, [...] aen d'Ed. heer Generaal geschreven, namentlijck haer voornemen om d'inhabitanten, onse subjecten, omtrent Quelangh ende Tamsuy wegens gepleechde ongehoorsaemheyt te sullen straffen, soo wanneer de cruyssende joncken van de Manilha weder gekeert waeren ende van de vrunden in Tamsuy hun advijs diesaengaende becomen souden hebben, ende dat de gelegentheyt sulcx toelatende, met een aensienelijcke crijschmacht, ten eynde niet alleen voors. inhabitanten maar oock de geheele landtstreecke van Cabilang ende van besuyden Tamsuy tot Dorenap onder onse gehoorsaemheyt te brengen [...]; doch alsoo 't de gelegentheyt van vaartuygh etc. 't selve tot noch toe niet heeft willen lijden, ende d'advijsen uyt Tamsuy jongst becomen resumerende, ondervinden dat geen goet ende

bondich redres in dat considerable gewest sonder macht ende wapenen en sullen erlangen, soo geeft den Gouverneur François Caron den raat in bedencken: Dewijle nu present van goeden nomber, namentlijck naar gedanen overslagh, van 650 soldaten als derselver officieren versien sijn, ende eenen bequamen tijt voorhanden hebben, off men niet en behoorde een goet gedeelte derselver eerstdaechs naer Tamsuy te schicken, soo omme de dorpen die onder Tamsuy geroert ende Quelangh sorteeren, die hun te voren onder den Nederlandtsen staedt begeven hadden ende wederom affgevallen sijn, andermaal met de wapenen tot hun devoir te reduceeren, alsmede die van de vermaerde landtstreecke van Cabilang, bestaende in veertig dorpen, met de Comp.^e te bevreedigen ofte door de wapenen t'onser devotie te dwingen, ende des verricht hebbende dat gissen in 't begin van 't noorder mousson sal wesen, wijder den wech van Tamsuy over landt naar Tayouan te openen, ende over de seven Lamcanse dorpen ende noch 15 à 16 dito andere die onder den grootvorst Quataongh sorteeren, herwaerts comen, omme deselve in 't deurtrecken door 't respect der wapenen mede tot des Comp.^es subjectie te brengen. [...]

fol. 216: Simon van Lamey die de Comp.^e nu omtrent ... jaren iverlijck met wassen etc. gedient heefft, wert op het voordragen van den Ed. Lemaire bij desen in 's Comp.^es dienst als derselver wasser toegeleyt een tractement van negen gulden ter maandt, ingaande van dato deser.

fol. 214: [...] Conform the proposals of the President and Council of Formosa, [...], written on 15^th of January last to the Honourable lord Governor-General: that they intended to punish the inhabitants of the northern region around Quelang and Tamsuy, their subjects, for their disobedience, as soon as the junks sent out to cruise for Spanish vessels in the Manila waters had returned and after the proper instructions about this matter had been received from the garrison stationed in Tamsuy. Weather conditions permitting they planned to send a considerable force thither with the intention not only of subjecting the mentioned northern inhabitants but to also subject the entire region of Cavalangh as well as the area south of Tamsuy to Dorenap to the Company's authority. However because we had not enough vessels etc. to carry out the expedition and because it is understood from the advice received from Tamsuy in the meantime, that not much can be accomplished over there in that vast region without a considerable, well armed force, Governor François Caron has asked the Council to consider the following: on account of the recent change of personnel, the Formosa garrison at that

moment is provided with a sufficient number of 650 soldiers together with their officers, furthermore the right season is drawing near, should we not send a sufficient number of men to Tamsuy to again force into submission those villages situated in the Tamsuy and Quelang area, who had subjected themselves to the Dutch State but who afterwards had abandoned the alliance. Also the forty villages situated in the notorious Cabilang area can thus be pacified by the Company, if necessary by the use of force. Once this has been accomplished it will most likely be the start of the northern monsoon season. Then on the way back the expedition army may open up the route from Tamsuy all the way to Tayouan, and subjugate, while passing through, the seven Lamcan villages as well as the fifteen or sixteen other villages belonging to the grand-ruler Quataongh by the show of arms.

fol. 215: [...] *(Consequently the Governor and Council resolved to send 300 men, divided into four companies of soldiers to the north before the month of September. The army would be commanded by captain Pieter Boon and by senior helmsman Simon Cornelissen.)*

fol. 216: Simon of Lamey who has diligently served the Company for about ... years, is recommended by the Honourable former president Lemaire to enter into the Company's service as laundry man on a monthly wage pay of nine guilders effective as from the present date.

233. Instruction from Governor François Caron for Captain Pieter Boon, Commander of the expedition force, sailing to the north with the yachts *Leeuwerick*, *Kievith*, *Breskens*, *Haringh*, the galliot *Hasewint*, the junks *Uytrecht* and *Brack*.
Tayouan, 5 September 1644.
VOC 1147, fol. 438-442. Extracts.

> fol. 438: En gesien wij sedert de conqueste van Quelangh ende 't besetten van 't fort Antonio in Tamsuy om de noort doorgaens vernoomen hebben, dat 't meerendeel van de vassale dorpen aen dien cant contrarie haere beloften aen den Ed. Lamotius ende Harousé gedaen, op onse insinuatie noyt, ofte maer heel weynich, nu jongst uyt vrese van daerover gestraft te werden, aen onse fortressen hebben geweest, nochte voorders soodanige gehoorsaemheyt de Comp.ᵉ bewesen als 't wel betaemde, ende wij harenthalven te besten verhoopt hadden. Soo is om daerinne na behooren te versien, ende te verhoeden dat niet geheel in rebbellie en vervallen, als

om de resterende Noordelijcke dorpen onder den Nederlandtsen staet te reduceeren, ende ons van de landstreke besuyden gemelte Tamsuy tot aen Dorenap ende beoosten Quelangh tot aen St. Laurens Baey volcoomen meester te maecken, den 22^{en} augustij passado in raden van Formosa, ten aensien nu van bastante navale macht, officieren ende soldaten rijckelijck versien sijn, geresolveert, een chrijghsmacht van 300 cloecke soldaten in vier compagnieen verdeelt onder 't beleyt ende gesagh van den Capiteyn Pieter Boon, met den eersten ende soo haest 's Comp.ˢ constitutie sulcx toe wilde laten, derwaerts af te steken, [...]

fol. 438: Alle jachten, joncken ende vaertuygen in Quelangh met lieff gearriveert ende bij den anderen gecomen sijnde, sult aldaer op 't gene tot de te doene tocht acht van noode te wesen ordre stellen, alles volcomen claer maken, ende U Ed. van soodanige persoonen uyt de Quelangh als Tamsuyse dorpen tot guides ende tolcken dienen, als bevinden sult nodich te hebben, ende van daer gelijckelijck met goeden wint ende hantsaem weder den noortoosthoeck van Formosa omsteken naer de bocht van Cabelaen loopen ende aldaer, des doenelijck sijnde, datelijck met de gantsche chrijchsmacht ende den treyn landen, om ons desseyn in vougen als volcht in 't werck te stellen. Edoch wint ende weder ofte 't aenrollen des zees sulcx niet willende gedoogen, sult UE. met de geheele vloot na St. Laurens Bay begeven, leggende ongeveer drie mijlen besuyden vooraengetogen bocht, ende aldaer bequaem weder ingewacht hebbende, sulcx alsdan met de behoorlijcke seeckerheyt soecken te doen.

Met de gantsche chrijghsmacht ter bequamer plaetse gelant wesende, sult met deselve UE. landewaert in omtrent hare dorpen, ofte ergens op een ander segoure plaetse, na te rade wert begrepen, ende d'outste van alle de veertigh Cabalaensche dorpen, binnen soo geruymen tijt dat bequamelijck verschijnen connen, voor UE. doen citeren. Gecomen sijnde haer in 't aensien van onse gewapende, ende in ordre gestelde chrijghsmacht uyt onse name aenseggen, hoe dat van 't gantsche lant van Formosa heere sijn, ende alle ingesetenen (excepto eenige weynige quaetwilligen, die t'sijnder tijt straffen sullen) ons volcomen gehoorsaemheyt bewijsen. Alleen dat door ongelegentheyt vande lantstreke ofte bocht van Cabelaen, hun tot noch toe noyt volcomen onder ons hebben gesubmitteert. Welcken volgende om haer hiertoe te reduceeren, met de presente macht van ons uytgeseth bent, dogh geenen last en hebt, nochte oock gesint sijt de wapenen tegens haer te gebruycken, voor ende aleer de vrundelijcke aenbiedinge van vreede ende dat ons nevens d'andere Formosanen niet gehoorsamen willen, nochte de jaerlijckse erkentenisse opbrengen verwerpen, dat derhalven spoedich hebben t'overleggen waertoe gesint

sijn, op dat weten moght, wat UE. voorder met haer te doen staet, waertoe om hun wel te mogen beraden gaerne bequamen tijt vergunnen cunt.

Tot resolutie gecomen wesende sult de geene die hun vrijwillich onsen staet onderwerpen vrundelijck bejegenen, naer de gelegentheyt carresseren, haere resolutie lauderen ende aendienen dat jegens hare vijanden bij ons voortaen sullen gemaintineert werden, maer dat gehouden sullen sijn, soo vredige possessie ende welvaren willen blijven behouden, dat oprechte gehoorsaemheyt ooc in al 't geen de Comp.ᵉ haer sal comen te gelasten, nevens d'inwoonders van gantsch Formosa te bewijsen, geene Nederlanderen beleedigen nochte eenigen oorlogh buyten onse kennisse jegens yemant aenemen, ende jaerlijcx hare recognitie bestaende voor yder huysgesin in: twee stucx elandtshuyden ofte vier stucx hertevellen cabessa ofte acht stucx dito barigos ofte 16 stucks ditos pees, naer een yder gelegen' comt te geven, op dien tijt die dan tesamen beramen cont aen onse fortresse in Quelangh te brengen hebben. Ende om proeve van hare belofte te nemen, dat noch voor 't vertreck van daer het teecken van gehoorsaemheyt (soo dat door ons bij den Formosaen steets genaemt wert) sullen moeten opbrengen, ofte dat UE. sich anders van hare getrouwicheyt niet ten rechtern cont versekeren. Waerin alsoo 't de eerste reyse, en dit volck noch gantsch teer is, discretelijck gaen, ende vrij wat deur de vingeren sien sult, haer insinuerende sulcx het aenstaende jaer moeten verbeteren, als wanneer ons oock te meer verbonden sullen vinden, haer jegens alle moetwil te hanthaven, en te bevrijden.

Alle d'andere dorpen der gemelter lantstreeck die haer door 't wel voorgaen hunner gebuyren, ende vrundelijcke noodinge niet en begeren onder onsen staet te begeven, maer halsterck blijven en sulcx verwerpen, sult met de wapenen ten exempel van anderen daertoe sien te brengen ende haer den oorloge op 't rigoreuste aendoen, dootslaende ende vernietigende alles dat in de wapenen vint ende tegenweer biet, haere huysen, thuynen ende graenvelden tot den gront toe afbranden ende verdestrueren, sonder yets dat boven d'aerde is te verschonen. (fol. 439) Edoch soo UE. begrijpen cont, daermede ons vergenougen sullen dat met het ernstich straffen van één der moetwillichste dorpen d'andere tot subjectie te brengen souden sijn, cont 't selve tot een preuve en eer voorder gaet ondernemen ende aen die van Kakitatapan berucht voor bittere vijanden van onse bevreedighde dorpen aen dien kant, ofte wel een ander recht schuldige plaets in 't werck stellen sich daerin gedragende na gelegentheyt van tijt, ende loop van saken, [...]

UE. saken in vougen voors. ofte wel soodanich te rade geworden sijt, verricht hebbende, sult naer alvoren de bevelhebbers van de Cabalaense als andere dorpen die hun tot onser subjecten begeven hebben, de behoorlijcke gehoorsaemheyt aen onsen staet, en dat alle voorgestelde poincten voortaen wel hebben t'observeren als de vredigen ommegangh onder den anderen serieuselijck hebbende gerecommandeert, de militaire persoonen, ende den treyn wederom [...] doen embarqueren, ende van daer te vertrecken. [...]

UE. sult in 't gaen naer ofte keeren van Cabelan met den Rhaet de rebellie als andere faulten van de St. Jagers etc. behoorlijck examineren ende hun naer de gewichtigheyt van dien, 't sij dan ofte met de wapenen de gantsche gemeente, ofte de voornaemste roervincken bij forme van justitie, ofte van twee à drie dubbele recognitie in vellen door de gemeente datelijck ende noch voor UE. vertreck op te brengen ofte wel op een ander manier, nadat gesamentlijck te rade moget werden straffen, ende hun wanneer vertreckt, op de hoogste indignatie insinueren dat haer hebben te wachten van in soodanige faulten weder te vervallen. Prefereeren wanneer begrijpen cunt 's Compagnies daermede bestevent wert, soo in desen als anderen diergelijcken voorvallen doorgaens, de sachste voor de straff bemiddelen, excuserende 't bloetstorten, in sonderheyt van vrouwen, kinderen als anderen weerlose mensen. [...]

(Capitein Boon kreeg opdracht om met zijn manschappen naar Tamsuy en Quelang te gaan om vervolgens:) [...] op den bequaamsten tijt, ende met soo veel soldaten als tot uytvoeringe van dat desseyn bevint te vereyschen, over lant door de Lamcansche ende Quataonghsche dorpen herwaerts keeren. [...]

fol. 440: Hoedanich ende wat cours in 't doortrecken van de gemelte dorpen, ende 't herwaerts comen tot Dorenap te houden hebt, en connen (alsoo in dat gewest onervaren sijn) niet pertinentelijck aenwijsen. UE. sich costij daervan door lantsaten dier kennisse van hebben moeten laten informeren, ende den rechten wegh, die buyten twijfel langhs de dorpen en door de vermaertste plaetsen van 't lant loopt, sien te becomen, [...].

UE. hebben dan allen debvoiren [...] in 't werck te stellen om de dorpen van Lamcan die men secht seven in getalle, ende groote vijanden onser subjecten omtrent Tamsuy te sijn, als oock mede de 15 à 18 dorpen, die onder den Quataongh sorteren, 't sij met minne ofte gewelt na UE. de gelegentheyt aenwijst onder onse gehoorsaemheyt ende haar, eer van daer scheyt, de recognitie boven aengewesen te doen opbrengen, met geloften van daer jaerlijcx in te moeten continueren. Gebruyckende in allen voorvallen soodanigen voorsichticheyt, dat de Comp.ᵉ hare intentie die

UE. ten vollen bekent is erlanght ende nevens de chrijchsmacht doorgaens buyten merckelijcke perijculen moght blijven, niemant vertrouwende maer naest Godt de Heere, op uwe wapenen ende voorsichticheyt steunende. Willende in 't alderminsten daeraen niet twijffelen, ofte dese voyagie van Tamsuy suydewaert aen tot Dorenap ofte Betgilim toe, sal gevoughelijck in tien à twaalf dagen ende omtrent halff november naer onse calculatie connen volbracht sijn.

Alle Chineesen die op dese tocht, soo in de Cabalaense Bocht, Quelangh, Tamsuy ende van daer herwaerts, doch insonderheyt in de Lamcanse, Quataonghse ende Dorenapse dorpen comt te bejegenen, dat veele roovers sijn, sult in UE. gewelt sien te becomen, ende ons die gevangen toebrengen, oftewel soo weerstand bieden, ende den noot sulcx medebrenght, inde furie dootslaen, alsoo sij de gene sijn die de inwoonders aen die cant jegens ons in oorloge opruyen, ende roofgaten tot verachteringe vande negotie als andere goede saecken, vande Formosaense havenen maken, met troupen meermaels op onse subjecten besuyden van haer gelegen, gelijck UE. kennelijck is, aengevallen sijn, ende haere dorpen verbrant hebben. Welcken volgende oock met goedt recht als vijanden behoorden getracteert ende van daer gedreven te werden, want het seecker ende gewis sij na ons meenichvuldige exempelen geleert hebben, dat soolange den Chinees onder den Formosaen verkeert wij nooyt rechte deech met haer hebben sullen, welcken volgende tot ruste onser onderdanen voornementlijck in gemelte Dorenap dienen uytgeroeyt, ende dat roofnest gestoort, [...]

Om over te treden tot andere saken die in 't vervolgh deses noch te seggen hebben, een besluyt onser desseynen te maecken, ende UE. onse ende des Ed. heer Generaels maxime over de Formosaense gelegentheyt naeckter voor oogen te stellen, soo sullen UE. sijne Ed.[ts] eygen woorden, [...] voorstellen, luydende als volght: 'in alles wat van dese lieden met vrundelijckheyt, reden ende billickheyt te becomen sij, sal rigeur ende strafheyt geexcuseert worden, doorgaens wel lettende van ongeregelt volck geen overlast comen te lijden, opdat van ons niet afkeerich werden. Geeft hun behoirlijcke liberteyt wanneer hare lasten, ende recognitie in padi, vellen etc.[a], daerop gestelt sijn, contribueren. De wrevelmoedige ende die hun tegen onse ordonnantie opposeren, dienen door vrundelijcke aenmaninge, ende inductie tot haer devoir gebracht, ende dat alles niet helpende, moeten met de wapenen gestraft werden, ende totalijck uytgeroeyt werden, opdat andere hun daeraen spiegelen, sonder deselve op haer versoeck (gelijck to nu toe gedaen is) in genade aen te nemen, ende hare faulten mits cleene boeten betalen, te vergeven, 't welck wel tot

quaetdoen ende afval verwerckt heeft, wetende op hun aenhouden van de
misdaden perdon becomen'.

fol. 441: [...] Om op den voyagie UE. daervan bij voorvallende
gelegentheyt te mogen dienen, gaen onder andere eenige cramerije, ende
cangans mede daer UE. sich naer behooren, soo tot ververschinge,
schenkagie als anders can van dienen. [...].

fol. 438: On 22nd August it was resolved in the Formosa Council that we
should send an army as soon as possible to the region situated to the south
of Tamsuy as far as Dorenap, and eastward of Quelang to St. Laurens
Bay. We are presently in a position to dispose of a considerable naval
force, as well as quite a number of officers and soldiers. This decision
was taken by the Council because we have heard that since the conquest
of Quelang and the occupation of the fortress Antonio in Tamsuy in the
north the majority of the allied villages have not kept the promises they
made to the Honourable Lamotius and Harroussé. In this respect they
have never, or at least very rarely, come to our fortresses when we
notified them to do so. In fact they came only recently out of fear of
punishment. Additionally, they have failed to show proper obedience to
the Company as we hoped they would.

For these reasons and to prevent them from indulging in rebellion, and
also to reduce the remaining Northern villages to submission to the Dutch
state and, as already mentioned above, in order to entirely take possession
of the region south of Tamsuy as far as Dorenap, and eastward of
Quelang to St. Laurens Bay, we should send an army of 300 able-bodied
soldiers, divided into four companies, and under the command of captain
Pieter Boon. [...]

fol. 438:[101] When all yachts, junks and vessels, God willing, have safely
arrived and gathered in Quelang, you will have to see to it that everything
you consider to be necessary for the imminent expedition is completely
settled and prepared. You will also employ such persons originating from
the Quelang and Tamsuy villages to serve as guides and interpreters as
you think necessary. Subsequently, when the wind is right and the
weather is fair, you will again sail round the north-eastern tip of
Formosa, enter the Bight of Cavalangh and, if possible, land there at once
with the entire army and the train, in order to carry out everything
according to the plan in the following way. However if wind and weather
are contrary or if heavy seas are running so that it is impossible to carry

this out, Your Honour will have to continue with the entire fleet to St. Laurens Bay, situated at about three miles south of the mentioned bight, and await the right weather over there, whereupon you can still undertake the following with the necessary security: When you have been disembarked with the entire army at the proper landing spot, you will march inland with your men. There, after having consulted one another, you will establish yourself at some safe place near their settlements or some other place, and summon the headmen of all the forty Cabalang villages to appear all together within a reasonable time span before Your Honour. Once they have arrived before our entire force standing in line and carrying arms, you will have to announce to them on our behalf that the Company has taken possession of the whole island of Formosa and that all the natives (except for some rebels who, in due time, will receive their just punishment) are now showing complete obedience to us. However, as the region of the Bight of Cavalangh is situated at such a remote location, the inhabitants have not yet submitted themselves entirely to the Company. Subsequently you will have to notify them that the army has been sent out by us especially to reduce their villages to submission, and that they should not fear that we will raise up arms against them if they offer us peace in a friendly way. However if they, unlike the other Formosans, refuse to obey, or wish to refuse to pay us the yearly tribute, then you will have to tell them that they should quickly make up their minds and come up with their precise intentions, so that Your Honour will know how to deal with them. You may allow them some time for consideration.

When they have reached a decision you should treat those who subject themselves voluntarily to our state with kindness, you should caress them as it suits you, laud them for their wise resolution and make them understand that in the future the Company will protect them against their enemies. Tell them also that if they wish to maintain secure possessions and prosperity they should be aware that they will have to show sincere obedience and be of use to the Company whenever they are ordered to. Like the inhabitants of the whole of Formosa, they should never affront any Dutchmen, nor start any warfare without having informed the Company first. Moreover they will have to pay tribute annually, which for every household amounts to: two elk-skins or four deerskins *cabessa*, or eight *bariga*, or sixteen ditto *pee*, as suits everyone best, which may be

delivered at a time that you agree together, at the fortress in Quelang. Consequently as a proof of their promise, they will have to present before your departure the sign of obedience as we always call this [tribute] while dealing with the Formosans, otherwise Your Honour will not be able to learn with certainty about their loyalty. Because this is the first time for these people and, as a matter of fact because relations with them are still rather delicate, we have to deal with them in a very tactful way. Therefore, every now and then you will have to turn a blind eye to them and tell them that we expect them to improve their behaviour next year, when we also will be bound further to protect them against all danger.

All the other villages of the mentioned region, who refuse to listen to our friendly invitations to ally themselves with our state, and refuse to follow the good example of their neighbours and who remain obstinate and choose to turn our offer down, you should reduce by means of force, as a warning to others. You will have to wage war against them in the most rigourous way, beating to death and destroying whoever raises up arms against you or opposes you. You have to destroy all their houses, gardens and wheat fields, burning everything down to the ground, and leave nothing standing above ground. (fol. 439) However, as Your Honour can understand we prefer such severe punishment to be given to one of the most spiteful villages, in order to move the other neighbouring villages to subject themselves. By means of a test, before you continue to use violence, you can undertake action against those of Kakitatapan, notorious for being mortal enemies of those of our pacified villages situated over on that side of Formosa, or any other truly rebellious village. For that matter, you will have to execute these matters as time and circumstances indicate. [...]

When everything has been executed in the mentioned way or in some other way, Your Honour will – after having recommended all the headmen of the Cavalangh, as well as the other villages in that region, who have subjected themselves to pay due obedience to our state and promise that they will observe the proposed articles and treat each other peacefully – let the military men as well as the army train embark and leave from there. [...]

Your Honour together with your Council will, either on the way to or on the return from Cavalangh, see to it that the rebellion as well as the offences committed by the people from St. Jago etc. will thoroughly be

examined and afterwards, as to the seriousness of the transgression, be punished by force of arms either against the whole community or by bringing to justice the most notorious agitators. However you can indicate to them that they can be pardoned if the community will agree to pay at once before your departure two or three times the tribute in deerskins, or any other way of penalty that you together in the Council will consider a fit retribution for the offences they have committed in the past. Furthermore you will have to ensure that you will make them understand upon your departure that the Company will be utterly outraged if they ever lapse again into similar errors. We prefer it if you yourself will understand that the Company in the end will benefit the most if these people are punished in the mildest possible way, refraining from bloodshed especially as far as the women, children and the defenceless people are concerned. [...]

(Captain Boon then was ordered to visit Tamsuy and Quelang and prepare himself and his men:) in order to pay, when the time is right, a visit to the Lamcan and the Quataongh villages on the return with as many soldiers as are required to carry out the plan. [...]

fol. 440: What direction you will have to take in passing through the mentioned villages and in coming over to Dorenap, we are not able to inform you about as we are not yet acquainted with that region. Therefore Your Honour will have to find out about it there from the inhabitants and see to it that you find a straight and passable route that will undoubtedly pass through the major places in that area. [...].

Your Honour will have to employ all possible means as the circumstances require [...] in order to subject into our obedience the villages of Lamcan, either by making use of force or in a non-violent way. Moreover, before your departure from there, you will have to make sure that each family has paid you the tribute, the same amount as mentioned above, and that they have given you the promise to continue to do so every year. Lamcan, it is said, consists of seven settlements. It is also said that the Lamcan villagers are sworn enemies of our subjects living in the region of Tamsuy as well as of the inhabitants of the fifteen or eighteen villages that belong to the Quataongh. On your way you should be very careful in all circumstances, because it is the Company's intention, as you know, to generally keep the expedition force out of considerable troubles. Therefore you will trust no one but hope for support of the Lord, your

arms and prudence. We have no doubt that this expedition from Tamsuy to the south as far as Dorenap or Betgielim, will take about ten or twelve days so that, according to our calculations, the journey will be completed half way through November.

Any Chinese you might encounter during this expedition, in the Bight of Cavalangh, Quelang, Tamsuy, and from there southward, including the Lamcan, Quataongh as well as the Dorenap villages, will mostly be pirates, Your Honour will try to round them up with force and send them over to us as captives. However, if they offer resistance, and if it is necessary, they may be beaten to death in the heat of the fight, because they are the ones that incite the people of those parts of the island against us. Moreover they turn the bays and natural harbours of Formosa into robbers' dens, much to the disadvantage of commercial as well as other interests. Those Chinese robbers, as Your Honour must be aware, have several times come in groups and attacked and burned down the villages of our subjects living in the area south of where they are hiding. They can be rightfully treated as enemies and need to be driven away from there, as many examples have taught us we can be positively sure that as long as Chinese are to be found in the villages of the Formosans, we can never completely trust them. It is clear that, in order to restore the peace among our subjects, especially in the mentioned village of Dorenap, the robbers' den has to be rooted out. [...]

Coming to other affairs that need to be mentioned in the continuation of these instructions in order to conclude our plans, as to call Your Honour's attention to the Honourable Governor-Generals' maxim about the affairs of Formosa's indigenous peoples, we present you the following written in his own words: 'whatever can be obtained from these people with friendliness, reason and fairness, may be done without strictness and severity, while as a rule an eye must always be kept that no irregulars from the Company forces will cause any trouble to the inhabitants as this can turn them away from Company. Moreover, you will give them a reasonable freedom when they do contribute the required tributes in paddy, deerskins etc. However those who oppose our orders and behave resentfully, at first need to be reminded of their obligations in a friendly way and persuaded to do their duty. When all that is of no avail, we have to punish them by taking up arms against them as to extirpate these rebels completely, so that the severity of our action will serve as a deterrent to

others, without providing them with a possibility to, upon their request, restore them again to grace. It used to be the custom that we pardoned their offences when they were willing to pay a small fine. This often caused them to do more evil and also lead to desertion as they knew perfectly well that their insisting eventually resulted in the forgiveness of their crimes'.

fol. 441: [...] Your Honour will receive some merchandise and *cangans* to take along on the expedition to the north, that occasionally may serve you, either as refreshment for your men, by means of presents or otherwise. [...].

234. Resolution, Tayouan, 6 September 1644.
VOC 1148, fol. 225-226.

fol. 225: Het schrifftelijck advijs des Kercken-raadts op het begeren van den Gouverneur ende Raadt affgevordert namentlijck hoe verre de macht der politicque ende oock der schoolmeesters ende geestelijcke residenten wegens de schoolen d'een den anderen voortaen souden hebben te comen ende hun te gedragen; item wien dat eygentlijck 't gesach, de censure ende straffe soo over de schoolmeesters als kerckelijcke persoonen competeert, in rade geresumeert ende g'examineert wesende ende den predicanten wijder mondelinge daarop naerder gehoort hebbende, in manieren dat haeren voorslach met onse meeninge achtervolgende het Sinodia Naetsionael, in den jaere 1619 tot Dordrecht gehouden, niet verscheelt maar volcomentlijck compt te accorderen, soo is gearresteert ende geapprobeert eerstelijck: Dat den Kerckenraad alle kerckelijcke personen naar haar verdiensten sullen vermogen van haer ampt aff te setten, suspendeeren, censureren ende wijder alsulcke persoonen den Achtbaaren Raadt van Justitie met haar advijs, in wat straffe behoorde gecondempneert te werden, overleveren omme bij den wereltlijcken rechten naar discretie ende goetvinden bij sententie gemulcteert te werden.

Ten tweeden dat alle scholieren t'eenemael onder 't gesach van de kranckbesoeckers ende residenten die als schoolmeesters in de Formosaense schoolen gebruyckt werden, blijven sullen, sonder dat d'selve door den politicus (dan bij hooch dringenden noot, voorweten ende toestaen der voors. residenten) in eenige diensten sullen vermogen gebruyckt te werden, wel verstaande soodanige scholieren die 't haar beurt sal sijn dier tijt ter schoolen te comen, blijvende niet te min d'andere

persoonen die 't haar beurt om in de schoolen te comen niet zij, onder 't commandement van den politicus.

Ten derden ende ten laetsten, soo wert mede verstaen, achtervolgende des kerckenraadts advijs, dat (fol. 226) de inlandtsche bevelhebberen gantsch geen gesach sullen hebben over 't licentieeren der persoonen uyt der schoolen; vermits veele noch heydenen sijn die hun aen de voorderinge van Godes kercke weynich gelegen laten, doch om redenen wert dit poinct den Sincanderen, dat wel de outste vroomste ende religeuste landtsaten sijn, bij provisie ende tot onse ordre noch toegestaen omme daer op naarder gedelibereert te werden. [...].

fol. 225: The written advice of the church council, demanded by the Governor and council of Tayouan, on to what extent the authority of the political administrators, the schoolteachers and clerical delegates is related in connection with the schools and how they should deal with each other, was summarized and examined in the Council. Also examined was the question of who will excercise the actual power and the censorship, and who will determine the punishments for the schoolteachers as well as for the clerical delegates. After we had listened further to what the church ministers had to say about it, we learned that their opinion hardly differed from ours, and that it was completely in common agreement with the propositions of the National Synod of the Dutch Reformed Church, held in Dordrecht in the year 1619. It was therefore decided and approved in the Council that the church council would initially exercise the authority to discharge from office, to suspend and to censor all clerical persons according to their merit, as well as to turn in persons to the Honourable council of Justice in order to be condemned by a secular judge, with the advice of what punishment should be inflicted on the offender.

Secondly, that all pupils come under the authority of cathechists and [Dutch] residents, who serve as teachers in the Formosan schools. Therefore they, (except when compelled by necessity, with the knowledge and at the intercession of the residents) will not be allowed to be used for any kind of services. This only counts for those pupils whose turn it is to come to the schools at that time. However those who are not due to visit the schools come under the command of the political administrator.

Thirdly and finally it is also understood that according to the church council's advice

(fol. 226) the indigenous headmen will not excercise any authority over discharging pupils from the schools, because many of the headmen still happen to be heathens who do not care about the progress of the church of God. However, for various reasons, this point does not apply to the people of Sincan, who happen to be the oldest and most pious and religious Christians on the island. To them it is provisionally still allowed to discuss this matter until further notice. [...].

235. Resolution, Tayouan, 9 September 1644.
VOC 1148, fol. 230-231.

fol. 230: Alsoo seeckeren Chinees genaampt Tiotouwa, woonachtich in Tavocan, eenen geruymen tijt met een inlandtsche Christen vrouwe, als man ende vrouw huysgehouden heeft ende oock selffs mede genegen is (alhoewel redelijck bedaecht zij) sich in de fondamenten der Christelijcke religie te laten onderwijsen, om in gevolge oock door het H. sacrament des doops als een Christen bevesticht te werden, soo is op het advijs van den Kerckenraadt bij den Gouverneur ende den Raadt g'arresteert dat men om voors. consideratiën denselven bij voors. vrouwe in voegen als voren sal laeten continueren, mits dat belijdenisse gedaen hebbende, deselve wettelijcq sal moeten trouwen. Ten welcken eynde voors. Chinees oocq onder 't gesach van den Kerckenraad ende voornaementlijck van den predicant die het opsicht in Tavocan heeft, sal gestelt, om (als gesecht) in de fondamenten van de ware religie geinstrueert te werden.

Insgelijcx dat alle Chinesen die met diergelijcke inlantsche Christen vrouwen (als verhaalt) huyshouwen, gelijck er noch wel eenige van die nature te vinden sijn, tusschen dit ende het uytgaen deses op het begin des aenstaanden jaers, gehouden sullen wesen aan den Kerckenraadt contentement wegens het Christen gelove te geven, off dat bij faulte van dien, van geseyde vrouwen scheyden, ende kinderen daerbij geprocreeert hebbende, voor d'selve middelen tot onderhout fournieren sullen.

Ende alsoo der noch veele bejaerde persoonen sijn die van wederzijden (man ende vrouw) noch heydenen wesende, met den anderen huyshouden ende seer beswaerlijck inde Christelijcke religie connen onderwesen werden, soo wert verstaen dat d'sulcke bij den anderen sullen vermogen te blijven, ende door den politijcque resident in den houwelijcken staet bevesticht werden, mits haar de gelegentheyt van de trouw-bandt, soo veele doenlijck inscherpen. Waarinne oock besloten worden soodanige

heydense persoonen die naderhant daerom mogen (fol. 231) versoecken, ende noch niet bij den anderen sijn, met den anderen te versamen.

Alsoo het getal der inlandtsche schoolmeesters op Formosa groot ende 54 sterck sijn, die alle maandelijcx maer een reaal van achten van de Comp.[ie] tot onderhoudt trecken waarvan niet wel en connen leven, ende oversulcx genootsaeckt sijn hun den meesten tijt met de jacht en landtbouw tot onderhout van hun leven te generen, sulcx nootsaeckelijck volcht daar door de schoolen niet naer behooren van deselve connen gedient werden; soo is mede g'arresteert dat men het voors. getal van 54 op 17 verminderen, en deselve wegen de Comp.[ie] vier realen contant (behalven den rijs die haar de inwoonderen, ider in 't dorp daer se dienst doen tot erkentenisse van dat goede wercq (voor soo veele tot hun behoefte van node hebben geven ende versorgen moeten), ter handt stellen sal. Waar mede geoordeelt wert dat hun daer voren rijckelijck sullen onderhouden ende beter op de schoolen sal connen gepast werden, alsoo wij hier mede verstaen dat voors. schoolmeesters hun met geen andere besongie, egeene uytgesondert, als alleene met hunne schoolen sullen te bemoeyen hebben. [...].

fol. 230: It was decided that the Chinese named Tiotouwa, domiciled in Tavocan, will be allowed to continue living as husband to the native Christian woman with whom he has been living for a considerable time. This decision was reached after careful consideration by the governor and council on the advice of the church council which confirms that the man concerned, although already quite elderly, is willing to learn the principles of the Christian religion and eventually to be converted to Christianity. The man's continued cohabitation with this woman will depend on his being confirmed in the Christian faith and contracting a lawful marriage. To this end the Chinese in question will be placed under the supervision of the church council and, in particular, in charge of the minister of Tavocan for the necessary instruction. Likewise, all Chinese living with Christian women – and there are indeed a good many – will have to inform the church council whether they are willing to be converted to Christianity. This information must be supplied to the necessary authority between now and the beginning of next year when the decision becomes effective. Anyone not willing to be converted to Christianity will be ordered to leave his wife, but will continue to be held responsible for the support of his children.

And because so many aged people are still to be found who, living together, both (man and woman) remain pagans and can hardly be taught the principles of the Christian religion, it was agreed to allow them to remain together if only they will be confirmed in the married state by the political administrator, on the condition that they will be made to understand as well as possible the meaning of the marriage-bond. Afterwards, it may be decided whether pagan persons who are not yet married, but who (fol. 231) request to have their bond recognized, will be allowed to continue living together.

Considering the large number of indigenous schoolteachers on Formosa - no less than 54 in total, who all receive one real of 8th a month from the Company for their maintenance, which is not a sufficient living wage, so that they are forced from necessity to occupy themselves most of their time in hunting and farming. This means they are not able to properly serve the schools, it was decided to reduce their former number of 54 to 17, and to pay these men four reals a month in cash (apart from the rice which the inhabitants of the village in which they are stationed as schoolteachers will give them in gratitude for their good work, in sofar as they are in need of it). It is our opinion that these teachers will thus be able to support themselves well and will take better care of the schools because they do not have to become involved in anything other than the business of their schools. [...].

236. Dagregister Governor François Caron on his voyage from Batavia to Tayouan, with the ships *Vrede*, *Swarten Beer*, the galliot *Hasewint* and the pilot boat.
Tayouan, 25 July -15 November 1644.
VOC 1148, fol. 140-211.
DRZ, II, pp. 301-357. Summary.

(On 11 October catechist Gerrit Jansz Hartgringh returned to the castle from Tapouliangh and reported that the inhabitants of Tarkavas had beaten to death two men from Potlong who had come to invite them to join them on the journey to Tayouan. Hartgringh informed the council that earlier, the headmen of Potlongh, together with those of Talasuy, Varangit and Pijnas had gone to Netne in order to go to Tayouan to subject themselves to the Company. Even those of Tarkavas and Poltij

intended to do the same if they could cross the river. Unfortunately before they had managed to carry out their intentions, one of the chiefs of Netne had become ill and consequently they had postponed their journey. In the meantime their former hostile feelings had flared up again with the above mentioned murder and other hostilities as a result.)

237. Dagregister by Commander Captain Pieter Boon of the expedition to the north via Tamsuy and Quelang to the Bight of Cabalan and the districts of Lancam and Quataongh.
7 September-15 November 1644.
VOC 1148, fol. 192-205.
See also DRZ, II, pp. 337-351.

238. Missive Captain Pieter Boon to Governor François Caron.
Tamsuy, 12 October 1644.
VOC 1147, fol. 447-452.

fol. 447: Den 6en september passato van costij gescheyden sijnde, arriveerden den 10en daeraenvolgende in Quelangh alwaer de gansche macht bij den anderen vonden. Blijvende aldaer noch drije dagen leggen om ons tot d'aenstaende tocht volcomen claer te maecken, [...] onderwijlen ons mede versiende van soodanige Kimauresche ende Tamsuysche inwoonderen als oordeelden op geseyde tocht tot vertolckinge en andersints van nooden te sijn.

Den 13en dito sonden den schipper Sijmon Cornelissen met de joncq *Utrecht* vooruyt naer de Bocht van Cabelan omme t'ondersoecken off ergens een bequame plaetse was alwaer met ons volcq gevouchlijck souden connen landen ende vorders naer de gelegentheyt dier volckeren ende hoedanich deselve geresolveert waren te vernemen, tot welcken eynde eenige Kimauresen met hem vertrocken.

Des anderen daechs sijn met de gansche macht gevolcht ende den 16en dito in voors. Bocht comende, dede voors. Sijmon Cornelisse geen seyn (waeruyt verstonden dat geen bequame plaetse om te landen gevonden hadde) maer stelden sijnen cours nevens ons naer St. Laurens Bay alwaer wij dien avont binnen quamen.

Gemelte Sijmon Cornelisse rapporteerden ons mede vernomen te hebben dat veele inwoonders naest de strandt wonende, uyt vreese van onse comste met alle hunne goederen, vrouwen ende kinderen landtwaert in gevlucht waren. Daeromme wij terstont eenige Kimaureesen derwaerts

sonden, omme hun t'insinueren en aen te dienen dat onse meninge niet en was, nochte tot dien eynde gecomen waren, om hun te ruyneeren offte te verderven, maer veeleer hun de vreede ende onse vrundelijcke correspondentie aen te bieden, niet anders als getrouwe gehoorsaemheyt, gelijck ons van meest alle Formosanen bewesen wiert. Van hun begerende mits dat teecken van dien jaerlijcx den cleene recognitie in vellen ofte andersins sullen moeten opbrengen. Alle die soodanich gesint waren soude niet een hair van haren hoofden gekrenckt veelmin van haere goederen berooft ofte andersints mishandelt maer ter contrarie tegens alle haere vijanden beschermt werden, mochten derhalven vrijelijck tot ons comen ende onse vordere meninge ofte naerdere verclaringe aenhooren. Maer die hun onse gehoorsaemheyt niet en wilden onderwerpen, nochte de jaerlijcxe recognitie opbrengen hun halsstarrich tegens onse vrundelijcke aenbiedinge, waeren gesint soodanich met de wapenen te tasten ende te straffen, dat anderen hun daeraen spygelen mochten.

Wij [...] sijn den 18en dito 's middachs omtrent 12 uuren (alsoo wij naer 't laegste water om aen de buyten sijde van een cleyn steyl geberchte langs de strant ende over de clippen te connen comen) naer voors. Cabalanse dorpen gemarcheert, comende tegens den avont omtrent ten vijf uiren voor een dorp genaemt Parissinawan, alwaer ons d'inwoonders eenige huysen tot corps du garden als anders om in te logieren maeckten. Onderwegen quamen ons de oversten van voors. dorp alsmede die van Cleen Mondamar ende Talebeauan (die onse meninge van de vooruyt gesondene Kimaureesen verstaen hadden ende daermede wel vergenoecht schenen te wesen), met veel volcx te gemoet, ende om hun gediensticheyt te bethoonen brachten eenigen bambousen met vers water 't welck aen 't volck te drincken gaven.

Voor gemelte dorp hebben twee dagen stil gelegen in welcken tijt bij ons op d'ontbiedinge verscheenen sijn d'oppersten ende volckeren van twaelff dorpen, die wij soo in't generael als perticulier d'oorsaecke (fol. 448) van onse comste in voegen als ons bij instructie gerecommandeert ende voorgeschreeven wert punctuelijck ende largo hebben voorgestelt, de welcke sulcx gewillichlijck aennaemen ende belooffden t'onderhouden, maer versochten dat hunne jaerlijcxe recognitie in rijs, namentlijck ider huysgesin twee sacxkens in plaets van vellen, mochten voldoen alsoo bij hun weynich gejaecht wert ende selffs de vellen van 't volck die in ende omtrent het geberchte woonen ruylen moeten. 't Welck hun toestonden vertrouwende dat se de Compagnie soo wel met den rijs als de vellen gedient sal sijn ende van de datelijcke opbrenginge der voors. erkentenisse excuseerden hun meest alle dat het nu in haeren principalen oegst ofte

sneydinge ende insamelinge van den rijs, mitsgaders haeren marnas ofte viertijt was, sijnde 't selve bij hun eene afgodische superstitie, werdende twee mael 's jaers (te weten in de saeytijt ende maytijt) onderhouden dat als dan ende geduerende voors. tijt in geen andre dorpen comen, veel min eenige goederen uyt brengen, nochte dulden dat andere in haere dorpen comen offte goederen daer brengen, gelooven anders dat het hun in dat jaer qualijck gaen ende den oegst niet succederen soude, doch beloofden alle, soo ras den oegst over ende hun marnas uyt was, voors. recognitie aen de fortresse in Quelangh te brengen ende sulcx jaerlijcx te continueeren, waerinne volgens UE. ordre discretelijck gegaen hebben.

Maer die van de dorpen Sochel Sochel ende Kakitapan en hebben onse aenbiedinge ende insinuatie spottelijcken veracht, cloppende op hunne hielen ende seyden dat naer de Hollanders niet en vraeghden ende deselve wel gaerne sien wilden, wij mochten vrij aencomen, sij waren sterck genoech om ons te wederstaen etc. Daeromme wij ons op den 21en dito naer voors. Sochel Sochel met de crijchsmacht transporteerden doch door den reegen mosten in 't visschers dorpjen, genaempt Cleen Moudamas leggende aen de strant op de reviere Kriouan dien dach ende nacht bleven leggen. Maer quamen des anderen daechs naer de middach in voors. Sochel Sochel, stekende 't selve terstont inden brandt, sijnde hunne achterhuysen meest vol rijs ende padie, doch in 't doortrecken van eenige nauwe paden aen weder sijden met lanck riet ende ruychte hebben de schelmen twee van ons volck doot geschooten ende drie à vier gequetst, comende uyt de ruyghte d'onse onversiens ende eer sulcx gewaer wierden op 't lijff, doch namen ter stont weder de vlucht. Ende op 't velt dicht aen hun dorp verthoonden hun wel veele om tegenweer te bieden maer daer onder met eenige musquettiers gesargieert sijnde, gingen terstont door ende twijffelen niet off daer sijn verscheyden van haer gesneuvelt. Dese selvigen nachts hielden ons in 't velt voor 't voors. dorp ende lieten goede wacht houden om niet overvallen te werden ende volgenden daechs 's morgens verbranden ende ruyneerden vorders al wat den daech te vooren overgebleeven was ende vertrocken weder van daer naer Kakitapan met intentie om 't selve noch dien daech mede soodanich als voors. Sochel Sochel aen te tasten ende te vernielen. Doch door den langen ende moeyelijcken wech overviel ons den avont ende namen daeromme onsen cours naer Talabeauan, leggende niet verre van de strant ende omtrent ... mijlen van St. Laurens Bay alwaer wij 's nachts logeerden, bevindende aen die luyden reedelijcke gediensticheyt ende goeden wille.

's Morgens den 24en dito verstaen hebbende dat voors Kakitapan een cleen dorp ende niet boven 80 huysgesinnen sterck was, achten onnodich met de

gansche macht derwaerts te trecken, maer commandeerden hondert cloecke musquettiers onder 't beleyt van twee luytenants, een vaendrich ende drie sargiants om 't geseyde dorp, gelijck vooren te verdestrueeren ende afftebranden, 't welck sij ijverlijck hebben verricht ende alles tot den grondt toe vernielt, de meeste huysen vol rijs ende padie sijnde omtrent 130 huysen groot, sulcx dat dese distructie bij de dorpen al vrij veel smarten sal. Ondertusschen vertrocken met de resteerende macht langhs de strant alwaer de voors. uytgesonden partije bij ons comende (fol. 449) marchieerden weder naer onse eerste legerplaets voor Parrisinawan.

In 't uyttrecken van voors. Talebeauan quamen bij ons d'opperhoofden van de acht noordelijcxte dorpen der Cabalaensche Bocht hunne onse gehoorsaemheyt mede gelijck de anderen gewillichlijck onderwerpende met belofte dat soo ras den oegst ende hun marnas (waerop hun mede excuseerden) over was de recognitie van rijs (dat hun mede beter gelegen compt) aen de fortressen ende opperhoofden in Quelangh souden leveren ende sulcx jaerlijcx continueeren.

Voor meer geseyde Parisinawan wederomme vier dagen stil leggende, hebben die voors. inwoonders mitsgaders die van Talebeauan, Moudamar, Kginoudus, Mabolauw ende Tachauan, 't welcq meest cleene dorpjens sijn hunne recognitie in rijs aen ons opgebracht daervan parthije bij de soldaten ende Chineesen gegeten ende geconsumeert ende 't resteerende, sijnde 400 sacxkens in 't jacht de *Leeuwrick* gescheept is.

Ondertusschen sijn noch thien dorps opperhooffden bij ons verscheenen met onderwerpinge ende beloften als vooren, doch hun al mede van de datelijcke opbringinge der recognitie op hunne oegst ende marnas excuseerende. Sulcx dat in 't geheel bij ons sijn geweest ende hun onder den stant ende gehoorsaemheyt van de Comp.ᵉ met belofte vande jaerlijcxe recognitie getrouwelijck te betalen gesubmiteert hebben dartich als per de nevens gaende memorie te sien is. Resteeren noch veerthien dorpen de Bocht ofte landwaerts in naer 't geberchte geleegen die niet bij ons verscheenen sijn, hun als vooren op de oegst ende marnas excuseerende. Doch hebben ons door andre hunne naebuerige volckeren laten weten ende aenseggen dat mede bereyt sijn, neffens alle de andere dorpen onder onse gehoorsaemheyt te submitteeren ende de jaerlijcxe erkentenisse in Quelangh te voldoen.

Ende dewijle ons door UE. bij instructie gerecommandeert wert de sachste voor de straffste middelen te prefereeren ende met dit volck vermits noch vrij teer sijn ende dit de eerste reyse is, vrij wat door de vingeren te sien, oock dat in desen tijt den regen begint toe te nemen ende 't landt vol waters wert sulcx dat bij ons niet heel veel offte sonderlingh soude connen

uytgerecht werden, hebben geresolveert voor dees tijt geen meerder hostiliteyt offe straffinge te gebruycken maer ons (naer andermale vermaninge van schuldige gehoorsaemheyt ende naercominge van gedane beloften vergenoecht te houden. [...]

fol. 450: De wederspannige ongehoorsaemheyt van de St. Jagers hebben t'onser eerste aencomste in Quelangh behoorlijck geexamineert ende bevonden deselve wel sware straffen waerdich te sijn. Doch aenmerckende haere ootmoedige biddinge, schultkennisse ende hartelijcke intercessie om wederom in genaden opgenomen te mogen werden met groote beloften van hun voortaen van diergelijcke fauten te wachten ende t'allen tijden als getrouwe onderdaenen oprechte gehoorsaemheyt te bewijsen, hebbende hun tot een straffe ende amende opgeleyt een drije dubbelde recognitie, 't zij in vellen, rijs ofte andersints binnen den tijt van 10 à 12 dagen ende voor ons wederkeeren van Cabalan in Quelangh te betalen, ofte bij foute van dien, souden haer met de wapenen op 't rigoureuste aentasten ende t'eenenmael ruineeren 't welck sij om de straffe te ontgaen gewillich aennamen ende hebben oock binnen voors. tijt de gestelde boete opgebracht ende bovendien voor de recognitie van dit jaer betaelt 132 stucx elandthuyden ende 30 sacxkens rijs, 't welck UE. met 't jacht de *Leeuwrick* toecompt, waermede hun voor ditmael hebben quijt gescholden met expresse waerschouwinge soo haer naer desen wederomme tegens de Comp.[e] opposeerden de gewisse langh gedreychde straffe niet ontgaen en souden, daervoor hun wachten conden. [...]

Naer dat wij vorders in Quelangh [...], ordre gestelt hadden, sijn selffs in persoon den 5[en] deser vandaer binnen door de reviere aff naer Tamsuy vertrocken comende des selvigen daegs inde voornacht aen 't fort Anthonio.

De Tamsuysche dorpen om de Noort om de riviere gelegen bethoonen jegenwoordich reedelijcke gehoorsaemheyt, doch niet soo volcomen als 't wel behoorden, dat vertrouwen metter tijt beteren sal. Oock is alhier aen 't fort voor d'eerste reyse bij ons verscheenen d'overste van Baragoutsack (sijnde een reedelijck groot dorp omtrent een daech reysens zuytwaerts van hier gelegen), den vreede ende onse vrundelijcke correspondentie neffens anderen te mogen genieten. Versoeckende met submissie van onse gehoorsaemheyt ende beloften vande jaerlijcxe recognitie op te brengen die daer toe (naer verclaringe van UE. ordre ende vermaninge dat sulcx t'allen tijden punctuelijck sal moeten onderhouden geaccepteert ende aengenomen is. [...]

fol. 451: [...] sijn der meninge noch heden, in den name Godes, onse vordere reyse over landt door de Lancamsche ende Quataongse dorpen

naer costij aen te vangen, tot welcken eynde op gisteren de crijchsmacht met alle 't gene tot den trijn van noode is over de riviere aen de zuytzijde gescheept [...].

fol. 447: After we had left [Tayouan] on the 6th of September last, we arrived on 10 September in Quelang, where we found the entire force together. We had stayed over there for another three days in order to prepare ourselves thoroughly for the next expedition. [...]. Meanwhile we provided ourselves with as many inhabitants of Kimaury and Tamsuy as possible to serve as our interpreters and for other tasks.

On the 13th we sent captain Sijmon Cornelissen with the junk *Utrecht* ahead to the Bight of Cavalangh in order to investigate if a good spot could be found somewhere where we could land safely with our men. Moreover he would try to obtain information about the situation of the peoples living over there and what their general temper was. For this purposes he had taken along some men from Kimaurij.

The next day we followed with the entire force. But on the 16th, when we arrived in the already mentioned Bight, we did not get any signal from Sijmon Cornelissen (from which we understood that he had not been able to find a suitable landing spot). Whereupon we, as he must have done before us, steered a course for St. Laurens Bay, where we arrived that same evening.

Sijmon Cornelissen reported us that he had learned that many inhabitants living close to the beach, had fled inland out of fear of our arrival, taking along all their belongings as well as their women and children. We immediately sent some men from Kijmaurij thither to notify them that we did not intend to ruin or kill them, but rather to offer them peace and friendly contact.[102] That we did not expect to get anything else but faithful obedience from them, as is rendered to the Company by most Formosans, from whom we only desire, as a proof of their loyalty, that they will come up with a small tribute of deerskins or something else every year. All who were willing to do this need never fear that we would touch one hair on their head, nor that we would rob them of their goods or maltreat them in any other way, that on the contrary, we intend to protect them from their enemies. Therefore they should freely come to meet us and learn more about our intentions or hear our further statement. However those who are neither willing to submit themselves to our authority, nor pay an annual tribute, and who continue to resist our

friendly offer, we will punish by taking up arms against them, so that others will take a warning from it.

On the 18th, at about twelve o'clock in the afternoon we started to march towards the Cabalang villages, because only at low tide could we pass along the cliffs at the foot of a small steep mountain ridge along the beach. Towards the evening, at about five o'clock, we arrived in front of a village named Parissinawan, where the inhabitants offered us some houses that could serve as guardhouse as well as lodges for our men. Meanwhile the elders of the mentioned village as well as those of Little Moudamas and Talebeauan (who, in the opinion of our Kimaurij scouts who had gone ahead, seemed to be very pleased at our arrival) came to meet us with many of their people. In order to pay us their respects they brought along some bamboo containers filled with fresh water, which they offered our thirsty men to drink from.

We stayed for two days in the village of Parissinawan, during which time our invitation was accepted by the headmen and peoples of twelve villages to whom we, in general as well as in particular, explained and dicussed the reason (fol. 448) for our visit, as required in our instructions. The inhabitants willingly agreed to accept our terms and promised to adhere to them. However they requested to pay the annual tribute in rice, that is two small bags for every household, instead of deerskins as there was not much hunting in their territory. They even had to barter for deerskins from the people who were living in or near to the mountains. We agreed to this request as we trust that the Company will be served by rice as well as by deerskins. Almost all of them excused themselves for not being able to pay the mentioned tribute immediately, because it was the season of their rice harvest, as well as the time of their *marnas* or festival. This is actually a certain superstitious worship that is celebrated twice a year (in the sowing season and in the harvest time). During those days they neither go to other villages, or take any commodities elsewhere, nor do they themselves tolerate any others to come to their villages to bring any goods, because they believe that this will bring bad luck as well as a bad harvest to them in the following year. However they all promised that, as soon as the harvest and their *marnas* had come to an end they would see to it that they would bring the required tribute to the fortress in Quelang and that they would continue to do so every year. In this matter we dealt discreetly according to Your Honour's orders.

But the inhabitants of the villages Sochel Sochel and Kakitapan have turned down our offer and notification in a mocking and despicable way, knocking on their heels saying that they were not the ones to ask for the Dutch. But if the Dutch wanted to meet with them they could come freely, as they were strong enough to withstand our force etc. We therefore marched with our army to the village of Sochel Sochel on the 21st September. However, because of the rain we were forced to spend the night in the fishing village of Little Moudamas, situated on the beach next to the mouth of the Kriouan River. The following afternoon, we arrived in Sochel Sochel and immediately set it afire, most of their rear houses being filled with rice and paddy. Unfortunately when we marched along some narrow paths, which on both sides were overgrown with tall reeds and coppice, the scoundrels shot and killed two of our men and injured three or four of them, suddenly coming out of the thicket and attacking us before we saw them, and then they immediately ran off again. Next many of their warriors appeared in the field close to their village in order to put up a strong fight, however when our musketeers charged they, at once, fled away and we have no doubts that many of them were killed in the charge. That same night we posted sufficient guards to prevent them from making a raid on us. The next morning we burnt down and ruined everything which had not been destroyed the preceding day. Afterwards we left again for Kakitapan, with the intention to attack and ruin that village on the same day, in the same way as Sochel Sochel, but because of the long and difficult route we were overtaken by darkness. We therefore changed course to Talabeauan, situated not far from the beach at about ... miles from St. Laurens Bay, were we stayed over for the night. The villagers proved to be reasonably helpful and of good will.

When we were told on the morning of the 24th that the mentioned village Kakitapan happened to be quite small, consisting of not more than eighty households, we did not deem it necessary to go there with the entire force. So we commanded a hundred able bodied musketeers under the command of two lieutenants, an ensign and three sergeants to destroy and set fire to to the mentioned village in the same way as at Sochel Sochel. They diligently carried out their duty and demolished everything. They came across about 130 houses, all of them filled with rice and paddy, so this ruin of the villages will hurt the inhabitants greatly. Meanwhile we

left with the remaining part of our force along the beach. After we were united again with the dispatched party, (fol. 449) we marched on to our first encampment in front of Parrisinawan.

When we left Talebeauan the headmen of the eight northernmost villages situated in the Bight of Cavalangh came to subject themselves voluntarily to us promising, as the others had done before them, that as soon as the harvest season and their *marnas* (for which they made their excuses as well) were finished, they would go to the commanders of the fortress in Quelang to pay their tribute in rice (which also will be more convenient to them) and that they would continue to do this every year.

They army stayed for four days in the mentioned Parissinawan. The inhabitants of that village as well as those of Talebeauan, Moudamas, Kginoudus, Mabolauw and Tachauan, most of which are small settlements that have already paid us their tributes in the form of rice. Part of that has been consumed by the soldiers and the Chinese, while the remaining rice, four hundred small bags, has been shipped on board the yacht *Leeuwrick*.

Meanwhile another ten village headmen came to submitt themselves in obedience to the Company. They also made excuses like the others that it happened to be their harvest season and the time of their *marnas* [so that they could not pay us their tributes immediately]. As a result thirty villages all together have appeared before us and subjected themselves in obedience to the Company and have promised faithfully to pay a tribute every year, as Your Honour can see in the memorandum included in this letter. A number of fourteen villages, located near the Bight as well as some more in the interior in the mountains, still have not shown up. However they have announced through their neighbours that they, besides other villages in the area, are willing to submit themselves in obedience to us and that in future they are willing to come to Quelang every year to pay us the tribute.

And because Your Honour recommended in your instructions that you prefer us to employ gentle means rather than tough ones against these peoples, because it is their first contact with the Company, so that relations are still quite sensitive. The more so because the rainy season is about to begin and as a result of this much of their lands will soon be flooded so that it will be quite impossible for us to carry out any action in that area. Consequently we have decided not to exercise any more hostility or inflict any punishment against them, but to content ourselves

with the status-quo after urging them once more to show obedience and redeem their promises. [...]

(Subsequently, in the morning of 29ᵗʰ September, Boon and his men left the village of Parissinawan and they reached Sint Laurens Bay in the afternoon. The same day they went aboard and the next day they set sail for Quelang, which was reached on 1 November by the entire force, except for Simon Cornelissen and his crew, who due to the strong northeastern winds had not succeeded in rounding the point. The junk had lost its mast and sail in the stormy weather and the heavy sea that was running near to the point. This he reported in a letter delivered at Quelang overland by some local people. Immediately after his letter was received the junk Uytrecht *was directed thither to salvage the junk and pick up Cornelissen and his men).*

fol. 450: Immediately after our arrival in Quelang we thoroughly examined the rebellious disobedience of the people of St. Jago and we concluded that they well deserved to be punished severely. However considering their humble begging for mercy as well as their admission of guilt and their cordial proposal for conciliation, together with the promises they made, to refrain henceforth from committing offences like that and to show obedience as loyal subjects, we decided to impose a fine on them amounting to three times the ordinary tribute. Within ten or twelve days, and before our return to Cavalangh, they will have to come over to Quelang to pay this, either in deerskins, in rice or otherwise. However if they fail to do this, we surely will take up arms against them and punish them in the most rigorous way so that they will be totally ruined. They have willingly accepted these conditions in order to escape punishment, and have paid the fixed penalty. In addition they paid the tribute for this year: 132 elk-skins and 30 small bags of rice, which will be sent to Your Honour with the yacht *Leeuwrick*. Thus we have remitted their punishment while warning them at the same time that if they ever oppose the Company again, they will never again escape their penalty. So we advised them to watch their step in the future. [...]

On 5 November, after everything was properly arranged in Quelang, I left for the fortress Anthonio in Tamsuy which by following the river, I reached in the evening of that same day.

The villages situated to the north around the river in the Tamsuy area behave themselves quite obediently at present, although not as nicely as

they should. However we do trust that in time their behaviour will improve. Over here at the [Tamsuy] fortress the chief of Baragoutsack appeared before us for the first time (this is quite a considerable village located at about a day's journey to the south) to request us peace and friendly relations. He confirmed that his people will submit themselves in obedience to us, promising that every year they will also pay a tribute. Whereupon we, having explained Your Honour's instruction and admonition to him, that they at all times should strictly observe these, accepted and accorded peace to him. [...]

fol. 451: [...] In the name of the Lord, we are of the opinion that we should continue today our further journey over land via the Lancam and Quataongh villages back to Tayouan. To that purpose the expedition army and all that is required for the train has crossed over to the southern side of the river. [...].[103]

(In the evening of 12 October Boon and his soldiers camped near the Lancam River. On the 14th they learned from their guide or interpreter from Tamsuy that near the Texam River, at a distance of a few miles inland, three villages were to be found that had not yet been visited by any Dutchman. Later on, the headmen and some people from one of those villages, Poucal, located on the banks of the Texam River at about half a mile from the beach, came to subject themselves to the Company. Although they promised to pay the tribute they said that at that moment they could only give a few deerskins because some Chinese traders had come there earlier with their junks with whom they had bartered all available deerskins. The next day, however, the people delivered a tribute of forty deerskins to captain Boon. On 16 October Boon forced an inhabitant of one of the villages near the Calabcab River to show the army the way to the villages, because, although the chief had promised to offer some pigs for tribute, the local people seemed neither very willing to render any assistance, nor to guide the soldiers in crossing the deep Calabcab River. In the afternoon the river was crossed and the men spent the night in a settlement called Laroudsoud. Two other villages, named Tommel and Paypas, were located in the neighbourhood of the mentioned river. The next day the villagers came up with deerskins instead of the pigs they had promised to pay for tribute the evening before. That same day the soldiers marched on to Daraudauw. They learned from the people there that the area was named Tara, after the river of that name. Six

other villages were situated near the Tara River: Brican, Warawar, Pourawan, Balabal, Nilaboan, and Caracha. Apart from those of Caracha that is situated high up in the mountains, the headmen of the other villages came to pay us their respect. They seemed willing to subject themselves to us. On 18 October the expedition force reached Warawar, situated near to the beach, but the next day, just when the men entered enemy soil, the interpreter from Tamsuy ran off. Now that they were no longer able to communicate with the inhabitants, Boon decided to continue the march along the beach without paying any visits to villages. On 20 October the army encountered a group of about hundred or more warriors who, after they at first had tried to direct Boon and his men in a certain direction, started to shoot with bows and arrows. However after a few muskets were fired they ran off, but when the army came near to Bodor the inhabitants had set fire to the grass and bushes. The army took revenge by burning to ashes the first village they reached. On 22 October, having spent the night in Dorenap, they heard from some Chinese as well as the inhabitants of Dorenap that several Chinese pirates, who had managed to escape the Company raid in July, were now hiding in Pasua. Due to the heavy winds the army could not set out at once on the three hour march to the pirates hideout. Yet on the next day, Pasua, that happened to be rather a large village, was completely devastated, without any resistance from the villagers. Next the army continued for Dorenap, Torchia, Sarboloo, and Tackais (named Gielim by the Chinese). Finally, on 27 October, after the soldiers had visited Vavorolang they reached the Poncan river, where the men boarded some sampans to sail to Tayouan.)

239. Memorandum of the headmen of the villages situated in the Bight and in the province of Cavalangh who appeared before the Honourable Field-Commander Pieter Boon and have submitted themselves voluntarily to the Company.
[Tamsuy, 25 September 1644].
VOC 1147, fol. 465.[104]

Headmen	Villages
Boutay Madawis	headman of Parissinawan
Rarassan	headman of Little Moudamas
Taramaun	headman of Kginoudus
Rabay	of First Mabolauw
Rabay	of Tachauan
Rabay	of Mattauan
Sabbattou	of Tanaborawan
Deng-au	of Barachoeyon
Wanouw	of First Tarong-an
Towack	Taloubayan
Passauw	Second Tarong-an
Wanou	Great Moudamas
Touack	Cgachioumas
Banouno	Pattoucan
Sobattou	Pattoubayer
Carowa	of Madipatan
Carowa	of Banouran
Abangh	Mabolauw
Courauw	Taptap
Aban	Tobe Tobe
Touack	Baboloan
Abangh	Sinachan
Ding-au	Serimin
Caroubien	Sannee
Dingh-au	Taradingh
Boutay	Maroutenoch
Abang	First Payrier
Boetay	Sinarochan
Pou-elats	Talebeauan
Boetay	Mabassingh

30 villages

The headmen of the following villages did not come to the Honourable field-commander themselves but, by means of their neighbours, they have

indicated that they are willing to submit themselves to the Company and pay the annual tribute:

Touack	headman of Wayaway
Wanou	headman of Tomechoch
Boutay	of Patongh Aduyan
Boutay	of Second Payrier
Siatong	Kgenabtoran
Carowa	Banarouban
Towack	Matouck
Bourij	Parattepassan
Piraen	Machatibor
Maronay	Pinabarat
Taburan	Paraud
Deng-an	Kgitatad
Touacq	Third Mabolauw
Boutay	Cakiocoucus

14 villages

The following villages have been ruined and burned to ashes:

Sabattauw	Sochel Sochel
Binock	Kakitapan

2 villages

240. Missive Governor François Caron to Governor-General Anthonio van Diemen.
Tayouan, 25 October 1644.
VOC 1148, fol. 256-280. Extracts.
See also FORMOSA UNDER THE DUTCH, pp. 203-205.

fol. 256: [...] Soo de joncke de *Goede Hoope* den 20en Maert voorleden met de laetste advijsen naer costij vertrocken was, is [...] den Noordelijcken lantsdach des anderen daeghs, item den Suydelijcken- en Oostelijcken- te samen den 19en april daeraen volgende beyde met de vereyschte solemniteyten op Saccam gehouden. [...] Sijnde aldaer in compententen

getalle verschenen de bevelhebberen met haer gevolgh van 33 dorpen om
de noort, 39 om de suyt (nu in 18 groote begreepen) ende 11 van den
oostcant van 't landt, daeronder 14 van de noort en 4 van de suyt die noyt
voor desen ons ten rechten gesubjecteert, maer tot noch tusschen beyden
gehangen hebben. In alle welcke dorpen, elc nae hare groote, uyt vrij een
meerder getal 4: 3: 2: ende oock wel maer één van de bequamste tot
bevelhebbers (om die nae onse ordre te gouverneren) gestelt, ende te dien
eynde ijder een rottangh, met 's Comp.ˢ wapen, in silver gegraveert
(sijnde het teken van gesagh) onder behoorlijcke beloften van
getrouwicheyt behandicht hebben. Mitsgaders om haer onse costuymen
ende 't gene tot verbeteringe van Formosas regeringe in 't één en 't ander
noodich oordeelden, bekent te maken, was hun tesamen in zes à zeven van
de gemeenste talen omstandelijck voorgehouden, namentlijc hoedanich de
politicque van de kerckelijcke regeringe t'onderscheyden hadden, wat
gesach ende eere d'één ende ander schuldich waren, dat de predicanten
etc. in waerden, ende de trage school- ende kerkgangers (daerover bij haer
geclaecht wert) op de verbeurte van seker amende, tot hun devoir mosten
houden; dat voortaen om den hinder die 't in beyden veroorsaeckte, geen
outste leeraers, noch geen leeraers outste, ofte bevelhebbers der dorpen
mochten sijn; dat alle jaren (nae d'ordre onser landen) eenige van
d'outsten souden afgaen, ende van de bequamste wederom nieuwe
aengenomen werden etc.; oock dat voortaen de gestelde hooffden, ijder
over haere dorpen in 't geheel, ende niet over één wijck alleen (gelijck tot
noch toe gebruyckelijck geweest is) souden te gebieden hebben; hoedanich
den politicq te respecteren, hem alle voorvallen te communiceren, wat
saken met sijner kennisse af te handelen, ofte aen 't casteel te brengen
hadden; dat het teken der gehoorsaemheyt voortaen, gaerne in vellen ende
niet padi als voordesen (soo 't geschieden conde) voldaen sagen; dat de
dorpen van 't geberghte, ten respecte nu eerst met ons bevredichden, dit
jaer van de recognitie souden geëxcuseert blijven, doch in 't aenstaende
sulcx op te brengen hadden, maer dat die van Oost ende West Salmo,
Groot Davolé, ende Valapais, omdat met den roover Kimwangh hadden
gehouden, tot een amende dubbelde erkentenisse (gelijck oock naderhant
geschiet is) betalen souden. Dien van (fol. 257) Tirosen wiert te laste gelecht
('t welck gewillich aennamen) soo veel rijs op te brengen als tot onderhout
van haren inlandtsen schoolmeester jaerlijcx nodigh was, 't welck tot een
proef geschiede om alle andere dorpen, alwaer d'onderwijsinge van de
Christelijcke religie plaets heeft, naer desen insgelijcx daermet te belasten;
item om wat redenen de Chinesen uyt de dorpen gehouden werden, ende
hoe echter besorgen wilden alle gebreeckende commoditeyten in hare

dorpen ter vente souden comen; voorders dat dit eenen vrijen ende onbekommerden lantsdagh ofte vergaderingh waer, daerop een ijder het gaen, keeren ende sijn gevoelen vrij uyt te spreken toegelaten was; dat dierhalven in oprechtigheyt ende ongeveynsdelijc te verclaren hadden, ofte ooc gesint waren 't voorverhaelde (hun soo in 't gemeen als elc in 't bijsonder rakende) punctueelijc naer te comen ende te gehoorsamen. Alle 't welcke bij haer eendrachtelijc gepresen, aengenomen, ende vastelijck belooft wert, hun voortaen daerna te sullen schicken etc. Hierop is haer tot besluyt den vreede onder malcanderen hoochelijc gerecommandeert, ende dat een ijder sijne naeste gebueren (noch met ons onbevreedicht sijnde) tot deselve, als de lantsdagen te noodigen hadden. 't Welc eendrachtelijc aennamen, waermede (gesamentlijc maeltijt gehouden hebbende) een ijder met besonder genougen gescheyden is, gelijc uyt d'annotatie van 't daghregister alles breeder gelieft te vernemen.

Verscheyde andere treffelijcke dorpen als Doretoc, 's Kadan, Talichieu, Potlongh, Tarckevos, Pacavorou, Caroboangh ende Varangith, alle om de suyt, oostwaert na ende in 't geberghte gelegen die hun neutrael houden en belooft hadden mede op den Suydelijcken lantsdach te comen, sijn vermits den vroegen regen en 't swellen der rivieren (soo voorgeven) niet verschenen, nochte ooc den vorst van Lonckjouw die sich naderhant door sijnen soon, omdat doen ter tijt sieckelijc was, aen 't Casteel heeft laten excuseren, versouckende voorders remis en nevens andere te sullen obediëren in alle 't gene hem opgelecht mocht werden, 't welc den selven toegestaen is, soo sulcx persoonelijc alhier comt versoecken, waerop tot noch toe niets was gevolcht, ende 't suyder mousson, dat de wegen onbruyckbaer maect, hem ten deelen verschoont. Werdende niet getwijffelt ofte sullen gesamentlijc 't aenstaende noorder mousson, benevens veele anderen daer d'apparentiën schoon toestaen t'onser devotie gereduceert werden.

Insgelijcx waren van d'oostcant van Formosa meest alle de voornaemste dorpen, excepto die van Pimaba ende enige naegelegene, op den voors. lantsdagh niet geweest, eenige haer excuse nemende op den langhen wegh, dat hare velden om te besaeyen mosten prepareren, ende door gebrec van victualie niet comen conden, daer vrij wat quaetwillicheyt onder gescholen heeft. Andere waren gestut ende door die van Vadan ende Tellaroma verhindert geweest te comen ende de recognitie op te brengen. 't Welcke twee plaetsen d'ooren seer opsteken, stout ende moetwillich sijn, sulcx exemplaerlijc gestraft dienen, soo vrede ende ordre aen dien cant begeren. Den resident Cornelis van der Linden in Pimaba was overleden, ende het dorp in Junij passado, sonder te weten door wien, gantsch afgebrant, ooc

's Comp.^{es} huysingen ende *f* 276: 14: 12 aen cargasoen, dat daer tot procure van den vellenhandel hadden, sijnde 't overschot ende 't gene geberght is van weynich valeur. De joncq de *Brack* hadde tot allen geluc eenigen tijt bevoorens de gehandelde als recognitie vellen ende padi van daer gehaelt ende behouden alshier gebracht.

Seeckere weynige huysgesinnen van Nieuw Tavocan, sterc ruym 60 sielen, op hun versoec ten tijden van den Gouverneur Traudenius om in de Christelijcke religie onderwesen te werden in Xincan te woonen toegestaen sijnde, hadden hun verstout, schoon 't selve versoeckende haer meermaels afgeslagen was, gesamentlijc van Xincan op te breken ende haer naer hunne voorige plaetse ter woon te begeeven, opnieuw huysen te bouwen, ende rijsvelden te maken, welcken volgende om te verhoeden dat sulcx (in dese gelegentheyt dat men doende is van veel cleene dorpen in een trecken) niet meer geschiede, voors. velden ende huysen geruyneert, de gemelte sielen wederom in Sincan te woon gebracht ende twee van de belhamels mette kettingh ten exempel van anderen gestraft sijn. Voorders was alles sedert de gehouden lantsdagen vredich toegegaen ende de visiten allerwegen naer behooren waergenomen. [...]

Soo om een begin ter bequamer plaetse van de geprojecteerde reduyt in Tamsuy te maken die vermits quade toevallen verleden jaer niet is (fol. 258) connen begonnen werden, als om de hooffden van de subjecterende dorpen aen dien cant bij den anderen te roepen, hares plichts te vermanen, de recognitie daer in te stellen ende op verscheyden andere dingen, gelijc bij de metgegeven instructie naerder blijct ordre te stellen, was den capiteyn Pieter Boon in 't begin van april met 't jacht *Breskens*, volladen met calck als andere nootlijcheden tot dien bouw noodigh, [...] derwaerts gesonden geweest. [...]

D'outsten van vier en twintich dorpen daer ontrent hadden soo op 't aenwesen van gemelten Boon, als naderhant in Tamsuy aen 't fort geweest, behoorlijcke onderdanigheyt ende recognitie op te brengen belooft, die vast dagelijcx in vellen voldeden ende met d'eerste gelegentheyt herwaerts verwachten. In Quelangh [...] [is] de behouden punt van de fortresse aldaer Noort Holland ende 't rondeel Victoria genaemt. Goede quantiteyt smeecoolen [...] was de gemeente van 't dorp Kemourij om die onder voors. punt op strant te brengen, tot verdraeghelijcken prijs aenbestelt, moet hebbende door ons volc eenighsints geholpen sijnde, daertoe ordre gegeven was, van die binnen uyt den bergh te sullen connen graven, als wanneer te verhoopen staet, genoughsame quantiteyt, ende vrij beter coolen als voor desen becomen hebbende t'erlangen sullen sijn, [...]

Eén van de hoofden van Kemourij voors. genaemt Theodore prompt in Castiliaensche tale, was met meergemelten capteyn Boon, om openingh van de gelegentheyt daer omher als Terroboan, dat vijftien mael besocht heeft te doen, voor onse comste aen 't casteel geweest, van wien redelijcke cuntschap dier saken, ende meer licht als oyt van ymant anders voor desen erlangen hebben, [...]

fol. 259: Tot verbeteringe van 's Comp.ˢ incomsten, ende om te voldoen 't geene den bevelhebberen der dorpen op de lantsdagen belooft is, was op primo may voorleden den handel van de voornaemste noordelijcke dorpen, de riviere van Ponckan, ende de gantsche suyt etc. onder gereguleerde conditiën aen den meestbiedende, soo aen Chineesen als Nederlanders om een preuve te neemen verpacht, te weten:

Tevorangh	Ra.140
Dorcko	140
Tirosen	285
Dalivo	115
Vavorolang	300
De gantsche suyt	800
De riviere van Ponckan voor een half jaar	220

Item voor den handel van Sincangia etc. tusschen Dorenap en Tamsuy om de noort met 4 joncken voor een voyagie comt 140

Is te samen: Ra. 2140

Waervan de helft op de hant ontfangen ende d'andere ten uytgaen van de pacht voldaen sal werden. Sijnde d'apparentie heel goet, om op dien voet vrij meer dorpen aenstaende mey te verpachten, ende de voors. somma te verdubbelen, gelijc dan ooc ten selven eynde, den thienden op de swarte suyckeren, Chineese smeer, kaerssen, tabac, arac, olie, smeer ofte veth, inlandtsche rottangh, couraelen als andere diergelijcke cramerije. [...].

fol. 267: Quelangh ende Tamsuy sijn twee havenen van consideratie. [...] Oock sijn het de vasticheden ende burchten daerdoor den principalen noortcant van dat eylant in dwangh, en de volckeren der lantstreeck, van daer tot Gielem, ende Favorolangh toe onder 's Comps. gehoorsaemheyt sullen gehouden werden. [...]

fol. 271: [...] Aen d'oostcant van Formosa blijven die van Vadan en Tellaroma noch even moetwillich met onse bontgenoten hostiliteyt aen te doen. Die van Sipien, westwaert van Pimaba in 't geberchte gelegen, een dorpken dat sich nooyt tegens ons gestelt heeft, hebben den corporael Allert Thomasz. die d'opsicht over d'Comp.ˢ cleenen omslach na het overlijden van Cornelis van der Linde in Pima bevolen hadden den 7ᵉⁿ September passado in één harer huysen moortdadich om 't leven gebracht,

ende verscheyde inwoonders van sijn geselschap swaerlijck gequetst, die 't
vorder met de vlucht ontkomen sijn, dat ten exempel van andere met
d'eerste bequame gelegentheyt voornemens sijn te straffen, ende volcomen
reddingh soo veel doenelijck aen dien cant te maken. [...].

fol. 256: [...] After the junk the *Goede Hoope* had departed for Batavia on
the 20th of March with the latest reports, [...] the Northern Land Day was
held the next day and also the Southern and Eastern Land Day jointly on
the 19th April. Both were held with the required ceremonies in Saccam,
where the principals appeared with their following, in full numbers, from
33 villages in the northern, 39 in the southern (now consisting of 18 large
ones) and 11 in the eastern region. Among the latter were 14 from the
north and four from the south who had never yet formally subjected
themselves, but had been wavering about what to do. In all these villages,
in proportion to their size, we have selected and appointed four, three,
two or even only one of the most capable men as commander (to rule
them in accordance with our instructions). After they had pledged their
loyalty, everyone was handed a baton with the Company's arms engraved
in silver (as a sign of authority). In addition, in order to inform them of
our customs and of the things we consider necessary for the improvement
of the government of Formosa, they were told in extenso, in six or seven
of the most widely used languages, how to keep political and religious
authority separate and what kind of obedience and respect they owed to
one another; that the ministers were to be held in high esteem and that
those who neglected school and church (about which were these
complaints), should fulfil their duties or pay a fine; that from now on,
because of the troubles it caused for both, no principal was allowed to be
teacher, nor any teacher to be principal or commander of a village; that
every year (in accordance with the procedures in our own country) some
of the principals had to resign and that new ones, from among the most
competent, should be appointed etc.; also that in the future the appointed
heads should rule over their villages as a whole and not over just one
ward (as had been the practice until now); what measure of respect they
owed the political officer, informing him of all events; what cases they
could settle in consultation with him and what cases they had to bring to
the Castle; that henceforth we liked to see their sign of obedience paid in
skins and not in paddy (if possible); that the villages in the mountains,
because they had only just made peace with us, were exempt from paying

tribute this year, but would have to do so in the coming year; however, that those of East Samlo (Little Davolee) and West Samlo (Great Davolee) and Valapais would have to pay a double tribute as a penalty, because they had associated with the pirate Kimwangh (which they actually did). The people of (fol. 257) Tirosen were instructed to supply the rice needed every year for the livelihood of their native schoolteacher (which they gladly accepted). This served as a trial, with the purpose of imposing it at later date on all other villages where education in the Christian religion takes place. Also they were told why the Chinese were kept away from their villages, but that we would see to it that all commodities that were needed in their villages, would be brought for sale there. Furthermore we told them that this was a free and untrammelled Land Day or assembly where everybody was allowed to come and go and to speak his mind freely. Therefore, they should sincerely and without pretending, declare if they agreed to strictly observe and obey the aforementioned [instructions] (applicable to them in general as well as in particular). All this was unanimously praised and agreed by them, as they sincerely promised to comply with these conditions from now on etc. Finally, it was impressed upon them that they had to keep the peace with one another and that every one should urge their immediate neighbours (not yet at peace with us) to do the same and invite them to the Land Days. Having accepted this unanimously, they all contentedly went their various ways (after enjoying a collective meal), as can be seen in more detail in the notes in the daily journal.

Several other important villages like Doretoc, Toutsikadangh, Talasuy, Potlongh, Tarkavas, Papaverouw, Caraboangh and Varangit, all situated in the south, in the easterly direction, and in the mountains, which remain neutral and had promised to also appear at the southern Land Day, did not show up because they claimed the early rain had swollen the rivers. Neither did the ruler of Lonckjouw, who later, through his son at the Castle asked to be excused, because he was ill at the time, begging our pardon and promising to comply with everything that might be imposed on him, just like all the others. This was granted on condition that he personally comes here to make this request. This has not happened so far, but he is partly excused because of the southern monsoon that has rendered the roads impassable. However, we do not doubt that during the

coming northern monsoon all will be back under our authority, and it looks very probable that many others will follow suit.

Furthermore, almost all important villages of the eastern region of Formosa, except for Pimaba and some of its neighbouring villages, did not show up at the Land Day. Some made the excuse that it was a long journey, that they had to prepare their fields for sowing or that they could not come owing to shortage of provisions, yet in many cases this was merely caused by recalcitrance. Others had been stopped and prevented from coming and bringing their tribute by the peoples of Vadan and Talleroma. Those two places are very unruly, insubordinate and obstinate, so that they will need an exemplary punishment if we want peace and order on that side of the island. The Company servant residing in Pimaba, Cornelis van der Linden, had passed away and the village was burnt down last June, it is not known by whom, including Company's buildings and a stock of commodities amounting to ƒ276:14:12, put there for the skin trade. What was left and had been salvaged was of little value. Fortunately, some time earlier the junk *De Brack* had taken the skins that were traded and the skins and paddy that were collected as tribute from there and brought them safely here [in Tayouan].

A few years ago, during the administration of governor Traudenius, some New Tavocan families, totalling 60 soul, had on their own request been allowed to settle in Sincan in order to be educated in the Christian religion. These families had subsequently been over-bold and moved out of Sincan in spite of their repeated requests to do so being refused. They had returned to their former homes and built new houses and laid out rice fields. In order to prevent this happening again (especially now that we are in the process of joining many smaller villages), we destroyed those fields and houses, moved the people back to Sincan and punished two of the ringleaders by putting them in chains as an example to others. Apart from this incident everything has been peaceful since the Land Days and all inspection visits have been duly undertaken.

(On 15 April Joost van Bergen returned from New Tavocan, which village was destroyed on governors' orders with the assistance of 200 warriors from the allied villages Sincan, Tavocan and Bacaluan. The sixty villagers, who had been repeatedly warned not to oppose the Company's orders, were then accompanied back to Sincan and seven [rogues] were sent to Tayouan for punishment.)[105]

Pieter Boon was sent at the beginning of April with the yacht *Breskens* with a cargo of lime and other requirements for construction purposes to Tamsuy in order to start the construction of the designed redoubt at Tamsuy which, because of unfortunate occurrences had not been started last year. (fol. 258) He was also to assemble the headmen of the subjected villages in those quarters, to admonish them in connection with their obligations, to decide about the recognition and bring into order some other things, as may be seen from the appended instruction. [...]

The elders of twenty four villages over there had in the presence of Boon, and later on in Tamsuy at the fortress, promised to show fitting humility and bring tribute, which almost daily they paid in deerskins, and which we expect to receive at the earliest opportunity [at Tayouan]. In Quelang [...] the preserved fortified point was baptized North Holland and the Martello tower Victoria. At a fair price a sizeable quantity of pitcoal was commissioned with the people of Kimaurij for delivery at the beach the aforementioned point. They trust that they can dig up the coal from inside the mountain with the assistance of our soldiers, who have been ordered to help, so that it is to be hoped that we shall receive a sufficient quantity and a better quality of coal than we have obtained so far. [...]

One of the headmen of Kimaurij, named Theodore who is fluent in the Castilian language, had been together with the above mentioned captain Boon before our arrival at the castle to throw some light on Tarraboan, which he had visited fifteen times; from him we received reasonable insights in those affairs and more informaton than we have ever received from anybody else. [...]

fol. 259: In order to improve the income of the Company and to carry out what has been promised by the chiefs of the villages during the Land Day, on May first the tax on trading in the most important northern villages, the area around the Poncan river, and all of the southern region was farmed out under regulated conditions to the highest bidders, Chinese and Dutchmen as well:

Tevorang reals	140
Dorko	140
Tirosen	285
Dalivo	115
Vavorolangh	300
The entire south	800

The Poncan River for half a year 220
Also the trade with four junks from Sincangia etcetera and Dorenap and
Tamsuy in the North, one voyage amounting to reals 140
In total reals 2140

Half of this was received immediately while the other half was to be paid
at the end of the tax farming period. It looks as if we may be able to farm
out next May the trading rights of quite a few more villages, and to
double the aforementioned sum. Likewise the tithes on black sugar,
Chinese grease, candles, tobacco, arrack, oil, fat, rattan, beads, etcetera
will be levied for the same purpose. [...]

fol. 267: Quelang and Tamsuy are two considerable ports. These are also
the strongholds and fortresses by which the most important Northern part
of the island may be kept under coercion, as well as the local peoples as
far as Gielim and Vavorolangh under obedience to the Company. [...]

fol. 271: [...] at the Eastern side of Formosa the peoples of Vadan and
Tellaroma continue to commit mischief against our allies. Those of
Sipien, a hamlet located west of Pimaba in the mountains, who have
never opposed us in the past, murdered corporal Albert Thomassen on
7 September in one of their dwellings who, after the death of Cornelis
van der Linden had been commissioned with the supervision of the
Company's smaller trading operations in those regions. Several natives
who were with him were severely wounded but managed to escape. As an
example to others we intend to punish the perpetrators at the first
opportunity so that full security may be striven for at that side of the
island. [...]

**241. List or memorandum of the annual expenses the General
Company has to defray for the church works on Formosa and what
receipts can be expected from the inhabitants every year.
Tayouan, [undated 1644].
VOC 1148, fol. 428.**

*(In a balance the expenses are given which the Company had to pay
annually for the salaries and provisions of the church ministers, the
visitors to the sick and the schoolteachers. In total this amounted to
f19,500, which equalled the receipts that were expected from the tribute
to be paid by the inhabitants, the licences for deerhunting, the leasing out*

*of the trade in the villages and the licences for the junks allowed to carry
the trade goods to those villages.)*

242. Resolution, Tayouan, 31 October 1644.
VOC 1148, fol. 246-248.

fol. 246: Alhoewel op 3^{en} December des voorleden jaers onder anderen uyt
goede consideratiën, ende op de clachten der inwoonderen van de dorpen
Soulangh, Sinckan, Bacoloangh, Mattauw ende Tavocan was gearresteert
dat de Chineesen, welcke haere bouwvelden te nae bij der inwoonderen
ofte aen de dorpen voornoempt waeren hebbende, deselve van doen aff
niet langer als noch een jaar genieten souden, gelijck oock sulcx ter
behoorlijcker tijdt bij placcate affgecondicht, item den inhabitanten
gecommuniceert is. Echter hebben onlanghs om goede redenen en op hope
van des Comp.^{ies} voordeel daardoor uyt te wercken den oppercoopman S^r.
Cornelis Caesar bij monde gelast naarder t'onderstaen hoedanich de
genegentheyt van geroerde landtsaten dien aangaende jegenwoordich sijn.
Dewelcke daarinne naar behooren procederende, de outsten van boven
genomineerde vijff dorpen bij sich ontbooden, de saecke voorgestelt, ende
haere meeninge [...] wel begrepen hebbende, relateert (fol. 247) ons
jegenwoordich in Rade, dat die van Sinckan ende Tavocan (ten aansien
haere velden weynich sijn) versoucken, den Chineesen absoluyt ende
gantselijcq den landtbouw omtrent haer dorpen mach blijven g'interdiceert,
doch d'inwoonders der drie andere dorpen (welcke rijckelijcker van
bouwlandt sijn voorsien) dat de Chinesen mach werden toegelaeten, de
landtneeringe aldaar te continueeren mits dat eenelijck sich buyten het
begrijp haerder besaeyde velden retireren, ende niet meer onder haar ofte
aen de vlecken eenich landt besaeyen.
Waerop [...] eendrachtelijck goetgevonden en geresolveert is, dat men de
Sincanse ende Tavocanse Chinesen metten eersten andermael
waarschouwen, ende insinueren sal, zij van nu aff bij off omtrent gemelte
dorpen niet meer sullen saeyen, maer eenelijcq 't gewas dat nu te velde
staet mogen insamelen, ende tot ultimo April aenstaende ende langer niet,
als wanneer degene die noch tot de landtbouwerije genegen zij sich naar
Saccam moeten transporteren, des neen connen in voors. dorpen vooreerst
blijven woonen, om haarlieden aldaer andersints te erneeren.
Soo sal oock van gelijcken den Chinesen die in de dorpen Soulangh,
Mattauw ende Bacoloangh tot noch toe landtneeringe doen bij provisie
werden aengesecht dat (als de bovenstaande) haere velden, in 't begrijp der
dorpen gelegen van nu aff (volgens de voordesen gegeven ordre) niet meer

sullen besayen, maer de vruchten die alsnu te velde staen, tot ultimo April aenstaende mogen innen, welcq termijn geëxpireert wesende, die noch tot den landtbouw gesint blijven, sich (met kennisse van onsen politijck, ende d'oudsten der dorpen) buyten 't circuyt der geseyde dorpen connen nederstellen ende andere bouwvelden beslaen, gelijcq haar alsdan van gementioneerde persoonen aengewesen werden sal, edoch met desen verstande dat gehouden blijven jaerlijcx voor het gebruyck van ijder kae (dat is ongeveer een morgen landts) aen d'Ed. Comp. te betaelen twee realen van achten, ende dat tot ons aff- ofte weder op seggens toe, ende die tot dese voorgestelde conditie niet, echter tot de landtneringe geneyght sijn, sich al mede naer Saccam te vervougen moeten gelijck oock die haer andersints meynen te geneeren, als die van Sinckan ende Tavocan, in de dorpen vermogen domicilie te houden.

Wijders op de hertevanghst en de ordre door d'Ed. heer Gouverneur-Generael dierwegen in mandato gegeven, rijpelijck gelet wesende, wert raadtsaem gevonden om deselve onder behoorlijck reglement in het werck te stellen, van medio November te beginnen, ende tot ultimo Februarij aenstaande, doch langer niet, te laeten exerceeren, sullende in alles niet meer als 400 licentie brieffkens werden uytgegeven, waarvan den politijcq 300 ditos tot de noort (om dat gewest te soulagieren) ende de resterende 100 stucx naer gelegentheyt der velden behoorlijcq verdeelt om de zuyt (welck naer gissinge maer omtrent 10.000 vellen te geven staet) verstrecken sal, waermede vertrouwen, den nomber van 50.000 ditos (volgens den cijfer ende ordre van welgemelte sijn Ed.ht) à contento te becomen zij.

Ende opdat d'Comp.ᵉ van de vijf gementioneerde dorpen, als van andere plaatsen tot soulagiement haere sware oncosten, al mede behoorlijcke incompste gemeten, item d'inwoonderen van nootwendicheden mogen werden gerieft, is van gelijcken verstaen, dat men op 12ᵉⁿ deses aen den meest biedende Chinesen de voors. dorpen sal verpachten, omme aldaer met cangans, rijs, sout ende voorts allerhande Chinese cramerijen meer, te mogen handelen, item weder opcoopen soodanige goederen, als gemelte plaatsen uytgeven, mits dat d'andere Chinesen, die aldaer (als boven twee mael aengeroert) met de wooninge blijven, niet en sullen vermogen haar met eenigen handel (sonder verloff der pachters) te bemoeyen, oock geenige aldaer vallende (fol. 248) commoditeyten coopen, als tot haar eygen noodtruft ende huyshoudinge behouven. De pachten sullen ingaen op geseyden dato, ende dueren tot ultimo April toecomende, ende werde Sr.Caesar meergenoemt gecommitteert omme met den aldereersten in de

vijff voors. dorpen met aenslaen van billietten den tijt der verpachtinge
ende de voorwaerden van dien aen een ijder te notificeren. [...].

fol. 246: On 3 December of last year it was decided for good reasons and
because of complaints by the people of the villages Soulang, Sincan,
Bacaluan, Mattauw and Tavocan that the Chinese who had fields too close
to those of the inhabitants of the aforementioned villages, would no longer
be allowed their use one year from that date. This was promulgated by
placard at the proper time and also made known to the inhabitants.
However, for good reasons and in the hope that the Company may profit
by it, we have verbally instructed chief merchant Cornelis Caesar to find
out what the native people's present thoughts are about this. Proceeding in
the proper manner, he summoned the principals of the aforementioned
five villages, put the case before them and having well understood their
opinion, he now informs the Council that the peoples of Sincan and
Tavocan (because they possess only a few fields) request that the Chinese
may be absolutely and completely forbidden to farm near their villages,
but the inhabitants of the other three villages (who possess more farming-
land) ask that the Chinese may be allowed to continue farming there, on
condition that they withdraw from the area of fields sown by themselves
and will no longer have any fields belonging to them or the hamlets.
Therefore it was unanimously approved and decided that at the first
opportunity the Chinese from Sincan and Tavocan will once again be
warned and given notice that from now on they cannot sow near those
villages and are merely allowed to harvest the crops that are now in the
fields, but only until the end of next April and not longer. Any of them
who wish to engage in farming after that will have to move to Saccam,
while the others for the time being can stay on in those villages and make
a living there by other means.
Likewise, the Chinese who are presently farming in the villages of
Soulang, Mattauw and Bacaluan will provisionally be given notice that
(like those mentioned above) from now on they can no longer sow their
fields situated on the territory of those villages (in accordance with the
order promulgated earlier), but are allowed to harvest the crops that are
now in the fields until the end of this coming April. After that time, those
who still want to carry on farming, can settle (having informed our
political administrator and the principals of the villages) outside the
territory of those villages, occupying other fields, which will then be

allocated to them by the aforementioned persons, but on the understanding that they will be obliged to pay the Honourable Company two pieces of eight per year for the use of every *kae* (which is approximately one *morgen*)[106] until cancellation or termination by us. Those who do not accept this condition but still want to farm, will also have to move to Saccam, while those seeking a living in another occupation may remain in those villages, like the Chinese from Sincan and Tavocan.

Furthermore, having given ample consideration to the hunting of deer and to the order the Honourable Governor-General gave us to execute in that respect, it was deemed advisable to enforce that order under proper regulations and to allow hunting from mid-November until the end of February and not longer. In all no more than 400 licences will be granted, 300 of these will be issued by the political administrator in the north (in order to give relief to that region) and the other 100 will be properly divided in the south according to the potential of the fields (probably yielding only 10,000 skins). In this way we trust that it will be possible to collect an amount of 50,000 skins à contento (in accordance with the figure and the order of His Excellency).

In order that the Company may enjoy income from the five villages mentioned earlier, as well as from other places, to reduce its high expenses, and so that at the same time the inhabitants may be supplied with commodities, it was also decided that on the 12th of this month these villages will be leased to the highest bidding Chinese, who will have the right to trade there with *cangans*, rice, salt and various Chinese goods and to buy in return the goods that are produced in those places. But the other Chinese, who are still living there (twice mentioned above), will not be allowed to engage in any trade (without the permission of the leaseholders) nor they may buy any goods produced there, excepts those needed for their consumption and use. The leases will be effective from the aforementioned date until the end of next April. Mr. Caesar was commissioned to announce the date of the leasing and its conditions by putting up placards in those five villages as soon as possible.

243. Dagregister of Governor François Caron on his voyage from Batavia to Tayouan, with the ships *Vrede*, *Swarten Beer*, the galliot *Hasewint* and the pilot boat.
Tayouan, 25 July-15 November 1644.
VOC 1148, fol. 140-211. Extract.
DRZ, **II, pp. 301-357.**

(On 3 November a note was received written by catechist Hartgringh from Tapouliang that Caylouangh, the brother of the ruler of Lonckjouw, had complained to him that every day some of his people ran away because (in his opinion) they did not like to be subjected to the Dutch State. To stop that he had ordered the heads of the runaways to be hacked off. This had happened to five women who however turned out to be his brothers' subjects. On 5 November Hartgringh was advised to investigate this case from both sides.)

244. Resolution, Tayouan, 5 November 1644.
VOC 1148, fol. 252.

fol. 252: [...] wert verstaen dat men door den politicus Cornelis Caesar de outsten van Xincan, Soulang, Bacoloangh, Mattauw, Tavocan, Tivorang, Dorcquo ende Tirosen sal laten aendienen dat jaerlijcx op dien tijt als haere recognitie betaelen oock op te brengen sullen hebben soo veel rijs als d'inlandtsche schoolmeesters van ider dorp voor haar persoonen tot voetsel ofte onderhout voor een geheel jaar vereyssen. 't welck op nieuwe jaer toecomende aenvang nemen sal.

fol. 252: [...] it was decided that the principals of Sincan, Soulang, Bacaluan, Mattauw, Tavocan, Tevorang, Dorko and Tirosen will be notified by the political administrator Cornelis Caesar that every year, at the time they pay their tribute, they will also have to provide as much rice as is needed by the native schoolteachers of each village as food or sustenance for a whole year. This will commence at the coming new year.

245. Resolution, Tayouan, 14 November 1644.
VOC 1148, fol. 253-254.

fol. 253: [...] is doenmaels geresolveert dat men de outsten van de Noordelijcke dorpen Xincan, Soulang, Bacoloang, Mattouw ende Tavocan, die groote moeiten met de jacht hebben, ende op haere velden selffs gejaecht werden volgens gewoonte tot 25 à 30 in 't getal, een vrij jaeghbrieffken geven sal. [...]

fol. 254: [...] Gemerckt de dorpen Xincan, Soulang, Bacoloan, Mattouw ende Tavocan voor 695 realen van achten aen de meest biedende verpacht sijn, soo is op 13en deser geresolveert omme den pachters te maintineeren, dat men een ider bij placcate publiceren ende verbieden sal dat in de voors. dorpen niets en sullen vermogen te gaen handelen, ofte oock die daer woonen iets anders handelen, als 't gene noodich tot haer huyshoudinge van doen hebben, op poenen van 't gemangelde ende daer en boven in een gelt boete van tien realen van achten.

fol. 253: [...] it was then decided that the principals of the northern villages Sincan, Soulang, Bacaluan, Mattouw and Tavocan, having many problems with the hunt, while their fields are customarily being used for hunting will be given a free hunting licence to an amount of 25 to 30 deerskins. [...]

fol. 254: [...] Considering that the villages Sincan, Soulang, Bacaluan, Mattouw and Tavocan have been leased to the highest bidder for 695 reals or pieces of eight, it was decided on the 13th of this month that in support of the leaseholders everyone should be notified through placards that it is forbidden to trade any goods in those villages, and that those living there can only trade what they need for their livelihood on penalty of handing over the traded goods and on top of that a fine of ten pieces of eight.

246. Missive Governor François Caron to Governor-General Anthonio van Diemen.
Tayouan, 17 November 1644.
VOC 1149, fol. 691-695. Extract.
See also DRB 1644-1645, pp. 149-155; DRZ, II, p. 358.

fol. 691: t Sedert is den cappiteyn Boon, soo den 12en October passado uyt Tamsuy scheyde, [...] den 29en daeraenvolgende met de gantsche chrijgsmacht die vrij wat gematteert was, over Vavorolangh ende de

riviere van Poncan alhier gearriveert, rapporterende dat alle de dorpen tusschen Tamsuy ende den Patientie-berch, daer 't lant van den Quataongh begint tot negen in 't getal hun goetwillich onder onse gehoorsaemheyt begeven ende de voorgestelde recognitie in de vellen op te bengen belooft hadden, maer dat vermits het ontloopen van den tolck die uyt Tamsuy, met namen Sprakeloos, sijnde in 't lant van gemelten Ongh verscheyden malen van d'inwoonders aengeranst waren, ende niet meer als twee dorpen Bodor, sijnde vol Indiaens geweer ende bouwtuych, ende Passoua, daer hun 't restant van den jongst geslagene Chineese roovers onder d'inwoonders onthielden, verbrant ende gantsch geruyneert hadde sonder eenige merckelijcke tegenstant van hun t'ontmoeten, anders als dat met de ruychte in brant te steken, sulcx sochten te verhinderen. Ende niet tegenstaende d'onse wel genegen waren van yets meer daer omtrent uyt te richten, soo heeft echter ten aensien niet na behooren, vermits 't herde weder door de boot met victualie conden geadsisteert werden, 't volck door 't nat weder ende den moeyelijcken wech, vrij sieckelijck beginnen te werden, 't selve niet connen onderleggen, maer tot naerder gelegentheyt in staet moeten blijven, 't welck oock naer desen voornemens sijn te doen, [...].

fol. 691: Captain Boon, leaving Tamsuy on October 12, has arrived here on the 29th via Vavorolangh and the Poncan river region with all his troops, who were quite tired. He reported that all the villages, nine altogether, between Tamsuy and Mount Patiëntie – where the land of the Quataongh starts – have voluntarily submitted to our authority and have promised to pay the proposed tribute in skins. However, because the interpreter from Tamsuy, called 'Sprakeloos' (Speechless), had run away, when they were in the land of the aforementioned Ongh, they were attacked several times by the local people whereupon they had burned down and completely destroyed two villages, Bodor, which was full of Indian sidearms and bows, and Pasua, where the remainder of the recently defeated Chinese were staying among the inhabitants. They had encountered little resistance, except that they tried to stop the [Dutch] troops by setting fire to the bushes. And although our people were prepared to do more, they could not do so because it was impossible to get provisions from the boat owing to bad weather, and because the health of our men was deteriorating because of the rain and the difficult journey. Therefore they had to leave it for now, but it remains their intention to undertake more at the next opportunity. [...]

247. Formosa Narrative compiled by Senior Merchant Johan Verpoorten from the reports sent from Tayouan between 2 December 1644 and 1 December 1645.
Batavia, [1 December 1645]. VOC 1158, fol. 1-51.
See also FORMOSA UNDER THE DUTCH, pp. 205-208; ZENDING, IV, pp. 17-21; DRB 1644-1645, pp. 123-176.

248. Order and instruction from Governor François Caron for Reverend Simon van Breen, departing to Vavorolang and the neighbouring villages to act as administrator in local political affairs during the absence of the Company representative in that district.
Tayouan, 7 December 1644.
VOC 1149, fol. 672-673.

fol. 672: UE. die metten eersten naer Vavorolangh [...] te vertrecken staet, omme aldaer ende inde omliggende dorpen [...] tot bekeeringe ende onderwijsinge der blinde heydenen des Heeren dienst te exerceeren, is ongetwijfelt uyt eygen bevindinge ten deele bekent dat menichte van mesusen ende enorme grouwelen, als noch onder de barbaren in swange gaen, die niet soo haest wij wel wenschen, maer allenskens door goede regeeringe ende straffen sullen moeten werden uytgewischt, gelijck oock veelderhande cleene sacken (die correctie vereyschen) wegens geseyde inwoonderen als ons eygen volcq connen voorvallen, ende alsoo tot noch toe (door ongelegentheyt) geen politijck persoon in dat gewest ordinarij wert gebruyckt, evenwel de swaerwichticheyt der saecken wel hoochnodich vereyscht, daerover goede ordre ende reglement werde gehouden. Soo hebben in onsen rade goetgevonden ende g'arresteert UE. t'authoriseeren omme vooreerst ende bij provisie de politijcke saken in UE. district (welcq bovenal de noordelijcke dorpen boven Tirosen ende tot West Gielem toe sich uytgebreydt) in absentie van onsen politicus ende met kennisse van de gestelde bevelhebbers der geseyde dorpen, te dirigeren tot welcken eynde UE. dit volgende te recommanderen hebben, namentlijck: Aengesien de inwoonders in vooraengeroerde begrijp veeleer wilde als redelijcke menschen schijnen, tot noch toe hare kinderen (die te veel hebben ofte niet wel voeden connen) als jonge honden dooden, ende andere heydensche grouwelen meer bedrijven, soo sult deselve dienen, allenskens door soete (doenelijck wesende) des neen met straffe middelen tot civilder maniere van leven te brengen; ende soo interim het dooden haerer kinderen (waerinne niet weten dat sij qualijck doen) ofte

diergelijcke abominabele acten blijven continueeren, sult to nader ordre den genen die daerop compt te attraperen, tot straffe doen betalen een volwassen vercken, gelijck voor desen op Formosa in diergelijcke occasiën gebruyckelijck is geweest, doch onvermogen tot voldoeninge bevint, wel dapper met slagen daerover doen corrigeren; op dat met Godes hulpe eenmael als menschen mogen geregeert worden.

Haere dooden verstaen wij datse in putten leggen ende alsoo sonder aerde gedect onbegraven laten, dat immers (behalven d'onhebbelijcke maniere van doen) door den grouwelijcken stanck seer groote infectie van de lucht ende dienvolgende geen cleene ongesontheyt in dat gewest causeren moet. Dese ongeschicktheyt sal UE. almede dienen te redresseren ende om die plaetse voor haer als onse natie verdraechlijcker te maken de inwoonderen bijwijlen tot de lantbouw ende aenquekinge van vee te animeren waertoe verhopen geseggelijck sullen sijn.

Ende opdat geen onnoosel bloet vergooten werde, nochte onse onderdanen in soo teeren beginsel tot verwilderinge geraecken, sult dat woeste volck (soo veel mogelijck in de toom houden met geestelijcke ende politijcke bevelen, deselve geensints toelatende jegens haere vijanden ten oorloge te trecken maer hun stadich inprentende soo van haere nabuuren werden verongelijckt, dan dierwegen aen ons hebben te clagen als wanneer daerinne na behooren sullen versien ende haer als onse ondersaten mainteneren.

Ingevalle (gelijck wel can gebeuren) in die contrijen noch eenige roovers mochten remoreren, blijft UE. gerecommandeert degeene die met hulp der inwoonderen (al waren sij maer daervan gesuspecteert) in UE. gewelt becomen cont, nevens attestatie t'haren laste herwaerts aff te senden, gelijck UE. oock met Chinesen, die sonder licentie brieffkens aldaer bevonden werden te negotieren, gelieft te handelen [...].

Eyndelingh willen UE. in 't generael gerecommandeert hebben alle andere cleene voorvallende saken, die door onervarentheyt voor als noch niet connen bedencken, ofte in desen specificeren, met communicatie der outsten (fol. 673) van de respective dorpen, naer consciëntie ende redelijckheyt te decideren die misdoen met boeten ofte andere straffen naer exigentie van saecken mulcteren, mitsgaders trachten soo veel doenelijck doorgaens de costumen onser landen ende alle goede zeden in te voeren, edoch saken van gewicht, oock die uytstel meriteren ende lijden mogen, herwaerts (met soo veel bescheyts als mogelijck zij) renvoyeren, [...].

fol. 672: Your Excellency who is about to leave for Vavorolangh to carry out Our Lord's will in converting and educating the blinded heathens, will

undoubtedly know from your own experience that many abuses and enormous atrocities are still being committed among the barbarians. These cannot be eradicated as quickly as we would wish, but only gradually by good governance and punishment. There also may occur all kinds of small incidents (that need redressing) with regard to those inhabitants as well as our own people. Therefore, although until now no political person was usually posted in that district (because of the unfavourable circumstances) seeing that the importance of the events requires that the right instructions and regulations are applied, we have approved and decided in Council to authorise Your Excellency to settle, for the time being and provisionally, the political cases in Your Excellency's district (which extends to the northern villages north of Tirosen and as far as West Gielim), in the absence of our political officer and with the knowledge of the appointed commanders of those villages. For this purpose we recommend Your Excellency the following: Because the inhabitants of this region seem to be savages rather than reasonable human beings, who still kill their children (having too many of them or not being able to feed them) like young puppies and committ many other heathen atrocities, you will have to gradually induce them to a more civil way of life, by friendly means (if possible), or else by harsh means. And if in the meantime they continue to kill their children (not being aware of its wickedness) or to commit suchlike abominable acts, you will, for the time being, make the culprits pay a full-grown pig as a penalty, as has been customary in Formosa in these cases; and if they are not able to pay, they will have to be punished by a severe caning, so that with God's help they may one day be governed as human beings.

We understand that they place their dead in a pit and leave them unburied, not covered with earth, which (apart from being a disgusting habit) will obviously badly infect the air because of the horrible stench, and will cause all manner of diseases in that region. You Excellency will also have to redress this undesirable situation. And in order to make that place more tolerable for them and for us you will now and then stimulate them to agriculture and cattle breeding, to which we hope they will be agreeable.

In order that no innocent blood is spilled, and that our only recently pacified subjects will not again fall pray to barbarism, you will (as much as possible) keep a tight rein on that savage people with spiritual and

political instructions. Under no circumstances you will allow them to go to war against their enemies, but always impress upon them that if they are wronged by their neighbours, they have to come to us with their complaints, and we will take the appropriate measures and support them as our subjects.

In case some pirates are still present in those parts (which is not unlikely) Your Excellency is instructed (even if only based on suspicion) to send to us all those Your Excellency is able to capture with the help of the local people, accompanied with a written indictment. Your Excellency will do likewise with the Chinese who are found trading there without licence [...].

Finally, we recommend Your Excellency in general to decide – according to your conscience and reason and with notification to the principals of the villages – in all other instances of lesser importance that may occur and that do not come to mind or can be specified now because of the unfamiliar circumstances. Offenders will be fined or otherwise punished according to the gravity of the case. And you will try as far as possible to introduce the customs of our nation and good moral behaviour. However, important cases, that need time and can be postponed, you will remit to us (with all the necessary documents).

249. Instruction from Governor François Caron for Merchant Antony Boey, departing as political administrator to the Southern villages. Tayouan, 13 December 1644. VOC 1149, fol. 674-677.

> fol. 674: [...] UE. sal bij alle occasiën den inwoonderen steets wel ende op 't minnelijckste bejegenen, patientelijck met hun omgaen ende met alle practicabele debvoiren doen blijcken dat de politicque regeringe oprecht ende billick tot voorstant van de goede ende straffe der quade bij Godt de Heere ingestelt is, dat om haare teerheyt voortijts gedoocht hebben, door de kerckelijcke persoonen geleyt sijn geworden, maer nu eenichsints tot meerder kennisse gebracht sijnde, oock den politicquen staet te haren besten ende na d'ordre onser landen onder haer soecken te practiseren, opdat de persoonen die haer duslange in de Christelijcke waerheyt onderwesen, daerdoor te beter bequaemheyt mochten hebben, om haer sonder anderen becommernissen 't padt der Salicheyt meer en meer aen te wijsen. [...] Vertrouwen wij den inwoonder allenskens van sijnene

brutaelen aert veranderen, merckelijcker ende tot recht begrijp van onse goede intentie sal connen gebracht werden, daer U bij alle occasie naerstelijck op te letten staet.

Alle saken die soo inde Politie als Justitie op Formosa voorvallen sullen na den reguel ende ordre onser landen gehanthaeft ende uytgevoert werden, daervan de crimineele ons voorbrengen, mitsgaders de cleene civiele met de hooffden van ijder dorp, daer de fault geperpreteert wert, affhandelen ende d'importantste ons eerst communiceren sult; latende de voors. hoofden doorgaens die eere genieten dat op d'aff te doene delicten eerst haer gevoelen van de straffe verclaren, die dan (soo met onse costuymen quadreren) ofte te volgen, ofte wel naer gelegentheyt (hun alvoren sulcx anders hebbende doen goetvinden) te verswaren ofte te verlichten hebt; gevende hun altijts bondige onderrechtinge om wat redenen dees en gene veranderinghe geprefereert wert, waerdoor ongetwijfelt seer tot ons wennen, ende te eerder onse lantsgebruycken cundbaer werden sullen, [...].

Omme van d'inwoonders tot soulaes van 's Comp.ˢ swaer dragende lasten op Formosa eenigen nut ofte dienst te trecken, daertoe voor desen niet gantschelijck gehouden, maer voor 't meerendeel tot noch toe in geëxcuseert gebleven sijn, soo sal U met alle heuschheyt betrachten dat niet alleen op alle dorpen, de kercken, scholen ende de huysinge soo van politicque als kerckelijcke persoonen van bambousen eens opgebout, maer ooc dat deselve ende de paggers daerom staende, steets behoorlijck onderhouden werden. [...] Met alle soeticheyt moet voors. inwoonders hiertoe allenskens sien te brengen, ende daerbij altijts eenige redenen tot voldoeninge voegen.

Ende gemerct 't gesaeyde dagelijcks incomt, 't welck omtrent ultimo deses achten meest alles ingesamelt sal sijn, hebben goetgevonden Ulieve bij desen te gelasten voors. tijt verstreken sijnde, de belooffde recognitie in vellen ende padie van de Suydelijcke dorpen (gelijck nu twee jaren naer den anderen geschiet sij) in te voorderen. 't Welck is voor yder huysgesin: twee goede elantshuyden ofte vier hertevellen Cabessas, ofte acht ditos Barigos ofte sestien ditos Pees ofte wel, als geen vellen hebben, twintich cattij suyveren padij. Doch sagen liever in vellen conden voldoen, omdat sulcx de Comp.ᵉ voorderlijcxst is, waerin (naer discretie moet gaen) ende nemen sulcx de luyden gelegen comt te geven (fol. 675) excuserende alle bevelhebbers gesinnen die in Regeringe sijn, ende alle impotente luyden.

De gemelte recognitie is de voorleden jaren bij ijder dorpsvolcq op een welgelegen plaets omtrent de riviere van Tamsuy, daer men met

vaertuygen gevouchelijck aff en aen can, in een expres daertoe opgeslagen huys gebracht ende voldaen, [...].

Opdat geen onnoosel bloet vergoten wert, nochte onse onderdanen op Formosa tot verwilderinghe geraken, soo sal U in geenen deelen toestaen, gelijck voordesen meermaels, jae buyten kennisse van de gouverneurs wel is geschiet, dat eenige derselver jegens hare vijanden ten oorloge ofte uyt vechten gaen, maer hun steets inprenten, dat soo ergens in verongelijct werden, ons sulcx te clagen hebben, ende wij daerinne naer behooren sullen versien, edoch besprongen werdende, hebben haer als mannen te defenderen. Ende op dat allenskens van de wapenen tot den lantbouw mogen gebracht werden, soo sal U met d'outste der dorpen alle practicable middelen in 't werck stellen, dat hunne rijsvelden vergroten ende die (gelijck de Chinees doet) leeren beploegen, besaeyen ende in oegsten, als wanneer bevinden met vrij veel minder moeyten meer gewasch erlangen sullen, 'dat 't gene boven hun dagelijcx onderhout t'over hebben, haer voor eenen redelijcken prijs bij de Comp.ᵉ sal affgenomen werden, ende dat dusdoende metter tijt tot aenwasch van middelen sullen connen geraken, [...].

Insgelijcx om alhier met geen onnutte, ende alle cleene saken (die den Formosaen aen ons te versoecken, ofte aen te brengen mocht hebben) geumbrageert te werden, soo moet den selven insinueren dat alle soodanige saken U eerst te communiceren sal hebben, omme naer op d'importantie van dien geleth ende ons die als vooren geadviseert hebt, met behoorlijcke kennisse benevens U persoon ende één der tolcken, ofte wel één tolck alleen, aff te comen als wanneer door U ten rechten van de voorstellende saken connen gedient werden, oock met des te beter begrip en fatsoen deselve steets sullen connen affhandelen, daer anders (sonder voorweten alhier verschijnende) telckens om tolcken ende dienstich onderrecht wat van hunne saken is, benoodicht sijn. [...]

Ende alsoo wij bij ervarentheyt bevonden hebben, waerover oock de predicanten meermaels clachtich gevallen sijn, dat eenige die, in commissie op Formosa gesonden waren, dickwijls buyten bijsonderen noot (tot achterdeel van de Christelijcke onderwijsinge) de kerckelijcke persoonen hier en daer tot haren dienst gebruyckt hebben, sijn te rade geworden opdat voors. onderwijsinge hierdoor niet te seer verachtert werde Ulieve bij desen te gelasten deselve t'excuseren 't welck, vermits Ulieve twee tolcken sijn bijgevoecht, des te beter can geschieden. Maer extra-ordonnarelijck eenige derselver tot 't innen van recognitie als anders nootsakelijck van doen hebbende, sal Ulieve sich met kennisse van den praedicant ofte' proponent onder wiens opsicht dat staen, daervan mogen

laten dienen, die altijts (soo bij der hant is) sulcx waerschouwen sult, ende des neen can Ulieve hem 't selve naderhant communiceren, opdat de vacerende plaetse ondertusschen met andere onderwijsers mach versien werden, [...]

Uyt de dagelijcxse voorvallen g'experimenteert hebbende, dat met het ondersoecken in de saken van Justitie, als 't uytvoeren van dien, ende d'inlantsche misdadigers als getuygen aen 't casteel te brengen men veele moeyten ende costen heeft. Soo wert Ulieve tot voorcominge van 't selve belast, alle soodanige misdadigers costi in hechtenisse te stellen, hare faulten ten overstaen van eenige bevelhebberen wel t'examineren ende ons bij eerster gelegentheyt de stucken t'haren laste beleyt, over te schicken om alhier bij den raet van Justitie daerop behoorlijck geleth sijnde, tot het uytvoeren van de Justitie voorder te procederen, ende ordre te stellen. (fol. 676) Aengesien voorleden jare de Sattenause, Dolatockse ende Panghsoise dorpen, die vrij cleen sijn, wijt ende sijt verspreyt leggen, versocht hadden dat in yder van deselve een leeraer, om hun in de fundamenten der Christelijcke religie te onderwijsen, gelecht mocht werden. 't Welcq om hare menichte, ende dat sulcx de Comp.ᵉ te lastich was, niet en heeft connen geschieden. Echter om dit goede werck te voorderen ende haer diesaengaende contentement te doen, soo sijn met bewilliginge van de bevelhebbers, de voors. dorpen ineen getrocken ende van achtentwintich cleene acht groote gemaect ende nu genaemt: Tapouliangh, Vorovorongh, Sattanauw, Tidackjan, Dolatocq, Netné, Tackriangh, Panghsoja, [...], Ulieve sij hoochelijck gerecommandeert behoorlijcke inspectie te nemen ofte 't selve nae onse goede intentie al heeft plaets genomen, ende 't gebrekende daeraen te doen voltoyen.

Opdat de sieckentroosters ende schoolmeesters in 't uytbreyden van de Christelijcke religie onder den Formosaen te onbecommerder souden mogen voortvaren, soo is den predicanten 't gesach over deselve opgedragen ende toegestaen; UE. sal derwegen niet gedoogen daertegens wert gepractiseert, noch dat de outsten haer met eenige authoriteyt over de scholieren bemoeyden want sulcx de kerckelijcke persoonen ende geen andere conveneert, soo wel over alle oude als jonge scholieren, dien 't haer beurt is om ter schole te comen, sonder dat den politicq, bij occasie eenige inwoonders van noode hebbende, vermogen sal ijmant van deselve tot sijne dienst (gelijck voordesen) te gebruycken, maer sal sich moeten behelpen met den geenen, die voor dien tijt van de scholen geëxcuseert sijn. Oock sullen geen outsten hare burgerije conscent mogen verleenen, om gelijckelijck met het gantsche dorpsvolck uyt jagen te gaen, maer blijft sulcx aen Ulieve gedefereert die daerin discretelijck sonder verachteringe

der scholen ende met kennisse van de kerckelijcke persoonen dient te gaen. [...]

Ende alsoo daer noch veele bejaerde persoonen in de dorpen van Ulieve district sijn, die van weeder sijden (soo man als vrouw) noch heydenen wesende, met den anderen huyshoudende ende seer beswaerlijck inde Christelijcke religie connen onderwesen werden, soo is ten hoochsten raetsaem geoordeelt, om in geen hoerdom te leven, dat soodanige bij den anderen sullen vermogen te blijven, ende door den politicq resident in den huwelijcken staet bevesticht werden, mits dat haer de gelegentheyt van den trouwbant (soo veel doenelijck) ingescherpt werde, waeronder oock besluyten soodanige heydense persoonen, die naderhant daerom mogen versoecken, ende met den anderen noch niet versamelt sijn, 't welck alsoo bij alle occasie t'observeren hebt.

Ten aensien de traecheyt in 't frequenteren der kercken ende scholen, dagelijcx bij d'inwoonders toenam, soo is op het voordragen van den Kerckenraet om geen verachteringe in dat noodige werck te lijden, langh voordesen goetgevonden ende rede in de Noordelijcke dorpen in gebruyck gebracht, dat ijder bedaecht persoon voor elcke reys dat uyt kerck ofte schoole comt te absenteren, een hinnevel verbeuren sal, welcke absentiën bij de schoolmeesters van ijder dorp partinentelijck aengetekent om de twee maenden eens bij de bevelhebbers ingevoordert ende den politicq ter hant gestelt werden sullen, die daervan eens 's jaers aen ons ofte gecommitteerdens, in 't bijsijn der outsten, rekeninge te doen sal gehouden wesen ende dan te sien hoedanich voors. boeten oirboorlijcxst gebeneficeert sullen werden. Edoch alsoo dese ordre tot noch toe in de Suydelijcke dorpen niet en is gepractiseert, soo sal Ulieve met kennisse van de kerckelijcke persoonen besorgen, dat sulcx naer behooren ende met discretie, dewijle aen dien cant noch vrij teer sijn, mede geobserveert werde.

Opdat alles om de Suyt in Ulieve circuit te gereguleerder mach toegaen, soo sal 't ten hoochsten geraden weesen dat in 't noorder mousson, als wanneer de wegen drooch ende reysbaer sijn, twee ende in 't suyder mousson ten minsten eenmael 's maents de visite allerwegen in de dorpen doet, om van alle voorvallende saken kennisse te nemen ende d'inwoonders hierdoor in ordre te houden. [...]

Ende opdat ons doorgaens gerust mogen stellen over 't beloop van saken om de Suyt, soo sal Ulieve tweemaels ter maendt praeciselijck ons den toestant van Ulieve gewest aencundigen, daerop wel te letten hebt, dewijle ons daerop verlaten sullen.

Alle dorpen die om de Suyt ende in 't geberchte met ons noch niet
bevredicht sijn, sult soo selve als door de bevelhebbers van de
subjecterende dorpen, bij alle occasie minnelijck tot onse vruntschap
nodigen, ende genegen sijnde, om aen 't casteel voorts te verschijnen,
deselve daerin behulpsaem wesen [...].

Dit is dan soo 't gene voor praesent tot uwer naerrichtinge in
d'aengevangen politicque bedieninge hebben goet gedacht Ulieve in
mandato te geven, ons voorders gedragende aen de notitiën van de
Noordelijcke ende Suydelijcke lantsdage, waerbij d'instellingen van de
regeringe der Formosanen [...] claerder uytgedruct hebben. [...].

fol. 674: [...] Under all circumstances and at all times Your Excellency will
treat the local people well and in a friendly manner, you will deal with
them patiently and by all practicable means show that our political rule is
sincere and just, ordained by Our Lord to protect the good and to punish
the bad. So far we have allowed them to be guided by clerical persons
because of their innocence, but now that they have been raised to a better
understanding, we intend to establish a form of political rule in their best
interests and based on the institutions of our nations, so that the persons
who have until now taught them the Christian truth will be all the more
able to direct them to the path of salvation, without [being troubled by]
other worries. [...] We trust that in the long run we can change the brutal
nature of the local people and make them fully understand our good
intentions. It will be your duty to zealously pursue this aim at every
opportunity.

All cases, political as well as judicial, that occur on Formosa will be
maintained and executed in accordance with the rules and regulations in
our countries. The criminal cases will be brought before us while you will
deal with minor civil cases in collaboration with the principals of the
villages where the offence is committed, but the most important cases
should first be communicated to us. In general you should give the
aforementioned principals the honour to offer their opinion on the
punishment for the offences in question, which you will then either follow
up (if it squares with our customs), or (having persuaded them to agree)
enhance or alleviate, according to the circumstances, always giving them
a concise explanation why you preferred one change or the other. In this
way they will without doubt become accustomed to us and more quickly
get used to the customs of our nation, [...].

In order that we may profit from the local people and make good use of them so that we can lighten the Company's heavy burdens on Formosa, you will make serious efforts that in all villages churches, schools and the houses of political as well as clerical persons not only will be constructed with bamboo, but also that these and their surrounding fences are kept in good repair. [...] Little by little you will try and induce the people in an amicable way to comply and you will always give them some reason for contentment with their situation.

Noticing that the crops are now harvested daily, which we think will be mostly completed at the end of this month, we have hereby approved to charge you to collect the promised tribute in skins and paddy at the appropriate time from the southern villages (as has already been done for the past two years). For every family this will amount to two good elk-skins or four deerskins *cabessa* (of the highest quality), or eight ditto *bariga* (of average quality) or sixteen ditto *pee* (of low quality), or if they do not have skins, twenty catties of pure paddy. However, we prefer being paid in skins, because it is more profitable to the Company. It is at your discretion to collect what is the more convenient for the people. All families of principals that are in power as well as destitute people will be excused.

Last year this tribute was paid by the people of every village by bringing it to a specially constructed building at a suitable place near the river Tamsuy, where vessels could easily come and go.

In order that no innocent blood is spilled and our subjects on Formosa do not fall prey to barbarism, you will under no condition allow, as has happened several times in the past even without the knowledge of the governors, that some of them go to war against their enemies or fight with them. You will always impress upon them that in case they are wronged they should bring their grievances before us whereupon we will take the appropriate measures. However, if they are attacked they will have to defend themselves like men. Furthermore, in order that they may be gradually led away from arms and to agriculture, you will – together with the principals of the villages – use all practicable means to make them extend their rice fields and make them learn how to plough those fields (as the Chinese do), how to sow and how to harvest. They will then see that they gather a bigger harvest with much less labour, and that what is left after their daily needs are satisfied will be bought from them by the

Company at a fair price and that thus in due time they will be able to gather wealth. [...].

Furthermore, in order that we are not overshadowed by insignificant and all the minor cases (that the Formosans may want to request us or would like to put before us), you will make it clear to them that they will first have to communicate all such cases to you. After assessing the importance of the case and having informed us as you have done in the past, you will personally come down here well informed together with one of the interpreters, or [send] one interpreter on his own, so that we may be well informed of the case before us and will always be able to deal with it with good understanding and in a fair manner. Otherwise (if they appear without our advance knowledge), we will over and again need interpreters and useful instruction on their case. [...].

We know from experience – and also from repeated complaints received from the ministers – that some people who have been commissioned to serve in Formosa, often without any particular necessity (to the detriment of the Christian education) have used clerical persons for their own [administrative] purposes. Therefore, in order that education does not fall behind because of this, we have decided to instruct you to put an end to this practice. This can be done all the more easily because two interpreters have been assigned to you. However, in exceptional cases, if you need some [clerical persons] for collecting tribute or for some other necessary business, you are permitted to call in their help, so long as you inform the minister or proponent under whose authority the people concerned are. You must always notify the minister (if available) of this and if not available you will tell him later, so that in the meantime vacancies may be filled by other teachers, [...].

From everyday experience we have learned that in investigations in judicial cases and in carrying those into effect, as well as in bringing native criminals and witnesses to the castle, much trouble and great expense are involved. To prevent this you are instructed to detain all such criminals in your village, to thoroughly investigate their crimes in the presence of some of the principals and then send us the bills of indictments at the first available opportunity in order to proceed with the enforcement of justice and to pass sentence after proper consideration by the Council of Justice here. (fol. 676)

Last year the villages of Swatalauw, Dolatock and Pangsoya, which are rather small and lie scattered far and wide, had requested that a teacher be appointed in each of those villages to educate them in the foundations of the Christian religion. This could not done because of their large number and the difficulties it would present the Company. However, in order to advance the good work and to satisfy them in this respect, we have, with the approval of the principals, joined those villages and created eight large ones out of twenty-eight small ones. These are now called Tapouliang, Verovorongh, Swatalauw, Tedackjangh, Dolatock, Netne, Taccareyang, Pangsoya, [...]. You are strongly advised to thoroughly verify if this has already been accomplished in accordance with our wishes and to complete whatever has not yet been done.

In order that the attendants of the sick and the teachers may continue spreading the Christian religion under the Formosans even more freely, we have allowed the ministers to be given authority over them. Your Excellency will therefore not permit any contravention, nor allow the principals to interfere with the authority over pupils, because it comes within the compass of the clerical persons and of no one else, to decide which pupils, young as well as old, are to attend school. The political administrator, in the event that he needs people, will not be allowed to use any one of these pupils to serve him (as he already has done in the past), but will have to make do with those students who are excused from attending school at that time. Furthermore, the principals will not be allowed to give their fellowmen permission to go hunting all together with the other villagers. This remains your responsibility, and you should discretely deal in these matters without neglecting the schools and with consent of the clerical persons. [...].

Because there are still many old people in the villages of your district who are living together while both (men as well as women) are still heathens and while it would be very difficult to educate them in the Christian religion, therefore it was deemed highly advisable, in order to avoid living in sin, to allow them to stay together and to have them confirmed in matrimony by the political administrator, on condition that the obligations of the bond of marriage are impressed upon them (as far as is possible). This will also apply to those heathens who may later make this request and are not yet living together. You will have to observe this rule at every opportunity.

The slackness of the local people in visiting church and school is increasing almost daily. On the proposal of the Church Council it has therefore been decided – as has been agreed and put into practice in the northern villages a long time ago – in order to avoid a decline in this necessary work, that every adolescent every time he fails to attend church or school will be fined a hind-skin. These absences will be recorded accurately by the schoolteachers of every village, collected every two months by the principals and handed over to the political officer, who will have to submit a statement to us or our representative in the presence of the principals, after which it will be decided how these fines will be put to good use. However, because this order has not yet been put into practice in the southern villages, you will make sure, keeping the clerical persons informed, that it should be implemented fairly and with restraint, because the people over there are still rather simple.

In order that all matters in the South in your district may progress in a more regular way, it is highly recommended that during the northern monsoon, when the roads are dry and easily passable, you will visit all the villages twice a month and during the southern monsoon at least once a month, to be informed of all events and to keep a tight rein on the inhabitants.

(Your Honour and the interpreters on all occasions will have to inspect the fishermen at Jockam, Tancoya and the Tamsuy River along the sea shore, the Chinese woodcutters in the forests over there and the 30 Chinese huntsmen in the Swatalauw or other fields in that area, as well as the 25 Chinese tax farmers in the Southern villages and furthermore everyone else who we have permitted to be involved in some business in that area. (fol. 677). You especially have to make certain that no Chinese, except those who have a special licence, (who have to be protected from the inhabitants) will be tolerated in that area. Offenders had to be sent to Tayouan [...].)

And so as to continually reassure us about the developments in the south, you will twice a month inform us accurately of the situation in your region. You will make sure of this, because we shall be relying on it.

.At every available opportunity you will personally as well as through the principals of the subjected villages, amicably invite all the villages in the south and in the mountains, that do not yet live in peace with us, to be

our friends, and if they are willing to appear at the Castle, you will assist them in every way [...].

For the present this is the advice we would like to give you as you take up the political office. For the rest we refer to the minutes of the Northern and the Southern Land Days, in which we have explained the institutions of the administration of the Formosans more clearly. [...].

250. Original missive Governor François Caron to Governor-General Anthonio van Diemen.
Tayouan, 27 December 1644.
VOC 1149, fol. 635-643. Extract.
See also FORMOSA UNDER THE DUTCH, p. 205; DRB 1644-1645, pp. 155-160; DRZ, II, pp. 358-359.

fol. 640: [...] Op den aenwasch van 's Comp.es incomsten, tot soulaes der sware ongelden, wert doorgaens met aendacht gelet, [...] gelijck tot een beginsel aende 5 dorpen Sincan, Tavocan, Bacoloangh, Soulangh & Mattauw is gebleken, welckers verpachtinge, tot ultimo April aenstaende, ongevaerlijck 200 reaal rendeert, gelijck de drij dorpen genaemt Gielem, Cleijn Davolé ende Dorenap tot 555 reaal in November verleden, voor den tijt als boven mede verpacht geworden zijn. [...]

fol. 642: [...] Den tijt beginnende te genaken, om volgens UEd. heers ordre ende 's Comp.s progressen op Formosa, de lanttochten bij der hant te nemen, tot straffe der moordenaers ende rebellen van Sapiën, Tellaroma, Vadaan ende andere malignanten, die sulcx meriteren, vermaninge der swacken, ende maintenue onser reputatie, voor de ooren ende oogen der geene, met dewelcke noch niet corresponderen, doch principalijck de poorten ende toeganck tot de goutmijn op te speuren, soo hebben bij resolutie vastgestelt ende besloten een armée (bestaende uyt 210 soldaten) [...] te formeren [...]. Ende alsoo desen tocht geprojecteert naerde noordoost cant van Formosa, veel reysens in heeft ende een werck is dat met verstant ende goet beleyt moet wesen uytgewrocht [...] soo hebben goet ende noodich gevonden dese armée te verstercken met [...] de oppercoopluyden Cornelis Caesar ende Nicasius de Hooge daernevens den capiteyn Boon gestelt zijnde die derde stemme in den raet zal wesen. [...] Voor gem. tocht ende 't verrichten ontrent de gout-mijne mitsgaders 't straffen der verhaelde dorpen volbracht wesende, zal in Pimaba, ontrent de plaets van het Nederlantse leger eenen generaelen lantsdach gehouden

werden, nae vermogen ende op de wijse als hier in Tayouan is geschiet, [...].

fol 640: In order to ease our great expenses we are continuously looking for ways to increase the income of the Company. [...]. This can for example be seen in the case of the five villages Sincan, Tavocan, Bacaluan, Soulang and Mattauw, the lease of which will yield about 200 reals until the end of April, while the three villages called Gielim, Little Davolee and Dorenap have also been leased last November for 555 reals, for the same period. [...]

fol. 642: [...] The time is drawing near to undertake, in accordance with Your Excellency's instructions and to the advantage of the Company, the expeditions over land to punish the murderers and rebels of Sipiën, Tellaroma, Vadan as well as other wrong-doers who deserve a lesson. This will serve as a warning to the weak and maintain our reputation in the ears and eyes of those with whom we have not yet established relations, although the main aim is to locate the access to the goldmine. Therefore we have decided and laid down in a resolution, that we will put together an army (consisting of 210 soldiers). Moreover, because this planned expedition to the north-east side of Formosa entails much travelling and should be executed wisely and carefully, we found it necessary, and have therefore approved, to reinforce this army with [...] the chief merchants Cornelis Caesar and Nicasius de Hooge, besides whom captain Boon is appointed, who will have the third voice in the council. [...]

After completion of the aforementioned expedition, the operations regarding the goldmine and the punishment of the villages, a general Land Day will be held in Pimaba close to the camp of the Dutch army, as far as possible in the same manner as here in Tayouan.

1645

251. Instruction from Governor François Caron to Sergeant Michiel Jansz., on his journey to Pimaba.
Tayouan, 3 January 1645.
VOC 1155, fol. 616-618. Extract.

(Sergeant Michiel Jansz went to Pimaba as successor of Corporal Cornelis van der Linden who had passed away. According to Governor Caron's orders, Jansz., during his journey, had to see to it that:)

fol. 616: [...] Egeene dorpen daer door passeert ofte namaels eenige Nederlanders comt te seynden en zult, gelijck voor desen tot desrespect onser natie veelmaels geschiet zij, om verckens, dranck, fruyten als dergelijcke eetbare waren ofte ietwes anders, wat het oock soude mogen wesen, anders als voor U gelt, voortaen selffs ofte door anderen van U geselschap, lastich laten vallen, nochte toestaen eenige debauche ende overlast ergens den Formosaen, daer voor wesen cont, aengedaen wert. Opdat door soodanige onhebbelijckheden denselven van ons geenen affkeer en crijge, tot verwijderinge comt ende met haer in moeyten geraken. Straffende een ider na merite, die sich daer in comt te vergrijpen. Want willen wij van den inwoonder behoorlijcke gehoorsaemheyt 't onswaerts gedragen, ende recognitie opgebracht hebben, zoo is immers reden dat voor allen overlast beschermt, ende voor 't gene men haer affvoordert betaelt werden, daer goede achtinge op te nemen hebt.
In Pimaba gecomen wesende, sult d'outsten van 't selve en alle omleggende dorpen met d'eerste bequame gelegentheyt bij den anderen versamelen, haar onsentwegen begroeten ende aendienen, dat vermits 't overlijden van Cornelis van der Linden op haer ernstelijck versoeck U persoon om de saken aldaer als gemelte Van der Linden in sijn leven gedaen heeft behoorlijck waer te neemen, derwaerts hebben gecommitteert. Dat niet en twijffelen ofte zult met den anderen wel gedient zijn ende goede correspondentie houden. Insgelijcks dat sij haer in alles na onse bevelen, beter als voor desen, sullen moeten schicken, daer eenigen tijt herwaerts maer passelijck genoegen in genomen hebben ende dat van nu voortaen sulcx moeten sien in alles te verbeteren, ofte zullen geen vrunden connen blijven.
Tot noch toe, schoon doorgaens tot verhoedinge vandien hun sulcx verbooden is, hebben generaliter alle de dorpen aen d'oostcant van

Formosa, wanneer hun geaffronteert reeckende, d'één tegens den anderen oorlogh gevoert ende bij wijlen malcanderen grooten affbreuck gedaen, 't welck naer desen in geene deelen meer gedencken te gedoogen. Weshalven UE. die van Pimaba ende alle andere dorpen daerover te gebieden hebben, gestadich ende (fol. 617) bij alle voorvallende occasie insinueren zult egeene de minste oorloge, onder wat pretext ende tegens wien het zij, en hebben aen te vangen; dat niet haer maer ons sulcx toecomt te doen, sij stil sitten en t'huys blijven zullen, ende soo haer eenich ongelijck van anderen aengedaen wert 't selve ons hebben te clagen als wanneer, naer op de rechtmaticheyt van dien gelet hebbende, daerinne t'sijner tijt behoorlijck versien, ende den schuldigers wel straffen zullen. Off ten ware van eenige vijanden ontrent hare dorpen ende rijsvelden bestoockt wierden, in welcken gevallen hun mannelijck daertegens stellen en al doodtslaen mogen dat hun vijantlijck voorcomt, waerin oock (met avantagie ende respect geschieden connende) UE. zal vermogen hun met het guarnisoen aldaer de hant te bieden.

Opdat de Comp.ᵉ eenichsints in hare groote ongelden mocht gesoulagieert werden, zoo hebben verleden jare de Oostelijcke nevens de Zuydelijcke ende Noordelijcke dorpen van Formosa recognitie van vellen ende padie, doch soberlijck om haer quaet gewasch halven, beginnen op te brengen, [...]

De dorpen die voorleden jare hebben beginnen recognitie op te brengen zijn, te weten: Pimaba, Loubongh, Sapat, Largornos, Soubrongh, Toutsikadangh, Rimel, Tavalij, Mornos, Pune Wattin, Pune Soere, Marentep, Langhlonck, Ripos, Koes Koes, Lappe Lappe, Pallay, Darkop, Soepra, Tarroma, Neckeboer, Batsilaer, Kinnebelouw, Koeterijn ende Terrewattij Wattij.

Alle dese plaetsen met zoo veel meer als onder onsen staeth resorteren, ende naermaels daertoe gebracht mochten werden, sult de voorgem. recognitie affvorderen, alles in Pimaba doen brengen, ende in 's Comp.ᵉˢ huysinge met goede omsichticheyt voor brandt, diefte, als anders, wel bewaren. [...].

fol. 616: [...] You will make sure that neither you, nor others of your company, will trouble any of the villages you have to pass through, nor any village where any Dutchman might be sent to in the future, for pigs, drink, fruits or similar provisions, or whatever else it might be, otherwise than on your own account. You will not allow, as often has happened in the past and much to the shame of our nation, that any inconvenience or harm is caused to the Formosans, which could make them become ill-

disposed towards us, which undoubtedly will result in our drifting apart. Therefore, to avoid the risk of creating problems with them you will judge every offender on his deeds and punish him accordingly. The reason for this is that if we require obedient behaviour from the Formosans and the payment of taxes, then they should be safeguarded from any nuisance and know that they will be properly paid for everything which we will acquire from them.

On the first possible occasion after your arrival you will order the headmen of Pimaba as well as the surrounding villages to assemble, so that you can greet them on our behalf and announce to them that, because of the death of Cornelis van der Linden, you in person, upon their urgent request, have been sent to take over his job. And that we do not doubt that you will assist each other well and that you will maintain good relations. Likewise, that they in their turn will have to follow up our orders better than before, because for some time they hardly seemed inclined to do so. They will have to conform themselves to the Company authority, or else it will become impossible to remain allies.

Even though war has been forbidden to them, even as a means of defence, all the eastern villages of Formosa continue to wage war whenever one of them feels offended by another. In that way they have frequently damaged each other very much, which we will no longer tolerate. You should, on any possible occasion, pay attention to warn Pimaba as well as the other villages (fol. 617) not to raise up arms against any supposed opponent anymore, because from now on the Company will take care of that. Consequently whenever injustice is done against some of them, they should remain quietly at home and inform the Company about it, as we reckon it to be our duty, after having considered the rightfulness of a claim, to punish the guilty ones. If any of their inhabitants, either in their villages or in their ricefields, should be attacked then they may be allowed to defend themselves courageously and beat to death their enemies. In that case, if it can be done in an advantageous and respectful way, Your Honour also are permitted to assist them with the garrison in the fight.

In order to lighten the burden of the Company's expenses somewhat, we levied last year an imposition of deerskins and paddy on the eastern as well as the southern and northern Formosan villages. However because they suffered from a failure of the crop, we contented ourselves with

quite a limited amount. [...] The villages which started to produce the recognition were: Pimaba, Loubongh, Sapat, Largornos, Soubrongh, Toutsikadangh, Rimel, Tavaly, Moronos, Pune Wattin, Pune Soere, Marentep, Langhlonck, Ripos, Koes Koes, Lappa Lappa, Pallay, Dorkop, Soupra, Tarouma, Neckeboer, Batsilaer, Kinnebelouw, Koeterijn and Terrewattij Wattij.

It will be your duty to requisition the mentioned tribute of all these places that belong to the Company's state as well as those that will later on be subjected. Furthermore you will have to make certain that the mentioned tribute is transported to Pimaba and that everything is safely stored in the Company's warehouse, while you will take sufficient measures to prevent fire and theft or other calamities. [...]

252. Missive Governor François Caron to Governor-General Anthonio van Diemen.
Tayouan, 7 January 1645.
DRB 1644-1645, p. 160; DRZ, II, p. 359.

253. Extracts from the Dagregister Zeelandia, concerning Lamey.
VOC 1170, fol. 626-627. Extracts 10, 14 January, 12 February 1645

fol. 626: 10en dito. Retourneert alhier oock overlandt den Chinesen coopman en burger deser stede, Samsiacq, die eeniger tijt geleden door den gouverneur ende den raedt gelast ende geconstringeert was, sich naer 't eylandt Lamey (ter oorsaecke 't selve in pacht, ende sijn volck daerop resideerende heeft) te transporteren ende aldaer soolange te verblijven totter tijt de 15 Lameytse persoonen (op dito eylandt als noch wesende) van daer medebracht. Volgens welcke ordre hij Samsiacq 13 van geroerde persoonen met hulpe van sijn volcq hadde becoomen, die alsnu aenden gouverneur overleverde, wesende: vijf mans, vier vrouwen, twee cleyne jongens, twee dito meyskens.

fol. 627: de resterende twee, sijnde manspersoonen, waren hem ontvlucht, doch gaff hij echter hoope dat deselve erlangen van gelijcken souden werden gevadt.

14en dito. Den Chineesen coopman Samsiack die [...] onlangs door ordre vanden Raedt naer 't eylandt Lamey geweest, 13 vande 15 zielen daervan hier gebracht, doch in 't bevorderen van dien aen dieverse oncosten over de 70 realen (soo hij affirmeert) gedebourseert heeft, wert alsnu ten

aensien van die ongelden als gedaene moeyte gebenificeert met 100 realen van 8ten.

12 Februarij. Heden werden de twee laeste Lameyers van 't Goude Leeuws Eylandt door de Chineesen in 't casteel gebracht.

fol. 626: On the 10th of January the Chinese merchant and citizen of this city of Tayouan, Samsiack, returns over land. This man was urged by the Governor and the Council some time ago to go to Lamey (of which he is the tenant and on which his people are dwelling) and stay there as long as necessary to get hold of the last 15 Lameyans, who still remain on the island so as to deliver them to the governor. According to that order Samsiack, with the assistance of his people, did indeed hand 13 of them over to the governor. They were: five men, four women, two little boys, two ditto girls.

fol. 627: The remaining two men, managed to escape, yet he had high hopes that they could be caught in the same way.

14th ditto. The Chinese merchant Samsiack who [...] has recently been ordered by the Council to go to Lamey and managed to get us 13 of the remaining 15 souls, had quite a lot of expenses of over 70 reals (as he confirms). For the effort that he has put into it he was remunerated with a sum of 100 reals of 8th.

On 12 February the last two Lameyans of the Golden Lion Island were brought into the castle by the Chinese.

254. Instruction from Governor François Caron to the Senior Merchants Cornelis Caesar and Hendrick Steen, and Captain Pieter Boon on the expedition to Tamsuy and Dorenap in the north.
Tayouan, 20 January 1645.
VOC 1155, fol. 619-623. Extracts.

fol. 619: [...] Omme de saken in 't lant van den Quataongh als 't gene vorders aen dien hoeck te verrichten zij te hervatten ('t welcq jongst bij den cap.n Pieter Boon in 't retourneren van Cabalaen ende Tamsuy, vermits 't volcq seer affgemat was, soodanich niet en heeft connen geschieden als ten dienste van de Comp.e wel gaerne gesien hadden) soo is in Rade van Formosa gearrestert deselve macht [...] derwaerts uyt te setten.

fol. 620: In Vavorolangh gecomen zijnde, Ued.s tot den mars ende 't vervolgen van ons desseyn volcomen geprepareert hebbende, zult van daer over Dorenap trecken langhs het strant van des Quataonghs lant, tot benoorden 't selve ende dat wederom op vruntsbodem ofte de dorpen die hun jongst onder onse gehoorsaemheyt begeven hebben. Comt. UEd.s in passant, gelatende als ofte vordre ende na Tamsuy wildet ende het op desselfs lant niet gemunt was, om hem alsoo te verabuseren ende eenichsints buyten achterdocht te houden middelerwijle bij alle occasie onder d'inwoonders (soo veel doenlijck) na de gelegenheyt dier lantstreecke ende waeruyt voordeel vermeynt te sullen connen trecken vernemende. [...] Soo sult oock mede alle de dorpen van benoorden 't lant des gemelten Quata-onghs tot aen Tamsuy toe, haer op de jongste tocht onder onse subjectie begeven, ernstelijck insinueren dat hunne recognitie die laestmael aen den capp.n Boon gepresenteert, ende hem een stuck weeghs naergedragen, nu met den allereersten in voors. Tamsuy aen 't casteel in vellen op te brengen hebben. Ende dat jaerlijcx daerin wat vroeger als nu moeten continueren, ende hun voorders na onse bevelen reguleren, als wanneer haer jegens hunne vijanden mainteneren ende voor allen overlast bevrijden sullen, daer ter contrarie anders doende sware ende soo danige straffe staen t'erlangen als den Quata-onger nu aengedaen werden sal, [...]

Ued.s de saken aldaer invoegen voors. verricht alles naer behoren wel geprepareert, ende uyt voorige becoomen ervarentlijck exactelijck overleght hebbende op wat manieren de vijfthien Quata-ongse dorpen, die als volcht genaemt werden:

Tavacul, Kakar, Tousack Oost, Tousack West, Tarida Suyt, Tarida West, Kakarsakalan, Kakarbarogh, Baberiangh, Asock, Babosock, Alack (fol. 621), Kosato, Tarigarige, Aboangh, best te genaken ende door de wapenen tot onderdanicheyt te brengen sullen zijn.

Sult Ued.s van boven aff herwaerts aen met het gantsche leger ofte wel een gedeelte van 't selve als 't sonder perijckel geschieden can, op U gemack sonder sich te verhaesten langhs en dwers soo de gelegentheyt best aenwijst door 't gemelte lant begeven, ende de voors. plaetsen alle (mogelijck zijnde) met soo veel meer andere alsser dan zijn mogen besoecken. Daertoe soo veel tijts spenderende als tot uytvoeringe deser sake van node is, betrachtende met alle practicabele middelen ende na voorval van saken, 't sij met minne ofte gewelt, deselve ons te doen subjecteren ende niet eer uyt dat gewest te scheyden voordat haere recognitie ter plaetsen door Ued.s daertoe aen te wijsen in vellen etc. opgebracht ende beloften gedaen hebben van daerin jaerlijcx te volherden.

Gebruyckende wijders in alle voorvallende saken soodanige voorsichticheyt dat de Comp.ᵉ hare intentie die Ued.ˢ ten vollen bekent is, erlanght ende nevens de chrijchsmacht gestadich buyten merckelijck perijckel mocht blijven. Niemant vertrouwen wie 't oock zij, maer naest Godt Almachtich, op Ued.ˢ wapenen ende goet beleyt steunende, niet twijffelende offe dese macht is bestant om ons van dien gantschen hoeck meester te maken. [...]

Die van Tavacul, zijnde één vande zuydelijckste dorpen van des Quataonghs lant, hebben verscheyde malen hunne naeste gebuiren, onse onderdanen, hostiliteyt aengedaen, ende noch jongst naerdat van d'outsten met eeten ende drincken wel onthaelt waren ... hooffden uyt gehaelt. 't Welck een stoute ende moetwillige daet is, die UEd.s ten hoogsten gerecommandeert wert met de wapenen tot affschrick van diergelijcke booswichten rigoreusselijck te straffen, opdat onse goede subjecten hierdoor te geruster in hare dorpen mogen blijven woonen [...].

fol. 622: Ja 't ware een gewenschte sake soo [...] ons toebrengen cont [...] den persoon van Quata-ongh selffs. [...]

Om een besluyt onser desseyn te maken ende UEd.ˢ onse, als den Ed. hr. Generaels maxime over de Formosaense gelegentheyt naecter voor oogen te stellen, zoo zullen UE. zijn Ed.ˢ eygen woorden voorleden jare over die materie in mandato becomen, voorstellen. Luydende als volght: in alles wat van dese lieden met vrundelijckheyt, reden ende billicheyt te becomen zij, al rigeur ende straffheyt g'excueert worden, doorgaens wel lettende van ongeregelt volcq geen overlast comen te lijden, op dat van ons niet affkerich werden. Geeft hun behoorlijcke liberteyt wanneer hare lasten ende recognitie in padi, vellen etc. daerop gestelt zijn, contribueren. De wrevelmoedige ende die hun tegens onse ordonnantie opposeren dienen door vrundelijcke aenmaninge ende inductie tot haer debvoir gebracht, ende dat alles niet helpende moeten met de wapenen gestraft ende totalijck uytgeroeyt werden, opdat andere hun daeraen spiegelen. Sonder deselve op haer versoeck (gelijck tot nu toe gedaen is) in genade aen te nemen, ende hare faulten, mits clene boeten betalen, te vergeven. 't Welcq velen tot quaet doen ende affval verwect heeft, wetende op hun aenhouden van de misdaden, pardon becomen. [...].

fol. 619: [...] In order to settle matters in the land of the Quataongh, as well as everything else which has to be arranged in that area (which to our regret, could not be carried out for the sake of the Company of late by captain Pieter Boon on his return voyage from Cavalangh and Tamsuy since his men were too exhausted) so it was decided in the Formosa Council to send out an expedition force thither. [...]

fol. 620: When the entire force has arrived safely in Vavorolangh, and when Your Honours are thoroughly prepared for the implementation of the plan, then you will march from there through Dorenap, along the beach of Quataongh's territory until you have reached the northern tip of it. There you will find yourself to be in allied territory again, since the villages in that area had recently subjected themselves to us.

Everywhere you should pretend that you are underway to Tamsuy, so that the Quataongh does not become distrustful about us having designs on his land, and in order to somewhat deceive him and keep him from becoming suspicious. Meanwhile, on every possible occasion, you should try to make as many inquiries as you can from the inhabitants, about the situation of that region so as to find out how this may be to our benefit. [...]

You will also have to pay a visit with the army to all the villages who subjected themselves during the preceding expedition located north of the mentioned Quataonghs' territory as far as Tamsuy. You should urgently announce to them that they will immediately have to come to the fortress in Tamsuy in order to deliver the deerskins they offered to Captain Boon last time and carried a long way for him, and that they will have to continue to annually pay this tribute at a somewhat earlier time of the year. They will have to obey all our orders and in return the Company will safeguard them against all their enemies and protect them from any trouble. But if, on the contrary these people back out of their obligations they should expect a sharp punishment, just like the punishment the Quataongh will soon undergo for his disobedient behaviour. [...]

When Your Honours have performed everything according to the plan, you will then have to consider carefully finding a way for the army to get near to the following fifteen villages, and in what way those villages could best be subjugated. Their names are: Tavacul, Kakar, Tousack Oost, Tousack West, Tarida Suyt, Tarida West, Kakarsakalan, Kakarbarogh, Baberiangh, Asock, Babosock, Alack (fol. 621), Kosato, Tarigarige, Aboangh.[107]

The expedition under Your Honours' command, has to be undertaken from the north. From there Your Honours can carry out the punitive expedition without trouble, either with the entire army or with any of your men. You can take your time, going along or right across the mentioned land in a southern direction in a way that the local situation

dictates. You will have to visit all the places mentioned and, if possible, as many others as are to be found, spending as much time as it takes to effectuate your orders. In order to reach your aim of reducing those villages to the Company, you will have to make use of all necessary means, either settling things amicably or by force. You are not allowed to leave that district until the people have shown their recognition by delivering deerskins at a certain place indicated by you. Moreover, you have to ensure that they promise to continue to make such a delivery every year. During the expedition you will deal with everything in a careful way and see to it that the Company's intentions, of which you are well aware, are pursued properly, and you will furthermore keep the expedition force out of serious trouble. Therefore you will trust no one but God Almighty, your own arms and your own good sense. Undoubtedly this force is sufficient to completely conquer that area. [...]

The inhabitants of Tavacul, one of the villages in the country of the Quataongh located the furthest to the south have, on different occasions, raised up arms and committed all kind of hostilities against their neighbours, who happen to be our allies. Their was even an occasion very recently that these men from Tavacul when they were welcomed by the elders of their neighouring villages and were treated well to food and drink, seized ... heads from their hosts. This is a dastardly deed which should be rigorously punished by force of arms, so that our faithful subjects can continue to live peacefully in their villages. [...].

fol. 622: Yea, it would be quite desirable if [...] you could capture the Quataongh himself and bring him over to Tayouan. [...]

As to finishing our plan and presenting Your Honours directly with the maxime of His Honour the Governor-General about the Formosan affairs, we will bring to Your Honour's attention the Governor-Generals' propositions concerning the matter put in his own words, which he sent to us last year by means of an ordinance of the following contents: It would be preferable if the Company rule over these Formosan people could be established so that we are then able to get them to do anything for us in an amicable and fair way, without having to make use of strict or rigorous measures. Meanwhile attention should be given to the behaviour of our men for the Formosans should not be troubled by the disorderly behaviour of any of our men which could incur their wrath against the Company. They will be allowed a reasonable latitude once they have

satisfied the imposition in paddy, deerskins etc. Rancorous people and those who oppose our orders at first, should be gently admonished to their duty. However, if such a reminder does not lead to the desired effect we will have to punish the obstinate ones by taking up arms against them and extirpate them completely as a deterrent to others, without showing any mercy (as we used to do before) when we restored them to favour if they were willing to pay a small fine. Such lenient treatment induced a lot of evildoers to become disaffected knowing that the crimes they committed would be pardoned. [...].

255. Missive Governor François Caron to Governor-General Anthonio van Diemen.
Tayouan, 15 February 1645.
VOC 1155, fol. 585-597.
See also FORMOSA UNDER THE DUTCH, pp. 208-209; DRB 1644-1645, pp. 164-169; DRZ, II, pp. 359-360.

256. Extracts taken from the Zeelandia Castle Resolution-books, concerning the resolutions on the island of Lamey, taken in the Formosa Council.
VOC 1170, fol. 599-600. Extracts 14 and 27 February 1645.

fol. 599: 14 februarij. Den coopman ende ingesetenen deser stede Samsjack die onlangs door onse expresse ordre den reyse naer 't Eylandt Lamey gedaen heeft ende volgens 't duydelijck bevel vande Ed. heer Generael van daer 13 vande 15 zielen hier gebracht (edoch soo hij affirmeert), [heeft] in die verrichtinge over de zeventig realen gedeboucheert. Wert alsnu, soo tot vergoedinge sijner oncosten, als ten aensien der moeyte en goeden dienst bij hem aen d'Ed. Compagnies daerinne gepresteert, begifticht met de somma van honderd realen van 8ten. Welcke doch, indien men met eenige macht hadden moeten (als voor desen) derwaerts gaen, op verre nae niet souden hebben toegereyct.

27 februarij. Wert van gelijcken goetgevonden de 12 alhier resterende Lameyers, wesende drij aen de kinderpockjens gestorven, van 15 die onlangs in twee tochten door den pachter als sijn volq van 't Goude Leeuws Eylant gehaelt sijn, onder opsicht van de substituyt Joost van Bergen die morgen vertreckt, naer Sinckan te largeeren om sich (fol. 600) aldaer te generen ende de cost te winnen. Op conditie dat wanneer d'Ed.

heer Generael mochte resolveren deselve na Batavia te ontbieden, tot allen tijden daertoe gewillich ende bereyt sich sullen aenstellen.

fol. 599: 14 February. The merchant and inhabitant of this city Samsjack who, on our express order, has travelled recently to the island of Lamey and who on the Governor-General's explicit orders has brought 13 of the 15 souls over to Tayouan, has spent over seventy reals. In order to compensate him for his expenses and for all his efforts and the good service he has given to the Honourable Company, he was presented one hundred reals of 8th. If we had done this job ourselves and if we had gone over there with quite a considerable force as we have done before, this sum would never have been sufficient.

27 February. Likewise it was permitted that the 12 remaining Lameyans of the 15 (three died of the smallpox) who recently, in two expeditions undertaken by the tenant Samsjack and his men, were deported from Lamey, will be sent to Sincan (fol. 600) under supervision of substitute political administrator Joost van Bergen who departs tomorrow. They will be able to support themselves there and earn a living; all this on condition that if the Honourable Lord Governor-General resolves to order them to be sent to Batavia, they should at all times be ready and willing to comply with his orders.

257. Dagregister Zeelandia 15 March-18 November 1645.
VOC 1158, fol. 655-765. Summary of March 1645.
DRZ, II, pp. 361-464.

(On 8 March the Northern Land Day took place in Saccam. Besides the headmen of 45 pacified villages, also those of 13 recently conquered villages did appear.[108] On 17 March four inhabitants from Vavorolangh, accompanied by two Dutchmen, arrived at Zeelandia together with four Chinese captives. They delivered a letter from the Reverend Simon van Breen who explained that the prisoners had been recognized by the inhabitants as the Chinese pirates who had taken part in robbery at Vavorolang and Vassican and three years ago had reduced a part of Dalivo to ashes. Van Breen wrote that in this northern area, apart from pirates of the lower ranks, there also were two Chinese captains who continued living there. They were esteemed by the local people, not only

*because they were engaged in trade but also because they were living with
Formosan women.)*

258. Resolutions Tayouan, 20 March-16 November 1645.
VOC 1149, fol. 870-903. Resolution 20 March 1645.
**See also Formosa under the Dutch, pp. 209-210; Zending, IV,
pp. 23-24.**

Onlangs naer het destrueren van de dorpen Sotimor, Sopinachola,
Soukinebanck ende Sonivach, heeft den vorst dier plaetsen aen de
opperhoofden onser crijchsmacht gelijck oock de hoofden van diverse
andere dorpen belooft, dat om vrede te maecken cortelingh hier
verschijnen wilde, jae oock andere verder affgelegene daertoe noodigen
etc. Ende hoewel te dier tijt niet anders daer op is gevolgt dan dat
eenelijck de bevelhebberen van Cavido op den jongst gehouden
Noordelijcke lantsdach sijn gecompareert, soo blijven echter van de
resterende noch goetgevoelen houden. Te meer dewijle de voornoemde
Cavidoors (naer genoten liberael tractement) met verwonderinge ende
sonderlingh genougen t'huyswaerts gekeert wesende, ongetwijffelt 't
gepasseerde aen Saccam (gelijck sij doenmaels iterativelijck voorgaven),
door de omliggende vlecken sullen hebben gedivulgeert; sulcx vertrouwen
de vreese haer nabueren (waerdoor misschien haere herwaerts comste
laestmael wederhouden is), ten vollen dissiperen sal. Edoch vermits de
Formosaense volckeren (gelijck wij dagelijx ondervinden), niet alleen voor
ons versaeckt ende schroomachtich, maer oock sonderlingh irresoluyt ende
langsaem in haer doen sijn, gelijck oock jongst om de noort (boven
gedaene toesegginge), met de oversten van diversche dorpen is
gebleecken; soo wert derhalven (om dat werck te vorderen) als nu
eendrachtich goetgevonden ende gearresteert dat den oppercoopman Philip
Schillemans, die de op de laetstverleden expeditie in dat suydelijcke
gewest geweest ende dier saken goede kennisse becomen heeft, weder met
den eersten, namentlijck op 22en stanti van een sergeant ende 12 soldaten
geaccompagnieert, derwaerts trekken zal om gementioneerden Sonivachsen
vorst, mitsgaders de bevelhebberen van de omleggende (soo desselfs
onderdanighe als andere naebuerige) dorpen, tegens den aenstaenden
Zuydelijcke lantsdagh (welcke precis op 7e april geprojecteert sij), te
citeren. [...].
Soo zal oock aen den politic Antonij Boey met eenen deser handelinge
advijs, item andermael ordre gesonden werden om insgelijx alle de outsten
van de Suydelijcke dorpen (reeds in Comp.es gehoorsaemheyt begrepen),

tegens dito lantsdach te beschrijven ende wijders den oppercoopman Schillemans met raedt ende daet te assisteren, [...].

Recently, after the destruction of the villages Sotimor, Sopinachola, Soukinebanck and Sonivach, the ruler of these villages promised the officers of our expedition force as well as the headmen of various villages located in that area, that he would soon appear here at Zeelandia Castle in order to conclude peace and that he would also invite the chiefs of some of the more remote villages to do the same. Although this only resulted in the appearence of the headmen of Cavido at the recently organised Northern assembly, we still do have a positive feeling about it. Especially because the mentioned delegates from Cavido who, much to their amazement received a generous welcome and returned to their homes in a very happy mood, and will undoubtedly give an account of the affairs at Saccam on the way back (as they repeatedly claimed at the time) so that by now that news must have been made known in all the surrounding hamlets. So we trust that the fear of their neighbours, which probably kept them from showing up here, will completely disappear. However, because the Formosan peoples (as we experience daily) are not only fearful and diffident but also unusually irresolute and slow in their doings, as recently became clear in regard to the headmen of several villages in the north (who did not appear at the Land Day notwithstanding the promises they had made to us). Therefore, in order to pursue the pacification of the villages, the Council unanimously agreed and resolved to send senior merchant Philip Schillemans, who during the most recent expedition to the southern region amassed considerable local knowledge. He will depart thither at the earliest opportunity, on the 22th of this month, accompanied by a sergeant and 12 soldiers so as to summon the mentioned ruler of Sonivach as well as the headmen of the surrounding villages (those subjected to Sonivach as well as other neighbouring villages) to come to the next Southern assembly (which is due to be held on 7 April). [...].
Likewise, political administrator Antonij Boey, will also be ordered immediately to summon again all the elders of the Southern villages who are already subjected to the Company's authority to appear at the mentioned assembly. Additionally, he will have to advise and assist senior merchant Schillemans. [...].

259. Instructions from Governor François Caron for Senior Merchant Philip Schillemans on his journey to Soetenau and the south to consolidate the peace with the allied villages and to summon the inhabitants of the newly pacified neighbouring villages to appear at the next assembly.
Tayouan, 21 March 1645.
VOC 1149, fol. 748-749. Extract.

fol. 748: UE. zij kennelijck hoe dat die van 't gebergte om de zuydoost van hier gelegen, staende onder het gebied van den Sonivachsen vorst, nadat door onse crijchsmacht onlangs gestraft waren, belooft hebben gesamender hand op onse waerschouwinge eerstdaegs op den Zuydelijcken landtsdach te verschijnen. Ten welcken eynde wij oock alreets voor enige dagen diesaengaende aen onse residenten derwaerts over remorerende ordre gegeven. Maer alsoo uyt UE. selffs verstaen hebben dat die luyden seer langsaem sijn, eensdeels door vreese ende ten anderen uyt aengeboren natuire aller Indianen, soo hebben wij met advijs van onse Rade, omme dat wercq te poucheren tot meerder verseckeringe van haere verschijninge noodich geacht, UE. onder sauve guarde van 12 soldaten ende den sergeant Gerrit Carsman derwaerts te committeeren, omme het navolgende [...], te verrichten. [...]

Soo oock de occasie ende nootsaecklijckheyt sulcx mochte vereyschen, authoriseren UE. selffs in persoon niet alleene nae Cavido, Sounivach, Sotimor, Savasavosey, Sipatgidarangh, Sopinachola, Soeckinebangh, Panguangh ende andere dorpen, maer oock naer Tapouliangh moogt verreysen, mits dat daerdoor de saecke in 't gebergte niet en verachterde. Te meer wij vertrouwen het aldaer door Sr. Boey ende Caesar van Winschooten wel beslecht werden zal met wien UE. door schrijven corresponderen condt.

Tot spijsinge uwer medehebbende geselschap, als tot onthael der outsten die bij UE. mochten comen, geven UE. mede (onaengesien de soldaeten voor acht dagen geprovideert hebben), dertig cangangs ende vijftig brieven tobacq die UE. mesnagierende (ten dienste van de Comp.e) gebruycken condt. [...].

fol. 748: Your Honour is aware that after the recent punishment by our army the inhabitants from the mountains situated to the southeast, who belong to the territory of the ruler of Sonivach, promised to appear altogether at the next Southern assembly when invited to do so. To

achieve that aim we have already ordered our residents, who are staying in that area, to summon up the people. But because we understand from Your Honour that those people are very slow, partly due to fear but also because of the inbred nature of all 'Indians' we, upon the advice of our Council, to speed up things and to make sure of their participation, have thought it necessary to send Your Honour, with the escort of 12 soldiers and Sergeant Gerrit Carsman thither, in order to carry out the following duties:

(On the way Carsman had to send a soldier to merchant Anthonij Boey, political administrator in Tapouliang, with the request to dispatch an interpreter to senior merchant Schillemans in Soetenau and to get another interpreter to stay with him in Tapouliangh so that he could invite the headmen from Lonckjouw, Pangsoya, and the villages surrounding Tapouliangh as well as the ruler of Caviangangh and the headmen of Doretock, Toutsikadangh, Papaverouw, Varangit, Caraboangh, Potlongh, Talasuy, Tarkavas and other villages, which had not yet been pacified by the Company, in case they were willing to come to the next assembly at Saccam on 6 April. Once the interpreter had returned, Schillemans should send him over to Tedackjangh to the gorge. He was to find out more about the people of Cavido and the recently pacified 'Indians' of Sonivach and then should instruct them to send messengers to Kinadauan, Panguangh and Patican to summon their villages to come to the Land Day. In the meantime Schillemans was advised to find out whether it would be a good idea to meet all headmen of the Southern villages around 3 April in Soetenau and convince them that it would be perfectly safe to travel to Saccam as he would personally accompany them.)

If the circumstances should require, we authorize you to travel in person not only to Cavido, Sonivach, Sotimor, Savasavosey, Sipatgidarangh, Sopinachola, Soeckinebangh, Panguangh and other villages over there, but also to Tapouliangh, if only the affairs in the mountains do not change for the worse, all the more so because we trust that Sr. Boey and Caesar van Winschooten, with whom you can communicate by correspondence, will sort things out over there.

In order to ensure that you are able to provide your company with enough food, and to entertain the elders who will come to meet you, Your Honour will receive (apart from the supplies for eight days we provided

your soldiers with) thirty *cangans* and fifty envelopes filled with tobacco, that Your Honour can dispose of for Company use.

260. Resolution Tayouan, 21 March 1645.
VOC 1149, fol. 871-872.

Tot bevorderinge van de Taraboanse crijchstocht welcq in december naestcomende te geschieden staet, is op 9en stantij in Raede vastgestelt dat men ontrent halff april aenstaende alle de vereyschte nootwendichheden ten behoeve van 250 coppen te waeter nae Pimaba soude schicken. Nevens vijftig soldaten, tot versterkinge van dat guarnisoen als specialijck om de derwaerts te brengen Comp.es ende verderen ommeslagh te helpen bewaeren, mitsgaders op het houden van de Oostelijcken lantsdach present te wesen.

Ende aengesien de geroerde saecken met hetgene daeraen dependeert niet op een sprongh off soo haest de geprojecteerde soldaten in Pima arriveren, sonder voorgaende preparatie sullen te verrichten sijn, soo wert derhalven dewijle den geprefigeerden tijt begint te naken, jegenwoordich (nae goede deliberatie geresolveert), dat men precijs op 24en deses den sergeant Abraham van Aerssen met 25 soldaten vooraff over landt naer meer gemelte plaetse depescheren sal. Sullende den capitain deses guarnisoens Pieter Boon met de resterende 25 coppen [...] te water per jonck *Diemen* volgen. [...]

(Michiel Janssen, resident in Pimaba, werd geïnstrueerd:) (fol. 872) dat de hooffden van alle de bevredichde dorpen aen dien gantsen oostcandt (aen de suytsijde van Calingit aff tot Taraboan toe om de noordt) in sonderheyt de veerst affgelegene, tijdelijck doen citeren ende vermanen dat in vougen als die van de zuydt ende noort aen dese sijde des landts tot Saccam, sij insgelijx tot Pimaba op den lantsdach compareren, precijs tegens ultimo april aenstaende, als wanneer Sr. Boon nae gissinge offte misschien eer aldaer sal connen wesen. Latende de plaetsen die noch niet bevredicht sijn, almede daertoe vermanen ende noodigen, door middel van de Pimabaers ende andere onse vrunden [...].

Eyndelijck dat soo secretelijck als geschieden can, ondertusschen vernemen naer de gelegentheyt der Sipienders ende off met een compagnie van twintig soldaten yet voordelichs op deselve te attenderen sij, ten eynde meergemelten capitain aldaer geparesceert sijnde, met de residenten overleggen mach tot wat wraecke over de moort aen Albert Thomassen door geseyde inwoonderen begaen, ondernoomen dient. Also wij ons gaerne over die meschante acte sagen gerevengieert.

In order to prepare the punitive expedition to Taraboan, which will be undertaken next December, the Council resolved on the 9th of this month that around the middle of April all the required necessities, for a party of 250 men, will be shipped to Pimaba. In addition, fifty soldiers were to be sent to strenghten the garrison so that they could assist in guarding the Company's belongings and furthermore can be present at the Eastern Land Day.

Because these and related affairs cannot possibly be accomplished immediately after the arrival of the projected soldiers at Pimaba, without sufficient preparations, therefore it was decided in view of time considerations that exactly on the 24th of March Sergeant Abraham van Aerssen would be sent overland to Pimaba, accompanied by 25 soldiers. The remaining 25 together with the captain of the garrison, Pieter Boon, will follow aboard the junk *Diemen.* [...].

(Michiel Janssen, resident in Pimaba, would receive orders to:) (fol. 872) summon up the chiefs of all the pacified villages along the entire eastern coast (from Calingit in the south until Tarraboan in the north) including the remotest ones, to present themselves just like the chiefs of the southern and northern villages on the western side of the mountains did when they went to Saccam. Likewise they had to appear at the assembly in Pimaba at the 30th of next April, when S#r#. Boon has probably already arrived there. Those villages that have not yet made peace should also be urged and invited to do so, through the mediation of the inhabitants of Pimaba and our other allies. [...].

Finally that you should, as secretly as possible, find out about the local conditions at Sipien, in order to see and to decide in consultation with the residing Dutchmen if an assault can be accomplished with a party of twenty soldiers, on account of which the above-mentioned captain has already arrived there, and how revenge can best be carried out for the villainous murder on Albert Thomassen. We would gladly see that crime avenged.

261. Dagregister Zeelandia. April 1645.
VOC 1158, fol. 663-670. Summary.
DRZ, **II, pp. 368-377.**

(On 5 April the Quataongh or 'Tackamacha', together with some headmen of several other villages from that area came to conclude peace with the governor in Tayouan. He accepted all articles of the contract and said that unfounded fear and ignorance had kept him from subjecting himself before. He said that fifteen villages were subordinated to his rule: Bodor, Darida North, Darida in the Middle, Darida South, Assock, Aboangh East, Abouangh West, Babosacq, Baberiangh, Tousack, Baroch, Sackaley, Tachabeu, Dosack North and Dosack East. On the same day Senior Merchant Philip Schillemans returned from his inspection of the southern villages. He had not succeded in convincing the ruler of Sonivach – who instead of being a ruler rather seemed to be an exorcist, with great power over the headmen of other villages, to come to the Southern Land Day.
On 7 April the Southern Land Day took place at Saccam in the presence of Tartar, the ruler of Lonckjouw. The assembly was also attended by the Quataongh, together with some his headmen, who had accompanied him on his journey to Tayouan. Various other chiefs of several northern villages, who had joined the Quataongh and his retinue voluntarily, observed the ceremony as well.)[109]

262. Resolution, Tayouan 11 April 1645.
VOC 1149, fol. 874.

Per missive van onsen resident uyt Pimaba, dato ultimo maert passado, g'informeert sijnde hoe dat behalven de gemeene schraelheyt aen dien hoecq ende consequent gebrecq van diverse vereyschte nootsaeckelijckheden, de siecten aldaer ende in de omliggende vlecken, geweldich regeerden, invougen niet mogelijck soude wesen het houden van den geprojecteerden Oostelijcken lantsdach, in goede ordre te laten voortganck nemen. Soo is naer de deliberatie deser saecke, bij den raet eenstemmich goetgevonden (te meer geen derden deel uyt de regerende hooffden der dorpen soude connen worden samengeroepen, wesende veele derselver gestorven ende andere door lichamelijcke swacte onmachtich te compareren), dat men 't houden van den voorgenommeerden lantsdach voor alsnoch [zou] staecken. Ende niettemin, tegen 18en stanti per Comp.es

jonck *Diemen* ende 25 soldaten, van hier naer Bottol affvaerdigen sal den capitain Pieter Boon, omme aldaer (volgens d'ordre vande Edelen heer Generael), te onderstaen wat ontrent die eylanders ten voordeele van de Comp.ᵉ soude connen worden uytgewrocht. Ten welcken fine oock van hier met partije cleeden, omme onder die natie tegen silver (dat aldaer te wesen ondervonden zij) te troucqueren, sal werden versien. Als wanneer geroerde capitain (den Bottolschen inboorlingh voor desen uyt die plaetse herwaerts gebracht ende nu weder medegaende) aen lant geset, ofte gelargeert ende alles geeffectueert hebbende wat bij de gelegentheyt soude mogen te verrichten sijn, wijder de reyse nae Pima vorderen sal, omme aen dien candt niet alleene te besichtigen in wat posture de saecken onder den inwoonderen allenthalven sich toedragen, maer bovendien, jae principalijck, goede acht ende sorge te hebben dat de munitie van oorloge ende victualiën (welcq per geseyde joncq derwaerts sullen seynden ende conform 't geresolveerde van den 21ᵉⁿ passado tot d'expeditie na Tarraboan ofte de goutmine gedestineert sijn), bequaem ende in behoorlijcke verseeckeringe werden opgelecht. [...].

From a missive, dated 31 March, from our resident in Pimaba Michiel Jansen, we learned that apart from the prevailing general dearth in that area, and a lack of various requirements, all kinds of diseases are rampant over there. He deemed it therefore to be impossible to proceed properly with the organization of the projected Eastern Land Day. After careful consideration, the Council unanimously decided not to organize the mentioned assembly because not even a third part of the ruling headmen of the eastern villages would be able to attend the meeting, as many of them had died and others would not be able to show up because of infirmity. Nevertheless, around the 18ᵗʰ of this month, the junk *Diemen* will be sent to Pimaba, and to the island Bottol as well, with 25 soldiers under the command of capitain Pieter Boon. They will pay a visit to the island, on the orders of the Honourable lord Governor-General, to see if something beneficial to the Company can be performed with the islanders. For that purpose a cargo of cloth will also be sent along as merchandise to be used for bartering with the islanders for silver (which is known to be found in Bottol). When captain Boon has carried out what can be done, and has returned the native of Bottol to his own people (who had been 'kidnapped' earlier from his island to Tayouan), the captain will sail on to Pimaba. There he must not only inspect the local situation and the behaviour of the inhabitants, but moreover he will have to see to it the the

ammunition and supplies will be properly discharged and safely stowed away, which will be carried by the mentioned junk according to the resolution of the 21th of last month, for the expedition to Tarraboan or the gold mines. [...].

263. Instruction from Governor François Caron for Captain Pieter Boon, departing to Pimaba and the island of Bottol.
Tayouan, 18 April 1645.
VOC 1149, fol. 746-747. Extracts.

> fol. 746: [...] Twee honderd stucx bruynblauwe cangangs tot coopmanschap, ofte ruylen met de inwoonders op het eylandt Bottol te gebruycken. In voegen dat alles welcq tot de depesche vereyscht was vaerdich is geworden, des UEd. met sijn volcq desen avont enbarqueren ende morgen vrouch [...] (fol. 747) onder zeyl gaen sult [...] naer 't eyland Bottol alwaer ten ancker loopen ende de inwoonder 't voorleden jaer van daer gehaelt wederom largeren sult. Item inder minne met die natie soecken te corresponderen ende haer hebbende silver aff te handelen, waertoe UE. de cangangs ende diergelijcke cramerijen medegegeven sijn. UE. bent van gevoelen dat volcq beswaerlijck van daer sal te haelen wesen, waerop echter noch geen vasten staet maken, maer in hope blijven t'eniger tijt de gelegentheyt sich daertoe openbaren zal. UE. zal derhalven de sake naerstelijck examineren, ende ons daervan t'zijner tijt rapport doen, ondertusschen alle sachte middelen gebruycken om met haer in eenicheyt te comen, waertoe UE. den inwoonder, welcq tot noch toe wel getracteert hebben een goet instrument wesen zal.

(The junk Diemen, with the destination Bottel Tobago carried:) fol. 746: [...] 200 pieces of blue/brown *cangans* either to serve as merchandise or to use in the barter trade with the inhabitants of the island of Bottol. Because everything is ready for the expedition you should embark with your men tonight and set sail tomorrow early in the morning [...] (fol. 747) [...] to the island. There you will anchor and send ashore the native Bottol-inhabitant, who was taken from there last year. You will have to try to establish friendly contacts with the Bottol nation and get them to barter their silver for the *cangans* and other merchandise that you have been provided with. You are of the opinion that it would be difficult to remove those people from their island, something which we are not yet sure about, but we retain the hope that in time, when the occasion arises

this can still be carried out. Therefore Your Honour will have to make assiduous inquiries into this matter and report to us about it. In the meantime you will have to persuade the inhabitants to enter into friendly relations with us; to that end the islander (who was treated well over here in Zeelandia) will certainly be of good use.
(After his delivery of the provisions at Pimaba, Pieter Boon had to investigate the fire in which most of the Company's merchandise had been lost, and had to make inquiries into the murder of Albert Thomassen in Sipien, notably to discover if the victim had given the inhabitants any motives for perpetrating that crime.)

264. Missive Junior Merchant Jan van Keijssel to Governor François Caron.
Tamsuy, 26 April 1645.
VOC 1149, fol. 764-766. Extract.

fol. 765: [...] Naerdat den capitein Boon voorleden jaer van hier te lande na Tayouan was vertrocken ende geen schrijvens bequamen hoedanich door de dorpen gepasseert was, resolveerde den 13en Januarij passato (mogelijck sijnde tot aen Dorenap ofte so veer als comen conden), seven van de Tamsuyse landsaten van hier derwaerts over tot ontdeckingh der passagie te senden. Maer na ses dagen dat uyt geweest waren, quamen wederom ende rapporteerden dat over de riviere van Lamcam hadden geweest, dat de landsaten aldaer niet veerder gewilt hadden sij passeren souden, vermits de Hollanders meest onderwege dootgeslagen ende sij daerom vijant van deselve waeren. 't Welcq van haer voor grove versierselen accepteerde, maer evenwel wiert sulcx daerom niettemin voor waerachtich bij de lantsaten van haer aengenomen. Der eyndelingh uyt ontstaen is dat één van de outsten, genaemt Ponap, uyt één van Tamsuys dorpen, hier geen meer bambousen begeerde te leeveren, die primo maert passato daerover in apprehensie bequamen. Ende wiert wederom gelost onder borghtochte van d'andere outsten, soo om sijn relaxatie dagelijcks quamen versoecken, mits dat gehouden was 600 reael van 8en in couraelen tot versekeringh van oprechte gehoorsaemheyt, ons, gelijck geschiede, in handen te laten. 't Welcq om reden dat soo verscheyden reysen voor desen die parten meer gespeelt hadt, geschiet is. [...]
Nopende de dorpen tusschen 't land van den Quataongh ende Tamsuy liggende, welcq de recognitie in vellen op te brengen mede belooft hebben, verstaen dat 16 in getal sijn. Daeromme volgens UEds. ordre

(vermits Tamsuy tot de ontfanck beraemt is) bij den substituit Van Bergen aengenomen zijn, andermael te insinueren dat hunne recognitie herwaerts brengen moeten. Oock om de outsten van dito dorpen gesamentlijck eens hier te doen comen, opdat men het getal der huysen ende groote van haer dorpen soude mogen weten. Item tot kennisse der wegen, om van tijt tot tijt onse missive derwaerts over, recht op Dorenap aff te senden. Soo hebbe derhalven goetgedacht, nevens de voors. Van Bergen, tot voors. Dorenap toe een soldaet ende vier vande Tamsuyse landsaten mede te senden om van daer met al d'oudsten van bovengementioneerde dorpen wederom herwaerts aen te comen, dat verhopen vruchtbaren zal. Te meer twee van de voorneemste dorpen per den voors. Van Bergen van daer mede gebracht (wel getracteert), nevens desen wederom derwaerts gaen. Waeruyt verstaen hebbe dat aen haer dorpen, ontrent 15 à 16 mijlen van hier gelegen, in de riviere bij haer genaemt Mattau binnen 15 à 16 dagen twee Chinese handeljoncken uyt China te paresseren stonden. Dat vermits daer jaerlijcx onvrije joncken comen, UEd. hebbe goetgedacht te adverteren om gelegen comende, vermits bij gelegentheyt met vaertuygh (dat UEd. herwaerts mocht comen te senden), die plaetse soude connen gevisiteert werden.

't Sedert voorleden jaer dat de lantsaten in Cabalangh door den capitein Boon bevredicht sijn, hebbe geen recognitie opgebracht, dat in januarij passato ons eenige van daer quamen aendienen, sulcx de noorde winden verhinderden, maer souden 't om desen tijt besorgen. Derhalven primo deser resolveerden door de Kimaurier Theodore haer te laten weten, vermits de goeden tijt dat al de voorneemste tegens den 25en deser met de recognitie van ijder dorp herwaerts moesten comen, dat insgelijcks die van St. Jago ende vordere dorpen onder Tamsuy ende Quelangh gehoorende, aengesecht is om generalijck nae gewoonelijcke wijse deselve tot haer debvoir ende presenteringe van beloften aen te manen, dat alsnoch niet en is geschiet. Vermits de Cabalanders (daer alleen 't wachten nae is), uyt alle dorpen (volgens 't schrijven uyt Quelangh) met haer recognitie op comende wege waeren, soodat aen haer ofte eenige andere dorpen onder dese fortresse gehoorende (met Godes hulpe niet te twijfelen is) ofte sullen haer recognitie nae behooren opbrengen. [...].

fol. 765: [...] After captain Boon had departed from Tamsuy overland to Tayouan last year, we received no message whether he had succeeded in passing the villages. On 13 January of this year we therefore resolved to send seven inhabitants of Tamsuy from here to explore the passage (they had to try and see if they could come as far as Dorenap, or near to that

place). However after only six days they returned and reported to us that they had crossed the Lamcan river, but that the natives of that area did not allow them to move any further because along the way Dutchmen were mostly beaten to death, as a result of which they considered themselves to be enemies of the Dutch and their allies. We took this to be a gross lie but the natives nonetheless took it for the truth. The end of the story was that Ponap, one of the elders from one of the villages near Tamsuy, refused to deliver bamboo to us any longer. On March first he was apprehended, but because other elders came to see us daily to request his release, we set him free with the personal guarantee of the others, on collateral security of leaving a large supply of beads valued at 600 reals of eight with us, as assurance of his sincere obedience, which was effected. The reason for our demanding security is because he has played such games on several occasions. [...]

With regard to the villages situated between the territory of the Quataongh and Tamsuy (of which there are 16 as we learned) these had promised to fulfil their (tax)charge in deerskins. Therefore, according to Your Honours' order (if they are collected at Tamsuy) we sent out the deputy political administrator Joost van Bergen again to those villages in order to suggest to the elders that they should deliver the tax at Tamsuy. Furthermore he had to invite those headmen to come over altogether so that we would be able to be well informed of the number of their houses and the size of their villages, and get a better knowledge of the roads in that area so that, at times, we will be able to send our missive straight to Dorenap. We agreed to send one soldier and four of the inhabitants of the Tamsuy area together with the mentioned Van Bergen to Dorenap, in order to escort them to Tamsuy all the elders of the mentioned villages, which we hope will work out in this way. Two men from the principal villages over there, who had already been escorted to Tamsuy by Van Bergen on another occasion, now returned with him again to their village (after they had been entertained well). They told us that within 15 or 16 days two trade-junks from China are about to appear at their villages situated at about 15 or 16 miles from here, near a river that is named Mattau by them. We agreed to communicate this to Your Honour because every year Chinese junks, without proper Company licences, call at that place, so that Your Honour, when the occasion arises, could order that place to be examined by a vessel (under way to Tamsuy).

Since last year the inhabitants of Cavalangh were pacified by captain Boon, they did not deliver the tax charge, but in January some of them came to tell us that the northern winds had prevented them from doing so. Yet they intended to [deliver the tribute] at about this time. On the first of this month we therefore resolved to send Theodore from Kimaurij to notify the headmen that this was the right time for them to come over on 25 April, with the tax of every village. Likewise those of St. Jago and the other villages that belong to Tamsuy and Quelang are notified to come together as usual so that we can urge them to their duty and keep their promises, which they have not so far fulfilled. Because the people of Cavalangh (being those we are actually waiting for), according to a message we got from Quelang, are reported to be on the way carrying the goods which serve to settle their taxes, with God's help we do not doubt they will comply with our orders properly. [...].

265. Dagregister Zeelandia. April-May 1645.
VOC 1158, fol. 682-683. Summary.
DRZ, II, pp. 386-387.

(Before returning from Pimaba to Tayouan, on 4 May Captain Pieter Boon sent a messenger from Pimaba to Tawaly, in order to bring down some people from Sipien (under the promise of safe-conduct) to the Tawaly River. Thus Boon and his retinue hoped to receive information about the murder of Albert Thomassen (on 7 September 1644). The other day the messenger returned and told Boon that the villagers of Tawaly had dissuaded him from going to Sipien as they feared that his head might be hacked off. However Tawaly had sent four of their own warriors to find out the true facts. When Boon with his little group of soldiers arrived at Tawaly on 6 May, the four men who had visited Sipien explained to him that due to the smallpox that raged in Sipien, and because it was the time of the millet harvest, the people of Sipien could not come down to meet the captain. In about six weeks time they would be ready to go Pimaba so as to settle the taxes and deliver the goods to the Company official. About the death of Albert Thomassen, they found out that he himself (except from seizing one pig) had done nothing in particular to offend the people of Sipien. Two men from Tipol and one from Maranas, who accompanied him as interpreters, had made a fuss demanding some

precious beads and guns. These two had already behaved quite villainously to Thomassen when they translated for him, and also deceived those of Sipien into believing all sorts of things. Eventually this angered them so much that in a rage they beat to death two of the interpreters as well as Albert Thomassen, who was sleeping at that moment. This was committed by some headmen who have since died from the smallpox. Sipien was situated high up on a mountain slope and very hard to reach, but the mentioned four men from Tawaly who had been to Sipien told Boon that the headmen of Sipien had requested that a Dutchman should come to stay into their village. They promised that no harm would be done to him. On 7 May Boon and his men left Tawaly and traveled back overland and reached Tayouan on 13 May.)

266. Missive Governor François Caron to Junior Merchant Jan van Keijssel.
Tayouan, 20 May 1645.
VOC 1149, fol. 791-793. Extract.

fol. 791: [...] Dat den outste genaemt Ponap, ter oorsaecke sijner onwillicheyt in 't leveren van bambousen gevat, doch weder (onder borchtochte) gerelaxeert. Item voor sijn gehoorsaemheyt 600 reaal in coraelen tot pant genomen hebt, is heel wel gedaen. Den Formosaen moeten in dwangh ende ontsach houden, of anders wert onse regeringhe bij hen gevreest nochte geacht, gelijck ons d'ervarentheyt dagelijcks genouchsaem leert. (fol. 792) Dito coralen sullen U tot onse naerder ordre in verseeckertheyt bewaeren.

Wij sijn voornemens in september, ofte uyterlijck october aenstaende, eenen generaelen lantsdach in Tamsuy te doen houden, invougen als met die van de Zuyt ende naeste Noorder dorpen jaerlijcks geschiet aen Saccam. Went ondertusschen alle vlijt ende diligentie aen om pertinent op een lijste te crijgen alle d'dorpen die wij tegenwoordich stellen onder het resort van het fort Anthonio. Sijnde namentlijck alle de dorpen bij noorden 's Quataonghs land tot costi toe, de plaetsen daeromher en onder Quelangh hoorende, ende eyndelingh die van de Cabelaense Bogt. Alle welcke (als gesegt), soo 't mogelijck is exactelijck sult doen opnemen, nevens perfecte aentekeningh van 't getal der huysen ende menschen in yder van deselve begrepen. Van hier sullen insgelijcks besorgen, dat hetselve correct ende na behooren geschiede met de Lamcanse dorpen, [...].

fol. 791: [...] The headman named Ponap, due to his obstinacy about delivering the bamboo canes to the Company, was taken into custody first and released again later (on collateral security). To impose a security of 600 reals in beads in order to keep him obedient, is a very good action. The Formosan needs to be kept under coercion and awe, otherwise, as we experience daily, they will stop to fear and respect our government. (fol. 792). The mentioned beads you can keep till you receive further instructions.

We intend to organise a general Land Day in Tamsuy in September, or at the latest in October in a similar way as those held yearly in Saccam for the villages situated to the south and to the north of Tayouan. In the meantime you will have to employ all your energy and diligence to draw up a list of all villages that, at present, are attached to the fortress St. Anthonio, namely all the villages north from the land that belongs to the Quataongh as far as the place where you yourself are stationed, the places around and the ones belonging to Quelang and finally those situated in the Bight of Cavalangh. All of these, as mentioned, you will have to list thoroughly, together with all particulars about the number of houses and people. From here we will see to it that likewise a proper list is made of the villages in the Lamcan area. [...].

(Junior Merchant Jan van Keyssel was ordered, to see that all levies were collected and also to inform the headmen of all northern villages to come over to Tamsuy in order to attend the Northern Land Day, once the precise date had been fixed in the Zeelandia Council. He also had to inquire after the junks that were said to moor in the Mattau River in the Lamcan region.)

267. Dagregister Zeelandia. 1 June 1645.
VOC 1158, fol. 689. Summary.
DRZ, II, pp. 393-394.

(On 1 June a note was received from Merchant Anthony Boey, stationed as resident in Tapouliangh. He wrote that on several occasions he had urged (even slightly threatening them) the inhabitants of the villages Potlongh and Talasuy to move over to Netne and those of the several hamlets around Pangsoya to move to the larger central village. But his

urging had been of no avail as they did not comply with the Company's wish.)

268. Resolution, Tayouan, 5 June 1645.
VOC 1149, fol. 879.

Van tijt tot tijt verneemen den ellendigen staet der inwoonderen van de jongst gedestrueerde Noordelijcke dorpen in het land des Quataonghs, alwaer niet alleene 12 wederspannige plaetsen tot den gronde geruineert, maer oock bijnae alle haren rijs, als andere montcosten met eenen door onse crijchsluyden verbrand zijn, soo dat selffs geene padij tot spijsinge ende onderhout voor desen tijt, veel min tot besayinge der velden tegens 't aenstaende jaer overich behouden hebben. Waerdoor die arme menschen tot soodanigen noot vervallen zijn dat 't meerendeel der selver, gelijck reede begonnen hebben, door den honger ellendichlijck sullen omcomen, bij aldien daerinne niet en wert voorsien. Soo is derhalven in rade goetgevonden ende geresolveert voors. desolate menschen (die doch sedert eenichen tijt onse vrintschap hebben aengenomen), met een duizent picols padij tot besayinge haerer rijsvelden ter leen te secundeeren, ende noch heden expresselijck aen den predicant domino Van Breen daerover te schrijven. Namentlijck dat sijn Ed. op 't spoedichste dito saecke wil examineren ende vernemen off dat arme volck met één à twee duizend picols padij (ten fine als verhaelt), soude gedient ende oock te helpen sijn. 't Welcq soo bevindende moest ons cito sulcx verwittigen, mitsgaders (om tijt te winnen), haer luyden aenstonts gelasten de handen aen acker ende ploegh te slaen. Wij wilden dan metten eersten van hier de toegeseyde padij te water opsenden, ende onder sijn Ed. hant stellen, om dan vorders pro rato ijders noot gedistribueert te worden, mits dat elcq dorp het aenstaende jaer sijn genoten portie, doch sonder eenige avance aen d'Comp.ᵉ restitueren zal.

From time to time we learn about the miserable situation of the inhabitants of the recently destroyed northern villages in Quataongh's territory. Not only were 12 rebellious villages over there demolished, but in addition almost all their rice stock, and other foodstuff was entirely burnt to ashes by our men. As a consequence they do not even have any paddy left to feed themselves and even less for sowing their fields next season. These poor souls have been reduced to such destitution that most of them may perish from starvation, as is already happening, if nothing is

undertaken to fill the needs. Therefore the Council resolved to help out these desolate wretches (whom we have already accepted as friends for some time) by issuing in loan to them 1000 piculs of paddy to sow their ricefields with. A direct letter will be sent to Reverend Simon van Breen today with the instruction that His Honour should examine this matter as quickly as possible to find out whether these people will be sufficiently supported with 1000 or 2000 piculs of paddy, (as it was mentioned). If this is the case he should inform us at his earliest convenience and (in order to gain time) see to it that the inhabitants directly start to plow their fields. Then we will be willing, on the earliest occasion, to ship the agreed paddy thither. As the person in charge, he should see to it that the paddy he receives is proportionally distributed among those who need it most. This help is given on the understanding that every village will restitute the advanced paddy, interest free, as we consider this to be a passive debt, to the Company the next year.

269. Missive Governor-General Cornelis van der Lijn to Governor François Caron.
Batavia, 19 June 1645.
VOC 869, fol. 273-288. Summary.

(We were pleased to hear that all the Lameyans have been deported from the Golden Lion Island and transported to Sincan where they have been housed under good supervision. We are looking forward to hearing about the results of the third expedition to the island Bottol, and do hope that we also will be able to capture the islanders so that they can be employed over here in Batavia, besides the Lameyans of whom we benefit greatly.[110] Your Honour will have to employ all possible means to make this happen.
Now that it became clear that no people are living on Malebrigo, the small island situated off Formosa's northeastern coast, you are allowed to stop further investigations and leave it like that. Also with gladness we learned that the Chinese pirates, who used to have their rendezvous a little north of Dorenap, were chased off, and that finally in Dorenap, by setting fire to their junks and belongings, they were completely ruined. In the future the same policy will have to be employed against these Chinese in order to deter them from establishing them on Formosa.)

270. Resolution, Tayouan, 20 June 1645.
VOC 1149, fol. 880. Extract.

[...] op de noordelijcke crijchtocht naer het landt van den Quataongh sijn in Februarij laestleden 15 Formosaense kinderen gegrepen, herwaerts gebracht, mitsgaders onder den Nederlanderen, gelijck onlangs noch drij andere van Favorlangh gecomen (om dienst te doen) verdeelt, mits dat deselve op soodanige conditiën ende soo lang souden mogen gebruycken als daernae bij den gouverneur ende sijnen Raed stont te werden geordonneert. Waertoe jegenwoordich comende, (doch alvoren den ouderdom van geseyde kinderen nae de scherpste gissingh opgenomen wesende), goetgevonden ende g'arresteert is dat de vrunden aen welke dito kinderen verleent sijn, deselve respectievelijck voor behoorlijck onderhout van voedsel ende cleederen mogen t'haren dienste houden, tot den ouderdom van sesthien jaeren, als wanneer deselve bovendien genieten sullen een halve sware reaal ter maandt. Des soo blijft een yder oock geoctroyeert bij vertrecq ofte andere occasie (die hem binnen den tijt van gemelte jaeren soude mogen voorcomen) soodanigen kint ofte kinderen, op de bovenaengetogen conditiën, aen yemand anders (doch met kennisse van den gouverneur) te transporteren. Ende opdat soodanigen opdracht in tijt ende wijlen behoorlijck mach geschieden, soo wert den secretaris deser vergadering gelast aen alle de personen respectivelijck, die reeds van voorgementioneerde 18 kinderen onder haer opsicht hebben, metten eersten een geautentiseert extract deser resolutie in forma van acte te behandigen, waerbij tot allertijt mach blijcken, aen wien de kinderen sijn g'intrageert, wat ouderdom hadden, ingevolge hoelange sonder eenich gelt boven cost ende cleederen te genieten, haer meesters ofte vrouwen moeten dienen, gelijckerwijs uyt d'onderstaende specificatie alles claer ende duydelijck can werden beoogt, hebbende den gouverneur François Caron t'sijner huise aengenomen een jongen van tien, één dito van vier ende een meysken insgelijx van vier jaeren. Den oppercoopman Cornelis Caesar een meysken van acht jaeren. Den fiscael Adriaen van der Burch één dito van vier jaeren. Den oppercoopman Nicasius de Hooge een jongen van vijff jaeren. Den oppercoopman Bocatius Pontanus één dito van twaelff ende één dito van drij jaeren. Den oppercoopman Philips Schillemans een meysken van vijff jaren. Den predicant Joannes Happart één dito van acht jaren. Den capitein Pieter Boon één dito van seven jaeren. Den secretaris Gabriel Happart een jongen van elff jaren. Juffrouw Maria aux Brébis een meysken van vier jaeren. Den ondercoopman Salomon Goossens één dito van anderhalff ende een jongen van acht jaeren. Den ondercoopman

Thomas de Rouck een meysken van vier jaeren. Den opperchirurgijn Mr.
Dirck van Echten één dito van vijff jaeren ende eyndeling Willem Gijssen
Croon een jongen van ses jaeren. [...].

[...] Last February during the expediton to the territory of the Quataongh
in the north, 15 Formosan children were seized and brought over to
Zeelandia Castle. Subsequently they were distributed among the Dutch for
domestic service in a similar way as were three other children recently
from Vavorolangh. This situation may continue provided that those
children are treated only under certain conditions and for as long as will
be determinded by the Governor and Council. After the childrens' age
was defined by means of careful estimation, it was agreed on and resolved
that our friends to whom those children have been allocated, may avail of
their domestic service, but in exchange the children should be provided
with adequate food and clothing. This settlement will remain in effect
until the children have reached the age of sixteen when they will
additionally receive half a real of eight every month. In this way
everybody is bound; and in the event of departure, or if the occasion calls
for it (or whatever might happen to them during the fixed period) the
employer is obliged to transfer the concerned child or children to
someone else (but only after informing the governor and under the
conditions mentioned above). In order that such a settlement is carried out
properly, according to the rules, we ordered the secretary of this Council,
on the earliest occasion, to hand over to all those persons who have taken
the mentioned 18 children into their charge, an extract of this resolution
by means of a deed. From this act it will always be evident to whom the
children were handed over, their age, and for how long they will have to
serve their masters and mistresses without receiving any additional
payment besides subsistence and clothing. All this can be seen from the
following list in which everything is specified in detail:
Governor François Caron took up in his household a boy of ten, a boy of
four, and a little girl also four years of age.
Senior Merchant Cornelis Caesar took in a girl of eight years.
Judicial Official Adriaen van der Burch: one girl of four years of age.
Senior Merchant Nicasius de Hooge: a five year old boy.
Senior Merchant Bocatius Pontanus: one boy of twelve and one ditto
being three years old.
Senior Merchant Philips Schillemans: a girl aged five.

Reverend Joannes Happart: one girl of eight years.

Captain Pieter Boon: one girl aged seven.

Secretary Gabriel Happart: an eleven year old boy.

Miss Maria aux Brébis: a girl of four.

Junior Merchant Salomon Goossens: one girl of one and a half years, and a boy of eight years.

Junior Merchant Thomas de Rouck: a girl of the age of four.

Master Surgeon Mr Dirck van Echten: one girl of the age of five.

Finally, Willem Gijssen Croon took in a boy of the age of six. [...].

271. Missive Junior Merchant Jan van Keijssel to Governor François Caron.
Tamsuy, 28 June 1645.
VOC 1149, fol. 773-776. Extract.

fol. 773: [...] Tot 't vorderen van de recognitie in Cabalangh, hebben [in] twee maenden naest Theodore, nevens twee soldaten, ende naderhant den Japander Jasinto (soo haest van costij quam) derwaerts gesonden, ende evenwel tot dato niet meer als ten deele van 't geen quijt wilde wesen en dat noch maer uyt eenige dorpen, als jongst g'adviseert, tot recognitie becomen. Wanneer de verdiende straffe dit presente jaer daer over [niet] met eene ontmoeten, staet in toecomende noch minder daervan te volgen, want selffs de lantsaaten (die als nu en dan de recognitie opbrengen) rechtuyt seggen dat nae dese de recognitie niet meer betaelen willen, wanneer degeen welcke de selve nu niet en voldoen, daerover niet gestraft werden.

Om de suydt, van de 17 dorpen tusschen 't landt van den Quataongh ende Tamsuy, hebbe de recognitie nae behooren uyt de ses naeste dorpen ontfangen. De resterende 11 dorpen, bestaende in 342 huyssen, hebben alle haer recognitie gereet leggen, uytgesondert de vier dorpen van Kalika Rusudt, bestaende in 60 huysen, welck soo verstaen (uyt de soldaten van daer gecomen) niet geneegen zijn de recognitie te voldoen, dat soo bespeure conne alleen door 't oproyden van de Chineesen (die met haer joncken aldaer om te handelen gecomen zijn) ontstaet. Evenwel sullen alle devoir om deselve aenwenden om nae dese nevens d'andere dorpen (vermits de reviere à present sulcx niet gedoogen), ons door desselfs inwoonders toegebracht te werden.

Gemelte Chinesen soo in de reviere aldaer (als gesecht) om te handelen gecomen sijn, verstaen dat dagelijcx in de dorpen bij de inwoonderen

verkeeren ende deselve alles wijs maecken dat willen (vermits doch niet
als alles quaets voor de Comp.ᵉ daervan te comen staet), sullen derhalven
sulcx soo veel als 't moogelijck is, van hier voortaen soucke voor te
comen. [...].

fol. 773: [...] Over the past two months, we have sent Theodore and two
soldiers, as well as the Japanese Jasinto (as soon as he arrived from
Tayouan) to collect the recognition taxes in Cavalangh. Yet we have still
only received part of the taxes (as we recently informed you) and only
from a few villages at that. Therefore we are of the opinion that if the
disobedient villages do not receive just punishment at once, we may
expect to receive even less in the future, because even those inhabitants
who paid up their taxes piecemeal, dare say frankly that next time they
will refuse to pay anything if those who have not paid as obliged, are not
punished.

Of the 17 villages situated to the south between Tamsuy and the
Quataongh's territory, six (those nearest to Tamsuy) paid the taxes
properly. The remaining 11 villages however, consisting of 342 houses,
prepared their recognition charges, except for the four villages of Kalika
Rusudt, consisting of 60 houses which, as we learned from the soldiers
who returned from there, were not willing to pay up. This can only be
caused by the agitation of some Chinese (who have arrived there with
their junks to trade). Nevertheless we will do everything to get the goods
delivered from there and the other village, which the present high water
level of the rivers does not allow us to carry out at the moment. The
Chinese who have entered that river (as was mentioned) to trade, are said
to be found daily in those villages. They deceive the inhabitants into
believing everything they want them to (which will only damage the
Company's reputation). Therefore we shall do everything possible to
prevent this from happening in the future.

**272. Instruction from Governor François Caron for Sergeant
Abraham van Aertsen to reside in Pimaba.
Tayouan, 5 July 1645.
VOC 1149, fol. 744-745.**[111]

*(Sergeant Abraham van Aertsen was sent to Pimaba as a successor to
Michiel Janssen to act as Company resident.)*

fol. 745: [...] Om ons des te geruster in de saken aen dien cant te mogen verlaten ende U geen ongeluck, gelijck Marten Wesselingh ende Albert Thomassen met hier en daer inde dorpen te gaen en beloopt, soo sal U sich doorgaens persoonelijck in Pima onthouden. Maer soo ergens iets te verrichten valt, sulx door de corporael g'accompagneert met eenige soldaten laten geschieden ofte 't en ware in extraordinaire gelegentheden, als wanneer U met behoorlijck geselschap ende omsichticheyt allerwegen moogt laten vinden, [...].

Tot besluyt soo seggen dan noch dat geduerende U aenwesen in Pima gestadich wel scherpelijck sult trachten te vernemen wat voor eenen naderen wegh als over 't gebergte van Tacabul daer noch herwaerts aen mach wesen, waervan steets gerucht, doch tot noch toe niet seeckers ervonden is. Vorders omsichtich in alle voorvallen te gaen ende soo veel doenelijck op den dienst van de Comp.ᵉ allerwegen behoorlijck te letten, item met eenen Christelijcken wandel d'inwoonders [...] voor te gaen [...], weerende seer scherpelijck debauche van dronkenschap ende hoererije, die wij met ons leetwesen vernemen daer seer in swange gaen. U sal daer voorwesen ende uw volcq beter in ordre houden, ende d'overtreders straffen, item de hartnekkige ons toesenden opdat hier als hoereerders ten exempel van anderen mogen gecorrigeert werden welcq wij U bevelen op poene van U officie soo wij t'eeniger tijt ondervinden dat sulx 't minste sult hebben verschoont, ofte met oogluykinge toegelaten. [...].

fol. 745: [...] In order to put our worries about that [Eastern] side of the island at ease and to avoid the kind of misfortune that Maerten Wesselingh and Albert Thomassen suffered while occasionally visiting the villages, you should make it a personal rule to stay in Pimaba. But if something needs to be done elsewhere, you should send the corporal accompanied by some soldiers to carry out the job, unless it concerns something that requires your presence. Under such circumstances you should be on your guard and go there only with a considerable retinue.

In conclusion we wish to remark that, during your presence in Pimaba, you will see to it that every effort is made to explore the supposed shorter route which according to ongoing rumours leads from here through the Taccabul mountains near to Pimaba. But we have not yet found hard evidence of this. Furthermore at all times you will act carefully, and see to it that whatever you do will be beneficial to the Company. Also you will live in a proper Christian way which will serve as an example [...] to the inhabitants. Therefore you will avoid the debauchery of drunkenness

and fornication, which we see signs of being the order of the day over there. In order to prevent lawlessness you will maintain your men under strict discipline and see to it that wrongdoers are punished. Persistent offenders should be sent over here so that they can be punished and exposed publicly as fornicators as a deterrent to others. We order you to carry out these instructions on penalty of your position, in case we discover that you failed to take action against these offences, or turned a blind eye to them. [...].

273. Resolution, Tayouan, 15 July 1645.
VOC 1149, fol. 883-884. Extract.

Onlangs, namentlijck in 't begin van Junio hebben iterativelijck uyt het schrijven van den coopman Anthonij Boey vernomen dat seecker outste van het dorpken Torroquan, gelegen om de zuyt deses eylants, met hulpe sijner complicen twee mannen ende zes vrouwen uyt Soudavang, Souloeroe ende Sopalidaran (sijnde gesamentlijck onse vrunden ende alssdoen om haren handel te doen in Tidackjan geweest) seer schandelijck als deselve t'huyswaerts keerden hadde omgebracht. Over welcke saecq hem Boey alsdoen precisie ordre hebben gegeven, namentlijck dat hij stillekens op het doen van geseyden outsten ende hun consoorten souden loeren, om haer alsoo t'eeniger tijt te attrapeeren schijnende niet geraden yets met openbare force tegens dat gespuys te attenteren.

Maer alsoo wij jegenwoordich met de opcomste eeniger Nederlandtsche schoolmeesters ende tolcken uyt voors. gewoste andermael ende claerder verstaen de gelegentheyt van gem. dootslagen ende dier vagabonden alsnoch continuerende boosheyt, wert derhalven in rade voorgestelt hoedanich ons in dito sake (welcq behalven d'enormiteyt van soo wreeden moort in regard onser verdere subjecten van quaden gevolge zij) dienden te gedragen, ten eynde meergeciteerde feyt na behooren gestrafft, 's Comp.^{es} respect bewaert, mitsgaders d'onderlinge rust ende vrede (aen dien cant door soodanige actiën dapper gekrenckt) werde gemainteneert [...]. Soo is [...] geoordeelt dat men in conformite van boven aengetogen ordre, voor desen aengeroerde Boey gegeven dito Nederlanderen (die in corten weder nae de zuyt reysen) ernstelijck sal ordineren stillekens ende voorsichtelijck (sonder yets te laten blijcken) op het doen van geseyden bevelhebber, als sijn adherenten item waer deselve meest grasseren ofte haren loop hebben, acht te slaen (fol. 884) omme haer alsoo (gelijck men secht) in slaep te wiegen ende tot securiteyt te brengen, mitsgaders (soo

wij hopen) door dien middel sonder bloetstortinge eenmael in de clem te crijgen. Welcq ingevalle echter (volgens onse intentie) niet en succedeert, soo sullen na desen wanneer 't saysoen gesonder, ende de rivieren gevoechlijck te passeren sijn, een competent getal [...] chrijchsluyden (hebbende nochtans alvoren de Torroquanders distincte reysen tot gehoorsaemheyt ende overleveringe der booswichten g'insinueert) derwaerts depecheren omme (met de hulpe Godes) een rechtvaerdige ende exemplaire straffe aen die meschante race te statueren, onse geallieerde vrunden (als wij schuldich sijn) te protegeren ende alle andere kitteloorige, ende als noch wrevelmoedige Comp.ˢ onderdanen omsichtiger te maecken. [...].

Recently, namely at the beginning of June, we repeatedly concluded from the writings of merchant Anthonij Boey that a certain headman and some accomplices of the little village Tarroquan, situated in the southern part of this island, had outrageously killed two men and six women from Soudavangh, Souloeroe and Sopalidaran, all allies of ours who were on the way back from Tedackjan where they had gone to trade. We have given Boey precise orders on how to deal with this matter, that is to quietly spy on the doings of those mentioned elders and their associates, so that in time they still can be caught, as it seems to be inexpedient to undertake anything against that scum with an expedition force.

However, because we were again clearly informed about the circumstances of the mentioned manslaughter and of the evil that still is being committed by those malefactors, by some Dutch schoolteachers and interpreters arriving from that region, a plan was proposed in the Council about how to deal with this matter (because it may have further adverse consequences for our other Formosan subjects apart from the enormity of the murder itself) so that the mentioned crime will be punished properly in order to maintain our peaceful relationship with those people and their respect for the Company's authority (which already has been greatly undermined in that area). Therefore it was decided, in accordance with the earlier mentioned orders issued to Boey, to commission those Dutchmen (who are bound to travel to the south again), to thoroughly investigate the doings of the mentioned Tarroquan headman as well as his associates, but in a careful, inconspicuous way so they remain unaware of being observed, but paying attention to where the men roam, or where they go on the rampage. (fol. 884) If we could manage (so to say) to lull

them to sleep and bring them within our control, we hope we can get them into our hands without any bloodletting. However if we do not succeed, then after some time, when the season is right and the rivers can be crossed, we intend to send a sufficient number of men (having urged the people from Tarroquan one more time to express their obedience and hand over the malefactors) to capture the offenders. Then (with God's help) we will be able to subordinate them with our arms and inflict a just and exemplary punishment on that malicious breed, with the purpose of protecting our allied friends (as we are obliged to do) and warn all the other rebellious and still rancorous Company subjects to be on their guard.

(First pilot Roeloff Sievertsen had left Tayouan on 6 July 1645 in a small 'coya' in order to check all coastal coves and inlets and rivers from Wancan northwards to Tamsuy for the presence of Chinese junks trading without Company licences. He returned on 22 July to Tayouan, delivering two letters (dated 28 June and 17 July) written by Junior Merchant Jan van Keijssel from Tamsuy. Substitute political Administrator Joost van Bergen had made the same trip over land.)

274. Missive Junior Merchant Jan van Keijssel to Governor François Caron.
Tamsuy, 17 July 1645.
VOC 1149, fol. 779. Extract.

fol. 779: Uyt Ued. gegeven ordre aenden opperstierman Roeloff Sievertsen per de gehuurde coeya, mitsgaders uyt desselfs ende den substituut Van Bergens rapport hebbe (op den 15en deser) verstaan, omme alle havenen, baeyen, inhammen etc. tusschen Tayouan ende Tamsuy soo te water als te lande te visiteren herwaerts aengesonden waren, item in de Lamcanse riviere, de Chinese handel joncken aldaer met een behoorlijcke passe van UEd.e hadde gevonden. d'Inwoonderen aldaer, gelijck mede inde meeste dorpen (daer de gem. joncken ontrent leggen) bevonden hadden, waeren in alles wat sij bevolen onwillich ende schuw van haer geweest, daer ter contrarie de voors. Van Bergen (wanneer de eerste reyse herwaerts quam) dito inwoondren in alles willich ende gedienstich na behooren hadt gevonden. 't Is seecker sulx nieuwers alleen uyt d'aldaer zijnde Chinesen, die dagelijcks in de dorpen d'inwoonders alles wijs maken dat willen,

ontstaet, vermits soodanich aldaer den meester spelen, dat nauwelijcks d'inwoonders om harenthalve aen onse natie eenich vlees ofte iet anders derven vercoopen, gelijck sulx die van Paricoesio in Lamcam ons selffs geclaecht hebben. Aen de vier dorpen van Kalika Rousut, die tot dato haer recognitie door haer ongenegentheyt in haer dorpen noch niet versamelt hebben (vermits te vooren heel willich zijn geweest), is 't mede wel te speuren dat door de Chinesen opgeruyt zijn. 't Welck onses oordeels sonder straffe ende 't achterblijven van de Chinesen niet wederom zal connen herstelt werden. [...].

fol. 779: From Your Honour's orders to first pilot Roeloff Sievertsen, sailing in a rented Chinese *coya* I understand he had to examine all harbours, bays, rivermouths, inlets etc. between Tayouan and Tamsuy, just as substitute deputy political administrator Joost van Bergen had to do, but on foot. On the 15th of this month I learned from the reports from Sievertsen and Van Bergen, that all the Chinese tradejunks they had inspected in the area north of Wancan as well as in the Lamcan River were provided with a Company's licence. However they had found the inhabitants of that area – especially those of most of the villages where the Chinese trade-junks were lying – to be timid, reluctant and unwilling to meet with the demands of our men, whereas when the mentioned Van Bergen had visited them for the first time, he had found those inhabitants to be willing and helpful in many ways. It is clear that this change occurred only because of the presence of the Chinese who daily frequent the villages and deceive the inhabitants into believing anything. They play the boss so strongly over the Formosans who hardly dare to sell us any meat or anything else, just as the villagers of Paricoutsie in Lamcam complained to us. As for the four villages of Kalika Rusudt, which until now, because of unwillingness among their villagers, have not yet collected their taxes, (although in the past they had been quite willing to do so), this attitude must also clearly be the result of the instigation by the Chinese. In our opinion this problem can not be solved without punishment and the removal of the Chinese from those places. [...].

275. Resolution, Tayouan, 28 July 1645.
VOC 1149, fol. 886. Extract.

[...] Dat de Chineesen [...] met de inwoonderen van Formosa van de Comp.^e affkerich te maken, jae tot openbare ongehoorsaemheyt op te hitsen, gelijck nogh onlanghs aen de gantsche zeecuste tusschen Dorenap ende Tamsuij (welcq den substituut Van Bergen, over 15 à 20 dagen te lande gepasseert is, ende specialijck aende vier dorpkens van Kalika Rousut (in die passagie liggende) gebleecken zij. Dewelcke volgens 't schrijven van den onderkoopman Jan van Keyssel, over lange volveerdich ende bereyt geweest, edoch jegenwoordich gantsch onwillich zijn, nevens haere nabuiren de belooffde recognitie te voldoen. Spruytende dito veranderingh als oock diversche plaetsen wrevelmoedicheyt aen dat geweste nergens anders uyt als uyt de verkeerde ende boose machinatiën der Chinesen die de dorpen, rivieren ende havenen om de noort tot noch toe (ofte met ofte sonder onsen passe) sijn bevarende. Wert derhalven (na diversche discoursen over die materie gehouden) hoochnoodich te zijn geoordeelt ende dienvolgende vast gestelt dat men van nu voortaen geene passen meer en sal verleenen op de noordelijcke plaetsen voorgenoemt, als daer sijn: Gommach, Pangsoa, Sinckangja, Mattou ende alle andere aen dien cant van boven Dorenap tot Tamsuy toe gelegen. [...].

[...] The Chinese [...] continue to encourage the Formosans to hate the Company, and they even incite them to open disobedience, (as was discovered about 15 or 20 days ago by the substitute political administrator Van Bergen, when he passed along the entire seashore between Dorenap and Tamsuy. This was even more the case in the four villages of Kalika Rusudt situated along that road. According to the writing of Junior Merchant Jan van Keyssel, these used to be ready to deliver the required taxes, but at present they showed themselves unwilling to do so. This change of mind as well as the resentment smouldering at several places in this area, results only from the spiteful and evil intrigues of the Chinese who continue to frequent the northern villages, rivers and inlets (with or without Company licences) with their junks. After profound discussions on this subject, it was therefore judged necessary and consequently determined that from now on trade licences would no longer be given to Chinese for the mentioned northern places such as: Gommach, Pangsoa, Sinckangia, Mattauw and all the other places situated on the northern side of Dorenap as far as to Tamsuy. [...].

276. Missive from Governor-General Cornelis van der Lijn to Governor François Caron.
Batavia, 31 July 1645.
VOC 869, fol. 416-421. Summary.

(fol. 416: We were pleased about the achievements of our expedition army in Cavalangh in the north, as well as in the southwestern parts of Formosa, and the fact that many villages have submitted to the Company's authority; also that finally revenge was taken on the inhabitants of Sotimor for their brutal actions of the past. Although those of Cavalangh still do not produce their taxes regularly, we do hope that the other settlements will meet with their obligations properly and that from now on the Company will be freed from the expenses of military operations. Later, when regular inspection visits will suffice, this will result in a saving in the expenditures. The newly constructed road from Tamsuy to Quelang will be very useful in this as well as in many other respects. [...]

fol. 417: We recommend that Your Honour should first of all fit out the expedition to Tarraboan and the eastern part of Formosa in order to find out the truth about the supposed gold mines once and for all. At the same time the inhabitants of Vadan, Sipien and Talleroma may be punished, as a deterrent, for their rebelliousness.

Because the Company, at present, has gained complete control over Formosa's lowlands, in which over 200 villages are situated, it will be necessary to protect the inhabitants against hostilities from the mountain peoples, who are greater in number than we expected them to be. Moreover, the Company will have to employ all possible means to also subdue the mountain people under our obedience. To that purpose it often necessary to force those who dwell in high, inaccessible places to come down in order to settle themselves on the plains as well. To that end you can best make use of the most able headmen of the nearest villages. In accordance with our Christian duty, you will always have to try to accomplish this with gentle pressure instead of applying harsh measures, in the same way, as we have heard, as has been done a few years ago in a very commendable way.

We are pleased at the way you induced the ruler of Lonckjouw to come to the castle, and under what terms reconciliation was brought about. In a

similar way you will have to deal with Tackamaha, the ruler of Sonivach and other rulers, who in the future should be reduced to obedience. We also would like to see that people everwhere are treated equally and that the law is enforced justly. It would be beneficial to the government and to the peace of mind of our Formosan subjects if you are able to deal with everyone equally.

fol. 418: It is a good thing indeed if all hamlets in the southern regions of Satanau, Dolatock, and Pangsoya, with the consent of those involved, are concentrated in a few sizeable villages. You have to pursue this policy. Separation will only be permitted on convincing arguments. We agree with Your Honour that this arrangement is highly beneficial to the Company because it enables us to collect our revenues in an easier way, and because we remain better informed about the military strength and the numbers of able-bodied men. For that purpose it remains necessary to determine the exact numbers of houses, and of the fighting men in all the villages of the area. [...]

To our amazement we learned from the account sent over to us that the expenses of the clerical work on Formosa amount to over 20,000 guilders a year. If only this considerable sum would contribute directly to the increase in the number of true Christians, as the ministers have claimed for several years, then we would not object to it. But since we understand that they have also started to have doubts about the real effects of their work, we take exception to it. Many people seem to be Christians in name only, (fol. 419) a suspicion that is confirmed by the fact that at present only seven or eight Company employees can be found who have mastered a Formosan language; a small number of teachers only can teach a few pupils! We order Your Honour to see to it that from now on this large sum of money appropriated for the propagation of the Gospel will be utilized well.

With regard to church affairs we were also surprised to hear that Reverend Van Breen was called to rebellious Vavorolang and the other villages situated in that area to the north of Tayouan. We consider it to be premature to convert the people of that area, whereas the inhabitants of Tamsuy and Quelang, because of the former presence of the Spaniards in their region, are more receptive to the Gospel. The objective is to educate indigenous Formosans who in due time will be able to teach their fellow-

countrymen, either as schoolteachers or as ministers. We expect you to employ all possible means to achieve this aim.

Although many of our people perish in the unhealthy southern region [of Formosa], (fol. 420) *the Company has to see to it that, according to our instruction, the local inhabitants will be visited at least once a year, and that the able ones are baptised by a minister or a delegate from the Church Council. Also you will have to make sure that a political commissionary will attend the meetings of that Council.*

We do not disapprove of the fact that Your Honour allowed Rev. Van Breen to be engaged in some administrative affairs, as we agree that it is sometimes inevitable in those remote places. However if we want the Formosans to respect the secular administration we should leave all those affairs to the secular authorities who have been appointed especially for that purpose. Then the ministers can devote themselves entirely to their clerical work.

Over two years ago we ordered, in order to promote the propagation of the true faith, all the old priestesses and sorceresses to be banished from all our allied villages. However, because not much has happened so far, and because this weed proves to be very harmful to the cultivation of the Christian seed, (fol. 421) *you should see to it, according to our previous order, that all these old women are banished from the Christian villages.)*

277. Dagregister Zeelandia. August 1645.
VOC 1158, fol. 713, 720. Summary.
DRZ, II, pp. 416, 422.

(Sergeant Abraham van Aertsen had taken over the command of the Company affairs in Pimaba. On 4 August a note was delivered in Tayouan in which he explained the present price level in Pimaba. At that moment 16 moose-, 60 deer-, or 60 rockgoat skins were bartered for one cangan; 20 rockgoat skins for ½ a yard Chinese 'heersay', and 30 ditto for a 'kattekijntje'. On 20 August at the castle a letter was received written in Verovorongh on 19 August, by ordinand Hans Olhoff. He had ordered soldier Jan Jansen Emandes to visit the six villages situated in a gorge along the new route to Pimaba: Maraboangh, Varangit, Pilis, Tourikidick, Toutsikadangh (which served as Emandus' place of residence) and Koulolou. It was Emandus' task to negotiate peace between the

inhabitants of the gorge and the Company. Once peace was concluded in that mountain area the Company employees would be guaranteed a safe passage to Pimaba. People from Potlongh and Talasuy complained by means of inhabitants of Cattia, about hostilities committed by those from Varangit.)

278. Missive Governor François Caron to Junior Merchant Jan van Keijssel.
Tayouan, 19 August 1645.
VOC 1149, fol. 794-799. Extracts.

fol. 794: [...] Voor alsnog en connen geene vasten staat maken, nochte de praecisen tijt bestemmen tot het houden van den lantsdach in Tamsuy. In gelegentheyt sullen daertoe peremptoire ordre geven ende U soo tijdelijck daervan adverteren, dat de citatie der bevelhebberen ofte outsten uyt alle de vereyschte dorpen nae behooren sal connen werden gedaen. Interim senden alsnu (gelijck voor desen hebben toegeseyt) een correcte beschrijvinge van 't gebesoigneerde op den Noordelijcke landtsdach, in Maert laetstleden gehouden aen Saccam, welck tot een formulier sal dienen om U in gelegentheyt daer na te rusten. Derhalven in deselve somtijts hebt te speculeeren, ten eynde onse intentie alsdoen met fondament mach werden uytgevoert. Competent getal van rottingen voor de Formosaense outsten is geprepareert, die U bij beter occasie te verwachten hebt.

fol. 795: Het opbrengen van de recognitie in die gewesten gaet (gelijck wij doorgaens mercken) vrij noch manck, besonderlijck in de Cabelaense bocht, sulcx voor tegenwoordich (hoewel ongeerne) met patientie moeten aensien, tot der tijt wij uyt Batavia ordre becomen ende 's Comp.s gelegentheyt toelaet, een aensienelijcke chrijchsmacht derwaerts af te vaerdigen om die inwoonderen met reputatie tot haer debvoir ende obedientie te brengen. Des U wert gerecommandeert interim daerop te speculeren ende met den anderen te overleggen, met hoedanigen getal soldaten yets aensienelijcx uyt te rechten, en dien hoeck te debelleren zij. [...] Echter eer het daartoe comt, sullen dito lantsaten alvoren met goedicheyt distincte malen doen insinueeren ende met gefondeerde redenen tot hun plicht vermanen opdat (bij continuatie van ongehoorsaemheyt) des te rechtveerdiger oorsaeck hebben om haer met de wapenen andermael te temmen. Wij sien dat Theodore (fol. 796), als den ouden Japander Jacinto tot invorderen der recognitie aldaer ruymen tijt gebruyckt sijn. Sulcx ons

wel gewrocht ende oordelen dito persoonen om soodaniche insinuatiën te doen niet ondienstich sijn, waerop U advijs, item de memorie der dorpen, huysen ende sielen onder Tamsuy resorterende, nae desen tegemoet sien.
Soo hebben oock met sonderling misnoegen verstaen de groote onwillicheyt der inwoonderen tusschen Dorenap ende Tamsuy [...] ondervonden, ende specialijck de verkeertheyt der inhabitanten van de vier dorpkens van Kalika Rousut, mitsgaders d'ongenegentheyt derselver, om de beloofde recognitie (die sij nevens anderen vaerdich hebben gehadt) jegenwoordich op te brengen, wij sustineeren met U dat de Chinesen tot noch toe met licentie op geseyde lantstreeck negotieren daarvan d'eenige oorsaeck [...] sijn. [...].

fol. 794: [...] For the time being we are unable to fix a date for the assembly in Tamsuy. When the occasion arises we shall send you preemptive orders and shall inform you in time about a date, so that the summoning of the headmen or elders from all the required villages can be done properly. In the meantime we shall send you (as we promised you before) an accurate description of the transaction of the Northern Land Day which was organized in Saccam last March, which may to serve as an instruction in how to deal in this matter. You will sometimes have to consider how our intentions may be carried out on a sound basis. A sufficient number of canes has been made ready for the Formosan headmen, which you may expect to be sent to you on a better occasion. [...]

fol. 795: The payment of the recognition charges in those areas (as we experience) still does not work properly. This counts especially for the Bight of Cavalangh, something which for the time being we have to watch with patience (although not with pleasure), until we receive precise orders from Batavia, when the situation of the Company will allow for the dispatch of a considerable force [to Formosa] in order to subject these inhabitants and reduce them successfully to obedience and point out their obligations to them. Therefore you are recommended in the meantime to consider and discuss with each other, how many soldiers would be required to accomplish something considerable so that warfare can be banished from that area. [...].

However before it comes to that, you should, in a friendly way, urge the inhabitants repeatedly and admonish them with well-founded motives to do their duty so that if they prefer to continue their disobedient behaviour

we shall have an even more righteous cause to tame them once more by making use of our arms. We learn that Theodore (fol. 796) as well as the old Japanese Jacinto have been employed for collecting the taxes.[112] We are satisfied with the excellent work they did and are of the opinion that the mentioned persons are not inexpedient in urging the people to obey our orders. Whereupon I await your advice as well as the list on which all villages, houses and souls, that come under Tamsuy, are registered.

Likewise we saw with extraordinary dissatisfaction, the considerable unwillingness shown by the inhabitants living between Dorenap and Tamsuy. [...] Especially the wrongness of the actions committed by those of the four hamlets of Kalika Rusudt, as well as their unwillingness to pay the promised recognition charges even though they had the commodities ready. We suppose, as you do that the Chinese who, until now were permitted to trade in that area with a Company's licence, are the only cause for this obstinacy. [...].

279. Instruction from Governor François Caron to Senior Merchant Hendrick Steen, on his way to the Company settlements in Tamsuy to assist Junior Merchant Jacob Nolpe in organising the Northern Land Day.
Tayouan, 1 September 1645.
VOC 1149, fol. 738-741. Extract.

> fol. 738: [...] Met dese gelegenheyt dat UEd. naer Tamsuy gaet sult oock (met advijs der verdere raatspersoonen) bevorderen dat den lantsdach bij UE aenwesen aldaar gehouden werde. Waertoe d'outsten ofte bevelhebberen van alle dorpen, onder Tamsuy resorterende ofte immers soo veer reycken condt, datelijck op uwe aencomste dient t'ontbieden, ten eynde sij aldaer mogen verschijnen. Onderwijlen UE. met 't bovengementioneerde besich sijt ende opdat den Tamsuysen lantsdach nae behooren, ordentelijck ende met reputatie geschieden mach, soo hebben UE.ˢ (gelijck voor desen aen Van Keyssel zaliger gesonden sij) de beschrijvinge wegens 't gepasseerde tot Saccam in Maert laetstleden (fol. 739) g'intrageert waarnaar UE. (nogtans in eenige deelen pro rato der Tamsuysche gelegentheyt) te reguleren hebt. Soo sijn oock 200 stucx rottanghs met silver (na ons d'ordinarie maniere) beslagen, ende UE. ter hant gestelt, welcke aen de hooffden ofte oudsten van den dorpen (volgens gebruyck) distribueren condt. [...].

fol. 738: [...] Now that you are leaving for Tamsuy you should also (with the advice of the other councillors) see to it that the assembly is organized during your stay over there. Therefore, immediately after your arrival, you will have to summon up the elders or headmen from all villages under Tamsuy, even those situated at the greatest distance, so that they will appear at the fortress on the fixed date. Meanwhile you should make certain that the Tamsuy Land day is organized properly, in an orderly way, and with the required prestige. Therefore we hand over to you (as we sent to the deceased Van Keyssel earlier) the description of the assembly organized last March at Saccam. (fol. 739) Your Honour will be expected (by keeping the local situation in Tamsuy somewhat in proportion) to act accordingly. To this purpose also 200 canes tipped with silver fittings (made in the usual way) were handed over to Your Honour for distribution, as is customary, among the village elders. [...].

280. Missive Governor François Caron to Senior Merchant Hendrick Steen.
Tayouan, 10 September 1645.
VOC 1149, fol. 800. Extract.

> In 't afftrecken van Tamsuy zult den capiteyn Pieter Boon, onder anderen mede schriftelijck opgeven, dat met Joost van Bergen alle de dorpen langhs die streeck naer Dorenap toe gelegen aen doet, visiteert ende de inwoonderen tot haren plicht vermaent, mitsgaders verdachtelijcken waerschouwt ende aenseght, dat haer voor rebellie ende ongehoorsaemheyt hebben te wachten, de recognitie jaerlijcx op te brengen ende wanneer onse natie ontmoeten wel te bejegenen, waerover wij rede (tot misnoegen) vele clachten hebben gehoort; ofte anders, soo zij in hare halsstarricheyt volharden, haer ruïne door vier ende swaert seeckerlijck te verwachten hebben. Gevende haer voorders te verstaen dat wij de Chinesen op straffe des doots verbooden hebben in hare dorpen te remoreren, oft' door vaertuygen eenigen handel met haer te drijven, tot geenen anderen eynde als omdat wij vernemen dito Chinesen gestadich arbeyden 't quade te wercken, den inwoonderen te verleyden, te bedriegen ende met verkeertheyt van haren plicht te trecken, [...].

While mapping out the Tamsuy region you will inform captain Pieter Boon in a letter that he, together with Joost van Bergen, should pay a

visit to all the villages as far as Dorenap and that they will remind the inhabitants of their duty. Moreover, that they will issue a warning to characters you suspect of bad behaviour, not to behave disobediently or to act rebelliously, but that every year they will have to come up with the recognition charges and that whenever they meet Company servants they should treat them well, something about which, to our regret, we have already received many complaints. However, in case they continue their stubborn behaviour, they can expect their village to be ruined by the sword, or by fire. Furthermore, you have to notify them that we, on penalty of death, have forbidden the Chinese to stay in their villages or to trade with them from aboard their vessels, because we understood that these Chinese continously create mischief, and seek to seduce and decieve the inhabitants and make them forsake their duties. [...].

281. Missive Merchant Jacob Nolpe to Governor François Caron. Tamsuy, 16 October 1645. VOC 1149, fol. 786.

> [...] Gints zijn niet aleene de verwachtende hooffden der dorpen rontsom alhier verscheenen, maer hebben oock den lantsdagh door den ondercoopman Nolpe [...] mitsgaders den vaendrich en vordere vrunden doen houden, meest op die wijse en maniere als bij UE. voor desen om de zuyt is geschiet. Hebbende ons zoo veel naer 't geschrift van dien gericht als mogelijck viel, maer 41 rottangen zijn der uytgedeelt, daeronder vijf Cabalangers die buyten vermoeden zijn gecomen. Alle hebben zij bij hanttastinge belooft de Comp.ᵉ in allen dele te gehoorsaemen, gehouw en trouw te blijven, mitsgaders t'sijner tijt hare opgeleyde recognitie willichlijck aen ons op te brengen, [...].

[...] Over here, not only the expected headmen of the surrounding villages did appear, but Junior Merchant Nolpe, as well as the ensign and other friends, were ordered to hold the assembly in almost the same way as you did at Saccam in the south. We followed the instructions of that assembly as well as possible but handed out only 41 canes, five of which were given headmen from Cabalangh, who appeared unexpectedly. All of them pledged, upon imposition of hands, to obey and stay faithful and loyal to the Company in everything. Moreover they promised, when the time comes, to deliver the imposed recognition charges, [...].

282. Missive Governor François Caron to President Cornelis van der Lijn and the Batavia Council.
Tayouan, 25 October 1645.
VOC 1149, fol. 817-866. Extracts.
See also FORMOSA UNDER THE DUTCH, pp. 210-213.

fol. 817: [...] den 22en Meert [was] den oppercoopman Philips Schillemans, met eenen troup van 50 soldaten, naer den zuydelijcke quartieren afgesonden, omme de hooffden ofte oudsten van alle bekende dorpen (soo daer als om de oost gelegen), tegens den bestemden tijdt te citeren, voornamentlijck diegene, welcq onlanghs te voren met onse chrijchsmacht bij contract vereenicht ende aen 't casteel te sullen comen, geaccordeert waren. 't Meerendeel van alle die gehuchten en dorpen hadden aangenomen ende belooft sonder fault te compareeren, dat hoewel niet achtervolchden, echter daartoe qualijck met gewelt (sonder groote macht ende apparent verlies onser soldaten) te dwingen sijn geweest. Liggende hare dorpen op soodaenige onaccessibele hoochten ende bergen, dat alsnoch genootsaeckt blijven het werck vooreerst in staat te houden, ende ondertusschen met onlust te hooren ende verdragen het moorden en dooden onder malcandren, jae selffs aen onse bontgenooten, die al voor eenige jaeren onder Comp.es sauve garde hebben gestaan, haar beloerende ende attrapperende bij nacht ende ontijden, op de wegen ende saey-velden soo dat (sonder wacker op hoede te weesen) buyten hare dorpen nergens vrij sijn. Dit moorden, rooven ende stroopen geschiet (als verhaalt is) door die van de geberchten, waarvan eenige haar woort om met ons in vrede te comen ende op den landtsdagh te verschijnen gegeven doch het selve niet gehouden hebben, werdende deurgaans opgeruyt door de gene die noch (fol. 818) noyt gewilligh sijn geweest om met ons in accoort te treden, soo dat de saecken om de zuyt vrij wat schabereus staen. Diverse clachten comen ons dagelijcx ter ooren, over moord ende dootslagen, selffs van de soodanige daarover wij (met Godes hulpe) wel rechtveerdige straffe sullen connen exerceren [...].

[De] Zuydelijcken landtsdagh is (volgens het besluyt) op den 7en April gehouden, alwaer den Tackamaha, alias Quata-ongh (zijnde eenen regent ofte oversten van 15 dorpen gelegen om de Noort, in Januarij verleeden door onse chrijchs-macht ten deele onder Comp.s gehoorsaemheyt gebracht) mede is verschenen. Die hem met sijne dorpen ende oudsten op de selve conditiën als drie maanden ten voren den Lonckiouwer aane de Comp.e heeft verbonden. Voorders is alles na de over-jarige wijse affgeloopen, excepto dat soo veel hoofden der geallieerde dorpen aldaar

niet en zijn verschenen, niet door haer eygen quaetwillicheyt ofte ongehoorsaemheyt, nae den aert der gener waarover zich vooren geclaeght hebben, maar vermits d'extreme siekte ende sterfte der kinder-pocken, die daar rontsomme seer regueren, doch noch meer, ende strenger aanden gantschen oostcandt, welcq oock veroorsaeckt heeft, dat den geprojecteerden Oostelijcken landtsdagh aldaer niet is connen gehouden werden. Zijnde den capitein Pieter Boon, (die op den 19en April met competente macht derwaarts was gecommitteert) onverrichter saecken wederom gecomen. Hebbende eenelijck per een joncq, de provisiën voor de armée (die op 't eynde van December naar de verhoopte goudt-mijnen te vertrecken staet) aldaer overgebracht, beneden Pimaba in een bambousen wooninge (expres daartoe doen maecken) opgeleght ende deselve met soldaten tot bewaringe beseth. Alvoren was geseyden capiteyn (volgens den inhout sijner instructie) naar het eylandt Bottol geseylt. Waarbij (fol. 819) gecomen zijnde heeft hij den inwoonder, die voordesen door de onse van daar gehaalt, ende van de rest sijner mackers noch in 't leven was gebleeven, nevens den tolcq (wesende eenen soldaat die de spraeck reede redelijcker wijs geleert hadde), per de chiampan naar landt gelargeert met expresse ordre aenden stierman dat voornoemden tolcq sich niet aen landt en soude begeven, maar den inwoonder eenelijck laten gaan ende wachten tot den selven met sijne landtsluyden gesproocken hebbende, weeder zoude keeren. Doch den Bottolder aen landt gesprongen sijnde, is meer gemelten tolcq, sonder vragen off spreecken hem nae gesprongen ende op 't eylandt gevolcht alwaer terstondt van 't eylandts volcq omcingelt werdende, is hij door hetselve met een snelle furie, ofte in eenen oogenblick tijdts (sonder eenich uytstel van aanspraeck te houden), in 't gesichte van 't chiampans-volcq vermoort. Als wanneer die race voorts·in 't geberchte gevlucht is, sonder dat daar iets tot redres off naarder ondersouck conde gedaan werden anders als dat den capiteyn tot revenge alle de huysen ende vaartuygen (daar men bij conde), heeft doen verbranden. De saecke was wel aangelecht ende de ordre behoorlijcq gegeven. Oock waren d'onse van alle cramerijen in dat landt begeert (naar 't advijs van den inwoonder die deselve in Tayouan hadde helpen opsamelen), om den handel te beginnen wel versien. Doch is door desen dwasen onverlaat alsoo misluckt, die oock (als verhaalt) seer jammerlijck sijn leven aldaer gelaten heeft.

fol. 820: Aen den west cant van Formosa gaet het redelijck wel, ende is ons jegenwoordich de geheele landt-streeck van Tayouan aff tot Tamsuy ende Quelangh toe veyl ende open. Sijnde daarvan diverse malen met drie à vier mannen tevens preuve genomen, ende ondervonden dat meest alle de

dorpen die het vier ende sweert gevoelt hebben, onderdanich ende wel tevreden sijn. Daarentegen degene die sonder haere schade met de Comp.e in alliantie geraecken, sich somwijlen ongehoorsaem ende wrevelmoedich thoonen, echter soodaenich niet, ofte is noch eenigsints verdragelijck. In gevalle hooger loopt ende saecke uytstel lijden can, sullen op UEd. heren bevel daarinne versien. 't Principaalste dat ons reden van misnoegen geeft is hare onwillicheyt in 't opbrengen der recognitie, besonderlijck in de dorpen die veer vande handt in de Bocht van Cabalaen, mitsgaders in den midden tusschen Tayouan ende Tamsuy sijn gelegen, welcq haar mettertijdt (soo wij vertrouwen) mede wel sullen vouchen. Gelijck bevinden aen den Tackamaha, hier vooren genoempt, sijnde met de Comp.e vereenicht, waar in reede verwin bespeuren, sedert dat de Chineesen uyt alle hoecken sijn van daer gejaecht. Want naedat wij hebben aengevangen die landtstrecq te door reysen, sijn de verholen plaatsen ende toegangen daar hun de Chinesen onthielden, mitsgaders de revieren, daer met hare vaertuygen inquamen, bekent geworden, waerover alsints reddinge hebben gemaeckt, dat gespuys verjaecht ende 't weederkeeren in dat gewest op hooge poene verboden.

Onlanghs hebben te water met een cleen jonckjen ende te lande door wackere loopers, alle die dorpen doen visiteren, met ordre dat dese visitateurs aen alle ingaande rivieren, bayen ofte bochten den anderen souden rescontreren, onderrichten ende ijder van sijn wedervaeren rapport doen, welcq tot genoegen soo volbracht is.

fol. 852: [...] Den lantsdach hadden tijdelijck vastgestelt om over de Noordelijcke dorpen (streckende van Gommach op-waarts naar Tamsuy, Quelangh, de Bocht van Cabalaen ende die geheele vlackte) gehouden te werden, blijvende eenelijck wachten naar den droogen tijdt, dat den rivieren souden doorganckelijck wesen, welcq verrichten in 't begin van September verleden alhier bij der handt genomen is. Doch niet over landt gelijck de meeninge was geweest, vermits de officieren daartoe nodich om te marcheren te swack waren, maer per een Chinese jonck te water met ordre om overlandt te retourneren, [...]

fol. 854: de oudsten der dorpen waeren reede van halffwegen de westelijcke landtstreecke door den substituut opwaerts gebracht ende tot Tamsuy verschenen, die van de Cabelaense Bocht bleven onwillich, excuseerden haar op den oogsttijdt ende en zijn niet meer als vijf oudtsten uyt de 46 dorpen aldaer geweest. Soo haest het mousson eenichsints gedoocht sullen trachten weder alles tot redres ende naer vermogen inde vorige ploy te brengen mitsgaders op middelen practiseren waarmede d'onwillige Cabalaenders tot gehoorsaemheyt sullen te reduceren zijn. [...].

fol. 817: [...] On 22 March senior merchant Philips Schillemans, was sent to the southern region in command of fifty soldiers, in order to summon the headmen or elders of all known villages (situated there, as well as in the east) to show up at the indicated time. These were mainly the elders who had concluded an alliance with our expedition force, and who had agreed to come to the fortress. The majority of all those hamlets and villages that had promised to show up without fail, did not fulfil their pledges. Yet we were hardly able to force them to attend with violence, without applying a considerable force and risking the loss of men. Their settlements are located on such inaccessible heights and mountains that, for the time being, we are compelled to leave things as they are. In the meantime, to our displeasure we learn and have to accept that the killing and murdering among them continues. This even involves attacking our allies, who already for some years have placed themselves under the Company's safekeeping. They spy upon our allies and attack them at any time of the day or the night on the roads and in their fields. Consequently, they can not go out of their villages without being on the alert. This killing, robbing and pillaging (as told above) is committed by the mountain people. Some of these have given us their word that they would appear at the northern Land Day and conclude peace with us. Yet they have not kept their promise, because they usually are provoked by those who (fol. 818) never have been willing to enter into negotiations with us. As a result of all this, matters in the southern parts of Formosa seem to be in a rather sorry state. Every day we get various complaints about blood and murder even among those people to whom we (with God's help) can mete out just punishment [...].

The Southern Land Day, as decided, was organized on the 7th of April. The ceremony was also attended by Tackamaha, alias Quataongh, the regent or ruler over 15 villages, situated to the north, which in January were partly reduced to the Company's obdience by our expedition force. Together with his people he has allied himself with the Company on the same conditions as the ruler of Lonckjouw had done three months earlier. Furthermore everything was carried out in the same way as in the past, with the exeption that many headmen of the allied villages did not show up. This was not owing to their own obstinacy, disobedience or to their disposition about which we complained earlier, but because of a grave epidemic of smallpox which was rampant over there. It raged even worse

and more extensively along the entire east coast, so that as a result the planned eastern assembly could not take place. As a result captain Pieter Boon, (who on the 19th of April was sent over there with a considerable force), returned empty-handed. He had only been able to deliver the provisions for the army in a junk (which we hope at the end of December will depart on an expedition to the supposed gold-mines). The goods were stored in a house constructed of bamboo, especially built for this purpose, a little south of Pimaba. Some soldiers were ordered to stay behind as guards. Before this, the capitain (according to his instructions) had sailed to the island Bottol. (fol. 819) When he arrived there, one islander (who had been picked up before, with some of his fellow-islanders, but who was the only one that survived),[113] besides the interpreter (a soldier who had learned to speak the local language reasonably well) landed in a sampan. The pilot of the sampan was ordered directly not to let the interpreter disembark at the same time with the islander. He should let the native go first and let him talk to his countrymen and await his return. But as soon as the man from Bottol jumped on land, the interpreter immediately followed him without asking or saying anything. On the island he was immediately surrounded by the islanders, and murdered by them in a sudden rage on the spot in front of the eyes of the sampan crew. Subsequently those people fled up into the mountains, without us being able to bring about some kind of redress or further investigation, apart from the fact that the captain, by means of a reprisal has set fire to all the houses and vessels that he could lay his hands on. This expedition was well prepared, and the orders well given. Our men were also well provided with all the merchandise that are in demand over there (on the islander's advice, who had helped to make the selection in Tayouan). Unfortunately due to that foolish miscreant it became a failure - as was mentioned a reckless act which he paid for with his life.

(The Island Malebrigo had also been circumnavigated by the junk Diemen *in May, but because of the steep cliffs surrounding the island the men could not find a suitable landing place so they had not been able to fetch any islander.)*

fol. 820: On the west coast of Formosa things are going reasonably well. At the moment the entire region from Tayouan as far as Tamsuy and Quelang is safe and open to traffic. On various occasions this was put to the test by sending out three or four men at a time, who experienced that

most of the settlements which had been destroyed by fire and sword, now act submissively towards us and are satisfied with their lot. On the contrary, those who had entered into an alliance with the Company without having suffered any damage, sometimes seem to behave disobediently and rancorously, yet not to such an extent that it cannot be tolerated. If this dissatisfaction becomes worse and the case can be temporised, we shall on Your lordship's orders deal with this matter. Our most principal reason for discontent is their unwillingness to deliver the taxes. This is especially the case with the people from the remote settlements located in the Bight of Cavalangh, as well as the villages situated in between Tayouan and Tamsuy, who as time progresses (so we trust) will finally conform themselves. We have notified the same with the aforementioned Tackamaha, who has united himself to the Company. His attitude seems to be improved especially since the Chinese were driven from every corner of that area. After we started to travel through that region, all the hiding places and entrances the Chinese hang out in, as well as all the rivers where their vessels entered, became known to us. We managed to solve that problem by chasing off that scum and forbade them to return to those places under a severe penalty.

Recently we had all those settlements inspected on water with a little junk as well as on land by brisk runners. These inspectors received strict orders that they should meet each other at a river mouth, a bay or a bight and report and exchange their experiences. This has been carried out to our satisfaction. [...]

fol. 852: [...] The date of the assembly was set for the northern villages, located from Gommach as far upward as Tamsuy, Quelang, and the Bight of Cavalangh, as well as the entire northeastern plain. Meanwhile we had to await the dry season before the rivers could be crossed which, finally, could be done last September. Yet we did not go overland as we intended, because the officers were too feeble to march but with a Chinese junk by water, with the order to return overland. [...]

(In September the Northern Land Day had not yet been held owing to various problems such as the high death rate of the Company employees stationed in the north. However the meeting had to take place anyhow because:)

fol. 854: The substitute political administrator [Van Bergen] had already directed the headmen from the villages located halfway in the western

region all the way up to Tamsuy. However, those of the Bight of Cavalangh continued to be unwilling. They pleaded as an excuse that it was harvest time. As a result only five elders out of a total of 46 villages showed up. As soon as the monsoon allows it we shall see to it that everything is brought again under our control as before and devise means by which we can teach those obstinate people from Cavalangh a lesson and reduce them to obedience. [...].

283. Resolution, Tayouan, 10 November 1645.
VOC 1149, fol. 899. Extract.

In 't eynde van 't voorleden ende begin deses jaars is menichmael in ende buyten rade over de gelegentheyt der hooch gerecommandeerde Taraboanse gout-tocht gediscoureert, oock geresolveert ende vastgestelt het onderleggen ende aenvangen van dien, maer sijn eyndelinge alle de gedane projecten ende concepten dienaengaande vruchteloos te sijn bevonden. [...] Welcke gewichtige ende lang gedebatteerde saeck alsnu finalijck met alle circumspectie ende aendachtelijck overwogen wesende, soo wert eenstemmich goetgevonden ende g'arresteert dat men op het spoedichste alle noodige preparaten tot den tocht zal toestellen omme uytterlijck op primo December aenstaende, [...] van hier op te trecken. [...].

fol. 900: [...] Bij aldien het oock den tijt ende gelegentheyt naer verrichten saecken ontrent Tarraboan sal toelaeten, soo sullen oock d'overhoofden der armée in 't wederkeeren [...] hun debvoir aenwenden om die van Vadaan, Tellaroma ende andere rebelle wrevelmoedige quanten ende specialijck de Sipiense moordenaars (in conformite onser resolutie van den 9en maert laestleden) na bevindinge van saken soodanich met de wapenen te straffen, dat eenmael aen dien cant in beter ontsach ende devotie mogen gehouden werden, [...].

At the end of last year and at the beginning of this one we repeatedly, in and outside the Council, discussed the highly recommended expedition to the gold-sites of Tarraboan and decided how and when this important undertaking could best be organized. Yet, in the end, after careful and deliberate consideration, we realized that all the earlier plans have proven to be useless. So having deliberated this weighty and long debated case with all circumspection, we unanimously agreed and arranged to make all necessary preparations on the earliest occasion, so that the expedition could leave Tayouan on the first of December at the latest. [...].

fol. 900: [...] If time and circumstances permit, after the affairs near Tarraboan have been accomplished, the officers of the army [...] should exert all their strength on the return journey to punish other rancorous rebels of Vadan, Talleroma and other areas. Special attention should be given to the murderers from Sipien (conform our resolution 9 March last) who, if possible, need to be punished by our arms in such a way that, once and for all, that area will subdued to the Company's authority.[114] [...]

(Lieutenant Hans Pietersz. Tschiffellij was appointed commanding officer of the army of 210 men, while Senior Merchant Cornelis Caesar would act as the commander of the entire expedition assisted by Senior Merchant Nicasius de Hooghe as second-in-command).

284. Instruction from François Caron for Senior Merchants Cornelis Caesar, Nicasius de Hooghe and Lieutenant Hans Pietersen Tschiffellij on the expedition to the eastern part of Formosa.
Tayouan, 27 November 1645.
VOC 1160, fol. 598-608. Extracts.

fol. 600: [...] Dien van Terraboan ende Amadola als andere dorpen die haer met het goutsoecken ofte handelen erneren zult, alsoo geen ofte heel weynich vellen ende rijs van haer selffs hebben, maar die van anderen voor gout ruylen moeten, haere recognitie in goedt suyver goudt opleggen. Te weeten voor ijder huysgesin één maes swaerte dito ende dat jaerlijcx daerin hebben te continueeren, [...] ende deselve [bewoners van Talleroma] bevorens doen insinueren dat sonder geweer bij UE. verschijnen ende vergiffenisse comen bidden, over haeren gepleechde moetwil, soo aenden Gouverneur Traudenius zaliger ende den cappiteyn fol. 601: Boon in 't doortrecken onser armaden beweesen, als dat 's Comp.^es onderdaenen beoorloght, recognitie geweygert ende oock andere daertoe gebracht hebben. Dit alsoo naer onser voorstel succederende, zullen de belhamels ende aenleyders van die boose acte echter met een civiele straffe van geltboete ofte andersints dienen gecorrigeert. Doch ter contrarie, ingevalle hartneckich blijven ende zij UE. vermaningen, noch serieuse beloften van trouw ende vreede verwerpen ende niet aen en nemen, zal UE. voornoemde belhamels ende aenleyders door gewelt der wapenen zien te becomen, ende mogelijck zijnde in goede verseeckeringe herwaerts aen 't casteel brengen. Vooral wel lettende dat geen onnoosel bloet noch van mannen, noch vrouwen, noch kinderen vergoten wert, 't selve naer

uytterste vermogen excuseerende. Naer verrichter zaecken zult alle dorpen daer ontrent ende die door passeert, uyt onsen name selffs off door andere, aencundigen de reden waerom dese straffe geschiet dat hun wel wachten van zulcx mede te pleegen en diergelijcke etc.

Den Vadanders welckers bevelhebbers, alhoewel zulcx op andere schuijven, gesuspecteert werden van den soldaet Jan Huybertsen (wie weet waeromme), ongeveerlijck vier jaeren geleden vermoort te hebben, zijn eenen geruymen tijt herwaerts, niet tegenstaende meermaels haares plichts door onse residenten in Pima vermaent zijn, zeer rebel ende wrevelmoedich geweest. Hebbende haer niet ontsien als aenleyders met die van gemelte Pima, Soupra ende Saccareya aen te spannen ende dien van Pissinangh, 's Comp.es hertelijcke toegedaene vrunden, omdat den voornoemden gouverneur ende cappiteyn in 't gaen en keren met de krijchsmacht veel goets en behulpsaemheyt hadden bewesen, vijantlijck aen te tasten, haer dorp te plunderen ende met haere complicen vierenveertich persoonen, soo mans, vrouwen als kinderen, de koppen aff te slaen ende deerlijck om 't leeven te brenghen. Oock hebben zij, zoo wij geïnformeert werden, haer niet ontsien 't opbrengen der jaarlijcxe recognitie fortelijck ende met vermetele woorden te weygeren, seggende wij mochten die selffs met wapenen comen halen. Welcq niet genouch in haere oogen wesende, hebbende daer en boven noch andere dorpen noordelijcker op gelegen, zulcx (fol. 602) te doen verhindert, dreygende hun met den oorlogh soo iets aende Hollanders opbrachten, ende den genen te dooden die om haer ten besten te vermanen uytsonden. Dienvolgens wanneer in Telleroema de zaken in maniere voors. affgehandelt zijn, zullen UE. om Comp.es gesach te bevestigen deselve ten exempel van andere geen minder straffe opleggen als gemelte Telleromaers. [...]

Die van Sipien zult doen affroepen ende tot vreede vermaenen sonder voorder straffe op te leggen, vermits de verantwoordinge wegens 't ombrengen van den corporael Albert Tomassen gedaen hebben, ende haere vasticheyt off woonplaetse oock zoo inaccesibel is dat qualijck connen werden gedwongen. UE. zullen sich daer van naeder informeren ende de zeeckerheyt naesporen, waermede ende hoedanich dat zij, ingevalle hartneckich blijven, te vermeesteren zullen zijn. [...]

fol. 603: Dat dien van Pimaba haer op ons ontbieden, doen jonckst den oorloge jegens den vorst van Lonckjauw voerden, niet te velt verscheenen ende doorgaens wanneer ons haere hulp ontbrack zeer onwillich in 't hantbieden geweest zijn. Dat met dien van Vadan, niet tegenstaende haer zulcx meermaels verbooden was, [...] den oorlogh jegens onse goede onderdaenen de Pissinangers gevoert, ende seven hooffden daervan

gebracht hebben. Item dat door eenige moetwilligers 's Comp.^{es} huysinghe
alleen om haer te beschadighen in brandt gesteken ende hierdoor vorders 't
gantsche dorp affgebrandt is, sonder dat tot noch toe de minste deligentie
bij de bevelhebbers aengewent zij, om soodanige moetwilligers in handen
te becomen, veel min van hun behoorlijck te straffen ende sorge te
draagen dat het goedt in de brandt gesteecken de Comp.^e wederom ter
handt gestelt werdt. UE. zullen derhalven trachten die brandtstichters ende
oock eenige van die moetwillichste gasten nae Tayouan te schicken. [...]
Sousangh, zijnde eenen oudtsten van 't dorp Tavalij, heeft dese plaetse bij
nae tegens danck van de meeste ingesetene langen tijt in rebellie gehouden,
op sijn eygen goetvinden, dat hem nochtans diverse malen verbooden
was, den oorlogh jegens die van Lonckjouw gevoert, verscheyde hooffden
van daer gehaelt, ende zijn volck die hem hierin niet wilden assisteren
haer beste goet affgenomen ende qualijck getracteert. Oock den cappiteyn
Boon jongst moed en math daer verbij marcheerende, met de wapenen
gedreycht te comen bestoocken (fol. 604) edoch naerderhandt om alles
wederom goet te maken, heeft op de menichvuldige waerschouwinge den
oorlogh verlaeten ende ten tijde de recognitie geïnnet werdt, sich weder
daer in wel gedragen, dat wel eenichsints te considereren staet, des UE.
zich naer bevindinge van zaecken daerin hebt te reguleren.
Alhoewel die van Tamalacauw over de vuyle moordt van den coopman
Wesselingh redelijcker wijs gestraft zijn, zoo en laten echter niet
doorgaens d'ooren op te steken, weygerende voorleden jaare nevens
d'andere dorpen de gestelde recognitie op te brengen, waer in den outsten
Sanghij ten principaelen voor gaet. Hebbende de zelven, zoo daer toe ten
besten van hem vermaent werdt, den regent Reduth seer smaedelijck ende
buyten fatsoen uytgescholden ende hierdoor gewert dat voorgangen jaare
geen recognitie van die plaets is opgebracht. In gevalle bevindt dat
daerinne noch continueert zal dienen bij den cop gevadt ende naer
Tayouan opgebracht off soodanich gestrafft te werden als zult bevinden te
meriteren.
Dien van Saccaraya hebbende nevens Pima ende Vadan den Pissinangers
bestoockt, stellen haer mede door toedoen van haaren outsten Alibanban
zeer moetwillich aen, weygerende niet alleen de gemelte recognitie op te
brengen maer dreygen noch daer en boven die van Soupra, Darcop ende
Pallan, met de wapenen aen boordt te comen, zoo iets dierwegen aen de
Hollanders geven etc. UE. zullen in voegen als vooren verhaelt daer naer
informeren ende deselve mede naer merite corrigeren.
Immer soo slim maken 't die van Tarroma, hebbende hun over twee jaer
van achteren 't landt, langhs eenen secreeten wegh door 't geberchte,

nevens die van Sotimor, Cavido ende Panguan, jegens ons ten oorloghe vervoecht, van daer uyt de geoccupeerde bagagie voor haaren buyt te rugge brengende een Engelsche muts, een grauwen hoet ende een paer silvere spooren die door twee jongelingen van haer dorp genaempt Poelonley ende Sackoeley, naer haer eygen zeggen inde batalie selffs becomen hebben, ende door Cornelis van der Linden ons van daer weder (fol. 605) herwaerts gebracht. Boven dit hierop moedich geworden zijnde, hebben naaderhandt d'inwoonders van Sipien uyt onsen name affgedrongen goede perthije elantshuyden als andere vellen, die tot voldoeninge van de recognitie, bijeen versamelt waeren, als wanneer nae 't becomen vandien, de luyden noch spottelijck beschimpt ende uytgejout hebben. 't Welck beyde vrij slordich compt ende nevens die van Tellaroma ende Vadan gestraft dient.

Den outsten Sarremene die lange, jegens onse expresse ordre, in Oudt Tipol met eenige aenhangh was blijven woonen, ende naaderhandt door gestaadige vemaninge eyntelijck omlaech in Nieuw Tipol sich meede needergeslaagen heeft, zult over dese ongehoorsaemheyt, ende opdat anderen hun daeraen mogen spiegelen nae dat bevindt te behooren, hierover perticulier in 't opbrengen eeniger amenden straffen. [...].

(The expedition to the eastern coast of Formosa was undertaken with the aim of discovering the Tarraboan gold sites, which we had been searching for for so long. Furthermore the men had to assist in organizing the Eastern Land Day in Pimaba.)

fol. 600: [...] Those of Terraboan and Amadola as well as the other villages who earn a living by seeking and trading in gold, hardly possess any deerskins or rice, which they have to barter for gold. Therefore you should impose on them taxes in pure gold. One family should deliver one mas of solid gold which has to be continued every year. [...]

(Afterwards the men were ordered to visit Talleroma:) You should announce to the inhabitants of that place that they will have to appear unarmed before Your Honour in order to ask forgiveness for the mischief committed by them in the past against the deceased Governor Traudenius as well as against Captain Boon (fol. 601) when they passed through their territory with their army. Furthermore they waged war against our allies and they refused to settle their taxes and even incited others do the same. We would like you to act according to our proposition in this matter, that is to first impose a moderate punishment, like a fine, on the principal rogues and instigators of those malicious acts. Subsequently, if they

continue their subordinate behaviour and if they pay no heed to your
admonitions, or if they renounce every serious promise of loyalty and
faithfulness, then You will have to get hold of the mentioned rogues and
instigators by force and, if possible, send them under heavy guard to
Zeelandia Castle. You will have to take care, to the best of your ability,
not to spill any blood of innocent men, women and children. After
everything has been carried out, you will on our behalf, make known to
every settlement your men are passing through, the reason why those
penalties were inflicted and warn them that they also should make sure
they do not commit similar offences etc.

The headmen of Vadan who, although they try to pass the buck on to
others, are suspected of the murder of soldier Jan Huybertsen, (who
knows why) committed some four years ago, have for a long time
behaved in a very obstinate and rebellious manner, nothwithstanding the
warnings of our residents in Pimaba. They even acted as instigators in the
conspiracy with those of Pimaba, Soupra and Sakiraya against those of
Pisanan, who happened to be the Company's cordial and dedicated allies
on account of their assistance to our governor [Traudenius] and captain
[Boon] when these passed by with their respective forces. The
conspirators attacked Pisanan, pillaging the village and cutting off the
heads of, and murdering 44 people, men, women and children.
Furthermore we were informed that Vadan boldly to refused to pay the
yearly taxes, saying that we could come ourselves to collect the goods by
force. As if that was not yet enough Vadan had even incited other
villages, situated further to the north, to do the same, (fol. 602) threatening
them that if they paid anything to the Dutch, they would wage war against
them and that they would kill anyone sent out by the Dutch urging them
to payment. Therefore, when affairs have been settled in Talleroma
according to plan, You should, in order to confirm the Company's
authority and as a deterrent to others, punish these people in the same
severe way as those of Talleroma. [...]

Those of Sipien you will have to summon to come down in order to
negotiate for peace, without inflicting any further punishment on them as
they have taken the responsibility for the death of corporal Albert
Thomassen. Moreover, we can hardly force them to come, as their
residence is situated on an almost inaccessible spot. Your Honour will
have to investigate this further and examine in what way and how they

may eventually be overpowered in case they continue with their tenacious behaviour. [...]

(Afterwards Caesar, De Hooghe and Tschiffellij had to invite all the eastern headmen to come to the next assembly. A hundred canes fitted with silver had been taken along to present to all the chiefs who might attend.)

fol. 603: Recently, when we waged war against the ruler of Lonckjouw, those of Pimaba did not bring their warriors into the field upon our summoning. They remained unwilling to help us out when we needed them later, and conspired with those of Vadan against our loyal subjects from Pisanan (though we had forbidden them to do so), and even seized seven heads from there. Some mischievous ones committed arson on the Company's house in Pimaba for the sole reason of committing sabotage, and as a result the entire village burned down. Yet the headmen did not make any real effort to catch the culprits, nor did they do anything to punish them properly or to claim restitution for the merchandise lost in the fire. Your Honours must therefore round up the fire-raisers and send them off to Tayouan. [...]

Sousangh, one of the elders of the village Tawaly has for a long time continued to keep his village in a rebellious mood, even if this went against the will of most of its inhabitants. Also, on his own instigation and against our will this man waged war against Lonckjouw and captured several heads. Those of his people who proved themselves unwilling to assist him in this warfare were treated badly and were deprived of their personal belongings. When captain Boon marched by Tawaly with his exhausted men recently, this Sousangh threatened to raise up arms against him. (fol. 604) However, afterwards he did his best to make up for the committed offences and has given in to our warnings by putting a halt to the warfare. However when we collected the required taxes, he behaved rather well, which is something you should keep somewhat in mind.

Although those of Tammalaccouw have been well punished for the mean murder of merchant Wesselingh, they still continue to behave in a rebellious manner. Last year they, and other villages, refused to deliver the imposed levies, principally on the instigation of the elder Sanghij. After he had been admonished for this by the regent of Pimaba, Redout, Sanghij cursed him in a most scornful and offensive way. As a result no taxes were paid by Tammalacouw last year. If you hear that this elder

continues to refuse payment, you either will sent him off to Tayouan or you will have to inflict whatever penalty you consider to be appropriate.

Those of Sakiraya have, together with Pimaba and Vadan, participated in the attack on Pisanan. Incited by one of their elders, Alibanbangh, they act very spitefully, not only by refusing to pay the taxes, but in addition they intimidate the inhabitants of Soupra, Daracop and Pallan, whenever these deliver anything to the Dutch. Your Honour, as mentioned earlier, should, after careful examination take the proper corrective measures.

Those of Tarouma acted just as badly. Two years ago they, together with the warriors of Sotimor, Cavido and Panguang, took a secret road through the mountains and raised up arms against our expedition army. They even managed to bring home some of the luggage of the men which was carried off as loot.[115] Later on resident Cornelis van der Linden (fol. 605) confiscated and brought back an English cap, a grey hat and a pair of silver spurs which two youngsters of Tarouma, named Poelonley and Sackoeley, said that they had captured during the fight. In addition, having become over-confident those of Tarroma, in our name, succeeded in cajoling a good supply of saved up elk- and other skins from the inhabitants of Sipien, which had been collected for tax purposes. After they had obtained all the skins they ridiculed and jeered at the Sipiens. Both offences can not be tolerated and therefore Tarouma needs to be punished, just like the inhabitants of Talleroma and Vadan.

Sarremene, the elder who, together with some of his followers, and contrary to our explicit orders had continued to hang on in Old Tipol, and who afterwards upon our repeated warnings finally came to settle down in New Tipol, should be punished on account of their disobedience, as a deterrent to others. [...]

(On account of the foregoing events it was decided to send out a punitive expedition to the eastern part of Formosa. Also the need for the organisation of the Eastern assembly was seen. All villages, especially the culprits who had behaved contrary to the Company rules, were to be admonished or punished. A clear instruction had to be drafted that the Formosans, unless they received explicit Company orders, were no longer allowed to wage war on their own authority against any other village. Further, they were obliged to annually deliver the required recognition charges or taxes. If they act according to the wishes of the Company then

in return they could count on military assistance against their enemies at all times.)

285. General Missive, Batavia, 31 December 1645.
VOC 1154, fol. 68-85.
FORMOSA pp. 237-239.

286. Missive Governor François Caron to President Cornelis van der Lijn and the Batavia Council.
Tayouan, 31 January 1646.
VOC 1160, fol. 147-170. Extracts.

fol. 147: [...] uyt Pimaba trocken voorts, ende werden alsints wel bejegent, totdat quamen bij de rebelle dorpen Saccareya, Tellaroma ende Vadan, van welcke moetwilligers eenige bij het leger verscheenen in een geveynsden en gemaeckten schijn van vrundtschap, die eenelijck in woorden bestaende, ende genoechsaem spottelijck was, want de minste sustentie van eenige ververschinge (jae tot water incluys) voor het leger te brengen geweygert wert. Derhalven d'onse vandaer weecken naer (fol. 148) een ander plaetse daer tot genougen water te becomen was. Marcheerden corts daer aen weder opwaerts tot eyndelijck in het dorp Tarrabouan quamen, alwaer van de inwoonders mede nieulijck ende (naer vermogen) wel onthaelt werden. [...] Soo en is echter geen ander bescheyt van de gelegentheyt en oorspronck des gouts becomen als 't gene hier vervolgens wert gespecificeert:

Eerstelijck hebben onse officieren bevonden, dat het dorp Tarrabouan (welck bij deselve riviere leyt daeruyt het goudt gewonnen werdt) niet meer als 70 huysen groot zij en bewoont met ongeveerlijck 450 sielen, daeronder 90 à 100 weerbare mannen. Wesende redelijck civijl, doch een arm, ellendich, catijvich volck dat seer becommerlijck levende, selden genouch heeft om den buyck te vullen, bestaende haer voetsel eenelijck in pattattas, oubijs ende weynich geerst.

Wanneer dese luyden door onse officieren gelast werden haere recognitie jaerlijcx in goudt op te brengen, te weten voor ijder huys een maes swaerte, ende zulcx tot een beginsel datelijck mosten in het werck stellen, bevonden daer groote swaericheyt in maecten ende veel onder haer daerom te doen was. Zij wilden ons (uyt grooter vreese) geerne contenteren, des oock met den anderen alle haer cieraet van dun geslagen gout, dat om den hals droegen (in bewijs harer gewillicheyt) gaven. Wegende (fol. 149)

tezamen 25 realen swaerte, zijnde zeer slecht van alloy welck bij dese inwoonders om de quantiteyt te vergrooten alsoo met silver vermenght werdt. Vijff realen aen silver ende twee realen swaerte zant gout (zijnde in wesen gelijck het zelve uyt gemelte riviere gewonnen werdt) brachten nae veel zouckens noch daer bij. Boven 't welcke geen meer gout in 't geheele dorp te becomen was, hoe nauw en scherpelijck daernae versochten, des oock de onse gelooven moesten zulcx de waerheyt te wesen, zonder haer in 't minste te connen inbeelden, eenich gout door dese luyden verborgen gehouden ofte versteecken zoude zijn, vermits 't contrarie uyt alle omstandicheden conden affmeten.

Over eenen tijdt geleden waren d'inwoonders van de Cabelanse bocht met een vaertuych bij haer geweest (gelijck oock jaerlijcx gewoon zijn daer te verschijnen) om gout te handelen, aen de welcke (naer eygen bekentenisse) twintig realen swaerte hadden verruylt tegens cangans waermet haere naecte huyt (voor de koude) bedecken, vermits de hertevellen daer seer spaersaem te becomen zijn. Dese verclaringe accordeert met de kennisse die ons der wegen is toe gecomen; naementlijck dat onse residenten in Quelangh om dien tijdt eenich goudt tot Tarrabouan hadden geruylt, welck wij UEd.ᵉ voordesen hebben toegeschickt. Onse officieren hebben geduyrende haer aenwesen dese luyden altoos vrundelijck bejegent, mitsgaders (onder andere redenen) vraechs-gewijse voorgestelt, ofte zij oock met de Nederlanders te handelen genegen zouden wesen. Hadden zoo veel van ons als van de Cabbelanders voor hun gout te verwachten, ende diergelijcke. Daerop antwoorden: 'Jae gantsch geerne', item dat jaerlijcx door het geheele dorpsvolck ongeveerlijck 40 à 50 realen swaerte uyt de riviere versamelt wert, zomtijts wat meer ende dan weder min, naerdat haer de tijden ende de winden behulpich waeren. Want dit gout niet dachelijcx noch ordinarij te becoomen is, maer eenichlijck bij stormich ende regenachtich weder alsdan compt het van boven dese riviere naer beneeden gesact, ende wert inde mont der riviere (daer het water in zee loopt) met groote moeyten, ende langdurigen arbeyt uyt het zant gesocht.

fol. 150: *[De rivier werd vier mijl stroomopwaarts gevolgd:]* [...] Omtrent een halffmijl vrouger, eer noch in de reviere door het water gestuyt werden, vonden op den steene wal ter zijden eenen wech naer boven, die beneden ten dele met clijne trapkens gecapt ende voorts naer boven met rottingen om bij op te comen versien was. Twee der flucste waechhalsen begaven haer, om dese steylte te beclimmen doch zijnde ongevaerlijck een vierde part geadvanceert, moesten weder naer beneden keren, dat oock (vermits de schrickelijcke steylte) niet zonder perijckel van vallen en 't leven te verliesen, toeginck. Desen wech (zoo de inwoonders van

Tarrabouan getuygen) comen de menschen met apenhooffden bij wijlen af, ende gaen weder naer boven. Welck padt men haer niet volgen kan, ende zoo 't iemandt zich wilde ondervinden, die werdt van boven zo danich met steenen gegroet, dat onmochelijck zij 't selve te volbrengen. [...]

fol. 151: *[Uiteindelijk werd besloten:]* datter twee à drie bequame luyden bij de revier in 't dorp Tarrabouan ofte Tackilis wierden gelecht om de spraecke te leeren ende mettertijdt (door ondervindinge van zaecken ende opmerckinge), naerder kennisse te krijgen. Namentlijck wat voor menschen die luyden, die men secht apenhooffden te hebben, wesen mogen, off deselve oock spreeckelijck ende te genaken zijn, off boven bij haer inde geberchten, ofte vlackten, daer sij souden moogen woonen, oock eenich gout te vinden is etc. Onderwijlen zouden dese residenten jaerlijcx met eenen troup van 20 soldaten connen werden besocht. Vertrouwen voortaen vredich zullen connen passeren want alle de inwoonderen aen dien oostcandt gelegen, in groote vreese gebracht zijn door de straffe die de malinquanten onlanghs in 't afftrecken onser armée hebben (fol. 152) gecregen, te weten de dorpen Saccareye, Tellaroma ende Vadan, ende dat volgens de dreygementen die haer van over drij jaeren om haer moetwillicheyt ende moorderijen gedaen zijn, van de welcke het moordtnest Vadan (dat één der grootste ende aensienlijckste dorpen, naer onser kennisse, op Formosa was), in d'assche gelecht werdt, met alle zijne proviande. Veertich getelde coppen zijnder in de furie gesneuvelt, doch 't getal der gequetsten blijft onbekent. Over de 500 menschen dootshoofden, in drie huyskens te pronck gestapelt staende, hebben d'onse aldaer gevonden, die dese landt bedervers van tijdt tot tijdt, uyt de dorpen omhergelegen hadden gehaelt. Jae selffs vande geene die met ons reede in verbondt getreden waren, gelijck aen 't dorp Piessenangh geschiet is, 't welck zij gestraft hebben, omdat desselfs inwoonderen onse soldaten behulpich hadden geweest, ende haer met rijscoecken als andersints versien. Doodende van deselve 44 onnoosele menschen, om het welck revensieren voor desen noyt gelegentheyt en is geweest. Die van de dorpen Tellaroema ende Saccareya waeren t'samengespannen met meyninge om op d'onse in te vallen, terwijlen een gedeelte van hare ons, in scheijn van vrundtschap ophielden, belovende victualie te brengen ende hutten te maken. Maer d'onse zoo haest zulcx vermerckten, ende een groote menichte daervan in de ruychten loerende, gewaer werdende, schooten in den hoop, doch bleven niet meer als ses persoonen doot. Het dorp Saccareya werdt voorts in brandt gesteecken, zulcx de inwoonderen van Tellaroma vernemende, quamen met groote verbaestheyt geloopen, brengende verckens, geerst, ende dat vermochten, schreeuwende ende

biddende om genade, dat men doch haer dorp van den brandt wilden verschoonen. Gelijck geschieden, werdende haren wrevel quijt gescholden ende zij voorts in vrede gelaten.

Dit aldus verricht wesende, is onse armée vandaer weder naer Pimaba gemarcheert, met intentie om [...] den Oostelijcken lantsdach aldaer te houden, waertoe de snaren, voor 't optrecken nae de noordt, bij de opperhooffden wel gestelt wesende, aldaer op de wedercompste heel ontstelt bevonden zijn. Want (fol. 153) geen oudsten van de dorpen aen dien candt, zoo lange onse macht daer was, bij haer en dorsten verscheynen, seggende dit was een practijcke om met haer te handelen, gelijck voor desen met Tipol geschiet was, die men in der minne ontboodt ende daernaer gevanckelijck wechvoerde etc. In somma d'onse vermerckende dat door geende middelen iets tot dese zaecke meer te voordren was. [...] fol. 167: [...] Langhs den gantschen westcandt van Formosa, bij zuyden ende noorden, houden haer de inwoonderen der vlacte (welck alle met de Comp.ᵉ vereenicht zijn) vredich ende wel. De clachten over de moetwil ende moorderijen om de zuyt zijn geexcuseert nae dat eenige van die gasten gestraft hebben, ende in de kettingh gaen laten. 't Schijnt dat de berchluyden oock wel met goedicheyt ende in der minne voortaen tot ons zullen te trecken zijn, gelijck rede in den tijdt van drie maenden persoonen van veerthien nieuwe, zoo groote als cleene dorpen, om vreede met ons te maecken aen 't casteel verscheenen zijn. Die wij deurgaens wel tracteeren, een cangangs pack ende één à twee stucken cangangs vereeren, mitsgaders recommandeeren dat haere naebuirige dorpen oock daertoe willen aenmanen. Welck zij ongetwijfelt naecomen, want zij door alle 't gepasseerde in dese één à twee jaren tot achter dencken ende vreese gebracht zijn. 't Zal een gewenste zaeck wesen, ingevalle dat zoo voortganck nemen ende continueeren mach, dat den Almogenden geve, zoo zullen vele oncosten (die den oorloch naer zich sleept) geëxcuseert ende die ongeschaeffde wilde menschen van schade in haer goedt ende bloet bevrijdt blijven.

From Pimaba the army marched on and they were treated well everywhere, until they reached the rebellious villages Sakiraya, Talleroma and Vadan. Some malicious villagers came to the army to welcome the men. It soon became clear that they only simulated friendship and that they availed themselves of hypocritical words, because the men did not receive the least support as the vilagers refused to bring any refreshments (not even a drop of water) to the army. Therefore, shortly after, it was decided to move and to march on (fol. 148) to another place were enough

water could be obtained. Finally they arrived in Tarraboan, where the soldiers were welcomed warmly (according to the inhabitants' ability). [...] However all the information our men could get about about the location and origin of the gold is the following: Firstly our officers did learn that the village of Tarraboan (which is situated next to the river in which gold is extracted) does not consist of more than 70 houses and is inhabited by about 450 souls, among them 90 or 100 fighting men. The inhabitants seem to be rather civilized but they lead a very poor and miserable existence, and rarely have enough to eat. They only feed themselves on sweet potatoes and a little millet.

When the people were ordered by our officers that they had to pay their annual taxes in gold, namely one mas of gold for every household, and that we expected them to observe this demand right away, we noticed that they were aggrieved and that many of them were concerned about this. Out of fear, they were willing to satisfy us, so that, in order to show us their obedience, they all together presented us the adornments of thin beaten gold which they were wearing around their necks. This, all together weighed (fol. 149) only 25 reals and was of a very poor alloy, because in order to increase the quantity, the inhabitants blend it with silver. After much seeking they came up with some more silver, weighing five reals, and some gold dust weighing two reals, similar to the gold gained from the mentioned river. Then, no matter how strongly we insisted, nothing else was to be found anymore in the entire village. We believed they spoke the truth, because it seemed quite obvious that they did not hide any gold from us. A while ago some inhabitants from the Bight of Cavalangh had paid them a visit in a vessel (as they are accustomed to do every year) to barter for gold. The village of Tarraboan confirmed to us that they had exchanged a weight of twenty reals of gold for *cangans* which they need for clothing to cover their naked bodies with for protection against the cold, as deerskins are very rare to get in that area. This statement agrees with the information we already got. Namely that our residents at Quelang earlier, just at that time of the year, had traded some gold originating from Tarraboan, which we forwarded to Your Honour. During their presence our officers used to treat these people in a friendly way, in the meantime making inquiries whether Tarraboan would be willing to trade with the Dutch, telling them that they could expect as much for their gold as they were used to receiving from

the people of Cavalangh. They replied: 'Yes, we gladly would like to', and added that the village people gathered about forty or fifty reals of gold each year from the river. Sometimes a little more and sometimes a little less, depending on the winds and the tide, as this gold could not be obtained easily in an ordinary way but only during stormy and rainy weather when the gold comes down with the current of the river and can be collected only with great effort and difficulty at the river mouth.

fol. 150: *(A small group of the men marched along the river as far inland as they could go. About four miles upstream they encountered a waterfall and the riverbanks became steep cliffs, blocking any further advance:)* [...] At about half a mile before [the cascade blockaded their way], they discovered at one side a path which led up along the steep-sided rocky bank. Below, a few steps were cut out and a little further upwards some bamboo canes were put to facilitate the upward climb. Two of our most bold daredevils went up to climb the precipice, but after having advanced for about a fourth part they had to return which also, because of the dreadful steepness, could not be done without great danger of falling to their death. This path, as was explained by the inhabitants of Tarraboan, sometimes is used by the people with monkey-heads to descend and also to ascend. It would be impossible to follow them along this path and those who might dare to try to do so and climb that route will be pelted with stones by means of a welcome. [...]

(Governor Caron concluded from this that the real goldmines were not to be found in the area. The only thing left to be done was:) (fol. 151) To station two or three able men at the river or into the village of Tarraboan or Tackilis in order to learn the language. In due course (being taught by experience) they might amass knowledge about what kind of people the so-called people with monkey-heads are, and whether we can get closer to them and somewhat communicate with them, and find out if any gold can be found up in the mountains and on the upland plains where they seem to be dwelling. In the meantime these residents could be visited each year by about twenty soldiers. We trust that from now on our men can travel safely through the entire eastern side of Formosa, because since our latest expedition, all the eastern people fear us very much thanks to the punishment inflicted (fol. 152) on the evil-doers: Sakiraya, Talleroma and Vadan had received this punishment for the murders and offences they

had continued to commit, notwithstanding that they already had received warnings for more than three years.

The murderers' den Vadan, according to our knowledge one of the largest and most considerable villages on Formosa, with all its supplies has been reduced to ashes. Forty people were killed in the heat of the fight, but the number of wounded people is not known. Our men discovered over 500 human skulls, piled on top of each other and displayed in three small houses. This scum had seized those heads from the villages that surrounded them, yes, even from those settlements who were already our allies, like the people of Pisanan. Because these had been helpful to our soldiers and had provided them with rice cakes and such, 44 innocent people were killed [by Vadan]. So far the opportunity has never presented itself to revenge our allies. Those of the villages Talleroma and Sakiraya had connived to attack us, while some of them, under the pretence of friendship, promised to come up with provisions and to build huts for us. But as soon as our men grew suspicious and noticed a crowd hidden in the bushes spying on them, they at once opened fire, but only six people got killed. Subsequently the village of Sakiraya was set on fire. When the inhabitants of Talleroma learned about that, they came running towards us in great fear, bringing pigs, millet and anything they could get, screaming and begging us for mercy so that we would save their village from the fire. We decided to do so and to forgive them their behaviour and left them in peace.

When this all had been carried out, our army marched back to Pimaba, with the intention of organising the [...] Eastern Land Day at that place for which, when the men started on their march northward, everything seemed to be fine to the headmen. Yet, upon our return everything turned out to be completely out of tune (fol. 153) as none of the headmen of the villages situated over there dared to appear in front of us. They said that it was only a trick to subjugate them, in a similar way as we did before with those of Tipol, whom we also had invited in an amicable way to come over, but who afterwards had been carried off as prisoners etc. To put it briefly, we realized that nothing could be done anymore to execute this matter.

(Because the men were exhausted, due to the many rivers crossed and mountains climbed during the march, it was decided to leave Pimaba and

postpone the Eastern Land Day until a future occasion. The army returned to Tayouan on 16 January 1646.) [...]

fol. 167: [...] Along the entire western side of Formosa, to the south as well as to the north, the inhabitants of the plain (who are all allied with the Company) behave themselves peacefully and amicably. The former complaints about malice and murder which occurred in the south, ceased after we had punished those culprits and put them into chains. It seems that from now on also the mountain people can be appeased by us in an amicable and friendly way, because within three months already people from fourteen new villages, large as well as small, appeared at the castle to conclude peace with us. As a rule they are treated well by us and are presented with a *cangan* package as well as one or two loose pieces of *cangans*. We also recommend them to urge their neighbouring villages to do the same, something which undoubtedly they perform because everything that happened during these one or two years probably gave them food for thought and reason to fear and respect the company authority. It is to be hoped that if affairs proceed like this (the Almighty may grant that) that all the expenses which are needed for warfare may be done away with and that these uncivilized savage people may be safeguarded from harm to their possessions and their kin. [...].

NOTES

1. See for the results of the military expedition to Lamey in 1633 (under the command of Claes Bruyn): *Formosan Encounter*, I, nrs.: 114, 118, 143.
2. See entry 27: *Dagregister Zeelandia*, Extracts concerning Lamey, 3-4 May 1636. VOC 1170, fol. 604-605.
3. See entry 4: Agreement settled between the VOC and Mattouw and Sincan, Tayouan, 18 December 1635.
4. The transcription of the text is taken from the original manuscript.
5. *Tamsuy*, this village is situated in the south of Formosa.
6. This letter has not been found in the archives.
7. *Jacques*, inhabitant of Tavocan.
8. *Swarte* (black) in seventeenth-century Dutch colonial vernacular denotes dark coloured Asians.
9. *Christoffel*, (Warner) Sprosman, corporal stationed in Sincan.
10. *Kockje(n)*, (Cockje), probably a Chinese who acted as Company's guide and interpreter in the southwestern region.
11. This letter has not been found in the archives.
12. Meant is major Adriaan Anthonisz. who left Tayouan aboard the *Grol*, as commander of an expedition to Quinam in February 1636, see: *DRZ*, I, pp 230, 235.
13. This missive has not been found in the archives.
14. *Joost van Bergen*, corporal stationed in Sincan.
15. The manuscript gives: *vermindren*, decrease. From the sentence it becomes clear that: *vermeerdren*, increase is meant.
16. This letter has not been found in the archives.
17. See: *Formosan Encounter*, I, pp. 270-287.
18. *Dicka*, headman of Sincan, see: *Formosan Encounter*, I, passim.
19. A duplicate can be found in VOC 1169, fol. 227-247.
20. This passage remains rather obscure. Junius may have meant to say: the crowns or silver and gold coins that the Lameyans were said to own; see Extract Dagregister Lamey, VOC 1170, fol. 604-606. Pangsoya and Sincan provided auxiliary troops for tracking down the runaway Lameyans. According to this sentence they even intended to go on their own account to the island to carry out their duty.
21. See also: *DRZ*, I, p. 251, *Formosa under the Dutch*, p. 115.
22. This letter has not been found in the archives.
23. The extracts copied in VOC 1170 are dated Tayouan, 21 November 1648.
24. A duplicate can be found in VOC 1169, fol. 227-247.
25. See the resolution of 2 June 1636: Entry No. 37.
26. Collectie Teding van Berkhout 14, fol. 16.
27. Extracts taken from the Zeelandia Castle Resolution-books concerning the resolutions about Lamey. VOC 1170, fol. 581-600. Extract 2 June 1636.

28. In the margin is written: This letter should be inserted on 13 June, two pages before.
29. Collectie Teding van Berkhout 14, fol. 16.
30. Extracts taken from the Zeelandia Castle Resolution-books, concerning the resolutions about Lamey. VOC 1170, fol. 581-600. Extract 14 June 1636.
31. A duplicate can be found in VOC 1169, fol. 227-247.
32. VOC 1170, fol. 613-614, see also: VOC 1120, fol. 433-435, published in: *DRZ*, I, pp. 259-261.
33. The manuscript gives Pacceij.
34. The fols. 1352-1355 are missing. After fol. 1356 another missive, Junius to the Batavia Church Council, Sincan, 27 October 1636 is inserted on fols. 1337-1339.
35. See also: VOC 1120, fol. 449-451, published in *DRZ*, I, pp. 271-272.
36. A duplicate can be found in: VOC 1123, fol. 682-721.
37. See: Memorandum how and in what way the people of Lamey are allocated over the ships of this fleet, Tayouan, [...] October 1636. VOC 1123, fol. 724: Entry No. 55.
38. See: Missive from Governor Hans Putmans to Governor-General Hendrick Brouwer, Tayouan, 21 February 1636, fol. 235: Entry No. 5.
39. This letter has not been found in the VOC-archives.
40. *In are* (Frans: ariter): confiscating possessions.
41. In the next passage (continuation of fol. 342 and the first part of fol. 343) the same information of the missive of 10 November (on fol. 29-30) is repeated.
42. In *DRZ*, I, p. 295, it is assumed that the Dae Mountains could be present-day Taiwu Range in the Pingtung district. See also *DRB* 1637, p. 37: 10 February 1637.
43. A duplicate can be found in: VOC 1169, fol. 227-247.
44. The extract resolution in VOC 1170, fol. 591 gives *Cageutel* and *Dahanangh*. But the manuscript of *DRZ*, VOC 1123, fol. 891 names them as *Tagutel* and *Tahanangh*.
45. A part of the same dagregister can be found in: Extract from Dagregister Zeelandia, Tayouan, 21 December 1637-12 December 1638. Collectie Salomon Sweers, 7.
46. Resolutions, Tayouan, 24 October 1637-14 December 1638. VOC 1128, fol. 511-553. Resolutions 24, 26 October 1637, fol. 511-512.
47. VOC 1128, fol. 448, published in *DRZ*, I, p. 391.
48. See: VOC 1128, fol. 427, 435-436; published in: *DRZ*, I, pp. 373, 379-381.
49. Duplicates can be found in: VOC 1123, fol. 939-942, and in VOC 1169, fol. 227-247.
50. The missive continues on fol. 914 with a summary of the expedition to Pangsoya and to Lamey in November 1637. See the dagregister: VOC 1123, fol. 939-942.
51. The manuscript gives 1000. From the the total number of 19,650 becomes clear that it should be 10,000. See also: VOC 1131, fol. 282: Entry No. 109.
52. A duplicate can be found in VOC 1169, fol. 227-247.
53. This passage, which is hard to read due to damage to the manuscript, has been reconstructed by means of information from other sources.
54. Some parts of this letter are illegible because of damage to the manuscript.
55. The instructions have not been found in the VOC-archives.

56. On fol. 531 a summary of Wesselingh's journey is given, which is covered by Wesselingh's own journal: VOC 1131, fol. 835-840: Entry No. 102.

57. The list of the allied villages drawn up in Pimaba in 1639 by junior merchant Maerten Wesseling (VOC 1131, fol. 841-844.) is included in the report. There is a slight difference in the spelling of the topographical names.

58. The continuation of this report is published in: *Formosa under the Dutch*, pp. 182-183.

59. This journal is not available anymore in the VOC-archives.

60. A duplicate can be found in: VOC 1169, fol. 227-247.

61. See for the names of the headmen: *DRZ*, II, p. 2. In his missives to the Amsterdam Chamber of 30 October and to Governor-General Van Diemen of 6 November 1641, Traudenius reports about the 'landdag': see the entries of those dates.

62. See for the expedition to Vavorolangh: Missive Governor Paulus Traudenius to Governor-General Anthonio van Diemen, Tayouan, 22 December 1641. VOC 1140, fol. 256-259: Entry No. 133.

63. See for the priestesses or *inibs*: *Formosan Encounter*, I, passim.

64. *Geuse*, seabeggar.

65. In the missive of Governor-General Anthonio van Diemen to Vice-Governor Paulus Traudenius, Batavia, 16 April 1642. VOC 866, fol. 147-158. Van Diemen urges Traudenius to severely punish the murderers of Wesseling and junior merchant Ruttens and his company of two men (fol. 156). He is not aware that at that moment the revenge had already taken place.

66. The expedition in January 1642 commanded by Traudenius. See: *DRZ*, II, p.12.

67. This dagregister is not available anymore in the VOC-archives.

68. The dagregister is not available anymore in the VOC-archives.

69. This dagregister is not available anymore in the VOC-archives.

70. See the report by Lamotius about St. Jago and the Cavalangh area in: *DRZ*, II, pp. 27-28.

71. Situated in Luzon, Philippines.

72. Probably Tafalla in Navarra (Spain).

73. The Spanish settlement in Quelangh was built in 1626.

74. Foster child.

75. Both places are situated in the northern part of Luzon, Philippines.

76. Soldier Adriaen Waetermondt was stationed in Pimaba and from 1642 in Vadaan and other eastern villages.

77. The expedition to Pimaba, Tammalaccauw, Vadaan etc. under the command of Traudenius, January and February 1642. Missive Governor Paulus Traudenius to Governor-General Anthonio van Diemen, Tayouan, 16 March 1642. See the summary inserted on that date.

78. The manuscript gives: Tayouan.

79. *DRZ*, II, p. 43.

80. See: VOC 1146, fol. 649-651.

81. See: Instructions Governor Paulus Traudenius to Commander Major Johannes Lamotius, on his exploration journey to Vavorolangh, Gielim, Betgilem (Dorenap) and other villages situated in the north. He was also ordered to look for an

overland route from these villages to Tamsuy; Tayouan, 20 November 1642. VOC 1146, fol. 649-651. The contents of this instruction add no new information to the letter of Traudenius, Tayouan, 4 December (Entry No. 158), and the missive from Lamotius himself, Vavorolangh, 27 November 1642 (Entry No. 157).

82. This is also mentioned in the missive of Traudenius to Van Diemen, Tayouan, 6 December 1642. VOC 1146, fol. 717.

83. The second part of this missive is a true reproduction of the missive written by field-commander Johannes Lamotius to Governor Paulus Traudenius, Vavorolangh, [27 November] 1642. VOC 1141, fol. 141: Entry No. 157.

84. See also: Instruction of Governor Paulus Traudenius to Major Johannes Lamotius, given upon his departure to sail to Pangsoya and to Lonckjouw where he was to punish the ruler and his people for their disobedience. Tayouan, 18 December 1642. VOC 1146, fol. 697-699. The contents of this instruction are almost identical to the resolution of the same date: Entry No. 160.

85. The names of the headmen of the northern vilages are mentioned in the dagregister by Pedel, *DRZ*, II, pp. 93-133.

86. The manuscript of VOC 1170 gives: *onthelsden*, decapitated but in the other copy: VOC 1169 on fol. 246 the word onthelsden is changed in: *omhelsden*, embrace. As it seems from the further sentence that the Pangsoyans let Tamarissa go and also nothing is mentioned about him on 16 February, the last meaning of the word seems to be the most likely.

87. The second part of this letter, from which the following extract has been taken, has not been published in: *Formosa under the Dutch*.

88. This dagregister by Pieter Boon is published in *DRZ* II. The missive of President Maximiliaen Lemaire to Governor-General Anthonio van Diemen, Tayouan, 12 October 1643 (Entry No. 209) gives a detailed report of the expedition. The brief instruction is not inserted as it contains no additional information to the dagregister: President Maximiliaen Lemaire to Captain Pieter Boon c.s. on the expedition to sail with three junks and two Dutch vessels via Tamsuy and Quelang on to Tarraboan and Amadola, to explore the goldmines in that area, Tayouan, 20 March 1643. VOC 1146, fol. 560-563.

89. The manuscript gives *Pimaba*.

90. The manuscript gives: '*opperhooffden overhooffden*'.

91. A copy of this missive can be found in: VOC 1146, 612-647.

92. The folio's 603-604 are missing in the manuscript. Folio 605, which has been preserved, does not contain any relevant information.

93. The names of the villages and headmen are mentioned in *DRZ*, II, pp. 237-242, 249-251. See also the letter from Governor François Caron to Governor-General Anthonio van Diemen, Tayouan, 25 October 1644. VOC 1148, fol. 256-280: Entry No. 240.

94. See for the names of these headmen: *DRZ*, II, pp. 256-257.

95. See: *DRZ*, II, pp. 257-263.

96. The fiscal's part in this does not become quite clear, probably he was present at Tamsuy to conclude some judicial affairs. In 1644 Adriaan van der Burgh held the rank of fiscal.

97. It does not become clear who this boy was and why he was kept in the fortress in Tamsuy.

98. Dirck Segerman was given permission to trade on his own account in the villages, see: *DRZ*, II, p. 254.
99. The memorandum is not available anymore in the VOC-archives.
100. See: *DRZ*, II, pp. 259-260.
101. Two folio's of the manuscript are numbered 738.
102. Boon's dagregister gives: 'we immediately sent some men from Kimaurij and Tamsuy thither'. *DRZ*, II, p. 339.
103. The journey over land from Tamsuy to Tayouan is described in Boon's dagregister, VOC 1148, fol. 201-205, in: *DRZ*, II, pp. 347-350.
104. The Dutch titles of the headmen in the original list have been translated into English. The first thirty villages are mentioned as well in the dagregister of Pieter Boon included in the manuscript of the Zeelandia Dagregister, *DRZ*, II, pp. 343-344. There are some minor variations in the spelling of the names.
105. *DRZ*, II, pp. 247-248.
106. One *morgen* is equal to two acres.
107. The names of the 15 villages differ from those on the list mentioned in the Dagregister Zeelandia: *DRZ*, II, p. 369.
108. See: Verbaal van Formosa, by senior merchant Johan Verpoorten, VOC 1158, fol. 43, in: *DRB 1644-1645*, p. 170.
109. See for the names of the headmen and villages: VOC 1158, fol. 668-670, *DRZ*, II, pp. 372-374.
110. The manuscript gives *Maleyers*: Malays.
111. The first part of the instruction is identical to the one issued out to Sergeant Michiel Jansz on his departure to Pimaba on 3 January 1645. VOC 1155, fol. 616: Entry No. 251.
112. For *Jasinto* see: *DRZ*, II, 54-56.
113. See: *DRZ*, II, p. 33.
114. The resolution of 9 March is not available anymore in the VOC-archives, see the resolution of 21 March 1645: Entry No. 260.
115. This had happened on 19 December 1643, see: *DRZ*, II, pp. 216-217.

GLOSSARY

Arack	liquor distilled from fermented sap of palm trees, molasses or rice
Armozijnen	fine silk cloth named after the city of Ormuz
Banserans	probably from *bangsa* (Malay) lineage, nobility, nation
Bariga	(Portuguese) *bariga* belly: second quality
Cabessa	(Portuguese) *cabeca* head: first quality
Cagiaenders	Company slaves originating from Caganayan (Luzon)
Cangan	(Hindustani) *kanga* a multicoloured cotton shawl usually from Coromandel
Catte merauwen	catamarans
Catty	(Malay) *kati* Chinese weight: 1 catty is 16 taels; 100 catties is 1 picul
Chitiatso	Chinese name for yellow coloured beads
Dagregister	daily register, journal
Damask	heavy Chinese silk
Massacauw	strong liquor of the Formosans
Gantang	weight
Hamadongh	shack
Heersay	first quality twilled woolen cloth
Kae	square measure
Kattekijntje	jacket
Koban	Japanese coin
Lanckins	first quality Chinese silk
Landdag	Land Day, assembly of the headmen of the Formosan villages
Limgout	Religious festival of Sincan
Marnas	Formosan harvest festival
Mas	weight
Moussous	unknown textile
Oranckay	(Malay) *Orang Kaya* lit. rich person: title of the Pimaba ruler
Padres	Spanish Catholic priests
Pampangers	Christian inhabitants of the Pampanga region (northeast of Manila, Philippines) who served as soldiers for the Spanish

Pangsies	Chinese silk textiles
Pee	(Portuguese) *Pe* foot: third quality
Picul	(Malay) a man's load: 1 picul is 100 catties is 125 Amsterdam pounds
Quel, quelpaert	small type of sailing vessel
Quataongh	Grandruler or *Tackamacha* of a number of villages situated in the nortwestern part of Taiwan
Real	Spanish silver coin of 6 stivers or 48 stivers: *Real of eight* or *Piece of eight*
Red dog's hair	worn by the Formosans as adornment
Sampan	a small type of vessel, probably from (Chinese) *sanpan*: three boards
Tackamacha	see *Quataongh*
Taycon	(Chinese) *Taikun* captain

BIBLIOGRAPHY

Andrade, Tonio
'Political Spectacle and Colonial Rule: The *landdag* on Dutch Taiwan, 1629-1648'
In: *Itinerario*, Vol. XXI-3 (1997), pp. 57-93

Ang Kaim
'Pei i-wang-ti T'ai-wan yuan-chu-min-shih - Quata (Ta-tu fan-wang) chu-k'ao' (A preliminary study of the Quata-ong - a forgotten page of Taiwanese aboriginal history)
In: *Taiwan Fengwu,* Vol. 42-4 (1992), pp. 145-188

Ang Kaim (Weng Chia-ying)
Ta T'ai-pei ku ti-t'u k'ao-shih (A Study of an Ancient Map of the Greater Taipei Region)
Taipei 1998

Beylen, J. van
Zeilvaart Lexicon, viertalig maritiem woordenboek
Weesp 1985

Blussé, Leonard
'De grot van de zwarte geesten; op zoek naar een verdwenen volk'
In: *Tijdschrift voor Geschiedenis* 111 (1998), pp. 617-628

Blussé, Leonard
'Retribution and Remorse: The Interaction between the Administration and the Protestant Mission'
In: Early Colonial Formosa' in Gyan Prakash ed., *After Colonialism, Imperial Histories and Post-colonial Displacements*, (Princeton 1995), pp. 153-182

Blussé, J.L., N.C. Everts, W. Milde, Ts'ao Yung-ho eds.
Dagregisters van het kasteel Zeelandia, Taiwan 1629-1662
Volume I: 1629-1641, RGP, grote serie 195
Volume II: 1641-1648, RGP, grote serie 229
Volume III: 1648-1655, RGP, grote serie 223
Volume IV: 1655-1662, RGP, grote serie 241

's-Gravenhage 1986, 1995, 1996, 2000

Campbell, W., ed.
Formosa under the Dutch, described from contemporary records
(reprint, Taipei 1992) First edition London 1903

Chang Hsiu-jung, A. Farrington, Huang Fu-san, Ts'ao Yung-ho, Wu-mi Tsa, Cheng Hsi-fu, Ang Kaim eds.
The English Factory in Taiwan, 1670-1685
Taipei 1995

Chen Chi-Lu
Material Culture of the Formosan Aborigines
Taipei 1968

Cheng Shaogang
De VOC en Formosa 1624-1662, een vergeten geschiedenis
(Thesis) Leiden 1995

Cheng Shaogang
Ho-lan jen tsai Fu-ehr-mo-sa (The Dutch on Formosa)
Taipei 2000

Chiang Shu-sheng
Je-lan-che-ch'eng jih-chi (The Diaries of Zeelandia Castle)
Volume I, Tainan 2000

Chiang Shu-sheng, Ts'ao Yung-ho, Pau Lo-shih, eds.
The Inventory of Dutch East India Company Related Documents (Ho-lan Tung-In-du kung-sze you kuan T'ai-wan tang-an mu-lu)
Volume 10 of the *T'ai-wan-shih tang-an, wen-shu mu-lu* Series
Taiwan University, Taipei 1997

Coolhaas, W. Ph., ed.
Generale Missiven van Gouverneurs-Generaal en Raden aan de Heren XVII der Verenigde Oostindische Compagnie
Volume I: 1610 -1638, RGP, grote serie 104
Volume II: 1639-1655, RGP, grote serie 112
's-Gravenhage 1960, 1964

Daghregisters gehouden in 't Casteel Batavia
21 volumes Batavia, 's-Gravenhage 1887-1928

Grothe, J.A., ed.
Archief voor de Geschiedenis der Oude Hollandsche Zending
Volumes III, IV: (Formosa 1628-1661)
Utrecht 1886, 1887

Kang, Peter
Chih-min chieh-chu yü ti-kuo pien-chui: Hua-lien ti-chü yüan-chu-min shih-chi chih shih chiu shih-chi-ti li-shih pien-ch'ien (Colonial contact and imperial frontier: the historical transformation of the Hua-lien aborigines from the seventeenth to the nineteenth century)
Taipei, 1999

Kang, Peter
'Transformation of Regional Village Powers within the North and Mid-section of Hua-tung Valley in the 1640s and the 1650s'
In: *Taiwan Historical Research*, Volume 5, no. 2, (2000) pp. 1-33

Kang, Peter
'A Preliminary Inquiry on the Settlement and Population of the Nan-shih Amis: From the Seventeenth to the Nineteenth Century'
In: *Taiwan Historical Research*, Volume 4, no. 1 (1999) pp. 5-48

Murakami Naojiro and Nakamura Takashi eds.
Batavia-jō Nisshi (The Diaries of Batavia Castle)
3 Volumes, Tokyo 1970-1975

Raben, R., H. Spijkerman, eds. (Inventory by M.A.P. Meilink-Roelofsz)
The Archives of the Dutch East India Company (1602-1795)
's-Gravenhage 1992

Shepherd, J.R.
Statecraft and Political Economy on the Taiwan frontier 1600-1800
Taipei 1995

Teding van Berkhout Collection
Algemeen Rijksarchief
Inventory by M.C.J.C. Jansen-Van Hoof
's-Gravenhage 1974

Teeuw, A.
Indonesisch-Nederlands Woordenboek
Dordrecht 1990

Ts'ao Yung-ho
'Taiwan as an Entrepot in East Asia in the Seventeenth Century'
In: *Itinerario*, Vol. XXI-3 (1997), pp. 94-114

Ts'ao Yung-ho and Pao Lo-shih
'Hsiao Liu-ch'iu yuan-min-ti hsiao-shih' (The extirpation of the original
inhabitants of Hsiao Liu-Ch'iu)
In: Pan Ying-hai ed., *P'ing-pu yen-chiu lun-chi* (A Collection of studies on the
Plains Aborigines), Academia Sinica, Taipei 1994, pp. 413-444

Verdam, J., E. Verwijs
Middelnederlandsch Woordenboek
's-Gravenhage 1885-1941

Yule, H., A.C. Burnell, eds.
*Hobson-Jobson, a glossary of colloquial Anglo-Indian words and phrases, and of
kindred terms, etymological, geographical and discursive*
(reprint London, New York 1986) First edition London 1886

INDEX

THE FORMOSAN ENCOUNTER

Volume II: 1636—1645 定價 1200 元

編 著 者	L. Blussé & N. Everts
出 版 者	順益台灣原住民博物館
	台北市(111)至善路 2 段 282 號
	☎(02) 2841-2611　Fax:(02) 2841-2615
	http://www.museum.org.tw
	e-mail:shungye@gate.sinica.edu.tw
國際書號	ISBN 957-99767-7-5
版　　次	2000 年 10 月初版一刷
印 刷 者	國順印刷有限公司
廠　　址	板橋市中正路 216 巷 2 弄 13 號

發 行 者	南天書局有限公司
	台北市(106)羅斯福路 3 段 283 巷 14 弄 14 號
	☎(02) 2362-0190　Fax:(02) 2362-3834
	郵政劃撥 01080538 號
	http://www.smcbook.com.tw
	e-mail:weitw@smcbook.com.tw